WALES' 1000
BEST HERITAGE SITES

TERRY BREVERTON

AMBERLEY

About the A

Terry Breverton is the author of twenty books of We
awarded 'Welsh Book of the Month' by the Welsh Bo
author). He lives in Maesycrugian in Carmarthenshii

Praise for Terry Breverton:

100 Great Welshmen
Welsh Book Council Book of the Month June 2001
'A celebration of the remarkable achievements of his countrymen' *The Guardian*

A-Z of Wales & the Welsh
'A comprehensive overview of Wales & its people' *The Western Mail*
'A massive treasure chest of facts & figures' *Cambria*

The Welsh Almanac
Welsh Book Council Book of the Month August 2002
'A must for anyone with a drop of Welsh blood in them' *The Western Mail*

100 Great Welsh Women
'A fascinating read' *The Daily Mail*
'Breverton's breadth, generosity and sheer enthusiasm about Wales are compelling'
The Sunday Express

Immortal Last Words
'Reading this splendid book will make you happy to be alive' *Daily Mail*

First published 2010

Amberley Publishing Plc
Cirencester Road, Chalford,
Stroud, Gloucestershire, GL6 8PE

www.amberleybooks.com

Copyright text and illustrations © Terry Breverton 2010

The right of Terry Breverton to be identified as the
Author of this work has been asserted in accordance with
the Copyrights, Designs and Patents Act 1988.

ISBN 978-1-84868-991-6

British Library Cataloguing in Publication Data.
A catalogue record for this book is available from the
British Library.

Typeset in 9.8 pt on 11 pt HS Garamond Pro
Typesetting and Origination by Amberley Publishing
Printed in the UK.

Introduction

Heritage is inclusive – it is what makes up a country. Thus this book includes not just the churches, castles and buildings one would expect to find, but also the industrial heritage of Wales, its islands, paths, Roman roads, SSSIs, Areas of Outstanding National Beauty, mountains, parks, gardens, holy wells, viewpoints and vistas – natural heritage which has to be protected just as much as medieval castles and cathedrals. It is, of course, impossible to give the 'best' sites, as that is a subjective opinion. Some may argue that this church or that town should have been given more detail, but it is a difficult task to place the thousands of sites in Wales in this book. There are over 3,000 sites associated with early Celtic Christian saints of the Dark Ages, for example. There are equally too many castles – the most per square mile in the world. Wales also in the nineteenth century had the largest number of places of worship in the world per head of population. Its holy wells, from the Dark Ages of the rest of Europe, deserve a multi-volume book alone. There are simply too many historic and prehistoric remains to do them all justice. All one can say is that this author has written over twenty books about Wales and the Welsh, is Welsh, lives in Wales and takes his holidays in Wales – there is still so much to see in this small nation.

It may seem idiosyncratic, but this author has kept to the 'thirteen historic counties' in geographical placements. For the majority who read this book, Clwyd or Powys means nothing compared to Radnor or Flint. Of these thirteen historic counties, Glamorgan (subdivided) and Anglesey remain, but Monmouthshire is now called Gwent. Clwyd now contains Denbighshire and Flintshire. Dyfed is Carmarthenshire, Pembrokeshire and Ceredigion. Gwynedd now contains Caernarfonshire, Conwy and Meirionnydd (Merionethshire). Powys contains Breconshire, Radnorshire and Montgomeryshire. Thus there are now five new 'super-counties' and the various other administrative areas, which make little sense and will probably alter again when the next local government reorganisation comes along, ostensibly to make savings. I apologise if anywhere has been omitted – please contact the publisher to forward any suggestions, which hopefully will be added in any later addition. A few sites in England, along the border with Wales, supplement the 1,000 Welsh sites, because of their significance in Welsh history. There are actually more than a thousand places included here, because there are sometimes adjoining sites, such as St David's Cathedral and the Bishop's Palace.

The purpose of the book, more than anything, is that we try to care for what we have left. Building over history is not progress. There are hundreds of hillforts and tumuli remaining, although many tumuli have been ploughed out. Forestry has covered ancient sites and spoiled vistas that have lasted for thousands of years. Celtic crosses broken up or used in field banks and lost forever. Holy wells, such as St Baruch's at Barri Island, have had new housing dumped on them. Wales' history is in its landscape – the survival of the language has given us detail about the Age of the Saints and their dedications. We can trace through our wonderful landscape where the Silures fought the Romans from their hillforts, how the Romans built their roads and forts to access precious Welsh minerals, how the early Welsh saints and princes used these Roman sites, how early churches were hidden from constant waves of invaders, how the Welsh princes were forced to push up castles against the Norman threat, where the Normans placed their castles on their constant invasion, where battles were fought, all the way up to how our industrial heritage is reflected in the landscape. It is a wonderful country to write about – an even better one to explore and fall in love with.

ABBEY CWM-HIR – CISTERCIAN ABBEY RUINS *North of Llandrindod Wells, Radnorshire LD1 6PH.* These remote ruins and fishpond lie in the secluded Clywedog Valley and date from 1176, and the patronage of Cadwallon ap Madog of Maelienydd. Under Llywelyn the Great, it was extended in the thirteenth century, but passed to the Mortimers, who neglected it in favour of Wigmore Abbey. The headless body of Llywelyn II is thought to be buried here, and there is a plaque to mark him. The abbey was damaged in 1402 during the War of Independence of Owain Glyndŵr. Its importance is indicated by the fact that its nave, at 242 feet, was only exceeded in length by those at the cathedrals of York, Durham and Winchester. In 1644, the buildings were besieged and captured by Myddleton's Roundheads and dismantled.

ABBEY CWM-HIR – GRADE II* VICTORIAN MANSION *Web: abbeycwmhir.com.* The Hall at Abbey Cwm-Hir (Long Valley) was built in 1834 and is one of Wales' finest examples of Victorian Gothic Revival architecture, overlooking the abbey ruins. The nearby church is interesting, and the village's The Happy Union Inn is itself a Grade II listed building.

ABERAERON – BEAUTIFUL COASTAL VILLAGE AND HARBOUR WHERE ONE IN FOUR HOUSES IS OF SPECIAL ARCHITECTURAL OR HISTORIC INTEREST *Between Cardigan and Aberystwyth on the A487.* The town has a long history as a fishing port, and in 1805, plans were laid to construct the harbour at the mouth of the Aeron River. This resulted in the town being greatly expanded with many fine houses being built, with John Nash reputedly involved in the planning of the new town. Shipbuilding also flourished with over sixty sailing vessels being built including thirty-five schooners. The town retains its Georgian charm with elegant brightly painted town houses. Offshore is Ceredigion's Maritime Heritage Coast, the first offshore conservation area of its kind in the UK.

ABERCAMLAIS – EARLY GEORGIAN MANSION *5 miles west of Brecon, off road to Sennybridge. E: info@abercamlais.co.uk.* With unaltered interiors, it is a splendid Grade I listed building in the Usk Valley, originally dating from the Middle Ages, but altered extensively early in the eighteenth century. In the gardens there is an octagonal Georgian dovecote serving as a bridge over the Camlais, leading to a walled garden. The dovecote's lower storey served as a privy (latrine). Thomas Williams, Vicar of Llanspyddid, inherited the house in 1570, and his descendants have lived here ever since.

ABERCASTLE – OLD FISHING VILLAGE AND NEOLITHIC REMAINS *(See ABEREIDDI to ABERMAWR) between Mathry and Trefin, Pembrokeshire Coastal Path.* A tiny working harbour which exported slate and farm produce, with ruined limekilns and corn store, below Carreg Samson burial chamber. Abercastle is so called because it is near Castell Coch, a Neolithic promontory fort with two ditches and ramparts.

ABER CASTLE MOUND (PEN-Y-MWD) – EARTHWORK MOTTE *Abergwyngregyn, Caernarfonshire – see GARTH CELYN.* The large, conical, flat-topped mound is constructed from river boulders and is known as Pen-y-Mwd. Mwd in early Welsh means vault or chamber, and it is thought to be a fifth- or sixth-century ceremonial site, which was reused in the eleventh century. Above it is Garth Celyn, the palace of the princes of Gwynedd.

ABERDARE – FORMER INDUSTRIAL TOWN *At the head of the Cynon Valley, at the confluence of the Cynon and Dar rivers, Glamorganshire.* On the southern edge of the Brecon Beacons, Aberdare was hugely important in the production of coal, but all the local collieries have been closed. St Elvan's church is Victorian, but commemorates Saint Elfan (Elfanus), who with Dyfan, Medwy and Ffagan helped evangelise Wales in the second century. There is a statue of Griffith Rhys Jones in the town centre, the conductor who led the South Wales Choral Union to win the first choir competition, held in the Crystal Palace in 1872.

4

ABERDARON - FORMER FISHING VILLAGE, ON THE PILGRIMAGE PATH TO YNYS ENLLI *At the tip of the Llŷn Peninsula, Caernarfonshire.* The Nobel Laureate poet R. S. Thomas was the vicar at St Hywyn's Church in the village. The National Trust owns nearby Mynydd Mawr, where there are fine views to Ynys Enlli (Bardsey Island). The pilgrim's pathways to Aberdaron for Bardsey came through Clynnog, Llanaelhaearn, Pistyll, Nefyn, Tydweiliog, and Llangian on the north side of the Llŷn; or Llangybi, Penrhos, Llanbedrog, Llangian, Llandegwning and Bryncroes in the centre; or Llangian, Rhiw and Llanfaelrhys on the south side. The ancient Y Gegin Fawr (the great kitchen) was where pilgrims ate before the perilous crossing to 'the Isle of 20,000 Saints'. Two miles away is Porth Oer with its famous 'whistling sands'.

ABERDEUNANT - TRADITIONAL CARMARTHENSHIRE FARMHOUSE - NATIONAL TRUST *Taliaris, Llandeilo, Carmarthenshire SA19 6DL. Tel: 01558 650177 (Dolaucothi Gold Mines).* In an unspoilt setting, Aberdeunant (The Mouth of Two Streams) provides an insight into traditional agricultural life, situated in an unspoilt setting in the beautiful Cwm Dulais (Dulais Valley). The 'gegin fawr' (large farm kitchen) and one bedroom are shown to visitors by Aberdeunant's tenant.

ABERDULAIS FALLS - NATIONAL TRUST - WATERFALLS USED AS AN INDUSTRIAL POWER SOURCE SINCE THE SIXTEENTH CENTURY *Aberdulais, nr Neath, Neath & Port Talbot SA10 8EU. Tel: 01639 636674.* Europe's largest electricity-generating water wheel can be seen in action here, next to famous waterfalls. The turbine house provides access to an interactive display, fish pass and observation window. Copper smelting started at this site in 1584, and the power of the waterfall was used for 400 years in manufacturing. This is a fascinating industrial site with a tin workers' exhibition, and it has been called 'Britain's most beautiful industrial heritage site'.

ABERDYFI (ABERDOVEY) - ANCIENT PORT *On the A493 west of Machynlleth.* There has been a ferry across the Dyfi since at least 1188, and Aberdyfi was recorded as a fishing port in 1569. Just east of Aberdyfi is an ancient house called Braich y Celyn, where a sea captain and his girlfriend were said to be walled up alive by her father. The poet John Ceiriog Hughes (1832-87) was known as 'The Shepherd of Aberdyfi' and wrote the lyrics of 'Men of Harlech' and 'Dafydd Y Garreg Wen' ('David of the White Rock'). The International Outward Bound Movement was founded in Aberdyfi in 1941.

ABERDYFI CASTLE (ALSO KNOWN AS DOMEN LAS AND CASTELL ABEREINION) *Just off the A487, 5 miles south-west of Machynlleth, seen from the Ynys Hir Nature Reserve at Glandyfi.* The remains of a motte and ditch, it was built by The Lord Rhys in 1156 in response to a threat from Owain Gwynedd. Roger de Clare seems to have taken it in 1158, but The Lord Rhys retook it in the same year. Llywelyn the Great held an assembly there in 1216, when he granted land to other princes.

ABEREDW CASTLES *Next to each other, behind the village of Aberedw near Builth Wells.* The original motte may date from 1093 and have been built by the invading Baskervilles. The Welsh regained it from 1135-50 and then seem to have built the second castle near it. This later stone castle has been badly damaged by railway workings in the nineteenth century and is sometimes called Llywelyn's Castle or Castell Elfael Uwch Mynydd. Gwallter Fychan ap Prince Einion Clud controlled this castle from *c.* 1213, and it was mainly in Welsh or Mortimer hands until the murder of Prince Llywelyn ap Gruffudd in 1282. The Mortimers, who had killed Llywelyn, then took the castle. It was crenellated on the orders of the king from 1284 but is in bad disrepair.

ABEREDW - LLYWELYN'S CAVE *On the opposite bank of the River Edw from Llywelyn's Castle.* There is a legend that Llywelyn Prince of Wales spent his final night in this small cave upon 10 December 1282.

ABEREDW CHURCH – MEDIEVAL CHURCH *Off the B4567 south of Builth Wells.* This beautiful church is on the site of a sixth-century Celtic foundation of St Cewydd, whose association as the patron saint of rain predated that of Swithin by centuries. Tradition is that John Giffard, the constable of BUILTH CASTLE nearby, refused to assist Llywelyn II shortly before he was killed. His wife pleaded for Llywelyn to have a Christian funeral, as he had been to Mass in Aberedw Church on the morning of his death, and had called for a priest as he lay dying on 11 December 1282. A defaced tombstone in the porch of the church reads:

> Here lieth the body of Jeremiah Cartwright, son of William Cartwright of Choulton in ye parish of Lidbury, County of Sallop, Free mason he left issue Jeremiah, William, John, Huphrey [*sic*], Sarah, Elizabeth and Anne: he died 8hr Ve 4th: 1722; Aged 73.

> Now Cartwright he with all his skill,
> Can use no Pencil Toole nor Quill.
> As he on others oft did write,
> Now others do on him Indite.
> But though he lie awhile in dust,
> We have assured? hope and trust.
> That man's great builder will him raise,
> And build —? to his praise.

The last two lines have been lost – it appears that Cartwright engraved the royal arms in the church.

ABEREIDDI TO ABERMAWR – NATIONAL TRUST – COASTLINE WITH OLD QUARRIES *North-west of St David's and south-east of Fishguard, within Pembrokeshire National Park. Tel: 01348 837860 (Estate Office); 01437 720385 (St David's Visitor Centre & Shop); Contact Ysgubor Fawr, Mathry, Haverfordwest, Pembrokeshire SA62 5HE.* A wild stretch of coastline stretches from ABEREIDDI BLUE LAGOON, ABERCASTLE to Abermawr beach and woodlands, via the fishing village of PORTHGAIN and some impressive former quarry workings. Abermawr was once selected by Brunel as a cable and railway terminus.

ABEREIDDI BLUE LAGOON – FLOODED SLATE QUARRY AND PORT (SEE ABEREIDDI TO ABERMAWR) There is a walk to flooded former slate quarry workings, with a tidal channel to the sea. The slate rocks are full of graptolites, rare 'tuning fork' fossils. The atmospheric quarry buildings and village remains can be explored, along with the ruins of Trwyncastell, a former watchtower.

ABERFAN – COAL MINE DISASTER SITE AND MEMORIAL GARDEN *Off the A4054, 5 miles south of Merthyr Tydful, Glamorgan.* On 21 October 1966, it took five minutes for the coal tip above Aberfan to slide down the mountain and engulf a farm, twenty terraced houses and a school. Children at Pantglas Junior School were just beginning their first lessons of the last day of term. A landslide of slurry, up to 40 feet high, smashed into their classrooms. Some children were able to escape, but 116 were killed. Twenty-eight adults also died, including five teachers. The tip had been placed upon known springs, and the Labour Government took money from the disaster appeal funds donated by the public. No one in the National Coal Board lost his job, despite a damning report. The shame of the story of Aberfan seems to have been quietly airbrushed from history. This is the saddest place in Wales.

ABERFFRAW BAY HERITAGE COAST – SITE OF THE COURT OF THE PRINCES OF GWYNEDD *On the west bank of the River Fraw, on the A4080 in south-west Anglesey.* A Welsh-speaking village of just 600 people, but for 800 years this was the llys (main court) of the

princes of Gwynedd and the most important administrative centre in medieval North Wales. The Vikings destroyed the llys in 853 and 968, but it was rebuilt and used with Garth Celyn on the mainland as a palace until the murder of Llywelyn ap Gruffudd in 1282. Aberffraw was the Royal Court of Maelgwn Gwynedd in the sixth century, and the royal palace of the princes of Gwynedd remained a centre of power until the Welsh defeat in 1282-83. It was sacked in 1284 and its treasures taken to England. In 1315-16, its stones were removed for building work at BEAUMARIS CASTLE and its timbers taken to repair CAERNARFON CASTLE. The llys was thought to be near the church at the south-west of the village but there are other possible sites. The village well was the sole source of water until the early twentieth century, and the old bridge was built in 1731. Once an important port, the estuary gradually silted up, leaving the present coastline of sand dunes of up to 30 feet and more. The dunes have also created the inland lake of Llyn Coron. Walter Steward, the ancestor of the Royal House of Stewards or Stuarts, Kings of Scotland, was born here. Cable Bay is the English name given to nearby Bae Trecastell because the Atlantic telegraph cable terminated there. In *The Mabinogion*, Aberffraw is mentioned as the site of the wedding festival of Matholwch and Branwen.

ABERFFRAW PARISH CHURCH This was founded by Saint Beuno ap Bugi ap Gwenlliw, who later became Abbot of CLYNNOG FAWR in Caernarfonshire and who died around 640 CE. The present structure mainly dates from the sixteenth century, on medieval foundations.

ABERFFRAW ROMAN FORT *West of Bodorgan Square, and under Chapel Street.* There is little to see of this first-century auxiliary fort, but its presence may have led to the princes of Gwynedd making Aberffraw the site of their main court and for St Beuno to establish his church there. Suetonius Paulinus attacked Anglesey in 60-61 CE. In 1640, an ingot of copper was found at Aberffraw, stamped 'SOCIO ROMAE-NATSOL'. It had probably been mined at Parys Mountain, smelted nearby, and then transported to Aberffraw for export.

ABERFFRAW ST CWYFAN'S CHURCH AND ISLAND The twelfth-century church of Saint Cwyfan (died 618) dates back to 605. Grade I listed, it is now cut off by the tide for much of the day. The church used to be on the mainland, but much of the coast slid into the sea, and the church is half its former size. A nineteenth-century sea wall protects it from damage, and services are held in summer at 'the church in the sea'. The legends of 'cantre'r gwaelod', the flooded lands, abound in this area.

ABERGAFENNI (Y FENNI, ABERGAVENNY) – ANCIENT MARKET TOWN AND CHURCH *Junction of A40 and A465, Monmouthshire.* Surrounded by mountains and with the Usk running through it, Y Fenni has been an important market town for centuries. It was a walled 'bastide' town of the Normans and is now a popular market town.

ABERGAFENNI, BATTLE OF, 1263 *Battlefields Trust records refer to a battle in 1263 on the Blorenge Mountains, 2 miles to the south-west of Abergafenni.* From November 1256, Prince Llywelyn ap Gruffydd attacked the Marches of Wales to return them to Gwynedd. From November to December 1262, the Welsh convincingly defeated Roger Mortimer at the Battle of Cefn Llys, and seized much of Radnorshire and Breconshire. The princes returned to Gwynedd. Peter of Montfort resisted a Welsh attack, led by Gronw ab Ednyfed and the princes of South Wales, in late February 1263. Roger Mortimer and the Marcher Lords next counter-attacked and defeated the princes of Deheubarth at Abergafenni on 3 March 1263.

ABERGAFENNI CASTLE – WELL-PRESERVED MEDIEVAL CASTLE AND MUSEUM Within its walls is the motte built by the Norman de Ballon before 1090. In the twelfth century, the same family endowed the local Benedictine priory and built the stone keep. In 1175, William de Braose invited Seisyllt ap Dyfnwal, Lord of nearby Arnallt, his son Geoffrey and other local Welsh

lords, for a dinner on Christmas Day. Unarmed, they were all slaughtered. De Braose then seized Seisyllt's lands, murdering his son Cadwaladr and capturing his wife. In response, the Welsh Lord of CAERLEON, Hywel ap Iorwerth, burnt the castle in 1182, and then destroyed Dingestow Castle. In the 1182 siege, Welsh arrows penetrated an oak door which was four inches thick, with the iron tips visible on the inside of the door. The castle fell to the Welsh several times. The gatehouse was added around 1400 in response to the threat of Owain Glyndŵr. Charles I ordered its slighting in 1645 to prevent Parliamentarians using it. In 1819, the square 'keep' was erected on the motte as a hunting lodge for the Marquess of Abergafenni, and it is now Abergafenni Museum.

ABERGAFENNI – MAINDIFF COURT *Ross Road, Abergafenni, Monmouthshire NP7 8NF.* Built in 1877 by Crawshay Bailey II, next to an ancient site, it became the residence of Deputy Führer Rudolf Hess from 1942-45, after he had been captured in Scotland in 1941. He was often seen walking in the area, and around the remains of WHITE CASTLE. It is now, rather aptly, a mental hospital.

ABERGAFENNI – PENPERGWM LODGE – RHS RECOMMENDED GARDEN *NP7 9AS. Tel: 01873 840208. Web: penplants.com.* The three-acre garden has been developed from the remnants of a garden designed when the Edwardian house was built. Recent additions to the vine walk, terraced potager and walks include a brick folly to commemorate the Royal Jubilee, and a canal descending from a brick loggia.

ABERGAFENNI ROMAN FORT Known as Gobannium, this was used *c.* 57-390 CE and had extensive timber granaries. The Romans used an earlier site to build the fort just to the west of the present castle, on the same hill overlooking the Usk, defended by steep slopes on three sides.

ABERGAFENNI – ST MARY'S PRIORY CHURCH Founded in the late eleventh century as a Benedictine priory, there is an immense and extremely rare Jesse Tree carving. Long stripped of its gilding and jewels, it was the centrepiece of a Tate Britain exhibition in 2001-02. The Tate called it 'the largest and most impressive example of wooden sculpture surviving from the fifteenth century'. The Church of St Mary was originally merely the chapel of the Benedictine priory and has tombs dating from the thirteenth century, with fourteenth-century choir stalls. There are beautiful medieval tomb carvings, including the superb 1325 wooden effigy of John de Hastings. The Herbert Chapel includes the marble and alabaster tomb of Sir William ap Thomas, 'the Blue Knight of Gwent', who built RAGLAN CASTLE and died in 1445. The nearby Roman Catholic Church of Our Lady and St Michael has an exceptional Victorian neo-Gothic reredos (altar screen).

ABERGAFENNI – TITHE BARN Possibly the oldest in Wales, this 900-year-old barn was built to house the tithes (taxes in the form of produce) paid to the monks of St Mary's priory. Used as a theatre in the seventeenth century, it is now a visitor attraction with historical exhibitions.

ABERGELE – HISTORIC TRADING PORT (SEE GARTH CELYN) *Between Colwyn Bay and Rhyl, North Wales coast, Conwy.* A Celtic Christian existed at Abergele in the eighth century when Elfod, Bishop of Bangor, gave a gift of land to the church there. A rounded part of St Michael's churchyard suggests an early 'clas'. The Celtic church had self-contained ecclesiastical communities or clasau, consisting of an abbot and a group of hereditary canons, sharing a common income, able to marry and living as secular clerks (claswyr). The claswyr would have lived in a group of wooden huts in a rounded enclosed area. The Norman tithe system did not exist. From Roman origins, by 1311 Abergele had grown into a market town, with twenty-four burgesses. On a tombstone in the medieval St Michael's church we read, 'Here lieth in St Michael's churchyard a man who had his dwelling three miles to the north.' The sea is only half a mile north. It is said that Prince Madoc ab Owain Gwynedd sailed from here in 1170 to discover America, 300 years before Columbus.

ABERGELE – GWRYCH CASTLE – GRADE I LISTED MOCK CASTLE The Norman castle was taken by Rhys ap Gruffydd (The Lord Rhys) of Deheubarth around 1170, who rebuilt the timber castle in stone. This castle was later destroyed by Cromwell's army in the Civil War. The present castle was built between 1819 and 1825. It was the first Gothic folly to be built in Europe, by a wealthy industrialist, Lloyd Hesketh. His son used his vast fortune to build the 4,000-acre Gwrych Castle Estate. The castle once had 128 rooms, including twenty-eight bedrooms, a huge marble staircase, an outer hall, an inner hall, two smoke rooms, a dining room, a drawing room, a billiards room, an oak study, and a range of accommodation for servants. There are nineteen embattled towers and the façade covers over 2,000 yards. Now sadly dilapidated and stripped of its furnishings, it is slowly being restored into a five-star hotel.

ABERGLASNEY MANSION – HOUSE RUINS AND GARDENS – RHS RECOMMENDED GARDEN *Llangathen, off the A40 at Broad Oak, between Llandeilo and Carmarthen, Carmarthenshire SA32 8QH. Web: aberglasney.org.* Around 1477, Lewis Glyn Cothi recorded 'nine green gardens' and orchards, vines and lakes here. The old house was rebuilt in 1603 by the Bishop of St David. Its three walled gardens date from the mid-seventeenth century and include a remarkable 'yew tunnel', a pool garden and the only surviving Elizabethan/Jacobean cloister garden with parapet walk in the UK. Near the LLANARTHNE National Garden Centre, the house was one of the most imposing in Wales. The site dates back to at least the early thirteenth century. The pastoral poet John Dyer was born here and wrote *Grongar Hill* in 1726, in which we read, 'A little rule, a little sway, /A sunbeam in a winter's day, /Is all the proud and mighty have/Between the cradle and the grave.'

ABER LLECH, BATTLE OF, 1096 *Near Llandeilo'r Fan, Breconshire, are Aberllech, Cefnllech and Cwmllech (LD3 8UB).* Gruffudd and Ifor ab Idnerth ap Cadwgan, who were the cousins of king Hywel ap Goronwy, rallied the men of Buellt (the area around BUILTH WELLS) to defeat a Norman force, which was invading Brycheiniog (Breconshire). In *The Chronicle of Ystrad Fflur* we read, '1096 In this year The French moved a host into Gwent and the Britons slew them at CELLI TARFAWG. And thereupon the French raided Brycheiniog and they were slain by the sons of Idnerth ap Cadwgan at ABER-LLECH. And the war-band of Cadwgan ap Bleddyn despoiled the castle at PEMBROKE.'

ABERLLEINIOG CASTLE AND BATTLE OF, 1098 *Near Llangoed, south-east Anglesey.* The only motte and bailey castle in Anglesey, marking the furthest extent of Norman advance, built around 1088 by Hugh d'Avranches, the Norman Earl of Chester. Hugh 'the Fat' had captured Gruffudd ap Cynan, Prince of Gwynedd, when ostensibly attending a peace meeting, and built the castle while Gruffudd was imprisoned in CHESTER for many years. When Gruffudd escaped, he took the castle and burnt it. Gruffudd's pencerdd (chief bard), Gellan, was noted as being killed in this battle, and is the first named harpist in Welsh records. The square stone keep dates only from the seventeenth century, and the site is being restored after centuries of neglect.

ABERLLYNFI CASTLE (GREAT HOUSE MOUND) *Gwernyfed, near Talgarth, Breconshire.* This low and compact motte and bailey dates from at least 1180 and was held by Walter de Clifford and Hugh Kinnersley against Henry III in the Barons' Rebellion. It was once surrounded by marshland and was captured after siege in 1233 from the royalists.

ABERMIWL (ABERMULE), BATTLE OF, 1263 *On the B4386, just off the A483, Montgomeryshire.* *The Chronicle of Ystrad Fflur* notes, 'In this year John Lestrange, constable and bailiff of Baldwin's castle (Montgomery), gathered a mighty host and came by night through Ceri. And the Welsh gathered in pursuit of them and slew two-hundred of the English, some in a field, others in the barn at Aber-Miwl (Dolforwyn). And the barons of England and the Welsh rose up against Edward and the foreigners, and desired to cast them forth from the kingdom of England. And Llywelyn

ap Gruffudd and his host took and destroyed the castles of Carreg Faelan and DEGANNWY. And Gruffudd ap Gwenwynwyn destroyed the castle of Y Wyddgrug (MOLD).' In the following year, Henry III was defeated at Lewes in the Barons' Revolt, but regained the ascendancy in 1265 at Evesham.

ABERMIWL – DOLFORWYN CASTLE The last castle built by a Welsh prince, erected by Llywelyn ap Gruffudd, in 1273. In that year, Edward I sent a letter to the prince, forbidding the building, but Llywelyn answered that he needed no permission to build in his principality. It overlooks Abermiwl, on the other side of the A483. Llywelyn tried to create a township around the castle to make it a competitor to Pool Castle (Welshpool) and Montgomery. It was taken in 1277 by the Mortimers, probably using siege engines, as stone balls have been found around the castle. Because of the irregular site, there is no gatehouse, and an unusual rectangular keep. Adjacent to the castle, one can see the site of the unexcavated town of Dolforwyn, to the west.

ABERYSTWYTH – UNIVERSITY TOWN AND HOME OF THE NATIONAL LIBRARY OF WALES *Ceredigion coast.* A seaside resort in Ceredigion, the Vale of Rheidol railway runs inland from here. As well as the first University College of Wales, it contains the superb National Library of Wales. In term time, students make up a quarter of the population. Britain's longest electric-powered Cliff Railway takes the visitor to possibly the world's largest Camera Obscura, overlooking 1,000 square miles of sea and landscapes, including twenty-six mountain peaks.

ABERYSTWYTH CASTLE On the seafront, this is near the site of Castell Tan-y-Castell, built by Gilbert de Clare in the early twelfth century, which was taken several times by the Welsh. Aberystwyth Castle was then built by Llywelyn ap Iorwerth, Llywelyn the Great, on a promontory next to the Rheidol estuary. Aberystwyth Castle was rebuilt by Edward I as a link in his 'iron chain' of castles, starting in 1277. In 1282, the incomplete castle was taken by Llywelyn ap Gruffudd's forces, so James of St George came to personally oversee the building. By 1289, £4,300 had been spent building the huge concentric fortress, and a Welsh siege in 1294 was finally beaten off as reinforcements and supplies arrived by shipboard. After a long siege, Glyndŵr took the castle in 1404 and held it until 1408. In this siege, it was the first castle in Britain to be subject to attack from great cannon. It was badly slighted by the Parliamentarians in the English Civil War, but was once one of the finest Welsh castles, on a par with HARLECH and CONWY.

ABERYSTWYTH OLD COLLEGE – FIRST BUILDING OF THE UNIVERSITY OF WALES John Nash built a house on this site on the esplanade of Aberystwyth, intending to make a 'Welsh Brighton'. In 1864, the neo-Gothic architect J. P. Seddon was given a commission to build a railway hotel to rival St Pancras in London. In a year, the massive hotel was bankrupt and the building was bought for £10,000 by a committee to found a national university of Wales. Previously LLANILLTUD FAWR in Glamorgan had been proposed, as it is said to be the site of Europe's oldest university, but the availability of such a splendid building ensured that Aberystwyth University would be situated here. LAMPETER also has claims to be the oldest university in Wales, the third oldest in England and Wales.

AMLWCH – PARYS MOUNTAIN – FORMERLY THE WORLD'S LARGEST COPPER MINE AND EUROPEAN ROUTE OF INDUSTRIAL HERITAGE ANCHOR POINT *Northern coast of Anglesey.* Apart from the gold in Dolaucothi, the Romans mined copper at Parys Mountain. The Roman road from London to Holyhead in Anglesey, now the A5, was driven both by the need to exterminate the centre of European Celtic Druids in Anglesey and to source Welsh copper. Before the Romans, the Celtic Ordovices had mined and exported copper from here, as at the Great Orme at LLANDUDNO. This is now an almost Martian landscape full of abandoned workings, but by the eighteenth century it had become the world's largest and most productive copper mine, following its rediscovery in 1768. Records at this time show that Amlwch had 6,000

inhabitants and 1,125 ale-houses, perhaps a world record for density of pubs, and its small rock-bound inlet of a port was one of the busiest in Europe. By the end of the eighteenth century, The Parys Mine Company employed 1,200 men producing 3,000 tons of copper ore annually. The pollution in the harbour was so bad that the iron hulls of ships did not corrode. When this was noticed, ships' hulls began to be sheathed in copper by their owners and boat builders, making another lucrative market for the mine. Because the world's leading supplier of copper was in Britain, the Royal Navy began copper-cladding its warships well in advance of any other navy. This directly led to its ships being faster and more easily sailed than those of other navies, leading to mastery of the seas. This, in turn, enabled the growth and protection of the British Empire. By the end of the nineteenth century, the mineral had been worked out and the area was left in the weird state we see today.

ANGLE (NANGLE) CASTLE *South-west Pembrokeshire, accessed from Castle Farm.* This was built by Robert de Shirburn during the reign of Edward III (1327-77). One of the very few pele towers in Wales, it is rectangular in shape, and near it is a medieval hall. The Seaman's Chapel was built in 1477 by Edward de Shirburn, 'knight of Nangle'. There are also three nineteenth-century blockhouse forts in Angle Bay. The Old Point House Inn is reputed to have had a fire burning constantly for over 300 years, and one can be cut off there by the tide.

ANGLESEY COASTLINE – AREA OF OUTSTANDING NATURAL BEAUTY Almost the entire 125 miles coastal zone of Anglesey was designated in 1966, but the zone also includes HOLYHEAD Mountain and Mynydd Bodafon. It is the largest AONB in Wales, covering one-third of the island. Included in the protected habitats are six candidate Special Areas of Conservation (cSACs); four Special Protection Areas (SPAs); one National Nature Reserve; twenty-six Sites of Special Scientific Interest (SSSIs); and fifty-two Scheduled Ancient Monuments (SAMs). The AONB also takes in three sections of open, undeveloped coastline which have been designated as 'Heritage Coast'. These complement the AONB and are North Anglesey seventeen miles, Holyhead Mountain eight miles and Aberffraw Bay four-and-a-half miles.

AREAS OF OUTSTANDING NATIONAL BEAUTY The first in Britain was the Gower Peninsula, and the others in Wales are the coastal zone of Anglesey, the Clwydian Range and the Wye Valley. There is a strong desire across Wales for the Cambrian Mountains and Mynydd Pumlumon around Nant-y-Moch with Glyndŵr's battlefield of HYDDGEN to also be designated, to prevent even more wind turbines, concrete platforms, substations, roads and pylons despoiling the landscape. The small country of Wales supplies more than twice its energy needs already, the excess being transported by pylons to England. The density of wind turbines in Wales per square mile is probably ten times that of England, and the huge 400-foot turbines can be seen from over twenty-five miles away. AONBs are designated to protect the aesthetic appeal and variety of landscape and habitats from inappropriate development.

BADON HILL, FIRST BATTLE *c.* **516 OR 518** At Mynydd Baddon (Mons Badonicus), this important battle has been placed as early as 493 or 503 CE, and could have been outside Bath or outside Maesteg at Mynydd Baidon. It is recognised as a great battle between the British and the Saxons, after which there was relative peace for many years, except for the Battle of Camlan, which may itself have been a battle between the kingdoms of Gwynedd and Glamorgan. Arthur, according to Taliesin, led the British. Other sources state that the Dux Bellorum was Ambrosius Aurelianus fighting Aell, King of the South Saxons. There may have been more than one battle at this place. In the *Annales Cambriae* entry for 516, we read, 'The Battle of Badon, in which Arthur carried the Cross of our Lord Jesus Christ for three days and three nights on his shoulders and the Britons were the victors.'

BADON HILL, SECOND BATTLE 665 The *Annales Cambriae* state, 'The first celebration of Easter among the Saxons. The second battle of Badon. Morgan dies.' The Saxons slowly turned to Christianity between 630 and 690.

BALA – STRATEGICALLY IMPORTANT HISTORIC TOWN *On the A494 and A4212, Meirionnydd.* Bala was founded by Royal Charter around 1310 by Roger Mortimer in order to enforce order at Penllyn (Head of the Lake). It lies on a geological fault line, which enables easy access from Chester down to Dolgellau and the western coastline. The heartlands of Glyndŵr supported him in the War of 1400-1415, and here is the largest natural lake in Wales, Cacs Llyn Tegid. Also known as Bala Lake, it is home to the Gwyniad, a kind of land-locked small silvery fish of the salmon family, left behind after the Ice Age. There is a statue of the noted Liberal MP Tom Ellis in the High Street.

BALA – LLANFOR ROMAN CAMPS *Just outside Bala on the northern floodplain of the River Dee.* On the Roman road between Penrhos and CAER GAI, this Roman fort was seemingly abandoned for the site at Caer Gai, and a substantial rampart encloses nine acres. Its large size indicates that it was a legionary garrison. There is also Llanfor Marching Camp, only discovered in 1976, just north-west of the fort, covering twenty-nine acres.

BALA – TOMEN Y BALA CASTLE *Adjacent to a large car park on Mount Street.* Tomen y Bala is a large Norman motte located at the end of the town, still almost 30 feet high and now an attractive public garden. Llywelyn the Great took it from Elis ap Madog, Lord of Penllyn, in 1202, and reduced its defences. From its summit one has extensive views of Llyn Tegid and the mountains of SNOWDONIA. One can also see the typical grid plan of the streets of 1310 and the regular burgage plots which still dictate the layout of the centre of the town. There are three Roman forts in the valley and four earthwork castles on the north side of the lake, indicating the importance of the area.

BANGOR – UNIVERSITY CITY *On the Caernarfonshire side of the Menai Bridge to Anglesey.* The Tudor town hall was formerly the home of its bishop. Between the town hall and the cathedral is the Bishop's Garden (Gardd yr Esgob), including the wonderful 'Biblical Garden', which contains most of the trees, shrubs and flowers mentioned in the Bible. Bangor allegedly has the longest High Street in Britain. The name 'Bangor' reflects its ecclesiastical origin in the sixth century by St Deiniol, meaning a quarter or corner which contained a choir. Its original meaning was a strong plaited rod, making a fence or wattle building. The circular fenced enclosures became holy land, a llan. There are also places named Bangor in Ireland and Brittany, being holy sites from the Age of the Saints.

BANGOR CATHEDRAL, EGLWYS GADEIRIOL BANGOR – THE OLDEST CATHEDRAL IN BRITAIN St Deiniol founded a monastic settlement at Bangor, named Y Cae Onn (The Field of the Ash Trees) in 525. It became a bishopric in 546 on land given by Maelgwn Gwynedd, and is thus the oldest diocese in Britain, predating Canterbury by eighty-one years. Llandaff, St Asaf and St David's also predate Canterbury or any other British cathedrals. Gruffudd ap Cynan and Owain Gwynedd were buried here. The cathedral was destroyed and rebuilt by the Normans in 1071, and subsequently damaged by King John, Edward I and in the Glyndŵr War. John's invading army killed and raped the citizens of the town and dragged the bishop from the sanctuary of the cathedral, before burning it. The present cathedral fabric dates from the thirteenth to fifteenth centuries, and was rebuilt by Sir George Gilbert Scott in 1884. The Mostyn Christ is a notable fifteenth-century life-size wood-carving of Jesus.

BANGOR – PENRHYN CASTLE – NATIONAL TRUST – VICTORIAN FANTASY CASTLE *Llandegai, 1 mile east of Bangor, LL57 4HN. Tel: 01248 371337.* Penrhyn is an extravagant castle with a unique furniture collection, spectacular gardens, wonderful views over Snowdonia and possibly the best private art collection in Wales. One of the greatest Victorian houses in Britain, Lord Penrhyn spent over £500,000 on building it in 1820, based on the profits of the greatest slate mine the world had seen, plus those from his West Indian sugar plantations. Thomas Hopper built

a cross between a Norman and a fairy-tale castle, building around the medieval manor core. There are a formal Victorian walled garden, dolls museum, massive Victorian kitchens, railway museum and adventure playground. There is slate everywhere in the massive edifice, even a huge 1-ton slate bed where Queen Victoria slept in 1859. However, to many it represents the disgraceful conditions suffered by Lord Penrhyn's slate workers.

BANGOR-IS-COED (BANGOR-ON-DEE) MONASTERY – THE OLDEST MONASTERY IN BRITAIN *South of Wrecsam, Denbighshire, perhaps in the area surrounding St Dunawd's Church, but changes in the course of the River Dee seem to have eroded any remains.* Founded in 180, by the seventh century it was said to have an establishment of 2,000 monks, of which 1,200 were butchered after the Battle of Chester in 616. They were praying for the princes of Powys, who were defending Chester and North Wales from the invading King Aethelfrith of Northumbria, and were massacred. The Venerable Bede in 731 praised the acts of the pagans against the Christian British, as the Welsh had not accepted the suzerainty of Rome. The survivors fled west to Bangor. The Battles of CHESTER and DYRHAM effectively sealed off the Celts in Wales from the other Britons, and made the modern border of Wales. Pelagius is said to have studied here, the man responsible for the Pelagian Heresy, which could have demolished the authority of the Roman Church in the fourth century. The Romans called it Bovinium and the Saxons Bancornaburg. The living is designated Bangor Monachorum, on account of its historical associations.

BARCLODIAD Y GAWRES – NEOLITHIC BURIAL CHAMBER CADW *Rhosneigr, near Cable Bay, Aberffraw, Anglesey.* The impressive Neolithic Burial Chamber, Barclodiad-y-Gawres, at Rhosneigr, has inside it five standing stones ornamented with zigzags, spirals, lozenges and chevrons. The only parallel in the British Isles is probably Newgrange in Ireland. The majority of these communal burial chambers, cromlechau, are found in Anglesey, with about fifty remaining, and Pembrokeshire, with around forty-five. They are similar to other megalithic monuments as far away as India. Excavation revealed a strange and ancient 'witches' broth' residue consisting of frogs, toads, snakes, mice, (sacred) hares, eels, wrasse and whiting. The chamber is 4,500 years old and its mound covers a cruciform-shaped inner chamber, used for the burial of the dead and approached by a covered passage.

BARDSEY ISLAND – SEE YNYS ENLLI

BARMOUTH, ABERMAW – ANCIENT PORT AND RESORT *On the A476, west of Dolgellau, Meirionnydd.* Colloquially called Y Bermo, this old port on the Mawddach estuary was transformed into a resort in the nineteenth century, with a two-mile promenade. The original Welsh was Aber Mawddach, the mouth of the River Mawddach, which by 1284 had been abbreviated into Abermau and then Abermaw. There is a lifeboat museum, a Grade II listed church, a fine medieval tower house, Tŷ Gwyn, and a nineteenth-century roundhouse prison, Tŷ Crwn.

BARMOUTH BRIDGE (PONT ABERMO) – UNIQUE TIMBER VIADUCT This is built on 113 wooded trestles to take the Cambrian Coast Railway across the Mawddach estuary. Completed in 1867, this is the only large timber viaduct in Britain still in use, with a walkway to cross the river. There are two steel girders at the north end, one of which used to swing to allow ships up river.

BARRI (BARRY) – FORMER COAL PORT AND MONASTERY ISLAND *7 miles west of Cardiff, Vale of Glamorgan Coast.* Barri was once Wales' eighth largest island at 170 acres, known as Ynys Peirio after the founder of its monastery. The mainland village and its island were transformed in the 1880s by David Davies into the busiest coal-exporting docks in the world, and Barry has grown into Wales' fourth largest centre of population (after CARDIFF, NEWPORT and SWANSEA). Davies built a causeway to link Barri Island to the mainland, and his docks effectively

ended the monopoly of Lord Bute, with all the MERTHYR and Cynon Valley coal previously being shipped through Bute's Cardiff Docks. With the replacement of coal as shipping fuel by oil in the 1930s, the town's fortunes declined dramatically. Apart from the Victorian Docks Offices with a statue of David Davies outside, hardly anything remains of the docks buildings.

BARRI (BARRY) CASTLE *Park Road, following signs to Porthceri Country Park, Barri, Vale of Glamorgan.* The ruins of a thirteenth- to fourteenth-century fortified manor house, the seat of the de Barry family, are on the site of a previous earthwork. It was destroyed by Llywelyn Bren, along with another dozen or so castles in the Vale of Glamorgan.

BARRI – BULWARKS IRON AGE FORT Outside Porthceri (Porthkerry) and used by the Silures and also in Roman times, a large double-banked promontory fort, some of which has been lost to the sea.

BARRI – MERTHYR DYFAN – CHURCH OF ST DYFAN AND ST TEILO *Easiest accessed via the pedestrian lane leading north from Merthyr Dyfan Cemetery in Barri, Vale of Glamorgan.* Almost hidden in a lane in the north of Barri, the church is twelfth to thirteenth century with a sixteenth-century tower. It is one of the claimants for the oldest Christian site in Wales, dating from when Pope Eleutherius sent the saints Ffagan and Dyfan to Wales. Dyfan was said to be martyred here, and there are Roman remains around the church. Teilo was later made a joint patron. In 1970 restoration, the font was re-based, and the stone altar repositioned, having been recovered from the nearby well, where it had been used as a scrubbing board.

BARRI ROMAN PORT BUILDING – SECOND-CENTURY REMAINS *Pebble Beach (Cold Knap), Barri.* Possibly part of a major Roman complex, but new buildings cover the rest of the site. There used to be an inlet to the sea here, now filled in with Cold Knap Lake.

BARRI ISLAND – ST BARUCH'S CHAPEL – SIXTH-CENTURY SITE *On Nell's Point, Barri Island.* The site of St Baruc's Holy Well has been disgracefully built over by 1990s housing, but the medieval ruins of St Baruch's Chapel still exist. St Dyfan was also associated with the town, with a church at Merthyr Dyfan. On the other headland of Barri Island, Friar's Point, are Neolithic hut circles. A Celtic Christian monastery existed on Barri Island, and the area is surrounded by Neolithic, Iron Age, Dark Age and Roman remains. Also at Barri Island was the 'Roman Well', built over in the 1980s without proper excavation.

BASINGWERK ABBEY – ABATY DINAS BASING ABBEY RUINS CADW *North of Holywell, Flintshire.* Probably founded in 1131 by the Earl of Chester, it was a Savignac foundation, but in 1147 the order merged with the Cistercians. Its substantial remains date from the twelfth and thirteenth centuries, featuring a huge dining hall. It was in the patronage of Llywelyn the Great. The abbey ruin is now part of Greenfield Valley Heritage Park. Dissolved in 1536, the abbey roof was sold to CILCAIN Church and the superb Jesse Window went to LLANRHAEADR-YNG-NGHINMEIRCH Church.

BASINGWERK, BATTLE OF, 821 King Coenwulf of Mercia, Offa's son and successor, was killed here and the Mercians routed. He had previously invaded Wales in 798, 816 and 818, killing Caradog ap Meirion, King of Gwynedd, in 798.

BASINGWERK CASTLE – HISTORIC EARTHWORK *Overlooking St Winifred's Well at Holywell, Flintshire.* Also known as Holywell Castle and Bryn-y-Castell, it was built by Normans inside the site of a Saxon frontier fortress. Before 1155, it had been destroyed during King Stephen's rule, and in 1157 was rebuilt by Henry II, who stayed there when visiting Gwenfrewi's Well. In 1165, as Henry II retreated from the Berwyn Mountains, the town and castle were besieged by Owain

Gwynedd, who destroyed the castle in 1166. In 1177, it was held by Owain's son Dafydd, then in 1209 burnt by Ranulf, Earl of Chester, following complaints from the monks of Chester that they had lost the income from pilgrims to the well. He then rebuilt it, but it was taken by Llywelyn ap Gruffudd before 1240. The building of nearby Flint Castle in stone made Basingwerk Castle obsolete.

BASKERVILLE HALL – THE ORIGIN OF A DETECTIVE NOVEL *Near Clyro, near Hay-on-Wye, Breconshire.* Now a hotel, this 1839 mansion is where Arthur Conan Doyle, a friend of the family, heard of the phantom hounds on the moorlands, and then wrote *The Hound of the Baskervilles* on nearby Hergest Ridge. The Baskerville family asked him to place the story away from their home, 'to ward off tourists', and Doyle set it in Devon.

BASTIDES – THIRTEENTH-CENTURY FORTIFIED TOWNS New towns were planned for English settlers next to powerful castles by the Normans. The best remaining town walls can be seen at Conwy, Caernarfon and Denbigh. They were meant to develop trade, laid out on a grid pattern, and usually able to be supplied from the sea. Notable bastides in North Wales were laid out next to the major castles of Flint, Rhuddlan, Cricieth, Beaumaris and Harlech. Further south, the best walled-town examples are at Montgomery, Pembroke, Brecon, Cydweli, Tenby, Caerleon, Cardiff, Chepstow, Hay-on-Wye, Haverfordwest and Cowbridge. Most of the traces have gone – in Haverfordwest they have totally disappeared, and Cowbridge has the only town walls remaining in Glamorgan. There are some scanty Cardiff remains underground, but with all these historic places the medieval pattern of streets imposed by the walls remains to some extent. Carmarthen in 1223 seems to have been the first walled town in Wales.

BAYVIL (Y BEIFIL) – ST ANDREW'S CHURCH FOFC *2 miles north-east of Nevern (Nanhyfer), Pembrokeshire.* This Anglican church is in the care of the Friends of Friendless Churches, and was built around 1812 in a simple style deliberately to attempt to appeal to Nonconformists. There is a plain Regency interior with Gothic windows, and a completely intact single-chamber interior with seven box pews and a three-decker pulpit.

BEAUMARIS, BIWMARIS – MEDIEVAL BASTIDE TOWN *South-east coast of Anglesey.* The name comes from the French 'beau marais', fair marsh, as the coastal site was suitable for water defences. The name was also intended by Edward I to attract Norman settlers, and it became the administrative capital of Anglesey. The Bull's Head was built in 1472 and has the largest door in Britain, 13 feet high by 11 feet wide. There is a medieval high street, with ancient taverns and gentry houses. In 1404, Glyndŵr's French allies defeated an English force here.

BEAUMARIS CASTLE WORLD HERITAGE SITE CADW Begun in 1295, this unfinished castle is the last and largest of King Edward I's Welsh fortifications. Designed by the king's mason-architect, Master James of St George, it is a perfect example of a concentrically planned castle. Formidable defences survive, surrounded by a partly restored moat. Beaumaris was the final link in the iron chain of castles around Gwynedd and, although uncompleted, is probably the most sophisticated example of a concentric castle (with ring within ring defences) in Europe. The most technically perfect castle in Britain, it was built on a flat swamp, where high tides swept around its walls. It was the last of Edward I's castles in Wales, on an entirely new site, in response to the rising of Madog ap Llywelyn in 1294-95. It is unfinished because funds dried up. Its six huge inner towers are only rivalled by William Marshall's tower at PEMBROKE and by William ap Thomas' tower at RAGLAN.

BEAUMARIS – CHURCH OF ST MARY AND ST NICHOLAS The late thirteenth-century Church of St Mary and St Nicholas contains the tomb of Llywelyn the Great's wife Joan, who died in 1237. She was the daughter of King John. The church has a defensive West Tower. The chancel

misericords are extremely fine, probably brought from LLANFAES ABBEY when Edward I razed it. (Misericords are carved shelves under folding seats, to give some support when standing for long periods of time.) The alabaster tomb of William Bulkeley (d. 1490) and his wife is also excellent. The effigies of a warrior and his wife, removed from PENMON PRIORY at the Dissolution, may be those of the sixth-century saints Sadwrn and Canna.

BEAUMARIS OLD COURTHOUSE – ORIGINAL CHAMBER, JURY AND ROBING ROOMS STILL IN USE Opposite the castle is the seventeenth-century County Hall of Anglesey, with a branding iron once used to stamp convicts for theft. The courthouse here was built in 1614. Trials were always held in English, so the local jury had no chance of following proceedings, nor the defendant of a fair trial with English judges, as no Welshmen were allowed to judge cases. The courthouse can be visited, and waxworks displayed, when the court is not in session.

BEAUMARIS OLD GAOL – HUMAN TREADMILL This is a fully equipped Victorian prison, complete with a condemned cell and factory for prisoners. Once the prison for the whole island, its walls dominate the streets around it. This visitor centre features the only treadmill left in a British prison.

BEDDGELERT – THE INVENTION OF A MYTH *Gwynant Valley, where the River Claslyn meets the River Conwy, Merionethshire.* Near Beddgelert (the grave of Gelert), a mound and monument supposedly marks the burialplace of Gelert, the hound left by Prince Llywelyn to guard his child. The dog, covered with blood, was killed by Llywelyn before he realised that Gelert had killed a wolf to save the child. The story was invented by the eighteenth-century innkeeper David Pritchard to attract tourists to his hotel. Pritchard is now reputed to haunt room 29 in the Royal Goat Hotel. Gelert's Grave is a cairn in the field next to the church, but as Israel Zangwill wrote, '*Pass on, O tender-hearted. Dry your eyes. / Not here a greyhound, but a landlord, lies.*' The place is probably named after the grave of the sixth-seventh-century St Celer or Celert, but he was traditionally martyred at Llangeler in Carmarthenshire. The two ancient stone bridges in the town are constantly being damaged by huge trucks, whose drivers prefer to use satnavs than learn to read a map.

BEDDGELERT ST MARY'S CHURCH The site of a Celtic 'clas', probably founded by St Celer, and recorded by Giraldus Cambrensis in the twelfth century, the pretty church is a Victorian remodelling of a twelfth-thirteenth-century building. Many, many Welsh saints' foundations were renamed by the Normans after non-British saints, such as this church. The East Window and Early Gothic North Arcade date from around 1230.

BEDDGELERT – SYGUN COPPER MINE *Outside Beddgelert, Meirionydd LL55 4NE. Tel: 01766 890595.* Open to the public as a visitor attraction and exhibition, it probably has pre-Roman or Roman origins, as a Roman fort protects it. The Victorian mines can be toured, and the surrounding area forms the setting for Ingrid Bergman's 1958 film *The Inn of the Sixth Happiness*. The stalactites and stalagmites here are of ferrous oxide, having formed since the mine workings were abandoned some 150 years ago. Guided tours are available. Beddgelert is surrounded by other old copper mines.

BERRIEW and GLANSEVERN HALL GARDENS *Berriew is located on the B4390, a short way off the A483 between Welshpool and Newtown SY21 8AH.* This is a picturesque village, where the Montgomeryshire Canal crosses the River Rhiw on an aqueduct, and at the confluence of the Severn and Rhiw, hence its Welsh name Aberiw (Aber Rhiw). In October, salmon leap the waterfall here. Old black and white timbered buildings line the River Rhiw which winds through the village. The seventeenth-century Lion Inn has exposed oak beams and sections of original wattle and daub. The Andrew Logan Museum of Sculpture is in the village. Reputedly a prince of Powys gave the site to establish a church, and his early home is supposed to have been here

where St Beuno's Church stands today. St Bueno later settled at Clynnog Fawr near Caernarfon, and was buried in 642. In 1833, Samuel Lewis noted 'Maen Beuno, a stone pillar bearing the name of the patron saint of the church' between the Welshpool Road and the Severn. This a Bronze Age pointed stone, a mile away in Dyffryn Lane, but there is no inscription to be seen today. The church has a sub-oval enclosure, denoting an early Celtic Christian site. Alex Carlile, the son of Polish-Jewish immigrants, is now Baron Carlile of Berriew and is noted for being the first Member of Parliament to campaign for the rights of transsexuals. Glansevern Hall adjoins the village and was built in Greek Revival style 200 years ago. Positioned on the banks of the River Severn, its gardens cover more than twenty acres and are open to the public.

BERSHAM IRONWORKS AND HERITAGE CENTRE – CENTRE OF IRON TECHNOLOGY INNOVATION *Near Wrecsam, Denbighshire LL14 4HT.* Bersham Ironworks were important in the development of the iron industry. Here in 1775 a new method for horizontally boring out cylinders was patented by John 'Iron-Mad' Wilkinson. The smooth circular bore enabled really accurate cannon to be manufactured for the American Civil and Napoleonic Wars. It also enabled the production of fine tolerance steam engine cylinders – James Watt was a customer – which speeded up the Industrial Revolution, with steam engines obsolescing water-powered production sites and replacing the horse and sail as methods of transport. Inside the ruins of the old ironworks there is a 'son et lumière' interpretation of life as a foundry-man. This is the local industrial history centre for the Clywedog Valley and it is on the Clwyedog Trail, a nine-mile footpath that links local industrial heritage sites.

BETHANIA – MELIN PANT-YR-YNN – PRESERVED SLATE MILL *200 yards from the A470 near Bethania, Blaenau Ffestiniog, Caernarfonshire.* This is a member of the Welsh Mills Society. The internal machinery is static but the external 24-foot waterwheel still runs. Now an art gallery, appointment is by arrangement. It is not generally known that Welsh slate was used all over Rome and its major cities, before and during Roman occupation.

BETHESDA – THE LARGEST OPENCAST SLATE QUARRY IN THE WORLD *6 miles inland from Bangor and Penrhyn Castle, on the A5 and River Ogwen, Caernarfonshire.* Bethesda grew rapidly with the opening of the quarry on facing Fronllwyd Mountain in Gwynedd in 1765, noted for its high-quality red, blue and green slate. The slate quarry is 1,410 feet deep and covers 560 acres, once employing 3,500 men. The town, like its sister slate town Blaenau Ffestiniog, is one of the last strongholds of Welsh as a first language. The Romans used Welsh slate to roof Segontium in Anglesey, and Edward I used it extensively in his 'Iron Ring' of castles built to subdue the people of Gwynedd. Penrhyn Quarry at Bethesda was owned by the Pennant family and the gallery system was introduced here, enabling large numbers of men to work on the same vein at different heights. Over twenty galleries were ultimately in use each connected by incline to the dressing mills at lower levels, and over 100,000 tons a year was produced. It possessed its own external and internal tramway system from an early date and had its own ships and port, Port Penrhyn near BANGOR. The massive profits which flowed from the quarry enabled the Pennants to construct PENRHYN CASTLE. The easily won slate at Penrhyn has enabled the quarry to weather the decline in the industry and it retains a premier position. Because the Pennants owned all the land on one side of the A5, all of Bethesda's ten pubs are on the other side of the road.

BETHESDA QUARRY STRIKE – BRITAIN'S LONGEST STRIKE In 1896, dissatisfied with conditions and wages, the workers walked out of Bethesda quarry, and were locked out for eleven months, returning but having won no concessions. On 22 November 1900, 2,800 men again walked out of Lord Penrhyn's quarry as they wanted union recognition, and remained locked out for three years. 400 returned to work in June 1901, leading to local unrest, and the community of Bethesda never fully recovered. During the Industrial Revolution, the Welsh slate quarries (like the English-owned coalmines and ironworks) were the world's largest producers. Slate dust,

tuberculosis and long working hours made the miners' lives miserable – like colliers, they even had to buy their own candles from the quarry owners. All managerial jobs had been given to the English or Scots, with very few going to local Welshmen, who had to become highly anglicised to be promoted in the works. Welsh-speaking Welshmen did all the skilled work, grading and splitting the slate, but the management refused to recognise their union. Some men eventually returned to work, because of the grinding poverty, but newspapers published their names, pubs and shops refused to serve them or their families, they were refused entry to chapel and stoned by furious strikers' wives. Eventually the fabulously wealthy Lord Penrhyn, the former George Dawkins, who was spending the equivalent of millions of pounds on building Penrhyn Castle, took some men back on even less money. However, several hundred strikers were blacklisted and were refused work. The bitterness split the community into the 'bradwyr', traitors, who now attended Anglican churches, and the betrayed, who went to chapel. Dawkins built a new village nearby, Tregarth, for the families of the workers who did not strike.

BETHLEHEM – THE HOME OF CHRISTMAS LETTERS *On a minor road to Felindre, in the Tywi Valley, 5 miles north-west of Llandeilo, Carmarthenshire.* The village chapel in the tiny village of Dyffryn Ceidrich was given the name of Bethlehem, from Bishop William Morgan's 1588 Bible translation of the Aramaic name for Christ's birthplace. By the nineteenth century, the village began to be known by the name of its chapel. The former post office there has the right to frank letters with the Bethlehem stamp, so attracts thousands of people to post letters there every Christmas. People from across the world also now send cards and letters to Bethlehem to be stamped at the post house.

BETWS NEWYDD – ST AEDDAN'S CHURCH – MEDIEVAL CHURCH, NORMAN MOTTE AND HILLFORT *About 3 miles north of Usk on the Clytha Road, Monmouthshire NP15 1JN.* A sixth-century foundation of St Aeddan, its reconstruction in the fifteenth century gave its name of Betws Newydd – New Chapel or Oratory. The ornate carved oak fifteenth-century rood screen with stairs, rood loft and tympanum partition is probably unique in Britain. There is a Norman font, and two 1,000-year-old yews in the churchyard. Behind the Black Bear Inn is a Norman motte and bailey and the area is filled with tumuli and Coed-y-Bwnydd Iron Age hillfort.

BETWS-Y-COED – THE PRINCIPAL VILLAGE OF SNOWDONIA NATIONAL PARK *Where the A5 passes over the River Conwy and crosses the A470, Conwy.* The village developed in the nineteenth century to serve the needs of growing numbers of tourists to Snowdonia, and is situated in the hills of the Gwydir Forests, where the rivers Llugwy, Lledr and Machno flow into the Conwy. Of exceptional interest are the many bridges in the area. Pont-y-Pair (the bridge of the cauldron), built in 1468, is almost covered by foaming water after heavy rain. A mile or so away is the Miner's Bridge, on the road to CAPEL CURIG, where the miners crossed the river on a steep ladder to their work. Thomas Telford's iron Waterloo Bridge was built in 1815, and carries the A5 across the River Conwy. Also worth visiting are the awesome Conwy Falls two miles away off the road to Pentrefoelas and the beautiful Fairy Glen off the A470 where the River Conwy flows through a narrow gorge. At the Swallow Falls between Betws-Y-Coed and Capel Curig, the Llugwy River hurls itself into a chasm. There are three falls pouring down a deep ravine, which has been a tourist attraction since Victorian times. The town is mainly Victorian, reflecting its fast growth in those times. David Cox and others formed an artists' colony based at the town's Royal Oak Hotel.

BETWS-Y-COED – ST MARY'S CHURCHES There was a sixth-century monastic foundation here, but the fourteenth-century church, one of the oldest in Wales, became too small for the town in Victorian times. This picturesque Church of Saint Michael Betws-y-Coed is now not used for regular services, and is to be found on the way to the Golf Club, situated close to the River Conwy. It contains the effigy of Gruffydd ap Dafydd Goch, grandson of one of the Welsh princes.

The new, much bigger church was built on the site of a former cockpit and fairground, completed as recently as 1873, despite its medieval appearance. The interior also features various types of stone – local bluestone, sandstone from Ancaster and black serpentine from Cornwall, with some Burne-Jones glass windows in the north aisle.

BLACKPOOL MILL *It lies 7 miles east of Haverfordwest, near the junction of the A40 and A4075, SA67 8BL.* Blackpool Mill is an old water mill that has been reopened as a tourist attraction. Much of the land in this area was a gift of local magnates to the Knights of St John of Jerusalem in the eleventh century. This religious order of hospitallers had their commandery at SLEBECH, which is about a mile down from Blackpool and on the opposite bank. Following the dissolution of the monasteries by Henry VIII, the land of the Hospitallers was sold by the Crown to Thomas and Roger Barlow in 1546. In 1813, the existing mill was built by Nathaniel Phillips. In 1843, the flood gates were destroyed by the followers of Rebecca. This movement was responsible for destroying tollgates, weirs, etc., in protest against social and economic conditions during the period 1839-43.

BLAENAFON IRONWORKS WORLD HERITAGE SITE CADW *A4043 north of Abersychan, Monmouthshire.* Blaenafon Ironworks opened in 1789, operating until 1900 and the remains, the best preserved in Western Europe, are open to visitors. This historically important site includes a bank of five early blast furnaces, casting houses, water-balance lift and two rows of ironworkers' cottages called Engine Row and Stack Square. On the Forge site, a young Welshman called Sidney Gilchrist Thomas, with his cousin Percy Carlyle Gilchrist, developed a new process of steel production in 1878. He used phosphoric ores, revolutionising steel manufacture by perfecting the 'Bessemer Process'. He sold the patent to a Scot called Andrew Carnegie, who then made multi-millions of dollars in the USA and elsewhere from what is known today as 'The Carnegie Process'. Sidney Thomas' discovery vastly accelerated industrial expansion in Europe and America. There have been attempts to turn Blaenafon into a 'booktown' similar to the original Hay-on-Wye, but the type of property available, geography and the hilliness of the town seem to militate against any great success. Nearby Garn Lakes have been created from opencast mining sites.

BLAENAFON BIG PIT NATIONAL COAL MUSEUM – EUROPEAN ROUTE OF INDUSTRIAL HERITAGE ANCHOR POINT *Off the B4246, Blaenafon NP4 9XP.* Big Pit was a working coalmine from 1840 until it closed in 1980, then in 1983 became a museum of the South Wales mining industry. For many years coal and iron were transported to the coast by road and canal, but in 1852 the railway from Newport came to Blaenafon and production started to soar. Big Pit got its name from the size of its elliptical shaft, which at 18 feet by 15 feet was the first in the area wide enough to wind two trams of coal side by side. Soon the colliery was producing more than 100,000 tons of coal p.a. from an area of about 12 square miles. The highlight of a visit is the underground tour, led by ex-miners, which takes one 300 feet down in the pit cage, to walk through underground roadways, air doors, stables and engine houses. On the surface, one can explore the colliery buildings: the winding-engine house, the blacksmiths' workshop and the pithead baths where one can learn more about the story of coal.

BLAENAU FFESTINIOG – CENTRE OF A HUGE SLATE QUARRYING COMPLEX – 'THE TOWN THAT ROOFED THE WORLD' *On the A470, 11 miles south of Betws-y-Coed.* This grey town is one of the last bastions of the Welsh language. Its narrow-gauge railway to Porthmadog on the coast, once used for the slate trade, is now a wonderful visitor attraction, passing through marvellous scenery. There is an astonishing transformation of colour as you cross the heather-covered hills towards Blaenau Ffestiniog - slate spoil tips and slate houses with slate roofs and slate quarries take over the vista.

BLAENAU FFESTINIOG – FFESTINIOG RAILWAY Established in 1832, it is the oldest independent railway company in the world, built to transport slate from Blaenau Ffestiniog to

PORTHMADOG. The thirteen-and-a-half-mile line has stations at Minffordd, Penrhyn and Tan y Bwlch. Visitors can hop on and off taking in attractions such as PORTMEIRION, the gardens of PLAS BRONDANW, Plas Halt (to see PLAS TAN-Y-BWLCH) or scenic walks at Tan-y-Bwlch.

BLAENAU FFESTINIOG – GLODDFA GANOL (MIDDLE MINE) – THE WORLD'S LARGEST SLATE MINE With forty-two miles of tunnels, it dates from the early eighteenth century and is formed from several other quarries. At its peak in the 1870s, it was producing 50,000 tons of dressed slate each year.

BLAENAU FFESTINIOG – LLECHWEDD SLATE CAVERNS VISITOR CENTRE One enters by electric train descending a steep 1:1.8 gradient to an underground lake, and there is an excellent mine tour and a heritage centre. Llechwedd quarry at its peak in 1884 produced 24,000 tons of finished slate per year and had 513 employees. It continues to produce slate on a limited scale. Maenofferen Quarry was purchased by the nearby Llechwedd Quarry in 1975 together with Bowydd Quarry. Underground production at Maenofferen ceased in 1999 and with it the end of large-scale underground working for slate in North Wales.

BLAENAU FFESTINIOG TANYGRISIAU SLATE QUARRY – PUMPED POWER STATION Tan y Grisiau is Welsh for 'below the steps', referring to the vanished steps, which led up to the mine above the village. Its high-quality black slate was used across the world. Its railway station is on the narrow-gauge Ffestiniog Railway. Ffestiniog Power Station here was the first pumped storage station built for the CEGB, and tours are available.

BLAENLLYNFI CASTLE – CASTELL BLAENLLYNFI *Near the A40 at Llanfihangel Cwm-Du, Breconshire, guarding the pass between Brecon and Crughywel.* This belonged to the Fitzherberts from 1208 to 1215, then to the de Braoses, but went back to the Fitzherberts before Llywelyn the Great sacked it in 1233. It was rebuilt, but taken by Prince Llywelyn ap Gruffudd in 1262. A Fitzherbert was back in control in 1273, but the castle was seized by the Crown in 1322 and given to the Despensers. The ruins are of a stone-built quadrilateral castle, *c.* 220 feet by 150 feet, with remains of walls, buttresses and towers, inside a broad moat, *c.* 400 feet by 330 feet overall.

BLAENRHONDDA IRON AGE SETTLEMENT *Take A4016 Treherbert to Hirwaun road, Glamorganshire. The site is located 3 miles north of Treherbert and on open moor near the road.* On high open moorland near Treherbert, this sprawling village is remarkable in that it has no defences, perhaps signifying the strength of the local tribe. Roundhouses are grouped together in an obvious community, known as Hen Dre'r Mynydd (Old Town on the Mountain). The dry wall layout of the ruinous site has led archaeologists to believe that the people who lived in the area were early farmers. It has been identified as the largest undefended Iron Age settlement in south-east Wales. Most of the walls are quite low, never more than 4 feet high, and are interlinked.

BLEDDFA CASTLE – MEDIEVAL MOTTE, ROBBED OF STONE WALLS *On A488 7 miles west of Knighton, Radnorshire.* In 1195, Richard I gave Huge de Say a licence to refortify this Norman castle in Powys, but that same year de Say was killed in battle at RADNOR. It was destroyed in 1262 by Llywelyn ap Gruffudd, after he captured it from the Mortimers. Much castle material was used in building the nearby church tower, after the church was destroyed during fighting in 1403.

BLEDDFA – CHURCH OF ST MARY MAGDALENE Bleddfa means 'place of the wolf', and the last wolf in Wales was said to have been killed in Bleddfa. The pretty church dates from the thirteenth and fourteenth centuries, rebuilt in the early fifteenth century after being damaged in war. Nearby Monaughty, on the KNIGHTON road, is a corruption of Mynachdy, the house of monks, so indicates a monastery site. Local tradition is that the church was founded by St Brendan, and it appears that Mary is a much later dedication for the site.

BODELWYDDAN CASTLE *Off the A55 near St Asaf, Denbighshire.* The history of the house and estate is pre-1460, though the association with the Williams family dates from around 1690. The castellated Gothic structure seen today is a creation of Sir John Hay Williams, dating from between 1830 and 1852. However, the loss of the main income source for the estate – lead mining – in the 1850s resulted in the decline of the Williams family fortunes, though further building refurbishment took place in the 1880s. The castle is set within magnificent parkland and a formal garden originally designed by Mawson in 1910. Bodelwyddan Castle is a regional partner of the National Portrait Gallery, and also displays collections of furniture from the Victoria & Albert Museum, and sculpture from the Royal Academy of Arts.

BODELWYDDAN – ST MARGARET'S CHURCH – 'THE MARBLE CHURCH' A superb church built from 1856-60 for Bodelwyddan Castle and estate, but now sadly cut off by the A55. A 200-foot spire, and a superb Anglesey marble interior with wooden furnishings make this an excellent site for visiting. Once known as 'the Pearl of the Vale', it was built by Lady Willoughby de Broke as a memorial to her husband.

BODIDRIS HALL – HOTEL AND HISTORIC HALL *Llandegla LL11 3AL. Tel: 01978 790434 Web: bodidrishall.com.* Claimed to be a Dark Ages site, it was the plas (hall or court) of the princes of Powys, owned by Owain Cyfeiliog (c. 1130-97). It was given to Llewelyn ap Ynyr as payment for his actions against Henry II's invasion in 1165. Llywelyn's descendants, the Lloyds, supported Owain Glyndŵr's War of Independence (1400-1415) and the hall was burned down in 1401. Rebuilt in 1465, Queen Elizabeth and the Earl of Essex are rumoured to have trysted there. There is a priest's hole, a cell and one can stay in a four-poster in the Elizabeth Suite where Elizabeth I was said to have slept. It is truly an ancient, remarkable and peaceful place to stay.

BODNANT GARDEN – NATIONAL TRUST – RHS RECOMMENDED GARDEN *Tal-y-Cafn, near Colwyn Bay, Conwy LL28 5RE. Tel: 01492 650460. Web: bodnantgarden.co.uk.* This world-famous garden, situated above the River Conwy and with stunning views across Snowdonia, is noted for its botanical collections. The gardens feature huge Italianate terraces and formal lawns on its upper level, with a wooded valley, stream and wild garden below. There is a lovely 'Tudorbethan' mansion here, rebuilt in 1831 from a Georgian predecessor.

BODOWYR BURIAL CHAMBER CADW *Signposted between Brynsiencyn/Llanidan and Llangaffo, Anglesey.* A Neolithic chambered tomb, or passage grave, it consists of three uprights and a 7-foot by 6-foot capstone.

BONCATH – CILWENDIG SHELL HOUSE AND CAPEL COLMAN *East of Boncath, 7 miles south of Cardigan SE37 0EW, off the B4332 road to Newchapel.* Cilwendig is a Georgian mansion built by Morgan Jones, now a care home for the elderly. Its Cilwendeg Shell House Hermitage is a most remarkable ornamental grotto, and a rare survival in West Wales. The floor is coated with animal bones and the walls with shells. There is also a mock-Gothic pigeon-house in need of restoration. It was built in the late 1820s for Morgan Jones the Younger (1787-1840), who inherited the Cilwendeg estate upon the death of his uncle. Capel Colman medieval church on the estate was rebuilt as a private chapel in 1833-35, dedicated to St Colman, the fifth-century original saint of FISHGUARD. A crossed stone was found here, said to be his grave marker. The Cilwendeg Shell House and the Capel Colman Church are both open for public viewing on Thursdays in season. A fabulous concert hall has recently been built at another nearby mansion house, Rhos Y Gilwen, with a varied programme of classical and folk music.

BONCATH – FFYNONE – MANOR HOUSE DESIGNED BY JOHN NASH *1 mile east of A478 Tenby to Cardigan road. Take B4332 past Newchapel, house on right.* Boncath means Buzzard in Welsh, and is surrounded by many fine manor houses, the most impressive being Ffynone. It was

designed and built by John Nash 1792-95 for the Colby family, with beautiful gardens (open only by written appointment).

BOSHERSTON LAKES AND FLIMSTON IRON AGE PROMONTORY FORT *Near Stackpole on the Castlemartin Peninsula, Pembrokeshire.* Also known as Bosherston Lilyponds nature reserve, these are three long limestone valleys dammed and flooded in the eighteenth century to make a country estate, complete with an inaccessible Iron Age camp on one of the peninsulas. The Church of St Michael and the Angels dates from the late thirteenth century, and the St Govan's Inn is sixteenth century. On the nearby coast, Flimston Bay has developed a large blow hole, where the sea has tunnelled underneath the cliffs and squirts up through the fort.

BOSHERSTON – ST GOVAN'S CHAPEL *A mile south of Bosherston, Pembrokeshire.* St Govan's sixth-century chapel is down seventy-six steps in a cleft in the rocks overlooking the sea, with a nearby dried-up holy well, although the tiny chapel is now deconsecrated. Legend links Govan with Sir Gawain fighting the Green Knight here, and the saint's body is supposed to lie under the stone altar.

BODYSGALLEN HALL – JACOBEAN MANSION AND GARDENS *2 miles south-east of Llandudno, Conwy LL30 1RS.* Now a superb Grade I listed hotel and spa, it has been under National Trust ownership since 2008. Bodysgallen was rebuilt in 1620 around the core of a thirteenth-century tower house, and its 200 acres of seventeenth-century gardens are remarkably intact.

BONTDDU ST PHILIP'S CHURCH *Caerdeon, 3 miles from Barmouth, on the Dolgellau Road.* Built in 1860 by a retired English clergyman, its design was inspired by Basque churches and is described by the writer Jan Morris as 'purest Pyrenean.' An open bell-cote containing four bells rung by a windlass system is probably unique in Wales. The church was originally built as a private chapel and only became a parish church after a great deal of controversy, being granted a licence to hold services in English only.

BRECON (ABERHONDDU) – ANCIENT BASTIDE TOWN The three highest peaks in South Wales are near this town, being Pen Y Fan, Cribin and Corn Du, and the town was built where the Usk meets the Honddu, hence its original Welsh name, Aberhonddu – the mouth of the Honddu. Brecon is named after the sixth-century Brychan Brycheiniog, and was the county town of Breconshire, with a charter dating back to 1246. A charter of 1366 gives it the right to hold fairs (which are still held), and the annual Brecon Jazz Festival is a highlight of the Welsh cultural year. The town has architecture dating back to medieval times. The Monmouthshire & Brecon Canal (1797-1812) terminates outside the town. Christ College is on the banks of the Usk and was founded in 1541, becoming a public school in 1853. It incorporates the chapel of a twelfth-century friary. The Brecon Museum is an excellent repository of local folklore and history, and the South Wales Borderers' Museum has thirteen of the twenty-three VCs awarded to the regiment's soldiers.

BRECON, BATTLE OF, EASTER 1093 *Traditionally in fields to the south of the village of Battle, 3 miles north-west of Brecon.* Rhys ap Tewdwr, Prince of Deheubarth, was killed here, allying with Bleddyn ap Maenyrch, the last Prince of Brycheiniog, against Bernard de Neufmarche. This crucial defeat was followed by a general invasion of South Wales by the Normans. It is not certain whether there was a battle, a skirmish or whether Rhys had been lured to a meeting and killed by treachery. Near the village of Battle there is Cwm Gwyr y Gad, the valley of the men of battle. (Rhys ap Tewdwr was also supposed to have been killed at Hirwaun in battle.) According to The Chronicle of Ystrad Fflur, Rhys, *'king of the South, was slain by* Frenchmen who were inhabiting Brycheiniog – and with him fell the kingdom of the Britons. And within two months the French overran

Dyfed and Ceredigion – and made castles and fortified them.' The village is in fact named after Battle Abbey in Sussex, which drew income from the parish here. Cynog was a son of the sixth-century king, Brychan Brycheiniog and St Cynog's church was first documented in the 1220s, as a dependent chapel of Brecon Priory. There is a Bronze Age Standing Stone near the village.

BRECON BEACONS NATIONAL PARK To the east lie the Black Mountains, with a high point at Waun Fach, forming a natural border with Herefordshire. The Central Beacons dominate the skyline to the south of the town of Brecon and rise to 2,907 feet at Pen y Fan, the highest point in southern Britain. Further west lies the sandstone massif of Fforest Fawr, comprising a series of hills known as 'Fans', with Fan Fawr being the highest point, and this area is full of waterfalls. The most westerly block of sandstone is Y Mynydd Du, The Black Mountain, culminating in the summit of Fan Brycheiniog, containing the two enchanting glacial lakes of LLYN Y FAN FACH and Llyn y Fan Fawr. The whole park is studded with castles, old villages and medieval churches.

BRECON CASTLE *Castle Square, Brecon.* On an ancient site, and near vital fords over the Usk, the first motte and bailey castle was built by Bernard de Neufmarche around 1100, after taking the land from the Welsh. The keep and parts of the structure date from the thirteenth century, and it became the headquarters of the Lordship of Brecon. Attacked by the Welsh six times between 1215 and 1273, it was taken three times, in 1215, 1264 and 1265. The Brecon Castle Hotel (www.breconcastle.co.uk) has been incorporated into the remains.

BRECON CATHEDRAL The site was a Benedictine priory from 1093, and the early thirteenth-century Priory Church of St John was designated a cathedral in 1923. It was restored by George Gilbert Scott, and there is an elaborately carved Norman font.

BRECON – CHURCH OF ST MARY Built within the town walls in the thirteenth century, most now dates from the fourteenth and fifteenth centuries except the sixteenth-century tower. In the heart of the town, the tower has been called 'the finest tower in Powys', and its red stone battlements and carved waterspouts can be seen from all over the town.

BRECON – PLOUGH UNITED REFORMED CHAPEL There are many chapels and former chapels in Brecon. Grade II Listed, this is also known as Y Drindod (The Trinity) and is neo-Baroque with superb pew carvings. Formally the Welsh Independent or Congregational chapel, it was named after the Plough Inn, upon which the original 1699 chapel was built.

BRECON – Y GAER ROMAN FORT CADW *Aberyscir, three miles west of Brecon.* There are remains of stone defences and gates of a Roman auxiliary fort, initially established about 75 CE near the River Usk. The perimeter walls still exist and finds are in Brecon Museum. Brecon Gaer lay at the hub of a system of strategic military Roman roads, running southwards in the direction of YSTRADGYNLAIS, northwards towards LLANDRINDOD, south-east along the Usk Valley to ABERGAFENNI, north-east to Kenchester and south-west to LLANDOVERY.

Y BREIDDIN HILLFORT *Near Middletown, 5 miles west from Welshpool to Shrewsbury on the A458.* Occupied from the Bronze Age, through the Iron Age and during the Roman occupation, half the site survives (after quarrying) on a ridge near OSWESTRY. It was said to be the site of Caradog's last stand against the Romans. Still eleven acres in size, it is one of the largest hillforts in the Welsh Marches, and its stone ramparts once stood 20 feet high.

BRIDGEND (PEN-Y-BONT AR OGŴR) – STRATEGICALLY IMPORTANT TRADING CENTRE *At the southern end of the Ogŵr (Ogmore), Garw and Llynfi valleys, Glamorgan.* The Afon Ogŵr runs through the town, which was developed because the river was fordable here. Because of its position, guarding against the Welsh coming from the north or west, there is a Norman castle,

New Castle, overlooking the town, plus other powerful fortresses within two miles at COETY (Coity) and OGMORE, forming a defensive triangle. Nearby EWENNI PRIORY was also heavily fortified. The town's stone bridge was built around 1425, but partially demolished by floods in 1775, following which it was rebuilt. The last recorded use of the bridge by a motor vehicle was in 1920. It is a Grade II* listed structure. One of Bridgend's most interesting buildings is the Hospice of the Knights of St John, a fifteenth-century church house used by the pilgrims.

BRIDGEND NEW CASTLE CADW The Norman castle appears to have been refortified by Henry II in the 1180s, as indicated by the exceptional quality of the masonry. The remains include parts of the curtain wall and two mural towers, but the best-preserved feature is the gateway, a fine specimen of Norman ornamental stonework. It guards a crossing on the Ogŵr, and the first castle here was the furthest western possession of Robert FitzHamon, dating from around 1106. Henry II expanded it in the 1180s.

BRIDGEND COETY (COITY) CASTLE CADW *Northern outskirts of Bridgend, Glamorgan.* Although originally established soon after 1100, much of the castle dates from the fourteenth century and later. Parts were rebuilt following the sieges by Owain Glyndŵr in 1404-05. This is a well-preserved site, with a fascinating history of sustained warfare.

BRIDGEND COETY – ST MARY'S CHURCH *Just across the lane that passes Coity Castle.* A marvellous medieval battlemented church, with two fine effigies of de Turberville women and an intriguing carved oak chest (possibly a very rare example of a portable Easter Sepulchre dating to 1500). There is a burial chamber north of the church.

BRITHDIR – CHURCH OF ST MARK – GRADE I LISTED ART NOUVEAU CHURCH **FOFC** *3 miles east of Dolgellau, Merionethshire.* St Mark's remarkable Italianate 'Arts and Crafts' church was built from 1895-98 to the designs of Henry Wilson.

BRITHDIR ROMAN FORT *On the south side of the Wnion valley overlooking Dolgellau from the east.* The plough-damaged platform was abandoned as early as 120 CE, and there is evidence of lead smelting and tanning on the site. The fort is located at a junction of Roman military routes in fields to the north of the line of the Roman road running south-west from CAERGAI, which met with the Roman road running south-south-east from the fort at TOMEN-Y-MUR. The main coastal route continued south-south-west to the Roman fort and settlement at CEFN CAER, PENNAL.

BRONLLYS CASTLE CADW *9 miles north-east of Brecon on A470 to Hay.* Late-eleventh- or early-twelfth-century motte with a thirteenth-century 80-foot-high round stone keep, on the confluence of the Llynfi and Dulais rivers. It was built to protect Brecon from Welsh attacks. In 1233 it changed hands twice, and from 1311 was owned by Rhys ap Hywel ap Meurig, as a reward for his loyalty to Edward I. However, for rebellion he lost his properties until 1326. In 1328, Rhys rebelled against Edward II and, with Henry of Lancaster, captured Edward and sent him to Berkeley Castle to be killed.

BRONZE AGE HOARDS Along with the MOLD CAPE, there have been other notable finds of artistic brilliance from the Bronze Age in north-east Wales. Important finds include: the CAERGWRLE Bowl (a shale, tin and gold bowl, the design of which forms a boat); the Westminster Torc (a twisted gold neck ornament); the Rossett Hoard (a socketed axe containing cut pieces of a gold bracelet and two pieces of a knife); the BURTON Hoard (a hoard containing a unique collection of bronze palstave axes and gold jewellery of great craftsmanship); and the Acton Hoard (a collection of bronze axes that point to a strong bronze-working tradition in this area).

BRYN BRAS CASTLE *3 miles east of Caernarfon.* A Grade II* Listed Building, it is set in thirty-two acres of grounds. It was built in the neo-Romanesque style, on an earlier structure between 1829 and 1835, for Thomas Williams, probably designed by Thomas Hopper, who built nearby PENRHYN CASTLE at the same time. The style of the Norman Revival is in evidence, and it is in private ownership.

BRYN CELLI DDU BURIAL CHAMBER CADW *Outside Llanfairpwllgwyngyll, Anglesey.* This is an extremely impressive Neolithic chambered tomb, with central pillar, partially restored entrance passage and mound, on the site of a former henge monument. The copy of a decorated standing stone is outside, the original being in the National Museum of Wales.

BRYNEGLWYS – CHURCH OF ST TYSILIO *5 miles north-west of Llangollen off the A5104.* Standing on the slopes of Llantysilio Mountain, the large fifteenth-century Church of St Tysilio is connected with the family who helped to found Yale University. Close to the village lies Plas-yn-Iâl, the former home of the Yale family and the birthplace of Elihu Yale's father. Elihu himself was born in 1647 in Boston, Massachusetts, and went on to become Governor of India before coming to Britain. Known for his philanthropy, Elihu was approached by an American College who, after receiving generous help, named their new college in Newhaven after him. In 1745, twenty-four years after his death, the whole establishment was named Yale University. (N.B. The joint founder of Brown University in Rhode Island was Morgan Edwards, who came from Pontypool. America's most famous female college is Bryn Mawr, Welsh for Great Hill, established by a Welshman. Johns Hopkins University was a Welsh foundation in the USA. Beijing University was formed out of the city's language school set up in 1869 by Welsh missionary Hopkin Rees, from Cwmafan.) Elihu Yale is buried in the Church of St Giles in WREXHAM.

BRYNFFANIGLE UCHAF EARTHWORK *Near Abergele, Conwy.* This motte is notable for being the home of Ednyfed Fychan (d. 1246), Chancellor and Chief Councillor to Llywelyn the Great, and the ancestor of the Tudor dynasty. It was the formerly the residence of Ednyfed's ancestor Marchudd ab Cynon, Lord of ABERGELE around 846. An old mansion here, now demolished, was her home in the early life of the poet Felicia Hemans.

BRYNTAIL – LEAD MINE BUILDINGS CADW *On the southern outskirts of Llyn Clywedog, north-west of Llanidloes, Montgomeryshire.* Buildings and structures associated with the nineteenth-century extraction and processing of lead ore, open to the public. There were three main shafts, Murray's, Gundry's and Western shaft. The majority of the scheduled buildings on the site are associated with Gundry's shaft, including a barytes mill, two crushing houses, ore bins, roasting ovens and water tanks. Other mine buildings include the manager's office, smithy, store buildings and a circular magazine.

BRYN Y CASTELL HILLFORT *Off the B4391 towards Bala about a mile from Ffestiniog.* Excavated in 1979-85, the rampart and certain buildings in the interior have been partially reconstructed, giving a good impression of how it might once have looked. There are roundhouses and evidence of iron smelting. The Celts would use bog iron ore, from beneath the peat that surrounds the hill, for smelting and working iron.

BUILTH (BUALLT) CASTLE Not generally realised, this was one of Edward I's 'iron ring' of castles, but has lost its stonework over the centuries. In 1183, there had been a battle here at the original motte and bailey site, and in the 1240s it was first fortified with stone. It had been besieged in 1223 by Prince Llywelyn, given to him in 1229, and on his death passed back to the Normans. It was repeatedly besieged from 1256 to 1260 when it fell and was demolished by the Welsh. From 1277, Edward I transformed it into a powerful castle with six towers. In 1282, Llywelyn ap Gruffudd left his castle at ABEREDW, three miles away, to ask for support from Builth Castle, and was shortly after entrapped and murdered. Owain Glyndŵr failed to take the castle.

BUILTH WELLS, BUALLT, LLANFAIR-YM-MUALLT – FORMER SPA TOWN *At the confluence of the Wye and Irfon, Breconshire.* Llanfair-ym-Muallt, the Welsh name for Builth, means 'The Church of St Mary in the Wooded Slope of the Ox'. Its sulphur waters were known as far back as 1740. Saline water was later discovered there in 1830, and by the late nineteenth century, the spa had a Central Pavilion for gentlemen and ladies to come and 'take the waters'. The wells were most popular around 1890, when the chalybeate and saline springs were used by those suffering from heart, kidney and gout disorders. The Royal Welsh Agricultural Show, held over four days every year, is one of Europe's finest shows of its kind, on the adjoining Llanelwedd showground.

BURRY HOLMS IRON AGE SETTLEMENT *Off Rhosili Bay, Gower Peninsula, Glamorgan.* The rocks can be reached at low tide, and there is an Iron Age settlement and remains of a twelfth-century church. In the Burry Estuary, Amelia Earhart landed in 1928, becoming the first woman to cross the Atlantic in her seaplane *Friendship*. With her companions Wilbur Stultz and Louis Gordon, she thought she had landed in their intended destination of Ireland.

BURTON HOARD *Found near River Alyn, Denbighshire.* A collection of fourteen gold adornments and bronze tools, originally buried in a pottery vessel, was found by metal detectorists in 2003. Declared treasure trove in 2004, the gold items include a flange-twisted torc, a wire-twisted bracelet, a composite pendant, four beads and three penannular rings. The tools include two Transitional Palstaves and a trunnion tool. The Hoard contains a couple of pieces that are unparalleled anywhere else in the UK – a bracelet with strands of twisted gold and a pendant consisting of a gold bi-conical bead.

BATTLE OF BUTTINGTON, 893 *Buttington, near Welshpool, Montgomery, near Offa's Dyke.* One of the most important battles of the Dark Ages, in the Severn Valley, where King Alfred the Great and King Merfyn of Powys, with some of Anarawd of Gwynedd's men defeated the Danes led by Haesten. Mentioned in the *Anglo-Saxon Chronicles*, it is either in north or South Wales. It is possibly Buttington in Montgomery, where 400 scarred skulls were found in the 1830s, or at somewhere on the Severn shore. The Danes had made their way by boat up the Thames and Severn rivers, and occupied a fort where they were besieged and badly beaten. There is a thirteenth-century Church of All Saints here. Nearby, TREWERN HALL can be visited, and Trewern Mound is a motte dating from 1256.

CAIO – CHURCH OF ST CYNWYL *Also known as Caeo and Cayo, it is between Llandovery and Lampeter, a mile off the A482, Carmarthenshire.* Caio is close to the Dolaucothi gold mine, first developed in the Roman period. It was formerly known as Cynwyl-Gaio, and numerous relics of Roman antiquity have been found here. According to tradition, it not only took its name from a Roman called Caius, but a large town was erected here by the Romans. The houses were made chiefly of brick, so it was called 'Y Drêf Gôch yn Neheubarth', or the Red Town in Deheubarth. The church is spacious structure, in the early style of English architecture, with a square embattled tower.

CAER BERIS MOTTE AND MANOR *Off A483, western outskirts of Builth Wells, Breconshire LD2 3NP.* The site may be that of Caer Peris, one of the '28 Cities of Britain', mentioned by Nennius in the eighth century. Pasgent ap Gwrtheyrn, King of Buallt and Gwrtheyrn, was said to have established his court here in 406 CE. The earthwork seems to have been raided by Vikings, and used for the first Norman castle in the cantref of Buallt, probably built by Philip de Braose in 1093. In 1168, The Lord Rhys invaded Brycheiniog and destroyed the castle. Various Welsh princes held it until the 1240s when BUILTH CASTLE became all-powerful. The nearby Caer Beris Manor is now a Grade II listed country hotel.

CAERBWDY VALLEY – NATIONAL TRUST (SEE SOLVA COAST) A beautiful sheltered valley running down to the sea, only one mile east of St David's, Pembrokeshire. Stone is still cut

from the seaward end of the valley for repairs to ST DAVID'S CATHEDRAL, which is largely built from the distinctive red rock.

CAER DREWYN HILLFORT *Hilltop overlooking CORWEN in the Berwyn Mountains. From the centre of Corwen, cross the River Dee and, behind the swimming pool and car park, there is a waymarked path that gives access to the fort.* The pattern of banks and ditches, and especially the collapsed stone ramparts, are evidence of the changing shape and size of the fort over time. There is a complex of defended enclosures. The fort is entered through an inturned entrance, almost like a funnel, which is now choked by stone. At its inner opening, there are the facing walls of a pair of guard-chambers. In places the collapsed dry-stone wall still presents a parapet and walkway. A commanding position of strategic importance, it guards a Roman road through the valley of the River Dee.

CAER DREWYN 1165 – THE ROUT OF HENRY II (SEE CROGEN) Henry II had prepared and mounted what was hoped to be the final blow to the recalcitrant Welsh princes. Forces were commandeered from the continent and from Scotland, a fleet was also summoned from Dublin 'proposing to destroy the whole of the Britons'. He assembled a force of 30,000 men at Weston Rhyn in Shropshire and began to march across Wales. His army headed up the Ceiriog Valley to CORWEN. However, Owain Gwynedd, Owain ap Gruffudd (Cyfeiliog) of Powys, and The Lord Rhys of Deheubarth assembled forces including those of Cadwallon ap Madog and his brother Einion Clud, at Corwen in the Dee valley. Gruffudd ap Rhys of Deheubarth, the husband of the murdered Gwenllian, was also with his followers in the Welsh army. With the three ancient kingdoms of Wales, Gwynedd, Deheubarth and Powys united, this was the largest Welsh army ever assembled. Henry retreated back across the Berwyn Mountains to England, ending the invasion. '... And after remaining there a few days, he was overtaken by a dreadful tempest of the sky, and extraordinary torrents of rain. And when provisions failed him, he removed his tents and his army to the open plains of England; and full of extreme rage, he ordered the hostages, who had previously been long imprisoned by him, to be blinded; to wit the two sons of Owain Gwynedd ... and the two sons of the Lord Rhys and many others ...' (Brut y Tywysogion)

CAER DREWYN 1400 – THE START OF GLYNDŴR'S WAR In 1400 Glyndŵr raised his Golden Dragon banner here and was acclaimed by other Welsh nobles as their prince to lead their renewed fight for liberation against the English. The place had been symbolically chosen because of the successful unification of the Welsh princes to fight off Henry II over two hundred years previously. The war lasted for fifteen years, and six Royal Expeditions into Wales each went back over the border without taking Glyndŵr.

CAERFFILI (CAERPHILLY) *On the A469, 5 miles north of Cardiff, Glamorgan.* It was renowned for the crumbly Caerphilly Cheese, and lies in the Rhymni Valley coalfield. From 1902 to 1964 it was also famous for its locomotive and carriage workshops. There is an annual Cheese Festival and Fair ('The Big Cheese') centred on the parkland near the castle.

CAERFFILI (CAERPHILLY) CASTLE CADW – ONE OF THE MOST IMPRESSIVE FORTRESSES IN THE WORLD Caerffili Castle (Caerphilly), is the biggest castle in Britain after Windsor, and was built mainly between 1268 and 1271, after Llywelyn ap Gruffudd destroyed the previous Norman castle. 'Red Gilbert' de Clare built it to defend his territories from Llywelyn, who by the Treaty of Montgomery (1267) had been acknowledged King of Wales by Henry III. Its thirty acres of water defences are unequalled in Europe, featuring a flooded valley, with the castle built on three artificial islands. The dams are a superb engineering achievement, with the south and north lakes deterring any sort of attack. The east wall is effectively a huge fortified dam and, together with the west walled redoubt, defends the central isle. This central core has a double concentric circuit of walls and four gatehouses. The depth and width of the moat was controlled from within the castle. It was the first truly concentric castle built in Britain, and its concentric

system of defences was copied by Edward I in building his 'iron ring' of castles around Gwynedd. Llywelyn held it for a time in 1270. It was attacked in 1294-95 and 1316, and Queen Isabella besieged it from 1326-27 to try and capture her husband Edward II. A gatehouse was damaged in the Llywelyn Bren siege, and Caerffili fell briefly in Glyndŵr's uprising of 1400-1415. Its leaning tower, at 10 degrees tilt, out-leans that of Pisa, possibly being damaged during the Civil War fighting. One of the most important fortresses in Europe, when Lord Tennyson first encountered it, he exclaimed, 'This isn't a castle. It's a whole ruined town.' Caerffili is the only castle in the world with full-size replicas of four different 'siege-engines'. On certain days they are demonstrated, with huge stones being hurled into the lakes.

CAERFFILI ROMAN FORT The mound to the north-west in the castle grounds is a Civil War artillery redoubt of 1645, built on the site of the Roman auxiliary fort, and the fort was discovered by accident only in 1963. The excavator considered the fort to have been established *c.* 75 CE and occupied at least until the middle of the second century. It covers twenty-one acres, with a bathhouse, but few traces remain.

CAERFFILI – GWERN Y DOMEN MOTTE AND BAILEY *A mile east of Caerffili, south of Bedwas Village, off the Rudry road.* A Norman earthwork fortress, which originally had wet defences, supports a strong D-shaped rampart. A dismantled railway line separates the remains of the bailey from the motte, and with the dense cover of vegetation, its best view is in winter.

CAER GAI BATTLE 656 The *Welsh Annals* record 'strages gaii campus' – 'the slaughter of campus gaius' for this year.

CAER GAI ROMANO-BRITISH FORT – AN OCCUPIED SITE FOR 2000 YEARS *Outside Llanuwchllyn near Bala.* A fort and settlement seemingly abandoned, like many Roman sites in Wales, around 120 CE. It then became a Romano-British settlement. Located on a spur in the valley of the Dee (Afon Dyfrdwy) overlooking the river from its north bank, the Caer Gai fort is square in plan, each side measuring about 420 feet, and covers an area of 4½ acres. The fort was furnished with timber buildings and was occupied from *c.* 75 CE until *c.* 130. Caergai Manor occupies the north corner of the fort and has destroyed most of the north corner-angle. The manor was burnt down in 1650 during the Civil War fighting, and rebuilt. Cai Hir (b. *c.* 468) appears to have been a real person who made his home at Caer-Gynyr near Bala in Penllyn which he renamed as Caer-Gai in the early sixth century. Cai is associated with early Welsh poetry, is in the *Mabinogion* as the companion of Bedwyr, and became the Sir Kay of Arthurian legend. A road must have linked this fort with TOMEN-Y-MUR fort.

CAERGWRLE BOWL This beautiful gold-foil-decorated bowl (*c.* 7 inches across the rim), was found in a bog at the foot of Caergwrle Castle Hill. It is perhaps the most extraordinary piece of gold work found in Wales. It may be twelfth to eleventh century BCE and is made of shale, with a design deeply cut into it. Originally all the elements in the design were filled with tin, over which was placed decorated gold foil. The decoration has been interpreted as forming the gunwales, oars and keel of a boat with waves running along its hull.

CAERGWRLE (HOPE) CASTLE – SUBSTANTIAL REMAINS OF THIRTEENTH-CENTURY CASTLE *In Flintshire, in the village centre, off Castle Street on the A451 5 miles north of Wrexham.* In Flintshire, it was built by Dafydd ap Gruffudd in 1277, being the last Welsh-built castle. From here Prince Dafydd attacked Hawarden in 1282, and then slighted it during King Edward's invasion. Edward I rebuilt it, using 1,000 workmen, who took two months to clear its well. It reverted to its English name of Hope Castle, but it accidentally burnt down shortly after. It lies in the corner of a hillfort and has a Welsh D-tower. The village has a seventeenth-century packhorse bridge. There is a Neolithic burial mound nearby at Cefn-y-Bedd (Ridge of the Grave).

CAERHUN ROMAN FORT *5 miles south of Conwy on the B5106, 1 mile south of Tŷ'n y Groes.* In Gwynedd, Canovium seems to have had a turbulent history, being built first of timber in 75 CE and then stone. It was destroyed around 200 CE, reused in the fourth century and abandoned around the beginning of the fifth century. A visit to the lower slopes of the Carneddau reveals two prehistoric forts, Pen y Gaer and Caer Bach, the Roman road from Canovium to Segontium, a chambered tomb, and Iron and Medieval Age farms and field systems. Local Roman sites include Caer Llugwy, Segontium, and the first-century early conquest marching camp at Pen y Gwyrd.

CAERHUN – THE CHURCH OF ST MARY AT CANOVIUM The church is thirteenth century, and built mostly of Roman stone blocks or 'ashlars' from Cheshire. It is constructed in the north-east corner of the Roman fort.

CAER LEB – ROMAN FORTLET CADW *West of Brynsiencyn, on A4080 Dwyran to Brynsiencyn, Anglesey, near Bodowyr Burial Chamber.* Caer Lêb is a low-lying rectilinear enclosure, defined by double banks and ditches, probably in use in the late Roman period. It seems to have been previously an Iron Age site, and after the Romans to have become a Romano-British settlement.

CAERLEON – THE FORTRESS OF THE LEGION (SEE CAERWENT) *Tourist Information Centre, 5 High Street, Caerleon, Newport NP18 1AE. Tel: 01633 422656.* Caerleon was perhaps the most important military site in Britain under the Roman Empire. It was the home of the II Augustan Legion, housing up to 6,000 soldiers and horsemen, with an amphitheatre, baths, shops and temples. Caerleon fort's walls still stand up to 12 feet high in parts, and the site covers fifty acres. Caerleon was built at the mouth of the River Usk in 75 AD, as the strategic base for the conquest of South Wales, and for ease of reinforcement and access to its gold mines at DOLAUCOTHI. The Hanbury Arms pub overlooks the site of the Roman port on the River Usk. Tennyson wrote much of *Idylls of the King*, his epic Arthurian poem, while staying at The Hanbury Arms. Isca was built to help control the Silures, at that time Rome's most difficult enemy. The site was named Isca Silurum by the Romans after the River Wysg, now known as the Usk. The position was also chosen because it was close to Llanmelin hillfort, the capital of the Celtic Silures tribe, which controlled south-east Wales. In the third century, Cardiff (Caerdydd) took over from Caerleon as the Romans' South Wales HQ. Caerleon was important as a port until the late nineteenth century, when the new Newport Docks took its trade. Only sections of the Roman town walls survive, many stones having been used in local buildings. Caerleon has a large green, flanked with pubs and is a congenial place to live. The record for Britain's longest marriage is that of Thomas and Elizabeth Morgan of Caerleon, who were married from 1809-91.

CAERLEON BATH HOUSE AND NATIONAL ROMAN LEGION MUSEUM – THE ONLY LEGIONARY BATH VISIBLE IN BRITAIN This graphically portrays the daily life of the garrison, and the monumental fortress baths had heated changing rooms, swimming pool, a huge gymnasium and bath halls.

CAERLEON CASTLE Caerleon Castle is an eleventh-century earthwork motte and bailey fortress, founded by Caradoc ap Gruffydd, Lord of Caerleon. It was taken by the Welsh in 1173 and 1217, held out in 1231, but was sacked by Glyndŵr. *The Chronicles of the Princes* tell us of Iorwerth ab Owen. In 1172, Henry II offered the return of Iorwerth's lands. He invited Iorwerth to meet him for a peace treaty, and gave safe conducts for him and his sons. The Welsh leader was well aware of Henry's practice of blinding hostages, and sent just one son, Owain, bearing gifts. Owain was killed, so Iorwerth crossed the Wye, attacking Gloucester, burning Hereford, and returned to Caerleon and rebuilt his town. In 1270, Gilbert de Clare founded the stone castle and crowned the steep motte with a high keep. The inner bailey retains part of its curtain wall and beside the River Usk are the remains of the Hanbury Tower, a round flanking tower.

CAERLEON – LODGE WOOD (LODGE HILL) IRON AGE CAMP An imposing hillfort on the north-west edge of Caerleon, overlooking the mouth of the Usk valley and parts of the Severn estuary. A tribal centre for the Silures, it comprises a triple-banked enclosure with out-works on the south, west and north, enclosing over five acres. Roman pottery has been found here.

CAERLEON ROMAN AMPHITHEATRE CADW – THE BEST-PRESERVED ROMAN AMPHITHEATRE IN BRITAIN The amphitheatre was thought by Geoffrey of Monmouth to be the site of Arthur's 'Round Table'. It could hold 6,000 men, the total population of the garrison. According to Geoffrey of Monmouth, Arthur was crowned here. Marie de France, in *The Lay of Sir Launfal*, wrote in the twelfth century, 'King Arthur, that fearless knight and courteous lord removed to Wales, and lodged at Caerleon-on-Usk, since the Picts and Scots did much mischief in the land. For it was the wont of the wild people of the North to enter the realm of Logres (England), and burn and damage at their will.'

CAERLEON ROMAN LEGIONARY BARRACKS CADW – THE ONLY ROMAN BARRACKS BLOCK VISIBLE IN EUROPE The amphitheatre and barracks are open free to the public all year. Each block housed a 'century' of eighty men, with each room holding ten men, and a separate room for the centurion. Once there were over sixty such blocks here.

CAERLEON – ST CADOC'S CHURCH This stands in the centre of the fortress, over the Principia or headquarters where Legionary standards were kept and statues of the Roman Emperors venerated. The earliest surviving part of the church dates back to the twelfth century and is thought to be the work of Hywel ap Iorwerth, who was also the founder of the Cistercian abbey of LLANTARNAM.

CAERNARFON (ABERSEIONT) – HISTORIC TOWN Caernarfonshire, facing Anglesey across the Menai Straits. Dominated by its castle, and situated where the River Seiont meets the Menai Straits. The battle site of Twt Hill is nearby, on a Bronze Age site with views to Anglesey and Snowdonia. Caernarfon was created a Royal Borough in 1963 and since 1974 has been a Royal Town.

CAERNARFON CASTLE WORLD HERITAGE SITE CADW King Edward I intended this castle to be a royal residence and seat of government for North Wales. The castle's symbolic status was emphasized when Edward made sure that his son, the first English Prince of Wales, was celebrated here in 1284. In 1969, the castle gained worldwide fame as the setting for the investiture of HRH Prince Charles as Prince of Wales. This is on the site of a Norman fort and then a Norman motte and bailey dating from 1090. It was in Welsh hands from 1115 until 1283. It is possibly the finest example of military architecture in Europe, its main gate being designed for no fewer than six portcullises, with assorted 'murder holes' above them. The arrow slits were designed for three archers to fire in rapid succession. There are two gatehouses, nine towers and walls 20 feet thick. Built by Master James of St George, its appearance, with the banded towers and eagles, was based upon Edward's experience of the Crusades, having seen the fortifications of Constantinople. Overlooking the Menai Straits, it was strategically important, allowing easy access to the other coastal castles of Harlech, Conwy and Beaumaris. Glyndŵr besieged it unsuccessfully in 1403 and 1404, and its Royalist defenders surrendered it to Parliamentary forces in 1646.

CAERNARFON LLANBEBLIG CHURCH *Half-mile south-east of Caernarfon LL55 1LF.* Thirteenth century, it is built on the site of the cell of St Peblig (Publicius), said to have been the Romano-Welsh uncle of Emperor Constantine the Great. He was the brother of Princess Elen (Helena), mother of Roman Emperor Constantine, who was said to be born here. She married Macsen Wledig (Magnus Maximus), who withdrew the Roman troops from Britain in 383 to attempt to become Emperor of Rome. Tradition has it that Constantine the Blessed was buried

here. Nennius recorded that he saw an inscription to Constantine at Segontium (Caernarfon), and in 1283 Edward I ordered that 'the Emperor Constantine' be transferred to Llanbeblig. The church dates in part from the fourteenth century. It has an oak roof and a tower with the unusual feature of stepped battlements.

CAERNARFON – SEGONTIUM ROMAN FORT AND MUSEUM CADW Remains of an auxiliary Roman fort on Llanbeblig Hill on the southern outskirts of Caernarfon, probably established in the late 70s CE. and modified through to the late fourth century. Many stones of the fort, associated with Magnus Maximus (Macsen Wledig), were used by Edward I in building Caernarfon Castle, and there is an interesting museum. Macsen Wledig and Caernarfon feature in the *Mabinogion*, and Gildas states that he was the founder of many Welsh dynasties.

CAERNARFON TOWN WALLS WORLD HERITAGE SITE CADW Complete circuit of walls, including eight towers and two twin-towered gateways, surviving in places to battlement height.

CAER PENRHOS CASTLE AND HILLFORT *Near Llanrhystyd in Ceredigion, 10 miles north-east of Aberaeron.* Caer Penrhos is a superbly sited, magnificent ring-work castle, built within an Iron Age hillfort, which has been used as a bailey. The castle was built in 1149, some say by Cadwaladr ap Gruffudd ap Cynan, and is also called Castell Cadwaladr. The earthworks are well preserved, on a site of considerable strength.

CAERSWS – CEFN CARNEDD HILLFORT *Ridge between Cerist and Trannon rivers, near Caersws, Montgomeryshire, 6 miles north-east of Llanidloes.* Some believe it to be the site of the last stand of Caractacus (Caradog) against the Romans. Once four acres, it was extended to fifteen acres with a triple-banked defensive system.

CAERSWS ROMAN FORTS *At the confluence of the Carno and Severn, Montgomeryshire.* The first fort was built quickly as the Romans fought their way through Wales. The second, larger fort also supported a civilian settlement. Roman roads lead from here to LLLANFAIR CAEREINION, FORDEN GAER and CAE GAER. It appears that this is Mediomanum ('the central fist') between Forden Gaer and CASTELL COLLEN, holding Central Wales. Caersws means 'the camp of the kiss' but it is more likely to have been 'the camp of Zeus'. The larger Caersws I camp at Llwyn-y-Brain is in a bend of the Severn $3/_4$ mile east of Caersws. The later Caersws II camp is partly beneath Caersws village, founded by Agricola around 78 CE. Almost 8 acres, it could house a 500-strong cavalry unit or up to three legionary cohorts (1,500 men). Its bathhouse was perhaps reconstructed *c.* 265 CE, and it was used until at least 337 CE on coin evidence.

CAERWENT ROMAN TOWN CADW (SEE CAERLEON) – BEST- PRESERVED ROMAN CITY WALLS IN NORTHERN EUROPE *5 miles west of Chepstow, Monmouthshire.* After suffering several major defeats, the Romans came to an accommodation with the Silures. Venta Silurum (Market of the Silures) was founded around 75 CE near Caerleon to become the new tribal capital of the Silures. Its impressive fourth-century walls still stand up to 17 feet high, a mile in length around the village, and are among the most perfectly preserved across the Roman world. They once were as high as 27 feet. Excavated houses and shops, a forum-basilica and a Romano-British temple also remain, but parts are still unexcavated. A Romano-Celtic temple there may have been associated later with the sixth-century St Tathan, and the site became a centre of the kingdom of Gwent after the departure of the Romans. The Normans built a motte within the Roman walls, as at Cardiff. Several inscribed stones have been found, including the famous 'Civitas Silurum' stone now in the thirteenth-century church: 'For Tiberius Claudius Paulinus, legate of the Second Augustan Legion, proconsul of (Gallia) Narbonensis, imperial propraetorian legate of (Gallia) Lugdunensis. By decree of the ordines for public works on the tribal council of the Silures.'

CAERWYS – CHURCH OF ST MICHAEL *5 miles west of St Asaff, 9 miles north-west of Mold on the B5122.* Caerwys is mentioned in the Domesday Book as a small market town. The church has two parallel naves and contains the cover slab of a tomb reputed to have been that of the daughter of the Earl of Derby, Elizabeth Ferrers (*c.* 1250-1500), the wife of Prince Dafydd ap Gruffydd, who was executed in 1283. Her daughter Gwladys was sent away to Sixhills Nunnery for life in 1283, and her sons imprisoned for life. The church has a late thirteenth-century tower and nave to which a chancel and a north aisle were later added, because the chancel has an inset south wall and there is a chancel arch. The dedication to St Michael points to an early eighth-century church, when the cult of St Michael became popular in Wales, and there is a well about half a mile to the west of the church known as Ffynnon Mihangel. Possibly a Roman signal station, Caerwys grew to become a place of such significance that it received a charter from Henry III. Caerwys is credited with being the place where, around 1100, Gruffydd ap Cynan called the first eisteddfod. The eisteddfod was revived here following the intervention of Elizabeth I, who gave permission for a competitive festival of Welsh music and poetry to be held here in 1568.

CALDEY ISLAND (YNYS BYR) ABBEY AND MONASTERY *Reached by boat from Tenby.* Caldey was settled by Celtic monks in the sixth century. Caldey Abbey was built in 1910 by Anglican Benedictine monks who came to the island in 1906. The Anglican Community converted to Roman Catholicism in 1913 and sold the abbey to monks of the Cistercian Order in 1926. They took up residence in 1929 and still occupy Caldey Abbey today. The building was designed in traditional Italianate style, and is a Grade II* listed building. At 500 acres, Caldey is the fifth largest island in Wales.

CALDEY ISLAND – OLD PRIORY AND ST ILLTUD'S CHURCH The fourteenth-century St Illtud's church is now the oldest British church in Catholic administration, with a floor of pebbles, shiny with age. The Old Priory and the adjoining St Illtud's Church, with its leaning spire, are among the oldest buildings on Caldey. The priory was home to the Benedictine monks who lived on Caldey from 1136 until the Dissolution of the Monasteries, but St Illtud's church is still a consecrated Roman Catholic church. The monks' original vaulted stone chapel now forms the sanctuary of the larger church, with the spire erected in the fourteenth century. The priory is believed to occupy the site of the original sixth-century Celtic monastery. The sixth-century Caldey Stone is displayed in the church, inscribed in Celtic Ogham script and also in Latin.

CALDEY ISLAND – ST DAVID'S CHURCH St David's is the medieval parish church of the island, and its churchyard, where simple wooden crosses mark the graves of monks and islanders, is the present-day cemetery. It stands on a pre-Christian Celtic burial ground, probably dating to the Romano-British period, about 1,800 to 2,000 years ago.

CALDICOT CASTLE, CASTELL CIL-Y-COED *5 miles south-west of CHEPSTOW, Monmouthshire.* This superb restored fortress stands on the Roman Via Julia to CAERWENT, and a motte and two baileys were built in 1086. Humphrey de Bohun built the round keep in 1221 and the fortifications passed on to Thomas de Woodstock, Duke of Gloucester and the son of Edward II. Responsible for building the great gatehouse, Gloucester was smothered in Calais in 1397. A later owner, the Duke of Stafford, was beheaded by Henry VIII in 1521. As at CARDIFF CASTLE, one can enjoy medieval banquets here. At nearby Black Rock, a small group of fishermen practise the ancient art of 'lave net' fishing on the River Severn.

CAMDDWR, BATTLE OF, 1075 *Probably near the River Camddwr around Llanbister, on the A483 Radnorshire.* The kings of South Wales, Rhys ab Owain and Rhydderch ap Caradog, overcame Llewelyn ap Cadwgan ap Elystan, his brother Goronwy ap Cadwgan and Caradog ap Gruffudd of Morgannwg in Maelienydd.

CAMLAN, BATTLE OF, 539 OR 532 – THE SITE OF ARTHUR'S LAST BATTLE Camlan means crooked riverbank or crooked shore, and there are many claimants for the site of Arthur's last battle where he was severely wounded. A persuasive case for the final Battle of Camlan being at Maes-y-Camlan (Camlan Field), just south of Dinas Mawddwy, has been made. This local tradition was recorded in Welsh by a local bard in 1893. In the area are two Camlans, Bron-Camlan, Camlan-uchaf and Camlan Isaf. Across the valley from Maes Camlan are Bryn Cleifion and Dol-y-Cleifion (Hill of the Wounded and Meadow of the Wounded). The nearby ridge overlooking the Dyfi River is Cefn-Byriaeth (Mourning Ridge) where graves were discovered. Five miles east is the site where Mordred's Saxon allies are said to have camped the previous night, and the stream there is still called Nant-y-Saeson (Saxon Stream). The date was 537 in the *Welsh Annals*, but the Celtic Church may have dated this from the crucifixion of Christ, making it actually 574. The *Welsh Annals* are generally wrongly dated by one or two years, because of the discrepancy between the Celtic and Roman calendars. The actual entry reads, 'The Battle of Camlann, in which Arthur and Medraut fell: and there was plague in Britain and Ireland.'

CAMPSTONE HILL, BATTLE OF, 1404 *Three miles south-west of Grosmont Castle, Monmouthshire.* The Earl of Warwick's forces were said to have defeated Owain Glyndŵr's followers and captured his standard from Rhysiart ap Elis.

CAPEL CURIG – ST JULITTA'S CHURCH *Where the A5 meets the A4086, on the Afon Llugwy, near Conwy, Caernarfonshire.* The smallest church in Snowdonia, it is now deconsecrated and fortunately unspoilt by Victorian restoration. This thirteenth-century church was once St Curig's Chapel, commemorating the sixth-century saint. Through confusion between Curig and Cyricus, the son of St Julitta, it was wrongly renamed. Nearby Hen Bont is the bridge built in 1790 by Lord Penrhyn to enable coaches to cross the river.

CAPEL CURIG – BRYN-Y-GEFEILIAU ROMAN FORT *About half a mile beyond Pont Cyfyng, towards the south-east end of Capel Curig.* There are remains of a bathhouse, but the four-acre fort was only used *c.* 90 CE – *c.* 120 CE, possibly to protect lead and silver smelting nearby.

CAPEL CURIG – TY HYLL (UGLY HOUSE) The headquarters of the Snowdonia Society is at the famous Ugly House, rescued from dereliction in 1988. It was said to have been built in the fifteenth century by two outlaw brothers. It was a 'Tŷ Un Nos' – or a house built in one night. Under ancient law, he who built a house between sunset and sunrise, with walls, roof and smoking chimney, could claim the freehold.

CAPEL GARMON BURIAL CHAMBER CADW *2 miles from Betws-y-Coed on the A5 towards Llangollen, turn right at Conwy Falls, near Llanrwst.* This Neolithic chambered long cairn tomb is similar in form to the so-called Cotswold-Severn group, and Beaker pottery has been discovered. What appears to be the entrance is in fact one of the inner burial chambers and the real entrance is on the south side from where a passage led to a rectangular space, which branched off to two circular burial chambers, the east and the west. The chamber has undergone considerable renovation but there are traces of the original stone walling in the lower courses of the eastern chamber. There is only one capstone remaining, but it is a huge piece of stone fourteen feet wide. There are two false portals leading nowhere, believed to be for ceremonial purposes only. The present entrance was formed for use as a stable in the nineteenth century.

CAPEL Y FFIN *7 miles south of Hay-on-Wye, in the Llanthony Valley.* From 1924-28 Eric Gill, David Jones and other artists worked in the Victorian monastery of Llanthony Tertia in this magical hamlet. The outstanding medieval church of St Mary the Virgin can only hold around twenty worshippers. It was rebuilt in 1792 and is a remarkably atmospheric place.

CARDIFF – CAPITAL OF WALES *Glamorganshire*. It may be that Cardiff was named after the Roman general Aulus Didius, being originally Caer Didius, and the huge Roman fort is at the heart of the city. Cardiff was sacked by Glyndŵr, given a Royal Charter by Elizabeth I and Cromwell's men took the castle from the Royalists in the Civil War. Cardiff used to be the busiest exporting docks in the world, taken over for a short time by BARRI, with all the valleys' coal pouring through its port. The city celebrated 100 years as a city and fifty years as a capital (Europe's youngest) in 2005.

CARDIFF ARCADES There are six Victorian shopping arcades in the city centre, with the Castle Arcade being the only three-storey arcade in Britain.

CARDIFF BUTE PARK Adjoining the castle, this was laid out by Capability Brown in the eighteenth century along the River Taff, and contains the remains of Blackfriars Monastery. Many of Britain's 'Champion Trees' are in the grounds, which reach as far north as Llandaf Cathedral and its ruined Bishop's Palace (sacked by Glyndŵr).

CARDIFF – CAERAU CASTLE HILLFORT On Cardiff's western outskirts, and overlooking the Ely River, a medieval ring work castle was placed inside it, with a spring for the defenders to use. On the site of the bailey is the vandalised thirteenth-century St Mary's Church.

CARDIFF CASTLE The first motte and bailey may have been founded by William the Conqueror when he made his pilgrimage to St David's, through South Wales in 1081. In the heart of the city, this is on the site of a massive Roman fort. Duke Robert of Normandy, the eldest son of William the Conqueror, was imprisoned by his brother Henry I and died here. Ifor ap Cadifor, Ifor Bach (Little Ivor), scaled the walls of Cardiff Castle in 1158 to capture William Earl of Gloucester, his wife and son. In 1183-84, a Welsh uprising damaged the castle, and in the 1270s it was refortified by de Clare in response to the threat from Llywelyn ap Gruffudd. The Despensers then took over the castle and imprisoned Llywelyn Bren there before illegally hanging, drawing and quartering him. In 1321, it was captured by barons rebelling against Edward II, and Despenser was hanged at Hereford, Edward being murdered at Berkeley. Glyndŵr's forces attacked and sacked the castle in 1404 and burnt the town. Other owners included the Earl of Warwick (King-Maker), the sister of Richard II and the great warlord Jasper Tudor. The Herberts offered Charles I refuge at the castle in 1645, but it was taken by Cromwell's forces. Cardiff Castle, up until the Second World War, was the longest continually inhabited building in Britain. It now features Roman fort walls, a Norman shell keep on a massive moated motte, and a restored medieval castle with eight acres of castle green. Restored in the nineteenth century by the third Marquess of Bute and the architect William Burges (as were CASTELL COCH and CAERFFILI Castle), it is one of Wales' greatest visitor attractions.

CARDIFF CIVIC CENTRE AND CITY HALL Cardiff's City Hall, the jewel in the crown of one of the finest civic centres in the world, was built in only five years, and opened in 1906. The Hall cost £129,708 and the adjoining Law Courts £96,583, massive costs at the time. With the adjoining National Museum, Temple of Peace, Welsh Office and University buildings, these glittering white edifices represent a time when Britannia really did rule the waves. Huge 12-ton and 15-ton blocks of Portland stone were carried by teams of six shire horses to the Town Hall site, where eight 5-ton cranes lifted and placed them. The cranes, operated by a local firm, Turner & Sons, made the Civic Centre the first all-electric building site in the world. Spread across sixty acres, next to the splendid castle, Bute Park, near the River Taff, and a couple of minutes from one of the best shopping centres in Europe, other European capitals find it difficult to rival this merging of history, nature, civic centre and city centre.

CARDIFF MARKET This unspoilt 1891 galleried indoor market still has one of the original traders, Ashton's Fishmongers, just inside the eastern entrance.

CARDIFF MILLENNIUM STADIUM The Rugby World Cup Final was held in the new Millennium Stadium in 1999. This all-purpose £100 million stadium has the largest retractable roof in the world, and takes 75,000 spectators. It held six FA Cup Finals and also Rugby League Cup Finals because of the delay in building the new Wembley Stadium. The last FA Cup Final was held there in 2006, just two years before Cardiff City appeared in the Final at Wembley. Football supporters have been so impressed by the city that at least one in ten has returned to Cardiff for a break or a holiday. There are no other capital city sports stadia integrated into the heart of the city like this futuristic white stadium on the banks of the Taff.

CARDIFF – NATIONAL MUSEUM OF WALES The National Museum, in the Civic Centre contains superb Impressionist paintings, one of the finest collections anywhere, donated by the Davies sisters. It is one of the best museums in Britain.

CARDIFF NEW THEATRE The New Theatre is an unspoilt Edwardian gem, dating from 1906, which can hold an audience of 1,570 people.

CARDIFF ROMAN FORT Its remains can be seen when one visits the castle. This large fort was occupied until the end of the first century, and then another shore fort was built of stone in the late third century, with walls ten feet thick to defend against the Irish. The nine-acre fort was abandoned in the fourth century, and features in the *Mabinogion* tale of Geraint and Enid as the home of King Ynwyl.

CARDIFF – ST JOHN THE BAPTIST'S CHURCH St John's Church was founded at the end of the twelfth century. It was sacked by Glyndŵr in 1404, and its wonderful pinnacled tower was endowed by the wife of the future Richard III in 1473.

CARDIFF BAY Europe's largest urban regeneration scheme impounded the outfalls from the Taff and Ely rivers to create a 500-acre freshwater leisure lake with eight miles of shoreline. The Cardiff Barrage, built to link Cardiff and Penarth and keep the 45-foot tides out, was completed in 1998. The whole project took over a sixth of the area of the capital, costing over £2.4 billion. The new Bute Avenue links up the city centre with its waterside at last. There are many Grade I and II listed buildings here, e.g. the excellent Wood's Brasserie is in the Grade I Pilotage Office. Locky's Cottage, Dolphins and Dock Sea Wall, the Iron-Framed D-Shed, the Oval Basin, Signal Platforms, the Big Windsor, Graving Docks, Pump House and Windsor Esplanade are all Grade II. Walking across the Barrage to Penarth, both Marine Buildings and the Custom House at the end of the Barrage are also Grade II. For visitors, please make the effort to walk away from the restaurants, heading west to the other side of the five-star St David's Hotel, to the nature reserve near Cardiff Yacht Club. Hardly anyone goes to watch the fish and birds – I have seen kingfishers, herons, shelduck, swifts, great crested grebes, little grebes, tufted duck, teal and cormorants there, without any effort.

CARDIFF BAY – COAL EXCHANGE Coal traders used to chalk up the changing prices of coal on slates outside their offices, or struck deals in the local taverns, but as Cardiff became the biggest coal port in the world, a building was designed to facilitate these deals. The Coal Exchange was built between 1883 and 1886, and hundreds of coal owners, ship owners and shipping agents met daily on the floor of the trading hall. Up to 10,000 people would use the building each day, and in 1907 the world's first million pound deal was struck at the Exchange. Around this time the price of the world's coal was decided here, and other attractive opulent banks and offices opened around Mountstuart Square – Baltic House, Ocean Building, Cory's Buildings, Cambrian Buildings, etc. The Coal Exchange closed in 1958, with coal exports ending in 1964. The Grade II* listed Coal Exchange was earmarked in 1979 as a future home of the proposed Welsh Assembly, but that plan for devolution was rejected in a referendum. It was run as a venue for rock and folk concerts, but

was closed in autumn 2007 for eventual redevelopment into flats and bars. Its central trading floor is listed, so will reopen as an entertainment venue.

CARDIFF BAY – NORWEGIAN CHURCH The port of Cardiff was one of the first to have a Norwegian Sailor's Church, built in 1860 to serve the needs of up to 73,000 Scandinavian seamen per annum. As the export of coal from Cardiff docks declined, Norwegian ships turned elsewhere for trade and the Norwegian Seaman's Mission decided to withdraw from the church in the mid-1960s. The church was dismantled in 1987 and re-erected nearby as a venue, gallery and café.

CARDIFF BAY – PIERHEAD BUILDING Grade I listed, this splendid terracotta building with superb brickwork and an ornate clock tower was built in 1896 as the headquarters of the Cardiff Railway Company, and dominates the Bay. Its like could never be built today.

CARDIFF BAY – SENEDD – WALES ASSEMBLY GOVERNMENT BUILDING Facing the waterfront, a huge timber canopy leads into the centre of government administration in Wales. Built in 2006, it is designed to be environment-friendly and is open to the public.

CARDIFF BAY – WALES MILLENNIUM CENTRE The 2000-seat Millennium Centre was opened in 2004 and has been fondly christened 'The Armadillo'. It is an exciting new theatre and the home for the Welsh National Opera. It is constructed of slate and wood, with a copper-covered dome. Its windows take the form of letters, reading 'In these stones horizons sing', and in Welsh 'Creu Gwir fel gwydr o ffwrnais awen', literally 'Creating truth like glass from the furnace of inspiration'.

CARDIGAN (ABERTEIFI) CASTLE *Ceredigion coast, where the county meets Pembrokeshire.* From the eleventh century, this was the site of constant battles between Norman invaders and the princes of Deheubarth. The Lord Rhys took it around 1170 and refortified it in stone, making it the first recorded Welsh masonry castle. In 1176, he held the first known eisteddfod there, with contests between bards and poets, and between harpers, crowthers (fiddlers) and pipers, with two chairs for the victors. Giraldus Cambrensis stayed with Rhys in 1188 when recruiting for the Crusade. Rhys' sons fought for the castle and it passed into Norman hands until Llywelyn the Great took it. It then changed hands several times between the Welsh and Normans, and it was slighted by Cromwell. It is presently being restored after many years of private neglect. Cardigan was once an important port and shipbuilding centre.

CARDIGAN – OUR LADY OF THE TAPER – NATIONAL CATHOLIC SHRINE OF WALES *North Road, Cardigan SA43 1LT.* During the Middle Ages there was a notable pilgrimage in honour of Our Lady of Cardigan. A legend describes how a statue of Mary was found by the side of the River Teifi, her son on her lap, and a candle burning in her hand. It was taken to the parish church but would not remain there, returning three or four times to 'the place where now is buylded the church of our Lady', the present St Mary's Church. The church dates from 1158. Benedictine monks cared for it until 1538, when they were expelled and the shrine destroyed.

CAREW CASTLE (CASTELL CAERIW) *On the A4075, off the A477, 6 miles east of Pembroke, Pembrokeshire.* Carew Castle was the site of the last medieval-style tournament held in Britain, in 1507, attended by Henry VII, his son Arthur and Arthur's wife Catherine of Aragon. 600 knights attended, and the arms of each member of the royal family can be seen on the south porch. It commanded a crossing point on the Carew River, and Gerald of Windsor built the first castle around 1100, on an impressive Iron Age site that had five defensive ditches. At one time King John seized it, but it passed in 1480 into the hands of Rhys ap Thomas, later a hero of Bosworth Field. With the new King Henry VII's patronage, he turned it into a superb fortified mansion.

Henry VIII's illegitimate son Sir John Perrot added the great North Wing, and it was partially slighted during the Civil War.

CAREW CELTIC CROSS CADW A superb tall eleventh-century stone with Celtic knotwork, commemorating the death of Maredudd ap Edwin in battle in 1035.

CAREW TIDAL CORN MILL – THE ONLY RESTORED TIDAL MILL IN WALES *Carew, near Tenby SA70 8SL. Tel: 01646 651782, part of the Carew Castle site, off the A4075.* Open to the public, there has been a mill here since the sixteenth century. The present building dates from about 1801, is open to the public and there is a huge twenty-three-acre millpond. A member of the Welsh Mills Society, it is being restored.

CARMARTHEN (ABER TYWI) *On the Roman road (A40), at the mouth of the River Tywi, Carmarthenshire.* Its old Welsh name of Caerfyrddin refers to its Roman name of Maridunium (or Moridunum) Demetarum, and the fort was built to pacify the Demetae after the Silures in the south-east had agreed to stop fighting. Julius Agricola then completed the Roman inroads into Wales, building forts at Carmarthen and Caernarfon as the new limits of Imperial power. CAERLEON, CARDIFF and Carmarthen are the oldest towns in Wales. The old manuscript from Carmarthen's priory, *The Black Book of Carmarthen*, is the oldest surviving work in the Welsh language, and is now in the National Library of Wales. The town was granted a Royal Charter by King John in 1201, and its 1405 eisteddfod was one of Wales' earliest recorded festivals. Only 300 years ago, with its population of 4000, Carmarthen was the largest town, and main port, in Wales. It was given permission for 'murage', to become a walled town, in 1223, probably the first in Wales. The medieval town walls, four gates and the Augustinian priory and Franciscan monastery have all disappeared. In 1479, along with Haverfordwest, the town was granted 'county status'. The strategic importance of the town and port is seen in constant warfare over the centuries. Apart from the following entries, there were battles at Carmarthen Bridge 29 August 1220; Carmarthen 26 April 1223; Carmarthen 1 August 1233; Carmarthen end of March 1234; and at nearby COED LATHEN 1257.

CARMARTHEN – BATTLE OF ABER TYWI, 1044 Gruffudd ap Llywelyn defeated a Danish force led by Hywel ap Edwin, and killed Hywel at Carmarthen.

CARMARTHEN, BATTLE OF, 1215 In April 1215, Llywelyn the Great attacked and took the castles of Carmarthen, Cydweli, Llansteffan, Cilgerran and Cardigan (Aberteifi).

CARMARTHEN, BATTLE OF, MID-APRIL 1258 *The Chronicle of Ystrad Fflur* tells us that in 1258 all the Welsh nobles made a pact to ally together, upon pain of excommunication, but Maredudd ap Rhys went against his oath: 'And Dafydd ap Gruffudd and Maredudd ap Owain and Rhys ap Rhys went to parley with Maredudd ap Rhys and Patrick de Chaworth, seneschal to the king at Carmarthen. And Patrick and Maredudd broke the truce and swooped down on them. And then Patrick was slain, with many knights and foot-soldiers.'

CARMARTHEN, BATTLE OF, 1405 This took place on Glyndŵr's march through South Wales to invade England, and the castle was taken.

CARMARTHEN (CAERFYRDDIN) CASTLE On a prominence above the River Tywi, its first name was Rhyd y Gors, mentioned in 1094. A Norman castle was built on the site by 1104, and in Crown ownership it became the administrative centre of south-west Wales. In the twelfth and thirteenth century, it was the scene of many battles between the Welsh and Normans, destroyed by Llywelyn the Great in 1215. Edmund Tudor, the father of Henry VII, died in prison here in 1456.

CARMARTHEN – ROMAN TOWN Maridunum (The Fort on the Sea) Demetarum (of the Demetae) was the 'civitas' or tribal capital of the Demetae, just as Caerwent was for the Silures. The fort there was founded in 75 CE, on the site of a Celtic hillfort. The amphitheatre, seating 5,000, is one of only eleven in Britain, of which the finest is at Caerleon. Giraldus Cambrensis tells us that in the twelfth century parts of the Roman town's walls were still standing. In Carmarthen Museum is the Vortiporix Stone, commemorating the sixth-century Romano-British King 'Vortiporix the Protector'. A son of Agricola (Aircol), he was one of the kings chastised by Gildas, who said he was 'like a panther in manners and wickedness'.

CARMARTHEN – ST PETER'S CHURCH Carmarthen's original parish church, and its oldest building still in use for its original purpose, this large church possesses a magnificent George III pipe organ. St Peter's recorded history dates from 1107 to 1124, but it may be on a Celtic site, since the church lies just inside the west gate of the Roman walls of Moridunum, and the churchyard appears to have been circular in origin. Parts of the tower, nave and chancel are thirteenth century, and in the porch stands a Roman altar. Buried in the church are Walter Devereux, First Earl of Essex, Sir Richard Steele (founder of the *Spectator* and *Tatler*), Bishop Robert Ferrar (burnt at the stake in the marketplace in 1555) and the great Sir Rhys ap Thomas (d. 1525, moved from the dissolved monastery in the town). The magnificent organ was initially ordered by George III for Windsor's Chapel Royal, but instead was sent to Carmarthen. In 2000, the tombs of his 'first wife' Hannah Lightfoot and her daughter were found in a brick-domed vault directly in front of the altar. There was no record of their burial, and a royal scandal was averted.

CARMARTHEN – SIR THOMAS PICTON'S MONUMENT 'The Hero of Waterloo' was born in 1758 in Pembrokeshire, and after service in the West Indies took command of the 'Fighting Third' division under Wellington in the Peninsular War. His bravery at the terrible battles of Badajoz, Vittoria and Ciudad Rodrigo made him popular with his men and the British public. He also fought at Bussaco, Fuentes d'Onor, in the Pyrenees, Orthes and at Toulouse. He received the thanks of the House of Commons on seven occasions and retired with honour to Ferryside, aged fifty-six. Napoleon escaped from Elba, and Wellington recalled Picton to command the Fifth Division. Picton's 'thin red line' held Quatre Bras in the face of murderous attacks, and he sustained grave gunshot wounds in his ribs and hip, which he and his valet concealed from his officers and Wellington. Two days later, Picton formed his division in a square and boldly led an unexpected charge with bayonets, at Waterloo. He was shot in the head. This manoeuvre effectively turned the battle in Wellington's favour. Picton had been in tremendous pain, with broken ribs from the earlier wound, and both hip and rib wounds were gangrenous. He may be the only Welshman buried in St Paul's Cathedral, and there is a monument to him in Carmarthen. He was loved by his men, leading from the front and serving forty-five years as a soldier.

CARMARTHEN – TRINITY COLLEGE Established in 1848 as a Church College to train teachers, it is a member of the University of Wales.

CARN DOCHAN – CASTLE (DOLHENDRE) AND GOLD MINE *Near Bala, 11 miles north-west of Dolgellau, Meirionnydd.* On a rocky summit near Llanuwchllyn and built by Llywelyn the Great, with a D-shaped tower it bears similarities to his CASTELL Y BERE, and has wonderful views. Near Lake Bala, it is only a mile from Caer Gai Roman fort. Castell Carn Dochan gold mine was discovered by accident in 1863 by a twelve-year-old boy, although many quartz boulders showing visible gold were scattered on the hillside, and became the fourth most productive of the Merioneth gold mines.

CARN FADRYN – CASTLE AND HILLFORT *Garnfadryn, near Llanbedrog, on the Northern Llŷn Peninsula, Caernarfonshire.* There is a stone-walled hillfort with stone huts, and a tower was

built by the sons of Owain Gwynedd, noted by Giraldus Cambrensis in 1188 as being one of the earliest Welsh stone castles. Until the twelfth century, Welsh castles had mainly been of earth and timber construction. About ten of the ninety round houses can still be seen, and it is associated with both Gwrtheyrn (Vortigern) and his granddaughter Modrun.

CARN GOCH, BATTLE OF, 1136 *On the road to Carn Goch Hospital off the A484, Mynydd Carn Goch Common, Loughor, Carmarthenshire.* On New Year's Day, rebellion broke out in the Norman lordships of South Wales, starting near Loughor. The Normans were defeated and a memorial stone has been laid on Carn Goch Common. The Welsh had been led by Gruffudd ap Rhys, the husband of Gwenllian, who then went north to try and involve the princes of Gwynedd in the war. When he left, the Normans attacked and executed his wife at CYDWELI.

CARN GOCH – IRON AGE HILLFORT *Brecon Beacons National Park, near Bethlehem, 4 miles from Llangadog.* One of the largest hillforts in Wales, impressively located on a hilltop dominating surrounding countryside, 700 feet above sea level. Carn Goch (Red Cairn) refers to a large prominent burial mound within the main enclosure. Carn Goch is the finest example of a Welsh hillfort with extensive storm wall ramparts. Construction follows the contours of the hill which enhances the protection offered by the ramparts. There are two hillforts at this location known appropriately and respectively as Y Gaer Fach (the small fort) and Y Gaer Fawr (the large fort), occupying two separate summits on the same long ridge.

CARNGUWCH – ST BEUNO'S CHURCH *1 mile from Llanaelharn and Llithfaen on the Northern Llŷn Peninsula, Caernarfonshire.* Mynydd Carnguwch has round barrows on its summit, and the ancient church is on the mountain, reached via a green lane through Penfras Uchaf Farm. The crowded gravestones are nearly all in Welsh, and are traditionally highly informative about the deceased.

CARN INGLI HILLFORT *Take the A487 to the west of Newport, Pembrokeshire, then turn down the Gwaun Valley road for 1 mile.* This covers two peaks, and did not require defending on its southern cliff. There were three gateways and about twenty-five house sites can still be seen. The ramparts originally stood 10 feet high. This is an evocative site, with wonderful views.

CARNO, BATTLE OF, 950 *On the A470 a few miles west of Newtown, Montgomeryshire.* The death of Hywel Dda inaugurated a period of internecine fighting among the Welsh princes, and the sons of Hywel Dda were defeated by the brothers Idwal and Iago ab Idwal Foel at Nant Carno. The superb landscape is now scarred by fifty-six huge wind turbines, access roads and assorted pylons, like much of Powys which has suffered the greatest from these uneconomic, ineffective and inefficient blights on the landscape.

CARNO, ALEPPO MERCHANT – SEVENTEENTH-CENTURY INN *On the A470 SY17 5LL.* The pub receives its name from the seventeenth-century merchant adventurer John Matthews, who built it. Laura Ashley, the fashion designer, is buried in St John's churchyard, and Murray the Hump, America's Number One Public Enemy was born here in Carno in 1899. St John's church is adjacent to the earthwork remains of a grange of the Knights Hospitaller, Caer Noddfa.

MOUNT CARNO, BATTLE OF, 728 There was a battle at Mynydd Carno, according to the *Annales Cambriae*. We are unsure whether this is Carno Hill in Glamorgan, at the head of the Rhymni Valley, or Mynydd Carno in Powys.

CARREG CENNEN CASTLE CADW *5 miles south-east of Llandeilo, Carmarthenshire.* Its spectacular ruins crown a precipitous 325-foot crag in a remote corner of the Brecon Beacons National Park. It has a passageway cut into the cliff-face, which leads to a natural cave beneath the fortifications. It seems that there was Dark Age and Roman occupation of the hill. A legend relates

that Urien Rheged and his son Owain, knights of King Arthur, lived there. The Welsh princes of Deheubarth built the first castle there, probably The Lord Rhys in the late twelfth century. Rhys Fychan of Deheubarth had the castle and it was betrayed by his mother, the Norman Matilda de Breos, but he had wrested it back by 1248. His uncle Maredudd ap Rhys Grug then took it, and it was captured in 1277 by Edward I. What remains was mainly built by the Giffards after the death of Llywelyn the Last in 1282. Glyndŵr's forces caused damage when besieging it. Despite its demolition by the Yorkists in 1462 during the Wars of the Roses, it is a formidable fortress.

CARREG COETAN ARTHUR BURIAL CHAMBER CADW *Near the crags of Craig Coetan on St David's Head, overlooking Whitesands Bay, Pembrokeshire.* The Neolithic tomb has a large capstone 13 feet long, supported by two of the four surviving upright stones. The earth covering has vanished.

CARREGHOFA CASTLE *At Carreghofa (Carreghwfa), near Llanymynech in the Tanat Valley, Montgomeryshire.* It was built in 1101 by Robert de Bellesme, and then captured by Henry I in 1102. Garrisoned by Henry II from 1159-62, it was taken by the joint forces of Owain Cyfeiliog and Owain Fychan in 1163. It was taken back by Henry in 1165, but recaptured by Owain Fychan by 1187. However, Owain was killed in a night attack by his cousins Gwenwynwyn and Cadwallon, and then it was retaken by the English. It was near Carreghwfa silver mine, which may have been the reason for this constant conflict. In 1197, Gwenwynwyn was given the castle to secure the release of Gruffudd ap Rhys. In 1212-13, Robert de Vipont rebuilt the site but it seems to have fallen to Llywelyn the Great in the 1230s and was slighted. Thus there are at least nine changes of hands that we know about in its 120 years of history.

CARSWELL OLD HOUSE CADW *West of Tenby, near St Florence, Pembrokeshire.* This is a distinctive two-storey later medieval house, with a barrel-vaulted basement.

CASNEWYDD BACH (LITTLE NEWCASTLE) The small church is dedicated to St Peter, and there is a nearby mound from which the 'castle' nomenclature derives. There is a village green, with a scattering of houses around it, and on the green is a boulder with a plaque reading commemorating the birth of 'Barti Ddu, y mor-leidr enwog (1682-1722)'. 'Black Bart, the famous pirate', was born John Robert in the village, and went on to be the most successful pirate in history. When captured by the 'Cavalier Pirate', fellow Pembroke man Howel Davis, in 1719, Robert soon became Captain 'Black Bart' Roberts, and took over 400 recorded prizes before he was killed by cannon fire by the Royal Navy. The trial of his crew was the greatest trial in pirate history, of 187 white men and 75 black men. For those interested in this barely known pirate, of far greater importance than Blackbeard, Captain Kidd and Uncle Tom Cobley combined, this author has written *Black Bart Roberts: The Greatest Pirate of Them All.*

CASTELL BRYN GWYN – IRON AGE FORT CADW *Near Brynsiencyn, Anglesey.* A circular bank of Neolithic origin, it survives to a height of 12 feet. It is unusually on level ground, despite being named 'White Hill'. It has a well-preserved circular bank 11 yards wide, and a filled-in, formerly deep, ditch. There is evidence for Iron Age and Roman use.

CASTELL Y BERE CADW *Near Llanfihangel-y-Pennant, north of Abergynolwyn in Gwynedd.* This is a native Welsh castle, probably begun by Prince Llywelyn ab Iorwerth ('the Great') around 1221. Two of the towers are the distinctive Welsh 'D' shape. It is on a great rock dominating the Dysynni Valley floor. Cader Idris looms over the site and it was the last castle to fall to Edward during the war of 1282-83. Prince Dafydd managed to escape, after previously escaping the capture of Dolwyddelan. Madog ap Llywelyn besieged and probably took it in 1294, as there were two relief forces sent by Edward I on 18 and 27 October, but it appears to have been burnt and destroyed at this time. Alone on a crag, in the centre of the plain of an isolated valley, it is a simply marvellous place.

CASTELL CAEREINION *On the A458 west of Welshpool, on a watershed between the Banwy Valley and the Sylfaen Brook.* There is only a 10-foot mound, 20 yards across in a corner of the churchyard. It was built by Madog ap Maredudd of Powys in 1156, and was the home of Owain Cyfeiliog until he was evicted for swearing allegiance to the English. Owain Gwynedd and The Lord Rhys then improved it in 1166. Owain Cyfeiliog then destroyed the castle with the help of an English army.

CASTELL CAEREINION – CHURCH OF ST GARMON Rebuilt in 1866, traces of embankment around the churchyard edge reflect the bailey of the castle. The church was first recorded in 1254 as 'Capella de Castell' and there seems to have been a single-chambered church of the early fifteenth century.

CASTELL CAER LLEION – HILLFORT *On the summit of Conwy Mountain, overlooking Conwy, on a footpath from Sychnant Pass car park.* On the north side, the hill is so steep that the fort needed no man-made defence. There are the remains of about fifty to sixty stone huts and levelled house platforms, within a thick stone wall, defended by an earthen rampart and ditch. Excavations at the site have found slingstones, querns, stone pestles and mortars.

CASTELL COCH CADW *Tongwynlais, 3 miles north of Cardiff, Glamorgan.* A late nineteenth-century 'fairytale'-style castle, built on thirteenth-century remains, it was designed for the third Marquess of Bute by William Burges. The earlier castle had been deliberately mined during some unrecorded siege. It is lavishly decorated and furnished in the Victorian Gothic style; a Romantic vision of the Middle Ages. The red sandstone walls give it the name of the 'Red Castle' and the conical roofs make it appear like a continental chateau overlooking the Taff Valley.

CASTELL COLLEN ROMAN FORT *Near Llandrindod Wells.* It was occupied until the early third century and finds are in Llandrindod's museum.

CASTELL CRUG ERYR – MOUNT OF THE EAGLE CASTLE *About 1 mile north-west of the junction of the A44 and A481 at Forest Inn, Radnorshire.* This small motte and bailey on a high hill seems to have been built in the 1150s by Cadwallon ap Madog, and is mentioned by Giraldus Cambrensis in his 'Tour of Wales' in 1188. It was captured by the Normans but retaken by the princes of Maelienydd, and later 'defaced' by Glyndŵr.

CASTELL CYNFAEL *Near the A493, Bryncrug, near Tywyn, at Bryn-y-Castell, Gwynedd.* The castle was built by Cadwaladr in 1147. However, by 1152 Cadwaladr was in exile, and Gwynedd was in the hands of his brother Owain Gwynedd, another son of King Gruffudd ap Cynan. The castle guarded a crossing across the Dysynni at the junction of the Fathew and Dysynni valleys.

CASTELL DINAS – IRON AGE HILLFORT AND CASTLE *Near the A479, above The Castle Inn, Pengenffordd, near Talgarth, Breconshire LD3 0EP.* At 1,476 feet above sea level, this is the highest castle in England and Wales, and is positioned to defend the Rhiangol pass between TALGARTH and CRUGHYWEL. The site was originally an Iron Age hillfort. It was probably built by William Fitz Osbern between 1070 and 1075, but superseded by the building of BRECON CASTLE. The castle was sacked by Llewelyn the Great in October 1233 and subsequently refortified by Henry III. It was also captured by Llewelyn II and held from 1263-68, but destroyed by Glyndŵr. Earth covers the crumbling walls, but one can also see the Iron Age ditches and ramparts here, with wonderful views over the Black Mountains.

CASTELL DINAS BRAN – SUPERBLY SITED MEDIEVAL FORTRESS *Overlooking Llangollen and the River Dee.* On a 1,000-foot-high crag, it seems impregnable, and there seems to have been a castle there as early as 1073, on an Iron and Dark Age site. Some of the hillfort ramparts were up to 24 feet high. The legend of King Bran of the *Mabinogion* is associated with

the castle. The stone ruin was the fortress of the princes of Powys Fadog, probably dating from the thirteenth century. It was besieged by the Earl of Lincoln in 1277 and destroyed by him. The Earl told Edward I that it could be rebuilt as the greatest castle in all of Wales, but it was never properly rebuilt. Dafydd ap Gruffudd held it in 1283 but was later captured and executed, and it was taken by Glyndŵr in 1402. By the reign of Henry VIII, Leland stated that its only inhabitants were eagles.

CASTELL DINERTH – MOTTE AND BAILEY *Near Aberarth in Ceredigion, on a spur of land between the Arth and its tributary Nant Erthig.* It was built be the de Clares around 1110, on a prehistoric defensive site. It has a history unlike many other castles. Gruffudd ap Rhys took it in 1116 and razed it to the ground, but it was rebuilt and destroyed by Owain Gwynedd in 1136. Hywel captured it in 1143 and Cadwaladr in 1144, but by 1158 it was back in Norman hands. The Lord Rhys sacked it in 1164, and it passed to his son Maelgwn, who lost it in civil war to his brother Gruffudd. Maelgwn was back in control by 1199. However, when Llywelyn the Great took over sovereignty of Deheubarth, Maelgwn completely destroyed it rather than give it to him. Over ninety years, it changed hands six times and was razed three times. Many castles in Europe have no military history – Welsh castles were fought over for centuries.

CASTELL HENLLYS (OLD COURT) – IRON AGE FORT – VISITOR CENTRE *Signposted on the A487 heading north from Newport to Cardigan.* The buildings, dating from 600 BC, have been reconstructed on their original sites. There are three huge roundhouses, a smithy, a grain store raised off the ground and a chieftain's house.

CASTELL HYWEL, BATTLE OF, 1153 *Between Lampeter and Newcastle Emlyn, Ceredigion.* The Norman Humphrey's Castle was destroyed by the Welsh in 1136 and rebuilt by Hywel ab Owain Gwynedd in 1153 as Castell Hywel. He lost the battle with Cadell ap Gruffudd of Deheubarth, which effectively moved southern Ceredigion from Hywel, after years of fighting. He fled for Ireland and returned to fight and die at PENTRAETH.

CASTELL MACHEN, CASTELL MEREDYDD *Near Machen, 3 miles east of Caerffili, Glamorganshire.* Morgan ap Hywel used this castle in the early thirteenth century, after losing Caerleon Castle to the Normans. In 1236, Gilbert Marshall, Earl of Pembroke, took it and fortified it further, and from 1248 it belonged to Morgan's grandson Maredudd, being also known as Castell Meredydd from this time. The de Clares later took it. Some stone walls remain, but the site is little known.

CASTELL MOEL, LIEGE CASTLE *Overlooking the Roman Road (now the A48) south of Old Post pub, Bonvilston, Vale of Glamorgan.* This small Iron Age hillfort was later castellated, but all the stonework has been robbed. Many stone slingshots and stone balls for ballistas have been found here, indicating an unknown battle between the Romans and Celts. The great pathologist Bernard Knight lived near here, and has a collection of the shot from his gardens, authenticated by the National Museum of Wales.

CASTELL TINBOETH *Near Llananno, 9 miles north-east of Llandrindod Wells, near Llanbister.* This is the remains of a thirteenth-century Mortimer castle with a huge ditch, surrendered to the king in 1322 with the disgrace of that family. It lies within a roughly circular Iron Age hillfort.

CASTLE MORRIS – TREGWYNT WOOLLEN MILL *One mile from the Pembrokeshire Coastal Path, near Abermawr, Pembrokeshire.* A working woollen mill, but its still-turning waterwheel no longer powers the spinning and weaving machinery. It is a member of the Welsh Mills Society. Melin Tregwynt no longer cards or spins, but weaving can be seen on weekdays.

CEFN COED COLLIERY MUSEUM *Neath Road, Crynant, Glamorgan SA10 8SN. Tel: 01639 750556.* In one of the most beautiful and unspoilt valleys in the South Wales coalfield, you can discover what it was like for miners who worked underground, in some of the most difficult conditions experienced anywhere in the world.

CEFNLLYS, THE BATTLE OF, 1262 *3 miles east of Llandrindod Wells.* Prince Llywelyn's men took Cefnllys Castle, and Roger Mortimer and Brian Brampton rode out from Wigmore Castle to retake it. Llywelyn had by now led his main force south and met the Marcher Army outside the castle and heavily defeated it in the Battle of Cefnllys. Mortimer took refuge for three weeks in the unprovisioned and sacked castle. Llywelyn left a force surrounding the castle and went on to take Mortimer's castles at KNUCKLAS, PRESTEIGNE, KNIGHTON and NORTON. They all surrendered quickly as Llywelyn had siege engines. He then returned to Cefnllys to give his cousin Mortimer safe passage back to Wigmore Castle, but kept Cefnllys until 1267.

CEFNLLYS CASTLE(S) Built by the Mortimers near Llandrindod Wells between 1240 and 1245, it was taken by rebels from Maelienydd in November 1262, who then were joined by the princes of Deheubarth and the Constable of Llywelyn the Last. By the Treaty of Montgomery in 1267, Llywelyn the Last was forced to return Cefnllys and Maelienydd to Roger Mortimer, prior to negotiating which lands should be settled between the Welsh Prince and the Marcher Lord. However, Mortimer would not negotiate. In 1294, Cefnllys fell to the rebels of Maelienydd again, in the general revolt led by Madog ap Llywelyn of Meirionnydd, Cynan ap Maredudd of Deheubarth and Morgan ap Maredudd of Gwynlliwg. There are two almost adjacent castle ruins here, with a huge rock-cut ditch, but all the walls have fallen.

CELLI TARFAWG, CARNANT, BATTLE OF, 1096 *Probably at Caerwent, Monmouthshire.* There was a rising of the men of Buellt, Gwynlliwg and Gwent (Brecon, Glamorgan and Monmouthshire) and a Norman army was sent by William II. Another army had been sent north into Brycheiniog (see ABER LLECH). The French army found no opposition, and was returning to England when ambushed and defeated in Gwent. If they were returning along the main Roman road, then the battle would have been at CAERWENT. Carnant is an alternative name for the battle, from Caer Nantes, and is itself a corruption of Caerwent.

CENARTH - ANCIENT TOWN AND MILL *Near Newcastle Emlyn, on the borders of Ceredigion, Pembrokeshire and Carmarthenshire.* Most people know Cenarth for the series of salmon falls along the River Teifi. Giraldus Cambrensis (Gerald the Welshman), journeying through Wales in 1188 with Archbishop Baldwin of Canterbury to secure recruits for the Second Crusade under Richard the Lionheart, describes the Church of St Llawddog, the mill with bridge and fish lake, an orchard and a beautiful garden. We know from Giraldus how the salmon leap was believed to have been hewn out of the solid rock by the hands of St Llawddog himself and that there existed on the rocks an extensive fishery, the Teifi even then being considered to be the best salmon river in Wales. The first recorded bridge at Cenarth is mentioned by Giraldus. The cylindrical holes in the present bridge provide a clue in that the son of William Edwards of PONTYPRIDD built it in 1787.

CENARTH CASTLE After 1093, Roger Montgomery penetrated as far as Cardigan and motte and bailey castles were constructed to cover the river crossings at Newcastle Emlyn and Cenarth. Cenarth was located in Parc y Domen (the field of the mound) which lies immediately behind the White Hart Inn. The mound remains 20 feet high and some 450 feet in circumference, lying on elevated ground to control the river crossing.

CENARTH - CORN MILL The seventeenth-century Melin Cenarth is now a visitor centre and gift shop at the bridge over the River Teifi. It is in working condition but can only be run in high water conditions. It is a member of the Welsh Mills Society.

CENARTH – NATIONAL CORACLE CENTRE The Romans described Celtic tribes using boats covered with skins, which have survived as the Irish 'curragh' or the Welsh 'cwrwgl' or coracle. With a basketwork frame, these one-man and two-man boats are extremely difficult to learn to handle, but ideal for netting sewin (sea trout) and salmon when worked in pairs. Dating from around the time of Christ, these primitive boats are used in the tidal Tywi river by twelve fishermen, with hereditary licences to net salmon. Their coracles are saucer-shaped replicas of the skin-covered boats used by the ancient Britons, but now use canvas stretched over wooden laths. The 1923 Salmon and Freshwater Fisheries Act effectively stopped all coracle fishing on the Severn, and restricted fishing severely on other Welsh rivers. Opposition from fly fishermen and legislation has almost killed the craft – licences are not renewed, and generally with the death of a coracle man, the licence is withdrawn on that particular river. Only a few remain – 3,000 years of tradition are being killed in front of us to favour a rich fly-fishing elite, mainly from outside Wales, who have bought the rights to fish long stretches of the best rivers. The National Coracle Centre exhibits nine varieties of Welsh coracle, and examples from Vietnam, Iraq, India and North America. The best place to see these pre-Roman boats in action used to be on the River Teifi at Cenarth. It is believed that coracle fishing is now only practised on three Welsh rivers, the Teifi, Tywi and Tâf. Salmon fishermen, in the four villages of LLECHRYD, Cenarth, Abercuch and CILGERRAN on the Teifi, formed closed communities where particular reaches of the river belonged to each village. In 1807, Malkin wrote that there was 'scarcely a cottage in the neighbourhood without its coracle hanging by the door'. Last century there were hundreds of licences, but now sadly only a couple of dozen at most – a pressure group is needed to help keep the craft alive. Designs and materials varied a great deal, depending upon the build of the fisherman and the type and flow of river – there are thirteen known different designs, Teifi, Tywi, Tâf, Cleddau, Ironbridge Severn, Welshpool Severn, Shrewsbury Severn, Conwy, Upper Dee Llangollen, Lower Dee Bangor and Overton, Usk and Wye, Dyfi and Loughor.

CENARTH – ST LLAWDDOG'S CHURCH Saint Llawddog himself was a descendant of a prince of North Britain, Nudd Hael, and he settled here during the great movement associated with the name of Cunedda Wledig in the sixth century. The present attractive little church with its beautiful and distinctive circular rose window under the bell turret was built in 1872. The 'Alehouse by the Church' is the oldest building in Cenarth, on Llawddog's monastic site. St Llawddog's holy well is near the river, and there are early inscribed stones at the church.

CEREDIGION HERITAGE COAST There are four separate sections totalling twenty-one miles, including several nature reserves and marine conservation areas, with cormorants, choughs, ravens, peregrine falcons, and buzzards. The Cardigan Bay Special Area of Conservation also supports a colony of some 130 bottlenose dolphins. Porpoises and grey seals are frequently seen close to shore. There are traditional seaside holiday centres at New Quay and Aberystwyth, but away from these areas the coast has many secluded corners.

CERI (KERRY), BATTLE OF, 1228 *3 miles east of Newtown, the battle took place as 'Cridia' in the Vale of Ceri. The Chronicle of Ystrad Fflur states*, 'In this year Henry, king of England, and with him a vast host came to Wales, planning to subdue the Lord Llywelyn and all the Welsh. And the Welsh gathered together in unity with their prince and attacked him in the place that is called Ceri. And the king after peace had been arranged ... without kingly honour, he returned to England.' The forces of Llywelyn I heavily defeated those of Hubert de Burgh, Justiciar of England, and William de Braose the Younger was taken prisoner for ransom. The Welsh, as Giraldus Cambrensis records, were a hospitable people, but when in 1230 William was found in Llywelyn's bed-chamber with 'King John's daughter, the prince's wife' he had transgressed the bounds of permissible behaviour. He was summarily hanged near GARTH CELYN.

CERI – CHURCH OF ST MICHAEL In 1176, both Giraldus Cambrensis of St David's and Bishop Adam of ST ASAFF claimed this parish for their respective dioceses, and excommunicated each other. Gerald of Wales roused a mob to throw stones at the bishop and it became part of St David's until 1849 when it rejoined St Asaff. It has a massive thirteenth-century defensive Norman tower, reflecting the vagaries of war, and there is a fourteenth-century roof.

CERRIG DUON – STONE CIRCLE AND AVENUE COMPLEX *Near Abercraf and Trecastle, in the Tawe Valley north of the Dan-yr-Ogof Show Caves.* Stone circles and henges date mainly from the Bronze Age, and there can be up to thirty large stones in a circle, but most have disappeared over the centuries. At Cerrig Duon a long avenue of outlier stones leads from the circle to a standing stone or menhir (maen hir = tall stone) about 1,000 yards away. There is an oval stone circle (about 65 feet by 55 feet), a stone avenue and a row of three stones. The twenty-one stones are sandstone and the tallest only reaches 2 feet. Ten yards to the north is a large block named Maen Mawr (great stone), over 6 feet high, around 4 feet wide and weighing up to 9 tons. In line with it are two small stones. There is an avenue of very small stones almost hidden in the grass 50 feet east of the circle, leading down the hillside towards the river. There is also a stone circle and row and nearby TRECASTLE.

CERRIGYDRUIDION – HILLFORT *10 miles west of Corwen, Denbighshire.* A collection of large stones here, including 'cistfaens' (stones forming a box for burial), disappeared in the eighteenth century. The place is supposed to have been associated with a meeting place for the druids, so it is assumed that they were removed and destroyed by religious fundamentalists. An ancient British fort, with a circular rampart, is on Pen-y-Gaer, a mile to the east. It was said locally to have been the place where Caractacus was taken prisoner, rather than in Yorkshire.

CERRIG Y GWYDDYL, BATTLE OF, 517 OR 520 *Trefdraeth near Llangefni, Anglesey. The site is also known as Cerrig Ceinwen, and the ancient farm there is called Cerrig y Gwyddel, Rock of the Irish.* Cadwallon Lawhir defeated the Irish settlers and finally drove them out of North Wales. He had defeated the invaders in several bloodthirsty clashes including this battle, at which the Welshmen tied their feet to their horses, in case their courage should desert them. Cadwallon forced the Irish into a mass retreat back to Holy Island. From here, many of them escaped in boats but their leader, Serigi Wyddel (the Irishman), was cut down at Llam-y-Gwyddyl (Irishman's Leap). His bravery was much respected, and the Welsh later erected a church over his grave at LLANBABO, Anglesey.

CHEPSTOW, CAS-GWENT – THE FIRST MAJOR NORMAN SETTLEMENT IN WALES AND MAJOR PORT *On the River Wye, 2 miles upstream from its confluence with the Severn, bordering Gloucestershire.* Once an important port, occupied continuously from 5000 BCE, at the southern end of Offa's Dyke. It was named Striguil or Estrighoiel by the Normans, from the Welsh *ystraigyl* meaning a bend in the river. By the fourteenth century, it was known in English as Chepstow, from the Old English 'ceap' or 'chepe' 'stowe' (market place), which it had become upon replacing Caerwent as the main port when the Romans left. In 1294, it had been given permission for a weekly market, and flourished because there was no English taxation in Wales at this time. Even as late as 1790-95 it was the largest port in Wales, with a tonnage of ships surpassing those of Cardiff, Swansea and Newport combined. Newport's Chartist Leaders were deported from Chepstow to Tasmania in 1840. Cas-Gwent means castle of Gwent, and it is the oldest stone castle in Britain. The road bridge across the Wye dates from 1816 and there is a small museum in the town.

CHEPSTOW BULWARKS CAMP CADW A double-banked and ditched Iron Age coastal fort on the coast at Chepstow, which was also settled in Romano-Celtic times.

CHEPSTOW CASTLE CADW – THE OLDEST SECULAR STONE BUILDING IN BRITAIN, THE GREATEST OF THE NORMAN WELSH FORTRESSES The centre of the

medieval Marcher lordship of Chepstow, the formidable castle was begun in 1067. It was modified and developed in successive stages throughout the Middle Ages and saw further action during the Civil War. Overlooking the Wye, it has no less than four baileys, a huge keep and a gatehouse which was built by William Marshall, First Earl of Pembroke. Wall-paintings in the castle are said to be the earliest domestic decoration in Britain. (Dinas Powys also has a claim to be the oldest stone castle, but is much smaller.)

CHEPSTOW - PIERCEFIELD HOUSE - RUINED NEOCLASSICAL MANSION DESIGNED BY SIR JOHN SOANE *Its extensive surrounding park overlooks the Wye Valley and includes Chepstow Racecourse.* The house is now but a shell, along with its extensive stable block. There has been a manor here since the fourteenth century, enlarged in the 1630s, and extended around 1700 by William Talman, the designer of Chatsworth House. It was sold in 1740, for £8,250, to Colonel Valentine Morris, a sugar planter born in Antigua. His son, Valentine Morris (1727-89), landscaped the estate into a park of national reputation, as one of the earliest examples of Picturesque landscaping. In the 1770s, Valentine Morris' gambling, business and political dealings bankrupted him, and he was forced to set sail for the West Indies. New building to John Soane's design began in 1792. In 1802, the house and estate were sold to Nathaniel Wells for £90,000 cash. Wells was born in St Kitts, the son of a Cardiff sugar merchant and one of his house slaves. In 1818, he became Britain's only known black sheriff when he was appointed Sheriff of Monmouthshire. Plans to develop the site as a hotel or for apartments have so far been unfulfilled.

CHEPSTOW - PORT WALL AND TOWN GATE CADW Remains of the town wall survive, built around 1294 when the town was given market status. The Town Gate through the wall at the end of the High Street was rebuilt in the sixteenth century as a tollgate.

CHEPSTOW - ST MARY'S PARISH AND PRIORY CHURCH There was a Benedictine priory established here in 1070, the same year as the castle, and St Mary's retains some Norman features. The central tower collapsed in 1700, so the crossings and transepts were rebuilt. There is a fine tomb of the Earl of Worcester (d. 1549) and his wife.

CHERITON - ST CATWG'S CHURCH AND IRON AGE CAMP *2 miles west of Llanrhidian, Gower Peninsula.* The thirteenth-century church in Cheriton is one of the most beautiful in Gower and is thought to have been built to replace a church in Landimore (a former port and weaving village) that was affected by the encroachment of the sea. There are castle remains at Landimore. Ernest Jones, the associate of Sigmund Freud, is buried in the churchyard. There is an old packhorse bridge, and the nearby listed Glebe Farm is the oldest inhabited house on the Gower, built in the twelfth century by the Order of St John of Jerusalem. Above Cheriton, on Llanmadoc Hill is the Bulwark Iron Age Camp.

CHESTER, CAER - THE MARCHER CAPITAL OF NORTH WALES Formerly the chief town in North Wales, and known as Caer Legionis and to the Romans as Deva, it is near the Welsh border and has been the English stronghold to subdue North Wales for centuries. It is the best-preserved walled city in England. The Roman Ostorius Scapula was worn out in his struggles against the Silures, who kept fighting after the capture of Caractacus in 51. From 52 to 57, Aulus Didius and Neranius could not defeat the Silures and Ordovices, so built the great forts of Isca Silurum (Caerleon), Uriconium (Wroxeter) and Deva (Chester) to protect the border. A millennium later, these centres were almost replicated by the decision of William the Conqueror to establish Marcher Lordships at Gloucester, Hereford and Chester to act both as a buffer against the remaining Britons, and as a method of conquest without using royal resources.

CHESTER, BATTLE OF, 616 Aethelfrith of Northumbria won the battle of Bangor-is-Coed (Bangor on Dee) near Chester, beating Brochfael the Fanged (whose arms were three severed Saxon heads - Ednyfed Fychan, the ancestor of Henry VII, took over this emblem). King Selyf ap Cynan of Powys

and Iago of Gwynedd were killed. The pagan Aethelfrith had massacred the monks of BANGOR-IS-COED, who had been supporting the Britons, and went on to defeat the main Welsh force at Chester. The *Annales Cambriae* record in 613, 'The battle of Caer Legion. And there died Selyf (ap Cynan). And Iago ap Beli slept (i.e. died).' This fateful battle marked the final separating of the Welsh from their fellows (Cymry) in the Lake District and Cumbria. The border with Wales, between Celtic nation and Saxon-controlled Britons, had been formed, and is still virtually the same. The earlier battle at DYRHAM had cut off Wales from the West Country Britons of Domnonia. The other major consequence of this battle was that Gwynedd replaced Powys as the chief kingdom of Wales.

CHESTER ROMAN FORT In a move reminiscent of the Normans with their Marcher Castles and Edward I's 'iron ring of castles', the Romans placed their largest legionary fort in Britain, for the twentieth Legion, on the far end of the Welsh borders from Caerleon, at Caer (Chester) in 79 CE. Chester has the largest amphitheatre in Britain, and its medieval city walls sometimes follow the line of the Roman walls. For two centuries. Rome kept two of its three British legions at Chester and Caerleon on the Welsh borders, with around 5,000 men in each legionary centre. (The other was stationed at York.) Chester gave access to silver from Flint and copper from Anglesey. Caerleon and then Carmarthen gave an easier route to DOLAUCOTHI gold mines. There were also thirty Roman forts in Wales, such as Y GAER, near BRECON, and the fully garrisoned Caerfyrddin (CARMARTHEN) and CAERNARFON (the Roman Segontium) probably each had around 1,000 troops garrisoned there. At Caerfyrddin (Moridunum) there was a Roman town, possibly even bigger than Caerwent.

CHWAREL WYNNE – SLATE MINE AND MUSEUM *2½ miles south of Llangollen off the B4500.* 'A little bit of heaven on Earth' was how Lloyd George described the Ceiriog Valley. At its heart is Glyn Ceiriog, an old slate-mining village, now home to the Chwarel Wynne slate mine and museum, with a guided tour of the eerie caverns.

CHIRK AQUEDUCT – THE TALLEST AQUEDUCT IN THE WORLD UNTIL PONTCYSYLLTE WAS BUILT This was built over the River Dee between 1796 and 1801 by Thomas Telford and William Jessop, and is 70 feet high with ten arches. At the northern end of the aqueduct, the canal enters Darkie Tunnel which is wide enough for a single barge and walkway. Using the walkway it is possible to walk through the quarter-mile-long tunnel.

CHIRK CASTLE – NATIONAL TRUST *Chirk, near Wrexham LL14 5AF. Tel: 01691 777701.* A magnificent medieval fortress of the Welsh Marches, it is the last Edward I Welsh castle still lived in today. There are award-winning gardens with thatched 'Hawk House', shrub garden, lime tree avenue and yew topiary, and a circular woodland walk through the medieval hunting park. It has been the home of the Myddleton family since the sixteenth century. Thomas Myddelton bought the castle, and became a founder of the East India Company. His brother Hugh created London's water supply with his New River Company. The huge iron gates are a masterpiece, made by local brothers Robert and John Davies of Bersham between 1718 and 1724.

CILCAIN – CHURCH OF ST MARY *2 miles west of Mold.* One is surprised in this lovely medieval church, by four huge, intricately carved angels, carried on alternate arch-braced and hammer-beamed trusses, as they seem out of scale. However, the roof of the church was bought from BASINGWERK ABBEY in the Dissolution of Monasteries in the sixteenth century.

CIL-Y-CWM – THE SEVEN WONDERS *On the west bank of the Afon Gwenlais, north of Llandovery.* For the sheer chutzpah of the above claim on the village website, they are listed here: the medieval Cil-y-Cwm Church; the Stone Circle in the above Cwm Gwenffrwd; Cwm Rhaeadr scenic waterfall; Cil-y-Cwm Village with its old houses, cobbles, and tavern; the eighteenth-century Soar Chapel; Pont Dolauhirion – the old bridge across the Tywi designed by William Edwards

and a copy of his Pontypridd Bridge; and the River Tywi. One wishes more villages and tourist operators would be just as proactive as Cil-y-Cwm, Llanwrtyd Wells and Cardigan Island Farm Park in marketing their attractions, perhaps combining to produce pamphlets, PR and websites. One also wonders about the attitude of some local councils and various church bodies. In the course of researching this book, information on some churches and localities is extremely poor. Perhaps the Welsh Assembly Government should devolve some of its marketing budget from the Wales Tourist Board to deserving causes for target marketing.

CILGERRAN, BATTLE OF, 1166 *The Chronicle of Ystrad Fflur* records, 'In this year the French and the Flemings came to Cilgerran. And after many of them had been slain, they returned again empty-handed.'

CILGERRAN CASTLE CADW – NATIONAL TRUST *4 miles south of Cardigan, SA43 2SF. Tel: 01443 336104.* A striking thirteenth-century ruined castle overlooking the spectacular Teifi gorge, with huge twin towers. It is on a promontory overlooking the River Teifi at its tidal limit, so the castle was able to control both a natural crossing point and also be supplied from the sea. Cilgerran is first mentioned by name in 1165, when The Lord Rhys captured it after Henry II's retreat from the Berwyn Mountains. It was retaken by William Marshall, Earl of Pembroke, in 1204, only to be taken again by the Welsh during Llywelyn the Great's campaigns in 1215. However, eight years later, William's son regained control, and it was probably he who built the castle we see today. It was badly damaged by Glyndŵr's forces in 1405. There is a coracle regatta every August in Cilgerran, near this craggy castle from where Nest (Helen of Wales) was abducted by Prince Owain ap Cadwgan from her Norman husband Gerald de Windsor in 1109.

THE CISTERCIAN WAY – LONG DISTANCE PATH LINKING THE CISTERCIAN ABBEYS This new path takes one across Wales on Roman roads, medieval pilgrimage routes and canal towpaths, past castles and medieval churches. The abbeys, in order of walking, are Llantarnam Abbey, Penrhys, Margam, Neath, Tenby, Whitland, Llanllyr, Strata Florida, Cymer, Conwy, Basingwerk, Valle Crucis, Strata Marcella, Llanllugan, Cwm-hir, Grace Dieu, Tintern and back to Llantarnam. All these abbeys are covered in this book.

CLOGAU GOLD MINE – THE GOLD OF ROYALTY *In Bontddu, near Barmouth, Meirionnydd.* The Clogau St David's Mine was the largest and richest mine of all the gold mines in the DOLGELLAU gold-mining belt. After producing copper and a little lead for many years, the mine developed into gold production in the 1862 Welsh 'gold rush', and continued as a major operator until 1911 during which 165,031 tons of gold ore was mined resulting in 2.4 tons of gold. Since 1911 the mine has been reopened several times for smaller scale operations, and finally closed in 1998. Since 1923 the Royal Family have been wearing wedding rings crafted from a single nugget of Clogau gold. Queen Elizabeth the Queen Mother, Queen Elizabeth II, Princess Margaret, Princess Anne, Diana Princess of Wales, Prince Charles and the Duchess of Cornwall all have had Clogau gold wedding rings. The seam produced a very beautiful Welsh 'rose gold', and the small supply of gold has made it perhaps the rarest in the world.

CLWYDIAN RANGE – AREA OF OUTSTANDING NATURAL BEAUTY WITH HILLFORTS *These hills run from Prestatyn in the north to Llandegla in the south.* Its highest point, Moel Famau, at 1,814 feet (554 metres) is 56 metres below the minimum height to be classed as a mountain, and straddles the Denbigh-Flint border. The ruined Jubilee Tower on its summit was built in 1810. The range includes a number of hills with Iron Age hillforts, including Foel Fenlli, Pen-y-Cloddiau and Moel Arthur. OFFA'S DYKE marks its eastern range.

CLYDACH GORGE (CWM CLYDACH) – IRONWORKS AND HISTORIC LANDSCAPE *Parallel to the A465 between Brynmawr and Gilwern, Glamorgan.* Clydach Gorge has no less than

seventeen waterfalls, and Cwm Clydach is a nature reserve with Britain's oldest beech wood, surviving 14,000 years on the side of the gorge. There is an 1824 cast-iron bridge over the River Clydach leading to the ironworks (a scheduled Ancient Monument). Clydach Ironworks was established close to sources of iron ore, coal and limestone in 1793. Coal in the form of coke had just been introduced as a fuel for blast furnaces, replacing charcoal which had been used by the Llanelli Furnace. The Ironworks remained in production for about sixty-five years. In 1841, over 1,350 people were employed, two-thirds of whom were winning iron ore and coal higher up the valley. Raw materials and finished iron were transported to and from the Ironworks by a series of railroads, tram roads and inclines. There are the remains of two blast furnaces that produced 'grey forge iron', fed from the charging houses above.

CLYNNOG FAWR – CHURCH OF ST BEUNO *On the A499 between Pwllheli and Caernarfon.* The impressive church of St Beuno (d. 642) is said to be on the site of his seventh-century clas (monastery). His shrine is in the battlemented chapel. It was burnt in 978 by Vikings, and again by the Normans, and was on the pilgrimage route to YNYS ENLLI (Bardsey Island). Cyff Beuno is an ancient chest made from a single piece of ash, used to keep alms donated by pilgrims. Maen Beuno (Beuno's Stone) has markings said to be those of the saint's fingers. In the churchyard there is a sundial dated between the late tenth and early twelfth century. Clynnog is strategically sited at the northern end of a pass connecting the northern and southern coasts of the Llŷn Peninsula, so the area has been the site of a number of battles.

CLYNNOG FAWR – BRON-YR-ERW, BATTLE OF, 1075 *On the hills above Clynnog Fawr, Caernarfonshire.* Gruffudd ap Cynan and his Irish and Norse mercenaries were defeated by Trahaearn ap Caradog of Powys and Gruffudd was expelled from Wales, once more to exile in Ireland. The battle took place after Gruffudd had defeated Trahaearn at Gwaed Erw in Meirionnydd, and was caused by the Welsh in the Llŷn Peninsula rising in revolt against the behaviour of Gruffudd's Danish bodyguard.

CLYNOG FAWR – BRYN DERWIN (DERWEN, DERWYN), BATTLE OF, JUNE 1255 *Near Clynnog, Caernarfonshire, on the borders of Arfon and Eifionydd.* This was the final in a series of bloody battles between the young Llywelyn ap Gruffudd and his brothers Owain and Dafydd, for the succession to the Princedom of Gwynedd. From the A487, at Pant Glas looking west you will see the hill marked on map today as Y Foel. Older maps refer to it as Moel Derwin, this is Bryn Derwin. Y Bwlch, the pass between Y Foel and Mynydd Cennin seems to be the site of battle.

CLYRO, BATTLE OF, 52 CE *1 mile north-west of Hay-on-Wye, Breconshire.* Caradog (Caractacus) had been taken by Rome after Cartimandua's treachery in 51, and Tacitus informs us in a long passage that Publius Ostorius Scapula's XX Valeria Legion was then nearly annihilated by the Silures in revenge. Ostorius died, worn out, and was replaced as Governor by Aulus Didius. Didius, though he quickly arrived, found that the Silures had gone on to also badly defeat the renowned XIV Gemina Legion of Gaius Manlius Valens. In 52/53 CE, the Silures stormed the legionary base at Gloucester and killed the Commander in charge.

CLYRO CASTLE *On private land at junction of A4153 and B4351, 1 mile north-west of Hay-on-Wye, Breconshire.* A natural hillock has been built into a large motte up to 130 feet across on the top, with a surrounding ditch. There are buried footings of a polygonal curtain wall probably with a keep, and the castle may date from the 1070s as a twin to Hay Castle across River Wye. Clyro was amongst the several castles in this area refortified in 1403 against Owain Glyndŵr.

CLYRO ROMAN FORTS *Situated on the north-eastern flanks of a small hill just north of Hay-on-Wye, immediately east of Clyro Castle, on the western bank of the River Wye.* Occupied at two different times, in addition to the vexillation fortress and large campaign base there is a temporary marching

camp nearby, and another Roman fort lies four miles to the north-east at Clifford. The earliest piece of Samian ware dates from around 60 CE. The larger fortress measures 1,300 feet from north-east to south-west, by 860 feet transversely.

CLYTHA CASTLE – LANDMARK TRUST AND CLYTHA HOUSE *4 miles west of Raglan, off the A40, Monmouthshire.* A strange castellated, triple-towered Gothic folly on a hill with superb views built in 1790 by William Jones to commemorate the loss of his wife. It can be rented for short stays. It was in the grounds of the neoclassical Clytha House (now private), with gates designed by John Nash.

COCHWILLAN OLD HALL – MEDIEVAL HALL *Tal-y-Bont, 2 miles south-east of Bangor LL57 3AZ.* The Great Hall is the freestanding hall of a medieval courtyard house, built by William ap Gruffudd in the 1450s on a thirteenth-century site. He was made Sheriff of Caernarfon for life after his support for Henry VII at Bosworth. With a superb hammer-beam roof, it measures 37 by 21 feet and is open by appointment.

COEDARHYDYGLYN – NEO-CLASSICAL REGENCY MANSION *Leaving Cardiff at Culverhouse Cross, head up the A48 towards Cowbridge, turning right towards the top of the immediate hill called Tumbledown after passing the Traherne Arms, Vale of Glamorgan CF5 6SF.* The antiquary John Traherne demolished his eighteenth-century house at Coedarhydyglyn (the wood at the ford in the valley) in 1823 and erected a gracious villa of stone with stuccoed elevations and stone plinth on the lower slopes of the hill. It replaced the house situated on the high ridge south-west, still known as Old Coedarhydyglyn. Coedarhydyglyn is a private house on land which has been owned by the Traherne family since the time of Henry VII. Sir Cennydd Traherne, Lord Lieutenant of Glamorgan from 1952 to 1974, also lived here and the present owner is Lieutenant-Colonel Rhodri Llewelyn Traherne. The gardens were landscaped when the house was built and are listed Grade II*.

COED LATHEN, CADFAN, CYMERAU, BATTLE OF, 10 JUNE 1257 *Because this was a running battle, there are several contiguous sites.* This was the most crushing defeat upon English forces before the battle of Bryn Glas in 1402, barely recorded in history books. Cadfan Farmhouse is the Towy Valley has an upper medieval banqueting hall. Henry III's army had landed near Carmarthen and laid siege to Dinefwr castle, but the Welsh forces attacked, forcing the English to dismount, before moving back at nightfall. The English pursued them west towards Broad Oak. However, the heavily wooded countryside meant that the English forces were stretched and continually ambushed. The fighting lasted all day, and covered an area from Langaethen to Broad Oak and north towards Llanfynydd and Capel Isaac. It was a running battle with dispersed groups from Coed Llathen to Cymerau, so is sometimes referred to as the battle of Cadfan or Cymerau. The army's leader, Stephen Bayzan (Bacon), a friend of Henry III, was killed near Pentrefelin and the small bridge there, Pont Steffan, is named after the event. It is recorded that Prince Llywelyn was present, returning to Gwynedd with huge booty. In 1867, the Rev. Lloyd Isaac wrote, 'The men at war prepared to devastate the lands of Ystrad Tywi ... arrived at Llandeilo-fawr ... where they fearlessly tarried over the night ... but the surrounding woods and valleys were filled with the followers of Meredydd ap Rhys Grug and Meredydd ap Owain, who had been summoned from Ceredigion and Ystrad Tywi ... on the 10th of June, the guide of the English, Rhys ap Rhys Mechell, forsook them and escaped in disguise to the castle of Dinevor ... from daybreak till noon the battle carried on in the deep woods ... near Coed Llathen, the English lost all their provisions ... they arrived as far as Cymerau ... more than 3000 English were slain that day ... the Welsh rendering thanks to God returned homewards, laden with the spoils and the arms of the enemy ... this memorable battle was fought between Castell-y-Gwrychion and Cefn Melgoed and Hafodnethyn, a basin about four miles in circumference ... covered in woods ... the old name Cefn Melgoed has become extinct, and Cadvan, the battlefield, has taken its place ... the following names on the map

of the parish (are) all within the circumference aforesaid ... Rhywdorth, the hill of Reinforcement; Llaindwng, the slang of oath; Conglywaedd, the place of shouting; Caeyrochain, the field of groans; Caetranc, the field of dying; Caefranc (Cae Ffrainc), the field of Normans; Cadvan, the field of battle; Caedial, the field of retribution, or vengeance; also Cilforgan, Caer Capel etc.' These field names all surround Cadfan Farmhouse. Other local places still record the carnage. Near the Cottage Inn are Rhiw Dorth and Rhiw Comorth – the hills where the wounded were given help, and comfort, and Castell y Cwreichion, the camp where flaming spears were thrown at the enemy.

COED YSPWYS, BATTLE OF, 1094 *The Wood of Yspwys (a Christian name) – an unknown site in Gwynedd.* In *The Chronicle of Ystrad Fflur*, 'In this year the Britons being unable to bear the tyranny and injustice of the French, threw off the rule of the French, and they destroyed their castles in Gwynedd and inflicted slaughter on them. And the French brought a host to Gwynedd and Cadwgan ap Bleddyn drove them to flight with great slaughter at Coed Yspwys. And at the close of the year the castles of Ceredigion and Dyfed were all taken except two.' In the next year, 'William, king of England, moved a host against the Britons but he returned home empty-handed having gained naught.'

COETY (COITY) CASTLE *North of Bridgend, Glamorgan.* Payn de Turberville began building this fine castle on the outskirts of Bridgend in the early twelfth century, a simple ringwork. It was at the western extent of the Norman invasion of South Wales, and Newcastle and Ogmore Castle were built nearby to consolidate the expansion. In the 1180s, it was fortified in stone by Gilbert de Turberville, and most of the extensive remains date from the fourteenth century. Glyndŵr failed to take it on his rampage through Glamorgan.

COLBY WOODLAND GARDEN – NATIONAL TRUST *Near Amroth, Pembrokeshire SA67 8PP Tel: 01834 811885.* This is a beautiful woodland garden with year-round interest, with one of the best collections of rhododendron and azalea in Wales, and a walled garden with a Gothic gazebo.

COLBY MOOR, BATTLE OF, 1 AUGUST 1645 *Between Wiston and Llawhaden, Pembrokeshire.* The Parliamentarian Rowland Laugharne took to the field with 800 men. Admiral Sir William Batten arrived at MILFORD HAVEN and met with Laugharne on 29 July to decide tactics to beat the Royalist army of Sir Edward Stradling. The battle was evenly matched, but Batten had landed 200 men from the frigate *Warwick* near Milford Haven, and they attacked Stradling's rear, resulting in a crushing Parliamentary victory. Other Royalist strongholds in Pembrokeshire then surrendered, and put Charles I in immediate danger, as he was in South Wales at that time.

COLVA – CHURCH OF ST DAVID – THE HIGHEST CHURCH IN WALES *2 miles north-west of Newchurch, 5 miles south-west of Radnor, Radnorshire.* This lies 1,250 feet above sea level, and is basically thirteenth century with a twelfth-century font and Tudor windows.

COLWYN BAY – HOLIDAY RESORT AND VICTORIA PIER *On the A55 between Rhyl and Llandudno, Conwy.* The railway line to HOLYHEAD from London was opened in the 1840s and skirted the bay, attracting holiday-makers and also English retirees, so by 1900 the population had grown to 8,000. There is a three-mile beach and its Victoria Pier, which opened in 1900, is 750 feet long. At present there is a legal dispute involving its restoration. The Mountain Zoo is a visitor attraction.

COLWYN BAY BRYN EURYN HILLFORT *Near Mochdre, the hill overlooking Colwyn Bay and the A55.* Called Dinerth (Fort of the Bear), it covers two summits and the hollow of a steep hilltop. Here a Roman expeditionary force led by Sempronius was ambushed and exterminated in

the valley between BRYN EURYN and the hills to its east. The valley is called Nant Sempyr, the Valley of Sempronius.

COLWYN BAY – CAPEL TRILLO – THE SMALLEST CHURCH IN BRITAIN *Llandrillo-yn-Rhos, close to Rhos Point, between Penrhyn Bay and Colwyn Bay.* Dating back to the sixth century, St Trillo's altar is built directly over a pre-Christian well. The tiny beehive cell, with a pebble floor, is situated in the undercliff and has room for just six worshippers to sit. It is close to the Rhos Point fishing weir, where the monks of Rhos Fynach caught fish, and it is believed that prayers were offered in the chapel three times a day in the salmon season. Up until 1918, the ancient fish-weir here paid a tithe of salmon to the church. A nearby cursing well was still being used in the first part of the twentieth century, when a gipsy who had threatened a Welshman by 'putting him in the well' was tried at the local assizes.

COLWYN BAY – EDNYFED'S CASTLE AND HILLFORTS On Bryn Euryn. Ednyfed Fychan was the chief advisor to Llywelyn the Great and it appears that his castle is a small motte near Bryn Euryn Iron Age and Dark Age fort. Llys Euryn is a deserted fifteenth-century mansion nearby, built for Robin ap Gruffudd Goch.

CONWY – ABERCONWY HOUSE – NATIONAL TRUST – THE OLDEST TOWN HOUSE IN WALES *Castle Street, Conwy LL32 8AY. Tel: 01492 592246.* This merchant's house dates from the thirteenth century, rebuilt in the mid-sixteenth century, and has been carefully restored to reflect the daily life of its residents over time.

CONWY, ABERCONWY, BATTLE OF, 880 OR 881 *At the mouth of the River Conwy, Aberconwy.* Anarawd ap Rhodri became King of Gwynedd after the death of his father Rhodri Mawr in battle in 878, and at Aberconwy the Earl Aethelred and his invading Mercians were slaughtered. It was known as 'dial Rhodri' (Rhodri's revenge), and noted in the *Annales Cambriae* as 'vengeance for Rhodri at God's hand'.

CONWY – ABERCONWY, BATTLE OF, 1194 Prince Llywelyn ap Iorwerth, just twenty-two years old, forced his uncle Dafydd ap Owain Gwynedd to surrender at Aberconwy, in his campaign to take over Gwynedd. Dafydd and Rhodri ap Owain Gwynedd had divided Gwynedd between them and had defeated their brother Hywel at Pentraeth. Combined with his victory at Porthaethwy on Anglesey, Llywelyn (the Great) now controlled all of Gwynedd.

CONWY CASTLE – WORLD HERITAGE SITE CADW Built for King Edward I from 1283 to 1287, Master James of St George's design at Conwy remains one of the most outstanding achievements of medieval military architecture. The distinctive elongated shape, with its two barbicans, eight massive towers and great bow-shaped hall, was perhaps determined by the narrow rocky outcrop on which the castle stands. Conwy was called 'incomparably the most magnificent castle in Britain' in a 1946 British Academy report. Seductive curves in the castle walls led attackers to a literal dead end in the West Barbican, where missiles and molten lead could be poured down from the murder-holes and machicolations above. As the guidebook states, 'forced entry is a virtual impossibility'. Edward I held out there in 1295 against the revolt of Madog ap Llywelyn. Richard II was betrayed to Henry Bolingbroke at Conwy Castle in 1399. In 1401, Gwilym and Rhys ap Tudur of Anglesey took the castle, as part of Glyndŵr's War of Independence, but Hotspur negotiated its surrender. The Parliamentarian John Mytton besieged it for three months in the Civil War before it surrendered. Standing where the River Conwy enters the Menai Straits between Caernarfonshire and Anglesey, the castle is at the centre of many Welsh legends. The most beautiful is that of Arianrhod's son, Dylan eil Don, in the *Mabinogion*. This 'Son of the Wave' was at home in the seas, and was killed by his uncle Govannon. The *Book of Taliesin* tells us that the waves of Britain, Ireland, Scotland and the Isle of Man wept for him. The sound of the waves crashing on the beach

is the expression of their desire to avenge their son. The sound of the sea rushing up the Conwy river was still known in the nineteenth century as 'Dylan's death-groan'. A nearby promontory, Pwynt Maen Dulen, preserves his name.

CONWY – PLAS MAWR CADW – THE FINEST TUDOR TOWN MANSION IN BRITAIN The 1576-85 house of Robert Wynn is an outstanding survival, with a courtyard and a great chamber reached by two spiral staircases. It dominates the town with its gatehouse, stepped gables and lookout tower. The interior with its elaborately decorated plaster ceilings and fine wooden screens, reflecting the wealth and influence of the Tudor gentry in Wales, has been almost entirely restored. The building is not only important in a Welsh context, but it is an extremely fine example of a European merchant house of the late Middle Ages.

CONWY – THE SMALLEST HOUSE IN BRITAIN On the quay is Britain's smallest house, two storeys but only 10 feet 2 inches high in total with a 6-foot frontage. Open to tourists, it was last lived in before the First World War by a 6-foot 3-inch fisherman, Robert Jones, who had to stoop in every room.

CONWY, SIEGE OF, 1401 On 1 April 1401, the garrison of fifty men-of-war and sixty archers was assembled in the town church for Good Friday services. A Welsh carpenter asked the guards to enter the castle for urgent repairs and as the gates opened forty men, led by Gwilym and Rhys ap Tudur of Anglesey, rushed in and took the castle. Henry of Monmouth (later Henry V) and Harry Hotspur, Earl of Northumberland, besieged the castle. Owain Glyndŵr did not have the forces to raise the siege, and there was no way out for the defenders. After three months, there was no food left. A deal was made whereby nine of the forty Welshmen would be executed, and thirty-one pardoned and allowed to go free, including the Tudur brothers. The nine were publicly hung, drawn and quartered, helping fuel greater resistance from Glyndŵr's forces, who went on to fight for a further fourteen years.

CONWY SUSPENSION BRIDGE AND TOLL HOUSE – NATIONAL TRUST *Conwy LL32 8LD. Tel: 01492 573282.* This elegant suspension bridge and restored toll-keeper's house were designed and built by Thomas Telford in 1826, next to Conwy Castle. Robert Stephenson's railway bridge to Anglesey is another marvellous piece of engineering.

CONWY TOWN WALLS WORLD HERITAGE SITE CADW – THE FINEST EXAMPLE OF TOWN WALL IN BRITAIN Over three-quarters of a mile of town walls, one of the finest and most complete sets in Europe, with twenty-one towers and three gateways, encloses much of the town. A statue of Llywelyn the Great stands in Lancaster Square, and he endowed Conwy's Cistercian abbey, where he was buried. Four decades after his death, Edward I symbolically chose Conwy as the site for his greatest castle after the murder of Llywelyn's grandson. The monks were moved to Maenan Abbey. The town walls are 35 feet high and 6 feet thick. The walls contain over 200 listed buildings, surviving with little alteration. Conwy thus is not only the best example of a medieval walled town in Britain, but it also has the finest example of an Elizabethan town house.

CORRIS RAILWAY MUSEUM *Station Yard, Corris, near Machynlleth SY20 9SH.* Corris employed over 1,000 men producing slate in its heyday, with a narrow-gauge railway taking the slate to Machynlleth. The Corris Railway Museum tells the story of the railway and the past workings at Corris, and trains run in season.

CORWEN – THE CROSSROADS OF NORTH WALES *9 miles west of Llangollen on the A5, Denbighshire.* This ancient market town is situated between the Berwyn Mountains and the River Dee. Facing onto the Town Square is the Owain Glyndŵr Hotel where the first eisteddfod to

which the public were admitted was held on 12 May 1789. Until then only competitors and judges had been allowed. The life-size bronze statue of Owain Glyndŵr was unveiled in 2007, and the motte of a Norman castle is in the town.

CORWEN – THE CHURCH OF ST MAEL AND ST SULIEN, AND STANDING STONES The town's origins can be traced back to the sixth century when the Breton-Welsh saints, Mael and Sulien, founded a religious community here, and Corwen's twelfth-fourteenth-century church still bears their dedication. The town was also once the headquarters of Owain Glyndŵr, who gathered his forces here before entering into his various campaigns. The church has an incised dagger in a lintel of the doorway that is known as Glyndŵr's Sword. The mark was reputedly made by Glyndŵr when he threw a dagger from the hill above the church in a fit of rage against the townsfolk. However, the dagger mark actually dates from the seventh-ninth centuries and there is another such mark on a twelfth-century cross outside the south-west corner of the church. The church is full of Neolithic or Bronze Age standing stones, which could stand up to 14 feet tall. There are nearby alignments, but many have been broken up, and used as gateposts or burnt for lime or building. Embedded in the porch of Corwen church is Carreg y Big yn y Fach Rewlyd (the 'Pointed Stone in the Cold Hollow').

CORWEN – LLANGAR OLD PARISH CHURCH CADW *Off B4441 1 mile south-west of Corwen*. Medieval, it contains damaged and faded fifteenth-eighteenth-century wall paintings, a wonderful seventeenth-century wall painting of death, old beams, box pews, pulpit and a minstrels' gallery.

CORWEN – RUG CHAPEL CADW *Off A494 1 mile north-north-west of Corwen*. This small private chapel was built for Colonel William ('Old Blue-Stockings') Salusbury in 1637. Wonderful seventeenth-century interior fittings, and set in delightful grounds, it inspired the work of Sir Edwin Lutyens.

COWBRIDGE – CAER DYNNAF IRON AGE FORT AND CASTLE RUINS Its old name of Llygod Old Castle means Old Mice Castle. It is a relatively unknown but huge multivallate hilltop fort, with fragmentary outer ramparts, with a well-defended western entrance. A series of low banks and platforms in the western half of the interior delineate houses, yards, lanes and so forth, some being of late Iron Age to Roman date. It seems that a small Norman castle was built here before being replaced by Llanbleddian Castle on the opposite side of the Thaw Valley.

COWBRIDGE HOLY CROSS CHURCH This is almost the largest early Norman building in Wales, a fine example of a fortified medieval church. LLANBLEDDIAN CASTLE protected the thirteenth-century walled town, but is half a mile outside the town walls, which necessitated such a strong church.

COWBRIDGE PHYSIC GARDEN A reconstructed walled garden next to the town walls, it is situated in the grounds of the eighteenth-century Old Hall which belonged to the Edmonds family. All its plants were available in Britain before 1800, being used for medicines as well as for decoration and scent.

COWBRIDGE (BONTFAEN) ROMAN MILITARY SITE Many Roman remains have been found in this beautiful town of Bomium or Bovium, situated along the main Roman road from Cardiff to Carmarthen, where it crosses the River Thaw. A bathhouse was found to the north of the High Street, and a statuary lion, and it is thought that it was defended by Roman walls, like Caerleon, Caerwent and Cardiff. There is a plaque where Iolo Morgannwg had his bookshop in the High Street, and blue plaques denote the former town houses of the Vale of Glamorgan gentry. Several buildings have medieval cores, such as the Duke of Wellington public house.

COWBRIDGE TOWN WALLS 1266 Cowbridge has the only walls remaining of Glamorgan's medieval walled towns, up to 14 foot high and over 12 feet wide, with only the South Gate still in place, built by Richard de Clare.

COWBRIDGE - LLANBLEDDIAN CASTLE *Opposite the hillfort of Caer Dynnaf, half-mile south-west of Cowbridge.* Also known as St Quintin's or St Quentin's Castle, it was built by Gilbert de Clare in 1307 and uncompleted at his death at Bannockburn in 1314. It was sacked by Llywelyn Bren. The gatehouse is still standing but the keep has fallen. Most outer walls have been robbed. The last time I visited it, I walked down towards the River Thaw to watch a brilliant white Little Egret fishing.

COWBRIDGE - LLANBLEDDIAN, CHURCH OF ST JOHN (FORMERLY ST BLEIDDAN) *Southern outskirts of Cowbridge.* The former head church of the 'clas' of Cowbridge, Llanquian, Llansannor and Welsh St Donat's, it was dedicated to St Bleiddan, and the tower was added in 1477. Bones of at least two hundred men found in the crypt are said to be those of the dead in the Battle of Stalling Down (1403). The medieval church has been restored, and entry into the tower space is guarded by two fifteenth-century carivings of jacketed peasants. The font is Norman, and the odd 1896 pulpit is made from Penarth alabaster, Forest of Dean stone, Quarella stone from Bridgend and Irish red marble. Some of the church is twelfth century and the tower was added in 1477, by the gift of Ann Neville, wife of Richard III.

CRAIG Y DORTH, THE BATTLE OF, 1404 Between Monmouth and Abergafenni. Warwick's forces were beaten by Glyndŵr's army, perhaps in a counter-attack after a Welsh defeat at Campstone Hill. English sources record a 'horrific massacre' with the survivors being chased to the gates of Monmouth, 'with the Welsh snapping at their heels'.

CRAIG-Y-NOS CASTLE AND COUNTRY PARK *Brecon Road, Pen-y-Cae, West Glamorgan SA9 1GL.* It was built in 1840 by Captain Rice Davies Powell. Dame Adelina Patti (1843-1919) purchased it in 1878 and began a major development, adding the north and south wings, the clock tower, conservatory, winter garden and theatre. Craig-y-Nos Castle was one of the first private residences in Britain to have electricity. As well as providing lighting for the castle and winter garden, it enabled Adelina to install the latest lighting technology in her theatre, which was modelled on the Theatre Royal in Drury Lane, London. It is still used today for operatic performances and offers one of the few remaining examples of fully functional, mechanically operated, Victorian backstage theatre equipment. A private road was constructed from Craig-y-Nos Castle to the small railway station at Penwyllt, where a lavishly furnished private waiting room was installed. A luxurious railway carriage was commissioned, and the railway company provided Adelina with her own train, to take her whenever and wherever she wanted to travel. The second most celebrated woman in the world in the year 1900, after Queen Victoria, she is today almost forgotten. Craig-y-Nos Castle and the forty-acre Country Park are open to the public, and recent restoration of the castle means that visitors can now stay in Adelina's former home.

CRESSELLY - GEORGIAN GENTRY HOUSE WITH ROCOCO CEILING *Near Jeffreyston and Kilgetty, 6 miles north-west of Pembroke, Pembrokeshire SA68 0SP.* This has been the home of the Allen family since it was built in 1769, and tours are available of the superb house. The nearby Cresselly Arms at Cresswell Quay (SA68 0TE) has flagstone floors and still sells superb beer direct from the barrel, unpumped. This author remembers when any lady wishing to 'spend a penny' was escorted upstairs to the landlady's own toilet. The gentleman's urinal was open to the elements, a long piece of slate positioned in a stone wall to drain into the adjacent field. Things have changed.

CRICIETH CASTLE CADW Born in nearby Llanystumdwy, David Lloyd George grew up in this Gwynedd seaside resort, and its castle was built on the site of a Celtic hillfort. The castle is

still dominated by the twin-towered gatehouse built by Prince Llywelyn ab Iorwerth ('the Great'). Extended by Llywelyn ap Gruffudd ('the Last'), it was later remodelled by Edward I from 1283-90 and Edward II. In *Brut y Tywysogion* we find that Llywelyn the Great's son Gruffudd was imprisoned here from 1239 by his half-brother Dafydd. In 1292, it withstood a siege by Madog ap Llywelyn, with supplies from Ireland enabling the garrison to hold out for months. Sir Hywel ap Gruffudd, Hywel of the Battleaxe, was appointed its constable for his services at Creçy. Owain Glyndŵr, with the assistance of a French naval blockade, starved it into submission in the 1400-1415 War, and burnt the castle. It was not rebuilt, but remains impressive, overlooking the beach.

CRICIETH – LLANYSTUMDWY – DAVID LLOYD GEORGE'S CHILDHOOD HOME
A mile west of Cricieth, just north of the A449. This is now a museum, a simple two-up, two-down cottage owned by Lloyd George's uncle, a cobbler, whose workshop is preserved downstairs. Lloyd George had been orphaned, and his mother's brother became responsible for the family, setting the future Prime Minister an inspiring example. Opposite it, the Moriah Chapel was designed by Clough Williams-Ellis in 1936, and also acts as a museum dedicated to Lloyd George. He refused to be buried in Westminster Abbey, preferring to rest under an unmarked rock in the River Dwyfor nearby, where he used to sit and daydream as a boy.

CROGEN, BATTLE OF, 1165 (SEE CAER DREWYN) *At Bron-y-Garth, along the River Ceiriog in the Upper Ceiriog Valley, on the west and south sides of Chirk Castle.* Henry II narrowly escaped with his life here. In *A Topographical Dictionary of Wales* (1849) we read, Chirk 'parish is remarkable in history as the scene of a conflict between part of the forces of Henry II and the Welsh, which took place in 1165, in a deep and picturesque valley, Henry, with a view to the conquest of Wales, collected an army at Oswestry, whilst the Welsh prince, Owain Gwynedd, mustered his forces at Corwen; and being eager to decide the struggle, the English monarch hastened to meet the enemy, but was interrupted in this valley by almost impenetrable woods, which he commanded his men to cut down, in order to secure himself from ambuscade, posting the pikemen and flower of his army to protect those at work. When thus engaged, a strong party of Welsh fell upon the English with indignant fury, and a battle ensued, which, while it ended in the retiring of the former, so reduced the strength of Henry, that although he contrived to advance to Corwen, yet, harassed by the activity of Owain, who cut off his supplies, he was at length compelled to fall back into the English territory, and relinquish his design. This encounter, in which numbers of men were slain on both sides, is called the battle of Crogen, and the place where it was fought Adw'r Beddau, (the pass of the graves.)'

CRICKHOWELL CASTLE AND IRON AGE FORT
There is an ancient fort on the top of Crug Hywel, or Table Mountain as it is now known. The motte and bailey castle, remains of which still exist, was probably built by the Turbervilles in the twelfth century, being rebuilt in stone by 1272. Glyndŵr sacked it. There is a sixteenth-century bridge spanning the River Usk. Thirteen arches can be seen from one end of the bridge, but only twelve are visible from the other end. The Bear Hotel is a former coaching inn which retains its 'post horses' archway and original cobbles.

CRICKHOWELL – GLANUSK ESTATE *Glanusk Park, near Crickhowell, Breconshire NP8 1LP.* The estate has been in the ownership of the same family since 1826 when the South Wales ironmaster Sir Joseph Bailey purchased the original site and built a mansion house there. His enormous wealth is shown by the fact that he bought similar estates in Radnorshire, Herefordshire, and Glamorgan. He was the brother of Crawshay Bailey of CYFARTHFA CASTLE. The family used to live in the mansion in the summer and then move into the Dower House, Penmyarth in the winter. The mansion was demolished in 1952 after serious fire damage during the Army's requisition of the house during the Second World War and the family now live in the Dower House. The rest of the estate is still intact and consists of 400 acres of private parkland, 800 acres of forestry, 3,500 acres of lowland and hill farms, the Park and forestry, 20,000 acres of Common

Land hills and five miles of the River Usk. There are many historic buildings remaining, including the Tower Bridge, over the River Usk, ancient Celtic standing stones, the private chapel, farm buildings and stables, all either Grade II listed or Grade II starred.

CRUG MAWR, THE BATTLE OF, OCTOBER 1136 *Almost 2 miles north of Cardigan, Ceredigion, at Penparc.* The entry in *The Chronicle of Ystrad Fflur* is as follows: 'In this year Gwenllian died, brave as any son of Gruffudd ap Cynan. And Morgan ab Owain slew Richard FitzGilbert. And thereupon Owain (Gwynedd) and Cadwaladr, sons of Gruffudd ap Cynan, the splendour of all Britain and her defence and her strength and her freedom, held supremacy over all Wales and moved a mighty fierce host to Ceredigion. And they burned the castles of Aberystwyth, Dineirth and Caerwedros. Towards the close of the year they came to Ceredigion again with a numerous host and against them came Stephen, the constable, and all the Flemings and all the knights. And after fierce fighting, Owain and Cadwaladr honourably won the victory at Crug Mawr. And the Normans and Flemings returned home weak and despondent, having lost about three thousand men. And Geoffrey wrote the history of the kings of Britain.' It was a notable setback in the Norman invasion of Wales.

CRUMLIN, SITE OF THE TALLEST MULTISPAN BRIDGE IN BRITAIN *5 miles west of Pontypool, Monmouthshire.* The tallest bridge in Britain is now the Newbridge Bypass over the River Dee in Clwyd at 188 feet. The tallest multispan bridge in Britain was the Crumlin Viaduct at 200 feet above the River Ebbw, which was criminally demolished in 1966. The viaduct was built to carry the Newport, Abergavenny & Hereford Railway over the valley of the Ebbw, and was around 1,650 feet long in two spans of 1,066 feet and 584 feet. (A viaduct is distinguished from a bridge in having separate supporting piers that are not connected together.) The viaduct was carried by cast-iron column members, which supported 'Warren truss girders' made of wrought iron. The viaduct was placed into service in 1857, and considered the engineering wonder of its day. As of 2009 the viaduct abutments are visible on the valley sides. Crumlin Viaduct was hailed as 'one of the most significant examples of technological achievement during the Industrial Revolution'. During 109 years of service, it remained the least expensive bridge for its size ever constructed, the highest railway viaduct in the British Isles and third highest in the world, outdone only by the Aqueduct of Spoleto in Italy and the Portage Timber Viaduct in the United States. The driver who took the first train across during testing was so drunk when he did so that he became known as 'Mad Jack'. The 1963 'Beeching Report' killed off 2,128 stations, 67,700 jobs and over a quarter of the rail network, and in 1964 the last train crossed the viaduct. In 1962, Crumlin Viaduct was scheduled as being of 'architectural and historical interest'. However, by 1964, this decision had been overruled by British Railways, who argued that demolition was the most sensible course of action, and it was duly demolished.

CRYNANT - CEFN COED COLLIERY MUSEUM - EUROPEAN ROUTE OF INDUSTRIAL HERITAGE ANCHOR POINT *On the A4109, 4 miles north-east of Neath.* Cefn Coed Colliery was opened as an anthracite colliery by the Llwynonn Colliery Company during the 1920s. The first coal was raised in 1930, with the shaft and workings powered by a steam engine, fueled by the gas from older workings. The best coal came from the deepest seam called Big Vein, broken into at a depth of 750 yards. Cefn Coed, during its working life at depths of over 2,500 feet, was the deepest anthracite mine in the world. However, at such depths and with many accidents due to methane gas and roof falls, the pit soon gained the nickname of 'The Slaughterhouse'. Nationalised by the National Coal Board, continual investment was required to combat the need to keep its roadways open at the extreme depths. Changing economics led to a reduction in the workforce from the 1950s, and the mine ceased production in 1968. The complete above-ground mine workings remain intact on site, with the steam winding engine from No. 2 shaft now electrically driven. Cefn Coed is one of only two sites in all of Wales where one can find Brammallite.

CWMYOY - ST MARTIN'S CHURCH 2 *miles north-west of Llanfihangel Crucornau, Monmouthshire.* The valley here splits a mountain in the shape of an oxen's yoke, hence the Welsh name Cwmiau, Valley of the Yoke. St Martin's Church in the Vale of Ewyas is unique in that no part is square or at right angles, owing to the geological formation of the underlying rock. The thirteenth-century church has a leaning tower, and the churchyard tombstones are all falling over.

CWMYSTWYTH LEAD MINE - SCHEDULED ANCIENT MONUMENT - THE OLDEST RECORDED METAL MINE SITE IN THE UK *Around 20 miles from Aberystwyth, through Devils Bridge to Rhayader via Cwmystwyth, Ceredigion.* The AA once described the B4574 through Cwmystwyth as one of 'the ten most scenic drives in the World'. From the Bronze Age onwards, at least 4,000 years of continuous mining has been carried out here. There are Roman and medieval workings for silver, lead and zinc in the area, and Cwmystwyth was the largest of all the mines. It is considered the most important non-ferrous metal mining site in Wales, and John Leland (1506-52) recorded the destruction of woodland for the massive workings here. By 1844 most of the known reserves of ore had been worked but by 1850 the mine was again producing over 1,000 tons of galena (lead ore) each year, as new lodes were found. Around 1900, zinc was mined in preference to lead, but the mine closed in 1921. In October 2002 the Banc Ty'nddôl sun-disc was discovered here. Over 4,000 years old, it is the earliest gold artifact discovered in Wales. Made of 94 per cent gold and 6 per cent silver with a copper trace, it is probably Wales' oldest metal artefact.

CWMYSTWYTH - BRYN COPA COPPER MINE - SCHEDULED ANCIENT MONUMENT - THE FIRST EXAMPLE OF MINE DRAINAGE *One and a half miles east of the hamlet of Cwmystwyth on the mountain road from Cwmystwyth to Rhayader.* Copper was mined here around 4,000 years ago. The first known example of mine drainage was found here, with hollowed-out logs being used to take out the water. There are many workings, shafts and leats here, so care must be taken when walking the site.

CYDWELI, BATTLE OF, 1 JANUARY 1136 *Just north of Cydweli (Kidwelly), Carmarthenshire, the field is marked Maes Gwenllian (Gwenllian's Field).* At the foot of Mynydd-y-Garreg, with the River Gwendraeth Fach in front, and Cydweli Castle two miles away. Gwenllian ferch Gruffudd ap Cynan's husband Gruffudd ap Rhys was in North Wales planning an attack upon the Norman invaders. He had gone to seek support from Owain Gwynedd, the brother of Gwenllian. Maurice de Londres, the detested Norman Lord of Cydweli, attacked the Welsh in South-West Wales. Gwenllian of Dinefwr Castle rallied the few defenders that were left in the area, although her youngest son, Rhys, was only four years old. Giraldus Cambrensis stated that 'she marched like the Queen of the Amazons and a second Penthesileia leading the army'. She led her army against the Normans at Cydweli. A Norman army had landed in Glamorgan, and was marching to join the force of Maurice de Londres. Gwenllian sent some of her forces to delay the oncoming invasion force from Glamorgan, but it evaded them and her remaining force was trapped between two Norman attacks. One son, Maelgwn, was captured towards the end of the fighting. Gwenllian and her son Morgan were captured and executed, Gwenllian being beheaded over the body of Morgan. She had pleaded for mercy for her son and herself, but was beheaded on de Londres' express order. Her four-year-old son Rhys became The Lord Rhys, the most powerful lord in Wales.

CYDWELI (KIDWELLY) CASTLE CADW *A superb Norman castle overlooking the Gwendraeth river, Carmarthenshire, 10 miles west of Llanelli.* The castle could be supplied from the sea when the tide was in. The Welsh took it several times in the twelfth and thirteenth century, and in 1159 The Lord Rhys burnt it, but he rebuilt it in 1190. By 1201 it was Norman and was never again taken by the Welsh. Glyndŵr's forces sacked the town and besieged the castle for three weeks in 1403, until it was relieved by an English army. There was much damage done during the siege, and it was further strengthened in the fifteenth century. Cydweli still has the medieval street pattern of its medieval

walled town, and the South Gate still stands. These are impressive remains of a castle established as a huge earthwork in the early twelfth century.

CYDWELI INDUSTRIAL MUSEUM This is based at the site of the 1737 tinworks, one of Britain's largest, with huge rolling mills, steam engines and sorting and boxing rooms.

CYDWELI – ST MARY'S CHURCH A Benedictine priory was established here in 1114, rebuilt in 1320, adjacent to the Gwendraeth Fach River, and now possessing a tall spire.

CYMER ABBEY CADW *At Llanelltyd, 2 miles north of Dolgellau, Merionethshire.* Substantial remains of the simple abbey church, founded in 1198 by Maredudd ap Cynan (the grandson of Owain Gwynedd) for the Cistercian order. The monks kept sheep, were involved in mining, and bred horses for Llywelyn the Great. Most of the monastic buildings have gone, but the roofless church survives. Its rood screen is in LLANEGRYN CHURCH.

CYMER CASTLE This is the first recorded mention of a native Welsh castle, built by Uchdryd ap Edwin in 1116. The motte survives, with remains of a folly on its summit.

DALE CASTLE *St Anne's Head, Pembrokeshire.* This thirteenth-century castle is now in private hands and not open to the public. Lucy Walter was from here. She legitimately married Charles II and was the mother of the Duke of Monmouth, executed after the Battle of Sedgemoor.

DALE – WEST BLOCKHOUSE – LANDMARK TRUST The outermost of Milford Haven's defences, the fort was completed in 1857 and could accommodate a garrison of thirty-five men.

DAN YR OGOF CAVES – THE LARGEST SHOW CAVE COMPLEX, IN THE LARGEST SYSTEM OF UNDERGROUND CAVERNS IN WESTERN EUROPE *Near Abercraf (Abercrave), five miles north of Ystradgynlais.* This runs for eleven miles under the Swansea Valley. A further ten miles are believed to exist. Its Cathedral Cave is named after its main feature, called the Dome of St Paul's, a 42-foot-high chamber approached by a long passage. Half a mile of the system is open to the public, with spectacular stalactites, stalagmites and a Bone Cave. In the Second World War, TNT and art treasures were stored here. Old photographs show the Morgan brothers exploring the four underground lakes in coracles in 1912, shortly after they discovered the complex.

DEGANWY, BATTLE OF, 1245 *Above the old slate port of Deganwy, outside Conwy, Caernarfonshire.* According to *The Chronicle of Ystrad Fflur*, 'In this year Henry, king of England, and along with him a mighty host came to Deganwy, planning to subdue all the Welsh. And there he fortified himself a castle against the will of Dafydd ap Llywelyn, and returned to England. And to commemorate his act, he left many corpses of his men dead in Gwynedd unburied, some in the sea, others on land.'

DEGANWY CASTLE The twin peaks were the home of the court of the sixth-century Pendragon Maelgwn Gwynedd, the patron of saints Cybi and Seiriol, but reviled by Gildas. In 822, the *Annales Cambriae* state that the fort was destroyed by Ceolwulf of Mercia and his Saxon army: 'The fortress of Deganwy is destroyed by the Saxons and they took the kingdom of Powys into their control.' In 1080, the Norman lord Robert of Rhuddlan built a motte and bailey at Deganwy. He was killed by javelins near the Great Orme in 1093. This castle was taken in 1212 and rebuilt by Llywelyn ap Iorwerth around 1213, but his sons later destroyed it rather than allow it to fall to the English under Henry III. Henry rebuilt the castle and strengthened it again, only to see it fall to Llywelyn ap Gruffydd in 1263. Llywelyn once more destroyed Deganwy, and it was never properly rebuilt. Edward I probably used many of the stones of Deganwy to build his new fortress

of Conwy. Conwy could be supplied from the sea, so was easier to defend. The ruins which can be seen today are mostly from Henry III's time, and include the foundations of the gatehouse towers, traces of curtain wall, and the bailey ditches and banks.

DENBIGH (DINBYCH) – BIRTHPLACE OF THE MOST FAMOUS AFRICAN EXPLORER OF THE NINETEENTH CENTURY *The County Town of Denbighshire, 8 miles north-west of Ruthin.* John Rowlands, later known as Henry Morton Stanley, was born in a cottage near the castle gate, and brought up in a workhouse in St Asaff. Granted a borough in 1290, the town was destroyed during the Wars of the Roses and was damaged as a Royalist garrison in the Civil War. The old County Hall is of sixteenth-century origins.

DENBIGH CASTLE CADW The stone figure above the gatehouse is said to be Edward I, who supported Robert de Lacey in building the castle from 1282. There had been a Welsh castle on the site, belonging to Dafydd, the brother of Llywelyn the Last. Parliamentarians under Major-General Thomas Mytton took the town and spent months besieging the castle before it fell in 1646. Colonel William Salesbury had sent a message to the king informing him that his men were starving, and Charles I sent him a message allowing him to surrender with honour. The substantial site is dominated by an impressive triple-towered gatehouse, the link between defended town and castle ward.

DENBIGH CARMELITE FRIARY CADW Established for the 'White Friars', the remains of this late thirteenth-century church survive near St Hilary's Tower.

DENBIGH – LEICESTER'S CHURCH CADW – WALES 'LOST' CATHEDRAL Remains of the only large new church built in the reign of Elizabeth I. Begun by Robert Dudley, Earl of Leicester, in 1578-79. It was intended to be a cathedral to replace that of ST ASAFF, but the project ran out of funds and it was never completed.

DENBIGH – ST HILARY'S CHAPEL TOWER CADW Built about 1300-1310 as a 'garrison chapel' to serve the new castle and town. The tower and a short section of the west wall survive. Apart from the tower, St Hilary's was almost completely demolished during the 1920s.

DENBIGH – ST MARCELLA'S CHURCH *Llanfarchell (Whitchurch), a mile east of Denbigh.* This was supplanted as the main parish church for Denbigh after the building of St Hilary's, which was more central to Denbigh. A huge church, it is one of the best places to see tomb monuments in Wales, especially those of the famous Salusbury family. Humphrey Llwyd, the great antiquary who died in 1568, is also buried here.

DENBIGH TOWN WALLS AND BURGESS GATE CADW A well-preserved circuit of the 1282 walls forming the castle's 'town ward', built to protect the new borough. These are probably the finest in Wales after those of CONWY.

DERWEN CHURCH OF THE BLESSED VIRGIN MARY – FRIENDS OF FRIENDLESS CHURCHES *7 miles south of Ruthin, Denbighshire.* Principally renowned for its medieval rood screen and its arch-braced roof also of the late medieval period, it is a Grade I listed building.

DERWEN CHURCHYARD CROSS CADW Decorated cross of the fifteenth century, depicting the coronation of the Virgin, the Crucifixion, the Virgin and the Child and an angel with scales assumed to be St Michael.

DEVAUDEN, BATTLE OF, 743 *Devauden (Y Dyfawden) is on the B4293 four miles north-west of Chepstow, Monmouthshire.* The name may be derived from Tŷ'r Ffawydden, or Beech Tree House,

and until recently the village was known as 'The Devauden'. The adjoining hamlet of Veddw comes from Y Fedw, or Birch Grove. The area was home to hundreds of illegal dwellings used by woodcutters, mule drivers, quarrymen and labourers involved in Tintern's wireworks and manufacturing in the Angidy Valley. In *The Anglo-Saxon Chronicle*, in 743 Ethelbald of Mercia and Cuthred of Wessex beat the British here. The village is on a ridge way from the coast at Mathern, where the Saxons may have landed. In 1739, John Wesley preached his first sermon in Wales on the village green. Nearby Chepstow Park Wood was established as a hunting forest in 1280.

DEVIL'S BRIDGE – ANCIENT BRIDGES OVER THE MYNACH *Pontarfynach, near Aberystwyth, Ceredigion.* Devil's Bridge is possibly the best-known beauty spot in Wales, consisting of three bridges, stacked one above the other, spanning a narrow 300-foot gorge. The top bridge is the modern road bridge, built in 1901. Underneath it is the stone bridge built in 1753. The lowest bridge is 'Pont-y-Gwr-Drwg' ('The Bridge of the Evil Man'), built by the monks of Strata Florida in the twelfth century. This oldest bridge was said to have been built by the Devil as no man could build a bridge here. The Devil was asked to build the bridge in return for the soul of the first life to cross the bridge, but was tricked by an old woman who threw bread onto the bridge and her dog followed, thus becoming the first life to cross the new bridge. From the viewing platform under this bridge, one can see 'The Devil's Punch Bowl', where the swirling River Mynach has made strange shapes in the rocks, before cascading over a series of superb falls. A short walk away, the river falls 300 feet into the Rheidol River. Pontarfynach (the Bridge over the Mynach) is the Welsh name for Devil's Bridge, and the terminus of the Vale of Rheidol Railway is here.

DEWSTOW GARDENS AND GROTTOES *Near Caerwent, Monmouthshire NP26 5AH. Tel: 01291 430444 www.dewstow.com/gardens.* These wonderful Grade I listed gardens were 'lost' after the Second World War and not rediscovered until 2000. Created around 1895 by James Pulham, there are grottoes, tunnels, ferneries and water features, and it is well worth visiting.

DINAS, DIN The prefix 'caer' or 'car' often signifies a Roman site in Wales, similar to the suffixes 'chester' and 'caster' in England. Dinas or din, however, nearly always denotes a pre-Roman fortification in Wales and Cornwall, usually Iron Age or Bronze Age, often associated with hillforts.

DINAS EMRYS HILLFORT – ANCIENT FORT AND PLACE OF LEGEND *Off the A498 a mile north-east of Beddgelert.* The most impregnable site in Gwynedd, it has three ramparts, the inner one of which may date from post-Roman times. There is also the base of a square tower, possibly twelfth century, at the site and a circular platform from the ninth century or earlier. Llywelyn the Great seems to have built a tower on the previous Dark Age fortress, which is said to be the fifth-century fort of Emrys Wledig, Ambrosius, who fought Vortigern. Later, Emrys became synonymous with Merlin. Nennius' legend of the battle between the Red Dragon of the Romano-Celts and the White Dragon of the Saxons, in a pool inside the mountain, is placed here. In the 1990s, a hidden lake was indeed discovered inside the hill. Because of the inaccessibility of the site, one must contact the warden at Craflwyn first, on 01766 510120.

DINAS HEAD HERITAGE COAST AND ST BRYNACH'S CHURCH *Near Dinas Cross, between Fishguard and Newport, Pembrokeshire.* One can walk around the cliffs at this promontory, with one end of the ditched 'neck' at Pwllgwaelod and the other being Cwm-yr-Eglwys. All that remains of St Brynach's medieval church, that gives Cwm yr Eglwys its name, is the west wall and belfry. The rest was destroyed by the Great Storm of 1859 that also threw up the great pebble banks at Aber Mawr, Newgale and other local beaches. At Pwllgwaelod beach is the remarkable 500-year-old Sailors Safety pub, and in the village of Dinas Cross is yet another old pub that refers to the history of the area, The Ship Aground (SA42 0UY).

DINAS MAWDDWY – PONT MINLLYN CADW This is a narrow bridge crossing the Dyfi at Dinas Mawddwy, built by Dr John Davies early in the seventeenth century.

DINAS POWYS CASTLE AND HILLFORT *6 miles south-west of Cardiff, on the A4055 to Barry.* This is an ancient site, with occupation though the Iron Age, Roman, and Dark Ages, and seems to have been the site of a prince's court in the times of Arthur. The Celtic hillfort overlooks Cwm George. A timber castle was built in the eleventh century, but it is not known if it is of Welsh or Norman origin. The stone castle was probably built by the Normans in the early twelfth century, and ruined in the fifteenth century, possibly by Glyndŵr. A mile away to the west is the fourteenth-century Norman Church of St Andrew, possibly on a Celtic Christian site of St Andras.

DIN DRYFOL BURIAL CHAMBER CADW *Between Aberffraw and Llangristiolus, Anglesey.* Excavations of this Neolithic chambered tomb have indicated several phases in the development of the 'long grave'. Today all that can be seen are two tall stones standing close together, and about 20 feet west of these, a jumble containing three uprights, two fallen stones and a capstone. The long cairn here was originally over 55 yards long, but nothing of this is visible today.

DINEFWR (DYNEVOR) CASTLE CADW *1 mile west of Llandeilo, Carmarthenshire SA19 6RT. Tel: 01558 824512.* There are substantial stone remains of a native Welsh castle, in a strong defensive position on a hill overlooking Llandeilo and the Tywi Valley. Possibly a stronghold of Rhodri Mawr in 950, King Rhys ap Tewdwr left here in 1093 to meet defeat at Brecon. It was the principal stronghold of the princes of Deheubarth, held by The Lord Rhys in the twelfth century. Later it was taken by Edward I, and retained as a royal stronghold, but abandoned in the sixteenth century. The views from its parapets are some of the finest in Wales, especially over the meanders of the Tywi.

DINEFWR CASTLE, BATTLE OF, 1146 In *The Chronicle of Ystrad Fflur*, 'Cadell ap Gruffudd overcame by force the castle of Dinefwr which Earl Gilbert had built. And soon after that he took the castles of Carmarthen and Llansteffan.'

DINEFWR CASTLE, BATTLE OF, 1282 Llywelyn II's forces defeated an English army here, shortly before his murder at Aberedw.

DINFWR CASTLE, SIEGE OF, 1403 A letter exists from its constable pleading for help against Owain Glyndŵr, who had just taken Carmarthen. It was surrendered on 2 July, and Glyndŵr went on to take Llandovery Castle.

DINEFWR COUNTRY PARK – PARC GWLEDIG DINEFWR AND ROMAN FORTS – NATIONAL TRUST These eighteenth-century landscaped gardens of 800 acres were said to have inspired Capability Brown, and they enclose a medieval deer park with ancient White Park Cattle. The remains of the largest Roman garrison site in Wales were discovered in 2003 in the eastern part of the park. The first fort appears to be much larger than the second fort and it may have been occupied by a large military unit, perhaps even a legionary detachment. The presence of such a large unit so far west indicates the existence of a fierce resistance to the Roman occupation. The later fort was probably occupied by an auxillary unit or cohort comprising about 500 foot soldiers. The forts probably date to the later part of the first century CE, soon after the military conquest of Wales. It is likely that they were abandoned early in the second century CE. The wonderful park includes an Iron Age fort, two Roman forts, the medieval castle, two medieval towns, an eighteenth-century farm and a seventeenth-century mansion.

DINEFWR – NEWTON HOUSE – NATIONAL TRUST Next to Dinefwr Castle, the Normans planted the 'new town' in the thirteenth century. The mansion was first built in Tudor

times by Sir Rhys ap Thomas, then rebuilt in 1660 and remodelled in 1770 and has been restored as an eighteenth-century manor house, open to the public. The interior was renovated in 1720, and the four turrets replaced in the nineteenth century when the stone-tiled roof was replaced with slate. It is separated from the park by a wall and a 'ha-ha', and one can see fallow deer and White Park Cattle from its windows. It is one of only three remaining enclosed deer parks in Wales and is an SSSI. One can combine a visit to Newton House with a walk to the castle and strolls through one of the best eighteenth-century designated landscape parks in Britain.

DINGESTOW, BATTLE OF, 1182 *North of the A40, halfway between Raglan and Monmouth.* In 1179, Ranulf de Poer, Sheriff of Abergafenni, assassinated Cadwallon and took Cymaron Castle, with the approval of Henry II. The castle lay on the River Aran, between Llanbister and Llangynllo in Radnorshire. The Welsh later narrowly escaped killing de Poer at Abergafenni in an attack. In 1182, he began building the castle at Dingestow, and was attacked by Hywel ap Iorwerth and the 'men of Gwent' and killed along with nine of his knights. It was a disastrous defeat for the Normans, as a large part of Powys and its castles was regained by the Welsh as a result of this battle. The original name of the village was Llanddingad, the holy place of St Dingad.

DINGESTOW CASTLES *Almost four miles west of Chepstow, just north of Caerwent, Monmouthshire.* This large motte secured the way from Monmouth and Raglan into South Wales, guarding the crossing over the River Trothi. The nearby later stone castle site is west of the church, and was destroyed by Hywel ap Iorwerth during its construction in 1182. No stonework remains. Hywel was avenging the murder in 1175 of Seisyll. The neglected remains of the twelfth to thirteenth-century castle of the Lords of Llanfair Discoed are, like many, many others across Wales in a sad state of non-preservation. They were built to safeguard the rights to the great forest of Wentwood.

DINORBEN HILLFORT AND THE PARC-Y-MEIRCH HOARD *Near Abergele, Conwy.* In the years from 1400 BCE, climate cooling meant that the high homesteads were abandoned. Wales saw the development of bronze and gold ornaments, and the manufacture of bronze axes and tools. Dinorben hillfort is the earliest dated in Wales, from about 1000 BCE, and over 600 other hillforts have been identified in Wales from the Bronze through the Iron Ages. There was some harvesting, indicated by the presence of grain mills, but from the evidence of bones, it appears that animal husbandry was the main source of food.

Excavations were carried out from 1912-22. From this time on quarrying consumed the promontory, fuelled by the massive needs of the now-closed Shotton steelworks. Because of this, rescue excavations took place from 1956-64, 1965-69 and 1977-78, with the result that while the site is now totally destroyed it is one of the best-known and published hillforts in Wales. The Parc-y-Meirch (Horse Park) Hoard was found immediately below the western defences of the hillfort. This hoard, over 100 items in size, consists entirely of horse harness fittings and is one of the earliest known examples from Britain to have survived. A rattle pendant or 'jangle' (one of only two discovered), was fixed to each end of a horse bit. The hoard was discovered before 1868, with early accounts suggesting the possibility of a warrior burial with the hoard.

DISERTH (DYSERTH) - BODRHYDDAN HALL - GRADE I LISTED MEDIEVAL HALL HOUSE *1 mile east of Rhuddlan LL18 5SB. Tel: 01745 590414 Web: bodrhyddan.co.uk.* Just to the west of the village lies Bodrhyddan Hall, the 1696 William and Mary manor house of the Conwy family, who have lived here since it was originally built in 1450. Its treasures include the Charter of Rhuddlan, and panels around the fireplaces in the White Drawing Room that came from the chapel of a ship of the Spanish Armada that foundered off the coast of Anglesey. There are Hepplewhite chairs, suits of armour and ancient weapons. There are a formal parterre, a woodland garden and picnic areas.

DISERTH CASTLE After the death of Llywelyn the Last, Henry III began a castle-building programme across Wales, strengthening Rhuddlan and Deganwy and beginning this castle near Rhuddlan in 1245. However, along with Deganwy, it was attacked by the Welsh in the year of its building, and was destroyed by Llywelyn the Last in 1263.

DISERTH – CHURCH OF ST CEWYDD *3 miles south-west of Llandrindod Wells.* Diserth has a 60-foot waterfall nearby, and this charming parish church has a striking stained-glass east window installed around 1450. Eighty years later a colourful Jesse Tree window was added. There is a superb sixteenth-century beamed roof, family box pews dating from the 1660s, and a 1687 three-decker pulpit. Cewydd ap Caw in the sixth century also founded churches at ABEREDW, Laleston (Llangewydd) and probably MONKNASH in the Vale of Glamorgan. He was known across Wales as 'Hen Gewydd y Glaw', Old Cewydd of the Rain, and the legend of forty days of rain following his feast-day was copied when St Swithun's relics were transferred into Winchester Cathedral in 971.

DOLAUCOTHI GOLD MINES – NATIONAL TRUST – A SITE OF WORLD IMPORTANCE IN THE HISTORY OF PREHISTORIC AND ROMAN TECHNOLOGY *Pumsaint, Llanwrda, Carmarthenshire SA19 8US. Tel: 01558 825146.* Perhaps the most important gold mines in Europe, they were in use from prehistoric times to the twentieth century. They were one of the main reasons the Romans invaded Britain, and there are miles of Roman aqueducts around the wooded site and its three estate walks. Guided tours of the underground workings are available, and one can try gold panning on this superb site. It is the author's belief that much Irish gold came from raids upon Wales, rather than from gold deposits in Ireland. The remnants of barracks and a bathhouse are on the site, but the Romans left in 390 CE. Pumsaint Roman fort was built to guard the gold mines at Dolaucothi in 120 CE but abandoned around 150. Two major aqueducts represent the highest and lowest of nine hydraulic systems. The Celts first found gold here, and the Romans further exploited the site by opencast and gallery workings. It was the most technologically advanced mining site in Europe. A seven-mile aqueduct was channelled along the hillsides to bring water from the rivers Cothi and Annell. The water was stored in tanks cut into the rocks, from which it was sluiced to remove topsoil, wash crushed ore and drive simple machinery. Gold was extracted to send to the imperial mints at Lyons and Rome, being one of the Empire's main sources of bullion. It was so important that they built a fort, where the Dolaucothi Arms Hotel now stands. Work stopped around the second century, until an Australian reopened some of the galleries in 1870, and they were worked again until 1939. Dolaucothi was the largest gold mine in the British Isles before the Romans came, with evidence of Iron Age and Bronze Age technology, and it is thought that most of the gold was extracted before the Romans invaded Wales for its minerals. The National Trust's head of archaeology, David Thackray, stated that 'this work shows Dolaucothi is a site as archaeologically significant as Stonehenge and Sutton Hoo, which are the National Trust's most important archaeological properties and which are World Heritage Sites'. There are ancient opencast workings there, and it is the only site in Wales marked upon Livy's map of the world.

DOLBELYDR – LANDMARK TRUST – SIXTEENTH-CENTURY HIGH-STATUS GENTRY HOUSE *Trefnant, Denbighshire. Tel: 01628 825920.* A fine example of a gentry house, it has a claim to be the birthplace of the modern Welsh language. At Dolbelydr, Henry Salesbury wrote his *Grammatica Britannica* in 1593 – the first Welsh grammar. It is open to the public at certain times.

DOLBENMAEN CASTLE *Near Porthmadog, Caernarfonshire, near a ford over the Dwyfor River.* This was a royal seat (llys) until Llywelyn the Great moved his court to Cricieth, the only other castle in the centre of Eifionydd. The motte still stands 20 feet high, but the bailey seems to be covered by the sixteenth-century Plas Dolbenmaen, itself possibly on the site of a medieval house.

DOLOBRAN QUAKER MEETING HOUSE *West of Welshpool, off the Meifod to Pontrobert Road, ³/₄ mile after leaving the A495 a lane on the right leads through Dolobran Isaf, Montgomeryshire.* This restored Friends' Meeting House, hidden in woodland, dates back to 1701, is reached on foot, along a lane and across a field. It was built to be difficult to find, because of religious persecution, and even today there are no notices advertising its presence. The red-brick chapel resembles a cottage rather than a place of worship. One side was the chapel, and the other was used as a schoolroom. It was built by Charles Lloyd of Dolobran Hall, whose descendant Samuel founded Lloyd's Bank.

DOLFOR – GLOG HILL ROUND BARROWS – THE LARGEST BRONZE AGE CEMETERY IN WALES *Off the A483 near Newtown, Montgomeryshire.* On the crest of Glog Hill, Dolfor nine tumuli are strung along this hill crest. A website devoted to megalithic sites calls it the 'Glog Hill lunar standstill alignment', believing it to be a lunar observatory lined up between Dolfor and Llananno.

DOLFORWYN CASTLE CADW *Off the A483 between Newtown and Welshpool, Montgomeryshire.* The castle was begun by Llywelyn ap Gruffudd ('the Last') in 1273, safeguarding his territory from the Norman lordship of Montgomery, and captured by the English in 1277. DINAS BRAN, another 'Welsh' castle, has a similar plan of layout. Edward I wrote to Llywelyn in 1273 forbidding him to build it but Llywelyn replied that he did not require the king's permission to build in his own principality. In 1276, King Edward had sent three armies into Wales. One regained Powys from Gruffudd ap Gwenwynwyn, the Earl of Hereford took Brycheiniog, and Roger Mortimer invaded Cedewain, Ceri and Gwrtheyrnion. Roger Mortimer besieged and took it in 1277 after two weeks, and razed the local settlement. Stone cannon balls at the castle probably date from its capture and the use of siege engines. Mortimer founded a new settlement at nearby NEWTOWN in 1279, and Dolforwyn was in ruins by 1398.

DOLGELLAU – ST MARY'S CHURCH *On the A470 and its junction with the A494, near the mouth of the Mawddach Estuary, Meirionnydd.* This is a large Georgian gem of a building in the centre of the town, built in 1716, but unfortunately its twelfth-century predecessor was totally demolished. There is a Quaker Heritage Centre in the town, as many of its people converted after a visit by George Fox in 1657. A Dolgellau Quaker, Rowland Ellis, founded Bryn Mawr, the women's college in Pennsylvania in 1686, named after his home. There is a plaque on a shop front, where a building that traditionally housed one of Glyndŵr's parliaments stood until its nineteenth century demolition. Over 200 of the town's grey dolerite and slate buildings are listed.

DOLGELLAU GOLD BELT AND MINES *Around Dolgellau, the county town of Meirionnydd, on the River Wnion.* To the east of Dolgellau is the highest road in Wales, 'Bwlch y Groes' (Pass of the Cross), which is 1,790 feet high. Dolgellau became Wales' answer to the Klondike in the nineteenth century, when gold was found in the hills above Bontddu on the Mawddach Estuary. Earlier the Cistercian monks at Cymer Abbey on the Mawddach had found small gold deposits in the twelfth century, and the Romans also found evidence of gold in the area. About twenty small mines were working in the area until the onset of the First World War. At the Welsh Gold Visitor Centre, near Dolgellau, one can chip away at rocks, but will usually only find iron pyrites, 'fool's gold'. The Clogau Gold Mine (sometimes known as the Clogau St David's Mine) was once the largest and richest mine of all the gold mines in the Dolgellau Gold Belt, situated in Bontddu, near Barmouth. After producing copper and a little lead for a number of years, the mine developed into gold production in the 1862 'gold rush' and continued as a major operator until 1911 during which 165,031 tons of gold ore was mined resulting in 5,372 pounds of gold. It worked the St David's lode of CLOGAU Mountain alongside the co-owned Vigra Mine. Since 1911 the mine has been reopened several times for smaller-scale operations. It last closed in 1998, but has been held by a local exploration company since 1999. The Gwynfynydd Mine, in Snowdonia National

Park (reopened for underground mining from 1981 to 1998) was the last mine still producing pure Welsh gold, producing 3,085 pounds of pure gold over its lifetime. Welsh gold is more precious than platinum, because of its rarity and difficulty of extraction. Two tons of ore produce just one ounce of gold, and it has a slight variation in colour to other gold. The nearby Coed-y-Brenin (Wood of the King) gold mines were worked until the 1930s. Near Pont Dolgefeiliau in Coed y Brenin, Ganllydd, are a nineteenth- century abandoned engine shed and old gold workings, next to the beautiful waterfalls of Pistyll Cain and Rhaeadr Mawddach. Cefn Coch Mine (New California Mine) & Berthlwyd Mine, Ganllwyd, were of minor importance compared to Clogau and Gwynfynedd mines, but Cefn Coed/Berthlwyd Mine was the fourth richest of the gold mines in the Dolgellau gold belt, its greatest output being in the 1860s. Cefn Coch was often worked jointly with the nearby Berthlwyd Mine that follows the same lode, and it is an important scheduled site. Dolmelynllyn Estate is a National Trust property near Dolgellau with nineteenth-century gold mines. There are several old copper mines also in the area.

DOLWYDDELAN CASTLE CADW *Just north of the A470, between Blaenau Ffestiniog and Betws-y-Coed.* A square stone keep, dating from the early thirteenth century, remains of this castle built by Llywelyn ab Iorwerth ('the Great'), who was traditionally born nearby. The site was remodelled by Edward I. It covers two routes into Snowdonia, including the Vale of Conwy. Its capture, possibly through treachery, on 18 January 1283, enabled Edward I to end the Welsh campaign that had seen the murder of Llywelyn the Last in the previous year. It was the key strategic event, enabling the capture in the next few months of the castles of DOLBADARN, CASTELL-Y-BERE and CRICIETH.

DOLWYDDELAN – CHURCH OF ST GWYDDELAN A 3,000-year-old yew signifies an ancient place of worship, and the sixth-century site had a medieval chapel and was rebuilt around 1500. The pews have 'sleigh' sides to stop mud encroachment. Bodies used to be buried inside churches, in earth floors, as worshippers wished to be buried inside churches rather than outside. Churchyards for burial purposes only date from the seventh-eighth centuries onwards. Usually people were only buried in churchyards from the seventeenth century.

DOWLAIS IRONWORKS – THE LARGEST MANUFACTURING CONCERN IN THE WORLD IN 1840 *Merthyr Tudful, Glamorgan.* Iron ore deposits in south-east and north-east Wales ensured rapid industrialisation after the 1770s, and from the early nineteenth century huge coal deposits were discovered, mainly in South Wales. Quarrying was also important, with slate in north-west Wales and limestone across Wales being extracted. Manganese, gold, silver, lead, uranium, copper and zinc have also been found in quantity across Wales. Wales was incredibly important in the early years of the Industrial Revolution across the developed world, e.g. Dowlais Ironworks from 1840 onwards was the largest manufacturing concern in the world. In the mid-to-late nineteenth century, only the USA and the Ruhr rivalled South Wales, a region of pure industrial power, with its vast outputs of coal, iron, steel, zinc, copper and nickel. In the early nineteenth century, it is not hyperbole to say that, backed by its natural resources and mineral wealth, Wales had become the first industrial nation. Dowlais Ironworks was one of the four principal ironworks in Merthyr. The others were Cyfartha, Plymouth, and Penydarren Ironworks. It started as the 'Merthir Furnace' in 1759. By 1815, John Guest dominated the company, and five blast furnaces produced 15,600 tons of pig iron. By 1823, no less than ten blast furnaces produced 22,287 tons of pig iron. In 1840 the works had 5,000 employees. By 1845, Dowlais Ironworks was the biggest ironworks in the world, with eighteen blast furnaces producing 88,400 tons yearly and 8,800 employees. In 1857, it constructed the world's largest rolling mill. Iron and steel production ceased in 1930, production having moved to East Moors Works in Cardiff, and the site was largely demolished, except for the Blast Engine House of 1909.

DRE-FACH FELINDRE – NATIONAL WOOL MUSEUM *Cambrian Mills, near Newcastle Emlyn, Llandysul, Carmarthenshire SA44 5UP. Tel: 01559 370929.* There are restored listed mill

buildings and historic machinery, and a raised walkway gives a view of textiles in production at Melin Teifi, the site's commercial woollen mill.

DRYSLWYN CASTLE CADW *On a hill overlooking the Tywi Valley, halfway between Llandeilo (Dinefwr Castle) and Carmarthen.* It was possibly built by The Lord Rhys (d. 1197), or Rhys Grug (the Hoarse) in the early thirteenth century, but is first mentioned in 1246 in the *Annales Cambriae.* A Welsh rather than Norman castle, Rhys ap Maredudd seems to have received the castle from the Crown for his loyalty in the 1282-83 war, and he extensively rebuilt it. Rhys rebelled however, in 1287, and escaped before its capture. Siege engines were constructed, and its mining was marred by the collapse of a wall, crushing to death a group of nobles who were inspecting the work, including the Earl of Stafford. It surrendered to Glyndŵr in 1403, and was later slighted by the English to prevent its use in any further war.

DUFFRYN ARDUDWY BURIAL CHAMBER CADW *On the A496 north of Barmouth.* Its excavation in 1960 resulted in a profound change in the dating of burial chambers. The remains of two chambers exist and both belong to the Portal Dolmen classification. It was discovered that Dyffryn Ardudwy was a two-period monument, the western chamber having been built first. This chamber was originally covered by a circular cairn with a small forecourt, and in the material used to block the forecourt was found fragments of shouldered bowls dating from the Early Neolithic Period. This find gave a conclusively early date for the western chamber and forced a re-evaluation of typological dating for this class of monument as a whole. The second chamber was covered by a massive rectangular cairn, which completely engulfed the earlier chamber and cairn. Much robbed over the ages, only a vestige of the cairn remains today, but its extent is clearly visible.

DUNRAVEN CASTLE *On the Glamorgan coast near St Bride's Major, take the B4524 to Southerndown.* Over the centuries altered into a fortified mansion from a castle, it had its own landing stage in Southerndown Bay. It was lived in until the 1940s, but punitive taxation meant that its owners stripped its roof and possessions and left it, to later be demolished in 1963. The walled kitchen gardens and icehouse can still be explored. Dunraven is now home to the Glamorgan Heritage Coast Centre where information on the fourteen-mile stretch of unspoilt cliffs and coastline is available.

DUNRAVEN (DUNDRYFAN) HILLFORT This cliff-edged promontory fort, with two giant ramparts, is one in a string along the Glamorgan coastline, including the Bulwarks near Porthceri and Summerhouses near Boverton. The original Welsh name of Dundryfan indicates a 'triangular fortress', and it was said to be the court of the Silurian princes of the first century. The headland upon which it stands, overlooking the beautiful beach at Southerndown, is Trwyn y Wrach (The Nose of the Witch).

DYFFRYN GARDENS AND ARBORETUM – RHS RECOMMENDED GARDEN *St Nicolas, Vale of Glamorgan CF5 6SU. Tel: 02920 593328. www.dyffryngardens.org.uk.* The beautiful fifty-five-acre Edwardian Gardens are Grade I listed and designed by Thomas Mawson around the Grade II* Dyffryn House. There are thirteen Champion Trees (the tallest or largest of their species in Britain), and there is a Pompeiian Garden, a Theatre Garden, a Fernery, a Physic Garden and Panel Garden amongst the grounds. Some of its fine collection of acers has been moved to the new National Botanic Garden of Wales, and the remaining gardens such as the Kitchen Garden, Rose Garden and Greenhouses are being restored.

DYFI FURNACE CADW *12 miles north of Aberystwyth on the road to Machynlleth.* In 1637, a branch of the Tower Mint was set up in Aberystwyth, to coin locally mined silver. Near Cwm Einion (Artists' Valley, popular with artists in the nineteenth century) is Furnace, a historic metal-smelting site, dating from silver smelting in the seventeenth century. Its restored charcoal-fired

furnace was constructed around 1755 for smelting iron ore, and the waterwheel powered a huge pair of bellows, which supplied compressed air vital for the blast furnace's operation. There is a nearby waterfall of the River Einion.

DYLIFE LEAD MINE – THE SITE OF THE LARGEST WATERWHEEL IN EUROPE IN THE 1850s *Near Ffrwd Fawr waterfall and west of Trefeglwys, on the lovely mountain road between Llanidloes and Machynlleth, Montgomeryshire.* The little village of Dylife once was populated by a community of 1,500 people dependent on a lead mine almost as rich as that at Van, near Llanidloes. There is evidence of Roman workings here. Started before Van, production reached 10,000 tons per annum in the nineteenth century. There was a 50-foot waterwheel to drain the lower levels of the mine. Mines in such hilly areas were able to use waterpower, fed along specially built channels to drive some of the pumps and other machines. Although steam-driven machines were available, waterpower was cheap, and saved on the cost of transporting coal to the more distant mines. The downturn in lead prices was even more disastrous than at Van, because lead had to be taken by packhorse many miles to Derwenlas. As in the case of the Van Mines, Dylife was unable to survive for long after the Victorian age because of cheaper imported ore from abroad. Sion Jones, the smith at Dylife mines, suspected his wife of adultery and murdered her in 1725. For an alibi, he also murdered his daughter, threw both bodies down a disused shaft and said that they had left him. When the bodies were found, he was tried and sentenced to death. His body was to be gibbeted in an iron cage. As the only ironworker in the village, he had to make his own cage, and he was hung on Pen-y-Grocbren, The Hill of the Gallows. His body hung from the gallows in the iron gibbet cage until he rotted away, the gallows collapsed and the whole was buried with wind-blown soil. The story was thought of as a local myth, until in 1938, the cage was unearthed, and the discoloured skull in its gruesome iron-piece is now in St Ffagans Museum, Cardiff. The Star Inn is an old farmers' pub here (SY19 7BW).

DYRHAM, BATTLE OF, 577 (DEORHAM) *Dyrham, nr Bath, Gloucestershire SN14 8ER. Tel: 0117 937 2501.* A fluctuating border between Celtic tribes and Saxons advancing from the West was solidified in the sixth century by two great battles at Dyrham and Chester. In 577, the three British /Celtic kings, Conmail, Condidan and Farinmail, were beaten at the Battle of Dyrham, forming a wedge between the South-West Britons and the rest of the British tribes. The south-west tribes were slowly pushed back westward and became the Cornish, with a similar language, until recently, to those of Brittany and Wales. This defeat to the West Saxons, north of Bath, not only led to the Welsh being cut off from their countrymen in Domnonia (the West Country), but also enabled the Saxon push up through the Severn Valley and also into Somerset and Devon. Around this time the Saxons occupied Gloucester (Glevum), Cirencester (Corinium) and Bath (Aquae Sulis), expelling the Romano-British. Dyrham Park (National Trust) is a seventeenth-century mansion with grounds on the site of the battle.

EBBW VALE (GLYN EBWY) – FORMER INDUSTRIAL TOWN *At the head of the Ebbw Valley, Monmouthshire.* Formerly known as Pen-y-Cae, it became a centre for steel and coal, and its now demolished steel and tinplate works used to stretch for two and a half miles. The coal mines closed in 1989 and the steelworks in 2002. Britain now imports most of its coal from countries practising inhumane labour conditions, and makes very little steel. In the 1930s, the steelworks were the largest in Europe, making the town a target for German bombers. The world's first rolled steel rail was made in Ebbw Vale in 1857. Aneurin Bevan was born in nearby TREDEGAR, and was MP for Ebbw Vale from 1929 until his death in 1960. Quite possibly the last man of pure principles to be a British politician, he is remembered as the 'Founder of the National Health Service'.

EDWINSFORD – RUINS OF ONE OF WALES' GREATEST MANSIONS *Near Llansawel, Talley, 9 miles north of Llandeilo SA19 7JA.* This vast, derelict, partly roofless mansion is on the left bank of the Cothi. Built in the seventeenth century it was greatly added to in the later nineteenth

century, but fell into dereliction throughout the twentieth century. It stood at the centre of extensive gardens and grounds with a park to the west under Moelfre hill. The stable court and Home Farm are on the far northern bank of the Cothi, and several houses still exist in their original form on the estate. The earliest part of the house was built in the 1630s to an unusual design, square in plan with a pyramidal slate roof rising to a tall central cluster of chimneystacks. The estate still has over 350 acres of wooded valleys, over 10 miles of private tracks, a stone arched bridge (rebuilt in 1783 by the famous William Edwards of PONTYPRIDD), a dovecote, and walled gardens. The mansion had forty-two bedrooms and its seventeenth-century origins and later architectural embellishments are still clearly visible. One can rent a cottage to stay on the superb estate, which has 5.5 miles of fishing rights on the Cothi.

EFAILWEN HISTORIC LANDSCAPE – BIRTHPLACE OF THE REBECCA RIOTS 1839-44 'THE LAST PEASANT REVOLT IN BRITAIN' *On the A487 south of Crymych, Carmarthenshire.* In rural West Wales, rioting took place against the hated tollgates and workhouses, simultaneously supporting the Chartist protests in industrial areas. This began at the hamlet of Efailwen, with the destruction of the tollgate and burning of the tollhouse, on the night of 18 May 1839. Improvements to roads were necessary, and thus roads had been put under the control of local 'road trusts'. These made their profits from large numbers of tollgates, set up along the roads. Local farmers were crippled by the charges, and could not afford to take their produce or herds to market. Local uprisings occurred across Wales, with groups of men dressed in skirts ('Rebeccas') with blackened faces, demolishing turnpikes and tollgates. The 'Glandy Cross Landscape Area' here is recognised as of considerable importance for its complex of Neolithic and Bronze Age ritual and funerary monuments which include Meini Gwyr stone circle, standing stones, round barrows, ring cairns and other upstanding sites, many of which are Scheduled Ancient Monuments. Also within this area is a Neolithic axe factory, and at least two Iron Age hillforts. There are six standing stones nearby including the Efailwen Stone and the Capel Nebo Stone. Castell Garw is an oval defensive enclosure dating from *c.* 800 BCE. Stukeley drew sixteen stones in Meini Gwyr stone circle but they have all been demolished and only the two large outliers remain in situ.

EGLWYS GYMIN – ST MARGARET MARLOS CHURCH *On the B3414, a mile north of Pendine on the road to Red Roses, Carmarthenshire SA43 4PD.* Subjected to a sympathetic Arts and Crafts restoration in 1900, its circular churchyard tells of an early Celtic Christian foundation, perhaps of the sixth-century St Cynin ap Brychan. It is dedicated to three Saint Margarets; St Margaret of Antioch, St Margaret of Scotland (who died in 1093) and St Margaret Marlos (a local woman who is also closely associated with the nearby church of Llandawke). A Latin and Ogham stone of around 500 CE in the church commemorates 'Avitoria filia Cynigni' (Avitoria, daughter of Cynin, who may have been the mother of Merlin). The church measures only 33 feet by 17 feet and has ancient wall paintings. The church's foundation is noted as 1093 but it has to be an older Christian community, and it is set within the ramparts of an Iron Age fort.

EGLWYSILAN – ST ILAN'S CHURCH *On the top of Mynydd Eglwysilan between the Taff and Aber valleys, Glamorgan.* The large medieval church is remote, lying between its huge graveyard and the old Rose and Crown pub. Dedicated to a sixth-century saint also commemorated in Brittany, there is an extremely rare eighth-tenth-century sandstone slab carved with a warrior. The 1100 *Book of Llandaff* refers to the site as Merthyr Ilan, and the graveyard is full of Welsh inscriptions on the gravestones of many of the 440 men and boys who died at the Senghenydd pit explosion, featuring fathers and sons and brothers. It is a humbling experience for one who has never had to work in such terrible conditions. Eglwysilan was in the cwmwd (commote) of Senghenydd, in the cantref (hundred) of Brenhinol, later called the hundred of CAERFFILI.

EPYNT (EPPYNT) – UPLAND LANDSCAPES *Take the road from Brecon via Upper Chapel to Builth.* One passes through these marvellous uplands, now closed off to the public and used for

military training. Fifty-four Welsh-speaking families were forced off their hill farms covering 40,000 acres in 1940, by compulsory purchase. The Mynydd Epynt range extends from Breconshire into Radnorshire. You will pass the sadly decaying Drovers' Arms on the drive. The Ministry of Defence has opened a footpath, the Epynt Way, but no camping or exploration is allowed in a landscape full of prehistoric remains.

ERBISTOCK – THE GARDEN HOUSE – RHS RECOMMENDED GARDEN *Near Wrecsam LL13 0DL. Tel: 01978 781149.* There is a Victorian dovecote, sculpture garden and a National Plant Collection of hydrangeas.

ERDDIG CASTLE *2 miles south of Wrecsam, Denbighshire LL13 0YT. Tel: 01978 315151.* In the park of the later mansion, this motte and bailey occupies a strong position on a steep-sided promontory, overlooking the junction of two streams. Its ramparts are adapted from a prehistoric hillfort, and also incorporate a section of WAT'S DYKE. It was called 'the Castle of Wrexham' when it was built around 1090, at a time when the Normans expected to be able to swiftly push into Wales.

ERDDIG HALL – NATIONAL TRUST – WINNER OF UKTV HISTORY 'BRITAIN'S BEST' HISTORIC HOUSE A fine seventeenth-century mansion in 1,900 acres, it has been restored by the National Trust to show what life was like on a wealthy landowner's estate. It has been called 'the most evocative upstairs-downstairs house in Britain'. The atmospheric house has a 1,200-acre country park, with staterooms displaying original eighteenth- and nineteenth-century furniture and furnishings. Bordered by the River Clywedog, Erddig overlooks a restored formal eighteenth-century walled garden, and there is a striking collection of outbuildings used by the servants, including a kitchen, laundry, bake house, stables, sawmill, smithy and joiner's shop.

EUROPEAN ROUTE OF INDUSTRIAL HERITAGE The European Route of Industrial Heritage (ERIH) is a network of the most important industrial heritage sites in Europe. The aim of the project is to create interest for the common European heritage of its industrialisation and its remains. Of its forty-eight major 'Anchor Points', five are in Wales. They are Amlwch – Mynydd Parys and Porth Amlwch (Mining, Transport and Communication); Blaenafon – Big Pit National Coal Museum (Mining); Crynant – Cefn Coed Colliery Museum (Mining); Llanberis – National Slate Museum (Production and Mining); and Swansea – National Waterfront Museum (Mining, Iron and Steel, Production and Manufacturing, Energy, Transport and Communication, Water). Wales supplies 3 million of Europe's population of 830 million (UN 2009 estimates). It thus has 10 per cent of Europe's main industrial heritage sites compared to less than 0.4 per cent of its population, no less than twenty-five times what would be expected.

EWENNI PRIORY CADW – SUPERB FORTIFIED NORMAN CHURCH *2 miles south of Bridgend, Glamorgan.* Ewenni is an impressive Norman monastic church within a fortified perimeter wall. It was founded for Benedictine monks of Gloucester Abbey by Maurice de Londres in 1141. The presbytery and transepts are in Cadw's care. Its impressive walls cover 5 acres and it is one of the finest examples of a Norman defensive church, with a strong 1300 gatehouse. In 2008, eighteen burials dating from the fourth century were found in the priory, indicating its antiquity as a holy site before the Normans. There are also Celtic crosses built into its walls, but the recent addition of a glass screen between the nave with its four massive Norman pillars, and the chancel, is discordant.

EWLOE CASTLE CADW – THE MOST COMPLETE AND UNALTERED OF ALL THE WELSH-BUILT CASTLES *In Wepre Ancient Woodland Park, Ewloe, near Connah's Quay, a mile north-west of Hawarden, Flintshire.* Llywelyn the Last captured it in 1257 and rebuilt it, according to the Chester Plea Rolls in 1311. He had reconquered the surrounding district of Tegeingl (northern Flintshire) and 'built a castle in the corner of the wood' only eight miles from the Norman

stronghold of Chester. A decade later, the English formally recognised Llywelyn as ruler of all Wales. The so-called 'Welsh Tower' was probably built in 1210 by Llywelyn the Great. In the remaining woodland of the great Forest of Ewloe, this D-shaped keep is typical of many Welsh castles such as CASTELL-Y-BERE. It is the oldest surviving stone castle in the Welsh northern borderlands, but in poor condition.

FAENOL FAWR – ELIZABETHAN MANOR *1 mile north of Bodelwyddan, St Asaf, Denbighshire, North Wales LL18 5UN. Tel: 01745 591691.* Now a country house pub, hotel and restaurant next to Bodelwyddan Castle, it is an authentic Elizabethan manor built in 1597 as a hall house.

FELINFOEL – ADULAM BAPTIST CHAPEL *The village is just north of Llanelli, Carmarthenshire.* This was built on the site of Tŷ Newydd, said by some to be the oldest Baptist settlement in Wales. Previously, the banned religion held its meetings in secret in a cave, Ogof Goetrewen, on the Morlais River four miles away. Adulam's baptismal pool on the Afon Lleidi was used for total immersions until the 1970s, and can be seen next to the Lleidi Bridge. The large chapel was founded in 1709, and rebuilt in 1830 and 1852.

FELINFOEL BREWERY – THE FIRST BREWERY OUTSIDE THE USA TO CAN BEER
The Felinfoel Brewery, home of the gold medal-winning Double Dragon ale, is the oldest in Wales, dating from the 1830s. In 1935, it started to sell its beer in a new type of container – the can.

FERRYSIDE – ST ISHMAEL'S – ISCOED HALL *1 mile east of Ferryside, near Carmarthen, on the Towi River.* Sir Thomas Picton, 'the hero of Waterloo', bought this red-brick Georgian house from the Mansell family. It has been allowed to become a shell, but a group is trying to rescue it as an arts centre, and hope to have the project completed by the 200th anniversary of Waterloo in 2015.

FFOSTILL NORTH BURIAL CHAMBERS/CHAMBERED MOUNDS *2 miles north-east of Talgarth, Breconshire.* In 1912, there was a stone circle here, but it seems to have disappeared. One round and two long Neolithic cairns on Ffostill Farm were partially excavated in 1921. The southern of the long cairns, 108 feet long and 68 feet wide at the east end, contained a chamber, with the remains of at least eight persons. This cairn is the better preserved and consists of a single 10-foot-long gallery grave at the north-eastern end of the cairn. The chamber had ten uprights supporting two capstones which are now displaced.

FISHGUARD, ABERGWAUN – HISTORIC PORT *Lower Fishguard (Cwm) is where the River Gwaun meets the sea, on the A487, Pembrokeshire.* Upper Fishguard is later than the original port of Lower Fishguard, and faces Goodwick, from where the Irish ferries sail. The Normans settled here in the eleventh century. The old harbour of Lower Fishguard was used for the filming of *Moby Dick*, starring Gregory Peck, and also for *Under Milk Wood* with Peter O'Toole, Elizabeth Taylor and Richard Burton.

FISHGUARD, INVASION OF 1797 – THE LAST INVASION OF BRITAIN A Franco-Irish force landed at Carreg Wastad Point, near Fishguard. A forty-seven-year-old cobbler, Jemima Nicholas (*c.* 1750-1832), single-handedly captured fourteen French soldiers. The force surrendered in The Royal Oak Inn in the centre of Fishguard, which still retains mementoes of the time. Lord Cawdor's force was outnumbered three to one, but accepted the surrender of the invaders at the Royal Oak Inn. It is said that the French had misjudged the strength of the defending forces as they mistook Welsh women in their red cloaks and tall black hats as 'Redcoat' soldiers. Fishguard is the only Battle Honour earned on British soil, awarded in 1853 to The Pembrokeshire Yeomanry in recognition of the defeat of the French. The most interesting and long-lasting effect of this invasion was the run it caused on the Bank of England. Investors panicked and wanted to recover their gold sovereigns from the Bank, which was forced, for the first time, to issue paper banknotes,

to the value of £1 and £2. It seems symbolic that the printing of all the UK's money is now carried out in Wales at the Royal Mint in Llantrisant.

FLAT HOLM (YNYS ECHNI) *In the Bristol Channel, near Steep Holm, which is English.* Flat Holm was used by Viking raiders and pirates and as a cholera hospital in the past. St Cadoc had a retreat here, and the saints Baruc and Gwlaches were drowned in the sixth century, returning to the island to retrieve a forgotten missal. From Lavernock Point on the nearby mainland, the first conversation over water was heard by radio waves. Marconi had stationed his assistant, George Kemp, on Flat Holm three miles away. The first words were, unsurprisingly, 'Are you ready?' It measures 95 acres (38 hectares), and daily boat trips run from Cardiff, subject to weather conditions. It is a SSSI, like thirteen other Welsh islands. For many years, the farm inn there was the only place one could drink on a Sunday in Wales. There are old military installations and an abandoned cholera hospital, and the island can be visited from Cardiff.

FLEMINGSTON – HOME OF IOLO MORGANWG *Between Cowbridge and St Athan, Vale of Glamorgan.* Iolo lived here for most of his life, but his cottage has been demolished. St Michael's Church dominates the village, next to the sixteenth-century Flemingston Court Farm with assorted old walls and ruins around it. The adjacent medieval deserted village was depopulated in the twelfth to thirteenth century. On one of the houses in the village is a carving of a face, said to be sculpted by Iolo. Nearby St Tathan's Church has some superb painted tombs of the de Berkerolles of the ruined West Orchard Castle on the banks of the Thaw.

FLINT – COLESHILL, BATTLE OF, 1150 *2 miles from Flint, Flintshire.* Because King Stephen was involved in civil war with Matilda, Owain Gwynedd took advantage to push the boundaries of Gwynedd further east. He had taken MOLD CASTLE in 1146 and RHUDDLAN in 1150. Madog ap Maredudd, last King of Powys, allied with Ranulf, Earl of Chester, to stop Owain Gwynedd pressing upon both their territories. Owain defeated them and took lands off both.

FLINT – COLESHILL, BATTLE OF, 1157, AND HEN BLAS CASTLE Owain Gwynedd, with his sons Dafydd and Cynan, waited for Henry II's army in the woods at Coed Eulo (Cennadlog) near BASINGWERK, on the Dee estuary. They almost took Henry prisoner, but he escaped through the woods. This Welsh victory in the pass at Coleshill is hardly noted in British history, but two texts tell us that Earl Henry of Essex, thinking that Henry II had been killed, threw away the standard and later was forced into a duel because of his cowardice. The remains of Hen Blas Castle are one-and-a-half miles north-north-west of Flint, documented as Coleshill Castle in 1244, and also known as Dinas Bassing, Basingwerk Castle and Coelshill Fawr.

FLINT CASTLE CADW Begun in 1277, Flint was one of the first castles to be built in Wales by King Edward I. Like Caernarfon, Conwy, Harlech and Beaumaris, it is a masterpiece of James of St George, the foremost castle builder in Europe. The walls of the Great Tower are 23 feet thick, possibly a world record. It is unusual that this strongest tower, or donjon, is only linked to the rest of the castle by a drawbridge. The River Dee used to run between the two buildings, so this was contrived to protect supply ships. It may have been called 'Flint' to symbolise it was the striking point for Edward's conquest of Wales. 2,300 men worked on the castle and its associated fortified town, or bastide. In 1282, it was besieged by Dafydd, the brother of Llywelyn the Last, and another attempt in 1294 was more successful. The Constable of the castle burnt the castle and its bastide to prevent their use by the Welsh. The castle was then repaired. Flint Castle features in history as the place where King Richard II was imprisoned by Bolingbroke, who became Henry IV. It was slighted by Parliamentarians in 1647 after a three-month siege. Flint's closeness to the border and inward migration means that only 18 per cent of the population identify themselves as being Welsh. Perhaps anyone reading this book may be persuaded that being Welsh has something to offer.

FOEL DRYGARN (DRIGARN) HILLFORT *Hill at the eastern end of the Preseli Range, Pembrokeshire – from Crymych on the A478, take minor road west towards Mynachlog Ddu for a mile.* Over 220 houses have been excavated on this massive site on the summit of Moel Drygarn in the Preseli Hills. 'Drygarn' refers to the three superb Bronze Age cairns, each still 10 feet high, at the centre of the impressive site, within two stone ramparts. The Celtic respect for the dead is shown by the fact that the Iron Age hillfort builders left the cairns alone. Finds from the site can be seen in TENBY Museum. This is the biggest hillfort site in north-west Europe.

FONMON (FWNMWN) CASTLE, FONMON CASTLE *5 miles west of Barri, north of Rhoose, Vale of Glamorgan CF62 3ZN. Tel: 01446 710206.* Built by the St Johns in the twelfth century, it has been lived in since that time, with only one change of owner. In 1656, the Parliamentarian Colonel Philip Jones took it over from the St Johns, and the Boothbys are his descendants. Georgian rococo interiors house an important collection of antique paintings, books and porcelain, all enclosed in fine walled gardens with a castellated Watch Tower and Stable Block. The Vale of Glamorgan Show is held annually in its grounds.

FORDEN GAER ROMAN FORT *Near Montgomery, at the conflux of the River Severn and the Afon Rhiw flowing from the hills of Dyfnant Forest.* Levobrinta was built in the mid-second century and remodelled in the third and fourth centuries. On a Roman road from Wroxeter to CAERSWS, the remains are impressive, with the ramparts still rising to over 6 feet. There is evidence of its destruction by fire in 296 and 350-360 CE. Whether this was done by local tribes or the Romans themselves is unknown. There was also a civilian settlement here, and the remains of an amphitheatre have been discovered.

FRIDD FALDWYN HILLFORT *Overlooking the Severn Valley and its confluence with the River Camlad, on the outskirts of Montgomery.* With multiple banks and ditches, this Iron Age hillfort (Maldwyn's Sheep Pasture) reminds us that the original name of MONTGOMERY was Trefaldwyn (Maldwyn's Town). The site, excavated in 1937-39, has four phases of building identified, the first being Neolithic, with three subsequent phases of Iron Age development. The area is of vital strategic importance, with the Roman fort at Rhydwhiman (Swift Ford) to the north-west, the medieval fortifications of Hen Domen just north-west, and the later thirteenth-century Montgomery Castle to the east.

GANLLWYD – THE OLDEST AND MOST EXTENSIVE FOREST IN WALES *Near Dolgellau, Snowdonia LL40 2HP.* Coed y Brenin forest ('King's Wood'), near Ganllwyd, used to be an estate of the princes of Gwynedd. In the 35 square miles of wood, there is a visitor centre, gold-mining remains, polecats, red kites, buzzards, an arboretum, the beautiful waterfalls of Pistyll Cain (150-foot drop) and Rhaeadr Mawddach (60 feet in three steps). Coed y Brenin was the first forest developed for mountain biking in Europe. The Tudor and Victorian Dolmelynllyn (Meadow of the Yellow Lake) Hall is next to the forest, and is now a hotel.

GARN BODUAN HILLFORT *On the Llŷn Peninsula, Caernarfonshire. Access the site on the B4354 road, about 300 m from the junction with A497.* A large promontory hillfort, the lines of three stonewalled defences can still be seen. It encloses the remains of over 100 stonewalled structures, roundhouses and round and rectangular buildings, and the remains of another 170 round huts are visible as collapsed rings of stone. Its location on a steep, isolated hill made it a well-defended site. The inner defensive wall may have been built in the centuries immediately after the Roman occupation. A small fort or citadel at one end of the site may be later in date. There are also two freshwater springs on the site. It was possibly used again after the Romans left by a chieftain named Buan, around 600 CE.

GARN (CARN) FADRYN HILLFORT AND CASTLE *In the centre of the Llŷn Peninsula, Caernarfonshire - accessed from Garnfadryn village on the western slopes of the hill. Take the A497 from*

Pwllheli, heading towards Llaniestyn. The first phase of this Iron Age hillfort enclosed 12 acres on this steep hill, around 300 BCE. From the second phase, around 100 BCE the main ramparts enclose some 26 acres of the hilltop, and an inner defence encloses the foundations of round huts. The third fort was built by the sons of Owain Gwynedd, Rhodri and Maelgwyn, shortly before 1188, according to Giraldus Cambrensis, and is one of the first Welsh stone castles.

GARNGOCH, BATTLE OF, 1136 *On the Gower Peninsula, a memorial near Fforestbach marks the site.* Prince Hywel ap Maredudd of Brycheiniog defeated an Anglo-Norman army on New Year's Day. That so much blood was spilt is reflected in the name of the common, Garn Goch, Red Cairn.

THE GARTH – THE STORY OF THE HILL WHICH BECAME A MOUNTAIN *North of Pentyrch village, in the Taff Vale above Cardiff, looking down onto Gwaelod-y-Garth.* Garth Mountain (also called Garth Hill and Mynydd-y-Garth) is visible for miles around, and at its summit can be found several tumuli dating back from the early to middle Bronze Age, around 2000 BCE. The mountain came into the news after the book *Ffynnon Garw* was made into a film called *The Englishman Who Went Up a Hill But Came Down a Mountain* in 1995 starring Hugh Grant. Set in 1917, the film tells the story of two English cartographers arriving at the fictional Welsh village of Ffynnon Garw who cause local outrage when they reveal that their mountain is in fact only a hill because it just falls short of the required 1,000 feet. The villagers then constructed a tall cairn to ensure that the hill was high enough to be classed as a mountain. The description of 'Ffynnon Garw' in the book implied that Mynydd-y-Garth and Gwaelod-y-Garth were the location of the fictional occurrence. The area is littered with the remains of iron ore workings since the sixteenth century. The old Gwaelod-y-Garth Inn serves Welsh specialities such as laverbread and bacon.

GARTH CELYN, ABERGWYNGREGYN – THE THIRTEENTH-CENTURY CAPITAL OF WALES *On the north coast of Conwy, between Bangor and Conwy, overlooking the port of Llanfaes.* Known traditionally as Tŵr Llywelyn, Llywelyn's Tower, above the shores of Abergwyngregyn, this Elizabethan manor house is on a Roman site and beneath a Bronze Age fort. The tower is far older, and contains secret stairways, hidden rooms, hollow walls and tunnels. Recently it has been discovered to be the 'lost palace' of the princes of Gwynedd, used by Llywelyn I and Llywelyn II, and dating back to 1211. The Royal Commission for Ancient Monuments called it 'the most important site to be discovered in Wales' in the twentieth century. Gwenllian ferch Llywelyn II was born here, her mother Eleanor died in childbirth here, and Joan, Llywelyn I's wife, died here. It was Llywelyn the Great's main home and court throughout his reign, although he also had a hunting lodge at Trefriw. It was more central for his court than the traditional palace at ABERFFRAW on Anglesey. Throughout the thirteenth century, up to the Edwardian conquest, Garth Celyn was in effect the capital of Wales, and used by Edward I after he captured Prince Dafydd in 1283. It became known as Pen-y-Bryn, and Prince Dafydd and one of his sons were captured on the hill above it. It was not built to be defended, but as a court and palace, but there seems to be an escape tunnel leading away from it. In Easter 1230, 'Black' William de Braose was found with Llywelyn the Great's wife Joan (the daughter of King John) in Llywelyn's private bedchamber. *The Chronicle of Ystrad Fflur* tells us, 'In this year William de Breos the Younger, lord of Brycheiniog, was hanged by the Lord Llywelyn in Gwynedd, after he had been caught in Llywelyn's chamber with the king of England's daughter, Llywelyn's wife.' William was publicly hanged by Llywelyn on 2 May 1230, at Aber Garth Celyn, the marshland at the foot of the royal palace of Garth Celyn. The place is still known as Gwern y Grog, 'Hanging Marsh.' William's wife did not want the body, which was placed in a cave for wolves to disperse it.

GARWAY – ST MICHAEL'S CHURCH – WHERE THE LAST TEMPLAR GRAND MASTER VISITED *Just north of Skenfrith, over the border of the River Mynwy, in Herefordshire.* This was formerly named Llangarewi, and was a Celtic Christian foundation around 600 CE, in a field

above the present church. The first stone-built church was established about 1180 by the Knights Templar, who were given the land by Henry II. This church was built with a circular nave, the capped foundations of which were only found in 1927. It was one of only six Templar churches in England and Wales. The tower was built separately from the church in about 1200, and used as a place of refuge from Welsh attacks. The tower was only joined to the nave in the fifteenth century. The place was so important that it even gained a visit from the Templars' last Grandmaster, Jacques de Molay, in 1294. The Knights Templar were dissolved by the King of France and the Pope during the period 1307 to 1314, with de Molay being tortured and executed. Their land at Garway was passed to the Knights Hospitaller of nearby Dinmore. The Hospitallers replaced the circular nave with a conventional nave in the fifteenth century. The Hospitallers also built the fine chancel roof around 1400. It has become something of a cult visitor centre for those interested in Templar history and is a remarkable building with many special features, as depicted on many websites.

GATEHOLM – ROMANO-BRITISH VILLAGE *It can be reached at low tide from Marloes Sands, Pembrokeshire SA62 3BE.* The tidal island is twenty acres and has easily seen hut circles and a round barrow. The name means 'Goat Island' and much of the site has eroded into the sea.

GELLIGAER – CARN BUGAIL BRONZE AGE ROUND CAIRN *Summit of Cefn Gelligaer.* Gelligaer Common is scattered with prehistoric and historic remains. This mound of stones measures 51 feet by 54 feet and it is bounded by a kerb of larger foot-high slabs, laid flat. On its top there are some slabs sloping upwards and overlapping towards the centre, where there is a damaged burial cist, probably originally lined with upright slabs. There is a record that Carn Bugail was opened in the 1700s and that some urns and burnt bones were found.

GELLIGAER ROMAN MILITARY STATION *On Gelligaer Common, near Hengoed, Glamorgan.* For over forty years, Gelligaer was a cornerstone of the Roman military network that controlled south-east Wales. The fort at Gelligaer is sited on a ridge between the Taff and Rhymney valleys. It commands an extensive view of this upland region, which was heavily wooded in Roman times. Constructed in stone, it is almost square and occupies an area of 3.5 acres, making it one of the smallest Roman forts in Wales. It was garrisoned by a cohors quingenaria (an auxiliary infantry unit of 500 men). The fort was defended by a wide outer ditch and an earth rampart faced on both sides by a stone wall. There were corner and interval towers and four double-arched gateways. The impressive headquarters building stood at the centre of the fort and next to it lay the residence of the unit's commander. The men lived in six barrack blocks, one for each century of eighty men and their centurion. Outside the fort on the south-east side was a walled extension containing a bathhouse, and attached to the fort was the parade ground. An inscription records the construction of the smaller fort on the site between 103 CE and 111 CE during the reign of the Emperor Trajan. The text reads, 'For the Emperor Caesar Nerva Trajan Augustus, conqueror of Germany, conqueror of Dacia, son of the deified Nerva, High Priest, with Tribunician Power, father of his country, five times Consul, four times acclaimed Imperator, (the Second Augustan Legion [built this]).' A large earthwork to the north-west was an earlier earth and timber fort, probably built at the time of the Roman conquest of Wales in 74-78 CE. The forts at Gelligaer were part of a military network across Wales which prevented any native rebellion. Gelligaer's nearest neighbours were forts at Pen-y-Darren to the north and Caerphilly to the south. Recent research indicates that the garrison was probably withdrawn at the time of the Emperor Hadrian (117-138 CE), by which time the Silures had been pacified. The fort was built on a Roman roadway from Cardiff to Brecon and traces of that road can still be found in Heol Adam leading out and across the common.

GELLIGAER STANDING STONE This ancient stone stands on the east side of Cefn Bugail, near an ancient track way and a later Roman road from Gelligaer to the north which is still visible. It is 8 feet 6 inches high and greatly inclined. There was an inscription running vertically on its eastern face, partially defaced before 1862, and then totally mutilated by a group of miners in 1875.

The inscription was 'TEFROIHI' or 'TEFSOIHI'. Former observers have recorded that the pillar stood at the edge of a small circular enclosure about 16 feet 9 inches in diameter and, according to William Camden, a person had been interred in the midst of the area. According to some researchers, it is an early Christian memorial monument, marking a burial, following the Roman custom of roadside tombs. South-west of the stone, 320 feet up the hill, there is a small round cairn. At a short distance, on the summit of the ridge, there is also Carn Bugail round cairn.

GLAMORGAN CANAL *Between Merthyr Tydful and Cardiff.* A wonderful piece of engineering, with fifty-two locks bringing coal from Merthyr to Cardiff. Parts still exist, but regrettably most has been filled in, in the late twentieth century. The canal was built to facilitate the growth of the Industrial Revolution, replacing packhorses and carts to transport iron, coal and the like. Construction began in 1790, funded by the Merthyr ironworks owners seeking a means of transporting their iron to the sea. The canal was completed in 1798 with the addition of a sea lock in Cardiff Docks. It was around twenty-five miles long, with a drop of around 542 feet. The canal lost favour after the Taff Vale Railway opened and only limited traces of the canal remain, some in Cardiff itself.

GLAMORGAN HERITAGE COAST This stretches for fourteen miles from Porthcawl to West Aberthaw. Some of the largest dunes in Europe are at Merthyr Mawr Warren, with its Candleston Castle. The ruins of Dunraven Castle stand upon the headland at Dunraven Bay, overlooking Southerndown Beach. Halfway along the heritage coast is medieval St Donat's Castle and church, and there are several Iron Age hillforts along the coast. This author has tried over the years to get the path doubled in size to extend from West Aberthaw to Cardiff Bay (see *Glamorgan Seascape Footpaths* by T. Breverton). At East Aberthaw is the thatched Blue Anchor Inn, dating from 1380, one of the oldest pubs in Wales.

GLASBURY-ON-WYE, BATTLE OF, 17 JUNE 1056 *Near Hay-on-Wye, Breconshire.* Gruffudd ap Llywelyn defeated the invading army of Leofgar, Bishop of Hereford. Leofgar was a Norman, and his force was made up of Saxons and Norman mercenaries. In the *Anglo-Saxon Chronicle* we read, 'In this year died Æthelstan, the venerable Bishop [of Hereford], on the IV of the Ides of February, and his body lies at Hereford town; and Leofgar was appointed Bishop. He was Earl Harold's mass priest. He forsook his chrism and his rood, his ghostly weapons, and took to his spear and his sword after his bishophood, and so went in the force against Griffith the Welsh King, and he was slain, and his priests with him, and Ælfnoth the shire-reeve, and his many good with them, and the others fled away. This was eight days before midsummer. It is difficult to tell the distress and all the marching and camping and the travail and destruction of men and horses which all English army endured until Leofric the Earl came thither, and Harold the Earl, and Bishop Aldred, and made a reconciliation between them.'

GLODDAETH (CLODDAETH) HALL *2 miles south-east of Llandudno, LL30 1RD. Tel: 01492 875974.* A medieval hall house belonging to the Mostyn family, it is now a private school (St David's College) in a mixture of Tudor and Jacobean styles. A superb survival, its Elizabethan woodwork is described by CADW as 'among the largest, best-preserved and most magnificent domestic survivals anywhere in Britain'. It has a priest hole, terraced gardens and a seventeenth-century formal canal with extensive eighteenth-century plantations and parkland. Gwen ferch Ellis was a local 'witch' and one of her incantations, written backwards and therefore deemed very dangerous, was discovered at the Hall – she was hanged for witchcraft in 1594. It is accessible upon application.

GLOUCESTER, CAER GLOYW Glevum was built by the Romans on the Severn, marking the boundaries of the Dobunni and Silures, to act as their base for the attack on the Silures, Wales and its minerals. It became a stronghold of the Norman Marcher Lords.

GLYNDYFRDWY CASTLE The motte can be seen from the main road near Corwen, and overlooks the Dee. The CADW plaque at the site reads, 'Near this spot at his manor of Glyndyfrdwy, Owain Glyn Dwr proclaimed himself Prince of Wales on 16 September 1400, so beginning his fourteen year rebellion against English rule.' It is not a matter of semantics, but this 'rebellion' against Henry IV was actually a war of independence, and Henry Bolingbroke had himself usurped the throne of England. This mount, known locally as Owain Glyndŵr's Mount, is actually the remains of the twelfth-century castle motte built to command the route through the Dee Valley. Like the motte nearby at Sycharth, it may have continued in use until the late fourteenth century, but Owain's manor was actually the square moated area across the field. This would have been defended by a water-filled moat, palisade and gate.

GOLDCLIFF – MESOLITHIC HUMAN FOOTPRINTS, ROMAN SEA DEFENCES AND A LOST PRIORY *4 miles east of Newport, Monmouthshire.* On the Caldicot Levels, land reclaimed from the sea, the Goldcliff Stone now inside the church records the work of legionaries building the sea wall. Only found in 1898, it reads, 'The Century of Statorius Maximus in the First Cohort (built) thirty-one and a half paces.' In 1113, Goldcliff Priory was founded, and the main drainage ditch nearby is still known as the Monksditch. Hidden in the laminated silts of the Severn estuary foreshore at Goldcliff are 8,000-year-old (Mesolithic) human footprints, recently shown in the TV documentary *Time Team*. It is now part of the extensive Newport Wetlands Reserve, which opened in March 2000 as compensation for the loss of Cardiff mudflats caused by the Cardiff Bay Barrage. Giraldus Cambrensis in 1188 described the small cliffs at 'Gouldclyff' as 'glittering with a wonderful brightness'. When the sun shines a bed of yellow mica reflects light to passing ships, giving Goldcliff its name. Its original name in Welsh, Allteuryn, means Gold Heights. The shore was used in living memory of the tidal fishing of salmon, using the 'putcher' basket traditionally made from hazel rods and withy (willow) plait, set out against the ebb tide in huge wooden 'ranks'. The last exponent of the art of wooden putcher-making at Goldcliff was the late Mr Wyndham Howells of Saltmarsh Farm.

GOLDCLIFF – CHURCH OF ST MARY MAGDALENE This small medieval church is opposite the old Farmers' Arms pub. It dates back to around 1424, when Goldcliff Priory was destroyed by a flood, so it is possible that some of the limestone blocks used to build the church came from the remains of the priory. The church has a small brass plaque, on the north wall near the altar, commemorating the Great Flood of 1607 when a tidal wave (possibly a tsunami) swept along the Bristol Channel killing 2,000 people. The plate, about three feet above ground level, marks the height of the floodwaters. Other churches in the Caldicot Levels and in the Wentloog Levels on the other side of Newport have similar mementoes of the flood.

GORS-FAWR STONE CIRCLE *Near Mynachlog-Ddu, on the Preseli Hills.* Also known as Cylch-y-Trallwyn, this small stone circle is only 72 feet across, and has sixteen glacier boulders and two pointer stones.

GOWER HERITAGE COAST, CHURCH OF ST CENYDD AND HERITAGE CENTRE – THE FIRST AREA OF OUTSTANDING NATIONAL BEAUTY IN THE UK (1956) This peninsula runs for 33 miles from Caswell Bay in the south to Salthouse Point on the north shore of the Gower (Gŵyr) Peninsula. The limestone cliffs of the south coast of Gower are riddled with caves, notably at Minchin, near Pennard, and Bacon Hole. Remains of hyena, elephant, bison, and rhinoceros have been found in the larger caves, which can be visited via steep, narrow paths. The northern coast of the peninsula is a made up of mudflats and salt marshes, with wading bird habitats. Worms Head, near Rhossili, is a low headland joined to the mainland by a natural causeway only at low tide. At the north end of Rhossili Bay is Burry Holms, an island accessible only at low tide. The island was the home of sixth-century hermit St Cenydd, and the remains of a medieval church can still be seen. The Gower Heritage Centre at Parkmill is housed

in a working fourteenth-century water-powered corn and sawmill. Of Gower's nine Bronze Age menhirs (standing stones), eight remain today, including Arthur's Stone near Cefn Bryn, and there are Iron Age hillforts on the cliffs.

GOWER – MINCHIN HOLE BONE CAVE *Near Southgate, between Mumbles and Penrice, but difficult to access, Gower Peninsula*. This dramatic cave is one of the most important Pleistocene sites in Wales with unrivalled evidence of interglacial events. To the rear of the cave is a series of Romano-British hearths where evidence of small workshops was discovered. It is the largest and most impressive of all the Gower bone caves, but is quite difficult to reach. Extensive finds can be seen at Swansea Museum, and include the remains of a straight-tusked elephant, bison, soft-nosed rhinoceros, cave bear, reindeer, wolf and hyena. Inhabited during the Upper Paleolithic period, later excavations proved that the cave was again inhabited during both the Romano-British occupation and again in the Dark Ages. Finds of these periods include over 750 pieces of cooking pots, jars, beakers, dishes and bowls, spindle whorls, combs, finely worked bone spoons, bronze brooches and numerous coins. Cavers are not welcome in the winter because of hibernating bats.

GOWER – 'THE RED LADY OF PAVILAND BAY' – THE FIRST INSTANCE OF THE SCIENTIFIC RECOVERY OF FOSSIL HUMAN REMAINS IN THE WORLD *Goat's Hole Cave at Paviland on the Gower Peninsula - this is difficult to access*. Found by Professor William Buckland in 1823, he correctly identified the skeleton as male, but the ochre-stained bones became a 'painted lady' in the national press, thought to have 'serviced' Roman soldiers. Perhaps the epithet 'painted lady' or indeed 'scarlet woman' comes from this misattribution of a 29,000-year-old man as a 1,800-year-old prostitute. Buckland was a devout Christian who believed that man evolved on earth only a few thousand years ago. He could not accept the evidence of flint artefacts, nearby bones of Ice Age animals such as Woolly Rhino and Mammoth and the ritual burial of the 'ochred man' as being before the time when man first officially existed according to biblical scholars. 'Paviland man' was a person of some importance, his robes died with red ochre which stained his bones, and buried with fifty rods made of mammoth ivory, ivory bracelets and perforated sea shells. The earliest modern humans in Europe were named Cro-Magnon Man after an 1868 discovery in France, but 'Pavilandian Man' was the original discovery, in 1823. This is the site of the earliest ceremonial burial known in the world, and the discovery has led to the theory that human burial could have originated in Europe, specifically in Wales. At the time of his burial, the cave was far inland, not on the coast. This area became temporarily habitable by humans when, around 29,000 years ago, the last cold stage of the Ice Age was interrupted by a sudden warm phase. Humans were forced to leave Wales again before the height of the last glaciation was reached around 21,000 years ago, when only the very tops of the mountains would have been poking out of the ice.

GRACE DIEU ABBEY A Cistercian abbey built in 1226 by John, Lord of Monmouth, which in 1233 was despoiled by the Welsh as it was on their land, and then rebuilt elsewhere. Monks from Abbey Dore settled there. Edward III gave the monastery to the Hermitage of St Briavel, in the Forest of Dean, and it moved to the present site, its second move. On its dissolution there were only two monks. Some books state that the site is 'lost' but the last monastery was at 'Trody', on the right bank of the stream, west of Monmouth. This is on the Trothy Brook and probably in the lower meadows of Parc Grace-Dieu.

GRASSHOLM, YNYS GWALES – THE FIRST RSPB SANCTUARY AND THE LIGHTHOUSE NIGHTMARE This has the second largest colony in the world of 60,000 gannets. Ronald Lockley returned to Wales in the mid-1930s to take out a lease on Skokholm, and pioneered studies of the puffin, shearwater and stormy petrel. His work helped gain recognition for the need for the Pembrokeshire Coast and islands to become a National Park. The first bird observatory was established on the island by Lockley in 1933. Petrels, shearwaters and puffins live in burrows and

shags, razorbills and guillemots also breed on this twenty-two acre lump of basalt rock. Six miles off Grassholm is the Smalls Lighthouse, first built in 1776. In the vicious winter of 1800-01, one of the two lighthouse keepers died. The survivor understandably did not want the decomposing body in either of the two small rooms. He therefore made a makeshift coffin and lashed it to the rails outside. It was all of three months before he could be relieved, having gone insane. After this, there were always three keepers in UK lighthouses. The present 126 feet-high lighthouse was built in 1861, and assembled and shipped from Solva in pieces to the Smalls reef.

GREGYNOG HALL *Near Tregynon, 5 miles north-west of Newtown, Montgomeryshire.* This Jacobean manor was reconstructed between 1837 and 1868 using the new material of concrete. It is faced to look like a huge Elizabethan black and white timbered mansion, and is one of the earliest examples of a concrete-clad building in existence. Lived in by the philanthropist Davies Sisters, who set up a high-quality printing press, it was bequeathed to the University of Wales. One notable panelled Jacobean room remains, the Blayney Room, dating from 1636. This author gave a talk at Gregynog upon 'Henry Morgan, the Forgotten General' in 2003, and greatly admired the huge gardens. There has been a famous annual music festival here since 1932.

GRESFORD – ALL SOULS CHURCH *Off the A483 north-east of Wrexham, on the Chester road.* With a 1,600-year-old yew tree, this fifteenth-century church has an eight-bell tower which was considered a 'wonder of Wales'. Much remains that is contemporary with its building, and it was endowed by the powerful Stanley family. A 1498 window has survived, and there is a medieval effigy of Madog ap Llywelyn in the aisle. A tablet in the church commemorates the terrible Gresford Colliery Disaster, where 266 men died on 22 September 1934. The miners' wages were docked half a day's pay as the victims had not completed a full day's shift. The pit closed in 1973.

GROSMONT, BATTLE OF, 1233 *10 miles north-west of Monmouth, Monmouthshire.* Henry III was beaten at Grosmont by a combined Anglo-Welsh force including Earl Hubert de Burgh, who took the castle.

GROSMONT, BATTLE OF, 11 MARCH 1405 Glyndŵr's forces under Rhys Gethin were badly defeated by the Earl of Shrewsbury after burning the town.

GROSMONT CASTLE CADW This was probably founded by Earl William fitz Osbern in his invasion of South Wales in 1071, on the site of an Iron Age camp, and he was killed in battle in the same year. One owner, Payn fitz John, was killed in 1137 fighting the Welsh. The substantial remains were mainly built by Hubert de Burgh in the early thirteenth century, raised on the earlier motte. One of the 'Trilateral' of castles including White Castle and Skenfrith, it was later remodelled by Prince Edmund, son of Henry III, between 1274 and 1294, who made it one of his main residences. He is responsible for 'the Great Chimney', a notable feature of the castle. He also developed the south-west tower into a five-storey massive keep for his living quarters on the upper floors. These could only be approached via a wooden stairway to the north, which could easily be destroyed. The east side of the keep had a giant 'false' doorway, only allowing access to the ground and first floors. The Welsh name for the place was Rhosllwyn, meaning rosebush or rose grove, and the castle was once known as the 'Castle of the Red Rose'. It has been suggested that the Lancastrians assumed this badge, or symbol, not only from the name of the castle, but from the profusion of red roses growing around the area.

GROSMONT – ST NICHOLAS' CHURCH A Norman Garrison Church. The church is in the Transitional and Early English styles, consisting of chancel, spacious nave, aisles, transepts with aisle, side chapel, north porch and a central octagonal tower with spire, containing six bells. It was partly built during the thirteenth century by Eleanor of Provence, Queen of Henry III. The

chancel, as an example of the Early English style, is unusually grand, and it reputedly possesses the best Norman nave in Wales. It was approaching collapse when restored in 1870-75 and 1896.

GUILSFIELD (CEGIDFA) – ST AELHAEARN'S CHURCH *On the B4392, off the A490, 3 miles north of Welshpool, Montgomeryshire.* A large medieval structure, with aisles, it has a two-storey porch and clerestory windows. Much of what is now visible is of fifteenth-century origin probably on an earlier core. The dedication is to a sixth-century prince and saint. Medieval doors and windows survive and inside there is a fifteenth-century arch-braced roof, and in the chancel a Tudor panelled canopy ceiling with 140 bosses. Nearby Cefn Du motte is in the corner of a hillfort. The original Welsh name, Cegidfa, indicates a place where either jays or green woodpeckers could be seen.

GUILSFIELD – GAER FAWR IRON AGE CAMP Gaer Fawr (Great Fort) is a large multivallate Iron Age hillfort crowning the summit of a prominent hill, overlooking the valley of the River Severn. It is a relatively unknown fort, hidden in woodland in the care of the Woodland Trust. The hillfort is roughly oval in shape and is 21 acres in extent. The defences are remarkably well preserved, with ramparts up to 26 feet high. Two highly developed entrance arrangements, lead to gateways and one recent researcher said that it was once a multi-tiered 'town in the sky' which would have been the equivalent of a modern-day skyscraper. Dr Toby Driver, aerial investigator of the Royal Commission on the Ancient and Historical Monuments of Wales, said, 'This great hill was a massive piece of civil engineering, with five terraces cut into the hillside on an incredible scale. It would have involved many centuries of development ... It was the Millennium Stadium of its day, located in a commanding position in the Severn Valley and would have been the only thing of its kind for miles around ... Built primarily for defence purposes to keep invaders out, it would have been like a skyscraper, that was visited by traders from miles around as one of the first farmers' markets in Wales ... Thatched houses and round houses would have been built on it. And an area five or six times the footprint of the Millennium Stadium, across hundreds of hectares, would have been stripped of woodland and dragged up the hillside to supply the timber and gateways.'

GUILSFIELD HOARD *Found near Crowther's Camp, heading towards Pool Quay from Guilsfield, Montgomeryshire.* This weapon hoard, largely comprising spearheads, spear butts and scabbards for swords contains over 100 objects. It is one of the most important British hoards belonging to the late Bronze Age metalworking industry. Items can be seen in the National Museum of Wales.

GWAUN VALLEY (CWM GWAUN) – WHERE NEW YEAR IS CELEBRATED ON 13 JANUARY *Inland from Newport, Pembrokeshire, heading into the Preseli (Bluestone) Mountains.* Residents of the valley still celebrate New Year on 13 January, after the Julian Calendar, which was abandoned by Pope Gregory XIII in 1582 in favour of the Gregorian Calendar. The valley itself is regarded by geologists as one of the finest examples in the UK of a glacial melt-water channel. The Dyffryn Arms (Gwaun Valley Road, Pontfaen SA65 9SG) is a traditional 'front-room' pub, known for decades as Bessie's, where you can still be served real ale from the cask via an enamel jug. The actual New Year historically should be 6 April, which is why so many company accounts still use this date.

GWERNVALE BURIAL CHAMBERS *Half a mile north-west of Crickhowell near the A40.* This is badly damaged and immediately next to the A40. Flint microliths dating back 7,000 years to the Mesolithic Era have been found. Cereals and nut shells and evidence of timber post holes show occupation of the area during the Neolithic Era (around 3750 BCE). Shortly after this a 50-yard-long trapezoidal stone cairn (now destroyed) aligned roughly south-east to north-west was built over the settlement with a horned forecourt at the eastern end. Built into the side of the mound were three stone burial chambers with capstones but most of the barrow has vanished under the road.

GWERNVALE MANOR – THE HOME OF GEORGE EVEREST, AFTER WHOM MOUNT EVEREST IS NAMED *Now called The Manor Hotel, Brecon Rd, Crickhowell NP8 1SE, just north of the A40 a mile out of Crickhowell.* George Everest was born here in 1790. He went to India in 1823 to complete the Great Trigonometrical Survey of the subcontinent, which had begun in 1806. The survey would take up twenty-five years of his life and would map a huge area. He knew the mountain as 'Jomo Kang-Kah' and the title of Mount Everest was adopted in 1865 as a tribute to Sir George by his successor, in the year before Everest died.

GYRN CASTLE – IMPRESSIVE VICTORIAN MANSION *Llanasa, 3 miles south-east of Prestatyn.* The tower of this castellated villa was used by a Liverpool ship-owner to watch his ships return. With 367 acres, it was sold in 2006 for around £3.5 million, and may be altered into a hotel and conference centre.

HAFOD – ONE OF THE FINEST EXAMPLES IN EUROPE OF A NATURALISTIC PICTURESQUE LANDSCAPE *Hafod Uchtryd, near Llanfihangel-y-Creuddyn, 12 miles south-east of Aberystwyth.* Thomas Johnes (1748-1816) built a new house in this remote location and laid out its grounds in sympathy with the 'Picturesque principles' fashionable at the time, with circuit walks allowing the visitor to enjoy a succession of views and experiences, creating a 'living picture'. He built a Regency mansion and gardens, and set out to enhance the beauty of the natural surroundings by planting trees on a massive scale, and by implementing some of the improvements which were revolutionising agriculture in other parts of Britain. Hafod soon became an essential destination for visitors touring Wales, and the newly created paths, views, gardens and mansion were the subject of many contemporary accounts. The estate passed through several ownerships until, in 1949, it was split up, with much of the land being bought by the Forestry Commission, and planted with alien conifers. The Nash mansion itself was demolished as a danger to the public in 1958. Thus was Wales most important Georgian landscape desecrated. The Hafod Trust is now engaged in a continuing programme to restore Johnes' walks, reopen vistas, and conserve what remains of the historic buildings.

HAFOD – ST MICHAEL'S CHURCH The chapel-at-ease of Eglwys Newydd at Llantrisant in Llanfihangel-y-Creuddyn was substantially rebuilt in 1800-03 by James Wyatt for Thomas Johnes. It was sensitively restored in 1933 after a fire in 1832. The charred 1812 memorial by Chantrey, to Johnes' only child, can be seen in the church and Johnes' vault is in the churchyard. Sir Francis Chantrey was the greatest sculptor of the day, who also created statues of George Washington, William Pitt, George III and George IV.

HAFODUNOS HALL – RUINED VICTORIAN GOTHIC MANSION BY SIR GILBERT SCOTT *Llangernyw, 8 miles south-west of Abergele.* Scott was commissioned to rebuild the 1674 manor of Hafodunos between 1861 and 1866, and after some years of dereliction this Grade I listed mansion was almost destroyed by two arsonists in 2004. In 2008, the receivers put the house and estate up for sale. The Guide Price is £500,000-£750,000 and the estimated cost of complete renovation is thought to be in the £8m region. The estate includes the Gate Lodge (listed Grade II), Carriage Drive, Hall (listed Grade I), Keepers' Cottage (listed Grade II), Games Pavilion, Gymnasium/Theatre, approx 20 acres of fields, formal gardens (listed Grade II), woodland and a Walled Garden (listed Grade II). As of late 2009, the condition of the remaining buildings is declining rapidly and the grounds are becoming increasingly overgrown as nature takes over.

HAFOD-Y-LLAN – NATIONAL TRUST – RESCUED SNOWDONIA FARMSTEAD *Canolfan Deilan Las, Craflwyn, Beddgelert, Caernarfonshire LL5 4NG. Tel: 01766 890473.* The 'Save Snowdon' appeal in 1998 raised £3.65 million, which was used to purchase the Hafod y Llan estate and its flocks of Welsh Mountain ewes. Since then, the landscape, wildlife and walks have been improved and the farm has been converted to organic status. The old farmstead of Hafod y Llan

extends from the valley floor to the summit of Snowdon, and is now being managed organically. The farm has recently reintroduced pedigree Welsh Black cattle, suited to the harsh mountain conditions.

HALKYN (HALYGAIN) MOUNTAIN, BATTLE OF, 1406 *South-west of Flint, Flintshire - take junction 32B off the A55.* A night attack on Hywel Gwynedd's mountain stockade proved successful after heavy fighting, with him being killed. This reverse for Owain Glyndŵr in his War of Independence marked the beginning of the period of decline in his military fortunes. Lead ore was taken by the Romans from the mountain for smelting at Flint, and pigs of lead produced there were stamped with the inscription Deceangli, the name of the Celtic tribe occupying the area. Near the top of Halkyn Mountain is the excellent eighteenth-century Blue Bell inn, which brews its own Blue Bell beers and cider. Moel-y-Gaer, Rhosesmor, is a substantial hillfort in this historic landscape.

HARLECH CASTLE WORLD HERITAGE SITE CADW *On the A496 north of Barmouth, on a cliff overlooking Cardigan Bay, LL46 2YH.* This powerful castle was built between 1283 and 1290 by Master James of St George, for Edward I. Following the capture of CASTELL Y BERE in 1283, around 1,000 men were used in its construction. It is designed on a concentric plan, with a small but powerful inner ward dominated by an impressive twin-towered gatehouse and four round corner towers. Formerly on the coastline, this concentric castle now stands 200 feet away from what would have been the shoreline. Harlech is probably the most stirring of the World Heritage Listed castles in Wales, once painted a dazzling white. It was besieged by Madog ap Llywelyn in his rebellion of 1294, and the site was formerly associated with the tragic *Mabinogion* tale of Branwen, the daughter of Llŷr.

HARLECH CASTLE, SIEGES OF, 1404 AND 1407-09 In the Glyndŵr Liberation War, it fell after a prolonged siege to Owain Glyndŵr, who made it his main headquarters and court in 1404. He summoned a Parliament here. A long siege under Henry of Monmouth with 1,000 men and great cannon followed from 1407-09. In 1408-09, the most terrible winter in living memory led to the starvation of the garrison, and the death of Edmund Mortimer, the son-in-law of Glyndŵr. The castle fell and Glyndŵr's wife, daughters and grandson were incarcerated until their deaths. The fall of Harlech effectively sealed victory against Glyndŵr, although the war lasted until 1415.

HARLECH CASTLE, SIEGE OF, 1460-1468 In the Wars of the Roses, Sir Dafydd ap Ieuan ap Einion held out for the Lancastrians for eight years to a Yorkist siege, inspiring the stirring song *Men of Harlech*. 'Black William of Raglan', Lord Herbert, eventually took the castle, but Dafydd had responded to his summons to surrender by saying, 'Once I held a castle in France till all the old women of Cymru heard about it. Now I'll hold this castle till all the old women of France hear of it.' On the point of starvation, they marched out with flags flying and music playing, having surrendered on honourable terms. Only famine had forced surrender and Dafydd handed the castle to Lord Herbert and his brother Sir Richard Herbert on honourable terms. It was the last castle of Edward IV to hold out against the Yorkist rebels, and one of its survivors was the twelve-year-old Lancastrian Henry Tudor (later Henry VII). Henry was taken into captivity at RAGLAN. His uncle Jasper Tudor had escaped through the besieging forces, giving the Lancastrians one last hope of victory. Seventeen years later, Jasper and Henry ended the Wars of the Roses at Bosworth Field.

HARLECH CASTLE, SIEGE OF, 1647 Harlech's fifth major siege was in the Civil War, defended by Royalists under Colonel William Owen against the Parliamentarians. History repeated itself as it was the last Royalist castle to hold out, its fall ending the First Civil War in 1647. It may be worth noting that a road in Harlech, Ffordd Penllech, is the steepest in the UK with a claimed 1:2.5 gradient. The steepest part is a hairpin bend, and motors are not recommended to try it.

HARLECH – CHWAREL HEN LLANFAIR SLATE CAVERNS *Llanfair, signposted off the A496 3 miles south of Harlech LL46 2SA. Tel: 01766 780247.* The slate in this mine is among the oldest in the world, and many industrial towns in the British Isles have their original roofs made of Llanfair slate. The entry is through the main tunnel, under the twin arches of the crypt, and into the lofty 'cathedral cavern'. The tunnels and nine caverns were excavated in the nineteenth century, using only candles for lighting. Upon coming back to the surface, one can see 'Shell Island' and at low tide trace the fourteen-mile-long natural causeway of St Patrick heading across the Celtic Sea.

HAVERFORDWEST – ANCIENT MARKET TOWN, PORT AND FORMER COUNTY *Where the A40 meets the A4076, Pembrokeshire.* This used to be an important trading port, as evidenced by the medieval Bristol Trader pub on its old quayside. Growing up as a market town under the shadow of its castle, from 1479-1921 it was a county in its own right, and is now the county town for Pembrokeshire. Until 1974 the official title of the town was 'The Town and County of Haverfordwest', and it received its first charter around 1215. A French army landed in 1405 to support Owain Glyndŵr, but all their horses died on the crossing. Allying with Glyndŵr they burnt the town, before moving through South Wales to invade England. The town changed hands five times in the Civil War. Nothing remains of the town walls, but there are three twelfth-century churches in the town. It was thus the only town in Wales with three parishes within its boundaries. (There is a fourth medieval church, St David's, but it was in the suburb of Prendergast which was not absorbed into Haverfordwest until 1833.)

HAVERFORDWEST AUGUSTINIAN PRIORY OF ST MARY AND ST THOMAS CADW – THE ONLY SURVIVING ECCLESIASTICAL MEDIEVAL GARDEN IN BRITAIN On the west of the Cleddau, near the Bristol Trader pub and Haroldstone House, it was recently excavated. A unique medieval garden with raised beds was discovered. Founded in 1200, it was dissolved in 1536.

HAVERFORDWEST CASTLE Built in the mid-twelfth century by the Earl of Pembroke at the centre of 'Little England beyond Wales', it was never captured by Welsh forces. Llywelyn the Great defeated the Flemings and burned the town, but could not seize the castle in 1220, and it survived an attack by Glyndŵr's men in 1405. It surrendered to Cromwell's men after the battle of Colby Moor. The substantial remains are well worth visiting. The order to the mayor by Cromwell to destroy the castle can still be seen.

HAVERFORDWEST – HAROLDSTON HOUSE Remains of the Perrot Elizabethan mansion. The ruined mansion in the fields was built by Sir John Perrot (1527-92), the illegitimate son of Henry VIII. The lost village of Haroldstone is just south of Haverford and was the site of St Ishmael's sixth-century cell and St Caradog's holy well.

HAVERFORDWEST – CHURCH OF ST MARY THE VIRGIN Built by William Marshall, Earl of Pembroke in the twelfth century, it is one of the finest early Gothic churches in Wales. To the massive Norman walls (up to 4 feet 2 inches in depth) in the thirteenth century was added the tower, south porch and north aisle. With a clock in its stubby tower, is an inescapable focal point, closing off the view up High Street. St Mary's is the biggest church in Haverfordwest and historically the richest, as it was the chosen church of the gentry. The building contains thirteenth-century work of outstanding quality, a wealth of monuments and a fine early-eighteenth-century organ. St Mary's also had a spire, removed in 1802, as Lady Kensington feared it might fall on her house.

HAVERFORDWEST – CHURCH OF ST MARTIN OF TOURS The earliest of the town parish churches, a little hidden away, but its slender spire is conspicuous from many angles. The original place of worship, it was placed for safety near the castle gatehouse (which has

been demolished). St Martin's was rebuilt in the fourteenth century, and heavily restored in the nineteenth century. The spire is a replacement and dates from about 1870.

HAVERFORDWEST – CHURCH OF ST THOMAS A BECKET This medieval church was extensively restored by the Victorians.

HAWARDEN – NEW HAWARDEN CASTLE *South of Queensferry, where the A55 meets the A494, Flintshire.* Built in 1752, it previously belonged to the family of Prime Minister Gladstone's wife, Catherine Glynne. Gladstone lived there until his death in 1752. The castle and estate are still a private residence owned by the Gladstone family.

HAWARDEN OLD CASTLE In the grounds of New Hawarden Castle, it is on an impressive Iron Age site, and has a strong round keep on a Norman motte. Llywelyn the Last took the castle in 1265, capturing its lord, Robert de Montalt, and destroying it. De Montalt was returned to power in 1267, on the promise not to refortify the site, but within ten years the existing keep had been built. Llywelyn's brother Dafydd staged a night siege in 1281, and took the castle and its constable Roger Clifford and Payn de Gamage, slaying all the other defendants. Llywelyn felt the need to support his brother, who had previously been a supporter of Edward I, and the great and fatal war of 1282-83 began. Dafydd was executed in 1283, and the castle was in English hands from that time. It was badly damaged in the Civil War when it finally surrendered to Parliamentary forces, after changing hands three times. The massive keep still stands 40 feet tall.

HAWARDEN – ST DEINIOL'S CHAPEL – GLADSTONE MEMORIAL CHAPEL The chapel houses the Victorian tomb of Prime Minister William Eward Gladstone, who had married into the local Glynne family and therefore acquired the huge Hawarden estate. Much of the stained glass is by Burne-Jones and other Pre-Raphaelites, friends of the Gladstone family.

HAWARDEN – ST DEINIOL'S LIBRARY St Deiniol's is a unique institution, Britain's only residential library. It was founded by William Ewart Gladstone and, following his death in 1898, became the nation's tribute to his life and work. The building was funded by public subscription and opened in 1902.

HAWARDEN WOOD, BATTLE OF, 1157 *The Chronicle of Ystrad Fflur* reads, 'In this year Henry II, king of England, led a mighty host to Chester, in order to subdue Gwynedd. And Owain, prince of Gwynedd, gathered a mighty host and encamped at Basingwerk and raised a ditch to give battle. And the sons of Owain encountered Henry in the wood at Hawarden and gave him a hard battle so that after many of his men had been slain, he escaped to the open country. And the king gathered his host and came as far as Rhuddlan and Owain harassed the king both by day and by night. While those things were happening the king's fleet approached Anglesey and plundered the churches of Mary and of Peter. But the saints did not let them get away for God took vengeance upon them. For on the following day the men of Anglesey fell on them; and the French, according to their usual custom, fled but only a few of them escaped back to their ships. And Henry, son of king Henry, was slain. And then the king made peace with Owain; and Cadwaladr received back his land. And the king returned to England.'

HAY-ON-WYE (Y GELLI GANDRYLL) – THE SECOND-HAND BOOK CAPITAL OF THE WORLD *Just south of the A438, Breconshire, on the border with Hereford.* Hay-on-Wye hosts a yearly important International Book Festival, and its invention as the world's first 'booktown' was due to Richard Booth, the 'King of Hay-on-Wye'. This remarkable man lives in Hay Castle, and declared independence for Hay-on-Wye on 1 April 1977. There are over twenty bookshops, including even the old cinema and Norman castle being used as stores. The village boasts many

ancient buildings and pubs. Its original Welsh name comes from celli or grove and candryll, meaning shattered or wrecked.

HAY CASTLE The original castle was built on a motte near the parish church of St Mary's, but the large stone castle in the centre of town was built by the de Braoses. When her sons revolted, Isabella was starved to death by King John, who burnt the castle and town in 1216. Llywelyn the Great also burnt the castle and town in 1231, and they were rebuilt by Henry III. In 1232 and 1237, the people of Hay were given grants to wall the town. It was taken by the army of Prince Edward in 1264 and by Simon de Montfort in 1265. Glyndŵr's men unsuccessfully attacked the town and castle in 1400, and the castle suffered further damage in the Wars of the Roses. The Duke of Buckingham remodelled the keep before his execution by Henry VIII in 1521. Much of the curtain wall was destroyed during the Civil War. Huge fires in 1910 and 1939 gutted the eastern and western wing respectively, but now the western wing is the home of Richard Booth and part is a bookshop.

HEN GWRT – MOATED SITE CADW *Off the B4233, Llantilio Crossenni, 7 miles east of Abergafenni.* Probably a manorial site belonging to the Bishops of Llandaff in the thirteenth and fourteenth centuries, later used as a hunting lodge. Only the moat now remains.

HENLLAN – ST SADWRN'S CHURCH AND THE LLINDIR INN *2 miles north-west of Denbigh.* The castellated bell-tower is over twenty yards from the main body of the medieval church, in the far corner of the church yard, on a rocky mound. The village's Llindir Inn is a thirteenth-century thatched building, well known for its ghost, 'an attractive woman in white'.

HENSOL CASTLE – GRADE 1 LISTED SEVENTEENTH-CENTURY CASTELLATED MANSION *Leaving the M4 Motorway at Junction 34, follow the signs for Llannerch Vineyard, Glamorganshire.* The castle and its 150 acres of parkland are being redeveloped into a hotel and spa and 'town-house apartments', following a period as a hospital and conference centre, and are adjacent to the Vale Hotel, Golf and Spa Resort. Formerly known as Hensol House, the south range is an extremely early example of the Gothic Revival style. In 1735, £60,000 was spent on adding the east and west wings. The Hensol estate dates from at least 1419, and in the Civil War its owner, Judge David Jenkins, was impeached for high treason by Parliament. There was an extensive remodelling of the manor around 1735, and there are many fine interiors. The strong rumours of ghosts in the attic may have been owing to birds getting into the massive convoluted spaces and not being able to find a way out, as hundreds of dead birds were found there.

HEREFORD – MARCHER CAPITAL A line of powerful castles and bastides formed from where Norman Marcher Barons launched attacks carving out Welsh territories. These lords were based at Chester, Shrewsbury, Wigmore, Ludlow, Hereford, Abergafenni and Chepstow. Hereford, like Chester, Ludlow and Shrewsbury, served as a garrison town to gather levies for royal invasions into Wales.

HIRWAUN, BATTLE OF, 1093 *This was supposed to be on Hirwaun Common, where there is now an industrial estate, 2 miles north-west of Aberdare, off the A40.* The name comes from Hirwaun Gwrgant, the long meadow of Gwrgant. Iestyn ap Gwrgant, with Norman allies, fought Rhys ap Tewdwr here, and local names such as Maes y Gwaed (bloody field), Carn y Frwydr (cairn of the combatants) and Gadlys (battle court) survive. After the battle, Rhys' head was supposed to have been taken to the shrine of Our Lady of Penrhys (the Head of Rhys).

HODGESTON CHURCH FOFC *3 miles from Tenby, on the road to Pembroke.* Bishop Gower is said to have been responsible for the fourteenth-century rebuilding of the chancel which is rather large in proportion to the rest of the church. Adjacent to the chancel arch are the stairs of a lost

rood loft. There are an elaborately carved fourteenth-century piscine and sedilia in the chancel. The medieval tower is unusually slender and the bells are fifteenth and sixteenth century. The font is Norman, but we do not know the dedication.

HOLT CASTLE AND ROMAN BRICKWORKS *In the village centre, off Castle Street, on the west bank of the River Dee. 10 miles south of Chester, on the A483-B5102.* Late thirteenth-century stone enclosure and bailey fortress, founded by John de Warenne, Earl of Surrey. Built as the administrative centre of the district of Iâl, it replaced the abandoned hilltop site of Castell Dinas Bran. The castle has been completely dismantled and only thin internal walls remain, built into a pentagon-shaped boss of sandstone. A planned town was placed next to it for English settlers, and burned by Glyndŵr in 1400, but the castle was not taken. After Civil War slighting, all the remaining stonework was used in the construction of the original Eaton Hall. It was also known as Chastellion or Castrum Leonis, as it has a lion sculpture above its gateway. Holt was also the works depot of the XX Legion, possibly known as Bovium. It was excavated between 1907-1914, and various structures included a barracks, bathhouse, six kilns, and a major Roman tile works. Clay tiles and pottery for Chester Roman garrison were inscribed with the insignia of the XX Legion.

HOLT MEDIEVAL BRIDGE Listed Grade 1 for its medieval origins and one of Wales' most important bridges, its eight segmental sandstone arches link Holt with its English neighbour Farndon, over the Dee. An arch exists in the causeway on the Welsh side, which was the site of a former chapel. The bridge was built during the reign of Edward III in 1338-39, but the present structure is more likely to be fifteenth or sixteenth century. The bridge featured prominently in the Civil War with both sides trying to take control of the crossing.

HOLYHEAD – CAER GYBI ROMAN FORT CADW *On Holy Island (Ynys Gybi), off north-west Anglesey.* Caergybi is the Welsh original name of Holyhead, as it is possible St Cybi used the remains of the fort as a preaching centre. Here is a third-century rectangular Roman fortlet, of which the walls still survive. Holyhead town centre is built around the medieval St Cybi's Church, which is built inside one of Europe's few three-walled Roman forts (the fourth wall being the sea, which used to come up to the fort).

HOLYHEAD MOUNTAIN – CAER Y TŴR IRON AGE HILLFORT AND ROMAN WATCHTOWER CADW This well-defended hillfort is on the top of Holyhead Mountain (Mynydd y Tŵr), and its walls remain up to 10 feet high in places. The Romans placed a watchtower on the site to look out for Irish raiders, from where signals could have been sent by semaphore to the legion's headquarters in Chester. Settlements in this area date from prehistoric times, with circular huts, burial chambers and standing stones featuring in the highest concentration in Britain.

HOLYHEAD MOUNTAIN HERITAGE COAST This heritage coast runs for eight miles up the western shore of Holy Island from the bathing beaches of Trearddur Bay to the dramatic cliffs at North Stack. From the cliffs and RSPB bird-watching station near the lighthouse at Ellins Tower near South Stack, one can see up to 4,000 pairs of seabirds mate at South Stack, including colonies of puffins, guillemots, razorbills, choughs, and peregrine falcons. There is also a grey seal population. The spectacular South Stack Lighthouse was built in 1809 to warn ships of the treacherous reefs at this most westerly point of Holy Island. Visitors may now descend over 400 steps to the lighthouse on a small island, which has been restored after a long period of closure. Nearby, the Iron Age hillfort and prehistoric hut circles on Holyhead Mountain itself are impressive reminders of this remote island's ancient past.

HOLYHEAD – ST CYBI'S CHURCH Endowed by the Normans in the twelfth century, it was probably on the site of St Cybi's clas, and was a college with twelve clergy until dissolution in 1547. Heavily restored by Sir Gilbert Scott in 1877, it features a William Morris window.

HOLYHEAD – TŶ MAWR HUT GROUP CADW AND PENRHOSFEILW STANDING STONES An Iron Age settlement at the foot of Holyhead Mountain, with up to fifty circular hut circles and evidence of settlement from the Middle Stone Age, Neolithic Age, Bronze Age and Iron Age. Twenty dry-stone-built huts can still be seen, with associated field systems, belonging to a series of prehistoric and later farmsteads. Penrhosfeilw Standing Stones are to be found in fields below Holyhead Mountain, near Porth Dafarch. The stones are almost 10 feet high and stand roughly the same distance apart. They may be part of a more complex monument and burial chamber, which has been destroyed but others insist that they have always stood alone.

HOLY ISLAND, YNYS GYBI *On the western side of Anglesey, joined by two roads.* Holyhead Mountain dominates the western side of this island of 15 square miles. It is called holy because of the concentration of early religious sites, burial chambers and standing stones. Irish barbarians invaded and held it until Cadwallon Lawhir drove them out. Ynys Gybi is Wales' second largest island after Anglesey, at 28 square miles. It is a Site of Special Scientific Interest (SSSI).

HOLY ISLAND – ST GWENFAEN'S CHURCH AND HOLY WELL *Near Rhoscolyn.* The original church was established in 630 CE, when it was dedicated to Saint Gwenfaen, daughter of Pawl Hen of Manaw (Isle of Man). Gwenfaen was chased away from her cell by druids and escaped by climbing the rock stack off Rhoscolyn head. The tide came in and she was carried away by angels, which is how Saints Bay got its name. The medieval church was destroyed by fire and rebuilt in the 1870s. There is fine stained glass in all the windows, including those in the porch. On the west slope of Rhoscolyn headland is her well, having two sunken chambers including an enclosed pool. It is credited with curing mental illness after an offering of two white quartz pebbles was made.

HOLYWELL – GREENFIELD VALLEY HERITAGE PARK *1 mile north of Holywell, Flintshire, accessible off the A548 or A55.* In the Abbey Farm Museum, the sixteenth-century Pentre Farmhouse was moved here from Moel Famau in 1983. A hall house, it has been restored to its status as it was in the seventeenth century. A Victorian Farm, Cwm Lydan, has also been re-erected nearby. Other cottages and buildings are being placed here after being rescued.

HOLYWELL – ST WINIFREDE'S WELL AND CHAPEL CADW – THE OLDEST CONTINUOUS PILGRIMAGE SITE IN EUROPE The holy well and chapel date to the early sixteenth century. Prince Caradog ab Alan, from Hawarden, tried to ravish Gwenfrewi (Winifred) and she fled to a church. Because he had been spurned, he cut off her head outside the church door. The earth then swallowed up Caradog. St Beuno, her uncle, restored her head to her body, and she became a nun at Gwytherin in Denbighshire. In 1138, her relics were moved from Gwytherin to Shrewsbury Abbey. St Winifred's Well at Holywell was once the most important in Britain, and has over 1,300 years of unbroken pilgrimage. (The holy well at Lourdes dates only from 1828.) The remarkable stone shrine was endowed by Henry VII's mother in 1490 and somehow escaped the destruction of the Reformation, possibly because she was Henry VIII's grandmother. Richard the Lionheart and Henry V were patrons of the well, which became one of the greatest shrines in Christendom. It was also visited by Edward IV and Henry VII. People even attended the well during the Reformation, when pilgrimages were punishable by death, and the Catholic King James II came here to pray for a son and heir in 1686, the last royal pilgrimage in the British Isles. The spring had been used by the Romans, who used the waters to cure gout and rheumatism. The spring, although smaller than in earlier times, was the most copious in Great Britain, pouring from 2,000 to 3,000 gallons per minute. One can bathe in the pool, and the chapel above is a small Perpendicular chamber.

HYDDGEN, MYNYDD HYDDGEN, BATTLE OF, 1401 *Nant-y-Moch Reservoir has drowned some of the area of the running battle. Head east from Tal-y-Bont off the A487, or north from Ponterwyd*

off the A44. It is around 8 miles east-north-east from Aberystwyth. 1,500 English soldiers and Flemish mercenaries marched from Pembrokeshire, on Henry IV's orders, to end the Glyndŵr War of Independence in its second year. They found Owain Glyndŵr with 120 followers on the slopes of Mynydd Hyddgen near Pumlumon Mountain. The Welsh were mounted, and harassed the army with archery from horseback, until they began to retreat. At least 200 of the English force were killed as it returned south. Two stones of white quartz stand near the battlefield, known as Cerrig Cyfamod Owain Glyndŵr (The Covenant Stones of Owain Glyndŵr). Henry IV heard the news on 26 May and summoned the men of fourteen counties to meet him at Worcester for a second full-scale invasion of Wales. Glyndŵr wrote to the lords of west Wales, 'After many years of captivity, the hour of freedom has now struck, and only cowardice and sloth can deprive the nation of the victory which is in sight.' The war lasted another thirteen years because of this Welsh success, but wind turbines are planned to cover the remote and hauntingly beautiful battle site.

ILSTON – ST ILLTUD'S CHURCH AND RUINS OF THE FIRST BAPTIST CHAPEL IN WALES *On the Gower Peninsula, on minor road between B4271 and A4118 at Parkmill.* The present church was largely built during the thirteenth century incorporating the sixth-century cell in the base of a massive embattled tower with a transverse saddleback roof. Two bells are rung, dating from 1716. The third, dating from the fifteenth century, now lies opposite the entrance. The massive yew tree in the churchyard is believed to be as old as the church itself. A little further down the valley are the ruins of the first baptised church established in Wales, by John Miles in 1649. When dissenting assemblies became illegal, John Miles and his flock emigrated to America in 1663 and founded Swansey in Massachusetts. Ilston is in a 'historic landscape area' where a third-century Roman hoard of coins was found.

IRON RING OF CASTLES This World Heritage Site of Harlech, Conwy, Caernarfon and Beaumaris castles, built by Master James of St George for Edward I to cut off Gwynedd, almost bankrupted the English Crown. It was paid for by huge loans from foreign moneylenders, and the twelve-year programme (including other castles such as Aberystwyth, Cricieth and Rhuddlan) cost many times Edward's annual income. All the castles were accessible by sea, to enable security of supplies in times of siege.

KENFIG, CYNFFIG – ROMAN SITE *West of Porthcawl beaches.* Kenfig was once given borough status, and its Town Hall now occupies the upper room of a local inn, The Prince of Wales. Parking near here gives one better access to the castle than the Kenfig Pool parking area. The tiny village had parliamentary representation up to 1832. It is mentioned in 348 CE when Vortigern visited his grandson Bodric, who commanded the Roman garrisons at Kenfig and Margam, and the burgesses were given common rights in 1330, and a charter at least as early as 1396. In it, burgesses were given freedom from tolls for repairs of the town walls, free use of the quay and the right to appoint two 'ale testers'. An Ogham stone found between Kenfig and Margam is inscribed 'Punpeius Carantorius'. Kenfig was burned by the Danes in 893, besieged by Morgan Gam in 1232, burned by Howell ap Meredydd in 1243 and sacked by Glyndŵr in 1405. St Mary Magdalene Church in nearby Maudlam dates from 1250.

KENFIG CASTLE AND HIDDEN MEDIEVAL BOROUGH Robert, Earl of Gloucester, built this important castle and town around 1150, and after constant Welsh attacks, they and the Church of St James (*c.* 1150) succumbed to drifting sand dunes from the thirteenth century onwards. A huge swathe of sand dunes protected most of the South Wales coast in the past. By 1181, it was recorded that twenty-four ships lay in Kenfig's harbour. By 1281, there were 142 burgesses living there, but by 1485 the site with its church, grange and castle had been virtually obliterated by sand dunes. Kenfig Medieval Borough is a scheduled monument of national importance, perhaps unique in Europe – it has never been built upon or redeveloped, and should be better funded to be uncovered by archaeologists. Nearby in the dunes is Kenfig Pool (Pwll Cynffig), a large natural

lake, the centre of a fabulous eco-system of sand dunes leading to the sea. Ninety per cent of Europe's Fen Orchid population is found here.

KINMEL HALL AND PARK – SITE OF CANADIAN SERVICEMEN RIOTS *Contact Hamilton House, Kinmel Park Estate, 3 miles south-east of Abergele, Conwy LL22 9DA. Tel: 01745 826263.* The great mansion, now semi-derelict, was designed by William Eden Nesfield in Queen Anne style, its magnificence being afforded by the Hughes family, who owned Parys Copper Mine. The present house was completed on the site of earlier mansions in the 1870s, with nineteen bays in the main façade. It has been damaged by fire and is being slowly restored, but Golden Lodge, its entrance lodge, is still in excellent condition. Eighteen acres of walled gardens survive. The estate has existed in its current form since the sixteenth century, following the marriage of Piers Holland I and Catherine Lloyd, thus uniting the key areas of the estate. Kinmel has had a chequered past, from the visits of Oliver Cromwell and Queen Victoria through to the infamous Kinmel Park Riots in 1919 when Canadian servicemen lost their lives. Today the estate stands at just 5,000 acres of owned land and sporting rights. It is small in comparison with its opulent Victorian history under Lord Dinorben, who once owned 85,000 acres across North Wales. In March 1919, there were two days of riots at Kinmel Camp, which held 17,000 Canadian troops waiting to return home after the end of the First World War. Five soldiers were killed during the riots and are among the eighty-five WWI Canadian soldiers buried in nearby St Margaret's Church, Bodelwyddan, which is opposite the site of the army camp. The gravestone of Corporal Joseph Young, who died of a bayonet wound to the head received during the riots, bears the inscription 'Someday, sometime, we'll understand'.

KNIGHTON – HISTORIC TOWN ON OFFA'S DYKE *On the A4113 halfway between Llandrindod Wells and Ludlow.* Most of the town is in Radnorshire, some in Shropshire. Its Welsh name is Trefyclawdd, town on the dyke, and it straddles the River Teme. Many of the buildings are seventeenth century, including the Swan Hotel and other buildings in Town Clock Square. A borough from 1203, the town and castle were burnt by Glyndŵr in 1402. It was a centre for the wool trade in the fifteenth century, and drovers used to pass through here. Just outside Knighton is the Powys Observatory with claims to be Europe's largest camera obscura.

KNIGHTON CASTLE There are two earthwork castles, one east and one west of the town centre, and Llywelyn the Last captured the latter one, destroying it in 1262, at the Battle of Cefn Llys.

KNUCKLAS CASTLE, CASTELL-Y-CNWCLAS (GREEN HILL) CADW *Off the B4355, near Knighton, Radnorshire.* Ralph Mortimer built castles at Cefnllys and Knucklas to consolidate the area of Maelienydd (Radnor) that he had seized. In 1260 the Welsh destroyed the town, ignoring the castle, and in 1262 Llywelyn the Last besieged Cefnllys and sent Owain ap Madoc to Knucklas, which surrendered on the sight of his siege engines. The castle was dismantled, but garrisoned by Edmund Mortimer in 1282. Glyndŵr took and burnt it in 1402. It may be a Dark Age site, and legend states that Arthur married Gwenhwyfar here.

LAMPHEY BISHOP'S PALACE CADW *Take the A4139 from Pembroke of Tenby.* There are extensive remains of a lavish country retreat used by the bishops of St David's, with buildings dating from the thirteenth to sixteenth centuries. It was mainly the work of Henry de Gower, Bishop of St David's from 1328 to 1347, who built the splendid Great Hall. Later additions included a Tudor chapel with a fine, five-light east window.

LAMPETER, LLANBEDR PONT STEFFAN – THE SMALLEST UNIVERSITY TOWN IN THE UNITED KINGDOM *Where the A482 crosses the A485, at the confluence of the Dulas and Teifi rivers, Ceredigion.* The first castle was built by the Normans during the 1080s on this major

trade route to North Wales. In 1187, Owain Gwynedd destroyed the king's castle of Pont Steffan (Stephen's Bridge). The remains of the castle became the foundations for nineteenth-century college buildings, now the university. Its borough charter was granted in 1284, and successive charters allowed many markets and fairs to be held in the wide High Street until the 1930s. A horse fair is still held here, and the small town is known to locals as Llambed.

LAMPETER – ST DAVID'S COLLEGE – THE EARLIEST WELSH UNIVERSITY BUILDINGS The first university founded in England and Wales after Oxford and Cambridge, the castellated Regency college opened in 1822 on a quadrangle design. It became part of the University of Wales in 1971.

LANCAUT, BATTLE OF, 1645 *Near Chepstow, on the River Wye between Monmouthshire and Gloucestershire.* Sir John Winter's Royalists were defending a crossing on the Wye, on the Lancaut Peninsula above CHEPSTOW, but were attacked at high water, with only twenty men surviving from a force of 180. Winter's successful evasion of Parliamentary forces after the battle gave rise to the tradition that he had leapt his horse down the precipitous Lancaut Cliff, part of which became known as Winter's Leap. The medieval St James's Church is in ruins here.

LANDSKER – THE INVISIBLE LINE BETWEEN THE ENGLISHRY AND THE WELSHRY This boundary is marked by a line of mainly Norman castles stretching across the Preseli hills. Stretching from Laugharne on the coast in the south-east the line heads north-west, consolidated by around fifty castles either along or on either side of the line. The name means divide, from the Norse *land* and *sker*, literally a cut in the landscape, and there is still a language divide on the north of the line from Carmarthen Bay to St Bride's Bay in Pembroke. North of the Landsker was, and still is, a Welsh-speaking area. South Pembrokeshire became a major base of Norman settlement, with many castles and deliberately settled by Flemings. Features of Flemish architecture still are seen in some of the older houses. Pembroke Castle was the base of Norman power here, with a keep 80 feet high and massive walls 20 feet thick. Because of the ever-present danger of Welsh attack, many castles stand close to the sea or on navigable estuaries and rivers, for example Tenby, Manorbier, Pembroke, Carew, Upton, Benton, Picton, Haverfordwest, Newport, and Cilgerran. Another line of castles including Roch, Wiston, Lawhaden and Narberth lie along the defensive frontier, the so-called Landsker that still defines the difference between the English place-name, English-speaking territory of 'Little England Beyond Wales', and the native Welsh on the Preseli Hills and beyond.

LAUGHARNE (TALACHARN) CASTLE CADW *Heading west on the A40 from Carmarthen, turn left at the roundabout at St Clears and take the A4066.* Established in the early twelfth century as an earthwork castle, it was rebuilt in stone by the Anglo-Norman de Brian family during the later thirteenth and early fourteenth centuries. Overlooking the Tâf estuary, it was taken by The Lord Rhys in 1189 after the death of Henry II. It was later taken and destroyed by Llywelyn the Great, and taken and burnt by the Welsh in 1257. In 1575, it was given by Elizabeth I to her half-brother Sir John Perrot, who converted it into a Tudor mansion. In the 1930s and 1940s, Richard Hughes, author of *A High Wind in Jamaica,* lived here, at the same time that Dylan Thomas lived rent-free in the nearby boathouse.

LAUGHARNE, BATTLE OF, 1403 Having taken Carmarthen, on Glyndŵr's march through Wales, he halted his army outside Laugharne, on 10 July. The town and its castle were defended by the renowned Lord Thomas Carew. Glyndŵr had the premonition of a trap, and at dawn on 11 July sent just 800 men to reconnoitre a possible escape route to the north. The column was cut to pieces, and Glyndŵr moved his main force on, rather than be delayed in a major battle. Henry (Hotspur) Percy had declared against the king at Chester on 10 July, and Owain's intention was

to quickly link up and help him against the usurper Henry IV. The delay saved Henry who won narrowly at Shrewsbury, as Owain's men arrived too late to help Hotspur.

LAUGHARNE CASTLE, SIEGE OF, 1644 It was captured by Royalists and then Parliamentarians in the Civil War. The Royalist Colonel Gerard left a force of 200 under Lieutenant-Colonel Russell here, but Rowland Laugharne with 2,000 men and artillery besieged it, and took the town. After two days of bombardments, the castle wall was breached and the outer ward was taken. Russell surrendered the next day.

LAUGHARNE – DYLAN THOMAS' BOATHOUSE Thomas worked in the nineteenth-century building in the four years before his death in New York in 1959. Here he wrote Under Milk Wood, interspersed with regular drinking sessions in Brown's Hotel in the village. His nearby studio has been left in an untidy mess, just as when he worked in it.

LAVERNOCK, LARNOG – THE SITE OF THE FIRST WIRELESS SIGNALS OVER OPEN SEA *On the coast between Penarth and Sully, Vale of Glamorgan.* In 1897, Marconi sent a radio signal from Lavernock Point, three miles to Flat Holm Island, proving that radio could operate over water and therefore be used by ships. The event is commemorated on a plaque in the recently closed twelfth-century church of St Lawrence. Lavernock Fort Gun Battery was built on Lavernock Point in the 1860s, with a clear view up the Bristol Channel. There were three muzzle loading cannon here, and the fortifications were added to in the 1890s, 1903 and during World War Two. The remaining main section of the gun battery has been listed as an Ancient Monument, which includes the gun emplacements, director-rangefinder observation position, guncrew and officers' quarters. A few yards away from the historic Marconi hut, there is a Second World War Royal Observer Corps observation post on the cliff edge. In early 1962, a protected nuclear fallout bunker was completed at Lavernock Point for the ROC, and volunteers spent nearly ten days underground during the Cuban Missile Crisis as the government prepared the country for potential outbreak of war.

LEIGHTON HOLY TRINITY CHURCH *2 miles south-east of Welshpool, Montgomeryshire.* This important Victorian church was built in 1853 for the Leighton Park Estate and Hall. Gothic in style, it surprisingly features the pagan symbol of a 'green man' over the north porch.

LEIGHTON PARK ESTATE, HALL AND POULTRY COTTAGE – LANDMARK TRUST When the Great Exhibition of 1851 was being planned, a Great House, model farm and small village, Leighton Park Estate and Hall, was being built to demonstrate the practical use of Victorian farming methods. Its owner, John Naylor, was particularly interested in trying out new ways to improve agriculture, for most farming methods had hardly changed for hundreds of years. The new estate included a large working farm, which used water-driven turbines to power different kinds of machinery, and a private gasworks to provide lighting for Leighton Hall. Leighton Hall, now a Grade I listed building, was remodelled and new gardens laid out. Pugin played a part in the design and there is a remarkable tower there. It is in private hands, but Poultry Cottage is a Landmark Trust property. Leighton Park is the birthplace of the much disparaged Cupressocyparis leylandii, and possibly has the tallest group of redwood trees in Britain. The garden is of exceptional historic interest, laid out in the 1850s by Edward Kemp.

LLAN Almost always, this prefix signifies a holy place, being a foundation of a Celtic Christian saint before the eighth century. Most are sixth century. There were over 1,000 known Celtic saints in Wales and the borders during the pagan Dark Ages of the rest of Europe, many only remembered by the place names or holy wells still in existence.

LLANABER – ST BODFAN'S CHURCH, ANCIENT STONES AND STONE CIRCLES *Just over a mile north of Barmouth, Cardigan Bay, Merioneth.* This holy place at the mouth of the

River Man has a thirteenth-century Early Gothic church with an exquisite chancel roof, an ancient font, and an old chest once used for public offerings. It was built by Hywel ap Gruffydd, Lord of Meirionnydd, and is possibly on an earlier Celtic foundation. The church also contains two ancient stones dating to the late fifth or early sixth century. The first was found on Barmouth Beach, inscribed with the words 'caelixti monedo regi' meaning Coelixtus, King of Anglesey. The second reads 'aetern et aetern(ae)' meaning the stone of Aeternus and Aeterna and was previously used as a footbridge. Near Sylfaen Farm is the prehistoric Cerrig Arthur Stone Circle, and near Pen-y-Dinas is Hengwm Stone Circle.

LLANAFAN FAWR – ANCIENT SETTLEMENT, CELTIC CHURCHYARD AND POSSIBLY THE OLDEST INN IN WALES *On the B4358 between Beulah and Newbridge-on-Wye.* The church lies on an Iron Age mound, with a yew around 2,200 years old in the churchyard. The circular churchyard indicates a sixth-century Celtic foundation of St Afan in an older site. St Afan's tomb can be found in the churchyard, with the inscription 'Hic Iacet Sanctus Avanus Episcopus'. There is an Iron Age ringwork dating from 2300 BCE in the field to the south of the church. The large mound in the middle of it may be a medieval motte or a prehistoric henge, known locally as Llanafan Castle. A gravestone is unique in Britain as it stated the name of the murdered victim and also the name of his murderer: 'John Price Who Was Murdered On The Darren Hill In This Parish By R Lewis April 21 1826.' There seems to have been a monastery here, but of the earlier churches only the foot of the church tower remains, the rest being rebuilt in 1886. Inside the church (the key is available at the Red Lion), there is a seventh-century single pillar stone incised with a Latin ring cross dating from the seventh century, a seventh-century font and two more carved stones dating from the seventh-ninth centuries. The Red Lion can be dated confidently back to 1188 as Giraldus Cambrensis recorded that he stayed there, and that the Lord of Radnor had slept with his dogs in the church. The current Red Lion cruck-frame building dates back to about 1472.

LLANALLGO – LLIGWY (LLUGWY) – NEOLITHIC AND EARLY CHRISTIAN SITE CADW *Off the A5025³ miles north-west of Benllech, Anglesey.* Here there is a superb Neolithic burial chamber dominated by a massive capstone weighing at least twenty-five tons. Adjacent is the well-preserved Din Lligwy Hot Group – stone-built huts in an enclosure dating from the Romano-British period. It is a wonderful complex of stone houses in a defended stone enclosure, with rows of iron-working hearths. Nearby is Hen Capel Lligwy in a field, a simple stone chapel, probably of early twelfth-century origin. It may be a foundation of Peithien, the sister of Gildas. This is a wonderful, peaceful site involving a half-mile walk from the road, but one of the most evocative places in Wales. The medieval church at Llanallgo itself was originally a foundation of Gallgo, Allectus, a brother of Gildas, who appears as Calcas in the *Mabinogion* fighting for King Arthur. Another brother, Eugrad, founded nearby Llaneugrad.

LLANANNO – CHURCH OF ST ANNO *9 miles north of Llandrindod Wells, near Llanbadarn Fynydd, Radnorshire.* Founded by St Anno, Ano, Winnow or Wonno in the eighth century, it lies on the east bank of the River Ithon. This tiny church has one of the most ornate rood screens in Wales, dating from the 1490s and from the Newtown school of carvers. The single-cell church was rebuilt in the Victorian period and apart from its magnificent screen has a few fittings surviving from the medieval era including a font and stoup. There is also a 2-ton block of stone carved as a seat, at the centre of a ruined stone circle in the parish.

LLANARMON DYFFRYN CEIRIOG – FIFTH-CENTURY CHURCH SITE AND DROVERS' CROSSROADS *In the Vale of Ceiriog, 10 miles north-west of Oswestry, on the B4500 south of Llangollen, Denbighshire LL20 7LD.* Bishop Germanus of Auxerre, St Garmon, came to Wales in 429 to combat the teachings of Pelagius, and won the famous 'Alleluia Battle' against pagan Picts and Saxons. St Garmon's Church is a fine early Victorian stone building of 1846, which replaced an earlier church in serious dilapidation. It is unusual in having two pulpits. The

grassy mound in the churchyard may be a Bronze Age burial mound, although it is known locally as Tomen Garmon and is said to be the place from which the saint preached. The graveyard contains many old slate headstones, some dating back to the 1700s. At least one of the yew trees here is over 1,000 years old. The picture postcard village is at the crossroads of two drovers' roads for sheep and cattle, and at the confluence of the Ceiriog and Gwrachen rivers. The West Arms Hotel is sixteenth century and the other inn in the village, The Hand at Llanarmon, also dates from that century.

LLANARMON-YN-IAL – CHURCH OF ST GARMON *5 miles south-east of Rhuthun, Denbighshire.* Llanarmon yn Iâl has a beautiful double-aisled church set in a circular churchyard suggesting a fifth-sixth century origin. It was rebuilt in 1736 but contains late medieval roof timbers. The church contains effigies of a knight and Abbot Gruffydd ap Llywelyn of Valle Crucis, monuments of the Lloyds, and a magnificent late-medieval brass chandelier, supposed to have been brought from Valle Crucis Abbey, like that at Llandegla. It seems to be in the site of a stone circle, and the nearby mound is usually referred to as the Motte and Bailey of Tomen y Faerdre. Owain Gwynedd is known to have had a castle in Iâl (Yale). However, some believe it is a Neolithic mound. The churchyard is sub-circular, and there are some blocks of limestone low in the churchyard wall on the north side, and a standing stone felled and inset from the wall can be seen. There are many tumuli in this area, in which urns containing the ashes of burnt bones have been found.

LLANARTHNE – THE NATIONAL BOTANIC GARDEN OF WALES – RHS RECOMMENDED GARDEN *Llanarthne, off the A48 east of Carmarthen SA32 8HG. Tel: 01558 668768. Web: gardenofwales.org.uk.* The first national botanic garden to be created in the new millennium, voted 'number 1 wonder of Wales' by *Western Mail* readers and helping to conserve some of the rarest plants in the world. It has the largest single-span glasshouse in Europe, designed by Norman Foster, with a constant Mediterranean climate, and a new Tropical House for orchids. It is on the site of Llanarthne Mansion, has a walk to Paxton's Folly and is a superb site for visiting.

LLANBABO – CHURCH OF ST PABO GRAVE SLAB OF THE KING OF CUMBRIA *On the opposite side of Llyn Alaw, 2 miles north-west of Llanerchymedd, Anglesey.* King Pabo, 'Pillar of the Britons', was a Cumbrian British king who was eventually defeated by Picts and Saxons and fled to Wales in 460 to become a monk, founding Llanbabo. In the reign of Charles II a sculptured slab was discovered 6 feet underground, which is now in the church. Said to bear his effigy, it reads, 'Hic Jacet Pabo Post Prud Corpors ... Te ... Prima'. The church maintains its Celtic character with a circular churchyard and contains two carved heads, one sometimes called the 'Llanbabo devil'. Nearby at Bodeiniol Farm is an 8-foot standing stone.

LLANBADARN FAWR – CHURCH OF ST PADARN – CENTRE OF WELSH CULTURE *On the A44, just inland from Aberystwyth, Ceredigion.* The fifth of the ancient bishoprics of St Asaf, Bangor, Llandaf and St David's, Llanbadarn Fawr has never achieved cathedral status, although it was founded in the sixth century. The current cruciform church, with an immense tower, dates from rebuilding in 1257 after fire. The stone arch which surrounds the south door may have come from Strata Florida. Saint Padarn, who was a contemporary of David and Teilo, founded the 'clas' here. There are two stone crosses which may be pre-Christian but which were used for Christian purposes between the ninth and eleventh centuries. There is a copy of the Welsh Bible translated in 1588 by William Morgan, who was once vicar of the parish. Sulien's room on the other side commemorates Sulien, the eleventh-century leader of the 'clas', who was twice Bishop of St David's. In the time of Sulien and his sons and grandsons, the clas at Llanbadarn was an important scriptorium, where texts were composed and copied. It was here that Rhygyfarch composed *Vita Davidis*. There are notable seventeenth-century wall monuments. Aberystwyth Castle was built on the site of what was known as Llanbadarn Castle in the thirteenth century.

Llanbadarn is said to have minted its own coins, and was a major centre during Owain Glyndŵr's rising. The National Library of Wales was founded here in 1907, and in 1963 'Cymdeithas yr Iaeth' (The Welsh Language Society) was started here.

LLANBADARN-Y-GARREG – CHURCH OF ST PADARN *5 miles south-east of Builth Wells, 2 miles east of Aberedw*. A small unicellular structure set in a D-shaped churchyard, bordering the River Edw, it may date back to the thirteenth century on a sixth-century site. This is a peaceful and lovely site, with tumbled graves and herons fishing in the river.

LLANBADRIG – ST PATRICK'S CHURCH *Near Cemaes, heading towards Amlwch on the north coast of Anglesey*. Local tradition is that St Patrick founded this church around 440. He was going to convert the Irish to Christianity, but was wrecked on Ynys Badrig (now called Middle Mouse Island) and swam to shore. He landed at Rhos Badrig, and discovered a cave, Ogof Badrig for his shelter and a nearby well for water. He then built the church on the high headland overlooking Middle Mouse as an offering to God for saving his life. However, it is more likely to have been the sixth-century Padrig ab Alfryd, a saint at Cybi's monastery on Anglesey, to which the same legend is attached. His three brothers were the saints Meigan, Cyfyllog and Garmon. A blackened gravestone in the church is said to be ninth century, and bears the fish symbol ICHTHUS. Some say that this type of stone is only found in third-century catacombs in Rome. Between 1840 and 1884, Llanbadrig Church was restored by Lord Henry Stanley, who converted to Islam, becoming the first Muslim member of the House of Lords. The use of blue, red and white in the tiles, mosaics and stained glass gives the sense of being inside a mosque.

LLANBEDR – CAPEL SALEM *Near Shell Island, at Pentre Gwynfryn, 1 mile east of Llanbedr*. The Baptist chapel is at the end of a small terrace, and features in perhaps the most famous painting of any Welsh subject. Sian Owen was painted in chapel by Sydney Curnow Vosper in 1908, in a traditional 'stovepipe' hat and shawl. The painting was used in advertising for Sunlight soap, but it is said that one can see the face of the Devil in the folds of her shawl. There is a baptism pool in the Afon Artro, boxed pews for the elders and stepped seating for the congregation. There is a stone circle of fourteen small stones near Llanbedr, between Waun Hir and Tal-y-Ffynonnau, but it is difficult to find. There are also two standing stones of 7 feet and 10 feet high off the road to Harlech and Afon Artro.

LLANBEDR – THE ROMAN STEPS *Turn up from the centre of Llanbedr and follow the signs for Cwm Bychan, about 7 miles up into the mountains*. Cwm Bychan is a naturally formed lake formed by the last glaciers some 1.6 million years ago. It holds a unique fish known locally as 'the red bellied char'. This area, the Harlech Dome as it is known geologically, is formed by some of the oldest rocks on earth, approximately 350 million years old. The paved path known as the Roman Steps runs from the car park at the far end of the lake. It runs from the lakeside up through the Bwlch Tyddiard but its actual origins are obscure. It is unsure whether it dates from the Roman (or Pre-Roman) era or from medieval times for the transportation by packhorse and mule-train of wool from the Bala area to the seaport of Pensarn. The path runs through the superb and isolated Rhinog National Nature Reserve.

LLANBEDROG – ORIEL PLAS GLYN-Y-WEDDW – WALES' OLDEST ART GALLERY *Near Pwllheli, on the A499 to Abersoch, Llŷn Peninsula, Caernarfonshire LL53 7TT. Tel: 01758 740763*. Oriel Plas Glyn-y-Weddw Gallery recently celebrated its centenary and a half. The Grade II* listed Gothic-style mansion was built in 1857 as a dower house for Lady Elizabeth Jones Parry of the Madryn Estate. (Her ghost is occasionally seen walking the upper landings.) Plas Glyn-y-Weddw has long been associated with art as it was purpose-built to house the widow's own art collection. With its magnificent Jacobean staircase, hammer-beam roof and ten airy gallery spaces, its Welsh name mean 'Gallery in the Vale of the Widow'. After the death of Lady Elizabeth in 1883, her son

Sir Duncombe Love Jones Parry, who assisted in the founding of the Welsh colony in Patagonia, let the mansion to the Angerstein family. They were notable bankers and art collectors of Russian provenance, and the elder Mr Angerstein was said to be a child of the Czarina Anna. In 1896, the mansion was sold to the Andrews family of Cardiff. They were entrepreneurs who developed the West End of Pwllheli, established a horse-drawn tramway between the Gallery and Pwllheli and opened the mansion to the public. It also houses two early Celtic Christian stones. Llanbedrog's Church is dedicated to St Pedrog (d. 564). He is one of the chief saints of Somerset, Devon and Cornwall, and also of Brittany. Pedrog is the patron saint of two other Churches in Wales, St Petrox near Pembroke and Ferwig near Cardigan.

LLANBEDR-Y-CENNIN – IRON AGE FORT WITH CHEVAUX DE FRISE *From the Old Bull Inn at Llanbedr-y-Cennin, south of Conwy, walk up the steep hill.* The ruins of two and three stone ramparts and ditches on a strong defensive site, with a complex of short, sharp standing stones called 'chevaux de frise' (the equivalent of the 'dragons' teeth' used against tanks in the Second World War). An additional defence to slow down an infantry or cavalry attack, they are extremely rare in Britain. There are the foundations of twelve huts, and circular platforms levelled into the hillside where wooden houses once stood. There is a standing stone with a single spiral marking in the churchyard.

LLANBERIS – DOLBADARN CASTLE CADW *Outside Llanberis, and overlooking Llyn Padarn.* This is a Welsh castle built by Llywelyn the Great before 1230. Owain Goch, the younger brother of Llywelyn the Last, was imprisoned here for twenty years. Dafydd, another brother, tried to hold it in the 1282-83 war, but it was seized by the Earl of Pembroke in 1282. It appears that Glyndŵr took it and held prisoners like Reginald de Grey and his son here. The castle is dominated by a massive round-towered keep, still standing up to 50 feet high.

LLANBERIS - DINORWIG (DINORWIC) SLATE QUARRY, WELSH SLATE MUSEUM – EUROPEAN ROUTE OF INDUSTRIAL HERITAGE ANCHOR POINT, 'ELECTRIC MOUNTAIN' AND LAKE RAILWAY *On the A4086 south-east of Caernarfon, where Llyn Peris and Llyn Padarn carve the great Pass of Llanberis in the Snowdonia mountains.* Dinorwig Quarry, the second largest producer in Europe after Penrhyn, used the same system of extraction using galleries. A tramway was first completed to Port Dinorwic (Y Felinheli) in 1824 and in 1842 it was replaced by the 4-foot gauge Padarn Railway. The quarry was also home to the highest locomotive shed in Britain. Dinorwig closed in 1969, and the site has been partly redeveloped as a pumped storage electricity power station, called 'Electric Mountain' open to the public. The quarry workshops were preserved and they are now the home of the National Slate Museum. The workshops include the largest waterwheel on the British mainland and amongst many other attractions are three rebuilt quarrymen's cottages from Blaenau Ffestiniog, and a working table incline. Adjacent to the museum is the Llanberis Lake Railway which uses some of the old quarry locomotives along Llyn Padarn and is built on the trackbed of the 4-foot gauge line.

LLANBERIS – DINORWIG QUARRY HOSPITAL – THE EARLIEST, STILL EQUIPPED INDUSTRIAL HOSPITAL The first hospital dated from 1830, and the present hospital opened in 1840, supported by a small subscription taken from the 3,000 slate-workers' wages. It has the original wards, dispensary, operating theatre, and the first X-Ray machines to be used in Britain (1898). This was only two years after their invention in Germany.

LLANBERIS – SNOWDON MOUNTAIN RAILWAY – THE HIGHEST RAILWAY IN BRITAIN In 1897, this annually took 12,000 passengers up Snowdon on the four-mile trip to the summit, and now takes 140,000 people on diesel and vintage steam trains. Unique in Britain, it uses rack and pinion technology. Ceunant Mawr Waterfall, on the outskirts of Llanberis

is 60 feet high, and superb in winter. Its smaller sister, Ceunant Fach, can be seen from this rack and pinion railway.

LLANBEULAN – CHURCH OF ST PEULAN *6 miles west of Llangefni, Anglesey*. The church is medieval in origin, and accessed down a grassy track – on a seventh-century site. The large stone font dates from the first half of the eleventh century and was almost certainly made in the same workshop as the fonts at Heneglwys, LLANIESTYN and one of the great Celtic crosses now in Penmon Priory. It has both Celtic and Romanesque panels. Peter Lord suggested that it began life as an altar and that 'as an altar of the pre-Norman period it is a unique survivor in Wales, and, indeed, in Britain'. (*Medieval Vision: The Visual Culture of Wales*, 2003)

LLANBISTER – THE CHURCH OF ST CYNLLO *8 miles north of Llandrindod Wells, Radnorshire*. Built into a steep slope, on a spur of the Ithon River, the Norman church has an excellent rood screen, and an eighteenth-century musicians' gallery. The tower is built into the mountain, leading to a three-storey structure lower down the hill. Probably on a Celtic foundation, it was a mother church, or 'clas' for the cantref of Maelienydd, and Giraldus Cambrensis spent a night here in 1176. The nave is thirteenth century, and there are fourteenth- and sixteenth-century additions before its restoration in the early twentieth century.

LLANCARFAN – HISTORIC CHRISTIAN SITE *2 miles north of Cardiff International Airport, Vale of Glamorgan*. Seven streams meet in the valley under the great hillfort, and the sixth-century monastery site is associated with Dyfrig, who was said to have lived at the nearby Garnllwyd monastery. Tathan was said to have lived at Llanfeithyn here, where his saint's day, mabsant, was held until the nineteenth century. A Breton tradition recorded the 'seven wise men of Llancarfan', the saints Talhaiarn, Teilo, Gildas the Wise, Cynan, Aidan, Ystyffan and Taliesin. St Cadoc, the son of the saints Gwynlliw the Warrior and Gwladys, founded the site and is remembered as giving sanctuary to a man who had killed some of Arthur's men. Cadoc's eleventh-century *Vita* (Life) by Lifris, is the most complete of all the 'lives' written in Wales, and Caradoc of Llancarfan, who wrote the lives of Cadoc and Gildas, records it as being still in Llancarfan in 1150, covered in silver and gold. This original life of Cadoc has been lost. At Llancarfan the saints Finnian of Clonnard and Canice (Kenneth) received instruction. It was possibly the most holy site in Wales for religious instruction, rivalling nearby Llanilltud Fawr, and there are bound to be Celtic crosses under the earth in this small village. By 547 the monastic foundation of St Cadoc (*c.* 497-577) it was already a centre of wealth and learning with a considerable population of monks and canons. In 988, Danes ravaged it, and, following the Norman Conquest of Glamorgan in 1090, the religious community was dissolved and Robert FitzHamon annexed the church of Llancarfan to Gloucester Abbey in *c.* 1107. The buildings of the clas were of wood, situated in the field to the South of the present church, and a well in the adjacent field is traditionally associated with the monastery. The establishment, which the Normans seized, had fallen far from the famous monastery of the sixth century. The present Norman church dates from the twelfth century, with a fourteenth-century embattled tower. There still survives a masterpiece of medieval woodcarving, identified as part of the tabernacle work from a set of stalls. During restoration of the church in 1877-78, a colour wash on the interior of the building was removed, and it was found that the walls had been stencilled with stars. It is recorded that a painting of the Blessed Virgin was found just inside the south door, but was covered over with lime-wash because it was considered too Roman Catholic. The wall paintings are being restored. The Fox and Hounds is a fine village pub/restaurant/village shop, bought by villagers to prevent its closure. There are numerous healing wells in the area, one attributed to Dyfrig. (See this author's *The Book of Welsh Saints* for more information upon Cadoc.)

LLANCARFAN – THE DITCHES HILLFORT It is located on a commanding position on a high spur overlooking the Nant Llancarfan Valley at the confluence of Ford and Moulton Brooks, and overlooks virtually the whole Vale of Glamorgan and the coast. The enclosure is around

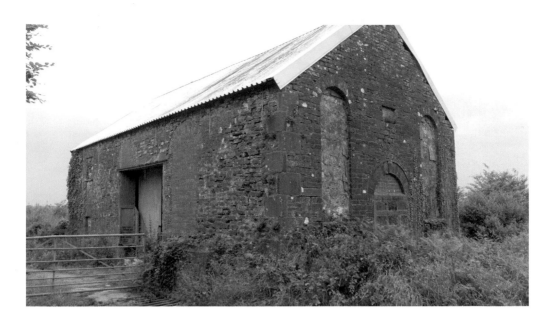

1. Abandoned Chapel near Pendine. By 1851 there were 2,784 Nonconformist chapels in Wales (compared to 1,176 Anglican churches). By 1914 there were over 5,000 chapels for a population of 2.25 million.

2. St Cewydd's Church, Aberedw, where Llywelyn ap Gruffydd is said to have attended mass on the morning of his murder, Friday, 11 December 1282.

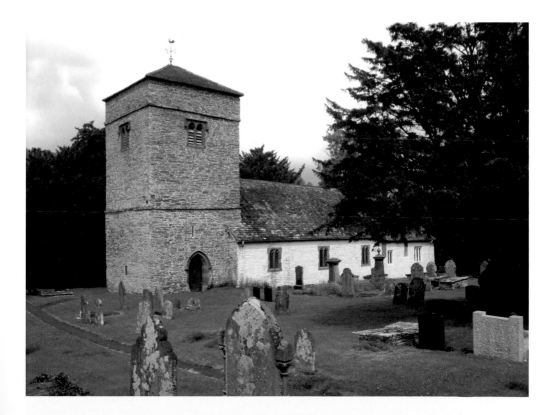

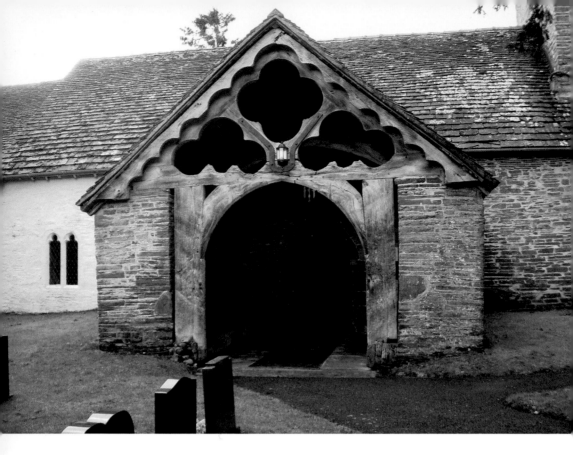

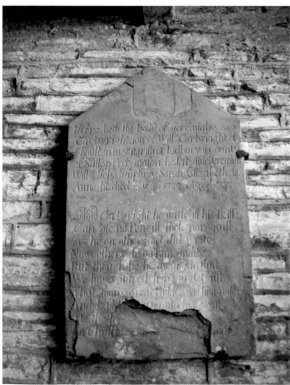

Above: 3. Church Porch of St Cewydd's, Aberedw. This is a thirteenth-century church on his sixth-century foundation, and the St Swithin's Day traditions were copied from those of the 'rain-saint' Cewydd.

Left: 4. 1722 Gravestone of Jeremiah Cartwright in Aberedw Church Porch. Over 200 skeletons from the Middle Ages were found here, possibly dating from the massacre in 1282, and the yews in the churchyard are around 1,500 years old.

5. Bodidris Hall – from 450 it was held by the princes of Powys, the last to live here being Owain Cyfeiliog (*c.* 1130-97). The 'plas' was burned in 1401 as its lords supported Glyndŵr. The present hall dates from 1465.

6. View from Queen Elizabeth's Suite at Bodidris Hall. It is thought that Elizabeth was romanced by the Earl of Essex here, and there is a tradition of her giving birth to a son at nearby World's End.

Above: 7. Medieval Porch in Bodidris Hall and Grounds. A large colony of the rare Lesser Horseshoe Bat lives in its stable block, and TV coverage is piped into the hotel. The estate covers 6,500 acres.

Left: 8. Caernarfon Castle Gatehouse – Caernarfon was probably the strongest of Edward I's 'Iron Ring' of castles, which are now a World Heritage Site.

9. Cardiff Bay, showing the 1897 Pierhead Building, the new Millennium Centre and Senedd Building. This has been one of the largest regeneration projects in Britain, reclaiming derelict land at Cardiff Docks.

10. Cardiff Bay Pierhead Building, known locally as 'The Docks Offices', which was formerly the head office of the Bute Docks Company. At the beginning of the twentieth century, Cardiff was handling more marine traffic than New York. The mud flats of the estuaries of the Taff and Ely are now a 500-acre freshwater lake, contained by the Cardiff Barrage.

11. Merchant Navy Memorial at Cardiff Bay. The face represents a drowned seaman figured into the hull of a ship, and the ship's 'ribs' are exposed on the other side. Wales lost proportionately more merchant seamen in both world wars than any other country.

12. The Wales Millennium Centre, Cardiff Bay, is home to the Welsh National Opera and the performing arts, opened in 2004. Its architecture, design and materials were inspired by the landscape and culture of Wales.

13. Cardiff Bay, Senedd Building in centre. On the right is one of the motor cruisers which offers trips across the bay to Penarth and the Cardiff Barrage, and up the River Taff into the heart of Cardiff.

14. Scott Memorial and the 'Tube', Cardiff Bay. The 'Tube' is what locals call the Cardiff Harbour Visitor Centre. Meant to be a temporary display, it is hoped that its life can be extended indefinitely. The Scott Antarctic Expedition sailed from Cardiff on 15 June 1910.

15. Cardiff Bay – Norwegian Church and 'Tube' Visitor Centre. Roald Dahl was christened in the sailors' church, which dates from 1868 and was deconsecrated in 1974. It was dismantled, moved a hundred yards and reopened as an Arts Centre in 1992.

16. Senedd Building, Cardiff Bay. The area around is often used for shooting the *Dr Who* and *Torchwood* TV series. The debating chamber of the Welsh Assembly Government was built along environmentally friendly lines.

Above: 17. Goleulong Lightship 2000 at Cardiff Bay is a Christian centre and café, formerly the *Helwick* LV14. It was last stationed off Rhossili, the Gower Coast, to warn of the Helwick Swatch, a notorious sandbank.

Right: 18. Cardiff Castle Clock Tower. William Burges' extravagant Gothic designs, for the Marquess of Bute, transformed the castle into the semblance of a medieval palace.

19. Cardiff Castle – the red stone line lies on top of the original walls of the large first-century Roman shore fort. The fort and castle could be supplied from the River Taff at high tide, as its course used to flow closer to the site.

20. The twelve-sided Norman Keep at Cardiff Castle, where Duke Robert II of Normandy, eldest son of William the Conqueror, was imprisoned by Henry I until his death in 1134.

21. The Animal Wall used to stand outside the gatehouse to Cardiff Castle, but was moved west to accommodate road-widening in 1925. Seven more sculptures were then added to the eight animals in the Grade I listed sculpture.

22. Cardiff is renowned as 'the city of arcades' for its Victorian, Edwardian and later covered shopping lanes. This is the unique three-storey Castle Arcade (1887). Other Grade II listed arcades include the Royal (1858), High Street (1885), Wyndham (1887), Morgan (1896) and Duke Street (1902).

23. Statue of Henry VII in Cardiff, in the 1904 Civic Hall. Its Sienna Marble Hall is the setting for the sculptures in Serraveza marble, 'Heroes of Wales', unveiled in 1916 by David Lloyd George.

24. Cardiff Market – this impressive Victorian glass-covered market is home to Ashton's Fishmongers, just inside the eastern entrance in the Hayes. The family firm has been here since its opening in 1891, and was in its predecessor from 1866.

25. St John the Baptist's church is the oldest surviving medieval building in Cardiff after the castle. Centrally situated near the market, it was sacked in the Glyndŵr War in 1404, and the battlemented tower was added around 1490. There are wonderful views from the top of the tower.

26. Castell Carreg Cennen at Dusk. This is one of the most evocative sites in Wales, surrounded by kites and buzzards, and like most Welsh castles it has a history of constant conflict.

27. Disused chapels in Pennal. The right-hand Calvinistic Methodist chapel was built in 1869 and rebuilt in 1908. The left-hand chapel is Wesleyan Methodist. There is, however, a thriving church in this small village.

28. Derelict chapel, Pennal – one can see through a broken window pane. It is an ongoing tragedy that so many chapels and churches across Wales are deteriorating.

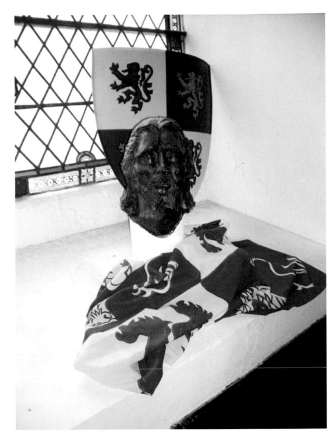

Right: 29. Bust, shield and flag of Owain Glyndŵr in the Church of St Peter ad Vincula, Pennal. The church is a sixth-century foundation, and also has a large oil painting of Glyndŵr's visit to Pennal in 1406. There is a lovely heritage garden here, with plaques to the heroes and heroines of Welsh history.

Below: 30. The medieval interior of Cefn Caer, Pennal, where Glyndŵr probably signed the Pennal Letter. Cefn Caer lies in a Roman Camp with a bath-house which guarded Sarn Helen Roman road where it crosses the River Dyfi.

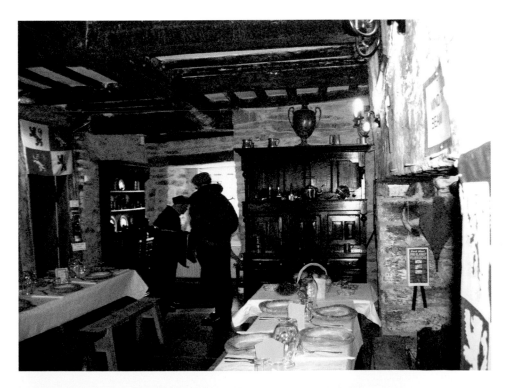

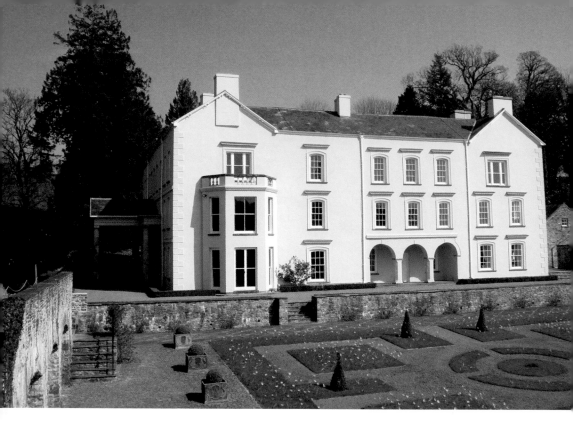

31. The façade at Aberglasney dates from 1715-25, fronting a much older house. The mansion and its 'nine green gardens, orchard trees and crooked vines' were noted by Lewis Glyn Cothi (fl. 1447-86).

32. Cloister Garden at Aberglasney – a unique survival in Britain. On three sides, huge stone arcades support a wide parapet walkway. Civil War in the seventeenth century and the Landscape Movement in the eighteenth century destroyed every other example.

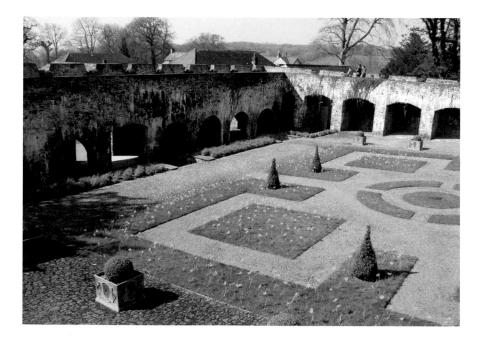

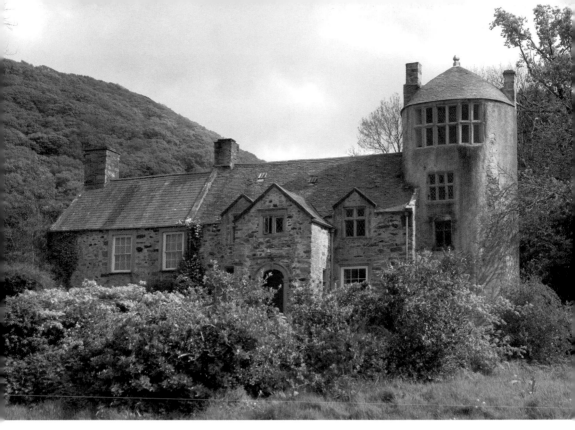

33. The Palace of the Princes, Pen-y-Bryn, above Abergwyngregyn. The princes of Gwynedd lived here, including Llywelyn the Great and Llywelyn the Last. The round tower has always been known as 'Twr Llywelyn', and there is a chapel to the left of the building.

34. Collapsed Masonry in the Undercroft of the Palace of the Princes, which has been called 'the most important house in Wales'. It is on a Roman site, and lies underneath a hillfort, looking over the old crossing to Anglesey.

35. Old Inglenook fireplace in the Palace of the Princes, Pen-y-Bryn, Abergwyngregyn. The hall needs conservation archaeology of the building and its environs.

36. Stone in the Palace of the Princes, previously placed at Cilmeri, where Llywelyn II's head was said to be washed after he was executed.

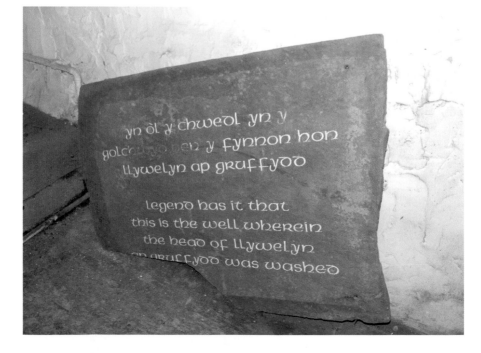

yn ôl y chwedl yn y
golch___ ___ y fynnon hon
Llywelyn ap gruffydd

legend has it that
this is the well wherein
the head of Llywelyn
ap gruffydd was washed

37. Cowbridge Town Walls are the only surviving walls in Glamorgan, with an intact South Gate. The Roman Road from Gloucester to Newport, Cardiff, Neath and Carmarthen previously passed though its east and west gates.

38. Cymer Abbey was a Cistercian foundation of 1189-90, under the patronage of Maredudd ap Cynan ab Owain Gwynedd. The monks supplied horses from their renowned stud to Llywelyn the Great.

39. Llanelltyd Bridge near Cymer Abbey was the first bridging point across the Mawddach from the coast, and was the site of a battle between Glyndŵr and supporters of Hywel Sele.

40. Dyffryn Mansion from the Croquet Lawns. The 1893 Grade 2* listed house is on a seventh-century estate, and is has been empty for over two decades.

41. Daffodils in the Spring at Dyffryn Gardens. The gardens are Grade I listed, laid out by Thomas Mawson in 1906 for the ship-owner John Cory. There is an arboretum and a series of garden 'rooms', hidden from each other by hedges.

42. Deserted Farmstead, Tŷ Uchaf, in the Valley of Nant Gwrtheyrn. The stream (nant) is named after Gwrtheyrn, the fabled Vortigern, and there was a Castell Gwrtheyrn near here, destroyed by quarrying.

43. Nant Gwrtheyrn Welsh Language Centre lies under the wonderful Iron Age fort of Tre'r Ceiri, on Yr Eifl. The valley is beautiful, and one can often see choughs, wild goats, seals and dolphins here.

44. Old Granite Workings at Nant Gwrtheyrn – there are three quarries along the cliffs that border the shingle beach, one of the best sites for industrial archaeology in Wales.

45. Ruined Quarryman's Cottage at Nant Gwrtheyrn. The chapel is now a Heritage Centre and Caffi Meinir offers splendid home-cooked food in this enchanted setting.

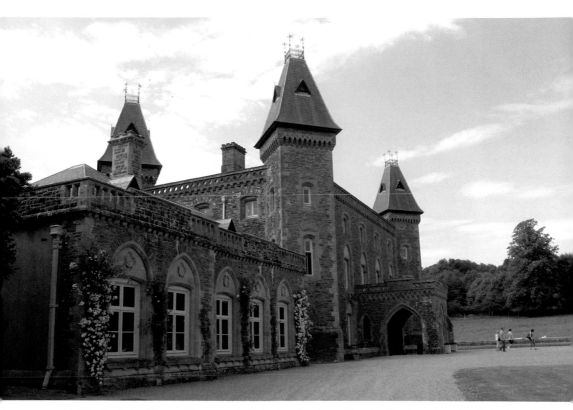

46. Dinefwr Park – Newton House was built in 1660 but has a Victorian façade, and much of it has been reopened to the public after many years of neglect.

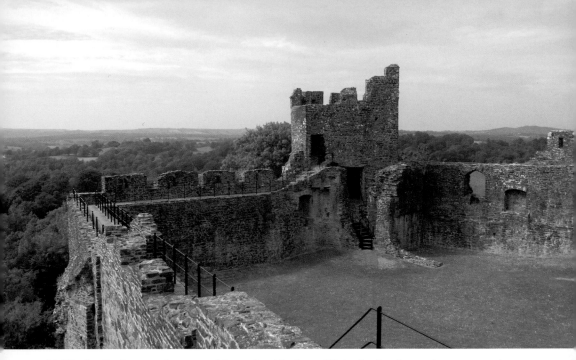

47. Dinefwr Castle was at the centre of the ancient kingdom of Deheubarth a thousand years ago, and The Lord Rhys ruled from here in the late twelfth century.

Left: 48. View from the twelfth-thirteenth-century Dinefwr Castle, overlooking the meanders of the River Tywi.

Below left: 49. White Park Cattle at Dinefwr Castle can be seen along with around 100 fallow deer in the deer park. The Dinefwr Estate is now over 700 acres of woodland and meadows.

Below right: 50. Dinefwr Park Meadows – the grounds were remodelled in 1775 by Capability Brown, and recently a Roman fort was discovered in the park.

51. Dolgellau Shop Front of T. H. Roberts, the possible site of a 1404 Parliament of Glyndŵr. The ironmonger still has original shop fittings.

52. Plaque commemorating Glyndŵr's Parliament at Dolgellau on 10 May 1404, outside T. H. Roberts' shop. In 1881, Cwrt Plas yn Dre on the site was demolished, reputedly a meeting place for Owain Glyndŵr.

Left: 53. Inside the 1716 Georgian Church of St Mary at Dolgellau, built on the site of a twelfth-century church.

Below: 54. Fourteenth-Century Stone Effigy of Meurig ap Ynyr Fychan at St Mary's Parish Church, Dolgellau. The effigy of this Lord of Nannau was removed from the medieval church.

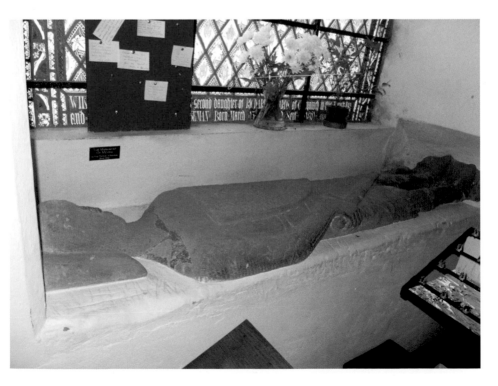

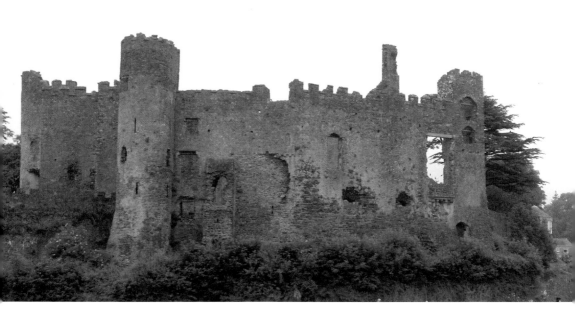

55. Laugharne Castle – the white house in the far distance is Dylan Thomas' Boathouse. Built in stone in the thirteenth century on a previous site, the castle was transformed into a great house in the sixteenth century by Sir John Perrot.

56. Laugharne Castle – view from inside the curtain walls. Held by the French and English for most of its history, it was badly slighted by Parliamentary forces in the Civil War.

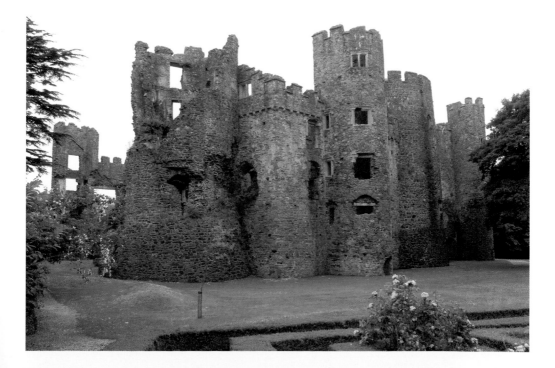

57. View through the window of Dylan Thomas' Writing Studio at Laugharne (Talacharn). Everything has been left intact, just as when he was using it.

58. Dylan Thomas' Writing Studio, the Garage of the Boathouse above the Tâf estuary at Laugharne.

59. View from the estuary of Dylan Thomas' Writing Studio. Laugharne is supposed to have been the model for the fictional village of Llaregub in *Under Milk Wood*.

60. Brown's Hotel, Laugharne, where Dylan Thomas is supposed to have drunk to excess on occasion. Laugharne Corporation, established in 1291, is the last medieval corporation existing in Great Britain. Among other duties it supervises the Laugharne open field system, one of only two surviving in use in Britain.

61. Eglwysilan Church is a massive edifice for a hamlet which consists of two farms and a pub. When the parish was created in the twelfth century, it had responsibility for 30,000 acres, including Caerffili, which accounts for its size.

62. Gatehouse at St Quintin's Castle, Llanbleddian. Through it one can see the remains of a collapsed keep, and the bailey looks out over the Thaw Valley.

63. Inside gatehouse tower at Llanbleddian Castle, this room was once used as a cell before Cowbridge Prison was built.

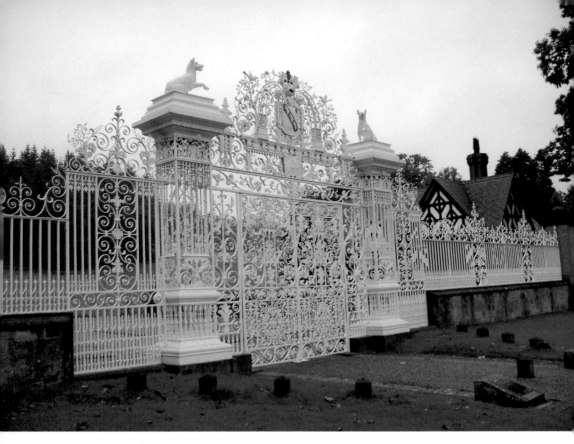

64. The magnificent gates at Chirk Castle were built in 1719 by John and Robert Davies of Croesfoel Forge, near Bersham, Wrexham, and feature the red 'bloody hand' emblem of the Myddleton family.

65. Grosmont Castle is one of the 'Trilateral' of Gwent castles together with White Castle and Skenfrith Castle, built to safeguard the southern Marches. At one time they were all under the lordship of the Justiciar of England, Earl Hubert de Burgh (*c.* 1179-1243).

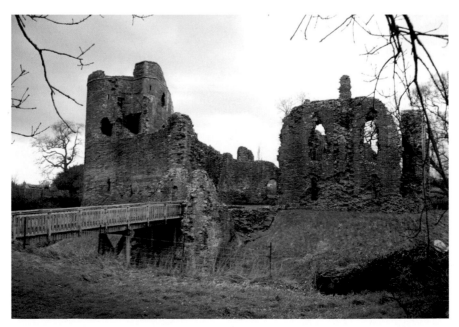

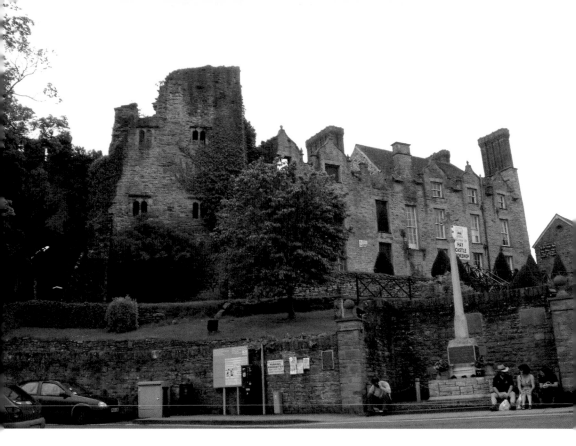

66. Hay Castle was sacked in 1402 by Glyndŵr, and again in 1460, and shows the damages caused by at least four major fires. Bought by Richard Booth, 'King of Hay', in 1961, part is now his bookshop.

67. Our Lady of Pilleth Church. The tower may be fifteenth century, added after the fourteenth-century church was burnt at the Battle of Pilleth on 22 June 1402. However, some sources place it as thirteenth or fourteenth century. One of the tower's bells dates to 1450.

68. Holy Well at Our Lady of Pilleth Church. This is just north of the tower, formerly roofed over and said to have cured eye illnesses. Glyndŵr was said to have used it before the Battle of Pilleth.

69. Inside Llansadurnen (Lansadyrnin) Church. This may have been a Celtic Christian site of St Sadwrnen, but the church was rebuilt in 1859. A Latin memorial stone was found here.

70. Llansadurnen Church Tower detail. The church stands in an elevated oval enclosure, and its saint may be Sadwrn the Warrior, the brother of St Illtud.

360 yards east to west by 120 yards north to south covering a fairly level plateau area on the west of an elongated spur. Continuous occupation into the Roman period and beyond is evidenced by finds from within the hillfort enclosure of later Roman potsherds. A rectangular earthwork feature to the south of the fort may be Roman.

LLANCAIACH FAWR GRADE I LISTED TUDOR MANOR WITH COMMONWEALTH RE-ENACTMENTS *On the B4254 between Gelligaer and Nelson, Glamorgan. Tel: 01443 412248. Web: llancaiachfawr.co.uk.* The stone-built, semi-fortified Manor House was erected in 1530 on the site of an earlier medieval dwelling, with some modifications in the seventeenth century. It was improved in the 1620s when the grand staircase was added in 1628 and it is furnished and laid out as it would have been in 1645, the year that Charles I visited Colonel Edward Prichard. After defeat at Naseby, Charles made for Wales, hoping to gather forces again. Prichard instead declared for Parliament, becoming Governor of Cardiff Castle and holding out against a Royalist siege, and also fighting at ST FFAGAN'S with distinction. The entrance hall or Cross Passage, the Kitchen and Servants' Hall can be explored, and the actors acting as servants of the Manor will talk about their work and lives. The Great Hall, Parlour and the Master's Bedchamber are on the first floor. On the second floor are located the Birthing Chamber, Mistress' Chamber and the Colonel's Study and his armoury. Recently it has become clear that the house had been constructed with the security of its occupants as the main objective. Even today the house suggests a defensive enclosure, with its massive walls, small ground floor windows and forbidding air. Other evidence shows there was intense rivalry at the time and in later generations – between the Lewis branch of the family at the Van near Caerffili and the Prichard branch at Llancaiach Fawr. It may be that the house was so constructed as protection against offensive action or possible reprisals. It is the survival of the evidence for this Tudor defensive arrangement that makes Llancaiach Fawr unique. The walls are 1.2 metres thick and access between floors was by stairs inside the walls. The entire house could be divided in two if attacked and only those in the secure east wing had access to the latrine (toilet) tower. At the same time a formal garden was laid out. The house is now restored to its 1645 appearance during the British Civil War, and has become one of the leading 'living history' sites in the UK. Llancaiach Fawr was also named as one of the 'Top Ten Most Haunted Buildings in Britain'. Strange happenings have been experienced in almost every room, along corridors and upon stairs.

LLANDAFF CATHEDRAL *One can walk through parkland along the river to Eglwys Gadeiriol Llandaf, which is on the west bank of the River Taff, just north of Cardiff Castle.* It was founded by St Dyfrig (Dubricius) in the sixth century, and probably contains both his tomb and that of St Teilo (who is also credited with founding the see). In 1120, Bishop Urban brought Dyfrig's remains from Ynys Enlli to Llandaf to improve the prestige of his bishopric. Llandaf has claims to be the oldest bishopric with a continuous history in Britain, as a religious settlement seems to have been there very quickly after the establishment of Christianity here. The Norman Bishop Urban re-dedicated the cathedral to St Peter, but Giraldus Cambrensis later referred to it as the church of St Teilo. The present building dates from a huge reconstruction in 1200. The collapsed south-west tower was rebuilt in 1840. The cathedral was hit by a German aerial mine in the Second World War. However, Llandaf has been restored, with a superb sculpture by Jacob Epstein of Our Lord in Glory spanning the nave. There is work by Dante Gabriel Rossetti inside, and the Llandaf Cathedral Choir School dates back to the ninth century, possibly the oldest in Europe. Llandaf Cathedral's *Chartulary*, also known as the *Book of St Teilo*, was stolen and renamed the *Book of St Chad* or the *Lichfield Gospels*. This superb illuminated manuscript is displayed at Lichfield Cathedral. Predating the *Book of Kells*, it originally was in Llandeilo, before being moved to Llandaff. It is a precious Welsh relic, containing in the marginalia the earliest written Welsh, and is the only large Welsh gospel book to have survived the centuries of English invasions and destruction. One of the excuses for it not being a Welsh manuscript is that there were no scriptoria in Wales, where monks copied documents, which is a blatant falsehood. There must have been hundreds of such illuminated manuscripts, all destroyed in the thousands of events of war across Wales from the

earliest Christian monasteries onwards to the destruction of Raglan's great library in the Civil War. The *Llandaff Charters*, a superb recounting of Welsh kings and saints, was collated from many sources by Galfrid in 1108. On the Cathedral Green is a ruined bell-tower and the preaching cross used by Archbishop Baldwin in 1188 to try to get support for the Third Crusade.

LLANDAFF – BISHOP'S PALACE Owain Glyndŵr destroyed the castellated thirteenth-century Bishop's Palace adjacent to the cathedral, but spared the cathedral in 1403 as it formed part of his plans for an independent Welsh church. The gatehouse was still inhabited in the eighteenth century, and the interior, open to the public, contains a herb garden.

LLANDANWG – CHURCH OF ST TANWG *In the village of Llanfair, 2 miles south of Harlech on road to Llanbedr, Meirionnydd.* A sixth-century hermit cell was established by Tanwg ap Ithel Hael, a Breton prince. On its site is a tiny twelfth-thirteenth-century church, slowly succumbing to the rise of the sand dunes around it. One has to step down into the dark church, where a fifth-century stone is built into the east window of the chancel as a lintel. Another stone has Roman capitals dating from the sixth century, in the south window of the chancel. The church was used as a chapel of rest for corpses going to Bardsey for funeral, until the eighteenth century.

LLANDDEWI BREFI – PERHAPS ST DAVID'S ORIGINAL MONASTERY *On the B4343 south of Tregaron, Ceredigion.* The Synod of Brefi was held here around 545, and such was David's eloquence in renouncing Pelagianism that Archbishop Dubricius, Dyfrig, is said to have resigned to give way to the younger man. The mound upon which the medieval church stands is supposed to be on the spot where David preached. Such were the crowds that the earth rose up so that all could see him. There are four old stones here, two cross-marked, and on inscribed to Dallus Dumelus. Another is marked in Latin 'Here lies Idnert son of Jacob who was killed because of the despoiling of St David'. 'David' and 'Jacob' cannot now be read, but the stone refers to the sacking of St David's in the seventh century by Vikings or Irish. One of the 'Christianised' cross-marked stones is called St David's Staff, which David and Dyfrig leaned on at the Synod.

LLANDDONA – THE CHURCH OF ST DONA *A beach village, between Beaumaris and Benllech in Anglesey.* It was built in the year 610 after Dona (Dwna) ap Selyf ap Cynon ap Garwyn ap Brochwel Yscythrog, who built a cell on the seashore. Dona's father was Prince Selyf Sarffgadau (The Serpent of Battles) who died fighting at Chester in 603. His great-great-grandfather was Prince Brochwel the Fanged. There is an ancient figured stone built into the nave, and two standing stones nearby. The present building dates back to 1878, although the porch dates from the fifteenth century. It is now part of the charmingly named benefice of 'Llansadwrn with Llanddona and Llaniestyn with Pentraeth with Llanddyfnan in the deanery of Tinaethwy'. In Llanddona is the famous Ffynnon Oer (Cold Well). It lies near the shore, and was said to have issued forth when three witches landed and commanded it to appear. Bela Fawr, Sian Bwt and Lisi Blac lived by begging, married smugglers and chanted their curses near the 'cold well'. One curse has been translated as:

> Let him wander for many centuries;
> At each step a stile;
> On each stile a fall;
> In each fall a breaking of bone;
> Neither the largest or smallest
> But the neck bone every time.

LLANDDWYN – THE ABBEY OF ST DWYNWEN – THE WELSH VALENTINE *On Llanddwyn Island near Newborough Warren, south-west Anglesey.* Feasted on 25 January, Dwynwen was the youngest daughter of Brychan Brycheiniog, King of Brecon, and her day is the Welsh

equivalent of St Valentine's Day, with Dwynwen cards being sold commercially. Dafydd ap Gwilym called her 'beautiful as the tears of frost'. St Dwynwen led a pure life after an unrequited love affair. Visitors would leave offerings at her shrine, which funded a substantial sixteenth-century church built on the site of her original abbey. It is now ruinous, but there are also two crosses on the island, bearing the date of Dwynwen's death, 25 January 465. Llanddwyn is not quite an island, being attached to the mainland at all but the highest tides, and St Dwynwen's Well on the island was famous for telling whether lovers would stay faithful. The handkerchief of the faithful lover will float on the surface, while that of the faithless lover will be attacked by a sacred eel. Fresh wheaten bread must be cast in the well to wake the eel, before the handkerchief is spread on the surface of the water.

LLANDEGAI, BATTLE OF, 1648 *1 mile east of Bangor, on the A5, Caernarfonshire.* In the Civil War, Sir John Owen's Royalists engaged the Parliamentarians and he was taken prisoner.

LLANDEGAI (LLANDYGAI) – CHAPEL OF ST TEGAI The remains of a small rectangular timber structure were found over a levelled Neolithic cursus. Many early Celtic Christian churches were built on such sites. The former timber structure contained a single east-west oriented grave with signs of later disturbance. It seems that the bones of the sixth-century Tegai ab Ithael Hael were exhumed from here and put in his fourteenth-century stone chapel, 600 yards away. Portions of his stone coffin are in the church. The Penrhyn family built the village of Llandygai for its estate workers in the eighteenth century. The church contains marble monuments to the Pennants of Penrhyn family, and a superb tomb for John Williams Archbishop of York, Lord Keeper of the Great Seal, who was one of King James I's closest advisers and was buried here in 1650.

LLANDEGLA – CHURCH OF ST TECLA (TEGLA) *Just off the A525 between Rhuthun and Wrexham, Denbighshire.* A Victorian rebuilding swept away most of the medieval structure, but there is a medieval font, a plank chest and a remarkable late-medieval brass chandelier said to have come from Valle Crucis Abbey after the Dissolution. (There is a similarly provenanced chandelier in Llanarmon-yn-Iâl Church.) The saint's well is near the church, on the banks of the River Alun. Like that at Llandegley, the water of Ffynnon Degla was said to cure epilepsy, which in one old Welsh Dictionary was called 'Clwyf Degla' (Tecla's Wound). A cockerel was held by the sufferer, pricked with a pin, and the pin thrown into the well.

LLANDEGLEY – CHURCH OF ST TECLA (TEGLA) *6 miles east of Llandrindod Wells, in the Radnorshire Hills.* Notable features include the late medieval screen and an ornate priest's door, thought to have been brought from Abbey Cwmhir. *A Life and Miracles of Thecla* manuscript in Lambeth Palace recounts miracles occurring in this church.

LLANDEGLEY – PALES MEETING HOUSE – THE OLDEST MEETING HOUSE IN WALES IN CONTINUOUS USE Up a hill, a mile north of Llandegley, the site was first an isolated Quaker burial ground around 1673. 'Friends' could not be buried in churchyards. In 1683, a meeting was broken up on the site by the High Sheriff and the 'Friends' were marched to Presteigne gaol. In 1717, Quakers felt safe enough from persecution to erect the thatched building, with a simple meeting room on one side of the building and a schoolroom on the other. Many Quakers emigrated from Radnorshire to Pennsylvania because of religious intolerance, and the very first American meeting house was called Radnor. One teacher at Pales was the American evangelist Yardley Warner from 1876-80, a prominent campaigner for the rights of slaves, and it was for him and his wife Anne that the present Wardens' Cottage was built.

LLANDEILO – ANCIENT MARKET TOWN IN STRATEGIC POSITION *Where the A40 meets the A483, above the north bank of the River Tywi, commanding the central Tywi Valley.* Known as Llandeilo Fawr, it had a monastery and scriptorium, and was originally the foundation of the sixth-

century St Teilo. Only in 2005 it was discovered that Llandeilo was an important Roman site with two forts and a settlement at nearby Dinefwr – many of the early saints began their missions upon Roman sites, which themselves were often on pre-Christian sites. Roman roads made their travels easier. Its importance for trade meant that it was formerly the county town of Carmarthenshire. In 1858, Llandeilo had the church, four chapels, eleven streets, no less than twenty-three public houses, seventy-three shops and 290 houses.

LLANDEILO, BATTLE OF, 1213 Rhys Grug (the Hoarse), the fourth son of The Lord Rhys, destroyed the town after being defeated at Talley, to prevent its use by the English.

LLANDEILO, BATTLE OF, 17 JUNE 1282 When Edward I took his army to the north to subdue Llywelyn II, Gilbert de Clare, Earl of Hertfrod, took a separate force to subdue South Wales. He lost five knights, including the son of the Earl of Pembroke, possibly at Caledfwlch (also the name for Arthur's sword), and the Welsh won. De Clare had been returning from taking Carreg Cennen Castle to store loot in Dinefwr Castle, when attacked.

LLANDEILO, BATTLE OF, 1316 The town and castle were badly damaged by fire during the Welsh revolt by Llywelyn Bren in 1316. Nearby Newton was later put to the torch in July 1403 during Owain Glyndŵr's march through the Tywi Valley.

LLANDEILO – ST TEILO'S CHURCH The medieval church was rebuilt in 1848-50, except for the battlemented tower of around 1400. Its outside turret staircase was used by the people of Llandeilo to seek safety in wartime. In the nineteenth century, the churchyard was a marketplace, the tombs serving as tables and the game of 'fives' was played against the church wall. On the window ledges may be seen Llandeilo's two cross heads, discovered in the ground during the rebuilding of 1848-50. They date from *c.* 900 CE, and their presence is a reminder of the former importance of Llandeilo Fawr as a Christian centre between 800 and 1000 CE, with its own bishop. The churchyard's large size and its oval shape are both typical of an ancient llan, or church enclosure. The road running through it was laid out as a turnpike in the late-eighteenth century. Llandeilo's greatest treasure was its fine gospel book, written in the eighth century, and donated to the community *c.* 820 by a man named Gelhi, who had bought it and had given it 'to the altar of St Teilo'. The margins of the gospel book were used in the ninth century to record land transactions, and settlements of legal actions. These short passages are of enormous importance, because they form the oldest surviving examples of written Welsh. At some time it was taken to Llandaff Cathedral, and then somehow to Lichfield, but should be returned to Wales.

LLANDEILO – GOLDEN GROVE (GELLI AUR) HISTORIC MANSION *Llandeilo, Carmarthenshire, SA32 8JR*. With a gatehouse, deer park and 100 acres of garden, the estate in 2009 is for sale for £1.5 million. For nearly five centuries Golden Grove has been one of Wales' most important houses and its family is amongst the most distinguished. The first mansion was built in the Elizabethan period by the Vaughan family, who were descended from the ancient princes of Powys. Created the Earls of Carbery, the Vaughans left the estate in 1804 to Lord Cawdor. In 1826, the first Earl Cawdor built a new mansion 700 yards above the original, the work being completed in 1834. Golden Grove is a substantial Grade II* listed house in the Tudor style with Scottish Baronial features, using Llangyndeyrn 'black marble' limestone.

LLANDELOY – ST EILW'S CHURCH – RESTORED MEDIEVAL ARTS AND CRAFTS CHURCH – FRIENDS OF FRIENDLESS CHURCHES *4 miles north-east of Solva, Pembrokeshire, south of the B4330 at Llanreithan*. There is a holy well to the south of the church, surrounded by a ring of stones but covered with vegetation. Early churches were always built near a well or running water, and usually hidden in valleys, as protection from sacking by coastal and other raiders. It was a ruin when restored in Arts and Crafts style in the 1920s. The architect restored the building to a

pre-Reformation framework, dominated by the splendid rood loft, carved screen and simple pulpit, all standing against the west face of the medieval screen wall. Both fonts are of stone. This may be a sixth-century site of St Eilfyw, who baptised St David and founded the nearby monastery of ST ELVIS.

LLANDDERFEL – CHURCH OF ST DERFEL *5 miles north-east of Bala, Meirionnydd.* Mentioned in the twelfth century, the present church was built about the reign of Henry VIII. It contains several stained-glass windows, and a remarkably good rood screen. It is dedicated to St Derfel Gadarn, Derfel the Mighty, of whom there was formerly a large wooden image, which was sent to London in 1538 and burned with Dr Forest in Smithfield. His decapitated wooden horse effigy and staff are still preserved, and used to be held in great veneration. Derfel was said to have survived Arthur's last battle at Camlan.

LLANDDERFEL – PALÉ HALL *Pale Estate, Llandderfel LL23 7PS.* Now an excellent hotel, Queen Victoria stayed here in 1889, and her original bath and bed are still in use. It is one of the finest Victorian mansions in Wales, with splendid interiors.

LLANDDEUSANT – BEDD BRANWEN TOMB AND REPLICA IRON AGE VILLAGE *On the banks of the Alaw, 10 miles north-east of Holyhead, Anglesey.* According to the *Mabinogion*, Queen Branwen died of grief at Aber Alaw after escaping the destruction of Ireland. On the banks of the Alaw at Llanddeusant the cairn of Bedd Branwen (Branwen's Grave) was dug up in 1800, and again in the 1960s when several urns and a cremation were found. The stones have been carted away and the mound destroyed. All that remains of this ring cairn is kerb of surrounding stones and a small standing stone in the middle, close to a cist. A replica Iron Age village has recently been built next to it. The village takes it names from its parish church which is dedicated to St Marcellus and Marcellina.

LLANDDOGED – ST DOGED'S CHURCH *2 miles north-east of Llanrwst, north of Betws-y-Coed, Denbighshire, between the A470 and A548.* Probably near the site of a Roman crossroads, it is a late medieval double-naved church within a raised, circular churchyard, implying a Celtic site. King Doged ap Cedig was St David's cousin, killed in 542 at Llanddoged defending his family, so was regarded as a martyred saint. Ffynnon Ddoged is a walled well sixty yards from the church, which was used to cure eye ailments. The church is a rare surviving example of a pre-Oxford Movement interior, and some of its box pews are named.

LLANDOGO, LLANEUDDOGWY – CHURCH OF ST OUDOCEUS (ST DOCHAU) *Midway between Monmouth and Chepstow on the A466.* Llandogo was once an important river port and barge-building village on the River Wye. The tide reaches this far, and the village pub is called The Sloop Inn. The pub dates from 1707 when it was built as a cider house and mill, and up until recently a stream ran through its cellars. Flat-bottomed barges known as trows, which worked the river between here and Bristol, gave the name to the seventeenth-century Llandoger Trow, a well-known Bristol pub near its old harbour. The village derives its name from St Oudoceus (Euddogwy), a son of Emyr Llydaw of Brittany, and who became Bishop of LLANDAFF in the sixth century. The Victorian Gothic church was built on his site.

LLANDOUGH-JUXTA-COWBRIDGE – LLANDOUGH CASTLE *South of Cowbridge, Vale of Glamorgan.* A much-rebuilt fourteenth-century fortified manor, possibly a tower house. There are the remains of a roughly square walled enclosure with a gatehouse and a strong tower. The tower was incorporated into a new house in 1803. Howe Mill Enclosure, near St Mary Hill, may be early medieval precursor. The medieval church is dedicated to Dochdwy, and the area was described as 'LLAN DOCH, in the Cwmwd of Pen y Bont, Cantref of Cron Nedd (now called the Hundred of Cowbridge), Benefice of Llandaff, County of GLAMORGAN, South Wales'.

LLANDOUGH – THE IRBIC CROSS *North of Penarth, Vale of Glamorgan.* Bishop Cyngar was the brother of Selyf and the uncle of Cyngar, and known as Doccuinus (Teacher), so the church of St Dochdwy is dedicated to him. This remarkable 10-foot-high pillar cross in the churchyard was erected around the tenth century from Sutton stone, in four moulded blocks. The cross head is missing, but the carving on the cross shaft is of a Celtic interlacing pattern, and the base includes a carving of a horseman and two human faces on the sides. The stone includes an inscription IRBICI. The cross head may yet be found. Nearby is Baron's Court, now a pub-restaurant, a late fifteenth-century hall house, probably built for Sir Matthew Cradock.

LLANDOUGH – ST DOCHDWY'S CHURCH – ONE OF THE LARGEST AND BEST PRESERVED EARLY CHRISTIAN CEMETERIES IN BRITAIN, AND THE LLANDOUGH GIRDLE Medieval Welsh charters refer to St Dochdwy's monastery at Llandough, flourishing between *c.* 650-1075, and one of the main ecclesiastical centres in south-east Wales. Evidence to support this claim was only found when rescue archaeology of a second-to fourth-century Roman villa revealed post-Roman burials. (The site was of national importance, with the iron collars which held wooden hot-water pipes still in situ, but it was covered by eight modern houses – sometimes despair is the only word to describe planning processes.) The remains of over 800 individual burials, all dating from the fourth century to the twelfth century, were found nearby, just north of the current church. The monastery itself is assumed to lie under the current churchyard. Many, many Welsh saints' foundations are associated with Roman and Romano-British sites. Llandough probably lost precedence to the cathedral at nearby Llandaff. High-status imported pottery found in the graves, such as olive-oil amphorae made in the eastern Mediterranean dating from *c.* 475-550, belongs to a type found at only a handful of sites in Britain, among them the early medieval royal centre at Dinas Powys. Llandough thus probably served as a cemetery for that court. Five burials, aligned east-west in the Christian manner, contained hobnails from boots – a well-known Late Roman burial tradition. One skeleton, of uncertain date, was found with two iron bands around its waist (now known as 'The Llandough Girdle') of a type unknown elsewhere. They seem to have been held about an inch apart by a wooden strut, and were perhaps the stiffeners inside a broad surgical leather truss, to support a hernia or a bad back.

LLANDOVERY CASTLE *At the head of the Tywi Valley, where the A483, A40 and A4069 meet.* Near the centre but hidden from general view, it was begun in 1116, and shortly after Gruffudd ap Rhys destroyed the outer bailey but could not take the tower. In 1158, the Welsh took it from Walter Clifford, and over the next decades ownership alternated between the Normans and several of The Lord Rhys' sons. From 1262 to 1276 it was in the hands of Rhys ap Gruffudd. In 1277, Edward I took it, and it was in English hands except for a few months in 1282 when it was taken by Llywelyn the Last on 4 July. It was strengthened from 1283, and resisted Glyndŵr's forces until burnt in 1402. It was slighted by Parliamentarians.

LLANDOVERY ROMAN FORT Llanymddyfri means 'church between the waters', and the Tywi, Bran and Gwydderig flow here. St Mary's medieval church stands in the corner of the five-acre fort named Alabum at Llanfair-ar-y-Bryn, built around 50-60 CE. One can see the Roman road, Sarn Helen, leading to Pumsaint.

LLANDOVERY (LLANYMDDYFRI) – STATUE OF LLYWELYN AP GRUFFUDD FYCHAN A magnificent faceless 16-foot-high stainless-steel statue was unveiled in 2001 on the north side of Llandovery Castle, overlooking the place of his execution in 1401. He had led the army of King Henry IV on 'a wild goose chase' under the pretence of leading them to a secret rebel camp and an ambush of Owain Glyndŵr's forces. Henry had him half hanged, disembowelled in front of his own eyes, beheaded and quartered – the quarters salted and dispatched to other towns for public display. His son Rhys ap Llywelyn fought to the end for Glyndŵr. Glyndŵr

went on to war for another fourteen years against the usurper Henry Bolingbroke. The statue won a national competition to choose a suitable statue, the winning design being that of Toby and Gideon Petersen.

LLANDOW AIR DISASTER 16 MARCH 1950 – THE WORLD'S GREATEST AIR DISASTER *Between Cowbridge and Llanilltud Fawr, Vale of Glamorgan.* Possibly due to pilot error, an Avro Tudor airliner with seventy-eight passengers and five crew crashed near Llandow Aerodrome on the return trip from seeing Wales play Ireland at rugby. Eighty people died, including six men who played for Llanharan Rugby Club, and three who played for Abercarn. It was the greatest loss of life in an air disaster at that time, and a small plaque marks the spot.

LLANDRINDOD WELLS – VICTORIAN AND EDWARDIAN SPA *Where the A483 and A44 cross, north of Builth Wells, Radnorshire.* Sulphur wells and saline rills were responsible for the rapid growth of this spa in Victorian times, and there also are many substantial Edwardian buildings. There had been a spa and hotel in the eighteenth century, but this most famous spa town in Wales began expanding after the arrival of the railway in 1856. Up to 80,000 visitors a year used to use the wells. Advertisements of the day claimed that 'saline, sulphur, magnesian and chalybeate waters are very efficacious in the treatment of gout, rheumatism, anaemia, neurasthenia, dyspepsia, diabetes and liver affections'. A chalybeate spring spouts out of a public drinking fountain in Rock Park Gardens. In the Pump House Tea Rooms at the Rock Park Spa, one could choose from draught saline, sulphur or magnesium water, and there are plans to modernise the site. A famous Victorian Festival, where all the locals dress up in Victorian costume, is held for one week every August.

LLANDRINDOD WELLS – CAE BACH UNITED REFORM CHAPEL *In North Avenue in the north of the town LD1 6BY.* It was founded in 1715 and has a virtually unaltered Georgian interior, with box pews painted cream and stone floors. The chapel has a simple hipped roof and ogee windows. The artist Thomas Jones (Pencerrig) was buried here in the family vault in 1803. It used to stand in fields, and the stables across the lane were built for the horses of the Dissenters to graze while chapel was being attended.

LLANDUDNO – ONE OF BRITAIN'S FINEST VICTORIAN SEASIDE TOWNS *Between Conwy and Colwyn Bay, at the northern terminus of the A470 from Cardiff, Conwy.* Wales' largest seaside resort is a long beach and promenade between the Great Orme and Little Orme headlands. It was the brainchild of Edward Mostyn and Owen Williams, who from 1824 began transforming a mining and fishing village. 'Professor Codman' brought Punch and Judy to Llandudno in 1860, and the Codman family still run the puppet show daily during the summer on the wide promenade near the pier.

LLANDUDNO – BATTLE OF MAESDU, 1098 *Llandudno Golf Course, Hospital Road, Llandudno LL30 1HU.* Also known as the Battle of Deganwy, this 'black field' outside Llandudno is now Maesdu Golf Course. A Norwegian force was defeated here.

LLANDUDNO CABLE CAR – BRITAIN'S LONGEST CABLE CAR The summit of the Great Orme (Pen y Gogarth), Llandudno, can be reached by this cable car. At over one mile each way, it is the longest Aerial Cabin Lift in the United Kingdom. It was built in 1969 and the four-seater cars are carried on an endless cable over two miles long and which weighs over 17 tons.

LLANDUDNO FUNICULAR RAILWAY – ONE OF ONLY THREE CABLE-HAULED STREET TRAMWAYS IN THE WORLD This tramway is a system where two tramcars are moved up and down hill by cable. As one comes down the Orme it helps pull the other one up using a system of counterbalanced weights. It was built in 1877.

LLANDUDNO – GREAT ORME'S HEAD COPPER MINE – THE LARGEST PREHISTORIC MAN-MADE CAVERNS IN THE WORLD, THE ONLY BRONZE AGE MINE IN THE WORLD OPEN TO THE PUBLIC *LL30 2XG. Tel: 01492 870447.* Four thousand years old, these Bronze Age copper workings show how prehistoric men mined for copper. Because the extraction process was simplified by a rock-softening process, known as dolomitization, this was once the most important copper mine in the world, before Parys Mountain took over. One Bronze Age cavern, 130 feet below the surface, and measuring at least 50 feet across, is the largest prehistoric man-made cavern in the world. Previously, the Great Stope Chamber was the largest man-made cavern discovered, on the same site. The site is the oldest copper mine in the world, as well as the largest Bronze Age mine cave ever discovered at 25 feet high, 25 feet width and 60 feet length. (Copper makes up 90 per cent of bronze.) The network of caverns were not rediscovered until 1987, and form the largest Bronze Age mining complex ever recorded, with four miles of tunnels so far excavated to a depth of 470 feet. Surveys suggest there are ten miles of tunnels, and 30,000 bone tools and scrapers and 3,000 stone hammers have been found. The site is far more extensive than the prehistoric copper mines in Austria, China or Grimes Graves flint mines, and tools have been dated back to 1850 BCE.

LLANDUDNO – GREAT ORME HERITAGE COAST The coastline is around the outline of Orme Head, which defines the eastern shore of Conwy Bay. The headland was home to Neolithic settlers, and there are numerous prehistoric remains to be seen. The best preserved is probably the burial chamber of Great Orme Cromlech, and there are several stone circles at Pen y Dinas.

LLANDUDNO – ST TUDNO'S CHURCH On the northern side of the Great Orme, in a sheltered hollow, it was built in the twelfth century on a Christian site dating from the sixth century, dedicated to the memory of its founder St Tudno. He was one of the seven sons of King Seithenyn whose legendary kingdom in Cardigan Bay was submerged by tidal activity. Tudno then established his Church on Cyngreawdr (the Great Rock – the Great Orme). Ogof Llech (a small cave on the headland, difficult to access, but with a clear spring of water) was Saint Tudno's cell.

LLANDUDNO VICTORIAN PIER – THE LONGEST PIER IN WALES At 2,295 foot long, it is one of the finest recreational piers in the United Kingdom. The Llandudno landing stage is still used by the Isle of Man Steam Packet Company, and also by the Waverley and Balmoral Steamer Preservation organisation.

LLANDYBIE – CHURCH OF ST TYBIE *3 miles north of Ammanford, Carmarthenshire SA18 3HX.* This impressive listed medieval church has a circular churchyard, indicating an early origin. It is attributed to St Tybie, a daughter of Brecon, and her sister Lluan is commemorated at nearby Llanlluan. A field nearby is called Cell Tybie, where she traditionally had her cell. (The word cell, meaning hermitage, is in Welsh 'cil', and some places in Wales prefixed with cil indicate an ancient holy site.) There was a noted holy well, Ffynnon Tybie, near here. There is a persistent tradition that soldiers, who fought for the assassinated Owain Lawgoch across Europe, brought Lawgoch's heart back to this church when they joined Owain Glyndŵr. At nearby Capel Hendre, there was a stone circle 60 feet in diameter, once consisting of fourteen stones and rich in folklore. It was destroyed in the twentieth century.

LLANDYSILIO – ST TYSILIO'S CHURCH *Llandysilio Island, off the village of Menai Bridge, 3 miles south-west of Beaumaris, Anglesey.* There are dedications to this sixth-century prince of Powys across Wales and Brittany, but this island church is probably his most evocative site. It is in the middle of an area of dangerous tidal currents known as 'The Swellies'. There is no electricity in the church, which was rebuilt on its medieval core in Victorian times, using medieval roof trusses and beams. It can be reached by a causeway.

LLANDYSUL – ROCK MILL – WALES' ONLY WORKING WATERWHEEL-POWERED COMMERCIAL WOOLLEN MILL *Follow signs from Llandyssul to Capel Dewi in the Clettwr Valley, Ceredigion.* This mill has been spinning and weaving wool since the 1890s. It is a member of the Welsh Mills Society.

LLANEGRYN – CHURCH OF ST MARY THE VIRGIN (FORMERLY ST EGRYN) *7 miles north-west of Aberdyfi, 10 miles south-west of Dolgellau, Meirionnydd.* The church contains a rood loft, said to have been brought from Cymer Abbey, a Norman font, and several monuments to the Owen family. The church is about a mile from the village, in the early style of English architecture. The chancel is separated from the nave by an elaborately carved magnificent rood screen and rood loft, brought from CYMER ABBEY, near Dolgellau, upon the Dissolution. The monks of Cymer had previously built a church and hospital here in the thirteenth century. A Celtic crossed stone is built into the wall of the church, and there is a circular graveyard, proof of the age of the site. Croes Egryn, the Cross of Egryn, has disappeared from near the church.

LLANEILIAN – ST EILIAN'S CHURCH – WALL PAINTING OF THE GRIM REAPER *Off A5025, 2 miles east of Amlwch, Anglesey.* Much of the copper ore extracted from the Parys Mountain was exported from the little port of Llaneilian. In 450, St Eilian, endowed by King Caswallon, built a chapel. The offerings of pilgrims were kept in an oak chest called Cyff Eilian, from the contents of which the church of St Eilian and the Chapel of Caswallon were remodelled in the mid-seventeenth century. It is a fifteenth-century battlemented church with tower and spire. The church contains a carved oak screen and carvings on the roof beams. The fourteenth-century chapel built over site of St Eilian's cell is on the same site. The west tower is twelfth century. The church famously retains many of its late medieval fittings and post-medieval restorations have been limited or restrained. There are traces of post-medieval wall paintings. The famous painting of a skeleton, the 'image of death', is accompanied by the inscription 'Colyn Angou yw Pechod' (The Sting of Death is Sin) on his reaper's blade. The use of 'Angou' brings resonances of the Breton language, which is very similar to Welsh. Their most powerful folk figure, in hundreds of churches, is the 'Ankou', the skeleton reaper of death.

LLANEILIAN-YH-RHOS – ST EILIAN'S CHURCH AND CURSING WELL *Near Llandrillo, Denbighshire.* There were many 'cursing wells' in Wales, the most noted being the well of Eilian, near Llaneilian-yn-Rhos in Clwyd. To cast a curse, the guardian of the well wrote it on paper and threw it in. The church authorities blocked off this particular well in 1929. Llaneilian Church is medieval with some remarkable fifteenth-century painted wooden panels. These were once part of the rood screen but have now been placed on the north wall of the nave. They are heavily restored but give a good idea of the decoration of a medieval church.

LLANELIDAN – NANTCLWYD HALL – THE BIRTHPLACE OF LAWN TENNIS *Just off the A494 between Corwen and Ruthin, Denbighshire (National Garden Scheme Open Days).* Small formal gardens and grounds with temples and follies designed by Sir Clough Williams-Ellis. Major Walter Clopton Wingfield (1833–1912) lived here and invented lawn tennis in 1874, calling it Sphairistikè. The nearby Church of St Elidan is fifteenth century, with a Jacobean pulpit, barrel-vaulted 'canopies of honour' over the altar, old box pews and a wonderful medieval rood screen.

LLANELLI – THE NINETEENTH-CENTURY 'TINOPOLIS' *On the A48 west of Swansea.* From being a centre for coal mining, it became one of the largest tin-plating centres in the world from the 1850s, known worldwide as 'Tinopolis'. Famous for rugby, its historic Stradey Park has been sold for development into housing.

LLANELLI HOUSE – A FINE GEORGIAN TOWN HOUSE Located opposite the Church of St Elli, it fell into a poor state of repair. However, after appearing on the BBC TV programme

Restoration, the town council is restoring it for civic and public use. It was built in 1714 by the MP Thomas Stepney, and John Wesley stayed there many times.

THE LLANELLI RIOT 1911 – THE LAST TIME THAT WORKERS IN BRITAIN WERE KILLED BY THE ARMY IN AN INDUSTRIAL DISPUTE The period of 'The Great Unrest' amongst an impoverished and over-worked people saw the Tonypandy Riots, major disturbances in the Cynon Valley, a riot among seamen in Cardiff docks in 1911, and the Llanelli Riot. It was just two days since the start of the National Railway Strike of 1911, which ended on the night of the killings. The 14.30 train from Cardiff to Milford Haven had been stopped, and the First Battalion of the Worcester Regiment had been called in to disperse the rioters. The troops were ordered to fire, although no one was threatening the troops. Two young Llanelli men were killed, and another two injured. Following this, ninety-six rail trucks were destroyed, shops were damaged and four people killed in an explosion. On the same day and following, there was disorder in TREDEGAR, Bargoed and across the coalfield. Thousands lined the streets of Llanelli for the funerals.

LLANELIEU (LLANELEU) – ST ELLYW'S CHURCH – FRIENDS OF FRIENDLESS CHURCHES *2 miles east of Talgarth, 9 miles north-east of Brecon, Breconshire.* A thirteenth-century core, with fifteenth-century additions, it is a simple, remote and charming church, with one of the oldest and largest rood screens in Wales, believed to be fourteenth century. The loft is painted red, and the altar rails are seventeenth century. It was used by the Aubreys of the medieval Llanelieu Court nearby.

LLANENGAN – CHURCH OF ST EINION *2 miles west of Abersoch, 7 miles west of Pwllheli, Llŷn Peninsula, Caernarfonshire.* Llanengan took the choir stalls and screens from the abbey of nearby YNYS ENLLI after the Dissolution. A medieval wooden chest, used for donations from pilgrims, may also have come from Ynys Enlli. It is known as 'Cyff Engan', being dug out from a single baulk of timber and bound. The lid has a large slot for coins. This is the only church on the peninsula from which one has a complete view of Bardsey Island, and is closely associated with the medieval pilgrimage route on the peninsula. The structure is mainly of the late fifteenth century and has two parallel naves, each crossed by beautifully carved sixteenth-century screens with misericords (hinged seats). The tower was added in 1534. Above the west doorway, in raised letters, is a Latin inscription recording the building of the tower reading: 'in honour of St Einion, King of Wales, Apostle of the Scots AD 1534'. Nearby is St Engan's Holy Well, and the church is near 'Hell's Mouth Bay'.

LLANERCHAERON HOUSE AND ESTATE – NATIONAL TRUST *Ciliau Aeron, 3 miles south-east of Aberaeron, Ceredigion SA48 8DG. Tel: 01545 570200.* An eighteenth-century Welsh gentry estate, with the house designed and built by John Nash, two restored walled gardens and a working organic home farm. There are many unaltered features including a service courtyard with original kitchens, dairy, laundry, cheese parlour, brewery and salting house. It is set in the beautiful Aeron valley with extensive estate and parkland walks. This eighteenth-century 'time capsule' in Ceredigion shows how country gentlefolk lived 200 years ago.

LLANERCHYMEDD – CHURCH OF ST MARY THE VIRGIN *Near Llyn Alaw in the centre of Anglesey, on the Alaw, 13 miles north-west of Beaumaris, where the B5111 meets the B5112.* There is a tradition that King Pabo and his wife were buried at Llanerchymedd rather than at Lanbabo. Historian Graham Phillips believes that the Virgin Mary is buried here after accompanying Joseph of Arimathea on his journey to Glastonbury. In research for *The Marian Conspiracy*, he discovered a letter to Pope Gregory in 597 CE, claiming to have found Mary's tomb in a church off the west coast of Britain. Phillips believes that Mary's remains were removed from the church and reburied beside the nearby well when the island was under attack by the Vikings in the tenth century. It

is a large medieval church, serving mostly an agricultural community since Llangefni took over as the prime livestock market in Anglesey. However, in the eighteenth and nineteenth centuries little Llanerchymedd held the island's biggest market and was home to up to 250 shoemakers. The shoemakers of Y Llan would sell their shoes at the various Anglesey and Arfon fairs and markets, carrying their wares in a sack. Some of its corn mills can still be seen, and in the nineteenth century the village was famous for the manufacture of snuff.

LLANELLTUD (LLANELLTYD) BRIDGE *Near Cymer Abbey, the junction of the A496 and A470 north-west of Dolgellau.* The wonderful bridge over the Mawddach here is probably eighteenth century or earlier, but there are references to a bridge being in existence near Cymer Abbey in 1400. The crossing would have been important not only for the monks but for trade in general. Owain Glyndŵr fought supporters of Hywel Sele at the bridge in 1402.

LLANFAIRFECHAN - WERN ISAF GRADE II* LISTED ARTS AND CRAFTS 'BUTTERFLY' HOUSE *Off the A55 west of Penmaenmawr, at Penmaen Parc, a mile south-east of Llanfairfechan, Caernarfonshire.* Local man Herbert North studied under Edwin Lutyens, before he built Wern Isaf as his family home in 1900. It is all open-plan, there are no corridors and the hall goes up to the second floor ceiling, so it has been called 'the house of light', with its open spaces and many windows. There are original furnishings and William Morris fabrics in the unspoilt interior, which is opened to the public at times by North's granddaughter. The 'Butterfly' style means that the line from the front door to the staircase lobby was carried on, with rooms set at an angle to this line, like the wings of an insect. The garden is one of the Historic Gardens of Wales. Between the two world wars, North also built The Close, a semi-circle of about thirty houses, and the Institute in Llanfairfechan.

LLANFAGLAN - ST BAGLAN'S CHURCH - FRIENDS OF FRIENDLESS CHURCHES *2 miles south-west of Caernarfon on the south shore of the Menai Strait.* St Baglan's is in the middle of a field, an ancient site with a sixth-century stone inscribed 'Filii Lovernii Anatemori' used as a lintel. There are two other fifth- and sixth-century stones here also used as lintels in the church, one seemingly depicting a masted boat. The church is thirteenth century with seventeenth-century additions, and still used occasionally. Ffynnon Faglan (Baglan's Well) was a pin well next to the church, destroyed in the nineteenth century, but the stone seat and a niche remain next to it.

LLANFAIR CILGEDIN - CHURCH OF ST MARY - FRIENDS OF FRIENDLESS CHURCHES *4 miles north-west of Usk, Monmouthshire, on the B4598.* A mile outside the village, up a farm track and near the River Usk, the church is famous for its 'sgraffito' murals by Heywood Sumner. The medieval church was restored by J. D. Sedding in 1873-76, when he laid the decorative tiled flooring, and Sumner painted sixteen Art Nouveau-style panels. The 'sgraffito technique' uses thin layers of different coloured plaster which are cut back to reveal the required colour underneath, and is Roman in origin. The chancel roof and much of the window tracery are medieval, and there is a fifteenth-century chancel screen and Norman font. There is a Norman motte and bailey on a farm near the village.

LLANFAIRPWLLGWYNGYCHGOGERYHCWYRNDROBWLLLLANTYSILIOGOGO GOCH - THE LONGEST TOWN NAME IN THE WORLD The next village to Llandysilio, Anglesey, it refers to Tysilio's island church and to the rapids swirling around it. This means 'The church of St Mary in the hollow of white hazel trees near the rapid whirlpool and the Church of St Tysilio of the red cave'. It is also the longest railway station name in Britain, and probably the longest domain name in the world. When the railway was built between Chester and Holyhead at the beginning of the 1850s, a local committee was put together to try and encourage trains, travellers and nineteenth-century tourists to stop at the village, in order to help develop the village as a commercial and tourist centre. It is believed that the new name was invented by local bard

John Evans (Y Bardd Cocos, 1827-95) from Menai Bridge, thus starting one of the most successful tourist marketing plans of all time. Today the village is signposted as Llanfairpwllgwyngyll (its original name), and is known to locals as Llanfairpwll or Llanfair. The Victorian railway station has been restored. Llanfair PG, as it is known across Wales, has another claim to fame in that Britain's first Women's Institute was established here, in 1915. Not to be outdone, the Fairbourne Steam Railway at BARMOUTH has also invented a 'more commercial' station name for a station board which is 64 feet long, of: Gorsafawddacha'idraigodanheddogledddollonpenrhynareurdraet hceredigion ('The Mawddach Station with its dragons' teeth on the Northerly Penrhyn Drive on the golden beach of Cardigan Bay' – the 'dragons' teeth' are the remains of Second World War concrete defences).

LLANFIGAEL (LLANFIGEL) – CHURCH OF ST BIGAEL FOFC *3 miles north-west of Bodedern, near Holyhead, Anglesey, on the River Alaw.* The early medieval church was in ruins until restored in the mid-eighteenth century by the Morris family. They kept the old layout with box pews for farmers, backless benches for servants, men on one side and women on the other. There was an empty space at the back for paupers, with straw for them to sit on. It was dilapidated, without electricity, and the FOFC is thankfully restoring it. It is not known who the saint is, being sometimes written 'Bugail' (Shepherd), and he is generally identified with the fifth-century Vigilius but this is unlikely. Maen Bigel is the name given to a rock in Holyhead Bay, and to another in the Sound of Bardsey. West Mouse Island, off north-west Anglesey, is Ynys Bigel.

LLANFIHANGEL (LLANVIHANGEL) COURT – SUPERB TUDOR MANOR HOUSE *Llanfihangell Crucornau, 4 miles north of Abergavenny, on A465 Abergafenni to Hereford Road, Monmouthshire NP7 8DH. Tel: 01873 890217.* A beautiful Grade I listed Tudor Manor, re-modelled during the seventeenth century with fine moulded plaster ceilings, oak panelling and a magnificent yew staircase leading to a bedroom where Charles I is reputed to have stayed. The main entrance overlooks seventeenth-century terraces and other seventeenth-century buildings – a banqueting house, one of the largest barns in Wales and an outstanding Grade I brick stable block with turned wooden pillars.

LLANFIHANGEL CRUCORNAU – THE SKIRRID MOUNTAIN INN – ANCIENT INN WITH A GRIM HISTORY Around 200 people were hanged here between 1110 and the seventeenth century, and the beam above the foot of the stairs was the original scaffold. The first execution, recorded in 1110, tells us that James Crowther was given nine months imprisonment for robberies with violence, and that his brother John was hanged for stealing a sheep. Scorch and drag marks of the rope can still be seen on the beam, and the pub is possibly the oldest in Wales, with beams that come from ships' timbers, medieval windows, and dining room panelling from a British man-o-war. Owain Glyndŵr's troops rallied in the inn's cobbled yard before marching on Pontrilas. Skirrid is derived from ysgyryd (a shiver), and legend says that in the hour of darkness after the Crucifixion the mountain shuddered and shivered before splitting into two into Ysgyryd Fawr and Ysgyryd Fach (Big Shiver and Little Shiver).

LLANFIHANGEL-Y-PENNANT – ST MICHAEL'S CHURCH – THE PLACE THAT INSPIRED THE FOUNDATION OF THE BIBLE SOCIETY *From the A487 Machynlleth to Dolgellau road take the B4405 near Minffordd, signposted Tywyn. Travel past the Talyllyn Lake to Abergynolwyn.* St Michael's Church is located close to the Afon Dysynni, near Castell y Bere. The church houses an exhibition about Mary Jones, 1784-1866, the local girl who in the year 1800, at the age of sixteen, walked twenty-six miles barefoot to BALA with all her precious life savings, to buy a copy of the Welsh Bible, Y Beibl. Her parents' graves are to be found in the churchyard of St Michael's. The church is also worth exploring not only for the Mary Jones exhibits, but also for an interesting 14-foot-long three-dimensional cloth map of the Dysynni valley. A memorial obelisk to Mary Jones can be found close by at the ruin of the cottage where she lived. Mary is buried

in nearby Bethlehem Chapel at Bryncrug, north-east of TYWYN. Her grave inscription reads, 'In memory of Mary Jones, who in the year 1800, at the age of 16, walked from Llanfihangel-y-Pennant to Bala to procure a copy of a Welsh Bible from the Rev Thomas Charles, BA. This incident led to the formation of the British and Foreign Bible Society in 1804.' The Bible Society's London headquarters still treasures and displays her Bible.

LLANFIHANGEL-YNG-NGWYNFA – CHURCH OF ST MICHAEL THE ARCHANGEL *North of Dolanog, on the B4382, 11 miles north-west of Welshpool, Montgomeryshire.* This stands on high ground, within a polygonal churchyard, and is a very early foundation, probably re-attributed from a Celtic Christian saint to St Michael by the Normans. The present church was rebuilt in 1862, but it was recorded at least as early as 1254, and has three inscribed stones of the fourteenth century in the vestry walls. The grave of Ann Griffiths (1776-1805), the famous Welsh hymn writer, is on the west side of the entrance path, marked by a red granite pillar. Ann was born in a nearby farmhouse called Dolwar Fach and her legacy has been the seventy hymns and eight letters which she left behind, all showing her vision and her awareness of the human and spiritual experience. When he was enthroned as Archbishop of Canterbury in February 2003, Dr Rowan Williams chose one of her hymns – 'Yr Arglwydd Iesu' (The Lord Jesus) – to be sung at the service. The Roman road from CAERSWS to Deva (Chester) passed through this parish.

LLANFILO – CHURCH OF ST BILO *Just south of the A470 west of Bronllys, Breconshire.* The present church is a wholly unspoilt medieval building, with 1630s pews, a porch dating from 1300 and a Celtic font dating from *c.* 900. There is a magnificently carved rood screen and loft dated around 1500. The attribution of the church is to St Bilo, 'a daughter of Brychan Brycheiniog', sixth-century king of Brecon.

LLANFOIST, BATTLE OF *Just south of Abergafenni, at the foot of the Blorenge Mountain.* It is said that Llywelyn the Great won a battle here, and that swords were found on the site.

LLANFOR ROMAN CAMP Near BALA, it encompassed a supply depot, watchtower and marching camp.

LLANFROTHEN – CHURCH OF ST BROTHEN FOFC *Near Penrhyndeudraeth, 8 miles north-east of Harlech, Meirionnydd.* This charming, medieval single-cell building has a gently sloping interior and a medieval arch-braced roof with cusped wind braces. It has notable woodwork including balustraded chancel stalls and screen, and has two fonts.

LLANFRYNACH – CHURCH OF ST BRYNACH AND DOUBLE COFFIN STILES *West of Cowbridge, on an unmade road near the Cross Inn, Llanbleddian.* This secluded thirteenth-century church is near a ploughed-out Romano-British farmstead and the site of the deserted medieval village of Llanfrynach. An early site, it served the village of PENLLYN, two miles north across the Roman road (now the A48). There is a series of four double coffin stiles between the fields on the hilly journey, which enabled the carriers to rest the coffin on the middle support between the stiles. Each has three stone piers in a line, with a style between each pier. There are occasional services, and the church has no electricity, gas or oil. There is a broken churchyard cross, and the nearby stream served for baptisms.

LLANFYLLIN – HISTORIC TOWN *From Shrewsbury take the A458 Welshpool Road and make for Llansantffraid-ym-Mechain - the A490 ends in the village SY22 5BW.* Llanfyllin was granted its charter as a borough in 1293 by Llywelyn ap Gruffydd ap Gwenwynwyn, Lord of Mechain. It thus shares with WELSHPOOL the distinction of being one of only two Welsh boroughs to receive their charters from native Welsh rulers, which gives the village of Llanfyllin the unique privilege of calling itself a 'Town' with its own elected mayor. The Manor House is early Georgian, built

for the stewards of Lord Powis. The Council House is opposite the church, dating back to 1740 with thirteen wall paintings in an upstairs room. Still in their original state, these paintings can be viewed on request to the owners. Lieutenant Pierre Augeraud was a Napoleonic prisoner-of-war, a number of whom were billeted in the town from 1812 to 1814, who painted this series of romantic landscape murals, using only sheep marker dye and formalin. He was returned to France to end his relationship with Mary Williams, the rector's daughter. When the war ended, Augeraud returned and the two were married. Their grandson, William, at his own request, is buried in the tomb of the Rector Williams in St Myllin's Churchyard. Pendref Congregational Chapel is one of the oldest Nonconformist places of worship in Wales, established originally in 1640. Ann Griffiths (1776- 1805) the famous Welsh hymn writer, was converted to the Christian faith at a service here in 1796, but the present building was built of local brick in 1829. The Hall (previously known as Plas Uchaf) was once the most important house in Llanfyllin, situated close to Manor House. Originally a two-storey timber-framed hall house, it was a centre of Roman Catholic recusancy in the seventeenth and eighteenth centuries and Charles I stayed overnight in September 1645, en route to Chester. There are eight windows on the façade and a total of almost 1,000 panes of glass.

LLANFYLLIN – CHURCH OF ST MYLLIN Demolished in 1629 by a new vicar, it is on the site of a seventh-century foundation of Myllin, regarded as the first cleric to baptise by total immersion in his holy well. The present building, dating from 1706, is one of very few Welsh churches to be built in the eighteenth century. Its interior has interesting benefaction boards, and the peal of six bells was founded in 1714.

LLANFYLLIN – ST MYLLIN'S HOLY WELL St Myllin was the first person in Britain to baptise by immersion, in the seventh century, and the citizens of the town used the well for centuries to cure their ills. There are hundreds of similar wells across Wales, most decaying through lack of attention. Restored in 1987, this former 'rag well' overlooking the town is well worth a visit.

LLANFYLLIN UNION WORKHOUSE The immense workhouse was built in 1838-39 and is situated in open fields half a mile south-east of Llanfyllin. It is a large, severe-looking complex in the shape of a cross, with an octagon at the centre, topped by a cupola. Known locally as Y Dolydd, it was derelict but featured in BBC TV's *Restoration* programme and is being restored as an arts centre.

LLANFYRNACH SILVER-LEAD MINES *On either side of the Afon Tâf half a mile north-east of Llanfyrnach Church, near Crymych, A478 Pembrokeshire.* There has been a Christian Community in Llanfyrnach since the fifth century, dedicated to St Byrnnach, a chaplain to Brychan Brycheiniog. The original site was probably about half a mile to the west of the present church, at Trehenry Farm. There were several other churches dedicated to him. Llanfyrnach presents one of the best examples of an undisturbed, technologically advanced, late nineteenth-century mining site. There may have been mining on the site in the sixteenth century, and it was continuously worked until the nineteenth century. After raising nearly 16,000 tons of lead ore and 764 tons of zinc ore in thirty-two years of continuous operations, the mine finally ceased production in 1890.

LLANGADWALADR – ST CADWALDR'S CHURCH – ROYAL MONASTERY AND BURIAL PLACE OF KING CADFAN *2 miles east of ABERFFRAW, Anglesey.* Established sometime around 615, it was a royal monastery patronised by the Kings of Gwynedd from nearby Aberffraw. Llyn Coron, the Lake of the Crown, is nearby. Llangadwaladr was originally called Eglwys Ael ('Wattle Church'), and is most famous as the burial place of King Cadfan of Gwynedd who died in AD 625 (his church is in nearby Tywyn). His seventh-century memorial, incised with a small cross, bears the inscription: 'CATAM-ANVS REX SAPIENTISSIMVS

OPINATISSIMVS OMNIVM REGVM' – 'King Cadfan, the Wisest and Most Renowned of All Kings [Lies Here]'. Cadfan was the grandfather of Cadwaladr ap Cadwallon, who seems to have taken Cadfan's remains from Bardsey for reburial here. The church was founded or built by Cadwaladr, the last of the Welsh kings of Britain, and is of architectural merit, with many gargoyles of interest. Cadfan's father Iago may also have been buried here, and his memorial stone may yet be discovered in the graveyard. King Cadwaladr the Blessed died in Rome in 664, and his body was returned to Eglwys Ael, which was renamed Llangadwaladr. Cadwaladr was canonised by Pope Sergius I in 689 as 'The Blessed King and Sovereign of Britain'. After his father Cadwallon was killed by Oswald and his pagans at Heaven's Field, Cadwaladr had been forced to lead the Christian Britons against the invading barbarian Saxons. Like most other early saints, Cadwaladr has more than one foundation. Another is in the remote hills seven miles west of Oswestry, with a curvilinear churchyard and some yews over 1,000 years old also signifying an ancient foundation.

LLANGAFFO – CHURCH OF ST CAFFO – COLLECTION OF GRAVE SLABS *4 miles south of Llangefni, Anglesey.* The early medieval cross shaft in the churchyard is thought to be contemporary with the wheeled cross fragment inside. There is also a group of cross-incised gravestones, the tallest being twelfth or thirteenth century, and the others ranging from the ninth to eleventh century. The earliest stone is an early seventh-century memorial in Latin in the sacristy, probably reading 'Gwernin, Son of Cuurius Cini, Set up this Stone'.

LLANGAMMARCH (LLANGAMARCH) WELLS *8 miles west of Builth Wells.* This spa town on the River Irfon attracted David Lloyd George, Kaiser Wilhelm II and foreign heads of government to its barium wells. Barium chloride allegedly helped cure heart disease, gout and rheumatism. The spring is in the grounds of the Lake Hotel, formerly known as the Pump House Hotel. Nearby Cefn-Brith was the home of John Penri (Penry), who was hung, drawn and quartered aged thirty-four in 1593 for his pamphlets denouncing absenteeism and immorality in the clergy. He left his four children all he possessed, a Bible each. The former spa was once famed for its horse fairs. The medieval church has been rebuilt, dedicated to a St Cadmarch (Battle Horse) rather than Cammarch (Lame Horse). Cammarch was a son of St Gwynlliw, and Cammarch was also a nickname of St Cynog ap Brychan, so the church's history is tangled. Then again, the Camarch is the river flowing through the village.

LLANGAN – THE CHURCH OF ST CANNA – CELTIC WHEEL CROSS DEPICTING THE CRUCIFIXION *Between PENLLYN and Treoes, 4 miles east of BRIDGEND, Vale of Glamorgan.* This has an almost perfect fifteenth-century preaching cross, but its main treasure is a Celtic sculptured wheel cross outside the church. There is a rare scene of the Crucifixion. Jesus wears a loincloth and Longinus and Stephaton are below his outstretched arms. The figure below may represent Mary Magdalene.

LLANGASTY TAL-Y-LLYN – TREBERFYDD HOUSE, SCHOOL AND CHURCH *Near Bwlch, 6 miles east of Brecon LD3 7PX. Tel: 01874 730205.* One of the finest examples of a country house built during the Gothic Revival movement of the nineteenth century, a Grade I listed house, surrounded by ten acres of gardens designed by W. A. Nesfield. Occupied by the Raikes family since it was built, nearly all the original features remain. Robert Raikes decided to leave his family home and build a house, church and a school here, in the spirit, ceremony and ritual of the High Anglican Church, in this centre of Methodism. The Gothic Revival movement was a reaction against classical architecture, and drew its inspiration from medieval abbeys, fortresses and castles. St Gastyn's church is within a polygonal enclosure, near the southern edge of LLANGORSE Lake. It is largely of nineteenth-century build though the tower is earlier. An early medieval origin is likely, and St Gastyn (Gastayn) baptised Cynog ap Brychan in the sixth century.

LLANGATTOCK COURT *Just south-west, across the Usk from Crickhowell, Breconshire NP8 1PH. Tel: 01873 810116.* A listed William and Mary Country House in the Brecon Beacons National Park, it was built around 1690 and is now a hotel.

LLANGATWG (LLANGATTOCK) LINGOED – ST CADOC'S CHURCH *North-east of Abergafenni, on the River Trothi, off the A465, Monmouthshire.* A pre-Norman settlement on a secluded hilltop overlooking a fertile valley, the first known stone church on the site was built by 1254, rebuilt in Victorian times. The whitewashed church has a squint (hagioscope) for the chantry priest to see the movements of the priest at the High Altar. The parish bier of 1711 is a survivor of the practice of burials where the body was wrapped in a shroud without a coffin. The impressive base of a medieval Cross south of the church is listed as an Ancient Monument. The Cistercian Way footpath and the Offa's Dyke footpath pass through the village.

LLANGEFNI – THE COUNTY TOWN OF ANGLESEY In the centre of Anglesey. Formerly called Llangyngar after the sixth-century St Cyngar, it is now named after the River Cefni. There is a Victorian church on Cyngar's foundation. Oriel Ynys Môn is an arts centre and museum with a History Gallery, which provides an insight into the island's heritage and culture.

LLANGEINOR – ST CAIN'S CHURCH, AND BIRTHPLACE OF WALES' GREATEST THINKER *5 miles north of Bridgend, Glamorgan CF32 8NU.* A Victorian Gothic restructuring of an original Norman building, on the site of a sixth-century foundation of Ceinwyry (Cein the Virgin), a daughter of Brychan Brycheiniog. The font is Norman, the nave is fifteenth century, and the tower was then added in the sixteenth century. The entire village is now protected as part of a conservation area. It was here, in Tynton Farm, that Dr Richard Price (1723-91) was born, a dissenting minister and radical who helped found the Unitarian Society. A close friend of Benjamin Franklin, Price supported the American Revolution, and *The Declaration of Independence* owes a great deal to *Price's Observations on the Nature of Civil Liberty*. He also drew up the first budget of the new American nation, and his expertise on demography and actuarial matters influenced the financial policies of William Pitt and Shelburne. John Davies calls Price 'the most original thinker ever born in Wales'. Price was officially mourned in Paris, when he died in 1791.

LLANGELYNNIN – CHURCH OF ST CELYNNIN *On the A493, 4 miles north of Tywyn, Meirionnydd.* A coastal single-cell church, where the 'gipsy king' Abram Wood was buried in 1799, most of the structure dates from 1200, with a seventeenth-century porch and a 1500 roof. Welsh gypsies were the last to speak Romany (Romani) in Europe. In the early 1900s, John Sampson, an expert on gypsy lore, discovered that a family in Wales still spoke the 'deep' or inflected Romany that had died out among the rest of the gypsy groups in Europe. Sampson wrote that the descendants of Abram Wood, reputed King of the Gypsies, had religiously kept the dialect intact 'in the fastnesses of Cambria'. Romani is a dialect of Hindu, as gypsies originally came to Europe from India some time in the thirteenth or fourteenth century. In Britain, their dark complexions and strange tongue led them to be called Egyptians or Gypsies. The Wood family, outstanding musicians, helped to keep alive many musical traditions that were forced underground during the eighteenth-century Methodist Revival. One member of the family was chief harpist to Queen Victoria, and the Wood family was fluent in three mutually unintelligible languages: Romani, English and Welsh. The sixteen named Georgian pews in the church are superb, and there are post-Reformation wall paintings. Capel Celyn, the drowned Welsh community under the hated TRYWERIN Reservoir, was also probably a foundation of this sixth-century saint.

LLANGELYNNIN – CHURCH OF ST CELYNNIN *Above the village of Henrhyd and the B5106, 4 miles south of Conwy, Caernarfonshire.* On a windswept hill, this tiny church was a centre of pilgrimage, with medieval remains and a holy well still in the churchyard. It was so popular that an inn once existed next to the churchyard. Celynnin was the son of Prince Helig, whose court and

lands were inundated off PENMAENMAWR. (Until the eighteenth century, stagecoaches could cross the Menai Straits at low tide to Anglesey – rising seas are not a new phenomenon.) Ffynnon Gelynnin once had a roof, and still has three sides of stone seats. Sickly children were bathed in the well, wrapped in a blanket and allowed to sleep. Their clothes were then washed in the well – if they floated, the child would recover. Most is fourteenth century, and the 'men's chapel' has a hardened earth floor. Ffynnon Gwynwy nearby was a pin well to cure warts. There is an Iron Age hut circle nearby, and also the Iron Age fort of Cerrig y Dinas.

LLANGERNYW – ST DIGAIN'S CHURCH – THE OLDEST TREE IN ENGLAND AND WALES *8 miles south-west of Abergele, on the A548 between Llanrwst and Llanfair Talhaiarn where the Afon Cledwen crosses the road, near Hafodunos Estate, Conwy.* St Digain ap Cystennin was a son of the King of Dumnonia (the West Country), born in *c.* 429. Digain was known as Cernyw, the Cornishman, hence his foundation's name. The churchyard's huge yew tree is up to 4,000 years old. The thirteenth-century church was extended in the late medieval period, acquiring distinctive cruciform shape. The churchyard contains two early pillar stones, and was once oval in shape.

LLANGEVIEW – CHURCH OF ST DAVID *Near Usk, Monmouthshire.* The building is largely fifteenth century; from which time date most of the windows and the screen and rood loft inside. The font is a medieval survival but the pews, pulpit and the larger squire's pew in the chancel are all eighteenth century. The altar rails, in twisted baluster, date from around 1700, and the north side of the nave is completely windowless.

LLANGIAN – CHURCH OF ST CIAN – THE ONLY EARLY MEMORIAL TO A MEDICAL MAN *In land from Abersoch, Llŷn Peninsula, Caernarfonshire.* In the churchyard, is a fifth-sixth-century stone inscribed in Latin, MELI MEDICI FILI MARTINI IACIT (Melus the doctor, the son of Marinus, lies here). This must be the only early memorial to a medical man in Britain. This was the manor of Neigwl in the Middle Ages, and before that the court of the princes of Cymydmaen. Near it is the long stretch of beach known as Porth Neigwl or 'Hell's Mouth'. The western end of the bay ends at Treheli where the road rises sharply and twists past a cottage obscured by the trees, Sarn-y-Plas, where R. S. Thomas lived after leaving his parish duties in ABERDARON. St Cian may have been a soldier or a bard. He is said to have been a servant of St Peris, the founder of LLANBERIS, and both saints are commemorated on the same date, the 11 December. The thirteenth-century church has a fifteenth-century roof.

LLANGOLLEN – HISTORIC TOWN *On the A5, 7 miles west of Chirk.* Founded by St Collen, its bridge over the tumultuous River Dee dates from around 1500 and was considered one of the 'Seven Wonders of Wales'. At nearby Berwyn, next to the Chain Bridge Hotel and Llangollen Canal, one can see the famous Chain Bridge. It was built over the Dee by Exuperius Pickering, to take coal to Corwen and Bala. The famous Horseshoe Falls near Llangollen were man-made in 1801 to divert water from the River Dee to the Llangollen Canal.

LLANGOLLEN, BATTLE OF, 1132 Near Llangollen, Gwynedd's advance was checked by the men of Powys, and Cadwallon ap Gruffudd ap Cynan, the brother of Owain Gwynedd, was killed.

LLANGOLLEN CANAL, CHIRK AND PONTCYSYLLTE AQUEDUCTS Telford built the beautiful Llangollen Canal in the Ceiriog Valley, and at CHIRK Aqueduct it passes 70 feet above the river. With magnificent scenery, the canal also passes over the River Dee via the spectacular PONTCYSYLLTE Aqueduct, 120 feet high and over 1,000 feet long. Built between 1795 and 1805 by Telford, there is a possibility that both the aqueducts and canal will become a World Heritage Site. The Llangollen Canal joins the Shropshire Canal after going through the 460 feet Chirk Tunnel and passing over the 70-foot-high Chirk Aqueduct.

LLANGOLLEN – ELISEG'S PILLAR CADW Part of a ninth-century inscribed stone erected by Cyngen, prince of Powys, in memory of his great-grandfather, Eliseg (Elisedd). Elisedd was the last independent King of Powys. At one time the cross was over 20 feet high, and gives its name to Valle Crucis (the Valley of the Cross). The dots indicate lost words in the inscription, when it was copied by Edward Lhwyd in the 1690s:

> † Concenn son of Catell, Catell son of Brochmail, Brochmail son of Eliseg, Eliseg son of Guoillauc.
> † And that Concenn, great-grandson of Eliseg, erected this stone for his great-grandfather Eliseg.
> † The same Eliseg, who joined together the inheritance of Powys ... throughout nine [years?] out of the power of the Angles with his sword and with fire.
> † Whosoever shall read this hand-inscribed stone, let him give a blessing on the soul of Eliseg.
> † This is that Concenn who captured with his hand eleven hundred acres which used to belong to his kingdom of Powys ... and which ... the mountain [the column is broken here and lines lost].
> ... the monarchy ... Maximus ... of Britain ... Concenn, Pascent, Maun, Annan.
> † Britu son of Vortigern, whom Germanus blessed, and whom Sevira bore to him, daughter of Maximus the king, who killed the king of the Romans.
> † Conmarch painted this writing at the request of King Concenn.
> † The blessing of the Lord be upon Concenn and upon his entire household, and upon the entire region of Powys until the Day of Judgement.

LLANGOLLEN INTERNATIONAL MUSIC FESTIVAL In 1955, a young unknown called Luciano Pavarotti sang with his father's choir from Modena, at the Llangollen International Music Festival. It is said that his hearing Tito Gobbi sing at Llangollen, combined with the acclaim and the award of first prize, were the spurs that made him decide to make singing his professional career. Started by Harold Tudor in 1947 in an attempt to bring peoples together after six years of war, Llangollen is the best place to see scores of national costumes and enjoy the most varied dancing and singing in Europe, and probably in the world. Over 12,000 international participants come as folk singers, choirs, dancers, groups and instrumentalists, with 150,000 visitors descending on this town of just 4,000 people, making it a marvellous cosmopolitan affair.

LLANGOLLEN – PLAS NEWYDD Home of the Ladies of Llangollen. This half-timbered Tudor-style house was the home from 1778 of Lady Eleanor Butler (c. 1745-1829) and Miss Sarah Ponsonby (1755-1831), two Anglo-Irish lesbians. They eloped from Waterford in Eire to a more hospitable atmosphere in Wales. The Duke of Wellington, Thomas de Quincey, Edmund Burke, Wordsworth and Sir Walter Scott visited them here. Their Gothic-style house is open to the public.

LLANGOLLEN – ST COLLEN'S CHURCH This fourteenth- to fifteenth-century church was founded by St Collen in the sixth century. The oak chest in the porch dated 1748 is of interest with its three keyholes, and dates back to the days when the parish comprised of three districts. Each district selected its own Warden and all three had to be present to open the churchwardens' chest. Beyond the font there is an ancient door to the choir vestry, which may be twelfth century and from Valle Crucis Abbey. It has peepholes, a reminder of the days when offenders could claim sanctuary in the church. The superb hammer-beam roof was built in 1450 by craftsmen under the guidance of the Abbot of Valle Crucis, and features carvings of drunks, women, jokers and rabbits. There is also a memorial to the Ladies of Llangollen whose tomb is near the entrance to the church.

LLANGORS LAKE, LLYN SYFADDAN – THE ONLY CRANNOG SITE IN WALES *8 miles south-east of Brecon, off the A40.* This is said to be the largest natural lake in South Wales.

Nearby is the sixth-century church dedicated to St Paulinus (St David's tutor) and a Viking burial stone. Giraldus Cambrensis referred to the legend that the lake covers a lost city. This can probably be attributed to the fact that a small artificial island in the lake is the only known Welsh site of a crannog, a defensible fort used by lake dwellers. A dug-out canoe dating from 800 CE was found here in 1925, and is in Brecon Museum.

LLANGORS, LANGORSE, BATTLE OF THE CRANNOG, 916 The *Book of Llandaff* records the grant of 'Llan-gors' to the church of Llandaff by the King of Brycheiniog in the seventh century, and it has links with royal and episcopal estates from this time. The crannog towards the northern side of the lake was a residence of the Kings of Brycheiniog in the ninth-tenth centuries. The *Anglo-Saxon Chronicle* records that, in 916, Lady Æthelflœd sent an army into which stormed Brecenanmere ('Brecon Mere') and captured the king's wife and thirty-three other members of the court. The attack on the mere almost certainly refers to the destruction of the royal crannog and the capture of the wife of King Tewdwr ab Elisedd, King of Brycheiniog. High-quality textiles from the period have been excavated in the silt on the site, and a *Time Team* BBC TV programme featured work on the crannog.

LLANGURIG – CAE GAER ROMAN FORTLET *By Pen y Crocbren, just south of the A44, about halfway between Llangurig and Ponterwyd.* The fort is a parallelogram, its sides measuring 400 feet and 300 feet and parts of the defensive rampart still survive up to 16 feet wide and 5 feet high. This 'Camp field' was possibly built to protect quartz mining.

LLANGWM-UCHAF – CHURCH OF ST JEROME AND GAER FAWR HILLFORT *3 miles east of Usk, on the B4235 road to Chepstow, Monmouthshire.* This thirteenth-century church has one of the most spectacular rood screens in Wales, dating from around 1500. There are also three pagan symbols of 'green men' on the chancel arch, carved heads with foliage issuing from their mouths. There is also a superb embattled tower, with three seventeenth-century bells. The parish has a second smaller medieval church, that of St John at Llangwm Isaf, again in the Early English style. One of the two churches is scheduled for closure soon. The huge Gaer Fawr Iron Age hillfort is about a mile south-east of Llangwm, with wide-ranging views over the Vale of Usk.

LLANGWNNADL – CHURCH OF ST GWYNHOEDL *7 miles south-west of Morfa Nefyn, Llŷn Peninsula, Caernarfonshire LL53 8NW.* Gwynhoedl was one of the sons of Seithenyn, who was responsible for the drowning of lands of Cantre'r Gwaelod, in Cardigan Bay in the sixth century. The tombstone which marked his burial place in LLANNOR was kept until recently in the Ashmolean Museum in Oxford, and is known as the Vendestle Stone. In the church there is another stone which is also reputed to be his tombstone, discovered during the renovations of 1940. It can be seen in the south wall of the church, and on it is cut a Celtic Ring Cross. Traces of red colouring are still visible, and it has been dated to around 600 CE. 'St Gwynhoedl's Bell' has been dated to around 900 CE, cast in bronze and decorated with animal heads, and is in the National Museum of Wales. It was removed during renovations in the nineteenth century to Madryn Castle, and only came to light again at the auction in Madryn in 1910, when it was sold for £44 2s 0d. However, there is a detailed casting of the bronze sanctus bell in the church. The original building was made of wattle, mud and timber, until Norman times when a stone building was erected. During the Middle Ages the Shrine of Gwynhoedl became very popular and was one of the main halts on the Pilgrim's Way to Bardsey Island. The field adjacent to the church, which belongs to Plas Llangwnnadl, is called Cae Eisteddfa to this day, which means the place where the pilgrims would sit and rest. This historic church was enlarged in Tudor times.

LLANGYBI CHURCH AND ST CYBI'S WELL *Between Caernarfon and Pwllheli, close to Llanarmon, Caernarfonshire.* As well as various menhirs, stone circles and tumuli in the area, there is the ancient holy well called Ffynnon Gybi. Girls who wished to know their lover's intentions

would spread their pocket-handkerchiefs on the water of the well, and, if the water pushed the handkerchiefs to the south, they knew that everything was right and that their lovers were honest and honourable in their intentions; but, if the water shifted the handkerchiefs northwards, they concluded the opposite. It is approached by crossing a stile at the east end of the churchyard and then following a path to the far corner, across another stile, and down the side of a field into the valley. The well is one of the most elaborate structures of its kind in this area of North Wales, consisting of two well chambers, a cottage for a custodian and a small detached latrine building. The main approach is across a stone causeway on the eastern side of a low-lying waterlogged field. The well was a place of pilgrimage and the waters were reputed to cure warts, lameness, blindness, scrofula, scurvy and rheumatism. The well continued in use, in one form or another, after the Reformation and there was still a box, Cyff Gybi, for offerings in the church as late as the eighteenth century.

LLANGYBI, LLANGIBBY – CHURCH OF ST CYBI, HOLY WELL AND HILLFORT

3 miles south of Usk and 5 miles north of Caerleon, Monmouthshire. The church has a tower, nave and chancel dating from the thirteenth or fourteenth century, and seventeenth-century internal fittings, including the pulpit, font, and monuments to the local Williams family. There are also wall paintings dating from the late medieval period and the seventeenth century. Outside, along the right side of the lane that runs eastwards from the church is the site of St Cybi's Well, which is boarded up but still running. A stonewalled Iron Age hillfort, Carn Pentyrch, lies on the hill above St Cybi's Well. The innermost ring with its thick, high stone wall may be early medieval; the other two lines consist of walls and banks and are prehistoric.

LLANGYBI CASTLE AND WHITE HART ANCIENT TAVERN

The castle is almost a mile outside the village. An existing motte and bailey was fortified in stone in the thirteenth century by the de Clares, and attacked by Llywelyn Bren in 1316. Held for the king, it was slighted in the Civil War. The White Hart Inn was built in the twelfth century for Cistercian monks, and is a listed building dating from the 1500s, given to Henry VIII as part of Jane Seymour's dowry. Cromwell is said to have used it as his Gwent headquarters, and the Catholic martyr David Lewis preached there before being executed at Usk in 1679. The inn has eleven fireplaces from the 1600s, exposed beams, original Tudor plasterwork and a priest hole.

LLANGYNOG – ST CYNOG'S CHURCH

At the head of the Tanat valley, on the B4391. There is a Roman fort here, and the church is built on the mound where the hermit healer Cynog may have preached. The church was first mentioned in the thirteenth century, and is rebuilt in Georgian style. The route through the valley is an ancient drovers' road, which used to pass in front of the sixteenth-century Tanat Inn. In the eighteenth century, lead was discovered and mined extensively. The village grew as the men came to find work and by the end of the nineteenth century there were five pubs, six shops and three chapels. During the eighteenth and nineteenth centuries, Llangynog was one of the largest lead mining areas in Europe and much evidence of the mining and quarrying can still be seen. On Craig Rhiwarth to the north are the remains of a Roman settlement.

LLANGYNWYD – ANCIENT VILLAGE, CHURCH, CASTLE, INN, LEGEND AND CUSTOMS

Llangynwyd, 2 miles south of Maesteg, Glamorgan. Along the Llynfi Valley, this hilltop village has a thatched pub, Yr Hen Dŷ (The Old House), which is reputed to be the oldest inn in South Wales. *The Maid of Cefn Ydfa* is a lovely tune, and the mansion of Cefn Iddfa in Llangynwyd is now in ruins. The song was dedicated to Ann Thomas (1704-27), the daughter of the mansion, who was said to be made to marry a local solicitor, Anthony Maddocks. Her true love, Wil Hopcyn, left the district in grief, and wrote the beautiful song *Bugeilio Gwenith Gwyn* (*Shepherding the White Wheat*) to show his love for her. He returned when she was mortally ill, she died in his arms, and he is buried next to her in Llangynwyd churchyard. There is a memorial cross to her in

the village between St Cynwyd's Church and The Old House. The ancient traditional Mari Llwyd (Grey Mare) custom, a horse's skull draped in a white sheet with flowers paraded to houses, is still held every New Year's Eve. All that remains of the original church of St Cynwyd is the stone socket of a wooden cross, which can be seen in the wall above the entrance. The church was rebuilt in the thirteenth century and has since been restored several times. The ruins of Llangynwyd Castle form a large mound, surrounded by a deep ditch on all but the north-east side, where there was a steep natural slope. It was an important outpost of the lordship of Glamorgan in the uplands of Glamorgan, but too vulnerable to Welsh attack. By 1262 it had been badly damaged by wars, and was stormed again around 1306.

LLANIDLOES, BATTLE OF, 1162 *On the banks of the River Severn, off the A470, 4 miles north of Llangurig, Montgomeryshire.* Hywel ap Ieuaf of Talgarth, Lord of Arwystli, was defeated by Owain ap Gruffudd (Owain Gwynedd) after he had taken Tafolwern Castle.

LLANIDLOES CHARTIST RIOTS 1839 Depression in the flannel industry, and the movement for political reform led to a riot that effectively overthrew the authority of the town's officials for five days, until troops could be mustered to 'restore order'. Llanidloes remained an occupied town for a whole year, whilst trials saw sentences of transportation and imprisonment imposed on over a hundred people.

LLANIDLOES – THE CHURCH OF ST IDLOES The timber-framed, weather-boarded belfry topping the tower, characteristic of the central Welsh Borders, has recently been tree-ring dated to around 1595. The beautiful early thirteenth-century stone pillars and arches – the entire five-bay nave arcade – was brought here from the dissolved monastery of Abbey Cwm Hir in 1542. This is why the church is so large. The magnificent timber 'Angel Roof' of the interior, surmounting the nave, was once thought to have come from the monastery. However, tree-ring analysis has proved that it was purpose-built to fit the new nave around 1542, so it may well be the last of its kind ever constructed in Britain.

LLANIDLOES – OLD MARKET HALL – THE ONLY HALF-TIMBERED MARKET HALL OF ITS KIND IN WALES Founded by St Idloes in the seventh century next to the River Severn, the town began to expand after the Norman Conquest of Britain in 1066, when a motte and bailey castle was constructed on the site where the Mount Inn now stands. In 1280, Llanidloes obtained its first Charter, granted by Edward I, and this was followed in 1344 by a Charter making the town a self-governing borough. This status was retained until as recently as 1974. The layout of wide streets in the shape of a cross that forms the heart of the town originated at this time. The Old Market Hall, still in its original position, was constructed on the centre of the cross early in the 1600s. Llanidloes was renowned for the quality of its wool in the sixteenth century, and its flannel during the eighteenth and nineteenth centuries. There are many timber-framed medieval houses in the town, which has a 'Timber House Trail' on its website.

LLANIESTYN CHURCH AND CARVED STONE *3 miles north-west of Beaumaris, near Red Wharf Bay, Anglesey.* The simple medieval church was founded in the sixth century by St Iestyn, the son of King Geraint. It was granted in 1243, by Llywelyn the Great, to the priory which he founded at Llanfaes. An image of a bearded, hooded St Iestyn is carved on a tomb lid inside the church with the Latin inscription 'Here lies Iestyn to whom Gwenllian ferch Madog and Gruffydd ap Gwilym offered this image for the health of their souls'. There is also an unusual twelfth-century font.

LLANIESTYN – BWRDD ARTHUR – PREHISTORIC HILLFORT At a short distance from Llaniestyn and Llanddona in Anglesey are remains of Bwrdd Arthur, or Arthur's Round Table, the largest camp in Anglesey. This hillfort overlooks the sea and if you search you can find a large

circular stone with twenty-four 'seats' around. Geologists would interpret this as part of a limestone pavement, however. Also known as 'Din Sylwy', it was used in Roman times. A limestone-walled fort occupies the summit of the prominent isolated limestone plateau. The single-walled circuit encloses an area of some seventeen acres, and the seven-foot-wide wall is set back from the cliff edge. The site has produced a quantity of Roman finds.

LLANIESTYN – CHURCH OF ST IESTYN *In the hundred of Dinlaen on the Llŷn Peninsula, 5 miles south-east of Nefyn, and 7 miles south-west of Pwllheli, Caernarfonshire LL53 8SG.* This is a Grade I listed building which dates back to about 1200, of architectural note, being double-aisled and with many interesting features including a minstrel gallery. The church is a spacious structure, partly in the later Norman, and partly in the early English style of architecture, consisting of a nave, south aisle, and chancel. The aisle is separated from the nave by a range of pentagonal pillars and circular arches, and is lit by a series of elegant lancet-shaped windows, and some fragments still remain of the exquisitely carved oak rood screen. Llaniestyn lies at the foot of GARN FADRYN Iron Age camp.

LLANILID CASTLE AND ANCIENT CHURCH OF ST ILID – 'THE OLDEST CHURCH IN BRITAIN' *5 miles north-west of Cowbridge, 2 miles east of Pencoed, Vale of Glamorgan.* Llanilid Castle is a 'raised' ringwork, consisting of a low, circular mound with a tree-clad rampart around the summit. Next to the church, it seems to never have been fortified in stone. St Ilid was said to be an Israelite, who, having embraced Christianity, is said to have accompanied Bran ab Llyr, the deposed prince of Siluria, from Rome, about the year 70. Bran was Caradog's father, and Trefran is nearby. Unfortunately, massive quarrying has destroyed ancient features around here. Ilid has always been identified with Joseph of Arimathea. Under the Normans, the church was rededicated to Julitta, and later to Illtud. It is quite isolated, and when the author last visited it there was a tawny owl perched on a gravestone. The time before a buzzard was disturbed from its perch. Not far from the church is a small wood which used to have a rag well. Near the church is a small enclosure named Y Gadlys, or Battle Court.

LLANILLTUD FAWR (LLANTWIT MAJOR) – ST ILLTUD'S CHURCH AND STONES *On the B4265 coast road between Barri and Bridgend, Vale of Glamorgan.* St Illtud's sixth-century monastery was said to be based upon that founded by St Eurgain in the first century, and then re-endowed by Tewdws. Many saints were taught there including David and Patrick, and it has claims to be the world's first university, in that students were taught there. (The Bologna claim of the eleventh century is based upon travelling professors, not a permanent site.) Remains of the monastery are north of Illtud's medieval church, and nearby Boverton was said to be the birthplace of Arthur. There are three superb Celtic stones in St Illtud's Church. These are the Houelt Cross, for Hywel ap Rhys; the St Illtud or Samson Cross, and the Pillar of Samson, all with Latin inscriptions and knotwork designs. The cross of Houelt is translated as 'In the name of God, the Father and the Holy Spirit, Hoult prepared this cross for the soul of Res his father'. Hywel ap Rhys, King of Glywysing, is recorded as dying in 886, which makes the cross late ninth century. The Pillar of Samson reads 'In the name of God Most High begins the cross of the Saviour which Samson the Abbot prepared for his soul and for the soul of Iuthahelo the king and Artmail (and) Tecan.' This is said to be late ninth century, but is almost certainly sixth century as it seems to relate Abbot Samson, his kinsman Arthur and King Iudicael of Brittany whom Arthur and Samson helped retrieve his throne. The Illtud Stone, or Cross-Shaft of Samson reads 'Samson erected this cross', '(Pray) For his Soul', 'Of Iltyd', 'Of Samson the King', 'Samuel' and 'Ebisar' on different panels. These are national treasures, but ignored in an out-of-the-way jumble at the back of the church. Llantwit Major also has a ruined castle, recently for sale but withdrawn from the market. The remarkable church is Grade I listed.

LLANILLTUD FAWR (LLANTWIT MAJOR) – BOVERTON PLACE – ELIZABETHAN MANSION OF LEGEND *On the eastern outskirts of Llanilltud Fawr.* This ruined substantial Tudor house was built in 1587 by Roger Seys, Attorney General for Wales in the 1590s, who had married Elizabeth Voss. It is believed to hold the largest ivy bush in Wales. It was the Seys family who built the octagonal summerhouse at the nearby coastal hillfort of Summerhouses in the 1730s. The place is in legend far older, associated with the birthplace and court of King Arthur. The Seys family moved out in the late seventeenth century, after its heiress married the owner of FONMON CASTLE, and it fell into decay in the following century. King John was supposed to have starved his wife Hawyse to death here, and her ghost has been seen many times. It was also reputed to be the sixth-century court of the kings of Glamorgan, where Meurig, King Arthur's father died. Its Welsh name is Trebeferad. When the bilingual roadsign was changed recently to Welcome to Boverton/ Welcome to Trebeferad, the Welsh translation mutated to 'Croeso i Drebeferad' prompting a complaint from one of the many newcomers to the town to write to the press about the unnecessary change of the name. The same type of people live in Spain, never learn the language and pine for Branston's Pickle.

LLANILLTUD FAWR – CAER MEAD ROMAN VILLA At Cae'r Mead, Cae Mead or Caer Mead, just north-west of Llanilltud Fawr, lies this remarkable site, hardly known even to local people. Over forty skeletons have been found here, some seemingly killed in battle in a fifth-century Irish raid. There are superb mosaics now covered in earth in its fifty-two rooms, dated to about 320 CE. It was lived in from about 150 to 350 CE, and its 'double-courtyard' construction is extremely rare in Britain. The extended site covers some eight acres. Nearby is a ploughed-out tumulus, near where a gold torc was found in 1861. On an 1885 map Ffynnon Caermead is marked next to the villa, so the villa may originally have been named Cae'r (field of) or Caer (fort of) Mhydew (from pydew, an old Welsh name for a well). Equally, the 'mead' element may have come from 'medd', which means mead.

LLANILLTUD FAWR – COLUMBARIUM, GATEHOUSE AND ALMSHOUSE This dovecote, west of the church, dates from the thirteenth century, with the birds being a food supply for the monastery. High on the outside walls, a timber platform was fixed which enabled the dovecote to be turned into a defensive tower when necessary. The fields in which it is situated have been cultivated for centuries and the mounds in the grass show the line of medieval walls of the monastic grange and buildings. Behind the thirteenth-century gatehouse to the Norman monastic grange, one can see the remains of the foundations of twelfth-century monastery buildings. Nearby Hillhead Cottages were once almshouses for the poor. Alongside the cottages is an ancient flight of steps known as 'Big Man's' or 'Pig Man's' steps. They are an awkward length as they take one and a half paces, but it is said that the monks who made them would have taken shorter paces because of their long robes.

LLANILLTUD FAWR – PORT OF COL-HUW AND CASTLE DITCHES PROMONTORY FORT The beach is the site of the port of Col-Huw, originating in the fifth century with boats crossing the Bristol Channel to Somerset and Devon. It was destroyed by storms in the sixteenth century and was never rebuilt, but some wooden timbers may still be seen. On its eastern cliff is Castle Ditches, dating from the latter part of the Iron Age, depending for its defence on a combination of steep-sided valleys and cliffs. It may have been used until the twelfth century, offering protection to local inhabitants from invasion. One attack was commemorated until the nineteenth century by local people on 3 May and known as the Annwyl Day Celebrations, taking place on Col-Huw Meadow.

LLANLLUGAN – ST MARY'S CHURCH – SITE OF ONE OF ONLY TWO CISTERCIAN NUNNERIES IN WALES *Between Llanfair Caereinion and Llanwnog, south-west of Welshpool, Montgomeryshire.* There has been a church on this site since the sixth century, and part of the shape of the original oval llan can still be seen in the wall surrounding the churchyard. The small church building dates from the late fourteenth century, and was built as a small abbey church for the convent. The window of three lights dates back to 1453, a very rare and superb example of fifteenth-century painted glass. It was hidden in a field to escape destruction in the Reformation. Llanllugan is the only Cistercian abbey church still being used for public worship, although others have survived. The church was founded by Llorcan Wyddel and his wife, followers of St Beuno. The presence of Llorcan's wife was important, as the church is thought to have become a Celtic Christian women's community at a very early stage. In the twelfth century, the Welsh Lord of Cedewain donated land, wood and water to the nunnery. The Cistercian nuns arrived before 1188, and the convent was confirmed by charter around 1240. However, the site of the nunnery buildings remains uncertain; they may have been in the meadow near the River Rhiw 200 yards south of the church. Llanllugan convent is famous for the Dafydd ap Gwilyn poem to Morfudd, *Cyrchu Lleian (Wooing a Nun)*.

LLANLLYR ABBEY – SITE OF ONE OF ONLY TWO CISTERCIAN NUNNERIES IN WALES *6 miles north-west of Lampeter on B4337 to Llanrhystud. Llanllyr, Talsarn, Ceredigion SA48 8QB. Tel: 01570 470900.* This Cistercian nunnery was founded by The Lord Rhys around 1180 as a daughter-house to Strata Florida, and despoiled by the monks of Strata Florida after his death. In 1284, it was granted 40 marks compensation for the damage done during Edward I's conquest of Wales. Little remains except fishponds since it was also stripped after the Reformation. It was one of only two Cistercian nunneries in Wales, along with Llanllugan in Montgomery.

LLANMELIN WOOD HILLFORT CADW *Take minor road north from A48 at Caerwent, Monmouthshire.* Dating from the third century, this impressive site is claimed to have been the tribal centre of the Silures, and Roman pottery has been found there. It has been associated with Camelot by some authors. Within a few miles are many other hillforts, Y Gaer (Tredegar Fort) and Stow Hill in NEWPORT, Wilcrick Hill at MAGOR, TWMBARLWM near RISCA and Lodge Hill in CAERLEON being the most notable.

LLANMIHANGEL – PLAS LLANMIHANGEL – GRADE I LISTED FORTIFIED MANOR AND COURTHOUSE *Llanmihangel, near Cowbridge, Vale of Glamorgan CF71 7LQ. Tel: 01446 774610. Web: plasllanmihangel.co.uk.* Dating at least from 1166, it has defensive origins with winding spiral staircases, slit windows, spy holes and massive timber door bolts. During the sixteenth century, the Sheriff of Glamorgan used the Great Hall as his courtroom with his prisoners housed in the cells in the undercroft. The manor house itself looks down over the thirteenth century Church of St Michael with its holy well, and across to the great barn. The Royal Commission on Ancient Monuments described the house as 'one of the finest and most complete gentry houses in Glamorgan'. The structure of the medieval house still stands but is now partly enclosed by early sixteenth century additions. On the first floor, the finest room is now known as the banqueting hall, and has a fine Tudor moulded plasterwork ceiling and seventeenth-century oak panelling. The stone fireplace is decorated with six carved heraldic shields, whilst the coat of arms of Elizabeth I adorns the doorway leading to a comfortable panelled parlour. The gardens include a rare example of an untouched William and Mary garden, which once had over a hundred ornamentally clipped yew trees in a geometric plan typical of the fashion of the late seventeenth century. One can stay in one of the twelve bedrooms in the thirteen-staircase manor. Below the mansion, the thirteenth-century St Michael's relies solely on oil lamps and candles for lighting. It has a large, simple font, stone benches in the porch, a harmonium for musical accompaniment, and is a Grade II* listed building.

LLANNON – BRYN MAEN STANDING STONE *11 miles south-east of Carmarthen, between Pontyberem and Pontardulais, Carmarthenshire.* There is a medieval double-nave church dedicated to St Non, the mother of St David. The parish was a centre for the Rebecca Rioters, and they are said to have used a 'secret passage' under the road from the church to the Red Lion public house. Near Mynydd Mawr are two meini-hirion (menhirs). The Bryn Maen menhir is nearer to Llannon, and at 15 feet tall is the highest in Carmarthenshire. The Bryn Rhyd stone is near Llanedi.

LLANNOR – CHURCH OF THE HOLY CROSS *Near Pwllheli, Llŷn Peninsula, Caernarfonshire.* The seventh-century Llannor stone was used as a gatepost to the churchyard (hence the four holes), and now stands in the porch, inscribed: 'FIGVLINI FILI LOCVLITI HIC IACIT', '(the stone of) Figulinus son of Loculitus he lies here.' There is a long thirteenth-century nave and chancel and the south transept was added in the late nineteenth century. The west tower, with a saddleback roof and stepped sides, is late fifteenth century and was increased in height during the sixteenth century.

LLANOFER – LLANOVER ESTATE AND ST BARTHOLOMEW'S CHURCH *On the east side of the A4042, 4 miles south-east of Abergafenni, Monmouthshire.* Augusta Waddington (1802-96), married Benjamin Hall, Lord Lanover, and ensured that only Welsh was allowed to be spoken in Llanofer Hall. ('Big Ben', at Westminster is named after Lord Lanover.) Lady Llanofer was responsible for a revival of interest in traditional Welsh dress and folk dancing. She had a personal harpist and her reputation grew to the point where she was called 'The Living Patron Saint of Wales'. With Charlotte Guest, her work led to the Welsh Revival of 1835-45 and the foundation of the National Eisteddfod, the Welsh Manuscripts Society and the Society of Cymmrodorion. A listed fifteen-acre garden and arboretum was laid out in the eighteenth century to include streams, canals, cascades, ponds, lawns and a circular walled garden. The earliest form of the name Llanover Church is Llanmouor (*c.* 1150), Llan Myfor. The sixth-century Myfor may have also founded MERTHYR MAWR in Glamorgan. The Normans renamed the church. There is a thirteenth-century nave and font, fourteenth-century rood-loft stairs, and sixteenth-seventeenth-century oak pews with carved heraldic arms. A fourteenth-century cross-incised tomb slab is supposed to be that of the founding saint, and the preaching cross in the churchyard has the top missing, but many of the stones at the base formed part of a pre-Christian stone circle.

LLANOVER – THE GOOSE AND CUCKOO INN – PUBLIC HOUSE *Upper Llanover, Abergavenny, Gwent, NP7 9ER. Tel: 01873 880277.* About 250 years old, an excellent place, first used by drovers on the old road between Blaenafon and Abergafenni.

LLANRHAEADR-YM-MOCHNANT – ST DOGFAN'S CHURCH *Off the B4396, in Denbighshire 12 miles south-west of Oswestry.* This is the former parish of Bishop William Morgan, and he completed his translation of the Bible into Welsh while here. The Welsh name translates as 'the church by the waterfall in the commote of the fast-flowing stream'. It was founded by Dogfan ap Brychan Brycheiniog and has a large curvilinear graveyard. The wagon ceiling, with carved Prince of Wales feathers, over the chancel is fifteenth-century and it is believed that a medieval barrel ceiling lies above this. Amongst the relics are a pre-Norman Conquest gravestone in memory of Gwgan ap Edelstan, a Welsh prince of the tenth century. Nearby Pistyll Rhaeadr in the Berwyn Mountains is the highest waterfall in England and Wales, plunging 240 feet in two stages. George Borrow in 1854 called it one of the 'seven wonders of Wales'. An ancient stone avenue of 150 feet was said to lead into Llanrhaeadr-ym-Mochnant, and there are three nearby menhirs, one moved in 1770 to be used as a milestone. A nearby stone circle on Rhos-y-Beddau (Moor of the Graves) had thirteen stones.

LLANRHAEADR-YNG-NGHINMEIRCH, LLANRHAEADR-DUFFRYN-CLWYD – ST DYFNOG'S CHURCH – THE FINEST JESSE WINDOW IN WALES *2 miles south of Denbigh on the way to Rhuthun.* A fine double-nave medieval parish church with a two-hammer-

beam roof with carved angels, west tower and many other features. The churchyard may originally have had a more curvilinear appearance. The huge stained glass Jesse window was bought from BASINGWERK ABBEY during the Dissolution, and hidden in a massive dugout chest during the Civil War to escape being smashed. The coffer is to be seen below the Jesse window.

LLANRHAEADR-YNG-NGHINMEIRCH – ST DYFNOG'S WELL The holy well is a short walk through the woodlands west of the church. This was one of the most renowned wells, able to cure skin diseases, dumbness, deafness and smallpox. Saint Dyfnog ap Medrod was an ascetic, standing in the well tank under the holy spring as a penance. In Georgian times, a marble 'bathing-tank' was installed, which can still be seen. There are almshouses in the village, and the well was said by Pennant to be roofed and full of small human statues.

LLANRYCHWYN – CHURCH OF ST RHYCHWYN *West of Llanrwst, above Trefriw near the B5106 in the Conwy Valley, Caernarfonshire.* Rhychwyn was the brother of St Celynnin ap Helig, who founded nearby LLANGELYNNIN. Some claim that the church is the oldest in Wales, dating from the sixth century. The church is known locally as Llywelyn's Church, and the oldest part dates from the late eleventh century – from which time we see the wonderful roof timbers. Llywelyn the Great married Siwan (Joan), the daughter of King John, around 1204. From his hunting lodge in Trefriw, they walked up to this church to worship but she grew tired of the walk, so he endowed another church in 1230, now called St Mary's, in TREFRIW. The church has many interesting features including an ancient square font, and a very early example of stained glass in the east window. It has remained largely with a Tudor interior, and is still lit by candlelight. The ancient oak door has wooden hinges, and its thirteenth-century bell possibly came from Maenan Abbey. The great bard Taliesin was said to have lived at nearby Llyn Geirionydd.

LLANRUMNEY (LLANRHYMNI) HALL – BIRTHPLACE OF A BUCCANEER *On the bank of the River Rhymni, in an eastern suburb of Cardiff, Glamorgan CF3 4JJ.* This is the birthplace of the father of the world's most successful privateer, Admiral Sir Henry Morgan. Morgan's uncles, Thomas and Edward, were also born here, and served as generals on either side in the Civil War, probably to ensure that the estates were not confiscated. The land here had been given to Keynsham Abbey after the Norman invasion of south-east Wales, and a Franciscan monastery was endowed by Gilbert de Clare. It supposedly contains the body of Llywelyn the Last, brought here in 1282 after his head was taken to London. John Hodder Moggridge, who lived at Llanrumney Hall from 1812 to 1823, came across a stone coffin containing a headless corpse inside a thick wall, while he was renovating the Elizabethan building. The abbey then evolved into a Tudor mansion owned by the Morgans, a cadet branch of the famous Morgans of nearby TREDEGAR HOUSE. After the Dissolution, the hall and its 700 acres of estates were lived in by the Morgans and the Kemys families until its compulsory purchase by Cardiff Council in 1951 to build a massive council estate. The hall became an approved school and then a pub, but has an old carved fireplace and ancient dining table that Henry Morgan would have known. A wonderful Tudor staircase there was accidentally burnt and destroyed during renovations. The building is 'tired' and its wonderful site, once half a mile from other houses, is surrounded except for a green park to its west. This author has written *Admiral Sir Henry Morgan: The Greatest Buccaneer of Them All*.

LLANRWST – ALMSHOUSES AND STONE BRIDGE *In the Conwy Valley, where the A470 meets the A458, Conwy LL26 0LE. Tel: 01492 642550.* The Grade II listed Llanrwst Almshouses were constructed in 1610 by Sir John Wynn of Gwydir to house twelve poor men of the parish. Its last inhabitant died in 1976. In 2002, they were reopened as a museum of local history and a community focal point. A working herb garden is in the museum grounds. Y Bont Fawr, The Great Bridge, is an elegant stone bridge over the River Conwy, built in 1636, reputedly by Inigo Jones.

LLANRWST, BATTLE OF, 954 Owen ap Hywel of Deheubarth invaded Gwynedd but was defeated, and peace was established. Owain controlled Deheubarth from 954 to 987, aided by his sons Maredudd and Einion, and their eastward expansion into former Welsh territory was the cause of a Saxon invasion in 981.

LLANRWST – CHURCH OF ST GWRST AND GWYDIR CHAPEL The church dates back to the twelfth century, burnt in the Glyndŵr War, rebuilt in 1470 and restored in the late nineteenth Century. The church features a richly carved oak rood screen with meticulous carvings of the Instruments of the Crucifixion in its tracery, and a minstrels' gallery above. These fixtures may have come from Maenan Abbey, as did much of the stone in Gwydir Castle. The adjoining Gwydir Chapel of 1610 is attributed to Inigo Jones, and has several historically interesting features including memorials to the Wynn family of Gwydir, together with the magnificent stone coffin of Llywelyn the Great (Llywelyn ap Iorwerth). After his death in 1240 Llywelyn was laid to rest in Aberconwy Abbey in Conwy but had to be removed to MAENAN ABBEY. The coffin was removed during the Dissolution, but there is no body. The chapel also contains some magnificent portrait brasses, and an effigy of a knight in armour accompanies the empty coffin of Prince Llywelyn. The early fifteenth-century effigy is of a descendant of Llywelyn, Hywel Coetmor, who fought both for Glyndŵr and at Agincourt.

LLANRWST – GWYDIR CASTLE *Half a mile south-west of Llanrwst LL26 oPN. Tel: 01492 641687.* Outside Llanrwst, it had been owned by Hywel Coetmor in the time of Glyndŵr, but was destroyed during the Wars of the Roses in 1466. Gwydir Castle is set within a Grade I listed, ten-acre garden, on the banks of the River Conwy. Rebuilt by the powerful Wynn family from around 1500, it is a superb example of a Tudor courtyard house, incorporating reused medieval material from Maenan Abbey. Its important 1640s panelled Dining Room has been reinstated in 1988, following its rediscovery in the New York Metropolitan Museum. Other original panelling is still missing. Gwydir Castle is situated in the beautiful Vale of Conwy in the foothills of Snowdonia. The first castle was built by the warrior Howell Coetmor in the fourteenth century, and it was rebuilt in around 1490 by Meredydd, founder of the Wynn dynasty and a leading supporter of Henry VII. In the 1570s Gwydir was the home of Katherine of Berain 'the mother of Wales', the cousin of Queen Elizabeth I.

LLANRWST – GWYDIR UCHAF CHAPEL CADW *1 mile south-west of Llanrwst. Tel: 01492 641687.* This simple stone-built chapel was built as a private chapel on his estate by Sir Richard Wynn in 1673. Plain outside, the interior is 'High Church', reflecting its owner's religious persuasions. It is noted for its colourful painted ceiling.

LLANSADWRN – CHURCH OF ST SADWRN AND THE SATURNINUS STONE *3 miles west of Beaumaris on the road to Pentraeth, Anglesey.* A stone was found buried in the churchyard in 1742, and roughly trimmed to fit into the chancel. It is believed to date from 530, commemorating Sadwrn, the founder of the church. It has been translated as 'Here Lies Blessed Saturninus and His Holy Wife. Peace Be With You (Both).' Sadwrn Farchog (the Warrior) was the brother of St Illtud, and his wife was St Canna, the daughter of Tewdwr ap Emyr Llydaw. The church has undergone several restorations.

LLANSADWRN – MELIN LLYNNON – THE ONLY WORKING WINDMILL IN WALES The 1775 windmill has been restored and is next to a replica Iron Age farmstead.

LLANSANNOR, LLANSANWYR – THE HAMLET THAT INCLUDES A COURT AND A CITY *North of Cowbridge, Vale of Glamorgan.* Llansannor House was built by Richard Gwyn and is an Elizabethan manor house with a formal façade, central porch and stoned mullioned windows. Its hall is oak-panelled with a carved frieze of strange animals, and a fine Renaissance-

style fireplace. The west wing was an earlier fifteenth-century manor house, with a central stone staircase. Adjacent is the hamlet of City, where the once renowned City Inn has closed. Llansanwyr may be named after St Cadog, whose body was said to be hidden here, with 'Sanwyr' meaning saintly man, or after the local stream. However, the medieval church is dedicated to St Senwyr, the brother of Tudno, and has a saddleback roof, sixteenth-century porch with sundial, wall painting and other architectural features of interest.

LLANSANFFRAID-YM-MECHAIN – THE CHURCH OF ST FFRAID *8 miles north of Welshpool, and 8 miles south-west of Oswestry, in Montgomeryshire.* The name of the village means 'The Church of St Bridget in the cantref of Mechain'. At the church's core lies a twelfth-century building, extended in the fourteenth century. A south porch and western bell-turret were added in the seventeenth century and there are also wooden furnishings of that time.

LLANSANFFRAID-YM-MECHAIN ROMAN COMPLEX A Roman supply base and granary in Bronhyddon field, where archaeology revealed a barracks and a centurion's house. The site is on Watling Street and the Roman road to CAERSWS. It is a polygonal double-ditched straight-sided enclosure. Nearby Plas-yn-Dinas seems to be a Dark Age site, used up to the fourteenth century. Y Foel Iron Age Camp is situated on the summit of the Foel Hill, to the west of the Winllan Road.

LLANSTEFFAN CASTLE CADW *Take the B4312 for 8 miles south-west of Carmarthen, Carmarthenshire.* Near Carmarthen, the castle was first erected in the twelfth century on an Iron Age promontory site. After Cadell ap Gruffudd had taken Dinefwr, Carmarthen and Llansteffan in 1136, Llansteffan was given to his brother Maredudd ap Gruffudd, who fought a combined Flemish-Norman army. In 1146, it was taken by the princes of Deheubarth and held until 1158. It was retaken in 1189 by The Lord Rhys, but fell to Henry II. Llywelyn the Great captured and burned it in 1215, and it was also burned by Llywelyn the Last in 1257 after the English defeat at COED LATHEN. Glyndŵr took the castle, and Jasper Tudor renovated the gatehouse in the late fifteenth century. The extensive remains are superbly sited, overlooking the outlets of the Towy, Tâf and Carmarthen Bay. The ancient manor of Plas Llanstephan nearby has fallen into disrepair. Llansteffan Church is dedicated to the sixth-century St Ystyffan and is medieval, being recently voted one of the 100 favourite churches in the UK by *Daily Telegraph* readers.

LLANTARNAM ABBEY *Five miles west of Newport, Monmouthshire, near Cwmbran NP44 3YJ.* It was founded Lord Hywel ab Iorwerth of Caerleon in 1179 and later colonised by Cistercian monks from Strata Florida. Its abbot John ap Hywel died fighting for Owain Glyndŵr. Dissolved in 1536, it was made into a country home by the Catholic, William Morgan in 1553, and the Great Hall rebuilt in the 1830s. St David Lewis was a Jesuit priest, captured close to the abbey opposite the present-day inn, The Greenhouse. He was martyred for his faith at Usk in 1679 and canonised as a Martyr Saint in 1970. The sisters of St Joseph of Annecy bought it in 1946 as their centre for their order in the UK and Ireland, and the chapel is open for worship.

LLANTILIO CROSSENNY, BATTLE OF, *c. 577 5 miles east of Abergafenni, on the B4233.* Prince Iddon ap Ynyr Gwent was losing to the Saxon invaders who had chased the survivors of the Battle of Dyrham into Wales. St Teilo's prayers swayed the battle and the Saxons were defeated. Iddon gave the land where the battle was fought to St Teilo, where he built the church.

LLANTILIO CROSSENNY – CHURCH OF ST TEILO Dedicated to the sixth-century Saint Teilo, Bishop of Llandaff, who apparently stood with a cross on a pre-Christian mound at this site and helped put the invading Saxons to flight in the sixth century. The Welsh for the village is Llandeilo Groesynni, 'the Holy Place of Teilo at the Cross of Ynyr'. The twelfth-century Norman font predates the thirteenth-century tower arches and the lancet windows in the west wall, when

the church was rebuilt in stone in the form of a cross. St Teilo's is a relatively large church because the medieval bishops travelled with a large retinue between their manors and used it as a cathedral. it was also the church for the nearby White Castle. In the fourteenth century the roof was raised and the north transept was enlarged, to form a Lady Chapel, now the Cil Lwch. The head on the right of the altar is thought to represent Edward II (1307-27). There have been several changes to the chancel wall which has a blocked doorway and a squint for the priest to see the high altar where gifts were laid and where there may have been relics of St Teilo. There is a pagan Green Man on a corbel in the north chapel, with his tongue hanging out and leaves sprouting from his nose. There is an annual festival of music and drama in the village.

LLANTILIO CROSSENNY – WHITE CASTLE (LLANTILIO CASTLE, CASTELL GWYN) CADW *A mile north of Llantilio Crosenny towards Llanvetherhine.* It was once lime-washed white, and was one of the Gwent trilateral of castles along with Skenfrith and Grosmont. Moated, it was built in the twelfth-thirteenth century and is a superb example of castle-building, and well worth visiting. With a twin-towered gatehouse it has four other defensive towers and sits on a mound. There is a deep-cut water moat, impressive outer defences and this is one of Wales' hidden gems.

LLANTHONY, BATTLE OF, 1136 *In the Vale of Ewyas, 5 miles north-west of Llanfihangel Crucornau.* Richard de Clare crossed the borders of Wales in April, heading towards his troubled lordship of Ceredigion with a small force. He was ambushed and killed by the men of Gwent under Iorwerth ab Owain and his brother Morgan, grandsons of the penultimate Prince of Gwent Caradog ap Gruffydd, in a woody area called 'the ill-way of Coed Grano', near the Abbey of Lanthony.

LLANTHONY PRIORY CADW AND ST DAVID'S CHURCH This is a beautiful ruined Norman priory in the mysterious Vale of Ewyas, with a pub/hotel built into the remaining tower. It was recognised as an Augustinian priory by 1118, but the Welsh had forced its desertion by 1135. The de Lacys brought canons from Gloucester and built the present priory between 1180 and 1230. It suffered during the Glyndŵr War of 1400-1415. Rhiw Pyscod is a footpath from Llangorse Lake to bring fish, still alive and wrapped in rushes, to the monks. Rhiw Cwrw is another path leading to the abbey, bringing beer from Abbey Dore. (Rhiw means hill, pyscod means fish and cwrw is beer.)

Adjacent to the priory, St David's Church predates it, on a Celtic foundation, but the present church dates from 1109. It has thick defensive walls and small windows, and the altar is sited to face the sun on 1 March, St David's Day. Llanthony is a corruption of Llan Honddu, itself an abbreviation of Llan-Ddewi-Nant Honddu – the holy foundation of David on the Honddu Stream.

LLANTRISANT – CAERAU HILLFORT *Overlooking the Clun on the hill of Rhiw Saeson, Llantrisant, Glamorgan.* Caerau Hillfort is an oval Iron Age enclosure, measuring 755 feet by 590 feet. Dating from 700 BCE, it is one of the largest known hillforts in South Wales. The defences comprise a set of two banks and ditches, with a counterscarp bank. Originally, the bank stood approximately 25 feet high, though much of it has been destroyed, and only 100 feet of the north-east (the best-preserved) bank remains. There were supposed to have been battles here in 720 and 873 CE.

LLANTRISANT – GARTH MAELWG (MAELOG), BATTLE OF, 720 OR 722 *Three massive cairns, named the Beacons, are supposed to mark the burial place of those slaughtered on Mynydd Garth Maelwg, killed on Rhiw Saeson (Saxon Slope.)* Arthfael fought the Saxons here, and was later killed fighting them near Cardiff in Glamorgan, being buried at Roath in Cardiff. 'On Mynydd Garth Maelwg, which stands on the right bank of the river, are three huge cairns. These are supposed to mark the site of a fierce battle, fought between the Welsh and the Saxons, the dead being buried

beneath them. On the hills on the other bank of the river is a large Roman camp. By means of the pass, through which the Ely enters the low ground, invading armies were able to make their way into the hilly district of the north. The pass also made it possible for any Welsh who had been driven to the hills to sweep down on enemies that had settled in the land to the south. It can be seen that the defence of this pass was an important matter. The Welsh had a fortress here, and after the Normans had conquered the county, they, in a very short time, took this and built one of their strong castles on the spot.' (from *The Story of Glamorgan*). There is also an ancient healing well called Garth Maelwg between Llantrisant and Llanharan.

LLANTRISANT CASTLE Richard de Clare built this in 1250 to control Meisgyn (Miskin), but only a tower survives to any extent.

LLANTRISANT BULLRING – STATUE OF DR WILLIAM PRICE 1800-1893 Llantrisant's main claim to fame is its nineteenth-century doctor/druid, Dr William Price, who proselytised not just vegetarianism, nudity, and free love, but also the unhealthiness of socks, the potential dangers on the environment from rapid industrialisation, revolution, republicanism and radical politics. He refused to treat patients who would not give up smoking, and prescribed a vegetarian diet instead of pills. He was the first doctor to be elected by a group of factory workers as their own general practitioner, being paid a weekly deduction out of wages paid at the Pontypridd Chainworks. This was the precursor of the miners' medical societies, which were, in turn, the origin of the National Health Service. A skilled surgeon, he attended Chartist rallies in a cart drawn by goats. He was forced to escape to France (disguised in a frock) to live in 1839, after taking part in the Chartist Riots in Newport, and returned seven years later. He held druidic ceremonies at the rocking stone near Pontypridd, which were considered satanic by the local Methodists. He did not approve of marriage as it 'reduced the fair sex to the condition of slavery' and lived openly 'in sin' with his young housekeeper. This precursor of the Hippy Movement had a son when he was eighty-three, and named him 'Iesu Grist'(Jesus Christ). When Iesu died, aged five months, in 1884, Dr Price cremated him on an open funeral pyre. Price was dressed in flowing druidical robes, and timed the event to take place as the locals were leaving their chapels. The local population attacked him, rescuing the charred remains of the child, and the police arrested Price. The mob then went to find the mother, Price's young housekeeper, Gwenllian, but were deterred by Price's twelve large dogs. The doctor was acquitted after a sensational trial in Cardiff, and cremation was legalised in Britain as a result. Another infant was born, named 'Iarlles Morgannwg', the Countess of Glamorgan, and in one of his many lawsuits he called the child as assistant counsel to him. He issued medallions to commemorate his legal victory on cremation, and at the age of ninety had another son, once again called Iesu Grist. At the age of ninety-three, he was cremated in front of twenty thousand spectators at East Carlan Field, Llantrisant. This was the first legalised cremation (1893), and a ton of coal and three tons of wood were used to accomplish the mission. Price had organised the cremation himself, selling tickets to the people that later attended it. Llantrisant's pubs ran dry. Price, with a long flowing beard and hair past shoulder-length, habitually wore only the national colours of red, white and green. His cloak was white, his waistcoat scarlet, and he wore green trousers – the colours of Wales. On his head was a red fox-skin pelt, with the front paws on his forehead and the tail hanging down his back. He built two round 'Druidic' towers in 1838 near Trefforest as a gatehouse for his projected eight-storey Druidic Palace, and they are lived in today. Dr Price's dying act was to order and drink a glass of champagne before he moved on to his next destination. His birthplace, the Green Meadow Inn at Waterloo, near Newport, was in the news in 1996. Discovery Inns wished to demolish it, to put up thirteen boxes that pass for living dwellings these days. CADW, the historic monuments society in Wales, washed its hands of the matter, although the local community desperately wanted to save this historic site. The houses were built. Sic transit gloria Cambria.

LLANTRISANT - THE CHURCH OF SAINTS AFRAN, IEUAN AND SANNAN FOFC *Near Holyhead, Anglesey.* This dates from the fourteenth and seventeenth centuries, with a Norman font (which is not original to the church). There is a major monument of 1670 to Hugo Williams. The church is listed Grade II*.

LLANVACHES - THE FIRST INDEPENDENT CHURCH IN WALES *Just north of the A48, halfway between Newport and Chepstow, below Wentwood Reservoir.* The village is named after St Maches, the sister of Cadog, who was killed by robbers. St Tathan of Caerwent built a church on the site where the fourteenth-century Church of St Dyfrig (Dubricius) now stands. The village was formerly called Merthyr Maches (the place of martyrdom of Maches). The United Reform Church Tabernacle in Llanvaches is built on the site of the first Nonconformist chapel in Wales. It was built in 1639 as a Congregationalist chapel, and marked the real beginning of Nonconformity in Wales. William Wroth founded the first Independent Church in Wales here the year previously, and is buried beneath the church porch. (The first Welsh Baptist chapel was at ILSTON in Gower and dates from 1649.) A castle formerly stood here.

LLANVIHANGEL Y GOFION (GOBION) - LLANSANTFFRAED COURT HOTEL *Near Abergafenni NP7 9BA. Tel: 01873 840678.* A superb listed country house hotel, it is near the medieval St Michael's Church. The site dates back to the twelfth century. The present house is built in the style of William and Mary and stands within twenty acres of private parkland, complete with ornamental lake and fountain. It has been an established hotel since the 1920s.

LLANWNDA - FORT BELAN - GRADE I LISTED COASTAL FORTIFICATION *On the Caernarfon coast at the south-west end of the Menai Strait, opposite Abermenai Point.* This was built in 1775 by the MP Thomas Wynn, later Lord Newborough, who was worried about an attack on Britain during the American War of Independence. It is believed to be the only fort in Europe the construction of which was linked to the American War of Independence. The fort was initially garrisoned by Lord Newborough's own troops, and still remains today very much as originally built, but converted into six holiday cottages. Belan's unique dock was largely constructed by the second Baron Newborough and completed in 1826.

LLANWENOG - ST GWENOG'S CHURCH - 'THE MOST COMPLETE MEDIEVAL CHURCH IN CEREDIGION' *5 miles west of Lampeter, Ceredigion.* The Grade I Listed church is dedicated to the virgin St Gwenog or Gwynog, and is thirteenth to fourteenth century, with a massive 64-foot-high tower. Sir Rhys ap Thomas fought for Henry Tudor at Bosworth, and erected the tower from 1485 in gratitude for the victory. The churchyard was originally roughly circular in shape, indicating an early date for this llan. There is a superb stone-carved twelfth-century font. A stone at the church reads, 'Trenacatus ic jacet filius Maglagni.' Ffynnon Wenog near the church was used to cure children with weak backs, who were immersed in its waters before sunrise. There are nearby tumuli, barrows and prehistoric forts. 'There was also within the last few years another relic of antiquity, called Carn Philip Gwyddyl, the cairn or barrow of Philip the Irishman, a curious bank of earth, six yards in length and four feet high, resembling in form the rude sketch of a prostrate human figure, without the head, and with the arm stretched out: it was situated in a field not far from the church, but was destroyed a few years since. Tradition reports it to have marked the burial-place of a freebooter, who lived in the tower of the church, and who, on leaping from it when closely pursued, broke his leg and was captured.'

LLANWNNOG - ST GWYNNOG'S CHURCH *A mile north of Caersws, Montgomeryshire.* St Gwnnog was also known as Abbot Gwynno and was a son of Gildas ap Caw, the first historian of the Britons. This author's grandfather was from Llanwnnog, so the thirteenth-century church has strong resonances. Its extremely fine rood loft and screen is dated around 1500, and like that at Llananno, was carved in Newtown. The crossbeams and the underside of the loft are carved

with vine and oakleaf trails, wyverns, interlace and circle motifs. Red sandstone in the walls of the church comes from the Roman forts at Caersws. In its Celtic Christian circular raised churchyard is the grave of the poet John Ceiriog Hughes. There is a jumble of late medieval glass in the windows which may have come from Llanllugan nunnery.

LLANWRTUD (LLANWRTYD) WELLS – THE SMALLEST TOWN IN BRITAIN *11 miles north-east of Llandovery on the A483.* This claims to be the smallest town in Britain, with a population of just over 600. Its well was documented in the fourteenth century as 'Ffynnon Drewllwyd' or 'Droellwyd' ('Smelly Spring'), as its overpowering smell is due to its having the highest sulphur content in Britain. The spring was rediscovered in 1732 when the local vicar saw a frog come out of it, and realised that it must be safe to drink. The Reverend Theophilus Evans then announced his cure of the 'grievous scurvy', and encouraged people to come and partake the waters, because the presence of healthy frogs meant that the water was pure. However, not until the Victoria Wells were exploited by piping the water in 1897 (thereby removing the frogs), did the range of magnesium, saline and chalybeate treatments become popular. Until this time, the tiny hamlet had been known as Pont-Rhyd-y-Fferau (Bridge over the Ankle-Deep Ford) as it was centred on the bridge which spans the River Irfon. In 1903, the Abernant Lake Hotel was built to satisfy the demand for visitors to the new spa. Locals claim that they 'invented' pony-trekking in the 1950s. The town stages offbeat events such as the annual 'Man versus Horse' Race over a hilly twenty-two-mile course every June. It also holds a Mountain Bike Festival including Bog-Leaping, the World 'Bog Snorkelling' Championships, the Welsh International 4-Day Walk, The Drover's Walk in late June following the old routes with a drovers' inn reopened for the day, the Welsh International 4-Day Cycle Race, the Real Ale Wobble and the Mid-Wales Beer Festival. Llanwrtyd is an example of a village constantly trying to promote itself as a tourist venue against world recessions and uncertain weather patterns – and succeeding.

LLANWYNNO, LLANWONNO – CHURCH OF ST GWYNNO *Near Ynysybwl, on the ridge between the Rhondda Fach and Cynon Valleys.* Every New Year's Eve, there is a 6km Race in Mountain Ash with international athletes, to commemorate the eighteenth-century shepherd Guto Nyth Bran (Griffith Morgan, 1700-37), who died after running twelve miles in fifty-three minutes. His death at the age of thirty-seven was attributed to being slapped on the back after winning the race. It was said that he could beat horses in races, keep up with hounds, and out-run a hare. A broken heart features on his gravestone in the churchyard of St Gwynno at Llanwynno, where most of the inscriptions outside the church are in Welsh. Most of those inside are in English. It is a wonderful place, with gravestones tumbling over on the steep, secluded graveyard. It has been claimed that Eglwyswynno was erected on a Roman catacomb containing not only the sacred remains of St Gwynno, a disciple of Illtud, but also being the last resting place of large numbers of Romans.

LLANYBYDDER – HORSE FAIR *On the River Teifi, on the B4337, just off the A485 south-west of Lampeter, Ceredigion.* The West Wales Horse Sale is the biggest monthly sale in the country and is held at Llanybydder on the last Thursday of every month. The Horse Fair has been going since the nineteenth century and the sales have continued without interruption ever since. Between 3,500 and 4,000 horses pass through the two Sale Rings every year. In the early days, heavy working horses, i.e. cart, collier and shire horses, were in the greatest demand to be taken to London to pull Brewery Carts, Milk Floats and general farm duties. During the war years there was a huge demand for Pit Ponies to work the coalmines of South Wales. Over the last thirty years there has been a call for good Hunters and strong cobs for hunting, and the Welsh Cob is now exported throughout the world. Eglwys Sant Pedr (St Peter's Church) has a tower that may be twelfth century, and it is known that in 1363 it was part of Carmarthen Priory.

LLAWHADEN CASTLE CADW *East of Haverfordwest, north of the A40 at Robeston Wathen.* A fortified palace of the bishops of St David's, first created as a ringwork in the twelfth century and totally rebuilt mainly in the fourteenth century. It was fortified in stone in the later twelfth century after a siege by The Lord Rhys. In the thirteenth century, Bishop Thomas Bek made the greatest impact at Llawhaden, when he established and expanded the village. He built the complex hall block, stone-vaulted undercrofts, and the bishop's elaborately adorned chambers above. During the next century, the bishops added the twin-towered gatehouse, the most impressive structure at Llawhaden Castle.

LLECH-Y-CRAU, BATTLE OF, 1088 *Probably Llechryd on the River Teifi - on the A484 3 miles from Cardigan, on the way to Cenarth, Ceredigion.* Rhys ap Tewdwr had been forced from his kingdom of Deheubarth by the sons of Bleddyn Cynffin, assisted by Normans. He returned with a fleet and defeated the invaders here, killing two of Bleddyn's sons, Madog and Rhiryd. The name Llechryd comes from llech (slate) and rhyd (ford) and slate was worked at local quarries. ('Crau' means stockade, so the ford was probably defended. However, llech can also mean 'flag', so Llech-y-Crau could have meant a stockade with a flag flying.) An old drovers' road passes over the seventeenth-century bridge over the Teifi here, but can be completely submerged in times of flood, as last happened in 2005. The crossing point has documented medieval origins, probably as a ford, which led to the formation of the elongated village along the banks of the Teifi. A chapelry to Llangoedmor, dedicated to the Holy Cross, was built to serve this new community, probably during the fourteenth century. Its remains lie on the bank of the Teifi, at the centre of the village. Nearby Manordeifi, just over the county border in Ceredigion, has a thirteenth-fourteenth-century church, with a coracle in its porch, providing a means of escape during floods.

LOUGHOR (CASLLWCHWR) CASTLE CADW *At the mouth of the Loughor River, where the A484 meets the A4240 west of Swansea heading to Llanelli.* On a strategically vital River Llwchwr crossing, the Roman garrison fort of Aberllwchwr, Leucarum, was built in 75 CE, abandoned in the second century but probably reused in the third-fourth century. It lies on the Via Julia linking Wroxeter with Caerleon, Cardiff, Neath and Carmarthen. In its corner a Norman castle was built in 1116, and there are the remains of a thirteenth-century tower. In 1151, it was attacked and burned by the Welsh, but rebuilt in stone. Scorched Norman chess pieces, possibly dating to this event, have been unearthed at the site. A Roman altar was found nearby, reused with a damaged inscription in Ogham, possibly reading GRAVICA.

LLYN BRENIG SACRED LANDSCAPE *On Mynydd Hiraethog, between the B4501 and A453, west of Ruthin, Denbighshire.* There are many remains of constructions from the Bronze Age people (c. 2000 BCE - c. 1500 BCE) who lived in the drowned valley of the reservoir of Llyn Brenig. An archaeological trail leads through some of the sites, such as a reconstructed platform mound, Maen Cleddau (the Stone of the Swords), a reconstructed ring mound, and Boncyn Arian (the Hillock of Silver). This latter burial mound has been grave-robbed, probably because of its name.

LLYN CERRIG BACH – THE LARGEST HOARD OF CELTIC TREASURE DISCOVERED IN BRITAIN It is now on RAF ground, as a runway was built over the sacred lake. Take the A5 to Caergeiliog, At the western end of the village, turn left at the Toll House, take the next left towards RAF Valley airfield, and the site is marked by a large boulder. This was found during the Second World War during the RAF construction when workmen recovered over 150 bronze and iron objects from the peat which had formed in a former lake. The first find pulled up by a harrow was an iron chain. It was so strong that it was used to pull a tractor out of the mud, before its true nature was ascertained – a slave-gang chain of iron with neck shackles. The hoard includes iron swords, shield fragments, spear heads, horse harnesses, chariot fittings, a bronze plaque, a trumpet, iron chariot wheels, fragments of cauldron and two iron slave-gang chains. Many of these items are now in the National Museum of Wales. It is believed that these valuable objects were thrown into the lake

by druids as offerings between the second century BCE and 60 CE. The iron swords were bent, thus making it impossible for them ever to be used again. Tacitus described Mona (Anglesey) as the European centre for druids and their training, and druids were the spiritual advisors of Celtic chiefs. Some believe the objects were thrown in when the Romans invaded Anglesey to wipe out the druids, as a relic of their last stand. Tacitus also described the sacred oak groves of the island.

LLYN Y FAN FACH – THE LAKE OF LEGEND *On a minor road from Llanddeusant, in the Black Mountains, set against the backdrop of Bannau Sir Gaer, Carmarthenshire.* This magical place gives us the legend of 'The Lady of the Lake'. She rose from its waters and married a local farmer, and had sons with magical healing powers, who became the 'Physicians of MYDDFAI'. After the farmer accidentally struck her three times, she returned to the lake.

LLYN FAWR – UNIQUE CELTIC HOARD *South of Rhigos, northern Glamorgan.* There may be a crannog yet to be excavated in this lake. Here was found the 2,500-year-old Celtic hoard of two great bronze cauldrons, harness equipment, an iron sickle and a massive sword, unique in Britain in its resemblance to Hallstatt weapons. The sword dates from around 650 BCE, and is the oldest iron artefact found in Wales. The discovery of the hoard in the early nineteenth century has given rise to the last period of the Bronze Age becoming known as the 'Llyn Fawr Phase'. The lake was then much smaller, being enlarged for a reservoir.

LLŶN HERITAGE COAST Most of this coastline, which is the north-west tip of Wales, is included in the Llŷn Area of Outstanding Natural Beauty (AONB). The fifty-five miles of the heritage coast takes in Bardsey Island, off the westernmost tip of the Llŷn Peninsula. Bardsey Island (Ynys Enlli) has early monastic remains and is a seabird sanctuary and wildlife refuge famous for its large population of grey seals. Llyn Llawddyn was Wales' first reservoir, built in the 1880s as the biggest man-made lake in the world.

LLYN TEGID – BALA LAKE – THE LARGEST NATURAL LAKE IN WALES *The A494 west from Bala runs alongside the entire northern edge of the lake.* A fish said to be unique to Bala and a couple of smaller Gwynedd lakes, a relic of the Ice Age, is the gwyniad. This white fish of the salmon species hides in the deep waters and allegedly has never been caught by a rod and line, but is sometimes found washed up on the shoreline. Tegid Foel and his wife, the Celtic corn goddess Ceridwen, in legend lived on an island in the middle of the four-mile-long lake, which may be the folk memory of a royal crannog here.

LLYSWEN – LLANGOED HALL – JACOBEAN MANOR WITH AN ARTS AND CRAFTS INTERIOR *5 miles south-west of Hay-on-Wye, Breconshire LD3 0YP. Tel: 08714 265655 Web: llangoedhall.com.* Originally known as Llangoed Castle, the site is said to date back to the sixth century, when Prince Iddon, the son of Ynyr Gwent, gave the land on the River Wye to the church in gratitude for the victory over the Saxons at Llantilio Croesenni. Rhodri Mawr (820-78), King of the Britons was said to have commanded a court to be built here, hence Llyswen (White Palace). It was to be used as a convenient meeting place for his three sons to settle their disputes, and as such has been called 'the first Welsh Parliament'. The oldest part of the building dates back to 1632, and original features include the Jacobean chimneys. in 1847, it was won in a game of cards. Most of the hall was rebuilt by Sir Clough Williams-Ellis, from 1912-19. The carved timber staircase and 95-foot-long pillared gallery are examples of his work. Sir Bernard Ashley, the husband of Laura Ashley, rescued the mansion from demolition in 1987 and turned it into a 5-Star hotel and restaurant.

LLYSWEN – CHURCH OF ST GWENDOLINE AND THE LLYSWEN STONE Rhodri Mawr is said to have founded the church at Llyswen. Sometime between then and the Norman invasion, the church adopted St Gwendoline as its saint, a local woman buried in Talgarth. The

Victorians retained the original Norman ground plan. A menhir is located in the centre of a field beside the River Wye, just south of Llangoed Hall, a mile from the village. It is 7 feet 8 inches tall, 2 feet 7 inches wide and leans at a remarkable angle of 35° from the vertical. There are at least thirty small hollows (cup-marks?) on the standing stone.

LLYWYL, LLOWEL – ST DAVID'S CHURCH AND THE LLYWEL STONE *On the A40, 8 miles west of Sennybridge, Breconshire.* The towered church is mainly fourteenth-fifteenth century, and contains a Norman font and village stocks. An early-medieval origin for Llywel is a possibility; but there are early Christian stones and a pre-Norman font. Llywel was a pupil of Dyfrig and a companion of Teilo, and may in fact be Prince Hywel ab Emyr Llydaw. However, before its rededication around 1203 by the Chapter of St David, the village was known as (Llan)Trisant and the church dedicated to the three saints David, Padarn and Teilo. There are possibly over sixty Ogham stones in Wales, though many more almost certainly were destroyed or used in building. Ogham script seems to have died out in Wales by around 600 AD. The Llywel Stone is inscribed in Ogham, decorated with symbols and pictograms, and reads in Latin: 'The stone of Maqutrenus Salicidunus'. A copy is in Brecon Museum, and the original is in the British Museum.

MACHEN CASTLE, CASTELL MEREDYDD *4 miles east of Caerffili, off the A468 to Newport, Monmouthshire.* It was used as a retreat by Morgan ap Hywel, after he had lost his main stronghold of CAERLEON to the Normans. Morgan probably built the round tower keep in 1217, but the bailey and curtain wall appears to have been constructed by Gilbert Marshall in 1236. In 1236, Gilbert, Earl of Pembroke, took this castle from Morgan ap Hywel by treachery, and fortified it, but gave it back 'for fear of the lord Llywelyn'. In 1248, the castle passed to Morgan's grandson Maredudd from whom it's original name is derived, and it was later held by the de Clares. It was a motte and bailey castle with the remains of a small keep, built on the edge of a cliff. It is visible from the road only, and is all that is left of the only native Welsh castle in Gwent.

MACHYNLLETH – THE FIRST WELSH PARLIAMENT HOUSE *Where the A487 meets the A489, Montgomeryshire, in the Dyfi Valley.* Owain Glyndŵr was crowned Prince of Wales, held a parliament here in 1404, and his Parliament House can be visited. The house in Maengwyn Street has been heavily restored, and it is still unsure if it dates back to the early fifteenth century. There is an Owain Glyndŵr Interpretative Centre here, housing the newly commissioned 'sword of state' of Glyndŵr. This author had the honour of composing a poem for its dedication in Cardiff Castle and in Machynlleth. The Elizabethan Royal House in Heol Penrallt is probably even older, with the legend that Glyndŵr's enemy Davy Gam was imprisoned here from 1404, and the tradition that Charles I stayed in the house in 1643. In 1644, there was a Civil War battle at Dyfi Bridge. In 1291 Owen, Prince of Powys was given a charter to hold a market every Wednesday, which is still popular 700 years later. The Tabernacle is the home to Modern Art Wales, and the Centre for Alternative Technology is nearby. The medieval Church of St Peter has a curvilinear churchyard and was founded by the sixth-century St Cybi – perhaps it should be rededicated to these saints jointly, instead of accepting the later Norman dedication.

MAEN ACHWYFAN CROSS (THE WHITFORD CROSS) CADW *In a field, a mile north-west of Whitford, Flintshire, itself off the A5026 west of Holywell.* This is a late-tenth-century cross, richly decorated and showing Scandinavian influence. It is probably dedicated to St Cwyfan, and Llangwyfan is not too far away, in Denbighshire. However, it is anomalous amongst Welsh stone crosses. While there is something Northumbrian about the character of the carvings, there are also features more usually seen on Viking monuments. In one panel, there is a figure of a spear-carrying man, who is trampling down a serpent on a ground of whirls. This is an almost exact copy of a design found on the shaft of a cross at Burton-in-Kendal in Cumbria. In other panels there is basketwork and a design based on a saltire cross. Down the sides of the cross shaft, there are other

carvings, including a person and some animals as well as a couple of series of interlocking rings. The wheel-head of the cross consists of a series of concentric circles enclosing a cross. It is one of the most intricate and puzzling monuments in Britain.

MAENAN ABBEY *Near Llanrwst, Conwy LL26 0UL.* Cistercians from Aberconwy Abbey were moved here, to enable Edward I to symbolically build CONWY Castle and walled town from 1283, on Llywelyn I's resting place. Compensation of £40 was paid for the land lost at Conwy. The abbey stood on this site until it was dissolved by Henry VIII in 1537, when the materials from the abbey were used to make repairs to the castle walls at Caernarfon and the remaining stone, timber, lead, slates and glass were sold to the gentry who were building mansions along the Conwy valley. At this time the remains of Llywellyn disappeared, with only the bottom half of his stone sarcophagus being recovered from the river in Llanrwst, now displayed in the church there. In 1599, the land passed to the Wynne family, who constructed a house on the site. Only the cellars remain of this house below the north wing of the current house, and the present granite building was constructed between 1851 and 1854 for the Elias family. The building is now a hotel.

MAENTWROG *On the A496 from Harlech to Blaenau Ffestiniog.* At Maentwrog, St Twrog's stone stands beside the church porch, as does Maen Llog outside Trallwng (Welshpool) Church. He was said to have hurled the stone to destroy a pagan altar. In the *Mabinogion*, this boulder was thrown by a giant to kill Pryderi, and Pryderi lies under it. Many of the sixth-century Christian foundations are on earlier places of worship. The church was redesigned in 1896 in the 'Arts and Crafts' mode, with a wood shingle spire added. The Ffestiniog Railway has a halt in the village at Tan-y-Bwlch.

MAES GARMON, BATTLE OF, 429 *On the outskirts of Mold, Flintshire, in the valley of Ystrad Alun; but other sites for the battle are claimed for the area around Carrog, off the Corwen to Llangollen road; near Saint Garmon's church of Llanarmon-yn-Iâl in the Alyn Valley; or among the high hills of Dyffryn Ceriog around Llanarmon-Dyffryn-Ceiriog.* This was 'the Alleluiah Battle' – when the Britons defeated a combined raiding party of Picts and Saxons. The tradition is that the heathens were ambushed, not by weapons, but by St Garmon telling the Britons to bang their shields and shout 'Alleluiah' at the top of their voices three times. The enemy fled in panic, as the noise echoed around the heights, many of them drowning in the River Alun. It was reputedly a bloodless encounter.

MAES MADOG, BATTLE OF, 1295 *In the foothills of Moel Rhiwen in Gwynedd, where the village of Rhiwlas is today, in the area known as Maes Meddygion.* In 1294, a national rising was planned as Edward I was to sail to France. The leaders were Morgan in Morgannwg, Cynan in Brycheiniog, Maelgwn in Ceredigion and Madog ap Llywelyn in Gwynedd. On 30 September 1294, Caernarfon Castle was captured by Madog, killing the castellan, and there were coordinated attacks on the King's castles at Aberystwyth, Denbigh Castle, Castell y Bere, Cricieth, Harlech, Cardigan and Builth. The Sheriff of Anglesey was killed, an army under Lord de Lacey was crushed in the Vale of Clwyd, and large parts of the country returned to the Welsh. Cardigan Castle was taken, and in Ceredigion, Morgannwg and Brycheiniog, many castles and manors were sacked. Madog pronounced himself Prince of Wales. Unfortunately, prevailing winds meant that Edward had not sailed to France as expected, and he told his lords to pacify their lands, gathering great armies at Chester, Montgomery and Gloucester. He brought his French invasion force up to Conwy and then moved to Bangor but lost his baggage train in an ambush and was forced to return and shelter in Conwy Castle in December 1294. Madog now moved south, looking for support from Powys, when he was attacked by the Earl of Warwick at Maes Madog, near Caereinion in 1295. On 3 May, the Earl of Warwick landed a force at Bangor and sent a secondary force of light cavalry to land at Caernarfon. The Bangor force under Warwick marched in direct view of the Welsh army from the Penrhyn dock area of Bangor and engaged Madog in the valley between Moel-Y-Ci

and Moel Rhiwen. The Welsh were initially successful, but the secondary force that had landed at Caernarfon concealed its approach, up through the present-day site of the village of Deiniolen, and ambushed Madog and the Welsh army through the saddle pass that runs between both hills. Madog escaped but many of the Welsh troops were slaughtered. Remains of two mass graves are still visible and various hordes of silver coins have been found, most notably at Cae'r Gof Farm and the Beran, possibly Madog's money for his troops. Warwick had used the King's funds to hire Glamorgan and Gwent archers, who broke the back of Madog's small army, mainly composed of North Wales spearmen. Five days later, the King's forces came on the remnants of the exhausted Welsh army and slaughtered 500 of them in a night attack at Maes Madog at Caereinion near Welshpool. Madog escaped, surrendered to John de Havering in August and his fate is unknown. However, one source says that Madog, Morgan and Cynan were eventually caught and executed using the normal barbaric Angevin methods.

MAESMAWR HALL *A mile east of Caersws, Montgomeryshire.* An Elizabethan manor of the cruciform type, after a fire it was rebuilt and then extended in the nineteenth century. The black and white façade is superb, and the manor is now a small hotel and restaurant.

MAESTEG – BETHANIA WELSH BAPTIST CHAPEL *In the town centre, four miles north of Bridgend, Glamorgan.* A massive five-bay 1906 chapel which celebrates the revival of religion across Wales, it is being restored by the Welsh Religious Buildings Trust.

MAESTEG – LLANGYNWYD – Y BWLWARCAU IRON AGE FORT On Mynydd Margam near Llangynwyd, between Bridgend and Maesteg, Glamorgan. There is a central pentagonal enclosure, enclosed by a bank and a deep ditch, and then an outer bank, another ditch, then two to three more defensive banks.

MAESTEILO – CHURCH OF ST JOHN *North-west of Llandeilo, on the lane from Pen-y-Banc to Capel Isaac, Carmarthenshire.* This superb little church has been renovated after being neglected. It was built for the estate workers of Maesteilo, now a care home. Three of its gasoliers have been restored, to be used as electric lighting.

MAESYRONEN UNITED REFORM CHAPEL – LANDMARK TRUST *4 miles south-west of Hay-on-Wye, high on a hill overlooking the River Wye at Glasbury-on-Wye.* The Maesyronen United Reformed Chapel is listed Grade I, and is the most important surviving building associated with the early Nonconformist movement in Wales. It is said to originate with the start of the Fifth Monarchist Vavasour Powell's ministry in 1640. The Welsh Assembly Government has given a grant of £50,000 for repairs including re-roofing and lime washing. One can stay in the adjoining cottage, which also belongs to the Landmark Trust. The chapel was formed from a fifteenth-century cruck barn in 1696, soon after the 1689 Act of Religious Tolerance, but its secretive location means that it was probably used for services well before its official existence.

MAGOR – ANCIENT MARSHLAND AND THE MAGOR PILL BOAT *From Newport take the A48 east (towards Chepstow) and turn right onto the B4245 for the village, Monmouthshire.* Magor Marsh is the last example of traditionally managed fenland in the Gwent levels, with a pattern of drainage ditches and other features, which have remained unchanged for centuries. It is a Site of Special Scientific Interest (SSSI). The original Welsh name of Magwyr possibly originated from the Latin *maceria*, meaning masonry walls or ruins. It may relate to a lost Roman villa, but more likely to sea defences or a causeway built by the Romans. Magor and the surrounding area contain many Roman ruins, and it is located at the inner edge of the salt marshes which the Romans began to reclaim as farmland. The local name 'Whitewall' may relate to the same causeway, which would have connected the village to a small now-vanished harbour on the Severn, known as Abergwaitha. In 1994, the remains of a thirteenth-century boat, used for trading along and across

the Severn estuary, and perhaps to Ireland, were found buried in the inter-tidal mud flats of the Severn Levels, mud of the estuary close to Magor Pill. The boat was discovered to be carrying iron ore from Glamorgan. It was the first medieval boat found in Welsh waters. It is a clinker-built, single-masted, vessel of which the stem post, floor timbers and approximately 50 per cent of the keel and lower outer planking survive, and is about 45 feet long. The boat dates from around 1194, and it was taken for conservation to the National Museum in Cardiff. According to tradition, the parish church dates from the seventh century, and was originally dedicated to St Leonard. The existing building has been described as 'one of the most ambitious churches in Monmouthshire', and thus known as 'The Cathedral of the Moors'. Its earliest parts date from the thirteenth century, at which time it was given by the Earl of Pembroke to Anagni Abbey in Italy. Remains of the Procurator's House are still standing just off the village square. The church was rededicated at some time to St Mary.

MAGOR – WILCRICK HILL IRON AGE FORT AND A ROMANO-CELTIC BOAT

Wilcrick is just outside Magor, Monmouthshire. Its original name was Chwilgrug, meaning the reeling 'twmpath', or hill. Newport Museum and Art Gallery has in store a boat known as 'The Barland's Farm Romano-Celtic Boat'. This was found in 1993 under Wilcrick Hillfort, during construction work sited in the Gwent Levels. The oak boat was found alongside a buried stone and timber quay, in the bed of a silted-up river channel. Much of the boat survives, including the bow, the lower hull and most of one side. The remains measured over 30 feet long (much smaller than the Newport Medieval Ship). Tree-ring dating of the boat timbers help show it was abandoned in the early fourth century CE, and was probably reused as a landing stage. Archaeologists suggest that Iron Age farmers moved their families and stocks to the hillfort in winter, to avoid the floods in the Caldicot Levels (see WENTLOOG LEVELS).

MALLWYD – ST TYDECHO'S CHURCH AND BRIGANDS' INN *On the junction of the A458 and 470, halfway between Dolgellau and Machynlleth, near Dinas Mawddwy, and on the boundary of Meirionnydd and Montgomery.* The church dates from the fourteenth century, and is a foundation of the sixth-century St Tydecho, the brother of the saints Samson and Tathan and the cousin of the saints Padarn and Cadfan. He was said to have turned the River Dyfi into milk for the poor, and part of the river near its source is still called Llaethnant, 'Milk Stream'. The church is unusual in form, being long and narrow with a balcony at each end, and has many wooden fixtures dating from the seventeenth century. The great grammarian, translator and Biblical scholar John Davies (1567-1644) was rector of Mallwyd for thirty years at the beginning of the seventeenth century, spending money on altering the church. He is said to have put up the two whalebones over the porch, washed up from the Dyfi Estuary. In the sixteenth century the 'Gwylliaid Cochion Mawddwy' ('the Red-haired Robbers of Mallwyd') terrorised Mid-Wales, before many were caught and executed by Baron Lewis Owen. They may have been established here initially as the remnants of Glyndŵr's forces as early as 1415. Around eighty were rounded up and condemned at a place where the house Collfryn ('Hill of Loss') stands. They were hung in 1554, two miles from Mallwyd on Rhos Goch ('Red', or 'Bloody Moor') and a mound, 'Boncyn-y-Gwyllinid' ('Robbers' Hillock'), is supposedly where they were buried en masse. A few weeks later, the baron was ambushed and murdered by surviving members at 'Llidiart-y-Barwn' ('the Baron's Gate') near Mallwyd. As well as Llidiart-y-Barwn, the nearby fifteenth-century Brigands' Inn (SY20 9HJ) remembers these redheaded bandits. Local place names recalling the event abound, such as Mynwent y Gwyllinid (where there is an old cemetery), Pont y Lladron ('Bridge of Thieves'), Sarn y Gwyllinid (a ford), Ffynnon y Gwyllinid (a well) and Ceunant y Gwyllinid (a ravine). People with red hair in Merioneth and Montgomery are still sometimes called 'red bandits'. This is red kite country, and beautiful for touring and staying.

MANORBIER CASTLE *South of the A4139 midway between Tenby and Pembroke.* Giraldus Cambrensis was born here, overlooking a beach near Tenby, and parts were built in the twelfth

century by Gerald's father, William de Barri. The Great Hall dates from the 1140s and may be the oldest stone building surviving in any West Wales castle. Unlike most castles of the time, it is almost perfectly rectangular. Surprisingly, the well-preserved castle only ever saw two assaults. The first was in 1327, when Richard de Barri invaded Manorbier to claim the castle which was lawfully his, and in 1645, when during the English Civil War, Oliver Cromwell's Roundheads seized and slighted the castle. The Philipps family has lived in the castle since the 1600s.

MANORBIER – ST JAMES' CHURCH *On the opposite side of the Shute Valley to the castle.* This was the church of the de Barri's of Manorbier Castle, and there is an early fourteenth-century de Barri effigy here. The white lime-washed crenellated tower is almost detached, probably as a defensive measure. The large double-naved church is twelfth-century Norman, with several stone vaults and furnishings. There is a standing stone here, and the site may be pre-Christian, becoming then a monastery paralleling the one on nearby Caldey Island.

MANORBIER – KING'S QUOIT BURIAL CHAMBER *On the side of a cliff path at Old Castle Head, the King's Quoit is high above Manorbier Bay.* This low tomb consists of two small side stones that support a large capstone measuring 15 feet by 9 feet. At the south-east corner there is another stone, probably the southern end-stone of the chamber. The internal height of the monument is 2.6 feet and the chamber is partially below ground, one side of the capstone being supported by earth alone.

MANORDEIFI – ST DAVID'S CHURCH FOFC *6 miles south-east of Cardigan. From Llechryd cross the River Teifi and turn left opposite the Malgwyn Castle Hotel.* On the banks of the Teifi, a coracle was available in the fourteenth-century church for any worshippers cut off by floods. It is known as Manordeifi Old Church as a new one was built on a more accessible site. It is listed as Grade II, and survives as a rare example of an unaltered 'pre-ecclesiology' interior. The chancel and nave date from the thirteenth century, and eighteenth-century fittings include a full set of box pews, those on the east with fireplaces to warm their occupants, and those on the west slightly raised and decorated with fluted columns. There are fine monuments to the great families of nearby Ffynnone and Malgwyn Castle, including one to Captain Charles Colby of Ffynone, who was killed by a tiger in Rawalpindi in 1852. Castell Malgwyn was built in 1795, and is now a hotel. It takes its name from a Norman castle, built inside an Iron Age earthwork, on today's Castle Malgwyn Farm.

MARGAM ABBEY CADW AND MARGAM ABBEY PARK *2 miles east of Port Talbot, Glamorgan.* On a Celtic monastic site, the Earl of Gloucester endowed the Cistercian abbey here in 1147, which became the largest and wealthiest in Wales in the twelfth century. The remains can be visited in the grounds of Margam Abbey Park. The chapter house remains, and the Abbey Church has windows by Burne-Jones. The church uses the nave of the Norman abbey, with the original Norman columns in the six-bay nave arcade, and there are superb tombs to the Mansells of Margam Castle.

MARGAM CASTLE AND ORANGERY In 1787, the Palladian Orangery was built, still the biggest in the world at 330 feet long. Margam Park was designed in 1830 by Thomas Hopper, the architect of Penrhyn Castle. One of the owners of this Margam estate, Christopher Rice Mansel Talbot, sailed his luxury yacht *Lynx* as the first ship through the Suez Canal in 1869. In fifty-nine years as the Member of Parliament representing Glamorgan, he only was known to speak once in the House of Commons, to ask another MP to close his window because he was 'sitting in a draught'. In 1813, Talbot inherited Margam, and demolished the house there, commissioning Thomas Hopper to design the present building. From 1942 to 1977 it was virtually derelict, and gutted by fire. However, unlike nearby Wenvoe, Cottrell and Dunraven mansions, it has been rescued as an education centre.

MARGAM STONES MUSEUM CADW *Housed in an early church schoolhouse, next to Margam Abbey Park and Margam Castle.* The collection includes a number of important pre-Conquest early Christian memorials. The Great Cross of Cynfelyn is one of the important Celtic wheel-crosses in this museum. This 'Cross of Conbelin' originally stood in Margam village street near the church. The base has a hunting scene, whilst figures of the Blessed Virgin Mary and St John flank the cross. A partly legible half-uncial inscription names Conbelin (Cynfelyn in modern Welsh) as the donor: 'CONBELIN P[O]SUIT HANC CRUCM P[RO] [A]NIMA RI[C?]' (Conbelin erected this cross for the soul of Ric ...). The Cross of Grutne comes from the churchyard at Margam. The Latin half-uncial inscription reads, 'I[N] NOMINE D[E]I SUM[M]I CRUX CRITDI PROPARABIT GRUTNE PRO AN[I]MA AHEST' (In the name of God most high. The Cross of Christ, Grutne made it for the soul of Ahest). Other stones include a Roman milestone which was turned into a Christian memorial and two sixth-century pillar stones, one of which is notable for its inscriptions in Ogham.

MARLOES AND DALE HERITAGE PARK *The Heritage Coast begins at Dale, at the head of the Milford Haven Estuary, Pembrokeshire.* Dale is where Henry Tudor landed on his way to fight Richard III at the Battle of Bosworth in 1485. At the tip of Dale's Great Castle Head lies an Iron Age fort. Past Marloes lies St Bride's, the site of a Mesolithic flint factory.

MARTLETWY – BURNETT'S HILL CHAPEL AND ST MARCELLUS'S CHURCH *A mile south-west of Martletwy, west of the A4075 between Carew and Canaston Bridge, near Oakwood in Pembrokeshire.* Burnett's Hill Calvinistic Methodist Chapel is a rare survival of early Pembrokeshire chapel architecture. It was built in cottage style in 1812 to serve the coal-mining community of Landshipping and Martletwy, and has been little altered over the years. As the church was segregated, with its raked seating facing a central pulpit, the hat rails on either side of the church are of different sizes. Like so many Welsh chapels, Burnett's Hill was forced to close in the 1980s for lack of a congregation, and it might have become a ruin but for the intervention of local people who formed themselves into the Friends of Burnett's Hill Chapel. It now hosts live music featuring musicians such as the superb John Renbourne. The double-aisled Church of St Marcellus in the village of Martletwy dates from the thirteenth century. Marcellus was a Briton who became Bishop of Trier and was martyred in 166 CE, according to Cressy.

MATHRAFAL CASTLE *On the banks of the River Banwy, 6 miles north-west of Welshpool, at the junction of the A495 and B4389, Montgomeryshire.* This was one of the three royal seats of Wales, the home of the princes of Powys, just as Dinefwr was for the princes of Deheubarth, and Aberffraw for the princes of Gwynedd. The hillfort half a mile north-west was perhaps the original seat, dating from the fall of Pengwern (Shrewsbury) in the seventh century, or perhaps from 520 when the capital of Powys was moved from Wroxeter. The ramparts and ditches of Mathrafal Castle form a square of about 100 yards across, upon flat ground beside the west bank of the Banwy, and might be tenth century. The 120 feet by 90 feet by 20 feet high motte in the east corner of the square and the small bailey in front of it were built either by Owain Cyfeiliog around 1170, or Robert de Vieuxpont on behalf of King John in 1212, after Gwenwynwyn, son of Owain, had transferred his chief seat from Mathrafal to Welshpool. The castle was destroyed in 1212 by Llywelyn the Great, and never rebuilt. Little remains of the original walls. University of York excavations around 1991 found an iron and bronze figurine of St Gwynlliw the Warrior (the founder of St Woolo's) here, in a cavity in a window base.

MATHERN – SITE OF THE DEATH OF THE MARTYR KING *2 miles south of Chepstow, Monmouthshire.* King Tewdrig controlled much of south-east Wales, and fought with Constantine the Blessed against the invading Saxons. He is said to have founded the college of Cor Worgan, or Cor Eurgain, later to become famous as Llanilltud Fawr. (Cor Tewdws is marked on old maps of the town.) After Constantine's death, Tewdrig allied with Vortigern to keep the peace, and passed

on his kingdom to his son Meurig. Tewdrig retired to Tintern, where he was attacked by Saxons. A stone bridge in the nearby Angidy Valley is called 'Pont y Saeson', 'Bridge of the Saxons', and this may be where the fight took place. The enemy were driven off, but not before Tewdrig was mortally wounded. His son Meurig arrived and took his dying father on a cart to Tewdrig's Well, now next to St Tewdric's Church in Mathern. A plaque there reads, 'By tradition at this spring King Tewdrig's wounds were washed after the battle near Tintern about 470 AD against the pagan Saxons. He died a short way off and by his wishes a church was built over his grave.' Mathern is the corruption of 'Merthyr Teyrn', 'the site of martyrdom of the sovereign'. In 822, Nennius described the well as one of 'the marvels of Britain', and also referred to the Well of Meurig. Pwllmeuric (Meurig's Pool) is a village near here. Meurig was said to be Uther Pendragon ('Wonderful Head Dragon'), leader of the Celtic army), and was the father of Arthmael, the accepted King Arthur of legend until the nineteenth-century revision of history. St Theoderic's Church in Mathern is dedicated to Tewdrig. Mathern Palace dates from 1419 and was used by the Bishops of Llandaff. Meurig was noted as giving the land to Llandaff.

MEIFOD – THE CHURCH OF ST MARY AND ST TYSILIO *On the A495 near Llanfyllin, in the Vyrnwy Valley 6 miles north-west of Welshpool, Montgomeryshire.* St Gwyddfarch is associated with the founding of this church, with his chapel in the churchyard. On the summit of the nearby Gallt yr Ancr, or (Anchorite's Hill) he was said to have had his sixth-century cell, and there are some traces of a British fortification. On the side of the same hill is Bedd y Cawr (Grave of the Giant). Defensive dykes and encampments surround the area. Meifod's earliest church is said to have been built by St Gwyddfarch, son of Amalarus of Brittany, *c.* 550. The site became a cult centre of his pupil, St Tysilio, then developed as mother church with a clas community in the early medieval period. From here churches at Llanfair Caereinion, Guilsfield, Welshpool and Alberbury (Shropshire) were founded. Traditionally, it was the burial place of the princes of Powys at Mathrafal, just two miles away. The church occupies a huge site, with a semi-circular churchyard occupying over five acres, and there are probably monastic buildings to be found here. The red sandstone church is mentioned in the *Brut y Tywysogion* to have been consecrated in 1156, after its construction by Madoc ap Meredydd, Prince of Powys. Subsequently, it belonged to Strata Marcella Abbey, when the dedication altered from Tysilio to Mary. The twelfth-century *Song of St Tysilio* referred to the beauty of Meifod, and the magnificence of its church and priests. Much of the twelfth-century church has disappeared under fourteenth-fifteenth-century reconstruction. A great stone slab in the church may have been the coffin lid of a ninth-century Prince of Powys, decorated with Welsh and Viking motifs and crosses. It may derive from the Battle of Buttington in 894, where an Anglo-Welsh force defeated the Vikings near Welshpool.

MENAI – THOMAS TELFORD'S SUSPENSION BRIDGE *Linking Menai Bridge on Anglesey and Bangor in Caernarfonshire.* Completed in 1825, this was the world's first iron suspension bridge, carrying the London to Holyhead (A5) road across the Menai Straits. A masterpiece of engineering, it is 1,265 feet long with a central span of 579 feet, and was then the longest single-span bridge in the world. Telford was forced to be radical in the design, as the Admiralty insisted it had to be 100 feet above the Menai Strait, to allow the masts of men-of-war to pass. All the wrought ironwork was heated and soaked in linseed oil before being put in place, not quite as the White Knight told Alice:

> I heard him then, for I had just
> Completed my design
> To keep the Menai Bridge from rust
> By boiling it in wine.

Telford was worried about the strength of the chains, and it was called 'the eighth wonder of the world'. Difficult to build because of two tides sweeping in, it was the precursor of all the immense

suspension bridges to follow. The great Robert Stephenson's Britannia Rail Bridge, finished in 1850, also stands near the Menai Bridge.

MENAI BRIDGE (PORTHAETHWY), BATTLE OF, 1194 Llywelyn ap Iorwerth (Llywelyn the Great) defeated his uncle Rhodri ap Owain Gwynedd at Menai Bridge on Anglesey in his campaign to take over Gwynedd.

MERTHYR MAWR - CANDLESTON CASTLE *South of the A48, almost three miles from Bridgend.* Amongst the wonderful sand dunes at Merthyr Mawr (once part of the largest sand dune complex in Britain), this fortified manor house was built by the de Cantelupes in the fourteenth century. The Welsh original name is Treganlaw - 'the place/town of 100 hands', but the original settlement is lost under the sands. Scenes from *Lawrence of Arabia* were shot in the dunes.

MERTHYR MAWR - ST TEILO'S CHURCH AND CELTIC CHRISTIAN STONES One of Wales' most beautiful villages is Merthyr Mawr, with its thatched seventeenth-century cottages. Merthyr Mawr House is Grade II* Listed, and St Roch's Chapel is a scheduled Ancient Monument. In St Teilo's Church are two stones from the early Christian chapel site. One is a 'Roman' fifth-century stone, and the other is part of a Celtic Christian cross with knotwork. The so-called Roman stone commemorates 'Paul, son of ...' (Pavli fili), and may be that of Paul Penychen, the sixth-century lord of the district. There are other tenth-century stones also in the church. Merthyr Mawr is a corruption of Merthyr Myfor, the place of martyrdom of St Myfor.

MERTHYR MAWR SHEEP DIP BRIDGE This 'Dipping Bridge' over the Ogmore River has been used for centuries. A flock of sheep is driven onto the bridge, and improvised gates erected at both ends. Sheep are then pushed through special holes in the parapet to drop six feet into the cold waters below. They swim to the bank, where watchful sheepdogs guide them back into the flock. At the demolished inn next to the bridge, the landlord was said to have murdered pilgrims on their way to St David's, and skeletons were found on the site.

MERTHYR TYDFUL (TYDFIL) - 'IRON AND STEEL CAPITAL OF THE WORLD' *Where the A465 'Heads of the Valleys Road' meets the A470, 19 miles north of Cardiff.* Iron was worked here from the sixteenth century, but with the Industrial Revolution Merthyr was for a time the world's greatest iron-making centre, and the largest town in Wales by 1801. With the fast-flowing Taff, plentiful local iron ore, limestone and coal, industry grew rapidly. In the 1840s, the Guest Ironworks at Dowlais became the biggest manufacturer in the world. Richard Trevithick ran the first steam engine in the world here in 1804, from Penydarren Ironworks to Abercynon in 1804. Merthyr was known as the 'iron and steel capital of the world' during the Industrial Revolution, and South Wales was producing half of Britain's iron exports by 1827. In 1831, Merthyr Tydfil still had the largest population in Wales, surpassing Cardiff, Swansea and Newport combined. Iron masters such as Francis and Samuel Homfray at Penydarren, John Guest at Dowlais, and Anthony Bacon, Richard Hill and the Crawshays at Cyfarthfa controlled their mills with the proverbial 'rod of iron'. Local museums and Ynysfach Engine House recall these oppressive days. Anthony Bacon's furnace at Cyfarthfa produced the rails for the earliest lines for Britain, America and Russia. Bacon retired in 1784, deeply worried by the fact that his works had supplied the iron for the guns that the Americans used in their War of Independence against England. Dowlais was the first plant in Britain to produce using the Bessemer process. All Merthyr's ironworks closed by the 1930s, Cyfarthfa having been the biggest foundry in Britain in 1800. Cyfarthfa had opened in 1765 and eventually closed in 1910. The other major ironworks at Merthyr – Dowlais, Penydarren and Plymouth, had opened in 1759, 1784 and 1763 respectively. Dowlais was the last to go, in 1936. Thankfully, Merthyr is now seeing regeneration after years of economic decline. The town is named after the martyrdom around 480 CE of Tydful ferch Brychan Brycheiniog by a band of Picts and Saxons.

MERTHYR TYDFUL – CYFARTHFA CASTLE, MUSEUM AND ART GALLERY – 'THE MOST IMPRESSIVE MONUMENT OF THE INDUSTRIAL IRON AGE IN SOUTH WALES' *Brecon Road, Merthyr Tydful, Glamorgan.* Costing £30,000 to build in 1824-25, this extravagant castellated Regency mansion now houses a magnificent museum and art gallery, in 160 acres of parkland. Commissioned by the ironmaster William Crawshay, it overlooked his huge ironworks. His son Robert Crawshay closed the works in 1874, rather than give in to worker demands for decent wages and conditions. He kept them closed until his death in 1879, causing terrible hardships. On the huge stone slab covering his grave in nearby Vaynor, the inscription reads 'GOD FORGIVE ME' – God may forgive, but the Welsh remember the terrible suffering still. Cyfarthfa Castle is a monument to the fortunes made by ironmasters. In 1870, Merthyr grocer William Gould unveiled the world's first secret ballot box, now displayed in Cyfarthfa Castle.

MERTHYR TYDFUL AND HIRWAUN – THE MERTHYR RISING 1831 The Great Depression of 1829 led to massive unemployment and wage cuts, making the working classes even more indebted to their masters. William Crawshay had lowered wages at his Merthyr iron foundries, there was a crisis among tradesmen and shopkeepers, and the Debtors' Court confiscated workers' property to pay off debts. Thomas Llywelyn, a miner, demanded compensation and led a demonstration that released prisoners and marched on Aberdare. At the same time in nearby Hirwaun, when the Debtors' Court had seized the truck of Lewis Lewis, miners, iron workers and tradesmen joined the political radicals – they had had enough. In 1831, hungry iron and coal workers took over Hirwaun and Merthyr for five days, parading under a sheet daubed symbolically with the blood of a lamb and a calf. The sheet acted as a huge flag, and on its staff was impaled a loaf of bread, showing the needs of the marchers. This was the first time that the 'red flag' of revolution was raised in Britain, and it may be the first time anywhere in the world. The tyrannical ironmasters Crawshay and Guest were locked up in Merthyr's Castle Inn, defended by Scottish soldiers, who opened fire on the huge crowd, killing around twenty-four people. Unemployment, filthy water supplies, lack of sanitation and reduced wages had fomented the unrest, and the workers burnt court records and their employers' property. The Argyll and Sutherland Highlanders had to be reinforced by the Glamorgan Yeomanry, and the supporting Swansea Yeomanry was forced back to Neath. Major Richards called out the equivalent of the Home Guard, the Llantrisant Cavalry, to rescue the regular soldiers, who sustained no losses. Lewis Lewis, the truck owner whose loss sparked off the initial revolt, was sentenced to death, commuted to exile for life. A twenty-three-year-old collier 'Dic' Penderyn (Richard Lewis from Penderyn) was accused of riotous assault and of a 'felonious' attack upon Private Don Black of the 93rd Highland Regiment. Dic Penderyn was hanged at Cardiff, his last words being 'Arglwydd, dyma gamwedd' ('Oh God, what an injustice'). Other defendants were transported to Australia. Forty years later, an immigrant from Merthyr, Ieuan Evans, confessed on his deathbed in the USA that it was he that wounded the soldier. The carter who took Penderyn's body back to Aberafan asked to be, and is, buried next to Dic Penderyn in the churchyard of St Mary's. The Merthyr Rising was described by John Davies as 'the most ferocious and bloody event in the history of industrialised Britain'. Gwyn Williams pointed out that 'these defeats inflicted on regular and militia troops by armed rioters have no parallel in recent British history'. Publicity was suppressed – after all the starving Welsh working class did not matter in the grand scheme of things. In June 1831, a Mrs Arbuthnot noted in her diary, 'There has been a great riot in Wales and the soldiers have killed twenty-four people. When two or three were killed at Manchester, it was called the Peterloo Massacre and the newspapers for weeks wrote it up as the most outrageous and wicked proceeding ever heard of. But that was in Tory times; now this Welsh riot is scarcely mentioned.' Gwyn Williams commented that 'bodies were being buried secretly all over north Glamorgan ... widows did not dare claim poor relief.' Richard Lewis, 'Dic Penderyn', was hanged in Cardiff Gaol on 13 August 1831. The day is now being commemorated in St Mary Street outside Cardiff Market, where the prison used to be, and a plaque marks the spot.

MERTHYR TYDFUL - PENYDARREN - SITE OF THE FIRST RECORDED STEAM LOCOMOTIVE *Between Merthyr and Dowlais, Glamorgan.* The first recorded steam locomotive drew wagons with men at Penydarren, on 22 February, 1804. It was built by Richard Trevithick, and predated George Stephenson's *Locomotion* by twenty-one years. The engine pulled 10 tons of iron and seventy passengers, from Merthyr Tydfil to Quaker's Yard, at around 5 miles per hour. Penydarren had the third largest of Merthyr's ironworks. However, Merthyr's ironmasters had invested so heavily in the Glamorgan Canal leading to Cardiff Docks, that they had no wish to invest in a competitive technology. Penydarren had a first-century Roman fort with a bathhouse, on a spur overlooking the Taff, but a football stadium was built on it in 1905.

MILFORD HAVEN, ABERDAUGLEDDAU *8 miles south of Haverfordwest, on the A4076, Pembrokeshire.* Its Welsh name means 'the mouth of the two Cleddau Rivers', there being both a White Cleddau and a Black Cleddau River. Described by Nelson as one of the finest natural harbours in the world, Henry II invaded Ireland from here and Henry VII landed from France to overcome Richard III. The town was founded in 1719 by William Hamilton, the husband of Nelson's mistress Emma, and grew as a whaling port. There was a royal dockyard here until 1814, when the making of warships was transferred to the new port of Pembroke Dock. The size of the estuary has attracted oil terminals and tankers, so it is now one of the largest LNG terminals in the world. Fort Hubberstone was built from 1858 to 1863 to defend the port, and the town's museum is housed in the 1797 Custom House.

MISKIN MANOR HOTEL *Off the A4119, south of Pontyclun, Glamorgan CF72 8ND. Tel: 01443 224204.* A superb Grade II listed nineteenth-century mansion, it is near the site of a sixth-century monastery of Meisgyn. Around 1100, Nest, a daughter of the Prince of Glamorgan lived here. For six generations the house was occupied by the important Basset family, who sold it to the coal owner David Williams (1809-63) in 1847. Known as the bard 'Alaw Goch', Trealaw in the Rhondda is named after Williams.

MOEL ARTHUR HILLFORT *At Nannerch, and near Offa's Dyke, in the Clwydian Hills. From the A525 between Ruthin and Denbigh, take the minor road signposted Llangwyfan and Llandyrnog.* This circular hilltop fort has a well-defined entrance on the east side, and from its summit cairn one can see the next hillfort of Moel y Cloddiau. The defences are very prominent, with multiple steep banks and ditches encircling the hilltop, and inward ramparts defending the entrance. The site is rumoured to be Queen Boudicca's burial place, and there are various legends of princes, ghosts and buried treasure regarding the hill.

MOEL Y CLODDIAU HILLFORT *Near Moel Arthur, in the Clwydian Hills.* Also known as Pen y Cloddiau, this is one of the largest hillforts in Wales. Pen means top, moel means a bare hill, and cloddiau means banks. A substantial bank and outer ditch encloses a ridge-like hill, and in places where the natural slope is reduced, there are additional banks and ditches. Forty-three roundhouse platforms have been identified.

MOEL FENLLI HILLFORT *Off the A494 towards Mold from Ruthin in the Clwydian Hills.* Near the two previous hillforts, it is the highest hillfort in the Clwydian Hills. Also known as Foel Fenlli, its banks and ditches enclose a large area, including a domed summit and a sloping area to its west, where the main entrance and inturned banks can be found. The strongest defences are on the north, where an enemy approach would have been easiest and most likely, so the northern defences are doubled, with a ditch behind each of the banks. There are forty roundhouse platforms here, the bases for the wooden Celtic shelters. In 1816, over 1,500 Roman coins dating between 250 and 307 CE were found.

MOELFRE, BATTLE OF, 1157 *Outside Moelfre Harbour, Anglesey. North of Benllech off the A5025 on the eastern coast.* This sea battle was also called Tal Moelfre, between the men of Anglesey and

Henry II's fleet, which was heading to Rhuddlan to support him. Owain Gwynedd's sons had defeated Henry at Coles Hill, and his men had been looting churches in Anglesey when attacked. The battle continued into the harbour. Henry's half-brother, leading the fleet, was killed, and the battle was celebrated by Gwalchmai, Owain Gwynedd's court poet. Moelfre is the site of the wreck of the *Royal Charter* in 1859. Almost home, from Australia to Liverpool, she was driven onto the nearby cliffs in a hurricane with the loss of 454 lives.

MOEL TŶ UCHAF STONE CIRCLE *Near Llandrillo, on the western edge of the Berwyn Mountains, Denbighshire.* The site is 1,263 feet above sea level, and there remain forty-one stones in this 'kerb-circle'. It seems to have been an astronomical site, and in its centre was a stone-lined 'cist' grave. Nearby is a platform cairn, other grave sites, 'Bwrdd Arthur' (Arthur's Table) and the prehistoric 'Ring of Tyfos' (the House of the Fist). Moel Tŷ Uchaf lies on the Bronze Age track way now known as Ffordd Saeson (Saxons' Road), which links the Dee and Ceiriog valleys.

MOEL Y DON, BATTLE OF, 1282 *Where the Vaynol Hall Estate meets the sea, Caernarfonshire.* Luke de Tany and Roger Clifford, having subdued Anglesey, crossed the Menai Strait against Edward I's orders, desperate for glory. A bridge of boats had been constructed across the Strait. Their force was made up of forty lances, 300 men-at-arms and up to 2,000 foot. They fought their way against Llywelyn II's forces to a hill, but the tide rushed in behind them and they were trapped, many drowning as they tried to return to the bridge. Luke de Tany and Roger Clifford were among those killed as were Philip Burnell and William Burnell, sons of the chancellor Robert Burnell. Sixteen English knights, many men-at-arms and 300 infantry also perished.

MOEL Y GAER HILLFORT *Also known as Moel-y-Gaer Rhosesmor, on the top of Halkyn Mountain, near Mold, Flintshire.* It commands views across the Clwydian Hills with its chain of hillforts, and across the Dee Estuary to Lancashire. Within the fort different phases of roundhouse construction were found. The prominent inner rampart includes an inturned entrance on the south-east side, and the site was defended by ditches as well as a low bank which is 30 feet outside the main ditch on the south and west. A triangulation pillar has been positioned on top of a Bronze Age round barrow, and caches of sling stones have been found there.

MOEL Y GAER HILLFORT *Surmounting Llantysilio Mountain, it can be accessed from Horseshoe Pass. Take the A451 from Denbigh to Mold and turn off on the B5123.* The inturned entrance lies to the east. The fort's remains are fronted by a ditch on the north, and significant banks and ditches defend the hillfort, but trail biking has eroded the defences. It is the smallest of the six Clwydian Hills hillforts.

MOLD, Y WYDDGRUG – ANCIENT MARKET TOWN *Where the A491 meets the A541, Flintshire.* This market town was the county town of Clwyd until 1996, and is the administrative centre of Flintshire. It is surrounded by burial mounds, and Y Wyddgrug means 'the tomb mound'. The town grew alongside its castle. The Welsh-language novelist Daniel Owen (1836-95) was born here. His novel *Rhys Lewis* was strongly influenced by the Mold Riot of 1869. Miners at the local Leeswood Green Colliery were banned from speaking Welsh underground, and their wages were cut by the English pit manager. Angered, they took him to the local police station, and seven were arrested. Crowds gathered to hear the trial verdict, and police were called in from all over Flintshire, supported by soldiers. After the guilty verdict, unrest broke out and four people were shot dead by soldiers.

MOLD BAILEY HILL – EARTHWORK MOTTE AND BAILEY *In the town centre, off the High Street, 13 miles west of Chester, on the A5104 and A549.* A late eleventh-century fortress, it was founded by Robert de Montalt. The existing motte and bailey may date from 1140. In 1146, the castle was taken by Owain Gwynedd and in 1167 was recovered by Henry II. Owain Gwynedd

captured it again in 1170, the year of his death. Traces of masonry are on the summit of the motte, and two stone walls of a possible hall have been located in the inner bailey. Llywelyn I burnt it in 1199. The castle was last mentioned in 1244 but since 1792 the site as been used as a recreation garden, with a Gorsedd Stone Circle on the northern side of the motte.

MOLD, BATTLE OF, 1199 With the death of Owain Gwynedd in 1170, the Normans had made fresh attempts to take over North Wales. Llywelyn the Great, by 1199, had the loyalty of most of the minor princes of eastern Gwynedd, and campaigned to reduce the Norman incursions from castles situated on the border. When the winter began, he set out to attack the border fortress of Mold, from his base at Dolwyddelan. His route was over the mountains and men and horses slipped in the snow and ice, falling to their deaths. Mold Castle was not expecting an attack in such treacherous conditions, as winter campaigning was extremely rare. Taken by surprise, the garrison succeeded in beating off the initial attack. One section of Llywelyn's force kept up the attempt to break in at the original position, while his reserves, under cover of woodland, attacked simultaneously two new positions, and the defenders surrendered. Llywelyn wished to reduce the use of Mold as a post for any further advances by Normans, so ordered it to be burnt, the smoke being seen from Chester twenty miles away to the east.

MOLD GOLD CAPE This is one of Britain's most famous ancient artefacts and, alongside the CAERGWRLE BOWL, is one of the most important European Bronze Age finds. In 1825, an elderly man and his wife claimed to have seen a ghostly warrior wearing golden armour while walking home from market. Eight years later, at the same spot, workmen were digging for road stone in a mound, when they uncovered a stone-lined burial chamber. They found a skeleton with a gold breastplate/cape in a field known locally as Bryn-yr-Ellyllon, which translates as 'Ghosts' Hill', because of the mound in the field centre. The cape was crushed and was further damaged as it was shared out between the finders. Initially, the cape was dated to the Dark Ages, as it was seen as too ornate to be dated before the Romans and its style was obviously not Roman. In the late nineteenth century, academics realised that the Bronze Age came before the Iron Age and the cape was dated to the earlier period, probably from 1950-1550 BCE. Research indicates that it may have been designed for a woman, and the grave goods, especially amber beads, also point to its owner being female. The British Museum acquired the cape in 1836, where it can still be seen.

MOLD - ST MARY THE VIRGIN CHURCH This is Grade I listed and stands on the site of an earlier Norman church. The Perpendicular building was initiated by Margaret Beaufort, Countess of Richmond, to commemorate the victory of her son, Henry Tudor, at Bosworth in 1485. Rebuilding the church was continued well after the Reformation, with contributions made by bishops of St Asaf up to 1594. In 1768-73, the old tower was replaced, incorporating a peal of six earlier bells dating from around 1720. In was restored by Sir George Gilbert Scott in 1856. One box tombstone marks the grave of Richard Wilson RA, 'the father of British landscape painting'.

MOLD (Y WYDDGRUG) - FFERM and HARTHSEATH Historic Houses *Off A5104 Pontblyddyn, near Hope, 3 miles south-east of Mold, Flintshire CF7 4HP. Tel: 01352 770217 (Fferm) 01352 770204 (Hartsheath).* Both houses are open to the public by appointment. Fferm hall house dates from around 1585 and is on the Hartsheath estate. Hartsheath is a Regency mansion of 1825 with contemporary plasterwork, marble fireplaces and Georgian wallpaper, with excellent nineteenth-century gardens.

MOLD - GWYSANEY HALL AND ESTATE *Denbigh Road, 1.5 miles north of Mold CH7 6PA.* The hall was built in 1550 by Robert Davies and survived a siege from Cromwell's Parliamentarian forces in 1645. Gwysaney Hall is surrounded by forty acres of traditional gardens and formal lawns and an award-winning Pinetum. The Gwysaney Estate covers 2,500 acres. Originally Gwysaney Hall was built on an H-plan, until it started to fall down the hill. The unsafe East Wing was

demolished around 1823, and it was a further forty years before the East Wing was remodelled. Regardless of Victorian alterations the house is Jacobean in the main, having been remodelled in 1603, but its wonderful front door bears the date 1640. The Davies-Cooke family own it, and can retrace their history back to the House of Powys. However, in 2009 Richard Davies-Cooke put Gwysaney Hall and about 2,000 acres of land, on the market, despite the opposition of his brother Paul.

MOLD – NERCWYS TOWER FORTIFIED HOUSE AND NERCWYS CHURCH *Nercwys, 3 miles south of Mold, Flintshire CH7 4EW. Tel: 01352 700220.* Tower is listed as Grade I, and is the only Welsh fortified border house still standing. The main section was probably built around the 1450s, but the crenelations are Victorian. Stained-glass windows display the family coat of arms, and the motto 'Heb Dduw, heb ddim' ('Without God you have nothing') is carved into the fireplace. Tower was in the hands of the Wynne family from the sixteenth to the late eighteenth century. Since then, it has remained in the hands of the Wynne Eytons until the present day. Apparently Robert Byrne, the ex-mayor of Chester, was murdered here by its builder Rheinallt ap Gruffydd ap Bleddyn, the famed defender of Harlech Castle. There is a hook in the vaulted main hall that may be where he was hung in 1465. The entrance is closed by massive ornamental wrought-iron gates known as the 'Black Gates'. These were brought here from Leeswood Hall, nearby, in the 1980s. They date from the late 1720s or early 1730s, and may have been the work of the Davies brothers of Bersham. The 'White Gates' at the nearby demolished Leeswod Hall are also from Bersham and are Grade I listed. In the small gardens there are traces of a seventeenth-century layout and other features from then onwards. Tower now operates as a luxury B&B. The Church of St Mary at Nercwys contains what is considered to be a Norman tower arch, and some medieval masonry in its nave. It houses a rich collection of furnishings and fittings, including fragments of medieval grave-slabs from the mid-thirteenth century and a late medieval arch-braced roof.

MONKNASH GRANGE, MILL AND PLOUGH AND HARROW INN *South of the B4265 between Llantwit Major and Ogmore, Vale of Glamorgan.* The grange was one of the largest monastic farms in Glamorgan, the land having been given to Neath Abbey in the twelfth century. It covers around twenty acres, where one can see ruined stone buildings, ditches, fishponds and levelled areas. The main entrance is thought to have been near where one can see a disused forge building. The columbarium is one of its best-preserved buildings, and on the inside there are a few remaining nesting boxes. There are similar dovecots in the Vale at Llantwit Major, Cadoxton Court in Barry, St Ffagans and Sutton. The ruined great barn is amongst the biggest monastic barns in Britain at over 200 feet long. It is so large that its porch incorporates a later house. Down the valley towards Traeth Mawr (Great Beach) you will find the remains of a monastic flourmill next to the stream. Into the walls of the grange is built the *Plough and Harrow*, dating back to 1383, with stone-flagged floors, inglenooks, a choice of real ales and many ghost stories. It was featured in the *Guardian* as one of the ten best seaside pubs in Britain, although it is a fair walk to the coast from here. It is one of the oldest pubs in Wales. The medieval church at Monknash is Grade II*. Nearby Marcross Church of the Holy Trinity is twelfth century and has an unusual font, a tower with a gabled roof and a leper's squint, a window through which people with infectious diseases could see the altar. It is Grade I listed. There is a simple circular walk from Monknash down the valley, east to Nash Point (see below), up another valley via the *Horseshoe* pub and back to Monknash to the *Plough and Harrow*.

MONMOUTH HISTORIC BORDER TOWN AND FORTIFIED BRIDGE *Where the Wye meets the River Monnow (Afon Fynwy), on the A40, Monmouthshire.* This is the only town with a fortified gateway on a bridge in Britain. Monnow Bridge is thirteenth century and once possessed a portcullis and a rampart for sentries. Only three such stone-gated bridges survive in Europe. There was also a Roman fort here, named Blestium, and the site has always had strategic value, developing as a walled town. Henry Jones, who patented self-raising flour, was born in Monmouth. The New Picture House is on the site of an Elizabethan theatre. Geoffrey of Monmouth (*c.* 1100-*c.*

1155) was born here, the author of *The History of the Kings of Britain*, who first gave the world the legends of Arthur and Merlin.

MONMOUTH CASTLE – GREAT CASTLE HOUSE The castle was established by William fitz Osbern in the late eleventh century, and the remains of the great tower date to the first half of the twelfth century. Edward II was imprisoned here. It was later remodelled by the Lancasters, and was the birthplace of Henry V, Harry of Monmouth, in 1387. The castle was of immense importance, in controlling the Welsh between the Severn and Wye river valleys. It was largely destroyed in the English Civil War, when it changed hands three times. Thus only parts of the Great Tower and Hall remain. In 1673, the Duke of Beaufort built Great Castle House on the castle site, using castle materials.

MONMOUTH – KYMIN NAVAL TEMPLE and VIEWPOINT – NATIONAL TRUST *Overlooking Monmouth in the Wye Valley AONB, on Offa's Dyke footpath NP25 3SE.* This is on a wooded hill with pleasure grounds, where there is a Georgian circular banqueting house built in 1794, where Lord Nelson and Sir William and Lady Hamilton had breakfast in 1802. There are superb views over the countryside. The nearby Naval Temple on top of the Kymin was built in 1800, and celebrates the glories of the British Navy and sixteen noted admirals.

MONMOUTH SHIRE HALL *At the top of Monmow Street, on Agincourt Square.* Renovated in 2009, it dates from 1724. The statue of Henry V was placed on its wall in 1792. There are six bays, and inside is a late Georgian courtroom. Here in 1840 the last sentence in Britain of hanging, drawing and quartering was handed down, to Chartist leaders (but thankfully commuted to transportation for life). Outside, in Agincourt Square is a Goscombe John statue of local man Charles Rolls, who founded Rolls-Royce. He is depicted holding an aeroplane as he was the first man to fly non-stop to France and back, and died in an air crash when his biplane broke up in mid-air in 1910.

MONMOUTHSHIRE & BRECON CANAL *This follows the Usk Valley for 35 miles from Cwmbran to Brecon through beautiful scenery, the World Heritage Site of Blaenafon and Goytre Wharf south of Abergafenni.* Completed in 1812, there are only six locks, of which five are in one flight, a tunnel and an aqueduct. More than twenty miles are on one level, the longest such stretch in Britain. For most of its thirty-five-mile length, it is in Brecon Beacons National Park. It is formed from two canals: the Monmouthshire Canal runs from Newport to Pontymoile and the Brecon Abergavenny Canal carries on from Pontymoile to Brecon. 'Fourteen Locks' is a series of locks on the Crumlin arm of the Monmouthshire Canal at Rogerstone, in the north of Newport. Some regard it as Britain's most remarkable staircase lock system, the canal level being raised 155 feet in just 800 yards. Four of the locks are currently being restored.

MONTGOMERY, TREFALDWYN – HISTORIC BORDER TOWN *Near Offa's Dyke, south of Welshpool on the B4388.* With a population of 1,000, this Georgian gem of a town used to be the smallest borough in England and Wales. With the 1267 Treaty of Montgomery, Henry III ratified the claim of Llewelyn ap Gruffydd, Llewelyn II, to the title of Prince of Wales. Montgomery was the administrative centre for the old county of Montgomeryshire, and therefore has many old and interesting buildings in the town, including an old gaol and a fine 'Georgian' market square. However, although the houses appear to be Georgian in style, they are often much older with Georgian façades, originally constructed from materials robbed from the overlooking castle. There are also many examples of houses in the traditional 'black and white' Montgomeryshire style of half-timber construction. The seventeenth-century Dragon Inn is a lovely old 'black and white' coaching inn, and an excellent place from which to explore the area.

MONTGOMERY, BATTLE OF, 1644 This was the largest battle of the Civil War in Wales, fought to gain control of the town and castle of Montgomery, as it controlled access to mid-Wales. The castle was held for the King by Lord Herbert of Chirbury. When a Parliamentary force under Sir Thomas Myddleton occupied the town, Herbert surrendered the castle to him in September. Within days, Sir Michael Ernley gathered together a Royalist force, which managed to surprise the Parliamentarians, who were divided, with 500 infantry remaining under siege in the castle, and Myddleton escaping to Shrewsbury. Here he raised a force of 3,000 men, and returned to Montgomery. The Royalists, meanwhile, had increased their force to around 4,000-5,000 men. The two sides met on 17 September 1644, probably close to the River Camlad. Lord Byron's Royalists had the best of the initial fighting, but the better-disciplined Parliamentarians were able to regroup, and secured control of the castle. Two thousand Royalists were killed or captured.

MONTGOMERY CASTLE CADW The first castle was built by Roger de Montgomerie of Calvados in the eleventh century. The Normans built it as a staging post for invasion into Powys, commanding the area of the Upper Severn River Valley, and as a defence against the might of the princes of Gwynedd. There is an important river crossing two miles away. The present castle is the one refortified by Henry III to command the approaches to Central Wales in his campaigns against Llywelyn the Great. It survived an attack by Llywelyn in 1228. In 1231, Llywelyn attacked again but only succeeded in burning the town, and Dafydd ap Llywelyn unsuccessfully besieged it in 1245. Town walls were built in 1279-1280, and more buildings were added to the castle after the defeat of Llywelyn the Last in 1282. It was held by the Mortimers in the fourteenth century. The Herberts were forced to surrender it to Parliamentarians in the Civil War, when much of it was demolished, including their mansion in its grounds.

MONTGOMERY – CHURCH OF ST NICHOLAS This is a large Norman church dating from the 1220s, with a fifteenth- to sixteenth-century hammer-beam roof over the west nave and a sixteenth-century wagon roof over the east nave. The fifteenth-century rood screen, rood loft, stalls and misericords were brought from Chirbury Priory, just over the English border, after the Dissolution, as Montgomery was a chapelry to Chirbury. There is a superb Elizabethan tomb to Richard Herbert of Montgomery Castle, and another tomb may be that of Edmund Mortimer, who died fighting for Glyndŵr at Harlech Castle in 1408. Mortimer was married to Owain's daughter Catrin, and the brother-in-law of Henry 'Hotspur' Percy. Percy died at Shrewsbury fighting the usurper King Henry IV (Bolingbroke). In 1821, a local man, John Davies, was accused of assault and robbery. He was found guilty and sentenced to be hanged, but continuously protested his innocence, and prayed that no grass would grow on his grave for a generation. His grave remained bare for at least a century, giving birth to the legend of the 'Robber's Grave', which (now grassed) can be seen in St Nicholas' churchyard.

MONTGOMERYSHIRE CANAL This is a thirty-four-mile narrow canal running south from a junction with the Llangollen Canal at Frankton, crossing the Welsh border at Llanymynech and terminating at Newtown. The canal was constructed in stages from 1790 to 1819, initially to transport lime for agricultural purposes. After lying derelict for many years, it is being reborn for pleasure cruising, and more than half of the waterway is once again in water. Seven miles are now navigable at the northern end, connected to the national network, and eleven miles are navigable around Welshpool but presently isolated from the rest of the inland waterway network.

MORGRAIG CASTLE *It lies on Cefn Onn ridge above Cardiff, accessible from the Traveller's Rest car park on the Cardiff-Caerffili road.* 'Lost' until 1895, this is a five-towered thirteenth-century castle. Lying between Welsh Senghennydd and English-controlled Glamorgan, there has been discussion as to whether it is a Welsh or Norman castle. It was probably built by the de Clares, because of the existence of Sutton stone from a quarry in the Vale of Glamorgan, which Welsh builders would

not have been able to access at that time. It was superseded by Caerffili Castle as the Normans established their hold on southern Glamorgan, and it desperately needs conservation work.

MORLAIS CASTLE *2 miles north of Merthyr Tydful, on a remote escarpment overlooking the Taf Fechan River.* In an Iron Age fort above the Taff Gorge are the remains of a large castle of Gilbert de Clare, Earl of Gloucester. The land was claimed by Humphrey de Bohun, Earl of Hereford, and war broke out in 1290. De Clare and de Bohun were fined by Edward I, who had to march from North Wales to intervene in their dispute. Morlais was taken by Madog ap Llywelyn in 1294 and the castle was never fully completed. Much stonework has been robbed but there is a fine crypt.

MORRISTON TABERNACL CONGREGATIONAL CHAPEL *Off the A48 and A4067, now a northern suburb of Swansea.* Dating from 1872, it replaced earlier chapels dating from 1796, and no expense was spared by its patron, the Swansea entrepreneur Daniel Edwards. Unfortunately, it is difficult to gain entry to the Gothic building to see its huge organ and seating amphitheatre. Also known as the Libanus Chapel, it has seating for 3,000, and is home to the famous Tabernacle Morriston Choir and the Morriston Ladies Choir. It has been called 'the Nonconformist Capital of Wales' and is Grade I listed.

MUMBLES, Y MWMBWLS, THE OLDEST PASSENGER RAILWAY IN THE WORLD *At the end of the A4067 just south-west of Swansea, on the Gower Peninsula.* The world's oldest passenger railway opened in 1807 in Mumbles, Swansea, and operated until 1960. It was bought by a competitor, the local bus company South Wales Transport, which closed it. Built by engineer Benjamin French, it ran along the front of Swansea Bay, from Swansea to Oystermouth, and the railway made Mumbles famous in Victorian times. The first train was pulled by horses, then steam trains, then electric power. There is a lighthouse on a nearby islet, a pier and a RNLI Lifeboat Station, and Dylan Thomas used to drink in the Mermaid pub in the village. There used to be 600 men in 100 skiffs, fishing for oysters here in season.

MUMBLES – OYSTERMOUTH CASTLE Oystermouth is the Anglicisation of Ystumllwynarth (the bend in the grove of the bear), and Castell Ystumllwynarth is the finest remaining castle in the Gower Peninsula. It was founded by William de Londres soon after 1106, but in 1116 the Welsh of Deheubarth burnt the castle. It was rebuilt, and destroyed again in 1137 by the princes of Deheubarth. In 1215, Gower was again taken by the Welsh, but they were expelled in 1220. The de Braose dynasty rebuilt Oystermouth castle in stone. A high curtain wall was built, a superb chapel, three-storey residential buildings with fireplaces and garderobes on each floor. Edward I stayed here in 1284. In the graveyard of the Oystermouth Parish Church, Thomas Bowdler (1754-1825) is buried, the man who expurgated Shakespeare.

MWNT – HOLY CROSS CHURCH *North of Cardigan (Aberteifi) near Gwbert and Y Ferwig, on the coast near Cardigan Island Farm Park.* Some claim this to be an early Celtic Christian site, but no churches were built with sightlines of Irish and Viking pagan raiders. All sixth-century and earlier sites known to this author are sheltered in valleys, and hidden if near the coast. There were no spires or easy access to attract barbarians to a settlement looking for goods or slaves - early churches were humble, secret places. Above the small sandy beach is a lovely fourteenth-century single cell church, which replaced an earlier one, as there is a twelfth century font. The church was on a pilgrimage route between St David's, Strata Florida and Bardsey Island. The church may have been built to commemorate a battle in 1155. It is thought that the Flemings invaded at Mwnt only to be repelled by the Welsh, and this became known as 'Sul Coch y Mwnt' - the 'Bloody Sunday of Mwnt'. There were also victories by the Welsh under Rhys ap Gruffydd at Crug Mawr in 1136 and at Cardigan in 1165, on either side of this victory, as he fought to keep Ceredigion from the Normans and Flemish.

MYDDFAI – THE PHYSICIANS OF MYDDFAI *Near Llanddeusant, near Llandovery, Carmarthenshire.* Llyn y Fan Fach is known as the place where Myddfai of Blaen Sawdde Farm met the 'lady of the lake'. After Myddfai offered her three kinds of bread, the beautiful woman promised to marry him, on the condition that he would never hit her three times without a cause. Her father gave the couple livestock, and they lived at Esgair Llaethdy Farm and had three sons. However, Myddfai tapped her thoughtlessly on three occasions: when she did not want to attend a baptism, when she cried at a wedding and finally when she laughed at a funeral. She immediately disappeared with all the animals, but reappeared to her sons on several occasions: at Llidiart y Meddygon (Physicians' Gate) and Pant y Meddygon (Physicians' Hollow). She taught them how to heal with herbs and plants, and her eldest son Rhiwallon became physician to Rhys Grug, Lord of Dinefwr. Rhiwallon's three sons were Rhys Grug's doctors when he died in 1234, and they founded a long line of physicians culminating in John Williams, Queen Victoria's eminent doctor. These places still exist, where the ancestors of this longest line of medical men in recorded history learned their profession. John Williams edited the thirteenth-century manuscript of their earliest folk remedies, *The Physicians of Myddfai*, and it was translated into English by John Pughe in 1861. An exhibition on the doctors can be seen at the National Botanic Gardens, Llanarthne. The medieval church of St Michael at Myddfai has twin barrel roofs.

MYNYDD CARN, BATTLE OF, 1081 *The battle occurred a day's march north of St David's, Pembrokeshire. It appears to have been at Mynydd Carn Ingli, inland from Newport, a few miles north of Fishguard, about 25 miles from St David's.* Gruffydd ap Cynan tried to gain the kingdom of Gwynedd from Trahaearn ap Caradog in 1075, but was beaten and forced to take refuge in Ireland. He returned with a force of Dublin Vikings and Irish in 1081, landing near St David's and meeting Rhys ap Tewdwr, the former King of Deheubarth. Rhys had recently been driven from power by Caradog ap Gruffydd of Glamorgan (Gwynlliwg), helped by Meilyr ap Rhiwallon of Powys and Trahaearn ap Caradog of Gwynedd. Rhys and Gruffudd decided to combine forces to fight their rival princes. Caradog ap Gruffydd and Trahaearn ap Caradog were killed by Gruffydd ap Cynan and Rhys ap Tewdwr, and they regained control of Gwynedd and Deheubarth respectively.

MYNYDD CARN INGLI HILLFORT (CARNINGLI) *The same directions as for Mynydd Carn, above.* Around twenty round huts and eight rectangular huts have been found on this superb hillfort, and the evidence of nearby field systems points to a large number of people living here, and on other prehistoric settlements on and around the mountain. St Brynach was said to climb to the top of Carn Ingli (The Rocky Summit of the Angels) in the fifth-sixth century to converse with angels, and his foundation is at nearby Nevern. The hillfort overlooks the sea and is near fresh water, to this author one of the most wonderful and evocative places in Wales. Mystics believe that the site possesses great power, near the famous Preseli 'bluestones'. It is a complex site, with signs that some of the defensive structures may have been dismantled, which makes this author believe that the Battle of Mynydd Carn could have taken place here.

MYNYDD LLANGATTOCK (LLANGATWG), BATTLE OF, 728 *Overlooking Llangatwg, on the opposite side of the Usk to Crickhowell, Breconshire.* There are many Neolithic cairns and remains on this escarpment in the Brecon Beacons. Ethelbert of Mercia fought with Rhydderch ('Molwynog') ap Idwal of Glamorgan and two huge cairns are supposed to be where the dead are buried. The remains of a warrior were found in one. The Mercians were chased back to the Usk, where many were drowned. Some of Britain's biggest cave systems lie underneath the hill, and there are hundreds of sinkholes scattered across it.

NANHORON – CAPEL NEWYDD *3 miles north-west of Abersoch, Llŷn Peninsula, Caernarfonshire.* This is extremely difficult to find, down a green lane, and is a long, low Dissenter Meeting House dating from 1772. It has been disused from the 1890s, and has a compacted mud floor and an

unaltered eighteenth-century interior with high box pews. Hopefully, some use may be found for this remarkable building, or it can be shipped and rebuilt at St Ffagan's Museum.

THE NANHORON ESTATE AND MANSION *Off the B4413 west of Llanbedrog, near Pwllheli, Caernarfonshire LL53 8DL. Tel: 01758 730610.* A beautiful Regency mansion, hidden in some of the most beautiful landscape in Wales, its estate has been the home of the Harden family for 700 years. Its superb gardens are set around the River Horon. The Hen Dŷ is the oldest surviving house on the estate, where one can book a holiday. It used to be the Gardeners' Bothy, Brew House and Laundry for the estate and has a bell tower, which was used to announce mealtimes. The estate covers some 5,000 acres on the Llŷn Peninsula covering every kind of landscape, and its extent is almost exactly as it was in the eighteenth century. The park, gardens and woodland walks were laid out at this time. The building of the present house was completed by 1803.

NANTEOS AND THE HOLY GRAIL *3 miles south-east of Aberystwyth.* One of the 'Thirteen Treasures' that Merlin had to guard was the 'Dysgl of Rhydderch', a sixth-century King of Strathclyde. It was a wide platter, where 'whatever food was wished for thereon was instantly obtained'. This was also a description of the 'Drinking Horn of King Bran the Blessed', in which one received 'all the drink and food that one desired'. 'Ceridwen's Cauldron' contains all knowledge, and she gives birth to Taliesin. The 'Cauldron of Diwrnach' would give the best cut of meat to a hero, but none to a coward. Bran the Blessed also had a cauldron in which dead men could be revived. This platter or cauldron of the Celtic mythology seems to be a precursor to the Holy Grail, or cup of the Last Supper. The cup used by Jesus Christ at the Last Supper was supposed to have been brought by Joseph of Arimathea to Glastonbury, and taken from there to Ystrad-Fflur (Strata Florida Abbey) for safety.

When Henry VIII dissolved the monasteries, the last seven monks are supposed to have taken the cup into the protection of the Powell family at nearby Nanteos, the descendants of Edwin ap Gronw, Lord of Tegeingl. A tradition says that the fragment of the wooden bowl remaining inspired Wagner to write *Parsifal*. Fiona Mirylees, the last Powell heiress, placed the treasured 'cwpan' in a bank safe in Herefordshire, as the Powell family left Nanteos Mansion in the 1960s. The remaining ancient fragment is about four inches across, made of olive wood. So little is left, because supplicants used to wish to take a tiny splinter home with them. Nanteos Mansion has no less than three ghosts: an early Mrs Powell who appears as a grey lady with a candelabra, when the head of the household is about to die; a lady who left her deathbed to hide her jewellery which has still not been found; and a ghostly horseman on the gravel drive at midnight. The wonderful mansion was rebuilt in 1739, and is slowly being renovated after a period as a craft centre. Its most interesting room is the rococo music room, where Gruffydd Evan played his harp for sixty-nine years, and Wagner was said to have composed.

NANTGARW CHINAWORKS MUSEUM *The historic village on the River Taff, just north of Cardiff, was destroyed by the new A470 dual carriageway. The museum is in Nantgarw House, Tyla Gwyn, Nantgarw, Glamorgan CF51 7TB. Tel: 01443 841703.* Porcelain was only produced at the Nantgarw Pottery between 1813 and 1817-20, making it extremely rare. William Billingsley attempted to make the finest porcelain in the world here, and it then became an earthenware pottery under the Pardoe family. Nantgarw and Swansea were centres for making high-quality porcelain between 1813 and 1820, which because of its scarcity is now very collectable. Pieces can fetch up to £10,000. Porcelain is displayed in the museum of Nantgarw House, and its stables are now an education block, with a reconstructed bottle kiln on the pottery site. The Glamorganshire Canal and the Taff Vale Railway ran through Nantgarw, and its colliery, opened in 1911 was the deepest mine in South Wales with two shafts of 856 yards.

NANT GWRTHEYRN – WELSH LANGUAGE AND HERITAGE CENTRE *Take the signposted narrow road to the sea from Llithfaen, on the northern coast of the Llŷn Peninsula,*

Caernarfonshire LL53 6PA. Tel: 01758 750334. Web: nantgwrtheyrn.org. This is located in a former granite quarrying village on the northern coast, offering Welsh for adults (as a second language) intensive residential courses. This author has stayed there twice in one of the quarrymen's cottages, and watched wild goats and choughs on the cliffs, and swam with a seal on the beach – it is a wonderful place for walking. The old chapel has been converted into a heritage centre. In the 1770s, Thomas Pennant wrote about a tumulus which was near the sea here until around 1700, called Bedd Gwrtheyrn (Gwrtheyrn's Grave), which had been opened to find the bones of a tall man. Castell Gwrtheyrn (Gwrtheyrn's Castle) was the name of a place nearby on early maps. Gwrtheyrn was Vortigern, King of the Britons, and the father of Vortimer the Blessed, in the fifth century. Vortigern invited the Saxons Hengist and Horsa into Britain and Vortimer fought them. The sad legend of *Rhys and Meinir* is also set here. There were three stone quarries opened in the cliffs along the beach, and there are many industrial remains, as the gravel was shipped out from the beach. In 1878, the company built twenty-four new houses for their workers and families, which are now used for accommodation by the Welsh Language Centre. They are in two L-shaped rows, one facing the sea, and one facing the mountain. There was also a large house on one terrace end, with a shop and a bakery behind. Another house was built on separate land, and this was the Plas, the home of the quarry manager, now used for teaching. In 1878, Capel Seilo was built, now the Heritage Centre. In 1970, Dr Carl Clowes moved from his native Manchester to run a new practice in Llanaelhaearn, and was determined to bring his children up as Welsh speakers. There was also a general feeling that a specialised centre was essential, a national language centre which would be open all year. Both ideas merged, and many tutors and friends decided to start a trust fund in order to purchase the village of Nant Gwrtheyrn. By 1978, they had sufficient funds (£25,000) to buy the village, which had been empty since 1959. They began to renovate the houses immediately and, in April 1982, the first group went to 'the Nant', despite the fact that there were no phones or electricity, to hold the first course. Over 25,000 students have studied here since that time. It is a wonderful place to visit or stay – a deserted beach, wildlife galore, industrial remains and a place with wonderful staff dedicated to keeping the language alive. One must mention Caffi Meinir here, with excellent cuisine, all home-cooked, overlooking the sea. In 1833, Samuel Lewis wrote, 'To the east of the church is a small vale, called Nant Gwrtheirn, or "the Vale of Vortigern", to which that prince is said to have retreated for shelter from his infuriated subjects, and where he built a castle, which is said to have been destroyed by lightning. This narrow vale is situated between Craig y Linn and Yr Eifl, and is accessible only by sea; the sides are bounded by barren and rugged rocks, on which not a blade of vegetation is seen. At one extremity rises the loftiest peak of Yr Eifl, and the only opening is towards the sea, by which it is bounded on the north: the sole agricultural produce of this vale is oats. Near the shore is a small verdant mound, said to have been the site of Vortigern's castle; and near it was formerly a tumulus, called Bedd Gwrtheirn, or "Vortigern's Grave", in which was found a stone coffin, containing human bones. No traces of these relics are now visible, but the spot is still pointed out where that unfortunate prince, who met his death in this retired spot, in 464, was interred.' This author is in love with the place.

NANT GWRTHEYRN – TRE'R CEIRI HILLFORT *One can approach this wonderful site from the lane to Nant Gwrtheyrn. Alternatively, take the A499 north of Pwllheli. At Llanaelhaearn, take the B4417 towards Nefyn. Less than a mile from the junction for the B4417, there is a limited parking space for a footpath on your right, taking you up the hill to Tre'r Ceiri.* This is the most spectacular and impressive hillfort in Wales, meaning 'Town of the Giants'. There are significant stone ramparts surrounding its entire circuit, in places still standing to over ten feet in height. The 5-acre fort occupies one of the twin peaks of Yr Eifl (the Rivals). The interior is packed with walled stone buildings, and the remains of 150 huts can be seen, with some of their walls still standing over three feet high. Some are roundhouses, others are larger, being rectangular or oval. The huts are grouped together in four or five bands across the fort, varying in size from 10 to 25 feet each. Set on the narrow summit of the hill, there are two conserved entrances, and the site is topped by a Bronze Age cairn. It is a miraculous place with views from Cardigan Bay to Anglesey.

NARBERTH CASTLE *Just off the A40, on the A478 to Tenby, Pembrokeshire.* Narberth is mentioned in the *Mabinogion*, and is on a hill in this old market town on the Landsker line. In 1116, *The Chronicle of Ystrad Fflur* notes, 'Gruffudd ap Rhys took the castle near Arberth and burned it. Many young hotheads gravitated to him and they carried off many spoils. And he burnt a castle in Gower and slew many within. And Owain ap Cadwgan was slain.' Narberth later belonged to the Mortimers, but it was forfeited to the Crown during the Glyndŵr War, as Edmund Mortimer had sided with him, and was then held against Glyndŵr's forces. Its castellan, Thomas Carew, was allowed to keep the castle and its lordship as his reward, but it later reverted to the Mortimers. It was slighted after the Civil War, but from 2005 has been made safe for visitors after being out of bounds for decades. Two of its four towers have virtually disappeared. The castle has provided building material for surrounding houses, and the remains are mostly single- and double-storey walls, with the barrel-vaulted kitchen cellars intact.

NASH POINT – IRON AGE DITCHES, LIGHTHOUSES AND YR HEN EGLWYS *Off the B4265 between Llantwit Major and Ogmore, Vale of Glamorgan.* The Iron Age promontory fort is one of several along the Glamorgan Heritage Coast, protecting a potential landing point from coastal raiders. Most of the fort has been destroyed by cliff erosion, and there is a late medieval pillow mound, thought to be an artificial rabbit warren. On the opposite cliff across the unspoilt valley of Cwm Marcross are the remains of a long cairn in boat-shape, now covered in gorse. It was described in 1811 as an ancient cromlech and was according to tradition the place of worship of the old village, known locally as Yr Hen Eglwys (Old Church). To this author it has the same shape and proportions as the 'navetas' of Minorca. There was a public outcry in 1832 following the loss of forty lives when the passenger steamer *Frolic* ran aground on the Nash Point sandbank. The two lighthouse towers here were then built 1,000 feet apart and carefully positioned so that they could be aligned by ships sailing up the channel. Navigation buoys were anchored on the sandbank at the same time. The higher lighthouse was the last manned lighthouse in Wales, with the keepers finally leaving in 1998. It can sometimes be visited.

NATIONAL PARKS
1. Brecon Beacons. This mountain range of 519 square miles was designated in 1957, and covers parts of four counties, Mid-Glamorgan, Powys, Gwent and Dyfed.
2. Pembrokeshire Coast National Park. 225 square miles were designated in 1952, and it is the only coastal national park in England and Wales.
3. Snowdonia National Park is 838 square miles in Caernarfonshire and Meirionnydd, designated in 1951.

NEATH ABBEY AND GATEHOUSE CADW *On the A4109, east of Swansea, Glamorgan.* Founded by Richard de Granville in 1130 as a Savignac monastery, it became a Cistercian foundation in 1147, and there is a superb thirteenth-century dormitory undercroft. Fairly complete remains of the abbey survive, together with the ruins of a sixteenth-century mansion raised within its precincts. Leland called it the 'fairest' abbey in all Wales, but it is now surrounded by an industrial estate. Neath is an ancient place, with the Roman fort of Nidum being abandoned in 120 CE. The sixth-century saints Illtud and Cadog founded churches here, and there is a central market.

NEATH – ABERDULAIS WATERFALLS – THE LARGEST WATERWHEEL SUPPLYING ELECTRICITY IN EUROPE – NATIONAL TRUST *Off the A4109, heading out of Cadoxton, Neath towards Crynant SA10 8EU. Tel: 01639 636674.* The village grew around the Aberdulais Falls, the site of successive industries and now a hydroelectric station. The waterwheel at Aberdulais produces electricity that powers the site, and the surplus is sold back to the National Grid. The first business here was copper smelting, and it was twice an ironworks site, using the nearby canal for transport. It has also had a corn watermill, and a tinplate site in the 1840s. Children used to work

seven days a week there, twelve hours a day, for 7 pence a day. The site has existed since Roman times, and among the industrial relics is a modern fish-pass to view salmon returning upriver to spawn.

NEATH CASTLE, CASTELL NEDD The site in the town centre was chosen to guard a river crossing over the River Nedd, and the first ringwork was built by Robert, Earl of Gloucester, in the twelfth century. It was probably destroyed by Llywelyn the Great in 1231, but rebuilt. It was also attacked when owned by Hugh Despenser, and rebuilt again in the fourteenth century. Edward II hid here before his capture. The main feature remaining is the superb fourteenth-century gatehouse.

NEATH – GNOLL ESTATE *On the B4434 Neath to Tonna Road, it is a short walk from Neath Victoria Gardens' main bus station.* By the seventeenth century a country house had been built on the hillside, and from 1710 onwards it became the home of the Mackworth family, who were wealthy industrialists and owned the town's copper works. The Gnoll Estate Country Park is an eighteenth-century landscaped garden with attractive woodland and lakeside walks. A major refurbishment in 1994 restored many of the remaining landscape features, with an ambitious reconstruction of the 1720s formal cascades. With the 1740 cascades in Mosshouse Wood previously restored, the Gnoll Estate is unique in having two sets of cascades from different periods of gardening fashion.

NEATH – CADOXTON-JUXTA-NEATH – CHURCH OF ST CATWG The 'murder stone', the slab marking the grave of Margaret Williams, stands in the churchyard, reading:

1823
To Record
MURDER
This stone was erected
over the body
of
Margaret Williams
aged 26
A native of Carmarthenshire
Living in service in this Parish
Who was found dead
With marks of violence on her person
In a ditch on the marsh
Below this Churchyard
On the morning
Of Sunday the Fourteenth of July
1822
Although
The savage murderer
Escaped for a season the detection of man
Yet
God hath set his mark upon him
Either for time or eternity
and
The cry of blood
Will assuredly pursue him
To certain and terrible but righteous
Judgement

She was employed as a serving girl in the house of the local squire, and allegedly embarked on an affair with the squire's son. In the summer of 1822 her body was found near the marshes. Margaret had been strangled, and her body thrown into a ditch. Suspicion fell on the squire's son, along with rumours of a secret pregnancy, and several witnesses had seen him with the girl on the night of her death. However, no charges were ever brought against one of the gentry. She was buried in the churchyard, near where she had been found. Local people erected her headstone, positioning it to face the manor house. The trees to the front were then cut down, so that every morning when the squire's son looked out of his window, he saw the gravestone looking back at him. The village is named so, to distinguish it from Cadoxton, now a suburb of Barri, which itself has a superb medieval church of Catwg with wall paintings.

NEATH AND TENNANT CANALS These were two independent but linked canals, usually regarded as a single canal. They are being restored and meet at Aberdulais Basin. The Neath Canal was constructed from 1792-95, and the Tennant from 1818-24.

NEVERN CASTLE, CASTELL NANHYFER *Off the A487 between Fishguard and Cardigan.* The original Welsh castle was taken by Robert FitzMartin in the twelfth century, but it was taken by The Lord Rhys in 1191 and given to his son Maelgwyn. The FitzMartins then built a new castle at Newport, in Pembrokeshire. In 1194, The Lord Rhys was briefly imprisoned in Nevern by his sons Hywel Sais and Maelgwyn, but was later released by Hywel. There are two mottes here, with a rock-cut ditch between them, and it is possibly an Iron Age site because of its embankments.

NEVERN – ST BRYNACH'S CHURCH According to one tradition, the weeping red sap from the old yew trees in the churchyard will dry up, when Wales regains its independence. Its thirteen-foot high Celtic Cross of St Brynach is probably tenth century, with twenty-one carved panels, each enclosing a different type of love-knot pattern of endless interlacing ribbon, the symbol of eternity. St Brynach was a friend of St David, founded seven churches, and is said to have gone to Mynydd Carn-Ingli to die alone in 570. Another stone near the gatepost of the twelfth-century church has Latin and Ogham inscriptions. In the church is the 'Maclogonus son of Clutari' Stone, again with Latin and Ogham carvings, and another beautifully carved cross. This has been associated with Maelgwn Gwynedd, the sixth-century 'pendragon' who succeeded Arthur, and who gave land to this church in 547. There is also an early cross-marked stone and an inscribed stone to 'VITILIANI EMEREOTO' (Vitalianus Emeretus). The 'Vortigern Studies' website makes a persuasive case for this being the fifth-century grave marker of Vortigern. On the road nearby is a very rare double-mounting step, with six steps on each side. A verse on a tombstone in the churchyard remembers the infant children of the Rev. D. Griffiths, who was Vicar at Nevern from 1783 to 1834. Anna Letitia and George were remembered thus: 'They tasted of life's bitter cup, / Refused to drink the potion up, / But turned their little heads aside, / Disgusted with the taste, and died.'

NEWBOROUGH (NIWBIRCH) HISTORIC VILLAGE *On the A4080, Anglesey LL61 6TN.* Formerly known as Rhosyr, the village dates from the uprooting of the Llanfaes population in 1294, for Edward I to build Beaumaris Castle. Llys Rhosyr has only recently been found, a royal court of Llywelyn I. Up until the 1920s the village was mainly involved in weaving baskets, mats and ropes from the marram grass upon the massive sand-dune complex of Newborough Warren. The renowned bird artist Charles Tunnicliffe lived here from 1945 until his death in 1979. Newborough is also the home of the Sir John Prichard Jones Institute, Pendref Street, considered an exceptional example of an early twentieth-century public institution. The Institute and the six single-storey cottage homes that accompany it were a gift to the village by Sir John Prichard Jones of Newborough. Beginning as a draper, he rose to be the chairman of Dickins & Jones in London. The neo-Tudor-style two-storey building, complete with clock tower, built in 1905 featured on the BBC programme *Restoration*. Tacla Taid, the Anglesey Transport and Agriculture Museum, is the

largest of its kind in Wales. It features over sixty classic cars and vehicles from the 1920s onwards. It is set in a replica of a 1940s cobbled village street, which includes two houses, a garage and a shop, with a window displaying old merchandise.

NEWCASTLE EMLYN, CASTELL NEWYDD EMLYN - CASTLE AND MARKET TOWN *10 miles south-east of Cardigan.* Llywelyn the Great seized the Norman castle in 1215, according to the *Brut y Tywysogion*. In a loop overlooking the Teifi, it was probably rebuilt in stone by Maredudd ap Rhys in 1240, and then held by his son Rhys ap Maredudd from 1287. It changed hands three times between him and the king until he was defeated and killed. In 1403, it was taken by Owain Glyndŵr's forces. Sir Rhys ap Thomas owned it in 1500. Rowland Laugharne's Roundheads were beaten off by Gerard's Cavaliers in the siege of 1645, but after the Royalist defeat, the Parliamentarians returned to destroy it. The twin-towered gatehouse is its most prominent surviving ruin. Newcastle Emlyn and Adpar are two adjacent communities in the Teifi Valley, on either side of the River Teifi. To the north is Adpar (formerly the borough of Trefhedyn) in Ceredigion, and to the south, Newcastle Emlyn in Carmarthenshire. During the eighteenth and nineteenth centuries, it was an important part of the drovers' network, a collecting point for the hogs and Welsh Black cattle which ended up at auctions in Bristol, Birmingham and London. The legend of 'Gwiber Castell Newydd Emlyn' (the Wyvern of Newcastle Emlyn) is a local tradition. The town gets its name as it was once the centre of the cantref of Emlyn.

NEWPORT *The M4 passes through the north of the city formed around the mouth of the River Usk, Monmouthshire.* The old borough of Newport grew rapidly with the onset of the Industrial Revolution, as its docks expanded. It has two large deepwater docks and one of the largest sea locks in the country. Its Welsh name is Casnewydd-ar-Wysg, i.e. Newcastle on Usk. The huge Celtic Manor Hotel overlooks the M4 outside Newport, the brainchild of billionaire local man Terry Matthews, and its golf course is the home of the Ryder Cup in 2010.

NEWPORT, BATTLE OF, 1044 Gruffudd ap Llywelyn defeated local princes here, to control south-east Wales, and with his defeat of Hywel at Aber Tywi later that year, added South Wales to his North Wales possessions, effectively uniting Wales.

NEWPORT CASTLE CADW Its ruins stand on the west bank of the River Usk, where it was built between 1327 and 1386, replacing the motte and bailey on Stow Hill, to guard the Norman settlement to be supplied by sea, and control the river crossing. Much of the surviving stone structure dates from around 1405 when the castle was extended and strengthened, following the sacking of the area by Owain Glyndŵr. It has three tall towers, dominating the Usk, and its linear form is dictated by its proximity to the river. For a brief time at the beginning of the sixteenth century, Jasper Tudor, Henry VIII's uncle, lived here.

NEWPORT - FOURTEEN LOCKS CANAL VISITOR CENTRE *On the road from Newport to Risca, alongside the Monmouthshire & Brecon Canal.* The flight of locks rises 160 feet in just half a mile, and is still an impressive sight. Visitors can trace the growth and decline of the canal, and its role in transporting commodities such as coal, iron, limestone and bricks from the South Wales valleys down to Newport docks.

NEWPORT - GAER, Y GAER (GOLLARS) HILLFORT *Overlooking the River Ebbw in the west of Newport, Monmouthshire.* This large Silurian site has multiple enclosures, the outer of which may have been used for stock. The inner enclosure is roughly pentagonal and surrounded by a single bank and ditch, best viewed on the west and south. The outer enclosure was defended by a large bank and ditch, which have been partially destroyed by quarrying in places.

NEWPORT MEDIEVAL SHIP *Ship Centre, Unit 22, Maesglas Industrial Estate, Newport. Tel: 01633 215708.* The Newport Medieval Ship was discovered in the banks of the River Usk in 2002 during construction of the Riverfront Theatre. The ship was excavated and lifted from the ground timber by timber, and an international team of specialists has cleaned and recorded all 1,700 ship timbers. 'The Newport Ship' is the most complete example of a fifteenth-century clinker-built merchant vessel ever found in the United Kingdom. She appears to be constructed in the Northern European 'keel first' shell-based tradition, in contrast to the cog and hulk traditions. One of the finds on the boat, the leather 'Newport ankle shoe', has an extremely pointed toe and an interesting form of decoration. On either side of the shoe around the ankle area are two elliptical cutouts. These 'peep holes' allowed the wearer to show a glimpse of their coloured hose through the shoe.

NEWPORT MUSEUM AND ART GALLERY *John Frost Square, Newport, Monmouthshire NP20 1PA. Tel: 01633 656656.* The museum features archaeology, art, natural sciences and local history. Displays include the Fox collection of ceramics, material from Roman Caerwent and objects and documents relating to the Chartists' Rising of 1839.

NEWPORT – ST BASIL'S CHURCH *In Bassaleg, a north-west suburb of Newport.* St Basil's Church was built in 1069, upon a site previously occupied by a tumulus or earthwork of pre-Roman origin, and overlooks the River Ebbw. Bassaleg's earliest known inhabitant was probably Saint Gwladys, the sixth-century wife of St Gwynlliw. She was supposed to bathe naked in Gwladys' Well, later called Lady's Well, on the Ebbw River in Tredegar Park, Newport. Bassaleg is the only British place name deriving from 'basilica', a term from early Christianity for a church containing the body of a saint, and until the mid-nineteenth century, a grave chapel for St Gwladys survived close to St Basil's Church. St Basil's is an impressive church, with a mixture of Georgian, Tudor and Victorian work. Bassaleg formed part of the Tredegar Estate, and the Morgan family of Tredegar House have a number of monuments within the church, and the Morgan family chapel remains within the church. When the Morgan family inhabited Tredegar House, their main carriage driveway led up to St Basil's Church. One can see the trees which once lined the long drive.

NEWPORT – ST MICHAEL'S CHURCH *Michaelston Y Fedw near Castleton, just off the A48 between Cardiff and Newport.* It is believed that this church dates back to around the fourth century, and was possibly a military post for the Romans. It has a number of interesting features, including a picture drawn on plaster which is said to commemorate the fifth-century St Medwy, who is believed to have been one of the saints from which the village derived its original name of Michaelston Y Fedw. Monuments of a number of members of the Kemys family of Cefn Mably are here, including Nicholas Kemeys, who defended Chepstow Castle against the Roundheads.

NEWPORT – CHURCH OF ST THOMAS THE APOSTLE *Redwick, on the Gwent (Caldicot) Levels south-west of Magor.* St Thomas is a large church for such a small village and dates from the thirteenth and fifteenth centuries. There is a thirteenth-century font, an unusual baptistery, the remains of a medieval rood screen and loft, the carving of a 'green man' and dials scratched into the buttress of the porch. A flood mark can be seen on the outside wall, indicating the height reached by the Great Flood of 1606-07. Two of the five bells date from 1350-80. The church was formerly dedicated to St Mary the Virgin and before that St Michael the Archangel, and may be a pre-Norman site.

NEWPORT – ST WOOLO'S CATHEDRAL, ST GWYNLLIW'S CATHEDRAL Anglicised to St Woolo's Cathedral, St Gwynlliw's stands on the summit of Stow Hill, on the site of Gwynlliw's fifth-sixth-century cell. The present church was begun by the Normans, with a superb decorated twelfth-century arched entrance. The nave was constructed from 1140-60. The Galilee Chapel has a 'green man' blowing a trumpet, and there is a superb Renaissance tomb of Sir Walter Herbert (d. 1568). According to legend, the soldier-prince Gwynlliw was converted to Christianity

when he was told in a dream to search for a white ox with a black spot on its forehead and, when he found it, to build a church as an act of penitence. The son of Gwynlliw and St Gwladys was St Cadog. In 1921, the Diocese of Monmouth was created and the church was designated a cathedral, which necessitated the enlargement of the east end in 1960. The site was earlier an Iron Age camp, and then a motte and bailey castle.

NEWPORT TRANSPORTER BRIDGE The largest of only eight such bridges left in the world, it carries cars and passengers across the Usk on a cradle platform hung from cables. It was built between 1902 and 1906 by a Frenchman, Ferdinand Arnodin, to accommodate tall ships and some of the highest tides in the world. 242-feet high, its four iron pillars support an iron grill, under which runs an electrically powered platform holding the cars. It has been a great attraction since the opening day when 8,000 people paid the penny toll to take the crossing, but it has always run at a financial loss. The opening of the Alexandra Dock in 1914 gave shipping access to the Bristol Channel beyond the Bridge, and the increase in the use of cars and the opening of the George Street Bridge in 1963, meant that the Grade I listed Transporter Bridge was used less and less. It was closed in 1985 and restored and reopened in 1995, then closed again in 2007-08.

NEWPORT – TREDEGAR HOUSE *NP10 8YW. Tel: 01633 815880.* Set in a beautiful ninety-acre park, this ancestral home of the Morgans is one of the best examples of a Charles II mansion in Britain. The earliest surviving part of the building dates back to the early 1500s. The house was the home of the Morgan family, later lords Tredegar, for over 500 years. By the end of the eighteenth century the Morgans owned over 40,000 acres in Monmouthshire, Breconshire and Glamorgan. Sir William Morgan entertained King Charles I here. Admiral Henry Morgan, the privateer, was a nearby cousin at Llanrumney Hall and Penkarne. Godfrey Morgan, Viscount Tredegar, survived the charge of the Light Brigade in 1854. His horse, Sir Briggs, is buried near the house. Here in the 1920s and 1930s, Viscount Evan Morgan dabbled in black magic and kept a menagerie of exotic animals. There are events throughout the year. The last Morgan of Tredegar House died in Monaco, having wasted the family fortunes and sold the house, which is now run by Newport Council as a visitor attraction.

NEWPORT WATERLOO HOTEL In Alexandra Road, in the Pill area of the city, it was erected in 1904 and is thought to have been given its name by an adjacent wharf. The Grade II listed building has an interior of exceptional quality, and is being restored to its former glory. For a brief period at the end of the nineteenth century, Newport's Alexandra Dock was the largest dock in the world.

NEWPORT – WENTWOOD FOREST *North from the A48 between Newport and Chepstow, around 5 miles north of Llanvair Discoed on the road to Usk.* Ancient woodlands, the remnants of the vast forest of native oak and beech stretching from the Usk to the Wye from the time of Christ, are now interspersed with huge Forestry Commission spruce and larch plantations.

NEWPORT – WESTGATE HOTEL AND THE CHARTIST RIOTS 3 NOVEMBER 1839 A Welsh speaker, John Frost was elected Mayor of Newport in 1836. He was one of the leaders of the Chartist march of 7,000 men which advanced upon Newport, in support of people's democratic rights. At least twenty-four men were shot dead by English troops firing from the Westgate Hotel. With other leaders, Frost was sentenced to be hung, drawn and quartered in a show-trial resulting from what Michael Foot called 'the biggest class-war clash of the century'. Frost's sentence was commuted to hard labour and transportation to Tasmania. 1,400,000 people had signed a petition asking for the pardon of Frost and other ringleaders. John Frost was pardoned when he was seventy-one and returned to be honoured in Newport, being carted through the town in a flower-bedecked carriage, drawn by his former Chartist comrades. The main square in Newport is now named after him, and you can still see bullet holes in the Westgate Hotel. The Corn Laws

were repealed in 1846, making bread cheaper, and 1867's Great Reform Bill doubled the electorate, adding another one million voters. At last some working people could now vote – Chartism had helped change British history.

NEWPORT WETLANDS NATIONAL NATURE RESERVE *Take West Nash Road, and before the entrance to Uskmouth Power Station, follow the 'brown duck' signs.* On 16 April 2008, eight years after it was officially opened, this was recognised as a nationally important haven for wildlife and designated as a National Nature Reserve. It was created as part of a compensation package for wildlife habitats lost when the Cardiff Bay barrage was built. Reed beds were planted on what were a power station's pulverised fuel ash disposal areas. These now attract nationally important numbers of breeding water rail and Cetti's warbler, and are the only known breeding site for bearded tit in Wales. Its saline lagoons have become a home to Wales' first pairs of breeding avocets.

NEWPORT (TREFDRAETH) CASTLE *6 miles east of Fishguard, on the A487, Pembrokeshire coast.* Built by William FitzMartin when The Lord Rhys ejected him from Nevern, it lies near the beach, and was twice destroyed by the Welsh in the thirteenth century. The castle was rebuilt and passed into the hands of the Owen family, now being a private home. The castle may be opened to the public in the future. The crescent-shaped earthwork, known as Hen Gastell (Old Castle), on the estuary to the north of Newport Castle is probably the site of the first wooden stronghold of William Fitzmartin, but that ringwork is overgrown and damaged. Newport is an excellent centre for exploring Neolithic remains. There are nearby cromlechs at Pentre Ifan, Llech y Drybedd, Trellyffaint and Carreg Coitan, and an unusual one with five chambers at Cerrig y Gof. There are stone hut circles above Newport on Carningli Common, Waun Mawr and Mynydd Caregog.

NEW RADNOR CASTLE *On the A44, west of Old Radnor, near Presteigne.* This is a moated motte near the medieval church, and possibly William FitzOsbern, Earl of Hereford, built the first castle here before 1071, or Philip de Braose built it around 1095. It was destroyed by the Welsh in 1196, 1216, 1231 and 1262. Edward Mortimer rebuilt it after Llywelyn II's death in 1282. The castle changed hands thirteen times in eighty years, showing its strategic importance. It was taken by Glyndŵr in 1403. In 1845, dozens of headless skeletons and a separate pile of skulls were found when foundations were being dug for a new church. Prince Charles stayed here in 1642, but it was dismantled by Parliamentarians. There was a siege at this time, as evidenced by cannon balls on the site. The village lies by the Radnor Forest, and has been said to have been built as a planned medieval town to replace Old Radnor. The castle was originally called Trefaesyfed, and the original site may be Roman.

NEW RADNOR – RADNOR, BATTLE OF, 1196 *At New Radnor Castle.* Having taken Colwyn Castle (Colwent or Glan Edw), New Radnor Castle was besieged with catapults and siege engines, and then sacked by the Welsh under The Lord Rhys, before a relieving force under Roger Mortimer and Hugh de Say arrived. The Norman army including forty knights was destroyed. The site of the battle may have been where the remains of a rampart block the valley. It was a pitched battle, forced upon Rhys by the Norman army blocking his retreat, and the Welsh attacked first. Rhys was then forced to return to his territories, as William de Braose had invaded and taken part of Cardigan, Rhys' main court alongside Dinefwr.

NEWTOWN, Y DRENEWYDD – THE PLACE OF THE BIRTH OF MAIL ORDER *Where the A483 meets the A458, on the Severn, Montgomeryshire.* The Welsh hamlet of Llanfair-yng-Nghedewain (The Holy Place of Mary in Cedewain) was prosaically renamed Newtown in 1279 when it was granted a market charter by Edward I, and lies near an important ford in a loop of the Severn. The great Robert Owen's birthplace in the town is now a museum. In 1859, businessman Pryce Pryce-Jones began to cater to the needs of many of his rural customers by offering goods for sale through the mail. Many of the area's farmers lived in isolated valleys or in mountain terrain

and had little time or suitable transportation to come into town. The Pryce-Jones mail order business started, succeeding because Post Office reforms in the 1840s had made the mail service cheaper and more reliable. His Newtown warehouses, packed with goods, began a service that quickly caught on in the United States, with its even greater distances and scattered population. Mail-order shopping had begun, and his two great Royal Welsh Warehouses can be seen today. Newtown grew in the eighteenth and nineteenth centuries around the flannel and textile industries and the arrival of the Montgomeryshire Canal, and in 1838, it experienced Wales' first Chartist riots. The town has seen fast growth since the 1960s, becoming, like many Welsh rural and coastal areas, drastically less Welsh in nature.

NEWTOWN CASTLE The region was returned to Llywelyn the Last by the Treaty of Montgomery in 1267. However, the Mortimers took Llywelyn's Dolforwyn Castle and town just four miles away, in 1277, and built Newtown Castle and developed the town. It now started to gain in importance as the administrative centre of the region of Cedewain. Their castle motte is near the council offices. This new broad-topped motte, 45 yards across and 16 feet high, was built to protect the southern side of the town. The older motte and bailey of Gro Tump, about a mile to the east, was left disused.

NORTH ANGLESEY HERITAGE COAST *This runs for 18 miles along the northern shore of the Isle of Anglesey from Church Bay in the west to Dulas Bay in the east.* The largest centre along this coast is the port of Amlwch, once home to the largest copper mine (Mynydd Parys) in the world, and now a Site of Special Scientific Interest (SSSI). There is also St Patrick's Church at Llanbadrig. He was shipwrecked on the islet of Ynys Badrig while on his way to convert the Irish to Christianity around the year 440 CE. He made his way to the shore, where he sheltered in the caves at Ogof Badrig, and built a simple wooden church in gratitude for his deliverance.

NORTHOP (LLANEURGAIN) – THE CHURCH OF ST EURGAIN AND ST PETER *Midway between Mold and Flint, just off junction 33 of the A55 North Wales Expressway, Flintshire.* The village of Northop is noted for its landmark church tower which is 98 feet high. It may be a sixth-century foundation, dedicated to a niece of St Asaf, and the church stands on a Celtic mound. The stone church was built around 1200. The name seems to be derived from North Hope, to distinguish it from the nearby village of Hope. The churchyard still houses the old grammar school for Northop, constructed during the sixteenth century.

NORTON CASTLE AND THE PUNISHMENT TREE *On the B4355 north of Presteigne, Radnorshire.* Norton Castle was probably built around 1086, about twenty years after the Norman invasion. One of its early keepers was Hugh de Say (1156-97), who, with Roger Mortimer, had been defeated in 1196 by The Lord Rhys. The remains of the motte are 25 feet high, on the opposite side of the road to the bailey. Some time after it was first erected, a stone castle was built on the site – it may have been on the motte, the bailey or both. The castle was destroyed in May 1215 by Llywelyn ap Iorwerth. The castle was rebuilt, only to be destroyed again in late December 1262 by Owain ap Madog, in support of the campaign of Llywelyn ap Gruffydd. This was during the Great Welsh War against the English from 1256-77. Norton Castle was not re-built, and it is likely that the stone and timber from the ruins were used in the erection of local houses, including Vicarage Cottage. The ruins of Stapleton Castle, between Norton and Presteigne, give an indication of how Norton would have looked. 'The Punishment Tree' in Norton churchyard was equipped with pairs of wrist manacles or fetters. It is thought that these were used over many years to secure wrongdoers whilst they were being whipped.

OFFA'S DYKE, CLAWDD OFFA – PERHAPS THE OLDEST BORDER IN EUROPE *The 168-mile Offa's Dyke Path stretches from Prestatyn on the North Coast, to Chepstow on the South Coast.*

King Offa of Mercia (ruled 757-796) seems to have wished to replicate WAT'S DYKE on a greater scale. He had led many invasions into Wales, but he decided upon a policy of stabilising the frontier. Natural barriers were used where possible, otherwise an earth embankment was built, still standing in places 18 feet tall. With its ditch, the dyke is up to 65 feet wide. It is nine miles longer than Hadrian's Wall and the present bank and ditch still serves as much of the present border. As well as a political barrier, it may have been a customs barrier for trade and cattle, because there are some notable places where it is missing. John Davies has called the dyke 'perhaps the most striking man-made boundary in the whole of Western Europe'. It solidified the border between Wales and the Saxons/Mercians, with the notable exception of Herefordshire, much of which stayed 'Welsh' for another 800 years. This national border, much of which the dyke marks, is older than that between Spain and Portugal, or France and Germany. In the past, a Welshman caught east of Offa's Dyke had an ear cut off.

OGMORE CASTLE CADW *On the B4524 south of Ewenni, on the road to Southerndown, Vale of Glamorgan.* Along the western frontier of early Norman control, it guards a ford across the Ogŵr, where ancient stepping stones still allow one to cross. William de Londres built the first castle here in 1116, including a ditch that filled up at high tide, and the remains are substantial. Maurice de Londres built the large tower in 1126. A remarkable stone from the sixth century was found here, used as a paving stone, inscribed, 'Be it known to all that Artmail gave this estate to God and Glywys and Nertat and his daughter.' This may be a grant of land from King Arthur.

OLD BEAUPRE CASTLE CADW *Between St Athan and Cowbridge, on the banks of the Thaw, in the Vale of Glamorgan.* This fortified medieval manor house includes a magnificently carved Renaissance porch, built around two courtyards. In the sixteenth century, it was modernised by Sir Rice Mansell and then the Bassett family, and it is said that the Magna Carta was first drafted here.

OLDEST PUBS IN WALES There is a great deal of argument, but these are some of the claimants: The Old House, LLANGYNWYD, 1147; The thatched Llindir Inn, HENLLAN, Denbighshire; The Old Nag's Head, MONMOUTH, 1200s; Cross Keys Inn, SWANSEA, 1300s; Pen-y-Bont Inn, LLANRWST, 1300s; Sun Inn, Rhewl (a drovers' inn near Llangollen) 1300s; the thatched Blue Anchor, East Aberthaw, 1380; Plough and Harrow, MONKNASH, 1383; Duke's Arms (formerly the Talbot) PRESTEIGNE, 1480; Red Lion, LLANAFAN FAWR, 1400s; and the Harp, OLD RADNOR, 1400s.

OLD RADNOR CASTLE (CASTELL MAESYFED HEN, CASTLE NIMBLE) *4 miles west of Kington, on the A44, east of New Radnor.* To the east of the church lie the remains of Old Radnor Castle in the form of a ditch which was probably the moat, and small earthworks.

OLD RADNOR - HARP INN - ONE OF THE OLDEST PUBS IN WALES This is a fifteenth-century longhouse, beautifully restored, overlooking Radnor Forest.

OLD RADNOR - ST STEPHEN'S CHURCH - EGLWYS YSTYFFAN SANT - THE OLDEST FONT AND OLDEST ORGAN-CASE IN BRITAIN This contains the oldest organ-case (*c.* 1510-30) in Britain, a wonderful piece of carving. Every single other case from this period was destroyed by Protestant reformers. The circular churchyard denotes great antiquity, and there are standing stones. The church was dedicated to the sixth-century St Ystyffan prior to the Norman Invasion, and the font is eighth century, the oldest in Britain. It is one of the finest medieval churches in Wales, with considerable architectural interest, and a significant range of internal fittings. The tower, restored rood screen, north aisle, south aisle and north chapel are fifteenth century and possibly at least part of the church was rebuilt in the twelfth century. Glyndŵr destroyed it, perhaps in 1401, which is the reason for the fifteenth-century rebuilding. The

only two examples in Wales of exposed medieval pavements, in use since they were laid, are at St David's Cathedral and in this church. (However, relaid medieval pavements are visible at several other sites, for example NEATH Abbey and STRATA FLORIDA Abbey.)

OLD RADNOR – STOCKWELL FARM – LANDMARK TRUST A 1600 traditional farmhouse, restored and available for holiday stays. At a similar nearby yeoman's house, Stones Farm, Charles I complained about the food in 1645, when retreating from Cromwell's army.

OREWIN BRIDGE, BATTLE OF, 11 DECEMBER 1282 *Cilmeri, near Builth Wells*. This is traditionally the bridge over the Irfon where Llywelyn the Last's army was defeated after his murder. However, there may have only been a minor skirmish, or indeed the Welsh may have surrendered on the news of the death of Llywelyn. There were no recorded English casualties, and no recorded survivors of the 3,000 followers of Llywelyn. In the words of Anthony Edwards: 'After the defeat of Llywelyn ap Gruffudd in 1282, King Edward carried out a systematic slaughter of the Welsh in many parts of Wales, probably to reduce the Welsh manpower. For instance, the 3,000 foot-soldiers, the leaderless remnants of Llywelyn's army, were put to death between Llanganten and Builth, and while King Edward was at Rhuddlan very many Welsh, including priests, were put to death, bringing on him the reproof of the archbishop of Canterbury.' For instance, the sons of Owain ap Maredudd of Elfael were escheated in December 1282. In legal terms, an 'escheat' is to take the estates of the dead. It appears that the Welsh lords of Elfael and their followers were executed at this time, but historians are notoriously loth to investigate such matters. Edwards believes that the 3,000 footmen and 160 horsemen were executed in cold blood where Builth golf course is today. Llywelyn was lured to a meeting with his teulu (bodyguard) of just eighteen men to a ford upstream of Orewin Bridge, at Cwm Llywelyn, and was murdered by the Mortimers. This is also the time of 'the massacre of the bards' – traditionally when Welsh bards, the purveyors of news and records, were purged across Wales.

OSWESTRY, CROESOSWALLT *Just over the English border in Shropshire, off the A483 between Welshpool and Ruabon*. A former Welsh-speaking market town, it was officially made English by Henry VIII's Act of Union. On the seventeenth-century Llwyd Hall is a double-headed eagle, given by the Holy Roman Emperor for service by the Llwyds (Lloyds) during the Crusades. In the Battle of Oswestry of 642, Penda of Mercia defeated Oswallt of Northumbria, and around this time Pengwern (Shrewsbury) and Wroxeter, seats of the princes of Powys, were destroyed.

OSWESTRY – OLD OSWESTRY HILLFORT Overlooking Oswestry, this may be the site of Cynddylan of Powys' court, rather than Wroxeter, which was burnt by the Saxons. It also may be the site of Caradog's last battle against the Romans. This massive Iron Age hillfort, the most impressive on the Welsh borders, was also called Caer Ogyrfan, supposedly after the father of King Arthur's Guinevere (Gwenhwyfar).

OVERTON-ON-DEE – CHURCH OF ST MARY THE VIRGIN *Near Bangor-on-Dee, 7 miles from Wrexham, in the detached portion of Flint known as Maelor Saesneg (English Maelor)*. There are twenty-one ancient yew trees in the churchyard, one of the 'Seven Wonders of Wales', the oldest being up to 2,000 years old and denoting an ancient place of worship. The church has a fourteenth-century tower, a Norman circle cross, and an Abyssinian brass processional cross thought to date from the sixth century. The hamlet is full of listed eighteenth- and nineteenth-century buildings, being once owned by the Bryn-y-Pys Estate. One is the 1890 'Cocoa and Reading Rooms' built to encourage temperance among estate workers. Overton is on the Maelor Way, a long-distance footpath.

OXWICH CASTLE CADW *Overlooking Oxwich Beach, Gower Peninsula, SA3 1LU*. Remains of a sumptuous, mock-fortified manor built by Sir Rice Mansel and his son Sir Edward in the

sixteenth century. They converted an existing castle to a superb mansion between 1520 and 1580, but became owners of Margam Abbey after the Dissolution, and moved their family seat there. Later generations came to use Oxwich less and less, and eventually it fell into disrepair, part of it being used as a farm. The south range has been roofed, partially restored and used for exhibitions. The ruined east range had four storeys, the towers had six storeys and there are the ruins of a huge dovecot.

PAINSCASTLE CASTLE *On a Roman site 4 miles north-west of Hay-on-Wye*. It may have been built by Pain FitzJohn, who was killed by Madog ab Idnerth in July 1137, with the castle being captured and destroyed. It was rebuilt and destroyed again. Maud de Braose is said to have defeated a Welsh attack here in 1195. The Lord Rhys next besieged it, and took it in 1196. *The Chronicle of Ystrad Fflur* records, 'Rhys ap Gruffudd gathered up a mighty host, and he fell on Carmarthen and destroyed it and burned it to the ground. And he took and burned the castles of Colwyn and Radnor. And Roger de Mortimer and Hugh de Sai (Say) gathered a mighty host against him. And Rhys armed himself like a lion with a strong hand and a daring heart, and attacked his enemies and drove them to flight. And forthwith Rhys took Painscastle in Elfael.' In 1198, Trahaearn, the cousin of Prince Gwenwynwyn of Powys, was tied to a horse, dragged through Brecon, and executed. Gwenwynwyn attacked Painscastle in retaliation but was defeated at the Battle of Painscastle in the same year. King John took it in 1208, but it was captured by Gwallter ab Einion Clud in 1215, who submitted to John and was made Lord of Elfael. In 1222, it belonged to Llywelyn the Great but was destroyed, and rebuilt in 1231 by Henry III. In 1265, the stone castle was taken and destroyed by the Welsh, and then rebuilt again. The Beauchamps garrisoned it in the Glyndŵr campaign in 1401. The massive earthworks at the small village, just three miles inside the Welsh border, point to its significance as a strategic stronghold. Welsh castles have enthralling, yet little-known, histories.

PANTYFEDWEN HOUSE *Grade II listed House, situated about one mile south of Strata Florida Abbey*. Part of the house was thought to have been built in the time of the abbey and is medieval in character, but most is early eighteenth and early nineteenth century. The coachhouse next to the main building has a formal design with a roundel made up of fragments from Strata Florida Abbey, and there are other stones from the abbey here. A huge and important range at the rear of the house was demolished by the Forestry Commission. Pantyfedwen was the childhood home of Sir David James, the entrepreneur and benefactor. He provided a million pounds to the Pantyfedwen Trust, and over a million pounds to other Welsh and religious foundations. On 2 October 1996, the Reverend William Rhys Nicholas died, aged eighty-two. His most well-known hymn, 'Pantyfedwen', won the 1967 Pantyfedwen Eisteddfod, which had been sponsored by David James with a donation of £120,000. In 1968, a competition to write a tune for the hymn was won by the Liverpool Welsh composer Eddie Evans. By the end of the 1970s, this beautiful hymn-tune had become 'a second national anthem', sung at festivals, weddings, funerals and chapel services.

PARC CWM LONG CARN, PARC LE BREOS BURIAL CHAMBER CADW *1 mile north-west of Parkmill, between Llanrhidian and Bishopston, Gower Peninsula*. There are two names for this important and partly restored early Neolithic long barrow, built between 4000 and 3800 BCE. It is trapezoid-shaped and about 72 feet long, belonging to the so-called Severn-Cotswold group. It tapers from 43 feet wide at its southern entrance to about 20 feet at its northern end. The cromlech was rediscovered in 1869, by workmen digging for road stone. Human bones of at least fifty people, animal bones and Neolithic pottery were found here, and the tomb was in use for up to 800 years. It lies in a deer park dating from the 1220s, established by the Marcher Lords of Gower.

PARC CWM – CATHOLE CAVE This is in a limestone outcrop, 500 feet north of the Parc le Breos Cromlech, and about 50 feet above the valley floor. There are two entrances, with a natural platform outside the larger of the two, and the cave has been used both as a Neolithic ossuary and as a shelter by bands of Mesolithic hunters. It was first excavated in 1864. Two projectile points

71. Kenfig Sand Dunes. The medieval borough of Kenfig has a rich history, and the walled town near the castle was sacked by Glyndŵr, and deserted by the 1600s as the sands drifted over the settlement, church and castle.

72. Wreck on Margam and Kenfig Sands. The beach here was the traditional home of the game of bando, played between rival villages until superseded by rugby from the 1870s.

73. The Trewythen Arms, Llanidloes' premier hotel, pictured before recent restoration, is a Georgian Grade II listed building, which was stormed by Chartists in 1839 to rescue three arrested protesters.

74. Llanidloes Old Market Hall is the only surviving timber-framed market hall in Wales, built between 1616 and 1622, using older timbers, possibly from the earlier market hall. It was known as the Booth Hall, because of the booths, or stalls that were clustered under and around it.

75. Plynlimon House, Long Bridge Street, Llanidloes, built in 1894. Edward Hamer was a long-established family butcher who had a royal warrant, displayed above the shop front.

76. Llanberis National Slate Museum Cottages. These quarrymen's houses are known as Fron Haul. No. 4 tells the story of the houses, which were brought to the museum. No. 2 recreates Bethesda from the time of the Penrhyn Lockout (1900-03), No. 3 recaptures 'the golden age' of Tanygrisiau in 1861 and No. 1 shows the end of mining in 1969.

77. Llanberis Slate Quarry – this is the Vivian Quarry, part of the Dinorwic Quarry, one of the biggest in the world, closed in 1969.

78. Llandeilo, showing bridge over the River Tywi and a row of Georgian houses leading up to the Church of St Teilo, which dominates the town. The town was strategically valuable for military control of the Tywi Valley, between Llandovery and Carmarthen.

79. Llandeilo Fawr – Church of St Teilo. The large church, on a Celtic Christian site, was completed in 1850, but the tower is late medieval. The Llandeilo Gospels, now in Lichfield Cathedral, can now be seen in digital form in a permanent exhibition in the tower.

80. Llandeilo'r Fan – This Breconshire Church of St Teilo on the southern fringes of Mynydd Eppynt has a late medieval roof, but is difficult to date. The graveyard was probably oval or circular at one time, bordering the Nant Eithrin brook.

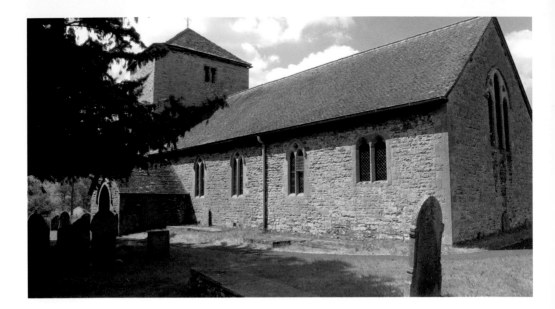

81. Llanfihangel Nant Brân Church of St Michael in Breconshire was reconstructed in 1882, and its tower appears to be sixteenth century. Like many churches, it borders water, in this case the stream named Nant Brân.

82. St Brynach's Church at Llanfrynach near Cowbridge. Other churches dedicated to this Irish chaplain of King Brychan of Brycheiniog are in Brecon, Crymych in Pembroke and St Brannock's at Braunston in Devon.

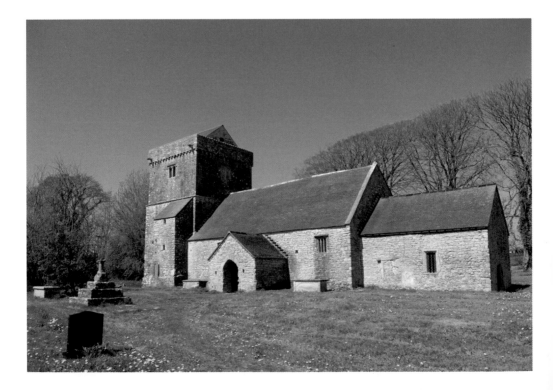

83. One of the double coffin-styles between Llanfrynach Church and Penllyn in the Vale of Glamorgan. The deserted village of Llanfrynach is on a Romano-British site, and its church served the village of Penllyn, 2 miles away.

84. Llangollen Chain Bridge at Berwyn. The first bridge was built here in 1814 to replace one further upstream. It has been closed for safety reasons since 1984, but there are plans to restore it.

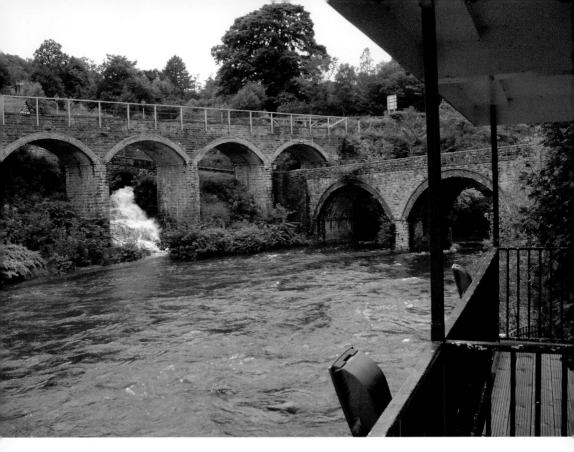

85. View from Llangollen Chainbridge Hotel over the River Dee. The Roman road from London to Holyhead, now the A5, passed over the Dee upstream, and the water supply feeder for the Llangollen Canal is next to the hotel.

86. Pleasure Boats at Llangollen. These are horse-drawn along the feeder canal for the World Heritage Site of the Llangollen Canal and Pontcysyllte Viaduct.

87. Llanwonno (Llanwynno) Church Graveyard has the gravestone of Guto Nyth Bran (Griffith Morgan), the legendary runner. Guto is the diminutive of Griffith, and Nyth Brân (Crow's Nest) was the name of his parents' farm.

88. Llanwrtyd Wells War Memorial Institute is a registered charity dating from 1928. There is a very fine war memorial in the gardens near the Strand.

Left: 89. Sculpture of Red Kite, Llanwrtyd Wells – the magnificent Red Kite is the unofficial symbol of wildlife in Wales, surviving when it was wiped out in the rest of Britain.

Below: 90. Cambrian Woollen Mill is on the outskirts of 'the smallest town in Britain', Llanwrtyd Wells, where one can take a guided tour of the processes involved in producing tweed, from shearing, cleaning, spinning and weaving.

Above: 91. Maesteilo Church is a fine example of a church built by local gentry, and was close to being closed until the local community worked together to ensure its survival.

Centre: 92. Medieval Door in St Mary's Church, Brecon. The 1510 church tower dominates Brecon, and the largest of its eight bells weighs 16 hundredweight.

Bottom right: 93. The fine Norman font at Brecon Cathedral dates from the twelfth century. The Priory Church of St John the Evangelist was elevated to cathedral status in 1923.

Above: 94. Abbey Cwm Hir
medieval fish pond has been
formed from a pool in the
Clywedog River. The abbey was
founded by the sons of Prince
Madog in 1143, re-established
by The Lord Rhys in 1176 and
transformed into a national
cathedral by Llywelyn the Great
from 1228.

Left: 95. Slate burial marker of
Llywelyn ap Gruffydd at Abbey
Cwm Hir. His headless body was
probably buried here, in the huge
235-foot nave. The abbey was
damaged in the Glyndŵr War, and
demolished in the Dissolution,
with an arcade possibly going to
Llanidloes Church.

96. The site of the Battle of Hyddgen, threatened by windfarm developments. Planners intend to place scores of 400-foot-high turbines across this sacred and historic landscape, with assorted access roads, pylons and buildings.

97. Slab commemorating Glyndŵr's victory at Hyddgen in 1401, unveiled by Gwynfor Evans. The rivers Rheidol, Severn and Wye all originate near this spot where the Glyndŵr rising sparked into the National War of Independence.

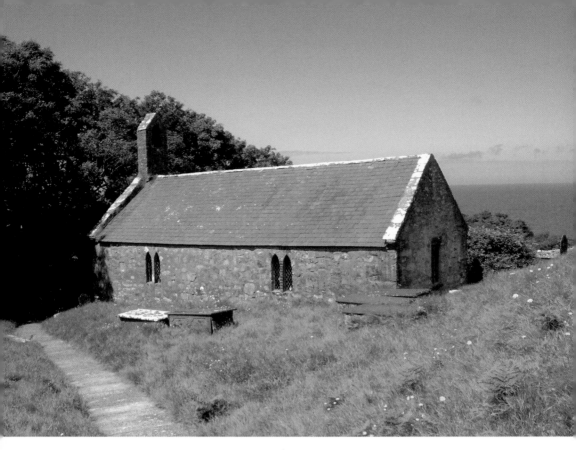

98. Pistyll Church of St Beuno has a Celtic Christian font with an interlinked design, and was on the pilgrimage route to Ynys Enlli, 'the isle of 20,000 saints'.

99. Pistyll has a circular Celtic graveyard, and pilgrims stayed at the adjacent monastery or at the hospice on Cefnedd Hill.

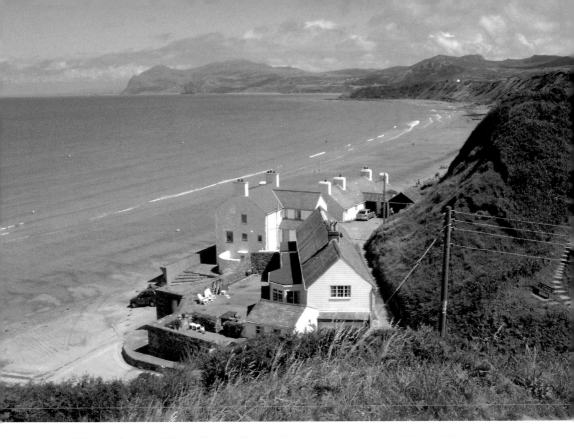

100. Porth Dinllaen beach, looking north-east - there is a 15-minute walk from the car park here, west across the beach to the National Trust village of Porth Dinllaen.

101. Porth Dinllaen – the excellent Tŷ Coch (Red House) pub is in the middle distance. The old port buildings include a large grain warehouse, and the Porth Dinllaen lifeboat is in the next cove around the headland.

102. Portmeirion Gate House was the first cottage to be constructed here after the Second World War, in 1954-55, and is an example of how Clough Williams-Ellis used the natural contours of the site, being built on a crag.

103. Portmeirion Village was built by the visionary architect Clough Williams-Ellis between 1925 and 1973, and is one of the premier tourist sites in Wales, used for filming *The Prisoner* TV series.

104. Portmeirion Vista. The architect wished to pay tribute to the Mediterranean style of building. The hotel, and the cottages called White Horses, Mermaid and The Salutation had been a private estate called Aber Iâ (Ice Estuary), dating from the 1850s.

105. Portmeirion Gardens. The exceptionally mild climate of the peninsula led to planting in the 1850s leading to some wonderful specimen trees. Planting carried on through the Edwardian period, and in the 1980s the lakes were reshaped.

Left: 106. Sculpture in stainless steel of the heroic Llywelyn ap Gruffydd Fychan outside Llandovery Castle. It is sixteen feet high, and was unveiled in 2001 on the 600th anniversary of his gruesome execution by Henry Bolingbroke.

Below: 107. Segontium Roman Fort, Caernarfon, was used from 77 until around 390 CE, the base for 1,000 Roman auxiliaries. They left, according to Welsh legend, following Macsen Wledig (Magnus Maximus) into Europe in his bid to become emperor.

108. Skenfrith Castle was once surrounded by a 20-foot-deep paved moat. The first castle on the site was flooded in the 1220s, and the new castle built over it. The hall of the original castle has been excavated and some original door hinges and window bars can be seen.

109. Snowdon Mountain Railway near the summit, in mist. This wonderful rack and pinion railway opened in 1896, and the journey takes up to an hour. On a fine day the Isle of Man and Ireland's Wicklow Mountains can be seen from the summit.

110. Snowdonia and lakes from the Snowdon Mountain Railway. The new visitor centre and café at the summit of Snowdon, Hafod Eryri, opened in 2009, and has been designed to blend with its surroundings.

111. Snowdonia Valley - Eryri, 'the Land of Eagles', was formed 450 million years ago and its peaks were once higher than Everest, but have been eroded over the aeons.

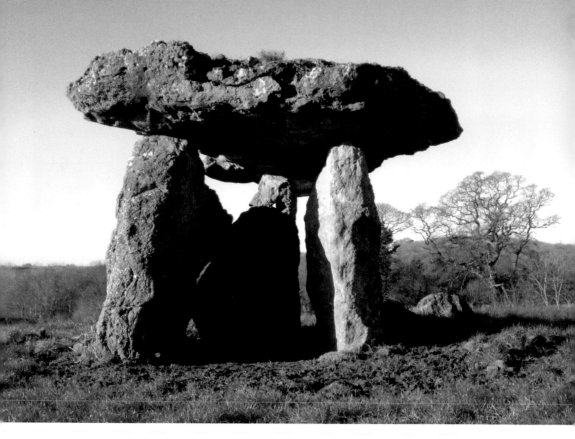

112. St Lythan's Cromlech is only a mile south of Tinkinswood portal dolmen, and the subject of many legends. The hole in the rear supporting stone is surmised to have allowed spirits to escape from the former grave mound, and the site has never been fully excavated.

113. Tinkinswood Cromlech has a limestone capstone which is over 40 tons and said to be the largest in Europe. It was formerly known as Tinkers' Wood, Castell Carreg, Llech-y-Filiast and Maes-y-Filiast. Built 6,000 years ago, at least forty people were buried here, and a stone avenue leads from the site.

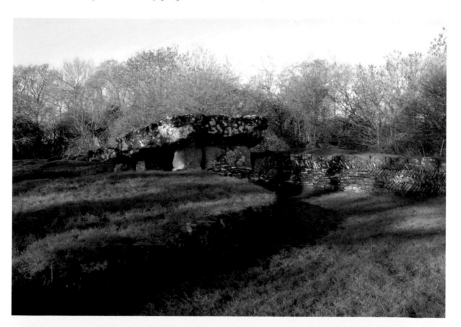

114. St Mary's Church, Beddgelert, lies under Moel Hebog and is surrounded by the mountains of Snowdonia. It is built on the site of an Augustinian priory, and retains relics of the building severely damaged by fire in the thirteenth century.

115. St Padarn's Church, Llanbadarn-y-Garreg. There is something deeply sad about this seemingly neglected tiny medieval church on the bank of the River Edw in Radnorshire. It is a wonderful, evocative place.

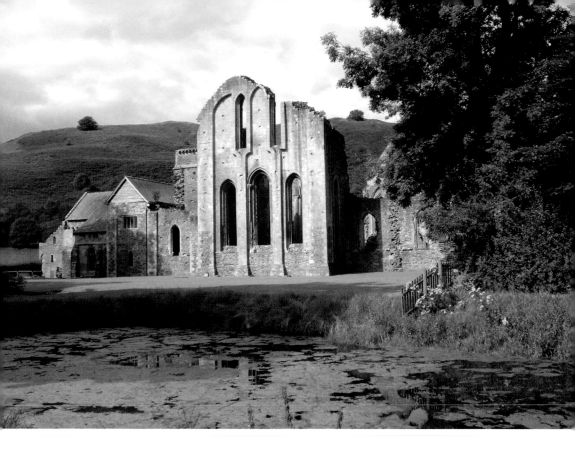

Above: 116. Valle Crucis Abbey, the east end from the Monastic Fishponds. This is a thirteenth-century Cistercian foundation, in the valley named after Eliseg's Pillar Cross, and sadly is almost surrounded by a caravan park.

Right: 117. Stonework at Valle Crucis Abbey. On its west front there is a wonderful rose window and a fourteenth-century inscription: 'Abbot Adams carried out this work. May he rest in peace. Amen.'

Above: 118. The Black Boy Inn, in Broad Street, Newtown, showing a picture of a child chimney sweep, has architecture typical of many former coaching inns across Wales.

Centre: 119. The Sportsman Inn, in Severn Street, Newtown, tells us something of the history of this market town surrounded by former sporting estates. Names of other pubs in the town include the Exchange, Waggon and Horses, Herbert Arms, Kerry Lamb, Buck, Pheasant, Cross Guns, Wheatsheaf and Flying Shuttle.

Bottom: 120. Statue of Thomas Edward Ellis on Stryd Fawr, Bala. Born and raised in Bala, he became Liberal MP for Merionethshire and advocated home rule for Wales, being the leader of Cymru Fydd. He died in 1899, aged only 41.

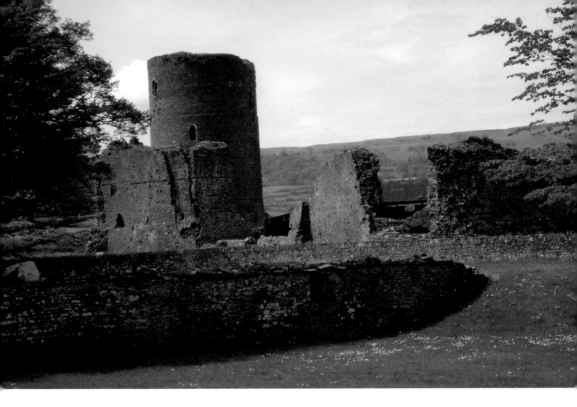

Above: 121. Tretower Castle was extensively updated in the thirteenth century, but fell out of use as a residence in the early fourteenth century, when Tretower Court was built a hundred yards away.

Centre: 122. Tretower Court Courtyard. The court is the best example in Wales of a late medieval defended house. The North Range was built in the early fourteenth century, the West Range in the fifteenth century, and the Gatehouse and wall walks in the east and south were added later that century to complete the square enclosure.

Below: 123. Tretower Court Hall. The interiors of the building are so well preserved because for almost 200 years they were mainly used for keeping animals and feedstock, with no alterations being made for human domestic purposes.

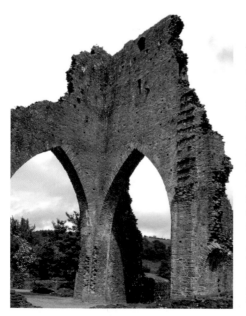

Above: 124. The Gatehouse at the Bishop's Palace, Llandaff. Also known as Llandaff Castle, it lies next to Llandaff Cathedral. Glyndŵr famously sacked the fortified palace, which is now a shell, but left the cathedral alone.

Centre: 125. The Glass Dome at the National Botanic Gardens, Llanarthne. Designed by Lord Norman Foster, it is the world's largest single-span glasshouse, measuring 344 feet by 204 feet. It is tilted at 7 degrees and orientated south for maximum sunlight.

Below: 126. The remains of the Crossing Tower at Talley Abbey, overlooking Talley Lakes. It was founded by The Lord Rhys in the 1180's for the Premonstratensians, or White Canons.

127. Dewstow Gardens. Built around 1895, the gardens were buried during the Second World War and only rediscovered by chance in 2000. There are 7 acres of tunnels, grottoes and sunken ferneries to be explored on this Grade I listed site.

128. In the Caves at Dewstow Gardens – some of the stone is natural, and some made of types of 'Pulhamite', a composite invented by James Pulham & Sons, landscapers, 'rock builders' and garden designers.

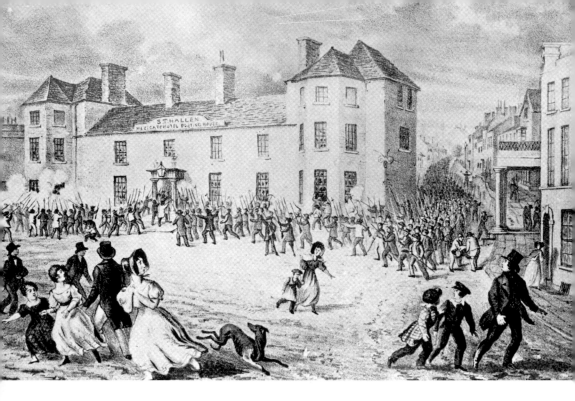

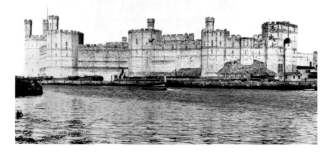

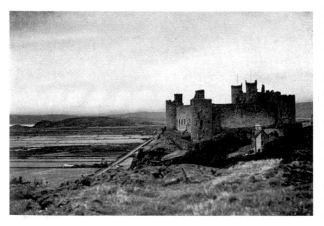

Above: 129. The Chartist Riot at Newport, 1839, shows the marchers coming down Stow Hill to congregate outside S. T. Hallen's Westgate Hotel Porting House, where troops were stationed.

Centre: 130. Caernarfon Castle's Eagle Tower with its three turrets was used as residential quarters, where Edward II was born in 1284. The Eagle Tower has been called the 'finest decorated medieval fortification', and the Castle Gatehouse 'the mightiest gatehouse' in Britain.

Below: 131. Harlech Castle is one of the strongest of the 'Iron Ring' of castles, which used to be supplied by sea, and became Owain Glyndŵr's home when he captured it in 1404.

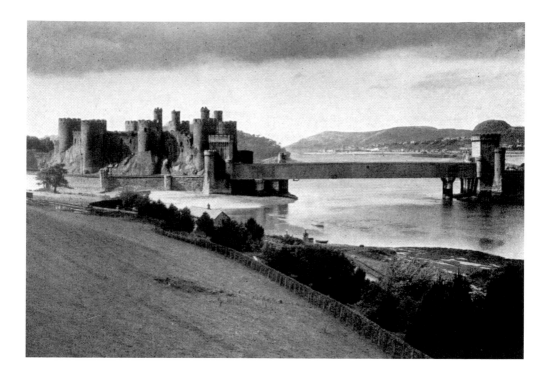

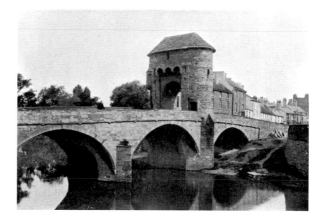

Above: 132. Conwy Castle has been called 'incomparably the most magnificent of Edward I's Welsh fortresses', and the walled town with twenty-two towers is one of the finest examples in the world. Robert Stephenson's bridge crosses to Anglesey.

Centre: 133. Monmouth Bridge, Monmouth, was built in the thirteenth century, and is the only surviving fortified medieval river bridge in Britain where the gate tower actually stands on the bridge.

Below: 134. Caerffili Castle is one of the greatest medieval castles in the world, the first truly concentric castle in Britain and with a revolutionary use of water defences. The picture was taken before the defences were restored.

Above: 135. The Last Invasion of Britain, 1797 - A Franco-Irish force landing at Carreg Wastad Point, near Fishguard, from a contemporary engraving.

Centre: 136. Pontypridd Bridge, from a 1795 watercolour by M. A. Rooker (1743-1804). The 1756 stone bridge had the longest single span in the world, of 140 feet, when it was built.

Below: 137. Parys Copper Mines from a watercolour by Julius Caesar Ibbetson (1759-1817). There was mining here from Celtic and Roman times, and by the eighteenth-century it was the world's largest copper mine.

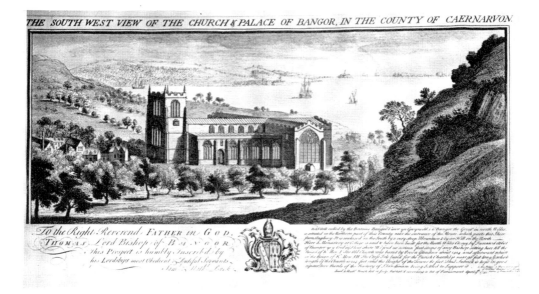

THE SOUTH WEST VIEW OF THE CHURCH & PALACE OF BANGOR, IN THE COUNTY OF CAERNARVON.

138. Llandaff Cathedral, from a lithograph of around 1840 by G. Hawkins. A sixth-century foundation, it is dedicated to the saints Dyfrig, Teilo and Euddogwy and later to Peter and Paul.

Centre: 139. Penrhyn Slate Quarries at Bethesda, from a line engraving of 1808. Opened in 1765, it became the largest open cast slate quarry in the world, a mile long and 1,400 feet deep.

Below: 140. Bangor Cathedral, engraving by S. & N. Buck of 1742. St Deiniol founded this oldest cathedral in Britain in 525, rebuilt in 1884 by Sir George Gilbert Scott.

141. Chepstow Castle, from a watercolour by Sutton Palmer (1854-1933). The castle stands on a crag guarding the bridge over the Wye. The oldest secular stone building in Britain; it was the centre of the Marcher Lordship of Chepstow.

142. Plas Newydd, the home of 'The Ladies of Llangollen' from 1778 until their deaths in 1829 and 1831, is open to the public.

dating from around 26000 BCE were found here, from the Interglacial Period, contemporary with the 'Red Lady of Paviland' found in a cave eight miles away. Many prehistoric tools have been found, including flint implements which must have been traded from the east of England.

PARC CWM – LLETHRYD TOOTH CAVE This is a Bronze Age ossuary site in a limestone cave, about 1,500 yards north of the Parc le Breos Cromlech, not discovered until 1961. It is on private land, and the remains of six adults and two children were found, along with Early Bronze Age collared urn pottery, flaked knives, a scraper, flint flakes, a bone spatula and a needle and bead, which are now in the National Museum. At nearly a mile long, the Tooth Cave is the longest cave on the Gower, and is kept locked for safety reasons, as it is narrow and subject to flooding.

PATRISIO – THE CHURCH OF MERTHYR ISSIO AT PATRICIO – THE MOST COMPLETE OF ALL THE OLD PARISH CHURCHES IN WALES *4 miles west of Llanfihangel Crucornau, near Llanbedr, 5 miles north-east of Crickhowell, Breconshire.* The village is known as Partrishow, Patricio or Patrishow, and the saint martyred here also has several names such as Isio, Issio, Issui, Isho, Ishaw, but 'the Church of Merthyr Issio at Patricio' is the official name of the church. Issui/Issi was a Welsh form of the name Esau. This hermit built his cell on the banks of the brook named Nant Mair (Mary's Stream) named for the Mother of God. After many years of service to God, he was killed by a stranger who wanted money. He was named a 'Martyr of the Catholic Church' by Bishop Herewald in the eleventh century. There is also a Holy Well of 'Pater Ishow' here, which is how the hamlet has come to be known as Patrishow or Partrishow. This is a wonderful place to visit. The church and churchyard are sited on a natural shelf on a remote hillside, overlooking the beautiful Gwryne Fawr Valley. The shelf has been extended by terracing, but previously it was a very small enclosure with a curvilinear west side. The church is eleventh century and somehow its furnishings escaped the destruction of wars, the Reformation, the Civil War, Nonconformism and unsympathetic Victorian restoration. It thus has a gorgeous, intricately carved sixteenth-century rood screen and loft, carved out of Irish oak, dating from *c.* 1500. At the rear of the church is a dugout parish chest carved out of a single tree trunk, with iron bands around it and three locks, used for the safekeeping of parish income. The rector and church wardens each held a key to one of the three locks, so the chest could only be opened when all three were present. The font of around 1060 is one of the oldest in Wales. An inscription 'Menhir made me in the time of Genillin' dates it to the time of Herewald, who was consecrated Bishop of Llandaff in 1056. Cynhyllyn Foel, the son and heir of Rhys Goch ap Maenarch, was Lord of Ystradyw (Crickhowell). However, the pre-Norman church is probably on Issui's sixth-century site. There are also two pre-eleventh-century stone altar slabs under the rood screen, and a medieval churchyard cross. Abutting the Norman nave and its sixteenth-century chancel is an 'eglwys y bedd', a small 'grave chapel' rebuilt in the thirteenth century, which may be the original grave of the martyred saint. It may be that his original cell stood here, and the church was built next to it. There is a celebrated 'Doom Figure', a wall painting of a skeleton with an hourglass and spade, indicating our transient presence on Earth. In the valley below the church is a bridge over the Gwryney, called Pont-yr-Esgob, or Bishop's Bridge, from which Baldwyn preached the Crusade alongside Giraldus Cambrensis. There is still the preaching mark to commemorate this on the wall near the church gate, a cross etched in a stone.

PAXTON'S TOWER – NATIONAL TRUST *From Llanarthe on B4300 turn left past post office. Keep left up hill to T-junction, sharp left again to Tower, which is across a field. Open all day. Carmarthenshire SA19 6RT. Tel: 01558 824512.* This Gothic banqueting hall and folly was built for the Middleton Hall estate around 1808-15, dedicated to Lord Nelson. Its elevated position gives spectacular views over the National Botanic Garden and the Tywi Valley. A Catalogue of the Middleton Hall Estate Sale describes it thus: 'A Gothic Tower, Erected by the late liberal-minded Possessor, in Commemoration of our Noble Hero, Lord Nelson; A grand Ornament and Land Mark in the County. On the Ground Floor, Three Spacious Lofty Arches for the Admission of

Carriages, On the Principal Story, A Banqueting Room, with Gothic Ceiling; A Boudoir and Closet, over which A Prospect Room or Observatory, with Turrets, Three of the Windows are fitted with Stained Glass, One Window representing his Lordship, the others emblematical of his Fate, From which there is a Panoramic View, of a grandeur and extent that may justly be said to stand unrivalled. On the upper Part a Lead Flat, and Two Entrance Lodges.'

PEMBROKE, PENFRO – THE CAPITAL OF 'LITTLE ENGLAND BEYOND WALES'
Off the A477, west of Tenby, Pembrokeshire. The town was in decline until 1814, when the Royal Navy Dockyards in Milford Haven were closed and moved to Pembroke Dock, two miles from Pembroke. The town had developed the woollen trade and its export, being the county town of Pembrokeshire, but there was gradual silting up of the shallow river access to Pembroke. St Mary's and St Michael's churches both date from the thirteenth century, and Monkton Priory Church is on a sixth-century site. Sections of the thirteenth-century town wall still remain. From the early days of the Norman Conquest, Pembroke was held as the most important bastide and castle complex in West Wales. When the Normans took south Pembrokeshire, they were able to effect their invasions into Ireland. The Welsh original name of Pembroke, Pen Fro, is made up of Pen, meaning head or end, and Bro meaning land or region, so the word literally means 'Land's End'. Unfortunately, the post-war years have seen much of this charming town's history washed away by council planning 'progress'. High-rise flats are being built upon the mudflats that attracted birds. (The town council's official website's main page throughout 2008-2009 has had an unforgivable direction to 'The Town and it's [*sic*] History', which possibly is an indicator of its approach to this lovely old town.) Pembroke was an important centre for the Knights of St John, who renovated Monkton Priory's remains. The first stone building in Pembroke was a defensive tower, now known as the Medieval Chapel, in Main Street, built on a cliff edge between 950 and 1000 CE. There are the remains of a great hall to the north and some important arched cellars have been filled in. York Tavern was Cromwell's base when he laid siege to the castle. The town is a wonderful place, but as across much of Wales, care has to be taken to conserve not just listed buildings, but the ambience in which they have existed for centuries.

PEMBROKE CASTLE One of the very few castles that never fell to the Welsh, it was founded by Roger de Montgomery in 1093. Gilbert 'Strongbow', Earl of Pembroke, later owned the castle, building the Great Keep around 1204, the largest and most impressive for that period in Britain. It is still 75 feet high, and the walls at its base are 20 feet thick. Under the castle is the Wogan Cave, where supplies could be brought in at high tide. In 1457, Henry Tudor was born at the castle. In the Civil War, it was besieged by the Parliamentarians and damaged, but still remains a wonderful building, despite Cromwell blowing up the barbican and the fronts of all the towers. In this author's mind Pembroke and Caerffili are the two most impressively strong castles in Wales, not the incredible Iron Ring castles of Harlech, Beaumaris, Conwy or Caernarfon. They seem to be rooted in the ground, more squat - impregnable markers of Norman power, which predate the loftier North Wales castles and seem even more oppressive to a Welshman. The Northern castles are better looking, but these bastions of French imperialism in the south and west seem terribly dangerous in their sheer invincibility. The castle was slighted during the Civil War, but sympathetically restored from the late nineteenth century.

PEMBROKE – MONKTON OLD HALL – LANDMARK TRUST *Monkton, near Pembroke Castle, Pembrokeshire.* Dating from before 1400, it was a guesthouse of the priory, on the pilgrimage route to St David's.

PEMBROKE, SIEGE OF, 1648 Rowland Laugharne and the remnants of his army fled back to Pembroke after the defeat at St Ffagans, but the Royalist rebellion had spread across Wales. Richard Bulkeley and Anglesey declared support for the king, Sir John Owen tried to take Denbigh Castle, Rice Powell took Tenby and Nicholas Kemeys took Chepstow Castle. Parliament ordered

Cromwell and five regiments to Wales to end the Second Civil War. They regained Chepstow and Tenby on their march across South Wales, but John Poyer and Rowland Laugharne held out in Pembroke Castle. Cromwell's chaplain wrote, 'Pembroke Castle was the strongest place that we ever saw ... We have had many difficulties in Wales ... We have a desperate enemy.' Cromwell's cannon could not break the 20-foot walls and his ladders could not reach 80 feet, so he attempted to starve the rebels into surrendering. A local man betrayed the source of the castle's water supplies, which Cromwell cut off. After eight weeks, with no food or water left, Cromwell had secured larger cannon from Gloucester, and the defenders' powder had run out. The Royalists surrendered. Poyer, Powell and Laugharne were court-martialled and sentenced to death, but Thomas Fairfax decided that only one should die. The condemned refused to draw lots, so a young child was chosen to draw, and Poyer was shot in front of large crowds at Covent Garden in 1649.

PEMBROKE DOCK, DOCK PENFRO – FORMER ROYAL NAVAL DOCKYARDS *2 miles north of Pembroke.* Formerly called Paterchurch, in 1814 the Royal Naval Dockyards were sited here, and five royal yachts and 263 warships were built. So important was the Royal Dockyard that a network of gun batteries and fortifications was built to defend it. One of these stands on the waterfront in Pembroke Dock – the Martello Gun tower, which has an exhibition of the military history of the dockyard. The dockyards closed in 1926, and in 1943 it was home to the largest operational base for flying boats (mainly Sunderlands) in the world, guarding the Western Approaches. In 1940, a Junkers 88 penetrated its defences, bombing oil tanks at Pennar. This was the greatest fire in Britain since the Great Fire of London, taking eighteen days to put out. The historic dockyard still plays an important role in the life of the town, being the departure point for the ferry to Rosslare. Many of the fine limestone buildings dating from the dock's Victorian prosperity can still be seen, including the Commodore Hotel, once the home of the dockyard superintendent. The vast hangars which can be seen were built during the Second World War to house squadrons of RAF Sunderland flying boats.

PENALLT – THE OLD CHURCH *3 miles south-east of Monmouth, Monmouthshire.* The twelfth-century church at Penallt is set in a little dip in the trees, about a mile north of the village. Most of the building is late medieval, with a 1539 porch (the date on the oak door is 1532) and a saddleback tower. Inside, the wagon roof has carved bosses with intriguing symbols – strange heads, the Instruments of the Crucifixion, and three fish symbolising the Trinity. There is also a splendid early seventeenth-century pulpit and a stone altar with the chi-ro symbol. Outside, there is the base of the churchyard cross. One local tradition is that the church was originally dedicated to St James, the patron saint of pilgrims. By the village green is the seventeenth-century village pub, the Bush Inn (NP25 4SE). The Boat Inn, with excellent real ales and ciders, is also in the village. The Argoed, a seventeenth-century mansion, lies to the south-east of the village. Designed by Inigo Jones, it was once owned by the father of the socialist reformer Beatrice Webb and the singer Robert Plant also owned it. In 2009, it was on sale for £2.5 million. On a footbridge across the River Wye, in England, is the village of Redbrook, which at one time had over forty iron forges and mills, and later in 1725 had twenty-six copper furnaces.

PENALLY, PENALUN – CHURCH OF ST NICHOLAS AND ST TEILO *Near Tenby, Pembrokeshire.* The thirteenth-century church was once named after St Nicholas, but renamed in the nineteenth century because of the tradition that St Teilo (d. 580) was born here. There are two Celtic crosses in his chapel, moved from the graveyard. Hoyles Mouth Cave, where Palaeolithic people lived, is in Penally, and the Gothic Abbey Hotel is on an ancient site.

PENARTH – TURNER HOUSE MUSEUM *On the coast across the Cardiff Bay Barrage from Cardiff.* 'The Garden by the Sea' has a Victorian esplanade, a flourishing new marina with access by boat to Cardiff Bay, and the Turner House Museum, formerly showing paintings from the National Museum of Wales. Its Victorian and Edwardian buildings show the prosperity brought

by its docks, which are now the marina. Penarth was once the third-largest coal-exporting port in the world. Penarth's promenade has a 685-foot Victorian Pier, built in 1894. In the summer months the paddle steamer *Waverley* and the M V *Balmoral* use the pier, from which they cruise to the various harbours in the Bristol Channel, including Lundy Island. From Penarth Promenade, one can look across the Channel to the islands of Flat Holm and Steep Holm. At the western end of the Promenade, the RNLI (Royal National Lifeboat Institute) has an inshore lifeboat station. It houses a small inshore craft and a larger 'Atlantic Class' boat. Alongside the lifeboat station is Penarth Yacht Club, founded in 1880. A walkway and cycle-path is being completed around the cliff from the promenade to link with the walk across the Barrage to Cardiff.

PENARTH – COSMESTON LAKES MEDIEVAL VILLAGE AND PARK *Between Sully and Penarth, Vale of Glamorgan. Tel: 02920 701678.* Walkways around flooded limestone quarry lakes are open all year. The reconstructed medieval village has an entrance fee for guided tours. Cosmeston Medieval Village is set in the year 1350, a troubled period in the history between the English and Welsh. The village grew out of a fortified manor constructed around the twelfth century by the Costentin family, who were among the first Norman invaders of Wales.

PENARTH – OLD COGAN – ST PETER'S CHURCH *About a mile's walk inland from Cosmeston Lakes, near Old Cogan Hall Farm. Access to the church can be arranged by telephoning 029 2070 8952.* There is herringbone brickwork here, making some believe that the church is Saxon, and it is the oldest site in the Penarth area. Some of the Herberts of nearby Cogan Pill are buried here. Their Elizabethan mansion is now a pub/restaurant called the Baron's Court and surrounded by roads. This little church probably started as a wooden building about 800. There is a reference to it in 1180, so it was probably constructed just before that of thin lias limestone slabs, a local stone, in a herringbone pattern more typical of earlier Saxon times. It is small, with the nave only 34 feet by 19 feet, and can seat no more than forty-seven worshippers. The windows in the chancel were renewed in red Triassic limestone in the fourteenth century.

PENARTH – ST AUGUSTINE'S CHURCH The parish church of Penarth, St Augustine's, can be seen from miles around as it sits on the headland Pen Arth, the Bear's Head, at the south-west tip of Cardiff Bay. There was an outcry amongst Bristol Channel pilots, when the architect appointed to design a new church in 1865 planned a short, square tower. With traffic to busy ports increasing, a better landmark was needed. The new church was built with a tower 90 feet high, rising to 320 feet above sea level. The landowner, Baroness Windsor, appointed William Butterfield to design the new church. The design of the interior comes as a surprise: it is warm, light and colourful. Butterfield used brick, stone and tiles in contrasting colours, a technique known as 'constructional polychromy'. The layout is open, and from every seat there is a view of the altar and the superb east window. Penarth is dominated by the impressive skyline of St Augustine's Church, which is the final resting place for Dr Joseph Parry, the famous composer.

PENARTH FAWR MEDIEVAL HOUSE CADW *North of the A497, between Cricieth and Pwllheli, Llŷn Peninsula.* A well-preserved example of a Welsh gentry house, it is a hall house built around 1450, with an impressive timber roof and aisle-truss.

PENCADER, BATTLE OF, 1041 *On the B4459, off the A485 between Carmarthen and Lampeter, 3 miles north of Alltwalis.* Gruffudd ap Llywelyn defeated Welsh princes to take Ceredigion in his quest for Welsh unity. Among those defeated was Hywel ab Edwin, and Gruffudd carried off Hywel's wife after the battle, while Hywel escaped to Ireland.

PENCADER CASTLE Only the great motte remains, possibly built by Gilbert de Clare in 1145, but soon retaken by the Welsh. Henry II came to Pencader to receive homage from The Lord

Rhys in 1162, and an old man told Henry that the Welsh language would survive until Judgement Day.

PENCELLI CASTLE *On the B4558 south of Llanfrynach in the Brecon Beacons, in Pencelli Castle Camping and Caravan Park*. It may have been built by Bernard de Neumarche in the 1080s, and was held by the Baskervilles during the war of 1093-99. It was seized from the Le Wafres by the de Braoses in 1215, regained by the Le Wafres, and lost to the Welsh in 1262. Retaken in 1273, the Mortimers built the gatehouse before it was siezed by the king in 1322. The Elizabethan manor house of 1583-84 on the site was built on the site of St Leonard's Chapel in the castle grounds, and is now a hotel. Its cellar was documented as a 'dungeon' and the shackles and chains were taken to the National Museum of Wales in Cardiff.

PENCOED CASTLE *Near Magor, east of Newport, Monmouthshire*. It was probably built around 1270 by Sir Richard de la More, and reinforced from 1306 by the de Kemeys. The Morgans of Tredegar built a fortified mansion in the first quarter of the sixteenth century, on the moated Norman site, and it is now sadly derelict. There were plans to build a 'theme park' around the Grade II* manor and its 370 acres, and it would be far more worthwhile for any Russian billionaire to spend his money on restoring this wonderful house, rather than on any football team.

PEN DINAS HILLFORT *On a promontory, it looks over Aberystwyth and Cardigan Bay and covers two summits*. The Wellington Monument, a pillar built in 1852, lies inside the hillfort, which is dated to about 400 BCE. One of the largest West Wales coastal sites, only the southern fort can be accessed.

PENDINE SANDS - THE HOME OF MOTOR SPEED RECORDS *The stretch of sands heading east from Laugharne, on Carmarthen Bay*. Malcolm Campbell set a world motor speed record of 146mph here in 1924, and four more record-breaking runs were made here between 1924 and 1927, two by Campbell and two by J. G. Parry-Thomas. The seven-mile beach was also used for motorbike and car races. Records were set previously at Brooklands and Arpajon, and after Pendine, Daytona and Bonneville became the major venues for record attempts. The Pendine Museum of Speed is dedicated to the use of the sands for land-speed record attempts and houses *Babs*, the land-speed record car in which Parry-Thomas was killed here. After forty years of burial on the beach, it was excavated and restored. Most of the beach is now unfortunately owned by the Ministry of Defence, access is restricted and there is the danger of unexploded bombs. Near the unrestricted parts of the beach there is an ugly sprawl of caravans. Just inland, there are interesting medieval churches at Llansadurnen (St Sadwrn) and Llandawke (St Oudoceus, Euddogwy).

PENHOW CASTLE *On the A48 between Caldicot and Newport, Monmouthshire, NP26 3AD*. This fortified manor house was probably founded by Roger de St Maur around 1130, when he took the lordship from a Welsh prince. In 1240, William St Maur (to become Seymour) agreed with his brother-in-law the Earl of Pembroke to take the nearby manor of Undy from the last Prince of Gwent, Morgan ap Howell. The Seymours who lived here were the ancestors of Jane Seymour, the wife of Henry VIII. A curtain wall encloses a small courtyard beside the stone tower. Over the centuries more comfortable dwellings were built beside the tower, leaving very little space in the courtyard, and incorporating or replacing most of the curtain wall. The range to the south is a medieval manor house that received alterations up to the Tudor period. In the late seventeenth century, the north range was replaced by a new house, built for the Lewis family. The castle was largely derelict when it was bought in 1973, but the new resident owner made extensive restorations and opened the castle to the public. In 2003, the castle was again sold, and is now a private residence no longer open to the public.

PENHOW – THE CHURCH OF ST JOHN THE BAPTIST This is a lovely church in picturesque surroundings, next to the inhabited Penhow Castle. The church is thought to owe its foundation to the Normans, and the tower is probably twelfth century. It was built by the St Maurs who also built the castle around the same time. The church tower still retains its arrow loops beside the bell-louvres, and possibly held the dual role of a rearguard defence if the castle was attacked. The remains of a medieval tombstone tell us of the daughter of a rector of Penhow, who died in 1783 aged 111 years, having lived through seven reigns. The font is made from local limestone, dating to around the thirteenth century. The church was restored in 1914.

PENLLECH – CHURCH OF ST MARY, EGLWYS SANTES FAIR FOFC *About six miles south-west of Morfa Nefyn, Llŷn Peninsula.* Take a farm track towards the sea from the road from Tudweiliog to Llangwnnadl, and the plain old church is in a farmyard. It appears that the Friends of Friendless Churches are now looking after this medieval pilgrim church, but it is not noted as such on their website, as of the end of 2009. The churchyard is overgrown but the cream-painted box pews are intact in its unspoilt Georgian interior.

PENLLYN CASTLE AND VILLAGE – THE LONGEST CONTINUOUSLY OCCUPIED CASTLE SITE IN BRITAIN *North-west of Cowbridge, Vale of Glamorgan.* A 1790s mansion and stables overlooks the Vale, embodying the remains of the medieval core. It is on a Dark Ages site in a commanding position above the River Thaw, across the Roman road (A48) from the hillfort of Caer Dynnaf. This was one of the first Norman keeps in Glamorgan, and the remains are now part of a derelict building. The mansion has been continuously occupied since the eleventh century by the following well known Vale families – Norris, Turberville, Seys, Stradling, Mansell, Lady Veron, Gwinnett, Villiers, Hayton (Clarendon), Homfrey and Cory. Internally the highly decorated reception rooms are a feature. There is a 'Tudorbethan' entrance lodge to the castle and its estate, adjoining the ruins of an eleventh-century hall house. Medieval buildings nearby include a fifteenth-century chapel of ease, from where coffins were carried to LLANFRYNACH Church. The Georgian three-storey Great House in the village was originally built as a two-storey cottage with thatched roof.

PENLLYN – DR SALMON'S WELLS This is a series of three masonry-covered wellheads and steps dating from the fourteenth to sixteenth centuries. In 1883, Dr William Salmon, concerned for the public health of the area, dedicated and conserved the wells to serve the public. A stone plaque bears the inscription, 'Dŵr Rhudd Yr Hollalluog Dduw' (Water, the Gift of Almighty God).

PEN LLYSTYN ROMAN FORT *Just north of Bryncir, on the A487 between Porthmadog and Caernarfon, on the east bank of the Afon Dwyfach, Llŷn Peninsula.* Unfortunately, the site is now almost completely lost due to gravel-working, like many other important prehistoric sites in Wales. Pen Llystyn, however, was mapped out in the 1960s, showing a wooden fort covering four and a half acres, built in 70-80 CE. It is near the Roman road from Segontium (Caernarfon) to Tomen-y-Mur, and its barrack blocks housed a cohort of 960 troops. It was sited to control the small Celtic tribe of Gangani on what the Romans named the 'Ganganorum Promontorium', the Llŷn Peninsula. In the garden of the nearby Llystyn Gwyn farm, a sixth-century stone was found with Latin and Ogham inscriptions, reading 'ICORI (X) FILIUS POTENT INI' (Icorix, son of Potentinus). Bilingual stones are almost unknown in north-west Wales.

PENMACHNO – AN IMPORTANT EARLY CHRISTIAN SITE *4 miles south of Betws-y-Coed, on the B4406, on the Afon Machno.* Penmachno featured during the great, yet little-known revolt of Madog ap Llywelyn in 1294-95, as the place where Madog signed the *Penmachno Document*, the only surviving direct evidence for his use of the title of Prince of Wales. There is a five-arched stone bridge dating from 1785 which links both parts of the village, and Penmachno was an important ecclesiastical centre in the Dark Ages. Both the church and the holy well, which is situated in

the cellar of the old post office, are dedicated to St Tudclud. The church contains some of the oldest Christian gravestones in Wales, dating from the late fifth and early sixth centuries. One commemorates Cantorix as a citizen of Gwynedd, reading, 'Cantorix, citizen of Venedos and cousin of Maglos the Magistrate'. Another of the Penmachno inscriptions reads, 'CARAVSIVS HIC IACIT IN HOC CONGERIES LAPIDVM' (Carausius lies here in this cairn of stones). Both this stone and one at Treflys (Cricieth) have the Chi-Rho symbol – a monogram formed from the first two letters of the Greek form of the name of Christ: X (chi) and P (rho), extremely rare in Wales. In Geoffrey of Monmouth's 1136 *History of the Kings of Britain*, Carausius is a Briton of humble birth, who is given command of a fleet to defend Britain from barbarian attack. Once given the fleet, however, he raises an army against Bassanius, King of Britain. Carausius defeats Bassanius and sets himself up as king. Hearing of Carausius' treachery, the Roman Senate send Allectus to Britain with three legions. Allectus defeats and kills Carausius and sets himself up as king in his place. There are also a stone slab with a cross, and a pillar stone with a defaced inscription. The fifth stone reads, 'FILI AVITORI IVSTI[NI] CON[SVLIS]' – 'son of Avitorius in the time of Justinus the Consul'. Justinus was consul in 540, which is possibly the date of the stone. He and Basilius, consul in 541, were the last Roman consuls to be cited on monuments in the western world. Others argue that this stone can be dated any time between 328 and 650. There is a Roman bridge in the woodland near here, and the Penmachno Woollen Mill can be visited.

PENMACHNO – TÝ MAWR WYBRNANT – NATIONAL TRUST – THE BIRTHPLACE OF WILLIAM MORGAN *Across Penmachno bridge into the Afon Lledr Valley, LL25 0HJ. Tel: 01690 760213.* A traditional stone-built upland sixteenth-century farmhouse, Tŷ Mawr Wybrnant is on the site of the birthplace of Bishop William Morgan (1545-1604), first translator of the whole Bible into Welsh. Carefully restored, it houses an impressive collection of Welsh and alternative Bibles, and it is an idyllic, isolated site.

PENMACHNO – TÝ'N-Y-COED-UCHAF – NATIONAL TRUST *Penmachno, Betws-y-Coed, Conwy LL24 0PS. Tel: 01690 760229.* A traditional smallholding with a nineteenth-century farmhouse and outbuildings, it provides a fascinating record of an almost-vanished way of life in a Welsh-speaking community. Of interest is the farmhouse furniture bought for the house by generations of its tenants. The house is approached by a walk along the River Machno and a visit to Tŷn-y-Coed Uchaf can be combined with a trip to Tŷ Mawr Wybrnant.

PENMAENMAWR – GRAIG LWYD AXE FACTORY – THE THIRD LARGEST NEOLITHIC AXE FACTORY IN BRITAIN *The mountain is above Llanfairfechan and Penmaenmawr on the coast facing Anglesey, west of Llandudno, Conwy.* The Graig Lwyd ('grey rock') Neolithic stone axe factory is situated on an extinct volcano. The fine-grained volcanic stone mined here could be broken off, roughly shaped with a hammer-stone and then polished on a grindstone similarly to flint. Graig Lwyd axes have been found all over Britain, many with minimal signs of wear, indicating that they were highly prized, and probably ceremonial in many instances. They date from around 3000 BCE onwards. The site is still being quarried on two sides, so access is difficult. On the mountain is an 8-foot-wide circular bank of loose stones with an internal diameter of 40 feet. Against the inner edge, the cremated remains of a slightly built adult were found. The circle has been dated as being used between 1405 and 155 BCE. Nearby is the Maeni Hirion group of monuments. The first monument looks like a collection of boulders, but excavation revealed two three-sided cists, each containing a cremation burial. The stone circle nearby is known as 'The Druids' Circle' but predates them by perhaps 1,000 years. In the centre was a cist, covered with capstone, containing the cremated remains of a child of about eleven. The remains were in a large urn, and nearby in a shallow pit was found another inverted urn which contained the cremated bones of a child of about twelve years, as well as a small bronze knife. Today about thirty stones, some still upright, form the circle which is 82 feet in diameter. Excavation has shown that many stones have been removed in the past, and that the western entrance to the monument has been

almost destroyed by quarry blasting. The remarkable site of Maeni Hirion (Long Stones) was erected at the crossroads of ancient tracks. About 100 yards from Maeni Hirion lies a small circle of five large boulders, 10 feet in diameter. More stone circles have been destroyed on this important site, for field-walls and by quarrying. It is amazing that Welsh heritage and culture is still under threat in the cause of progress.

PENMARK CASTLE *Almost hidden in a field behind the church in the village, which is just north of Cardiff International Airport in the Vale of Glamorgan.* Defended on one side by the steep 100-foot drop to the Waycock River, there was a timber castle in the twelfth century, and the stone remains date from the thirteenth century, but the moat has been filled in. It appears to have been sacked by Glyndŵr, and there was action here in the Civil War when the Royalists were bombarded by Cromwell's troops. The large Church of St Mary in Penmark is of twelfth-century origin and is Grade II* listed.

PENMON CROSSES CADW *North-east of Beaumaris, on the south-east tip of Anglesey.* Two tenth-century finely decorated pillar crosses, that once stood in front of the monastery, are now inside the church. The larger cross is more badly weathered, because it stood outside until 1977, in the Bulkeleys' deer park. It is almost complete, but the other cross is smaller, with an arm of the cross cut off because it was used as a lintel for the refectory windows.

PENMON DOVECOTE CADW Built in about 1600 by Sir Richard Bulkeley, the massive domed columbarium had room for up to 1,000 nests and has a central pillar.

PENMON – ST SEIRIOL'S PRIORY CADW St Seiriol had his first cell on the nearby island of YNYS SEIRIOL (Priestholm), and this priory is on the site of his sixth-century monastery. It was burnt by the Danes in 971. Around 1140, under the patronage of Gruffudd ap Cynan and Owain Gwynedd, the abbey church was built in stone, and became Augustinian in the reign of Llywelyn the Great. The church font was once the base of a cross, with a Celtic knotwork pattern.

PENMON – ST SEIRIOL'S WELL CADW A small chamber with stone seating surrounds the holy well attributed to Seiriol. It is a spring emerging from a cliff behind the church, reached by a path just beyond the car park, skirting the monastic fish pond. The roofed inner chamber around the pool is of brick, and dates from 1710. The lower courses and lower antechamber, with seats on either side, are probably much earlier, but no medieval finds were made during recent excavations. Seiriol was buried on Ynys Seiriol (Priestholm off Anglesey). He was known as Seiriol the Pale as he used to head west in the morning to meet St Cybi, and return east in the afternoon. St Cybi of Holyhead, travelling in the opposite direction, was known as Cybi the Tanned.

PENMORFA – CHURCH OF ST BEUNO, EGLWYS BEUNO SANT FOFC *2 miles north-west of Tremadoc, on the Cricieth road, Caernarfonshire.* Surrounded by slate headstones and tomb chests, St Beuno's simple exterior conceals a more elaborate interior, with medieval stained glass, monuments and nineteenth-century fittings associated with the William-Ellis family. It has a fine carved wooden lectern with an almost life-size angel. The interior also contains the tomb of Sir John Owen of Clenenney, who was taken prisoner at the battle of LLANDEGAI by the Parliamentarians under General Mytton. A Romano-British inscribed stone was found, being used as the lintel of a nearby beudy (cowhouse) at Gesail Gyfarch, reading 'FILI CVNALIPI CVNACI [HIC] IACIT [–] BECCVRI'. It may read, '(The stone) of Cunalipus (Cynllib) son Cunacus (Cynog). He lies (here) ... of Beccurus (Bicior)'. Artur ap Bicior was recorded as killing Mongan by throwing a stone, in a British invasion of Ireland in 624. Cynllib is a form of Cynllo, and one of the two saints named Cynog was the second Bishop of Llanbadarn, dying in 606. Thus the stone could be early seventh century, if it commemorates Artur and Cynllo. Incidentally, Cynllibiwg, the land of Cynllib, was another name for the district, called 'Rhwng Gwy a Hafren' (between the Wye and Severn).

PENMYNYDD – THE BIRTHPLACE OF THE ROYAL HOUSE OF TUDOR *The village is on the B5420 between Menai Bridge and Llangefni, Anglesey.* The Tudors of Penmynydd were instrumental in the initiation and success of Glyndŵr's War of 1400-1415. They were descended from Ednyfed Fychan, the lord steward, or seneschal of Llywelyn the Great. Tudur ap Goronwy of Penmynydd had five sons, and his grandson Owain ap Maredudd ap Tudur married Henry V's widow in 1429, having three sons. Owain was executed, but his grandson became Henry VII. Plas Penmynydd, the home of the Tudors on Anglesey, was built after these events, in 1576, on the site of their previous plas, and rebuilt in the seventeenth century. There are almshouses in the village, and the church was founded by St Gredifael in the sixth century. The present church is fourteenth-century and its Tudor Chapel contains the alabaster effigies of Gronw Fychan and his wife. The chapel also contains a stained-glass window, with the symbols of the Tudor family. The motto reads UNDEB FEL RHOSYN YW AR LAN AFONYDD AC FEL TŶ DUR AR BEN Y MYNYDD, which translates as 'Unity is like a Rose on a River Bank, and like a House of Steel on the Top of a Mountain'. The phrase Ty Dur (House of Steel) refers to the name Tudur, and Pen y Mynydd means top of the mountain. The window was smashed in 2007 but has been repaired.

PENNAL – CEFN CAER – THE HOME OF CORON GLYNDŴR *4 miles west of Machynlleth, Meirionnydd.* On the site of a Roman fort with views over the Dyfi Valley, this early medieval hall house with a fourteenth-century fireplace and internal oak walls is much as it was when Glyndŵr stayed here in 1406. Meticulously restored by Elfyn Rowlands, it is possible to attend medieval banquets here. The Coron Glyndŵr, a replica crown, is kept here, and this author had the honour of composing a poem to celebrate its dedication in 2007 at Machynlleth. Replica bolts encircle the crown, to indicate the fact that medieval crowns were bolted to helmets in time of war. Sarn Helen, the Roman road, passes by the village. The hall was an important centre of Bardic patronage, and to visit, call Elfyn Rowlands on 01654 791230.

PENNAL – CHURCH OF ST PETER AD VINCULA The original sixth-century Celtic church was dedicated to St Tannwg and St Eithras. Named St Peter ad Vincula in the eleventh century, its only sister churches of 'Peter in Chains' are the Chapel Royal in the Tower of London and a church in Rome. There is a stained-glass window of 'the green man' in the east window, and this author knows no other stained-glass representation in England and Wales. The church includes Roman remains from the nearby fort at Cefn Caer, and 'the Welsh Juliet', Lleuci Llywd, was buried under the altar in 1390. It is claimed to be Glyndŵr's Chapel Royal, and there is a Welsh heritage theme garden in the oval churchyard. The 'Pennal Letter', a radical programme for Wales as an independent nation once again, was written in Pennal in 1406, probably at Cefn Caer. The original is in Paris, but there is a copy in the church, as well as a painting of Glyndŵr's coronation.

PENNAL – DOMEN LAS ROMAN FORT AND MOTTE The Roman remains have vanished, but a Norman fort was placed on its site, and the small motte can be seen just outside Pennal. It is on private farmland off the lane leading to Plas Talgarth, but can be seen from the main A493 road. Glyndŵr is said to have issued orders from the castle on his visit to Cefn Caer and Pennal Church in 1406.

PENNANT MELANGELL, THE SHRINE CHURCH OF ST MELANGELL – THE UNIQUE COFFIN SHRINE OF A SEVENTH-CENTURY SAINT *Follow the B4391 for 2 miles from Llangynog, Powys SY10 0HQ.* An ancient pilgrimage church with the only Romanesque shrine in Britain, it lies at the head of the Tanat Valley in the heart of the Berwyn Mountains. Some of the yews are among the oldest in Britain, over 2,000 years old, and the circular churchyard was a Bronze Age burial site. In 604, Prince Brochwel Ysgythrog ('the Fanged') of Powys came hunting where the virgin St Melangell lived as a hermit, and a hare took refuge under her cloak. The prince's dogs refused to attack, and Brochwel gave her the valley as a sanctuary. Pennant Melangell has been a place of pilgrimage since that time, with Melangell being the patron saint of hares. Parts

of the building date from the twelfth century, and it contains a fine fifteenth-century oak screen with carvings that tell the story of Melangell and Prince Brochwel. There are also two medieval effigies, one of which represents the saint, a Norman font, and a Georgian pulpit, chandelier and commandment board. The greatest treasure is the 1160 coffin shrine of Saint Melangell, supported on pillars, and supposedly containing her relics. This was dismantled after the Reformation and its stones, carved with a blend of Romanesque and Celtic motifs, were built into the walls of the church and lych-gate. They were reassembled in the 1950s and have now been re-erected in the chancel. The shrine is unparalleled in Northern Europe and is visited by pilgrims.

PENNARD CASTLE *It stands on the cliffs at Three Cliffs Bay, on the Gower Peninsula.* With a sheer drop on two sides and superb views over Penmaen Burrows and the bay, the remains are worth visiting. In the early twelfth century, the first Earl of Warwick, Lord of Gower, probably built the ringwork castle here. It had a bank and ditch around it, and a primitive stone hall. On the opposite side of the valley, at Penmaen, a similar castle was built at the same time. In the late thirteenth or early fourteenth century, Pennard Castle was rebuilt in stone, but soon was abandoned because of encroaching sands. Just one wall remains nearby of the medieval St Mary's Church.

PENRHOS FEILW – STANDING STONES CADW *On Holy Island, Anglesey, on the minor road north from Trearddur.* Two stones, ten feet apart, standing ten feet high, probably date to the Early Bronze Age of 2000-1500 BCE. Also known as Plas Meilw, some reckon the site was once far more extensive.

PENRHYNDEUDRAETH – CASTELL DEUDRAETH, DEUDRAETH CASTLE *Outside Portmeirion, off the A4085 north of Penrhydeudraeth LL48 6ER. Tel: 01766 770000.* Castell Deudraeth is mentioned by Gerald of Wales in 1188 as being unusual, in that it was a Welsh castle made of stone. However, this probably refers to where a folly is now sited at Portmeirion Village, as 'deudraeth' means 'two beaches'. Castell Deudraeth is now an early-Victorian castellated mansion, with a walled garden, and was opened as a luxury hotel in 2001. Clough Williams-Ellis purchased the building and its grounds in 1931 in order to expand the Portmeirion estate, and to give him a proper driveway from the main road. He referred to the Castell as 'the largest and most imposing single building on the Portmeirion estate'. The original gardens are being restored.

PENRHYNDEUDRAETH – PLAS BRONDANW GARDENS – RHS RECOMMENDED GARDEN *Llanfrothen, Gwynedd LL48 6SW. Tel: 01743 241181.* This is the extremely original garden laid out by Clough Williams-Ellis, seventeen years before starting to develop nearby Portmeirion.

PENRICE CASTLE AND PALLADIAN MANSION *Can be seen off the A4148 west of Nicholaston, Gower Peninsula.* The Penrice Estate came into the Mansel family's ownership after the Norman conquest of the Gower Peninsula in the twelfth century, so the core of the land around Penrice Castle and the village has remained in the same family for twenty-nine generations. After the Norman Conquest, an earthwork castle was built near present-day Penrice village, behind the cottage of Sea View. Henry de Beaumont's original castle earthworks are extensive but very much overgrown. It was replaced by the stone castle which still stands today overlooking the family's Georgian mansion. The castle was re-fortified because of the Welsh revolts of the thirteenth century. The Mansels continued to live at Penrice until the mid-fifteenth century when they built Oxwich Castle, a semi-fortified manor house nearer the sea. By the 1770s the Estates belonged to the young Thomas Mansel Talbot, newly returned from the Grand Tour, and as a result he decided to build himself a neoclassical villa at Penrice. The architect may have been Anthony Keck, who designed Highgrove, and the landscape designer was William Emes, who had studied under Capability Brown. Penrice is the largest castle on the Gower and has a number of unusual features. The keep, gatehouse and much of the surrounding walls are still high, but in a ruinous state. Penrice Castle is on private land, but a public footpath allows viewing of portions of the curtain wall, keep and towers.

PENTRAETH, BATTLE OF, 1170 *At Rhos-y-Gad (Battle Moor), or actually on the beach at Pentraeth, where the River Nodwydd meets the sea, Anglesey.* Upon Owain Gwynedd's death in 1170, his sons fell into dispute over the lordship of Gwynedd. Hywel ab Owain was forced to flee to Ireland, but returned the same year and was defeated and killed at Pentraeth by his half-brothers Rhodri and Dafydd. The seven sons of Hywel's foster-father, Cadifor, were killed alongside this warrior-poet Hywel ab Owain, and were commemorated in verse, which states that the battle was fought in the hollow above the beach.

PENTRE IFAN BURIAL CHAMBER CADW *Near Felindre Farchog on the A487, on the Preseli Hills, it looks over Cardigan Bay.* This is a Neolithic chambered tomb of the 'portal dolmen' variety, and is one of the most loved Welsh sites because of its situation. Made of the same Preseli bluestones as Stonehenge, its capstone is 16 feet across. The inner circle at Stonehenge originally consisted of forty to fifty of these holy 'bluestones', each 9 to 10 feet high, 2 to 3 feet wide and weighing up to 2 tons each. Laboriously cut and shaped, they were possibly dragged down to a harbour, taken up the Bristol Channel, and dragged across to the Wiltshire Plains on rollers. Nearby there is a standing stone, Neolithic fort, other tumuli and Beddyrafanc (Grave of the Beaver) chambered tomb. W. Y. Evans Wentz (1927 editor of *The Tibetan Book of The Dead)* writes in *The Fairy Faith in Celtic Countries,* 'The region, the little valley on whose side stands the Pentre Ifan cromlech, the finest in Britain, is believed to have been a favourite place with the ancient Druids. And in the oak groves (Tŷ Canol Wood) that still exist there, tradition says there was once a flourishing school for neophytes, and that the cromlech instead of being a place for internments or sacrifices was in those days completely enclosed, forming like other cromlechs a darkened chamber in which novices when initiated were placed for a certain number of days … the interior (of Pentre Ifan) being called the womb or court of Ceridwen.'

PEN Y CRUG HILLFORT *In Brecon, turn off the B4601 immediately north of the bridge. In Cradoc, after 5 miles, turn right. Park in the lay-by on the left 1 mile further on.* Pen y Crug is an impressive site, occupying the summit of a prominent and steep hill. The defences were built by throwing material down the steep slopes, forming a quarry ditch inside the inner bank and a counterscarp bank outside the outer ditch. A series of defensive ramparts surround the summit of the hill, the innermost still standing 14 feet high. The superb site, overlooking the valleys of the Usk and the Honddu, is near the Roman camp of Y Gaer.

PENYGWRYD HOTEL – THE TRAINING BASE FOR THE EVEREST EXPEDITION *Pen-y-Gwryd is a pass at the head of two rivers, at the junction of the A4086 from Capel Curig to Llanberis, and the A498 from Beddgelert, a mile from the head of the Llanberis Pass.* This was a simple farmhouse dating from 1811, which developed into an inn and then a hotel. In May 1898, The Climbers Club originated at Pen-y-Gwryd, but is now based at Helyg on the A5. Penygwryd also became a Mountain Rescue Post. The first successful Everest expedition operated from here in 1953, as did the first successful Kangchenjunga expedition in 1955. Training and testing of oxygen equipment for the expeditions took place at Helyg near Capel Curig. On the right at the hotel entrance there are the signatures, written on the ceiling, of the team that made the first ascents of Everest and the third highest mountain in the world, including Edmund Hilary, Tenzing Norgay, Sir John Hunt, Charles Evans and Joe Brown. In Millennium Year a tiny chapel was built in the grounds of the hotel. There was a Roman marching camp at nearby Dyffryn Mymbyr, on the route between Chester and Caernarfon.

PEN Y WYRLOD BURIAL CHAMBER – THE 6,000-YEAR-OLD FLUTE *Overlooking Mynydd Troed, south of Talgarth, Breconshire.* The Neolithic chambered tomb at Penywyrlod (c. 4000 BCE) was discovered in June 1972 by a farmer when clearing a stone mound from a field for use as hard-standing in the farmyard. A mound, 60 yards by 28 yards and 10 feet high, was excavated. A number of human remains were found along with a bone flute, a human rib and some

worked flints and stone. The bone flute was made from a sheep bone and has three holes. This is the oldest dated musical instrument found in Wales, and one of the oldest in the world. The chambered tombs of Wales, comprising the communal tombs of the earliest Neolithic farmers, are amongst the oldest surviving man-made structures. Breconshire alone has seventeen known or possible chambered tombs in the south of the county, most of which are in the Black Mountains, including two at Ffostyll, and others at Little Lodge, Croes Llechau, Gwernvale, Mynydd Troed, Tŷ Isaf, Cwrt y Prior, Twyn y Beddau, Penywyrlod Talgarth and Penywyrlod Llanigon. Other well-known sites include the tombs at Tŷ Illtud and Pipton.

PICTON CASTLE AND WOODLAND GARDENS – RHS RECOMMENDED GARDEN

Near Haverfordwest, Pembrokeshire SA62 4AS. Tel: 01437 751326 www.pictoncastle.co.uk. In 1108, to strengthen his toehold in Pembrokeshire, Henry I settled Flemings around Haverfordwest. Around this time Picton was founded, with a Flemish leader, Wizo, founding Wiston Castle, three miles to the north. Picton Castle passed through the Wogans to the Dwnns and then to the Philipps. The castle was probably built by Sir John Wogan, Justiciar to Ireland from 1295-1308. Picton Castle has been the historic home of the Philipps family, who are direct descendants of Sir John Wogan, who built the castle over 850 years ago. The forty acres of gardens are open to the public, with fine collections of shrubs among the oaks and giant redwoods. Picton Castle is an unusual building – half fortified manor house and half fully developed medieval castle.

THE BATTLE OF PILLETH (BRYN GLAS) 22 JUNE 1402 *South of Knighton, looking over the River Lugg, Radnorshire.* An international humiliation for the English, the news of their casualties on St Alban's Day reached Rome within days. Sir Edmund Mortimer had an army of 2,000 men to defeat Owain Glyndŵr, who had been proclaimed Prince of Wales by his fellow princes. The Normans had taken the title in 1283 after the murder of Llywelyn in 1282. It appears that Mortimer saw Pilleth Church burning, crossed a marsh and headed uphill through scrubland. The hill is not continuous, and it appears that Mortimer saw about 600 Welshmen on what he thought was the top ridge, and headed towards them. As they approached the small force, the bulk of Glyndŵr's army, led by Rhys Gethin (the Fierce), appeared over a higher ridge at the top of the hill, and began pouring arrows into Mortimer's army. Mortimer was on the lower slopes, with the marsh behind him. His own Welsh archers, seeing the Golden Dragon flags of Glyndŵr, turned on their English compatriots, and Mortimer's force was crushed, with Mortimer being captured and later joining Glyndŵr's forces. At least 1,100 of Mortimer's men were killed. After two years of war, this was the breakthrough by Glyndŵr's guerrillas, and led to another thirteen years of fighting. Four redwood trees above the church mark the site of a mass grave found in the late nineteenth century.

PILLETH – CHURCH OF THE VIRGIN MARY The earliest recorded church at Pilleth was a dependency of St Cynllo's at Llangunllo, and it has been suggested that the parish feast day being on St David's Day reveals its earlier pre-Norman dedication. In the Middle Ages pilgrims were attracted by a notable image of the Virgin. North of the fifteenth-century tower is the holy well, approached by five stone steps. It was formerly roofed over and was reputed for its healing properties. Glyndŵr was said to have tasted its waters before the battle here.

PISTYLL – CHURCH OF ST BEUNO *Soon after leaving Nefyn on the road to Llithfaen, turn left at the sign, on the Llŷn Peninsula.* Pistyll church was used for worship by pilgrims on their way to Bardsey Island. Pilgrims used to rest at the adjacent monastery, at the inn, or at the hospice on nearby Cefnedd Hill. Lepers were probably confined in a smaller building on Cae Hospice field. The original church of wood, plaster and thatch could have had a circular boundary fence but the present churchyard wall is oval in shape. The font is of Celtic origin. Since 1969 this church has been decorated with wild medicinal herbs, strewn herbs and rushes laid on the floor at Christmas, Easter and the early August Lammas Festival. It is a lovely, hidden site for one of the most simple

churches in Wales, with a tumbledown graveyard overlooking the sea. The large painted board over the altar reads 'Clodforwch yr Arglwydd canys da yw' ('Praise the Lord for He is good').

PLAS NEWYDD – NATIONAL TRUST – COUNTRY HOUSE AND GARDENS *Llanfairpwllgwyngych, Anglesey LL61 6DQ. Tel: 01248 715272.* A superb eighteenth-century mansion, home of the Marquess of Anglesey, it has spectacular views of the Menai Strait and Snowdonia. Plas Newydd possesses the largest collection of Rex Whistler works, and a military museum with relics from the Battle of Waterloo. On the banks of the Menai Strait, is an elegant country house designed by James Wyatt and built by the Marquess of Anglesey, one of Wellington's commanders at Waterloo. On horseback, when a cannon ball took off his leg at Waterloo, he turned to Wellington and exclaimed, 'Begod, there goes me leg!' The phlegmatic Duke replied, 'Begod, so it do!', and carried on supervising the battle. The marquess's artificial leg, made of wood, leather and springs, was the world's first articulated leg, and is on display in Plas Newydd's Cavalry Museum.

PLAS YN RHIW – NATIONAL TRUST – MANOR HOUSE *Rhiw, near Pwllheli, Llŷn Peninsula LL53 8AB. Tel: 01758 780219.* A manor house with ornamental garden, it has wonderful views across Cardigan Bay and a woodland walk. The house has medieval origins, with Tudor and Georgian additions, and was in a bad state when it was bought by the three Keating sisters in 1938. Clough Williams-Ellis carried out some work for them, and they were largely responsible for restoring the house, giving it to the National Trust. The sisters also set up the Council for the Protection of Rural Wales.

PLAS TEG JACOBEAN MANOR *3.5 miles south of Mold, on the A541 to Wrecsam, at Pontblyddyn, Flintshire CH7 4HN. Tel: 01352 771335.* Plas Teg is one of the most important Jacobean houses in Wales, built by Sir John Trevor about 1610, utilising the Renaissance concepts of symmetry, proportion and elegance. Recent restoration, part-funded by CADW, has recreated the ideal of an early Stuart country house. The house is built upon a cross-hall plan, with the great chamber above and a cross-axial gallery to the second floor. Tours are available of this remarkable building, whose sympathetic owner has spent a fortune repairing it. Plas Teg is one of Wales' most haunted houses, and the group 'Girls Aloud' featured in a TV programme about its ghosts in late 2009.

PONTARGOTHI – HOLY TRINITY CHURCH *Near Nantgaredig, 6 miles east of Carmarthen SA32 7NH, open every Thursday 14.00-16.00.* The church includes many architectural styles including Romanesque and Gothic, with a hexagonal fleche being one of the most beautiful features of the exterior, with windows filled with Clayton and Bell glass. Designed by B. J. Bucknall, a follower of Pugin, its dull exterior of 1865 is in contrast to the inside, which is extravagantly and colourfully decorated. The church was constructed with a cavity wall so that damp would not destroy the painted decorations, and there is an extensive scheme of murals. The nave has a wooden barrel vault with decorated tie beams, and a very ornate chancel. The fittings were also designed by Bucknall, and it is one of the most unusual churches in Britain. The building was ordered by Henry James Bath of Alltyferin (now demolished) across the River Cothi. There are traces of the private bridge that he used to go to church. Mr Bath did not understand the Welsh services held at the parish church of Llanegwad, so decided to have a church of his own built on the estate, with English services. Bath made his money in Swansea's copper and shipping trade, and named his ships after the letters of the Greek alphabet. Catherine Zeta Jones received her unusual middle name from one of Bath's ships, via the name of her paternal grandmother, a descendant of Bath.

PONTARGOTHI – SALUTATION INN A seventeenth-century coaching inn (tel. 01267 290336), its restaurant was originally a cowshed and the bar still has original rings to cure hams. It is one of the most haunted pubs in Wales with eight ghosts which can be traced back to 1759.

PONTERWYD – LLYWERNOG SILVER-LEAD MINING MUSEUM *A mile west of Ponterwyd in Ceredigion.* One can follow a trail through a site that operated from 1740 to 1914. There is a 'panning shed' and an extended underground tour. This mining of silver-rich lead ore was a major rural industry in mid-Wales for over 2,000 years. The site is fairly well preserved, being miles from anywhere. In 1637 a branch of the Tower Mint was set up in Aberystwyth, to coin locally mined silver. Before the Romans came to Wales for its silver, lead, gold and slate, Celts also mined for minerals all over Wales.

PONTCYSYLLTE AQUEDUCT – UNESCO WORLD HERITAGE SITE, 2009 This was the highest canal aqueduct ever built for 200 years, succeeding nearby Chirk aqueduct, and is one of the world's most spectacular achievements of waterways engineering. The structure pioneered cast-iron construction, and symbolises the world's first Industrial Revolution. It was built between 1795 and 1805 to carry the Ellesmere Canal over the Dee Valley in North Wales. The approaching levels of the canal on either side required a crossing at 121 feet above the River Dee. The resident surveyor responsible was Thomas Telford, working under William Jessop, the most prolific canal engineer of the period. The height necessitated new methods, to replace the heavy construction of earlier aqueducts which had double skins of masonry and puddled clay fill. The spans were instead made of cast-iron plates bolted together into a trough, with cast-iron arch ribs supporting them from beneath. Altogether, nineteen spans were built, comprising an overall length of 1,007 feet. The towpath was supported on iron braces above a 12-foot-wide cast-iron trough, allowing water to move freely as boats passed. The tapering masonry piers were built hollow in their upper sections to reduce their weight. Only one man was killed in its construction, and according to the engineers, he was at fault. The aqueduct carried 10,000 canal boats and 25,000 pedestrians each year, and when built, it was said that crossing it was the closest experience one could get to flying. The narrow boats that use it weigh 12 tons, and its water is contained in the huge cast-iron trough. The sections of the trough were sealed and made watertight with Welsh flannel boiled in sugar, and bedded into mortar made of lime, iron filings and ox-blood. Sir Walter Scott called Pontcysyllte Aqueduct 'the greatest work of art the world has ever seen.' One can walk across, alongside the canal, and it can be a nerve-wracking experience for some people.

PONTYPOOL PARK AND FOLLIES *On the Afon Llwyd, where the A472 meets the A4043, Monmouthshire.* Pontypool grew principally from the manufacture of iron, from 1425 onwards. Richard Hanbury bought land in 1588 and constructed an impressive ironworks. Later, the first American ironworks, at Sagus River in Massachusetts, used Pontypool equipment. The Hanburys lived in what was to become Pontypool Park and made a fortune from iron production for the Napoleonic Wars. Pontypool Park House was extended between 1779 and 1840. The house is now a school, and the 150-acre park features ice houses, Italian gardens, the Folly Tower, and the Shell Grotto, which is a nineteenth-century Hanbury summerhouse lavishly decorated with shells and bones. Japan lacquerware was produced from the eighteenth to the nineteenth century here. From 1730, tinplate was manufactured in Pontypool, breaking the previous German monopoly, and for many years Pontypool 'japanned ware' (such as teapots and serving trays) was famous, being very collectable today. Examples of Pontypool lacquerware can be seen at the museum in Pontypool Park, set in a Georgian stable block. Pontypool has always been associated with rugby, and this author remembers vividly playing for Redcar on a tour of Wales against nearby Garndiffaith RFC, whose skipper was known to one and all as 'the beast'. I met him in a pub on an international day thirty years later, and recognised him instantly.

PONTYPRIDD – CENTRE OF THE INDUSTRIAL REVOLUTION *12 miles north of Cardiff, off the A470.* Brunel designed an impressive skew stone-arch viaduct for the Taff Vale Railway here, still used today, spanning 110 feet over the River Rhondda. Pontypridd Railway Station was built in 1840, and progressively re-modelled during the nineteenth century. Because of the narrow steep-sided geography of the valley, and the need to accommodate many converging

passenger routes with passing coal trains, it was designed as two back-to-back termini. This gave it the then-longest platform in the world, capable of accommodating two full-length trains on each side of the island platform. In 1818, the Brown Lenox Chain and Anchor Works opened, making cables for suspension bridges and from the mid-nineteenth century was sole contractor to the Royal Navy for the supply of anchor chains. Leading engineers such as Thomas Telford and Brunel specified chains and cables from Pontypridd. Also known as The Ynysangharad Chain Works, it was situated alongside the Glamorgan Canal and made the huge anchor chains for the *Mauretania, Queen Elizabeth, Queen Mary* and *QE2*. The factory closed in 2000 – one of the last British-owned factories still producing anything in Britain. Ynysangharad Park is a public park opened by Field Marshal Viscount Allenby as a war memorial park in 1923. The Edwardian park was laid out on a triangular area of land between Ynysangharad House and the Brown Lennox Chain and Anchor works. There is a superb memorial to Evan and James James, lyricist and composer respectively of the national anthem 'Hen Wlad Fy Nhadau (Land of My Fathers)'. The Museum of the History of Pontypridd is located in a former chapel, next to William Edwards' famous bridge. Mention must be made of the Grogg Shop in Pontypridd, where since 1965 John Hughes has made 'ugly' clay figures, especially of Welsh rugby heroes.

PONTYPRIDD BRIDGE – THE LONGEST SINGLE-SPAN STONE-ARCH BRIDGE IN THE WORLD IN THE EIGHTEENTH CENTURY The name Pontypridd is from 'Pont-y-tŷ-pridd' (bridge by the earthen house), and the famous stone bridge over the Taff was built in 1756 by the Methodist Reverend William Edwards. This bridge was the fourth attempted by Edwards, and rises 35 feet above the level of the river, being a perfect segment of a circle, the chord of which is 140 feet long. Notable features are three holes (spandrels) of differing diameters through each side of the bridge, to reduce the weight of the bridge. At the same time the arched masonry built into the spandrels tied the walls together, and strengthened them against any tendency to buckle. The mid-eighteenth century saw a rapid growth of wheeled traffic and a consequent spate of bridge building. From Monmouthshire to Carmarthenshire William Edwards of Pontypridd and his sons were now asked to build many of these new bridges. In 1857, a new bridge, the Victoria Bridge, paid for by public subscription, was built adjacent to the old one and carries road traffic. There is a famous 'rocking stone', 5 feet high, on the common near Pontypridd Hospital.

PORT EYNON – SALT HOUSE AND CULVER HOLE *On the most southerly tip of the Gower Peninsula*. The headland at this sandy beach has the remains of the great Salt House, a mansion destroyed by storms some three hundred years ago. More prosaically, it may have been built to extract salt from sea water, on the remains of the vanished Port Eynon Castle. A short walk takes one to the mysterious Culver Hole, a strange walled-up fissure in the cliffs possibly used for smuggling, and definitely as a medieval pigeon/dovecote. Smuggling was common in the area, and the beach, like all South Wales beaches, is losing its sand because of continued and senseless dredging of sand from the Bristol Channel.

PORTHCAWL HOLIDAY RESORT AND NEWTON HISTORIC VILLAGE *South-west of Bridgend, on the Glamorgan coast*. In 1831 its docks were built in response to demand from the coal trade, but closed in 1906 and the town developed as a holiday resort, with fine beaches, a funfair, a huge caravan site at Trecco Bay and an excellent links golf course, Royal Porthcawl. The Grand Pavilion was built for entertainment, on the sea front in 1932, and there is a lifeboat station. The superb 1880s Esplanade Hotel on the listed promenade has been replaced by a garish apartment block which locals hate, and call 'the bottle bank'. Porthcawl lighthouse was the last coal- and- gas powered lighthouse in the UK. Newton adjoins Porthcawl, and its fortified St John's Church was founded by the Knights of the Order of St John of Jerusalem 800 years ago. Also on the village green are the Jolly Sailor pub, the oldest in Porthcawl, the Ancient Briton pub and the medieval St John's healing well.

PORTHCAWL – SKER HOUSE AND THE THE MAID OF SKER Elizabeth Williams (*c.* 1747-1776) of Sker House, Porthcawl, fell in love with the house's harper, Thomas Evans. Her father made her marry an English industrialist, Thomas Kirkhouse, and she died of a broken heart. R. D. Blackmore, the author of *Lorna Doone*, used to stay in the house, and wrote the unrelated novel *The Maid of Sker*. Sker House was built as a monastic grange for the Cistercians of Neath Abbey in 1170. Known locally as the Great House, Jenkin Turberville extensively altered it in the sixteenth century. The glory of the house is the great hall, and it almost seems as though the entire building was designed around it. It occupies the entire width of the first floor of the building between the two turrets on the east side, and extends up through the second floor to the roof. Sker House was put up for sale in 2003 after much-needed renovation work was completed. It is now privately owned but hopefully may be open to visitors in the future. Its name derives from the Scandinavian 'sker', meaning reef, and Porthcawl's Sker Rocks have sunk many ships over the centuries. Part of the large barn known as Tŷ'r Ychen (The Oxen's House) nearby is also said to be medieval.

PORTHDINLLAEN – HISTORIC PORT AND PUB *Near Morfa Nefyn on the northern Llŷn Peninsula, Caernarfonshire.* This tiny village on the seafront is owned by the National Trust, lying underneath a golf course and Iron Age fort on the headland. The only way to reach the excellent Tŷ Coch pub is by walking as traffic is not allowed in the village.

PORTHGAIN HARBOUR – CONSERVATION AREA *On the cliff top walk from Abereiddi to Abermawr, between St David's and Goodwick, Pembrokeshire.* There is an extensive disused coastal quarry from which granite was taken for roadstone. This was dispensed from the huge brick hoppers into boats in Porthgain Harbour. These hoppers were used to store crushed granite before shipment, and are now a Scheduled Ancient Monument. Porthgain itself is a conservation area. The pub in the harbour, the *Sloop*, used to be called the *Step In* when boats were able to dock beside the pub and the crews could step into it.

PORTHMADOG SLATE AND SHIPBUILDING PORT *On the A487 between Penrhyndeudraeth and Cricieth, on the Glaslyn Estuary, Meirionnydd.* Porthmadog came into existence after William Madocks built 'The Cob', a long seawall, to reclaim land from the sea in 1811. It is unsure whether the port is named after Madocks, or after Ynys Madoc, a small island in the Glaslyn Estuary, from which Prince Madoc was supposed to have sailed in 1170 to discover America. Its harbour was well known for the building of three-masted schooners, known as the 'Western Ocean Yachts', and slate wharves were built to export slate, carried on narrow-gauge specially built railways to Porthmadog. The Croesor Tramway, Gorseddau Tramway, Welsh Highland Railway and Ffestiniog Railway all terminated here, and the latter two still operate as tourist operations. In 1863, the Ffestiniog Railway, which runs between Porthmadog and Blaenau Ffestiniog, took delivery of the world's first narrow-gauge steam locomotive for public services. Named *The Princess*, it is still in working condition.

PORTMEIRION VILLAGE AND TOWN HALL – RHS RECOMMENDED GARDEN *Penrhyndeudraeth, 2 miles south-east of Porthmadog, Meirionnydd LL48 6ER. Tel: 01766 770000.* Clough Williams-Ellis created this surreal Italianate coastal village from 1926 to 1976 to show that 'the development of a naturally beautiful site need not lead to its defilement'. Words fail to describe the impact of this gaily coloured village, and the vision of Williams-Ellis has been fully realised. It is one of the 'must-see' sites in Britain, especially outside the main tourist times of visiting. If one stays there, one can appreciate it before and after visitors leave. The overwhelming feeling is that one wants to selfishly enjoy the village and its superb woodland and beach walks by oneself. It is magical, and it is impossible to pick any highlights as each building or vista complements the next. The building carried on from 1926 to 1976, with many of the houses, ornaments, arches, colonnades and porches saved from demolition. There is an Italianate bell-tower, and the seventeenth-century 'Town Hall' is the great hall, rescued from Emral Hall, in Flintshire. This has the best Jacobean ceiling in Wales, and was bought by Williams-Ellis for £13 in 1937, taken down

and rebuilt at Portmeirion. The wonderful gardens and ponds have themselves been developed since Victorian times. The cult TV series *The Prisoner* was filmed here.

PORTSKEWETT, PORTH-IS-COED – HAROLD'S HOUSE *Immediately west of Portskewett church, on the B4245 a mile east of Caldicot, Monmouthshire.* A *Time Team* TV excavation in June 2007 found the earthworks of a medieval manor house with a fortified tower, probably on the site of a late Saxon royal hunting lodge. It was believed to have been built by King Harold around 1063 after a victory over the Welsh. Lying in a field marked as Harold's Field, local tradition was that King Harold's Palace lay on the site. The hunting lodge is recorded as being destroyed by the Welsh soon after it was built. 'Harold's House' is also the site of an early welsh llys, or Prince's Court, linked with Caradog Freichfras, one of Arthur's knights. There was once a tidal inlet, now silted up. Dressed stone was recovered from the site, which proved to be the same size and style as used on St Mary's Church, which dates to the early 1100s. At the eastern end of the village is Heston Brake; a group of pudding stones where Neolithic human remains were found. There was also a Roman villa in the village, on an Iron Age site, and a Roman temple on Portskewett Hill. Nearby Black Rock was a crossing over the Severn, known to have been used by Romans travelling between Bath and Caerwent. This is a tiny place with a wealth of history.

POWIS CASTLE AND GARDENS – NATIONAL TRUST *Overlooking the A483, a mile south of Welshpool.* This was a strong Norman castle at the heart of the kingdom of the princes of Powys. In the reign of Edward I, the Gwenwynwyn family, to keep the castle, had to renounce all claims to Welsh princedom of Powys, and took up the name De La Pole. It is now a grand mansion, and has been inhabited by the Powis family for over 500 years. The castle gardens, laid out in 1722, are especially fine. There is a golden state bedchamber dating from 1688, and the castle has strong connections with Clive of India. The exterior is fourteenth to sixteenth century, clad in red sandstone, so it was once known as 'the Red Castle of Pool'. The interior has ornate Stuart staterooms, and the contrasting servants' quarters are also visited. The superb formal gardens were created between 1688 and 1722 by the Welsh architect William Winde, and are the only formal gardens in Britain of this date which survive in their original form.

POWIS CASTLE – SARN-Y-BRYN-CALED TIMBER CIRCLE This stood near Powis Castle, and the Welsh name means causeway of the dry, or harsh, hill. However, if the original name was 'brwyn', not bryn, it would mean causeway of harsh grief. Aerial photography showed a prehistoric ritual and funerary site on the floodplains of the Severn, and 1990s excavations showed it to be a huge timber double circle built *c.* 2100 BCE, a possible prototype henge for Stonehenge. The Welshpool bypass now covers it.

PRESADDFED BURIAL CHAMBER CADW *A mile east of Bodedern, a short distance off the B5109, near Holyhead, Anglesey.* A double-chambered Neolithic tomb, with the southern dolmen's capstone is still in situ. The chambers are only seven feet apart, so it possibly once was a portal dolmen. Tŷ Newydd dolmen is only 100 yards away, and the seventeenth-century manor of Presadfedd Hall is nearby.

PRESTATYN *On the North Wales coast, east of Rhyl, Denbighshire.* In the eighteenth century, this was an important centre for lead mining, it is now an established seaside holiday resort. There are Roman remains here, including a bathhouse in Melyd Avenue and probably a fort of the XX Legion, but nearly all Roman remains have been destroyed by housing. The town lies at the northern end of Offa's Dyke Pathway.

PRESTATYN CASTLE Henry II built the original castle in 1157, and it was expanded by Robert de Banastre in 1164, but destroyed by Owain Gwynedd in 1167. The Earls of Chester took the castle over, and the small motte can still be seen.

PRESTEIGNE – HISTORIC MARKET TOWN *Where the B4355, B4356 and B4362 meet, between Kington and Knighton, Radnorshire.* Dating at least from the eleventh century, it was once the county town of Radnorshire, on the main coach route from London to Aberystwyth. Thirty of its buildings were once coaching inns, and there is an excellent 'town trail' guide to its historic buildings. In 1565, a bell-ringer was endowed by John Beddoes to ring a 'day bell' at 8 a.m. and a 'curfew bell' at 8 p.m., and the custom is still carried out. The remains of 'The Warden', the site of Presteigne Castle are on the outskirts of the town – it was destroyed at the same time as NORTON CASTLE. In the thirteenth century, Stapleton – a mile to the north of Presteigne – seemed likely to absorb its then smaller neighbour. It was granted the right to hold a market and had a stone-built castle protected by walled towers. The ruins which remain are those of the fortified manor, which replaced Stapleton Castle at the end of the seventeenth century.

PRESTEIGNE – CHURCH OF ST ANDREW On the Welsh side of the River Lugg, the border with England, Presteigne's Welsh name is Llanandras, the holy place of St Andras. This may be the Welsh saint Andras or a later Norman dedication to Andrew. It is architecturally the best church in Radnorshire, but is in the diocese of Hereford. From the thirteenth century to the Reformation, the Augustinian Canons of Wigmore Abbey held the rectory of Presteigne, and were responsible for the fine chancel and other improvements. It is assumed that there was a late Saxon church here on the basis of masonry survivals, and then a very early Norman church was built on the site. There is an early sixteenth-century Flemish tapestry in the church.

PRESTEIGNE – JUDGES' LODGINGS AND SHIRE HALL In 1855, the Lord Chief Justice called Radnorshire's Shire Hall 'the most commodious and elegant apartments for a judge in all England and Wales'. Dating from 1826, the judge's apartments, servants' quarters and cells have been restored and are open as a municipal museum. Lighting is by gas and oil, and it has the only working gasolier in Britain, a decorative brass light fitting with a circle of eighteen open flame burners.

PWLLGWDIG, BATTLE OF, 1078 *Probably on Goodwick Moor, outside Fishguard.* In this battle between Welsh princes, Trahaearn ap Caradog of Powys defeated Rhys ab Owain and his brother Hywel. Rhys 'fled like a wounded stag before the hounds', according to *The Chronicle of Ystrad Fflur.* After the brothers' flight from the battle, they were killed by the forces of Trahaearn's ally, Caradog ap Gruffudd.

PWLLHELI – MAIN MARKET TOWN OF THE LLŶN PENINSULA *On the A499 between Criccieth and Abersoch.* The name means 'pool of salt' and in fact it lies in an estuary. It was given by the Black Prince to Nigel de Loryng in 1349, along with neighbouring Nefyn, and was given a charter in 1355. Pwllheli developed from a market town in Victorian times to a huge seaside holiday resort on Cardigan Bay. Plaid Cymru was founded here, and it is a stronghold of the Welsh language.

PWLL MELYN, BATTLE OF, 1405 *Adam of Usk recounts that Monkswood was 1.5 miles north-west of Usk. There is a Monkswood village on the A472, 2 miles north-west of Usk. If the Welsh crossed the river near the castle, trying to escape, the highest point, perhaps Mynydd Pwll Melyn, is Coed Duon, and the Welsh would have probably tried to escape north-west from here towards Monkswood.* A tragic battle in the War of Liberation, when Owain Glyndŵr's brother Tudor was killed. Owain's eldest son Gruffudd was also taken prisoner by Lord Grey of Codnor here, after a failed attempt to take Usk Castle. After the battle, the fleeing Welsh regrouped on Mynydd Pwll Melyn (Yellow Pool Mountain) but were routed and chased through Monkswood Forest. John ap Hywel, Bishop of Llantarnam Abbey, rallied seventy men on the riverbank, trying to buy time for others to escape, and was killed. 1,500 Welshmen are said to have died. The English thought that they had slain Owain himself, as his brother Tudor was similar in appearance. Gruffudd was sent to the Tower of

London and died there after six years imprisonment – the war, already five years old, lasted another ten, but Owain's power dramatically waned after this battle.

RADNOR VALLEY (THE WALTON BASIN) – THE LARGEST PREHISTORIC ENCLOSURE IN BRITAIN, AND PREHISTORIC SITES *This is in the east of Radnorshire, about 5 miles south west of Presteigne, and about the same distance from Kington in western Herefordshire.* The largest village is New Radnor, and other settlements in the valley include Llanfihangel-nant-Melan, Walton, Old Radnor, Evenjobb and Kinnerton. Found by aerial photography, Hindwell Farm Enclosure consists of postholes which had been occupied by regularly spaced oak posts about 28 inches to 40 inches in diameter, spaced on average 26 feet from edge to edge, each post hole being about 7 feet deep. The enclosure was about eighty-four acres with a circumference of over 1.24 miles, and is the largest in Britain and second largest enclosure of the period in Europe. Radiocarbon dating of the postholes suggests a time of 2050 BCE, roughly contemporary with Stonehenge. Each post would have weighed about four and a half tons, so the site involved the felling of 6,300 tons of oak for 1,410 posts, plus manpower to dress the timber and transport and erect it. The enclosure's purpose is unclear, but it is likely that the posts which were so close together were linked by a fence. This important site is barely known. The mysterious enclosure is one of many Neolithic constructions in the Radnor Valley. There is a cursus near the village of Walton and another near the Four Stones. These were parallel ditches for which the purpose is unclear. The Walton Cursus ditches were each about 10 feet wide and about 3 feet deep. These two parallel ditches are 65 yards apart and 700 yards in length. Over 500 yards long and over 50 yards wide, the Four Stones Cursus has yet to be excavated. The Four Stones Circle is just to the west of the Hindwell Enclosure. Six standing stones appear to be in linear settings which may define routes across the basin. There are important Neolithic settlements at Upper Ninepence, with evidence of settlement in two phases just before 3000 BCE. The predominant feature of the valley is the high incidence of Bronze Age barrows (nineteen identified) and ring ditches (twelve identified), which may be barrows. There are at least nine and possibly twelve rectangular enclosures thought to be of Iron Age date (800 BCE to 43 CE), all identified from aerial survey and some confirmed by ceramic evidence. In addition there are two hillforts, Castlering in the north and Burfa in the east. This landscape must be protected at all costs.

RADNOR VALLEY – STANNER ROCKS – THE OLDEST ROCKS IN WALES The oldest objects from Wales are rock specimens from around Old Radnor, which formed about 700 million years ago. These rocks form the three small distinctive conical hills of Hanter, Stanner and Worsel Wood, and are composed of gabbro, dolerite, and granite – igneous rocks that were once molten. When these formed, Wales lay deep in the southern hemisphere.

RAGLAN CASTLE CADW *Off the A40, 7 miles south-west of Monmouth.* This impressive castle was built by Sir William ap Thomas and his son Sir William Herbert, first Earl of Pembroke, from 1432, and remodelled by William Somerset, third Earl of Worcester, 1549-89. Despite demolition attempts during the Civil War, much of the moated, hexagonal Great Tower and state apartments still survive. Henry VII lived here as a prisoner as a boy. The polygonal keep has a double drawbridge, unique in Britain. Henry, Earl of Raglan, poured all his fortune into the Royalist cause and held out in 1646 for the King Charles against the Roundheads. After three months it was taken, mainly because Fairfax joined the siege with large cannon. Although Harlech Castle fought on, the fall of Raglan effectively marked the end of all Royalist hopes against Cromwell. The Great Tower, 'Yellow Tower of Gwent' was partially demolished after the Civil War, and was so resilient to cannon that teams of workmen had to laboriously carry out the work with pickaxes from the roof, until two of its six sides fell. The Duke of Beaufort removed many of the fittings to his more accessible country seat at Badminton, including the great parlour chimneypiece.

RAGLAN – ST CADOC'S CHURCH A plaque in Raglan Church commemorated the first practical steam engine, built by the second Marquess of Worcester at Raglan Castle in 1663, and Wales has many notable 'firsts' regarding steam engines and railways. The church is partly fourteenth century with additions dating from the fifteenth century, but suffered much damage during the Civil War, and was partly restored by 1698. In the 1860s further restoration and enlargement took place. The chancel has a barrel roof and stained glass dating from the Victorian restoration. The Beaufort Chapel houses a Sweetland organ which was fully restored in the 1980s.

RHANDIRMWYN – TWM SIÔN CATI'S CAVE *Near Tregaron, Upper Tywi Valley, Carmarthenshire.* Rhandirmwyn is a small scattered farming community, and its name derived from 'Rhandir,' meaning 'shareland', and 'Mwyn,' which means mineral. Huge lead deposits were mined in the area for centuries, along with smaller quantities of zinc. In 1791, the lead mine employed 400 men. An old hollow oak tree is reputed to date from the twelfth century. Nant-y-Bai Mill is Grade II listed, with an overshot, timber and cast-iron wheel and corn-drying kiln within. The Royal Oak Inn is often voted the best 'real ale' pub in Carmarthenshire. Thomas Jones was a well-known highwayman who originated from Tregaron but had a strong association with Ystradffin and Rhandirmwyn. There is a hiding place located on Dinas Hill (now a RSPB reserve) which was known as Twm Siôn Cati's cave, above the River Tywi. It was recently effectively closed off to the public by the RSPB in order to protect nesting Red Kites. Twm Siôn Cati (1530-1609) was known as the Welsh Robin Hood, and often hid from the Sheriff of Carmarthen in the slopes of the thickly wooded Dinas Hill. It is said that he eventually married an heiress and Tom Jones, or Twm, became a squire and magistrate.

RHAYADER – 'THE OLDEST TOWN IN MID-WALES' *North of Builth, where the A470 meets the A44, Radnorshire.* Rhayader is the first town on the River Wye, lying just twenty miles from its source on Pumlumon. It is a market town, on important routes from north to south, and east to west Wales. The town's Welsh name, Rhaeadr Gwy, means the 'Cataract on the Wye'. Until its destruction, during the building of the first stone bridge over the River Wye in 1780, there was a great waterfall here. Neolithic axes (3000-1700 BCE) have been found in or around Rhayader, and are now in the collections of the local museum. In 1899, a collection of gold jewellery on Gwastedyn Hill to the south of the town was found. This treasure trove, thought to have belonged to the Saxon Princess Rowena, is now housed in the British Museum.

RHAYADER CASTLE It was built in 1177-78 by The Lord Rhys, as a response to the killing of his son-in-law Einion Clud in an ambush by the Mortimers at Llawr Dderw in 1176, on his return from Rhys' eisteddfod. The castle is on a crag which overlooks the River Wye. It was further strengthened by Rhys in 1194, protecting the borders of his kingdom of Deheubarth. It fell to Maelgwn and Hywel, the sons of Cadwallon ap Madog of Maelienydd, and then to the English before Rhys retook it. It was lost again, and then retaken by the Welsh in 1202. It was also known as Castell Gwrtheyrnion after the region. Only the motte remains.

RHAYADER – GIGRIN FARM – RED KITE FEEDING STATION *Half a mile heading south from Rhayader, turn left where signposted.* Up to 400 kites feed here daily, and can be seen from five hides. See gigrin.co.uk for times of feeding. By the late eighteenth century, Red Kites had bred for the last time in England and Scotland. Only in rural Mid-Wales did Red Kites hang on, their numbers down to just a few pairs by the 1900s. Over a period of around 100 years, efforts to maintain a fragile breeding population were made by committed generations of landowners and rural communities. Despite severe threats from that breed of moron known as egg collectors, poisoning and some modern farming practices, Red Kite numbers have increased since the 1980s to sustainable numbers, and it has been reintroduced successfully into England. Scientific research at Nottingham University showed that the entire population of Welsh kites in 1977 came from just one female bird. The kite, which has become the national bird of Wales, was incredibly close to extinction.

RHAYADER - GLASCWM - ST DAVID'S CHURCH A lovely towered church with a curvilinear graveyard, St David's lies on south side of the Clas Brook near Rhayader. The church has two medieval phases of building and almost certainly originated as a mother church (clas) in the early medieval period. A twelfth-century book refers to a magic hand bell called Bangu, which was in Glascwm Church, thought to have belonged to St David. The legend is that the wife of one of the prisoners in Rhayader Castle obtained the bell, and sent it secretly to the keeper of the castle on the understanding that her husband would be released. He was not freed, and a soldier was told to fasten the bell to a wall in a room of the castle. That night a great fire burnt everything except the wall on which the bell hung. When the foundations of a new tower for St Clements Church in Rhayader were being dug, several skeletons were discovered laid neatly in a mass grave. One was of enormous size with a thigh bone longer than a yard. It is generally agreed that these were soldiers of the garrison of Rhayader Castle who had been slain by Llywelyn the Great and that the 'giant' was the Castle Commander. The Church of St Clement in Rhayader was previously dedicated to its founder, St Cynllo, and should be re-dedicated.

RHIWLEN - CHURCH OF ST DAVID *6 miles east of Builth Wells, off the lane from Aberedw to Painscastle.* The survival of this lovely, tiny, whitewashed thirteenth-century church is due to the English settlers in its isolated hamlet. There are several gorgeous old churches nearby. Eleanor Madoc Davies, at nearby Cwm-Moel on the road to Aberedw, offers singing lessons at the B+B working farmhouse. This author has stayed there and thoroughly enjoyed the breakfasts, the ambience, the place and the singing lessons.

RHONDDA HERITAGE PARK - ANCHOR POINT OF ERIH EUROPEAN ROUTE OF INDUSTRIAL HERITAGE *Trehafod, near Pontypridd, Rhondda, Glamorgan CF37 2NP.* This tourist attraction offers an insight into the life of the coal-mining community that existed in the area until the 1980s. Visitors can experience the life of the coal miners on a guided tour through one of the mine shafts of the Lewis Merthyr Colliery, on a tour led by former colliery workers.

RHONDDA VALLEYS *North of Cardiff, Glamorgan.* The long and wooded Rhondda Fawr (Big) and Rhondda Fach (Small) valleys were altered forever by intensive coal mining in the nineteenth century, and the influx of population was accommodated by strings of terraced houses clinging along the steep sides of the valleys.

RHOSSILI VISITOR CENTRE AND SHOP - NATIONAL TRUST *Coastguard Cottages, Rhossili, Gower SA3 1PR. Tel: 01792 390707.* Set amongst spectacular countryside and beaches, and situated on the tip of the Gower Peninsula, there is a cliff top walk, with breathtaking views of Worms Head. The Norman church has a memorial in the graveyard to Edgar Evans, who was the first to perish on the Scott Expedition to the South Pole. The *Terra Nova* had sailed from Cardiff. There was a local tradition that there had been a village and church closer to the sea, abandoned after a sand inundation in the fourteenth century, the same that overwhelmed Candleston and Kenfig Castles and villages. In 1980, the tradition was confirmed by excavation.

RHUDDLAN, THE BATTLE OF, 796 OR 797 *Just south of Rhyl, on the road to St Asaf, now in Denbigh, but was in Flintshire.* Offa was said to have died here, and may have been killed when the Mercians beat the Welsh at Rhuddlan and took control of Tegeingl (Englefield). Tegeingl is named after the Deceangli Celtic tribe. Offa was the first man to call himself Rex Anglorum, King of England, and had also invaded Wales in 778 and 784. For 796, the *Annales Cambriae* note, 'Devastation by Rheinwg son of Offa. The first coming of the gentiles (Norsemen) among the southern Irish.' For 797, we read, 'Offa king of the Mercians and Maredudd king of the Demetians die, and the battle of Rhuddlan.'

RHUDDLAN, BATTLE OF, 1167 Also called the Battle of Twt Hill. Owain Gwynedd, his brother Cadwaladr and The Lord Rhys won here and took Rhuddlan Castle before advancing on Prestatyn, where Owain razed the castle and town of Robert Banastre.

RHUDDLAN – BODRHYDDAN HALL *LL18 5SB. Tel: 01745 590414.* The home of Lord Langford, Bodrhyddan is a seventeenth-century house upon the site of fourteenth-century and fifteenth-century buildings, with nineteenth-century additions by the famous architect, William Eden Nesfield. The Queen Anne-style house and extensive gardens have been in the hands of the same family since it was built. Bodrhyddan is Grade I listed, making it one of the few such houses in Wales to remain in private hands. There are notable pieces of armour, pictures, period furniture, a 3,000-year-old mummy, a formal parterre, and a woodland garden.

RHUDDLAN CASTLE CADW In 1277, Edward I accepted Llywelyn II's submission at Rhuddlan. At Rhuddlan Castle, in the 'Iron Ring of Castles', Edward canalised the River Clwyd. The river was rerouted and straightened by 1,800 'ditchers', from its estuary at Rhyl to where it passes the castle, three miles inland, enabling it to be supplied from the sea. The castle was built from 1277 to 1282, with James of St George taking charge of the works. Edward also laid out a new town nearby, upon which the present street pattern is based, and tried unsuccessfully to have the bishopric moved from St Asaf to Rhuddlan. The castle was attacked by Madog in 1294 and by Glyndŵr's followers in 1400, when the town was overrun, but the castle was not taken. A Royalist castle in the Civil War, it was slighted by Parliamentarians in 1648. The earthen motte of Gruffudd ap Llywelyn, known as Twt Hill, is just south of the remarkable thirteenth-century castle remains.

RHUDDLAN – ST MARY'S CHURCH The first church in the Norman borough was built about 1080, but in 1301 the present structure was erected, above the River Clwyd and a few hundred yards from the new castle. The tombstone of William de Freney (*c.* 1250-1300), Archbishop of Edessa in Syria, is in the church. It was brought from Rhuddlan's Dominican Friary upon its dissolution in 1536. His uncle Gilbert de Freney had been sent by St Dominic to found the Dominican Order in England in 1221. The Dominicans were always associated with the French Normans in Wales, the Cistercians and the Franciscans being favoured by the Welsh and their princes. There are also inscribed Biblical quotations (one of only two sets found in Britain, the others being at the Grade I Church of St Cosmas and St Damien at Sherrington, Wiltshire) dating back to about 1650. These are in Welsh, and the text is from the Welsh Bible of 1620. The building was substantially restored in 1812 and by George Gilbert Scott in 1870, and is a typical 'Clwydian' or double-naved church of the late fifteenth century.

RHUDDLAN – STATUTE OF RHUDDLAN, 1284 After the death of Llywelyn II in 1282 and his brother Dafydd's execution in 1283, Edward legalised the annexation of Wales, forcing it to be governed by English law instead of Welsh law. Regular circuits by judges brought law to the people. Often judges were the Marcher Lords. Primogeniture was implemented instead of divisible inheritance, and illegitimate children were no longer allowed to inherit. Taking away the Welsh laws was a massive blow to the sense of nationhood, as Edward I well knew. The English system of shires, each with royal officials such as a sheriff and coroner, was instigated and the shires of Cardigan (Ceredigion), Carmarthen, Flint, Caernarfon, Anglesey and Merioneth (Meirionnydd) date from this law.

RHUDDLAN – TWT HILL CASTLE Just south of Rhuddlan Castle, this large motte lies next to the River Clwyd. There was a fort here or nearby, constructed in 921 by Edward the Elder, the son of King Alfred. Rhuddlan was the royal seat of Gruffudd ap Llywelyn ap Seisyll, the High King of Wales, but in 1063 he was driven out by Earl Harold Godwinsson, later to be killed at Hastings. A motte was built, on the site of Gruffudd ap Llywelyn's palace, by Robert of Rhuddlan

and his cousin Hugh 'the Fat', Earl of Chester in 1073, to consolidate local landgrabs. William the Conqueror had ordered motte and bailey castles to be erected, to hold Norman conquests in Wales. In 1086, William granted Robert power over all of North Wales beyond Clwyd, for an annual rent of £40. The castle and its neighbouring borough, dating from 1056, changed hands several times between the Welsh and Normans before Edward I began construction of Rhuddlan Castle north of it in 1277. The borough had its own church and mint, and silver pennies were minted there from the reign of William I and from *c.* 1180-1215.

RISCA, RHISGA – TWMBARLWM HILLFORT AND MOTTE *A mile north-east of Risca, Monmouthshire.* It is also known as Twm Barlwm, Twyn Barlwm, and locally known as 'The Tump' (from twmpath), in relation to the mound that lies on its summit. It is 1,375 feet high and commands extensive views. The Iron Age hillfort belonged to the Silures, and there was possibly a Roman signal point. A substantial motte and bailey castle is embedded in the eastern end of the fort. Twmbarlwm features heavily in local tradition with stories of a giant buried here, druids using it as a sacred site, and treasure guarded by swarms of bees.

ROMAN FORTS Wales is criss-crossed with Roman fortlets, marching camps, villas and roads, much more intensively than any other part of the Roman Empire. Historians have uniformly ignored the major reason why Rome expanded into Gaul – for minerals and Celtic mining technology. Then they came to Britain for Welsh slate to roof Rome, to the largest copper mines in the world, and for iron, lead, silver and especially gold. All these were being worked previously, exported by Phoenician trading ships into the Mediterranean. This is why Rome came to an accommodation with the Silures after several hardly recorded defeats. They wished to push through Wales. Two of their three legions were permanently stationed on the Welsh borders at Caerleon and Chester. The density of Roman forts shows the importance of minerals to the Romans. From south to north, those thirty-four permanently occupied in 75 CE were at Cardiff, Caerffili, Gelligaer, Neath, Loughor, Usk, Penydarren, Coelbren, Abergafenni, Carmarthen, Pen-y-Gaer, Brecon Gaer, Llandovery, Pumsaint/Dolaucothi, Beulah, Colwyn Castle, Llanio, Castell Collen, Dolau Gaer, Leintwardine (then in Wales), Trawscoed, Pen Llwyn, Cae Gaer, Caersws, Forden Gaer, Pennal, Caer Gai, Llanfor, Tomen-y-Mur, Pen Llystyn, Bryn-y-Gefeiliau, Ruthin, Caernarfon and Caerhun. By the mid-second century, only the following seven were still in use as well as Caerleon and Chester – Brecon Gaer, Castell Collen, Leintwardine, Caersws, Forden Gaer, Caernarfon and Caerhun. Historians believe that Cornish tin was unimportant, but the author has recently discovered that the Romans took most of their pewter, for dishes and drinks containers, from Britain. Cornish tin and Welsh lead makes pewter, which is yet another reason for the Roman invasion.

ROMAN MINES Mining was carried on extensively before the Romans came to Britain, and traded with the Phoenicians and all over the Mediterranean, but recorded details are sketchy. There are dozens of important sites across Wales. We tend to think of lead mining as unremarkable, until we realise that silver was the coinage of the Roman Empire, and that silver used to be more expensive than gold until the Spanish exploited South American silver and flooded the European markets. The only way to produce silver in the days of Rome was by 'cupellation' from lead. Lead was a by-product, used for pewter paints, roofing, etc. The Flintshire mines (along with some in the Mendips, Yorkshire and Derbyshire) were an important lode for the Roman mints, worked by slaves by 74 CE. Pliny the Elder noted how easy it was to extract lead from Britain, by opencast mining. The centre for mining was at Halkyn Mountain, with a mining settlement at Pentre Ffwrnais, a mile south-east of Flint. The Talar Goch lead mine at Meliden probably supplied the Roman site at Prestatyn, what was then a navigable coastal creek. There were other Roman mines on the slopes of Pumlumon, in Ceredigion, and at Machen in Glamorgan. As regards copper, Wales had the world's premier supply on the Great Orme in Caernarfonshire, well known before the Romans invaded, again carried out by slaves under the Romans. There were also major

deposits at Parys Mountain, Aberffraw and Pengarnedd in Anglesey and on the Wales-Shropshire border at Llanymynech. As a result, even when the XX legion left Chester after 367, Caernarfon (Segontium) had a major Roman presence until 383. At this point, Magnus Maximus (Macsen Wledig) took the Caernarfon garrison with him in his attempt to become Emperor. Tin was traded from Cornwall by the Veneti of southern Brittany before the Romans came, but was believed to be of minor interest as the Roman conquest of north-west Spain made cheaper Spanish deposits available. However, pewter was exported in enormous quantities from Britain across the empire – it is tin, mixed with lead. The only gold mine worked in Britain by the Romans had been worked extensively before, at Dolaucothi, the most productive mine in Europe. The Romans exploited iron in the Sussex Weald and in the Forest of Dean, bordering Monmouthshire, which necessitated the building of Ariconium at Weston-under-Penyard, when the Silures agreed to peace in the first century. Slate was taken from North Wales for Roman roofing. A huge quantity of salt was mined at Droitwich and at Middlewich in Cheshire.

RUTHIN (RHUTHUN), THE BATTLE OF, 1401 Glyndŵr captured his hated enemy, and the instigator of the War of Independence, Reginald de Grey, and later ransomed him for 10,000 marks, effectively bankrupting the Marcher Lord. (See the author's *Owain Glyndŵr - The Story of the Last Prince of Wales* for details.)

RUTHIN – ANCIENT MARKET TOWN *On the A494, it is the County Town of Denbighshire.* Ruthin has retained its medieval street plan and many historic buildings built in red sandstone are still standing. There are also many half-timbered buildings scattered around St Peter's Square. The Myddleton Arms Pub was built in the Dutch style in the mid-seventeenth century. The building fronts on to St Peter's Square with seven protruding dormer windows, which have led the building to be nicknamed 'the eyes of Ruthin'. In use from 1654, Ruthin Jail was renovated during the nineteenth century, when a four-storey wing, styled on Pentonville Prison was added. It is now a visitor attraction.

RUTHIN CASTLE *On the A494, it is the County Town of Denbighshire.* A hundred feet above the Clwyd Valley, this controls a river crossing, and the first recorded castle here was forfeited by Prince Dafydd ap Gruffudd to Edward I in 1277. A Welsh-built castle, it was known as Castell Coch yn yr Gwernfor, the red castle in the great marsh. Ruthin actually comes from rhudd (red) and din, which denotes a fortress site which is usually pre-Roman. The Romans had a fort here, abandoned around 100 CE. Reginald de Grey took the castle over after Llywelyn ap Gruffudd's death in 1282 and used James of St George to further fortify the site. Glyndŵr burnt the town but did not attempt to take the castle. Captain Sword led its Royalist defenders in the Civil War, but in its second siege in 1646 surrendered when the attackers were ready to explode mines in tunnels under its walls. It was slighted after the Civil War, and much of its stone used for buildings in the charming town, but the Myddletons bought it and built a mansion there in 1826. This is now the Ruthin Castle Hotel.

RUTHIN – NANTCLWYD HOUSE MUSEUM, OLD COURT HOUSE, MAEN HUAIL AND CHRIST'S HOSPITAL ALMSHOUSE *In Castle Street, and in the main square of St Peter's.* Nantclwyd y Dre was previously known as Tŷ Nantclwyd, and was built around 1435 by local merchant Gronw ap Madoc. It may be the oldest surviving town house in Wales. The building was restored from 2004, and opened to the public in 2007, containing seven rooms which represent various periods in the buildings' history. The half-timbered Old Court House dates from 1401 and is now a bank, which features the remains of a gibbet used to hang, draw and quarter the Franciscan priest Charles Meehan in 1679. Maen Huail (Huail's Stone) stands in St Peter's Square in Ruthin. Huail, the brother of Gildas, was killed by King Arthur, either for killing Arthur's nephew Gwydre fab Llwyd (according to Caradog's *Life of Gildas*), or for stealing Arthur's mistress (according to Elis Gruffydd's *The Soldier of Calais Chronicle*). Huail was beheaded on the stone.

RUTHIN – FREE GRAMMAR SCHOOL In 1574, Dr Gabriel Goodman re-founded Ruthin School, which had been originally founded in 1284, and is one of the oldest public schools in the United Kingdom. In 1590, Goodman also established Christ's Hospital for twelve poor persons around St Peter's Church on the square, and was Dean of Westminster for forty years (1561-1601). The hospital is now on the outskirts of the town, but the original Tudor building is next to the church.

RUTHIN – ST PETER'S CHURCH AND SQUARE All the main streets in Ruthin lead to St Peter's Square, named after the church. Founded in the early fourteenth century, its main attraction is the sixteenth-century oak roof. It consists of 408 carved panels, with intricate carvings of Tudor roses with detailed floral and geometric designs. The wrought-iron gates outside were designed by the famous Davies brothers of Bersham. The church was formerly a chapel of the Greys, Lords of Ruthin, and then it became the parish church and an Augustinian priory. Unfortunately the Victorians in their restoration destroyed box pews and misericords. Christ's Hospital and Almshouses date from 1590 and are in the grounds of St Peter's Church.

RHYD-Y-FRO – CARN LLECHART RING CAIRN *Rhyd-y-Fro, near Swansea, Glamorgan.* This is one of the largest ring cairns in Wales, an unusual circle of twenty-five stones leaning slightly outwards and surrounding a central burial cist. The existence of stone circles elsewhere may have led to people placing tall stones around the bases of their own round cairns, also seen at TALSARNAU with Bryn Cader Faner. Carn Llechart circle is 40 feet in diameter, and the central cist has its east side stone and capstone missing. It seems that there is no entry to the circle and no trace of covering mound. A possible date for the site is the second millennium BCE. There are also in this area a Neolithic burial chamber and some Bronze Age cairns.

RHYD Y GROES, BATTLE OF, 1039 *Pont Rhyd Y Groes near the A490, Marton, south of Welshpool SY21 8JJ.* Gruffudd ap Llywelyn destroyed the forces of Leofric, Earl of Mercia, (the husband of Lady Godiva) near Welshpool, and pushed them back into Mercia. Rhyd-y-Groes is the vital ford on the Severn mentioned in *The Dream of Rhonabwy* in the *Mabinogion*. Pont Rhyd-y-Groes, where there is a caravan park, may not be the correct site, as it is two miles east of the Severn, unless the Severn has altered its path.

RHYL *West of Prestatyn on the Flintshire coast.* Excellent beaches attract holidaymakers, but its huge funfair has largely gone. Once an elegant Victorian town, Rhyl has suffered adversely from a huge influx of population from the North-West and Midlands of England, like much of the North Wales coast, Anglesey and other attractive parts of Wales. Well over a third of the population of Wales are not born in the country, the highest inward immigration of any developed nation. The majority of incomers are retirees looking for a healthier and cheaper place to retire, or unemployed, looking for a more congenial place to receive benefits. There are concomitant excessive strains upon social housing, education and the health services. Partially as a result Wales has the lowest GDP and GNP per capita (measures of wealth) in the UK, and Anglesey is the poorest area in the UK, poorer than some regions of Poland. Wales is dependent for over 69 per cent of its income (the highest in Britain, along with Northern Ireland) upon Government sources, from employment to benefits, which is the indicator of how little progress has been made in creating wealth in the country. There is a major seafront regeneration scheme at Rhyl, partially funded by the EU.

RHYMNI, BATTLE OF, 1072 *Near the banks of the Rhymni River, Llanrumney, Cardiff, where there are the remains of a motte.* Maredudd ab Owain ab Edwin had regained his dynasty's lands of Deheubarth upon the death of Gruffudd ap Llywelyn. He fought the Norman incursions into Gwent, but came to an agreement not to resist and was rewarded by William I with lands in England. However, when the Normans pressed into Glamorgan, he met them in battle and was

killed, to be succeeded by his son Rhys. According to *The Chronicle of Ystrad Fflur*, he 'was slain by the French and Caradog ap Gruffudd ap Rhydderch on the banks of the Rhymni.'

RHYMNI (RUMNEY) CASTLE, CAE CASTELL, CARDIFF Overlooking the River Rhymni, this motte was attacked and abandoned around 1289, as evidenced by a coin hoard. The ringwork is in a school playing field.

ROCH CASTLE *Just off the A487 a few miles north-east of Haverfordwest.* Built in the thirteenth century, by Adam de Rupe as part of the chain of castles forming the Landsker, it was by the Civil War in the hands of the Walter family. Roch was taken by Parliamentarians, recaptured by the Royalists and retaken again. The daughter of Walter Lacy, who owned the castle at this time, was Lucy Walter, whose son by Charles II became the Duke of Monmouth. The rightful king of England, as Lucy had married Charles in secret, Monmouth was executed by James II after the Monmouth Rebellion. On a low crag, the castle can be seen for miles and is being updated as a 'luxury corporate retreat' for people who do not live in the real world anyway.

RUABON – RHIWABON – HISTORIC TOWN *On the A483, 6 miles south of Wrecsam, Denbighshire.* Offa's Dyke runs through its western outskirts, and Wat's Dyke lies to the east, and they come as close as a quarter of a mile to each other here. The ancient parish of Ruabon comprised the townships of Belan, Bodylltyn, Cristionydd Cynrig (Y Dref Fawr), Coed Cristionydd, Cristionydd Fechan (Y Dref Fechan, or Dynhinlle Uchaf), Dinhinlle Isaf, Hafod (Hafod y Gallor), Rhuddallt, Tref Robert Llwyd, Moreton Anglicorum (or Moreton Above), Moreton Wallichorum (or Moreton Below). 'Above' and 'Below' refer to the English and Welsh sides of Offa's Dyke. The first church at Ruabon is believed to have been established by St Mabon during the sixth century, when the place was called Rhiwfabon, the Hill of Mabon. It was mentioned in the *Norwich Taxatio* of 1254, when the dedication was to St Collen. There have been Bronze Age discoveries in the town. The Roundhouse is an early eighteenth century jail, used to imprison drunks and undesirables overnight, and is one of only three in North Wales. A few yards away is the Wynnstay Arms, an old coaching inn named after the Wynn family, who owned massive estates around the area. Near the thirteenth-century Church of St Mary is the Old Grammar School and almshouses. The school was founded in 1618 and in use until 1858. The church has a fascinating churchyard, some notable monuments, and a fourteenth-century fresco entitled 'The Works of Mercy'. Gardden Lodge was the home of the High Sheriff of Denbighshire, Edward Rowland, in the early nineteenth century, and it has a notable icehouse built for the storage of meat. Y Gardden Hillfort dates back to the early Iron Age. Extending to four acres, and partly enclosed by a drystone wall, it was defended by two banks and three ditches on the south side. In 1167, a battle was won here by Prince Owain Cyfeiliog against the English and Normans. The poem 'Hirlas Eucin' was written to commemorate the event. This battle is also credited for the naming of the Afon Goch, which is reputed to have overflowed with the blood of the English, 'coch' being the Welsh for red. Wynn Hall is a seventeenth-century house, named after the family who built it.

RUABON – CHURCH OF ST MARY This Grade I listed church, built on a pre-Norman site, and possibly a sixth-century foundation, was formerly dedicated to St Collen. By the end of the thirteenth century, the church had been granted to the Cistercian Abbey of Valle Crucis, and the church was re-dedicated to the Blessed Virgin Mary. The tower is fourteenth-century, and sepulchral monuments date from the first twenty years of that century. During the 1870 restoration, there was uncovered the magnificent fifteenth-century wall painting depicting 'The Works of Mercy'. This is reputed to be the finest medieval wall painting in Wales. In the north chapel is one of the finest monumental effigies in Wales, the Latin inscription reading 'Pray for the souls of John ap Elis Eyton, knight who died on 28 September 1526 and Elizabeth Calveley his wife, who died in 1524'. He fought at the battle of Bosworth in 1485 and was rewarded with large estates in Ruabon. The exquisite and delicate font, designed by Robert Adam, was given to the church by Sir Watkin Williams-Wynn in 1772.

RUABON - WYNNSTAY HOUSE On the site of the great house of Madog ap Gruffydd Maelor, the founder of Valle Crucis Abbey, is Wynnstay, the seat of the famous Watkin Williams-Wynne family for centuries. As at Llanover Court, this family kept a harpist until the late nineteenth century. Sir John Wynn (1628-1719), 5th Baronet and MP for Merionethshire, was such a prominent figure in Welsh life that he was nicknamed 'The Prince in Wales'. They owned several mansions but the main home was at Wynnstay in Ruabon. The town is near estates owned by John ap Ellis Eyton, who fought for Henry Tudor at Bosworth, whose tomb is in Ruabon Church. Knighted after the battle, Sir John altered the name of his estate to Watstay after Wat's Dyke. Watstay passed through marriage to the Evans family, and the daughter of Eyton Evans, Jane, married Sir John Wynn. They changed the estate name to Wynnstay. Sir John and Lady Jane Wynn died childless, and their huge estates went to Jane Thelwall, the great-granddaughter of the first Baronet, another Sir John Wynn. She was married to Sir William Williams, 2nd Baronet, and a condition of the will was that they added Wynn to their surname. The Williams family and the Wynn family had the two largest estates in North Wales. Thus the new line of Williams-Wynne, based at Wynnstay, owned most of North Wales, hence the number of pubs named Wynnstay, as they were on the lands of the Wynnstay estate. As Wales' 'first commoners', the most famous member of the family became always known as the 'Prince in Wales', not the 'Prince of Wales', to distinguish them from the non-Welsh variety. The great Victorian pile is Grade II listed and has been converted to luxury apartments.

RUNSTON - ST KEYNE'S CHAPEL, MANOR HOUSE AND DESERTED VILLAGE CADW *Near Mathern, Monmouthshire*. The small roofless chapel was established early in the twelfth century. The CADW sign on the remains reads, 'The chapel, along with the village which it served and whose remains are visible under the turf, fell into ruin in the eighteenth century.' Part of its font is in St Julian's Church, Newport, incorporated into the north-west entrance as a holy water stoup. Within an area measuring roughly 100 feet by 100 feet, on the north side of a ruined church, lie the remains of a small medieval fortified site, known as Runston Manor. There is also a complex of earthworks, with the sites of twenty-five buildings identified, along a series of tracks, close to the village green, church and manor house. By the late eighteenth century just six houses were left occupied, and it seems that the tenants were evicted shortly after.

RUPERRA CASTLE *Near Draethen and Machen, east of Caerffili*. Built in 1626 by Sir Thomas Morgan, Charles I stayed there for four days after the Battle of Naseby. It was rebuilt in 1785 and in 1875 Captain Godfrey Charles Morgan, Lord Tredegar, lived there. There was a disastrous fire in 1941 when British troops were stationed there. It is a Grade II* listed building, and the Ruperra Conservation Trust is campaigning to save the seriously deteriorating Scheduled Ancient Monument. The Royal Commission on the Ancient and Historical Monuments of Wales states: 'RUPERRA CASTLE is an unusual early Jacobean mock castle of exceptional historical importance with its attendant deer park and structural remains of contemporary formal gardens. The site includes an outlying hilltop mount of great historic interest, with spiral walk and stonewalled top, the site of a seventeenth-century summerhouse. During the early decades of the twentieth century the gardens were elaborately laid out, with a magnificent glasshouse, still largely intact, as the centrepiece. The main building periods are 1626-55; 1785-89; 1909-13 and the 1920s.'

As a superb castellated Jacobean mansion, it has few rivals in Britain, and desperately needs a compulsory purchase order to prevent further damage. The old Maenllwyd Inn in Rudry is not far away, but if over 5 feet 8 inches you may bump your head on its ceiling.

ST ARVANS, LLANARFAN - CHURCH OF ST ARFAN *2 miles north of Chepstow on the A466, Monmouthshire*. St Arfan was a ninth-century hermit who supported himself by fishing for salmon on the Wye, but drowned when his coracle capsized. However, there is a 'St Arvan's Stone' at Llanafan Fawr, so it may be a foundation of this sixth-century bishop, instead. In 955, it was noted

as the 'church of Jarman and Febric', and in the *Book of Llandaff* as being dedicated to 'Sancto Arunyo'. The circular nature of the churchyard suggests that it is a Celtic foundation, and there are remains of a Saxon stone cross. Dating from the thirteenth century, the church dominates the village, the centre of which is a Conservation Area.

ST ASAPH, ST ASAFF CATHEDRAL *Between Denbigh and the coastal resort of Rhyl, Flintshire.* Saint Kentigern founded his church here in 560, and when he went to Strathclyde in 573 he left Asa (Asaff) as his successor. The present building was begun in the thirteenth century and is reputed to be the smallest ancient cathedral in Great Britain. The original name of the town was Llanelwy, the holy place on the River Elwy. The cathedral has been destroyed by fire twice, and was destroyed by the soldiers of Henry III in 1245 and by the armies of Edward I in 1282. It was rebuilt between 1284 and 1381 only to be burned in 1402 during Glyndŵr's War of Liberation. In 1715, the tower was completely demolished in a storm. The existing building is mainly fourteenth century, with many alterations due to the remodelling by Gilbert Scott in 1867-75. The south aisle contains monuments of the Williams family of Bodelwyddan, and near the south transept is a memorial tablet to the poet Felicia Dorothea Hemans (1793-1835). Close to this is the 'Greyhound Stone' of *c.* 1330. The sword is placed diagonally behind the shield, and below it is a hound chasing a hare. A hare is the herald of death in Welsh tradition. In the south aisle is the effigy of Anian II (Einion Saes), bishop from 1309-28. The Parish Church of St Asaph and St Kentigern is just down the hill from the cathedral. Many sites around Holywell commemorate St Asa, such as Ffynnon Asa, Asaff's Well.

ST ATHAN, LLANDATHAN – CHURCH OF ST TATHAN *Between Barri and Llanilltud Fawr, Vale of Glamorgan.* The village is erroneously signposted Sain Tathan instead of Llandathan. Tathan was a sixth-century abbot from Caerleon who was said to have founded the church here. There is a legend concerning the granddaughter of Meurig ap Tewdrig of Trebeferad (nearby Boverton). The niece of King Arthur, her name was Braust, and after many adventures and tragedy, she retired from court to live a holy life at Llantwit Major, taking the name of Tathana to honour St Tathan. According to Augusta F. Jenkins, Meurig ap Tewdrig died at Boverton, Arthur's birthplace, surrounded by his family. His daughter Anna (Arthur's sister) and her children Princess Braust (Tathana) and Saint Samson were present. The legend of St Tathana ends with her living in a cell at the mouth of the River Ddawen (Thaw), and in 1999 the author has found the foundations of an unrecorded medieval church at this site, aligned east to west, 25 feet by 15 feet, just above where high water mark used to be. In the *Taxatio* 1291 and *Valor Ecclesiasticus* 1535, the village church is referred to as Sancta Tathana in Llandathan. In the South Transept, the windows are fourteenth century, and the defensive tower might be earlier. There are painted tombs of the Berkerolles family here. The bells are dated 1635, 1707, 1720 and 1744, with another two bells added in 1919, thus one of the village's two pubs is known as The Six Bells. The almost hidden church is Grade I listed.

ST ATHAN – EAST ORCHARD CASTLE Two famous orchards at St Athan, constructed from 1377 to *c.* 1400, were guarded by West Orchard Castle, now in ruins and said to have been sacked by Glyndŵr, and East Orchard Castle, overlooking the Thaw Valley. More of a fortified manor house, the latter was destroyed by Llywelyn Bren. There are the remains of a dovecote, chapel and substantial house, and it was the seat of the Berkerolles. There is a charming stone packbridge below it, but the whole hardly known ambience is spoilt by the pylons stretching through the valley from Wales' worst polluter, the coal power station at Aberthaw.

ST BRIDE'S BAY HERITAGE COAST The heritage coast runs for five miles along the open shore of St Bride's Bay, between the headlands of St David's and Marloes. Druidston Haven beach is sandy and its cliffs have been declared a Site of Special Scientific Interest (SSSI), a distinction shared by the cliffs at Nolton Haven, another sheltered beach along the coast.

ST CYBI'S WELL CADW *Just north of Llangybi Church, on a lane north-east of Pwllheli, Llŷn Peninsula.* This is a sixth-century holy well with two well chambers, and a cottage for its custodian. It was a place of pilgrimage, and cured warts, lameness, blindness, scrofula, scurvy and rheumatism. Until the eighteenth century, there was an ancient chest, Cyff Gybi, for offerings to the saint. Carn Pentyrch, an Iron Age hillfort, lies on the hill above the well, and its central stonewall core may be medieval.

ST CLEAR'S CASTLE *This motte and bailey is at the junction of the Taf and Cynin rivers.* It was probably captured by The Lord Rhys in 1153, when known as Ystrad Cyngen. In 1188, a young Welshman was heading to St David's to join the Crusade, but was murdered by twelve English archers. The Englishmen went on Crusade as a penance. In 1189, The Lord Rhys again took the castle and gave it to his son Hywel Sais, but William de Braose took it in 1195. In 1215, Llywelyn the Great captured and destroyed it, but it was later in the hands of William Marshall, Earl of Pembroke. Glyndŵr's men attacked it in 1405. The settlement outside the castle was protected by a massive earthen bank and ditch, but all stonework has been removed.

ST DAVID'S BISHOP'S PALACE AND CLOSE WALL CADW *On the A487, north-west of Haverfordwest and south-west of Fishguard, at the tip of Pembrokeshire.* The remains of this imposing palace are within the defended perimeter of the cathedral precincts. The surviving buildings date chiefly from the thirteenth and fourteenth centuries, particularly the work of Bishop Thomas Bek (1280-93) and Bishop Henry de Gower (1328-47). His arcaded parapet is a superb piece of workmanship.

ST DAVID'S – CAERAU PROMONTORY FORTS Twin Iron Age sites on the coast near St David's are linked by a bank and ditch. Like many Welsh coastal hillforts, the builders used promontories as the main site and then dug ramparts and ditches across the 'neck' of the promontory for defence.

ST DAVID'S CASTLE An earthwork was built for the protection of the bishops of St David's, but it was never as well fortified as Llawhaden. William the Conqueror probably stayed here on his pilgrimage to St David's. It was superseded by the nearby Bishop's Palace.

ST DAVID'S CATHEDRAL The *Annales Cambriae* commemorated in 645 'the hammering of the region of Dyfed, when the monastery of David was burnt'. William the Conqueror was allowed to pass peacefully through Wales on pilgrimage here. Edward I and his queen also made a pilgrimage to St David's. It is, along with the other Welsh bishoprics, one of the oldest Christian sites in Britain, and the present cathedral dates from 1176. The tomb of The Lord Rhys is here, along with those of Bishop Henry Gower and Edmund Tudor, the father of Henry VII. The small city of St David's is the only city in Britain to lie entirely within a National Park. The cathedral itself was built with stone from cliffs at Caerbwdy on the Solva coast. St David's Cathedral may be the oldest cathedral settlement in Britain, founded by St David in 550 and based on his monastic site. The ruined Bishop's Palace of 1342 stands next to the present cathedral, which was burned down in 645, ravaged by Danes in 1078 (when the Bishop Abraham was killed), burned again in 1088 and rebuilt from 1176 by Peter de Leia. By 1120, Pope Calixtus II had decreed that two pilgrimages to St David's equalled one to Rome, and three pilgrimages would equate to one to Jerusalem. Santiago de Compostela in Spain was given the same dispensation, showing the importance of St David's. St David's boasts that it is Britain's smallest city, if we take the definition of a city as a town with a cathedral. The tower collapsed in 1220, and the structure was damaged by earthquake in 1248. The Holy Trinity Chapel has a wonderful fan-vaulted ceiling, and the nave has a marvellous Tudor timbered roof. The glorious choir stalls are fifteenth century and the Bishop's Throne is one of the finest in Britain. Its situation in the Vallis Rosina, a sheltered valley, reminds one of the siting of Llanilltud Fawr, Llancarfan, and

other ancient holy sites, hidden from the ever-present threat of Irish, then Viking destruction and Norman desecration. This is the finest church in Wales.

ST DAVID'S COMMONS – NATIONAL TRUST The wet heaths of Dowrog, Tretio, Waun Fawr and St David's airfield are surviving fragments of an extensive area of commons with orchids, being restored into 'Living Heathland', by grazing with cattle and Welsh ponies.

ST DAVID'S HEAD – NATIONAL TRUST *A dramatic headland north-west of St David's and Whitesands beach dominated by the peak of Carn Llidi.* This circular coastal walk features the little cove of Porthmelgan, the great stone chambered grave of Coetan Arthur and ancient field systems.

ST DAVID'S PENINSULA HERITAGE COAST – NATIONAL TRUST *North and west of the city of St David's within Pembrokeshire National Park.* The heritage coast stretches fifty miles, following the contours of St David's Peninsula from St Bride's Bay to Fishguard. Such are the currents and cliffs that there is no landing place along the north coast of the peninsula until one reaches Abereiddi, six miles from St David's Head. A ruined chapel in the lifeboat station at Porthstinian marks the burial place of St Justinian (Iestyn), a contemporary of St David. Just off the coast here lies the nature reserve at Ramsey Island, and seabirds in large numbers breed along the cliffs. At Carreg Sampson a Neolithic burial chamber overlooks the cliffs, and there is a large earthwork near Trefasser.

ST DAVID'S – ST NON'S CHAPEL AND HOLY WELL CADW The remains of a tiny medieval chapel are on a site traditionally identified as the site of St David's birth, and dates from the sixth century. St Non was David's mother, and the holy well was always well attended on St Non's Day, 2 March, the day after St David's Day.

ST DOGMAEL'S ABBEY, ABATY LLANDUDOCH CADW *A mile south-east of Cardigan, over the River Teifi, near the B4546, Ceredigion.* Founded about 1115 for Tironian monks, the extensive remains date from the twelfth to sixteenth centuries. There was a Celtic foundation here previously. From 1120, the monks followed the order of St Benedict. There are around fifty stones with Ogham script, a series of slashes, in Wales. One in St Dogmael's Church has inscribed on its face 'Sagrani Fili Cunotami'. This Latin inscription, matched against the Ogham carvings on the edge of the stone, enabled scholars in 1848 to decipher for the first time the Ogham code, left by Irish visitors.

ST DOGMAEL'S (LLANDUDOCH), BATTLE OF, 1091 Einion ap Cadifor ap Collwyn, his brother Llywelyn, their uncle Einion ap Collwyn and Gruffudd ap Maredudd (a direct descendant of Hywel Dda) conspired against Rhys ap Tewdwr, the Prince of South Wales, and took a force to his court at St Dogmael's, hoping to take the prince by surprise. However, Rhys was prepared, and Llywelyn and his brother Einion were killed in the battle. Gruffudd was beheaded as a traitor, and Einion ap Collwyn escaped to seek sanctuary with Rhys' enemy Iestyn ap Gwrgan, Prince of Glamorgan.

ST DOGMAEL'S (LLANDUDOCH) – Y FELIN CORN MILL This is a working restored mill of seventeenth-century origin, and a member of the Welsh Mills Society.

ST DONAT'S CASTLE AND ARTS CENTRE *3 miles west of Llanilltud Fawr, on the Vale of Glamorgan coast.* A medieval castle, it was owned by the Stradlings and later owned and restored by the newspaper magnate William Randolph Hearst (portrayed forever in film as *Citizen Kane*). Dating from the twelfth century, it now houses Atlantic College, the first of the United World Colleges to be established. Hearst took parts of buildings from all over Britain and France to

restore the castle, including Bradenstoke Hall from Wiltshire in its entirety. Within the castle grounds lies St Donat's Arts Centre, housed in a fourteenth-century tithe barn.

ST DONAT'S CHURCH In the valley under the castle is the medieval St Donat's Church with a fifteenth-century calvary, unusually non-vandalised during the Civil War. It was once named Llanwerydd, a Celtic foundation of St Gwerydd, and is Grade I listed.

ST ELVIS CHURCH, HOLY WELL AND MONASTIC REMAINS – NATIONAL TRUST

The NT owns the coastal area from St Elvis Farm to Pen-y-Cwm, east of St David's and west of Solva, Pembrokeshire. St Elvis Parish is the smallest in Great Britain, and the title Rector of St Elvis was superior to that of the vicar of nearby St Teilo's in Solva. The name St Elvis has appeared on maps since at least the sixteenth century. On the site is the 5,000-year-old St Elvis Cromlech, a huge burial chamber with two tombs, and a few yards away the foundations of a square tower, possibly a lookout post or storage barn for the monks on this site. The remains of the church are large, and unusually situated north-south, now covered with blackthorn. Nearby is St Elvis Holy Well, which was still pumping out 360 gallons an hour during the great 1976 drought, and had to be used to water the cattle at that time. The well is near St Elvis Farm, where a barn was built in the early twentieth century from the dressed stones of St Elvis Church. The last marriages took place in St Elvis Church in the 1860s and are recorded in the Haverfordwest Archives. The site, where the Preseli Hills sweep down to the sea, is just two fields inland, but well hidden from Irish and Viking pirates. St Elvis Rocks, off the mouth of the picturesque Solva Harbour, are now known as Green Scar, Black Scar and The Mare. The name 'Elvis' as a place name is only found here in all of Europe, and seems to be a corruption of St Ailbe, so St Aelfyw's monastery became St Elvis' Church. Two very important ley lines are said to meet here, one going to Stonehenge, and the site is littered with graves. The farmer has said that often in building sheds, etc., he has seen 'chalk-marks' in the soil, which when touched powder into dust, i.e. ancient bones. The holy well was not recorded by Francis Jones, but local tradition is that St David was baptised by his cousin St Elvis here, with water from the holy well, in the font at St Elvis Church. This font is now in St Teilo's in nearby Solva. St David's Cathedral is just a few miles away. A cross-marked sixth-century pillar, formerly a gatepost, was taken to St Teilo's Church, but its partner post was 'lost' in 1959. Even more intriguing, and of massive historical importance, is a square stone, with the simple face of a man carved into it. It is thought that National Trust employees used it to repair a field-bank. There are extremely few Dark Age facial representations among the ancient stones of Wales, and a non-intrusive survey may well find it. It was formerly in the centre of the ruined church and had holes bored into its top and bottom as sockets to allow it to act as a door, perhaps to a relic, which may make it unique. There is no record of this stone except in the memory of the farmer and his son who own the land, which is why it is being recorded here. This author noted in a previous book the name Elvis from near the Preseli Mountains, Elvis Presley's twin brother, father and mother all had Welsh names (Jesse Garon, Vernon and Gladys). The first recorded Presley in America was David Presley. A 'Was Elvis Welsh?' headline gained more international publicity than thirty years of Wales Tourist Board advertising. Perhaps the well water should be bottled and exported to the USA for drinkers to order a 'bourbon and Elvis'.

ST FAGAN'S, ST FFAGAN'S, BATTLE OF, 1648 *Just outside the west of Cardiff, to the north-west of the National History Museum.* The Second Civil War was instigated by Parliamentary leaders from Pembroke, being infuriated at the appointment of ex-Royalists to positions of power. Their forces of 8,000 Royalists advanced on Cardiff, led by Rowland Laugharne, against 3,000 Roundheads led by Colonel Thomas Horton. The Parliamentary forces were far better drilled and equipped, and after being beaten in a skirmish, Laugharne's men regrouped before attacking Horton at St Fagan's. Cromwell was known to be heading for Wales, which forced the action. After a bloody battle, 3,000 Royalists were captured, many being sent to Barbados as slave labour. Seven hundred men were killed, supposedly sixty-five men from St Fagan's alone, whose widows had to bring in

the corn in the following summer. Half of the Royalist army made it back to Pembroke, where Cromwell defeated them.

ST FAGAN'S CASTLE Lord Meurig ap Howell lost the land to Peter le Sore, who raised a ring work here in 1091. The thirteenth-century curtain wall remains, and the castle has developed over the centuries into a mansion and court which lies within the superb Museum grounds. St Fagan's Well in the castle grounds was said to cure epilepsy.

ST FAGAN'S NATIONAL HISTORY MUSEUM AND GARDENS There is simply too much here to describe in this book, e.g. St Teilo's Church has been moved here from Llandeilo Tal-y-Bont and reconstructed stone by stone to look as it would have done around 1520, with restored wall paintings. The museum has been an example for the rest of the world to follow since its opening in 1948. Chapels, a cockpit, a tollhouse, ancient farmhouses, a working woollen mill, farm workers' cottages, etc., from all over Wales have been rescued, and restored with original furniture. Even a Miners' Institute has been moved there and reinstated – a former heart of learning where colliers could gain access to thousands of that precious commodity, books, for a penny a week. The terrace of ironworkers' cottages comes from Merthyr. My mother, from Mid-Wales, remembers the (working) smithy as a girl, and more especially the Montgomeryshire tannery because of its terrible smell. Huge guard dogs kept the rats down and their faeces were used in the leather curing process. The National History Museum has been renamed from being the Museum of Welsh Life, and some exhibits are housed in the huge sixteenth-century manor house, inside a medieval curtain wall.

ST FAGAN'S NATIONAL HISTORY MUSEUM – IRON AGE BUILDINGS There are three roundhouses, roofed with straw and defended by a palisade and ditch, based on the remains of excavated buildings. The stonewalled house is based upon one at Conderton in Worcestershire. The first wattle-walled house as one enters the site is from Moel-y-Gaer Hillfort in Flintshire. The large house, with its roof supported on posts, is from Moel-y-Gerddi in Gwynedd. There are working fires, firedogs and other utensils of the time in the huts, giving one an invaluable insight into Iron Age life.

ST FAGAN'S NATIONAL HISTORY MUSEUM – MILLS There are six reconstructed mills here – a corn mill, sawmill, bark mill (in the Tannery), water-powered woollen factory, gorse mill and a horse-powered cider mill. The corn mill and woollen factory mill are still in use. Craftsmen like potters, coopers and wood-turners can be seen working at the museum. The wonderful gardens cover 100 acres.

ST HILARY CHURCH *A mile east of Cowbridge, south of the A48, Vale of Glamorgan.* This is a charming village, with thatched cottages, and the lovely thatched Bush Inn, all centred around the church. It has a twelfth-century chancel arch, was rebuilt in the fourteenth century and the tower is sixteenth century. It was restored by Sir Gilbert Scott in 1861-62, at the expense of Charlotte Traherne of 'Coedriglan' – Coedarhydyglyn a few miles east.

ST LYTHAN'S BURIAL CHAMBER CADW *Turn south from the A48 at St Nicholas, past Tinkinswood Burial Chamber and Dyffryn Gardens and turn left at the junction. The cairn is just along the lane on your right. Vale of Glamorgan.* This is a stone chamber, now denuded of its cairn, belonging to the so-called Cotswold-Severn group of Neolithic chambered tombs. Its capstone is 14 feet by 10 feet and it stands 6 feet high. The back supporting stone has a hole in it to let the spirits of the dead escape. There are many legends about the chamber, which is similar to that at Pentre Ifan.

SARN HELEN ROMAN ROAD Sarn Helen was the Roman road that crossed Wales from Moridunum (Carmarthen in the south) to Segontium (Caernarfon in the north). It was known

as 'Helen's Causeway', but is possibly a corruption of 'Sarn Y Lleng', 'Causeway of the Legion'. Newer roads follow some of it, but parts of Sarn Helen are just as laid down by Roman slaves almost two thousand years ago. A 'new' Roman road appears to have been discovered west of Carmarthen, and the Roman network makes for some superb country walking. By 78 CE, Wales was effectively under Roman control until 390 CE. Several Roman roads across Wales are known as Sarn Helen. The best preserved is near Ystradfellte and its marvellous waterfalls, and at Maen Madoc the cobbled surface and ditch is exposed, allowing one to see the construction.

SAUNDERSFOOT *Off the A478, heading south towards Tenby, Pembrokeshire.* Bill Frost (1850-1935) of Saundersfoot seems to have been the first man to fly, having patented a craft which was a cross between an airship and a glider in 1894, and staying in the air for ten seconds. He covered 500-600 yards until the undercarriage caught in a tree in 1896. His family and neighbours claimed that if he had cleared the tree he would have crossed the valley. Orville Wright's flight in 1903, seven years later, lasted only twelve seconds. Frost's flying machine was destroyed in a gale. He described himself as 'the pioneer of air travel'. Upon 26 July 1998, *The Sunday Times* carried a long feature 'Welsh airman beat Wrights to the skies'. Solva harbour was built in 1829 to export anthracite coal, although coal was exported from the beach for centuries before this. The course of the tramway from Bonville's Court Mine bisects the village and ends at the jetty. The tramway from Amroth forms the sea front of this holiday resort.

SENNYBRIDGE (PONT SENNI) CASTLE *On the A40, west of Brecon, north of Defynnog.* Known as Castell Du, Black Castle, and as Castell Rhyd-y-Briw, it was probably built by Llywelyn the Last in 1262, and held by his ally Einion Sais from 1271. Only a fragment of wall remains.

SEVEN WONDERS OF WALES

> Pistyll Rhaeadr and Wrexham Steeple,
> Snowdon's Mountain, without its people,
> Overton yew trees, St Winifrede's Wells,
> Llangollen Bridge and Gresford's Bells.

The 'Seven Wonders' are all in north-east Wales and as follows:

1. Pistyll Rhaeadr plunges 240 feet near Llanrhaeadr ym Mochnant.
2. Wrexham Steeple is on the Church of St Giles, a superbly decorated 136-foot tower, completed in 1520. Endowed by Margaret Beaufort, Henry VII's mother, the Perpendicular tower has twenty-nine sculptures. The superb 1720 wrought-iron gates are by the Davies brothers of Bersham, who also made the gates at Chirk Castle. Elihu Yale, the founder of Yale University, is buried in the churchyard, and Parliamentary forces melted the organ pipes in the Civil War, to make bullets.
3. Snowdon, or Y Wyddfa Fawr, is the highest mountain in England and Wales. Many paths and trails run up its 3,560 feet.
4. There are twenty-one yew trees in the churchyard at St Mary's, Overton, some dating from the twelfth century. Overton was once an important borough with its own castle.
5. St Winifrede's Well at Holywell was visited by several English kings. From the thirteenth century until the Reformation, it was in the care of the Cistercian monks of nearby Basingwerk Abbey, which gained a healthy income from pilgrims.
6. Llangollen's Trefor Bridge, named after John Trefor, Bishop of St Asaf, dates from 1354, was rebuilt in the sixteenth century and later widened for modern traffic.
7. The bells are at Gresford Parish Church, Clwyd, which also has superb medieval stained glass and a fourteen-hundred-year-old yew in its churchyard.

SEVERN BRIDGE – THE LONGEST BRIDGE IN BRITAIN The second Severn Bridge, completed in 1996, is the UK's longest-span cable-stayed bridge, with a main span of almost 1,500 feet. The overall length of the structure is around 17,000 feet, and it carries the six-lane M4 motorway.

SEVERN TUNNEL – FORMERLY THE WORLD'S LONGEST TUNNEL The almost forgotten Thomas Andrew Walker (1828-89), of Caerwent, built the fantastic Severn Railway Tunnel (1872-77) and the Manchester Ship Canal, Barry Docks and Preston Docks. When he died (possibly from overwork), Walker was working simultaneously on the Government Docks at Buenos Aires, Barry Docks, Preston Docks and the Manchester Ship Canal. The lych gate at Caerwent Church is a memorial to Walker, who lived at Mount Ballan. His gravestone is in St Tathan's Church in Caerwent. The Severn Tunnel made history in the 1880s as the first tunnel beneath an estuary, and was also the longest tunnel in Britain until the Channel Tunnel was built. Two and a quarter miles of the 4-mile 600-yard tunnel are under water.

SHELL ISLAND (MOCHRAS) – CORS-Y-GEDOL HALL *Shell Island is reached from the A496 south of Harlech by leaving the road at Llanbedr, Merioneth.* The privately owned island is connected to the mainland, and a fee is charged for access across a causeway that spans a tidal estuary. During spring tides, when the water is low, a reef, Sarn Padrig (St Patrick's Causeway), can be seen from the main car park in the sand dunes. This reef funnels the shells on to the island's beaches. The causeway was once thought to be a road to Ireland used by the saint, and there are folk memories of wading to Ireland, recorded in the *Mabinogion*. In legend, the shingle causeway was also one of the walls protecting the lost lands of Cantre'r Gwaelod. On the island is an old farmhouse, seemingly recorded in the 1086 Domesday Book. It was occupied by a Welsh bard, Siôn Philips, who drowned in 1620 while attempting to cross back to the island. A tunnel was said to run for three and a half miles from the farmhouse to Cors-y-Gedol Hall, perhaps used for smuggling. Access to the island has been vulnerable to flooding, so an embankment was constructed in 1961 but still breached by a high tide in 1963 and 1972. Unknowingly, it was built over the tunnel. Charles I stayed in the hall in the 1640s while escaping the Parliamentarians. The present house was built in 1576 by Richard Vaughan, and the gatehouse in 1630.

SHIRENEWTON – THE CHURCH OF ST THOMAS A BECKET *5 miles west of Chepstow, Monmouthshire.* The name derives from the creation of the village in a forest clearing by the Sheriff of Gloucester, around 1100, meaning 'Sheriff's New Tun'. Tun is the old word for a homestead. Its Welsh name is Trenewydd Gelli-farch, 'new settlement at the stallion's grove'. The small village of Mynydd Bach is just a single field away and there are four excellent old pubs, two in each village. The church is an excellent example of a Norman fortified tower church, commanding an elevated position overlooking the Severn Estuary, and was built at the end of the thirteenth century by Humphrey de Bohun.

SKENFRITH CASTLE CADW *On the B4521 east of Abergafenni, and on the B4357 north of Monmouth, Monmouthshire NP7 8UH.* A circular keep dominates a rectangular ward, with a round tower at each corner. It belonged to the king in 1160, and in 1187 Henry II instructed his engineers to rebuild it in stone. Hugh de Burgh improved it from 1207, and from 1219-32 Hubert de Burgh further fortified it, but in 1239 it was seized by Henry III, who lead-roofed it. This impressive castle is one of the 'Three Castles' defensive trilateral along with Grosmont and White Castle, and commanded one of the main routes between England and Wales, beside the River Monnow.

SKENFRITH – ST BRIDGET'S CHURCH The medieval church is near the church and has a wooden dovecot-topped tower, next to the remains of a medieval quay. Ynysgynwraidd, from which Skenfrith is derived, means an island that was formerly rooted, or full of roots. The church

was founded in 1207 by Hugh de Burgh who was rebuilding Skenfrith Castle at the same time. The tower, nave and chancel date from this time. The north and south aisles and porch were constructed in the following two centuries. In the chancel is the stone altar, returned there at the turn of the last century. It had been hidden in the floor to protect it from destruction during the Reformation. The pews include two examples of elaborately carved box pews dating to the sixteenth century. The heavy Jacobean pews are from around 1600, and there are examples of light pine pews from 1855. There are also fine oak pews dating to the 1909 refurbishment. The 'Skenfrith Cope' is a garment like a cape, worn by bishops and senior clergy in some churches, and is an example of the type of embroidery known as 'Opus Anglicanum'. Expert opinion dates the cope to the latter half of the fifteenth century, and it can be seen in the church by drawing the curtains that protect it from the light. There are six bells, all dating from 1764 – it is thought that the original bells were melted down during the Commonwealth.

SKERRIES *These rocks are off the north-west tip of Pen Carmel, off Anglesey.* They are known in Welsh as Ynysoedd y Moelrhoniaid, the Islands of Bald-Headed Fur Seals. Hugh Owen Thomas (1833-91) pioneered orthopaedic surgery across the world, and his 'Thomas Splints' are still used for hip and knee illnesses. He was descended from a long line of famous 'bone-setters' from Anglesey, supposedly descended from a survivor from a shipwreck of the Spanish Armada in 1588. Other sources say that it was a shipwreck in 1745 at the Skerries or West Mouse Island when a young Spaniard struggled to the shoreline. Dyfrig Roberts, a descendant, believes that twins speaking a 'strange tongue' struggled ashore during the Jacobite rebellion, and that they could have been Scottish, Manx or Spanish. The shipwreck survivor called himself Evan Thomas, and specialised in setting dislocated bones, passing his skills on to his five sons, who all qualified as doctors. There is a memorial in Llanfair PG to him, and a descendant was the inventor of the 'Thomas Splint'. This great-great grandson Hugh Thomas's splint cut fatalities from broken femurs from 80 per cent to 20 per cent, and the splint is now mainly used for children with femur fractures.

SKOKHOLM ISLAND *South-west of Gateholm Island and Marloes Sands, Pembrokeshire.* Skokholm had Britain's first bird observatory in the seventeenth century, and rare Manx Shearwaters nest here, along with puffins, storm petrels, razorbills, guillemots and oystercatchers. The shearwater population of 195,000 pairs on Skomer and Skokholm is internationally important, as the world's largest colony of this burrow-nesting bird homes into its burrows at night. Skokholm is 263 acres, Wales' seventh largest island, and is a SSSI.

SKOMER ISLAND IRON AGE SITE *West of Wooltack Point and Marloes Sands, Pembrokeshire.* The island is covered with remains of Iron Age round huts, field systems, field-clearance cairns and walled enclosures, dating from the first century BCE. Skomer, like Skokholm, has a Viking name. It is Wales' third-largest island at 722 acres, is home to the unique Skomer Vole and one of the most important seabird sites in Britain. The vole is almost tame and can be picked up. Skomer is a SSSI.

SLEBECH HALL, PARK, GARDENS AND MEDIEVAL CHURCH *On the Eastern Cleddau, 4.5 miles east of Haverfordwest, Pembrokeshire SA62 4AX.* Slebech Hall is an elegant mansion, now a hotel. It was erected on the site of a commandery and church of the Knights of St John of Jerusalem. The site was granted to Worcester Cathedral by Wizo of WISTON CASTLE before 1130, but was acquired by the Hospitallers between 1148 and 1176. It was then one of the most important commanderies in Britain. Now all that remains of the buildings is the Knights' Chapel, the medieval church of St John, which stands roofless, by the water's edge. The Commandery also possessed BLACKPOOL MILL and Canaston Mill, and a quay on the Eastern Cleddau. The latest building on the site, the three-storey castellated Slebech Hall dates to 1773. Formal gardens, including terraces overlooking the river and parkland, were laid out at about the same time. On the A40 nearby is the massive, now-redundant, nineteenth-century church of St John the Baptist, the replacement for the medieval church. Legend has it that the architect designed the church with

the altar facing in the wrong direction, and when he realised he hanged himself in the bell tower. In the open tombs in the crypt can see bones.

SNOWDON – YR WYDDFA – THE HIGHEST MOUNTAIN IN ENGLAND AND WALES The summit of Snowdon is Cop yr Wyddfa, from cop meaning summit and gywddfa meaning tumulus. Yr Wyddfa refers to the now-vanished tumulus of one of King Arthur's victims, the giant Rhita Gawr. It is in the mountain range of Eryri (Snowdonia), and Yr Wyddfa, at 3,560 feet, is the highest mountain in England and Wales. Llyn Llydaw on Snowdon is supposed to be the lake where Sir Bedevere threw Excalibur, when Arthur was wounded at Bwlch-y-Saethau (Pass of Arrows), in his last battle with Mordred. Glaslyn is an elliptical lake formed in a cwm about two thirds of the way up the mountain, and is the source of the Afon Glaslyn, the major river of Gwynedd, which runs east to Llyn Llydaw before turning south-west to reach the sea at Porthmadog. The legend is that the Conwy Valley was constantly plagued with terrible floods that both drowned livestock and ruined crops. The cause of the floods was the Afanc, a legendary Welsh water monster, who lived in Llyn-yr-Afanc in the River Conwy. It was a gigantic beast which, when annoyed, was strong enough to break the banks of the pool causing the floods. The people sent for Hu Gadarn and his two long-horned oxen to come to Betws-y-Coed. They hid near Llyn-yr-Afanc. A beautiful girl approached the Afanc's lake and began to sing a gentle Welsh lullaby. Slowly the massive great body of the Afanc crawled out of the lake towards the girl. So sweet was the song that the Afanc's head slowly sank to the ground, in slumber. The girl signalled and men emerged from their hiding places and bound the Afanc with iron chains. They had only just finished their task when the Afanc woke up, and with a roar of fury at being tricked, the monster slid back into the lake. Fortunately the chains were strong, and had been hitched onto the mighty oxen. The oxen dragged the Afanc up the Lledr Valley, and then headed up Snowdon towards Llyn Ffynnon Las (Lake of the Blue Fountain), now called Glaslyn. On the way up a steep mountain field, one of the oxen was pulling so hard that it lost an eye, and the tears the oxen shed formed Pwll Llygad yr Ych (Pool of the Ox's Eye). The mighty oxen struggled on until they reached Llyn Ffynnon Las, close to the summit of Snowdon. There the chains of the Afanc were loosed, and with a roar, the monster leapt straight into the deep blue water that was to become his new home. Encased within the sturdy rock banks of the lake he remains trapped forever. The lake can be seen when one takes the train up Snowdon, or walks. The walk is hard, but massively worth it if the air is clear. and there is good visibility across Snowdonia.

SNOWDONIA – ERYRI – THE LAIR OF EAGLES Eryri is the massive mountain complex of North-West Wales, Eryri meaning the 'land of eagles' or 'eagles' lair'. The English word eyrie probably comes from this. Near Yr Wyddfa, Carnedd Ugain at 3,494 feet is the second highest mountain in England and Wales, and Crib Goch at 3,023 feet and Y Lliwedd at 2,947 feet are other high peaks in the Snowdon Range of 'Seven Peaks'. Many arctic/alpine species grow in Snowdonia, and its cliff ledges support Welsh Poppy, Alpine Saw-Wort and globeflower. The rare rainbow leaf-beetle has survived in the area since the last Ice Age. The last glacier in Wales, in Snowdonia, melted about ten millennia ago. Carneddau, Wales' second highest range of mountains, is also in Snowdonia, with the peaks Carnedd Llywellyn (3,485 feet) and Carnedd Dafydd (3,424 feet) being the highest. Carn Llugwy (3,184 feet), Pen-yr-Oleu-wen (3,210 feet), Foel Grach (3,195 feet) and Foel Fras (3,081 feet) are other major peaks in this range. Carneddau is dangerous and wild scree area, with the unique Snowdon Lily, globeflower, roseroot and mountain sorrel growing, and birds such as chough, ring ouzel and peregrine falcon can be seen.

SNOWDONIA, BATTLE OF, 798 Somewhere in the mountain massif, Coenwulf of Mercia overcame Caradog ap Meirion, King of Gwynedd, who had ruled from 754. Caradog is noted in the *Annales* as 'killed by the Saxons.'

SOAR-Y-MYNYDD – ISOLATED WELSH CALVINISTIC METHODIST CHAPEL *Near Abergwesyn, 8 miles east of Tregaron - on the bank of the River Camddwr, on the road from Tregaron to*

Llyn Brianne. Perhaps the most remote chapel in Wales, this is deep in the 'Great Wilderness' as the late Wynford Vaughan Thomas called the vast, high tract of moorland between Tregaron and the Upper Wye. The chapel was built in the 1820s by Ebenezer Richards, the minister at Tregaron and father of Henry Richard (1812-88). The two-storey chapel with box pews is built to a traditional design and was also used as the local school until the 1940s.

SOLVA COAST – NATIONAL TRUST *In the Pembrokeshire Coast National Park, between Newgale to the south-east and St David's to the west*. Eleven miles of a rugged stretch of coastline, including old Solva Harbour, Gwadyn beach and the Gribin, a beautiful headland overlooking Solva village.

SOLVA – PORTH-Y-RHAW IRON AGE FORT – NATIONAL TRUST *Nine Wells Valley is a steep cwm heading down to the sea, just west of Solva, Pembrokeshire*. A survey by Cambria Archaeology has found that of fifty promontory forts on the Pembrokeshire coast, nineteen are suffering erosion, and seven of these are in a critical condition. The most seriously affected are Sheep Island, Linney Head, Flimston Bay, Great Castle Head near Milford Haven, Black Point Rath, Castell Tre Ruffydd near Cardigan and Porth y Rhaw. Excavation is now concentrated on Porth y Rhaw, one of the most elaborate of the endangered coastal hillforts with a quadruple defensive earthwork, where at least 10 feet of the fort has disappeared in the past three years. Six stone-footed roundhouses have been found, one of which had the unusual feature of an internal circular gully, perhaps for a screen. In 1862, one of the largest trilobites ever found was unearthed from the rocks at Porth-y-Rhaw inlet. Over two feet long, it has become one of the most famous fossils in Britain and helps us understand how Wales was once connected to North America before the Atlantic Ocean even existed.

SOLVA WOOLLEN MILL *At Middle Hill, one mile north of Solva and the A487, Pembrokeshire, 3 miles east of St David's*. Built in 1907, the waterwheel was restored in 2007, and it is a member of the Welsh Mills Society. It uses traditional skills to produce flat-weave carpets and rugs.

SOUGHTON HALL – VICTORIAN GOTHIC MANSION *2 miles north of Mold, at Northop, Flintshire CH7 6AB. Tel: 01352 840811*. Built in 1714, it was altered in the 1820s and 1867 and is now a luxury hotel and restaurant, with many original interiors. Distinguished residents have included a Bishop of Bath and Wells, two knights, three High Sheriffs, a Chaplain to Queen Victoria, a Lord Chief Justice, a Lord Chancellor's secretary and William John Bankes, one of the greatest travellers and collectors of the early nineteenth century. Bankes was responsible for re-working Soughton Hall in the 1820s. Inspired by his adventures in the Middle East he added the mullioned windows, the first-floor drawing room and dining room and the Islamic turrets upon the court walls. His plans were drawn by fellow traveller Charles Barry, later Sir Charles Barry, architect of the Houses of Parliament. Bankes also used Barry to develop Kingston Lacey mansion. In 1841, Bankes had to flee Britain to escape prosecution for homosexuality.

SOUTH PEMBROKESHIRE HERITAGE COAST AND CALDEY ISLAND This heritage coast stretches forty miles from Caldey Island, near Tenby, to Angle Bay in the Milford Haven Estuary. The area is also included in the Pembrokeshire Coast National Park. Just south of Tenby is Caldey Island, which lies one mile off Giltar Point. The island is owned and farmed by a small community of Cistercian monks, and can be visited via a twenty-minute boat trip from Tenby. The monks provide guided tours of their monastery for men only. St Illtud's Chapel houses an Ogham stone. On the mainland, the village of Manorbier is the home of Manorbier Castle, the twelfth-century fortification that was the birthplace of Giraldus Cambrensis, medieval scholar and tutor to both Richard I and King John. Nearby are the Neolithic standing stones of King's Quoit. There is a steep climb down the cliff to St Govan's Chapel near Bosherston. The chapel is an amazing medieval relic clinging to the rugged rocks halfway down the cliff. There was at one

time a holy well near the chapel, but the well has since dried up. Legend has it that the chapel was founded when St Govan hid in a rocky fissure of the cliff to escape from pirates. Bosherton, just inland from St Govan's Head, is famous for its freshwater ponds, home to lilies which bloom in June. The ponds are man-made, created in the eighteenth century.

SOUTH WALES MINERS' MUSEUM *Near Cymmer, at Afan Argoed, south of the A4107 trunk road, Afan Argoed Country Park, Cynonville, Glamorgan SA13 3HG. Tel: 01639-850-564.* In Afan Argoed Country Park, the museum charts the rise and fall of the South Wales Coal Industry.

STACKPOLE ELIDOR AND BOSHERTON – NATIONAL TRUST *3 miles south of Pembroke, Pembrokeshire SA71 5DQ.* Next to a beautiful and varied stretch of coastline, Bosherston is a National Nature Reserve, a haven for otter and chough. The eighteenth-century Stackpole Quay is a tiny harbour used by local fishermen, from which one can walk to the stunning Barafundle Bay. *The Times* and *Country Life* have both placed the bay in their 'Ten Most Beautiful Beaches in the World'. Bosherton Lakes are three narrow valleys flooded between 1780 and 1860, with an Iron Age and monastic history. In Stackpole Woodlands, footpaths radiate from the site of Stackpole Court, a superb mansion demolished in 1963, although some outbuildings remain. The 'Garden Pavilions' are two ornamental features thought to date to the late eighteenth century, but later converted to house furnaces for a hot wall in the court's walled garden. On the coast path to Trewent Point, the collision of continents 290 million years ago left the dramatic geology you can see north-east of Stackpole Quay. The footpath to Trewent Point passes a fine coastal fort at Greenala.

STACKPOLE ELIDOR – DEVIL'S QUOIT STANDING STONES The Harold Stone is also known as the Stackpole Home Farm Stone and the Dancing Stone of Stackpole. It is over 6 feet high, and somehow associated with the pre-Norman campaigns of Harold Godwinsson, who never came this far into Wales. Half a mile north-west is the Bronze Age stone known as The Devil's Quoit, at Stackpole Warren, 5 feet high. The stone was erected on the site of a circular structure that burnt down about 1395 BCE, and was part of a complex setting of small stones. A cremation was inserted into this complex about 940 BCE, and a later Iron Age and Romano-British settlement were also recorded here. A mile south-east of the Harold Stone is another 6-feet standing stone called variously Sampson's Farm Stone, Sampson Cross Stone and East Hole Stone. All three are in line and each is sometime's called the Devil's Quoit, and there may be further lost stones in the alignment.

STACKPOLE ELIDOR (CHERITON) – CHURCH OF ST JAMES AND ST ELIDYR The mid-fourteenth-century tomb of Sir Elidyr de Stackpole and his wife is one of the finest in Wales, and there are impressive Lort and Cawdor tombs here. Under the east window is a rough pillar stone with a damaged Latin inscription, 'CAMULORIC -/- FILIFANNUC' (Camulorix, son of Fannucus). The Earls of Cawdor owned huge estates around here, and paid Sir Gilbert Scott to renovate the church. In 1883, the second Earl of Cawdor owned more than 100,000 acres of land in Britain, 17,735 acres of which were in Pembrokeshire, and Stackpole Court was one of the greatest country houses in the kingdom. There are 160 different species of lichen in Stackpole churchyard, according to the British Lichen Society, the greatest number of any churchyard in Great Britain. Not a lot of people know that.

STRATA FLORIDA ABBEY, ABATY YSTRAD FFLUR (VALE OF FLOWERS) CADW *Take the B4343 north-east to Pontrhydfendigaid, Ceredigion, where the abbey is signposted, 2 miles to the east of the village.* Initially founded in 1164 on a site two miles away, the present buildings were erected under the patronage of The Lord Rhys (d. 1197). The Cistercians at Strata Florida were loyal supporters of the Welsh princes. It is the traditional burial place of Dafydd ap Gwilym, one of the great poets of medieval Wales. The first Cistercian abbey, founded by Robert fitz Stephen, is on the banks of the Afon Fflur, and was a daughter house of Whitland. It seems that the new

site was the wish of The Lord Rhys, to distance it from the Normans. It was his favourite abbey, with the new building starting in 1184 on the banks of the River Teifi. Under his patronage it became the scriptorium for the native Welsh annals. *Brut y Tywysogion, the Annals of the Princes*, was probably recorded here. Ystrad Fflur became the largest abbey in Wales, in the course of fifty years of building work. Llywelyn the Great summoned princes from across Wales to meet here in 1238. Apart from the wonderful Romanesque west arch, little survives of 'the Westminster of Wales', which was larger and grander than St David's. King John had threatened to destroy it for its Welsh partisanship, and it suffered during the Madog rebellion in 1294. Graves of Welsh princes are here, including two of The Lord Rhys' sons. The 'Monks' Trod', an ancient road, led to Abbey Cwmhir in Radnorshire, and was later used by drovers. At Strata Florida the White Cistercian monks kept a healing cup made of wood from Christ's Cross. Later it was transmuted into 'The Holy Grail', used at the Last Supper and sought in legend by Arthur and his knights. It passed to nearby Nanteos Mansion on the Dissolution, where the Powell family became its custodians. Pontrhydfendigaid has its name from its proximity to the ruined abbey, meaning 'the bridge over the blessed ford'. Since 1995, a puma known as the 'Beast of Bont' is thought to have mutilated and killed around fifty sheep in the area.

STRATA MARCELLA ABBEY, ABATY YSTRAD MARCHELL *Near Welshpool, Montgomeryshire.* This was the largest Cistercian monastery in Wales, founded in 1170 by Owain Cyfeiliog, who invited monks from Whitland Abbey to inhabit it. Owain retired here as a monk, where he died. The building of the monastery went on from 1190 to the early fourteenth century. The church of the monastery was 273 feet long with an aisled nave, a transept and a chancel. The Strata Marcella monks were involved in the struggle between the Welsh princes and the Marcher Lords, and between Llywelyn the Great and Edward I. In 1330, Edward III demanded that the monastery was to be controlled by Buildwas Abbey in Shropshire, owing to its support for the Welsh. The Welsh community at Strata Marcella was replaced with English monks. Between 1400 and 1405 the buildings were subject to destruction during the Owain Glyndŵr War, and the monastery never seemed to recover completely. After Henry VIII had ordered the Dissolution of the Monasteries in 1536, his men discovered that Lord Powis had bought the buildings from the monks the year before, and all valuable items had disappeared. The site was dismantled completely, but many pieces of stonework were sold in the area, to Buttington church, Llanfair Caereinion church and Trewern Hall. Virtually no trace of the abbey exists today, apart from a few small areas of masonry and some earthworks which denote the positions of the church and cloister. The site is now a field of pasture on the west bank of the River Severn.

SULLY ISLAND, YNYS SILI *This can be reached at low tide from Swanbridge, on the road from Penarth to Sully, Vale of Glamorgan.* There is sea-holly, and the remains of an Iron Age fort on the Eastern end. Some Saxon or Viking raiders were trapped here and killed a millennium ago. It is a SSSI, twenty-eight acres in size, and in 2009 was for sale for over a million pounds. On nearby Bendricks Rock were discovered the only Upper Triassic Dinosaur footprints in Britain, in biped and quadruped modes. There were once many such fossilised remnants along the rocky coast from Sully to Barri, but 'collectors' have been illegally removing them over the years.

SUMMERHOUSES IRON AGE FORT *East of Llanilltud Fawr, take the road from Boverton to the sea, Vale of Glamorgan.* The octagonal summerhouse, set within an octagonal enclosure, was built in around 1730 by the Seys family of nearby Boverton Castle. Surrounding the Summerhouse is an Iron Age fort dated 700 BCE to 100 CE. The barely known fort has several ramparts and is semi-circular with the sheer sea cliff on the South side. Just east of the fort, along the cliff path is the Seawatch Centre, housed in a converted HM Coastguard Station.

SWANSEA, ABERTAWE – 'COPPEROPOLIS' *Between the M4 and Swansea Bay, at the start of the Gower Peninsula.* The second largest city in Wales is called Abertawe, as it lies on the mouth of

the River Tawe. Its docks were established in 1306 for ship-building and developed in the eighteenth century. Swansea became an important port for limestone in the sixteenth century, which was shipped out of South Wales for use as fertiliser. The Industrial Revolution saw an increase in coal exports, with Swansea becoming a European centre for copper-smelting from the 1720s. It was known as 'Copperopolis' by the nineteenth century, producing over half the world's copper. The Swansea Valley was the most important copper-smelting area in the world. (Nearby Llanelli was known as 'Tinopolis)'. At this time Swansea had the largest nickel works in the world. In the mid-nineteenth century, Swansea Docks was also the biggest coal exporter in the world. The world's first passenger train ran from Swansea to Mumbles in 1907, but the rails were pulled up in 1960 by a thoughtless city council. Much of the dock area has been redeveloped into a charming marina housing the National Waterfront Museum. The city centre was badly damaged by German bombing in 1941 and needs some sympathetic architecture. Swansea University was recently voted the 'most student-friendly' university in Britain, and Swansea people are known as 'Jacks' probably because of the exploits of a dog that saved twenty-seven people from drowning in its docks.

SWANSEA CANAL This was constructed by the Swansea Canal Navigation Company from 1794 to 1798, stretching sixteen miles from Swansea to Abercraf. There were originally thirty-six locks on the canal to raise it from sea level at Swansea to 375 feet at Abercraf, and aqueducts at Clydach, Pontardawe, Ynysmeudwy, Ystalyfera, and Cwmgeidd carry the canal across major rivers. It transported coal from the Upper Swansea Valley to Swansea for export, or for use in the metallurgical industries in the Lower Swansea Valley. The period 1830-40 saw the development of towns around the canal. Clydach, Pontardawe, Ynysmeudwy, Ystalyfera, Ystradgynlais, Cwmgeidd and Abercraf came into being, as industries developed at those locations. The canal remained profitable until 1902, when losses were first reported. This decline in revenue and profits was due to the competition from the Swansea Vale Railway. The last commercial cargo carried on the Swansea Canal was in 1931, when coal was conveyed from Clydach to Swansea.

SWANSEA CASTLE CADW These are the remains of the de Braose castle dating to the late thirteenth century, and are in the centre of the town. The later distinctive arcaded parapet is reminiscent of the episcopal palaces at Lamphey and St David's. The castle was used by the Earl of Warwick as his seat of administration for the lordship of the Gower, and razed by the Welsh in 1217. Bishop Henry de Gower built a stone castle here in 1306, and it was badly damaged by Owain Glyndŵr in the fifteenth century. It changed hands many times, being first attacked by the Welsh in 1116. It was almost demolished by Parliamentarians in 1647.

SWANSEA – GLYNN VIVIAN ART GALLERY *Alexandra Road SA1 5DZ. Tel: 01792 516900*. The original bequest of Richard Glynn Vivian includes work by old masters as well as an international collection of porcelain and Swansea china. The twentieth century is also represented with modern paintings and sculpture by Hepworth, Nicholson and Nash alongside Welsh artists such as Ceri Richards, Gwen and Augustus John and Alfred Janes. These are housed in a handsome classic Italian-style gallery building, complemented by contemporary art in the modern wing.

SWANSEA GUILDHALL The 1930 Art Deco building in white Portland stone has a 160-foot-high clock tower. Frank Brangwyn's superb murals were meant to go into the House of Lords in 1931, commemorating the Great War, but were refused because of their pacifist overtones. The seventeen large panels are now in Swansea Guildhall.

SWANSEA NATIONAL WATERFRONT MUSEUM – EUROPEAN ROUTE OF INDUSTRIAL HERITAGE ANCHOR POINT This is housed in a magnificent building that elegantly combines old and new architecture. A Grade II listed former dockside warehouse built in 1902, it contrasts with a spectacular 2006 glass and slate structure, and the project cost over £35 million. The museum tells the story of industry and innovation in Wales, now and over the last 300 years.

SWANSEA MUSEUM *Victoria Road, The Maritime Quarter, Swansea SA1 1SN.* Swansea Museum is the oldest museum in Wales. The Museum building was completed in 1841 in the grand style of neoclassical architecture, and is a Grade II* listed building. There are six galleries. The museum was set up by the Royal Institution of South Wales, a group of local people who wanted to investigate and discuss all aspects of history, arts and science at the beginning of the nineteenth century. This author had the honour of editing and publishing *Heroic Science: Swansea and the Royal Institution of South Wales 1835-1865,* which sold in miniscule quantities, but related why Swansea was chosen as the 1848 venue for the Royal Association for the Advancement of Science. Great scientists like Michael Faraday came from all over Europe by boat and carriage – this was before the railway reached Swansea – as it was at the forefront of world scientific investigation. The local men who drew them to the Royal Institution were all Fellows of the Royal Society, and included John Henry Vivian (leader of the world copper industry), Lewis Weston Dillwyn (zoologist and producer of Swansea porcelain), John Gwyn Jeffries (the first British conchologist), Sir Henry de la Beche (first director of the Geological Survey of Great Britain), Sir William Edmond Logan (to become Canada's greatest scientist, and first director of the Geological Survey of Canada), Dr Thomas Williams (pioneer of microbiology) and William Robert Grove (inventor of the fuel cell).

SWANSEA – SINGLETON ABBEY AND SINGLETON PARK *Gower Road, Sketty, Swansea SA2 9DU.* Singleton Abbey is a large nineteenth-century mansion in the neo-Gothic style, built for John Henry Vivian, an industrial magnate of great wealth. In 1920, Singleton abbey became the core of Swansea University and now houses the University's administration. The Abbey is architecturally and historically fascinating and houses many acclaimed works of art. Singleton Abbey Park is on a hillside running alongside Swansea Bay, and its old walled garden houses a famous Botanical Garden.

SYCHARTH CASTLE *Outside Llangedwyn, near Llansilin, 7 miles west of Oswestry.* This motte and bailey belonged to Glyndŵr and was razed by Prince Henry in 1403 along with Glyndŵr's other court at Glyndyfrdwy. Huge amounts of burnt materials were found in the 1960s excavations. Glyndŵr's neighbour and friend, the bard Iolo Goch, wrote the following lines about Sycharth:

> Encircled by a bright moat
> What a fine court! The lake bridged,
> A gate for a hundred loads ...
> Every drink, white bread and wine,
> Meat and fuel for his kitchen,
> Peaceful haven, home to all ...

TAFF'S WELL *Just north of Cardiff, this is only a few yards from the River Taff (Taf).* Taff's Well was used for over 200 years to cure muscular rheumatism. The pale-green water is almost identical chemically to that of Bath, and is a constant 67 degrees Fahrenheit. Unfortunately, at present it is closed off to the public. The well used to stand in open fields until a weir re-routed the river nearer to it, and it was used from Roman times until the nineteenth century. Wells were sacred to the early Celts, and they used the hot springs of Bath before the Romans came to Britain. Aqua Sulis, or Bath, is named after the Celtic Goddess Sulis.

TAFOLWERN CASTLE, CASTELL DOMEN FAWR *Built between the Afon Twymyn and the Afon Rhiw Saeson, on the B4518 near Llanbrynmair, just off the A470, SY19 7DL.* It was probably built by Owain Cyfeiliog, when he was given the commote of Cyfeiliog by his uncle Madog ap Maredudd. In 1160, it was taken by Owain Gwynedd, but then captured by Hywel ap Ieuaf, Lord of Arwystli in 1162. Owain Gwynedd then defeated Hywel at Llanidloes and rebuilt the castle, returning it in 1165 to Owain Cyfeiliog. However, because Owain Cyfeiliog sided with the Normans, the castle was taken from him again, and held by Rhys ap Gruffudd. The Normans then

helped Owain Cyfeiliog retake the castle. It was occupied by Owain ap Gwenwynwyn of Powys in the late twelfth century. His grandson Gruffudd was besieged there by a Welsh army in 1244, because of his support for Henry III. Only a low motte remains.

TALGARTH – PARISH CHURCH OF ST GWENDOLINE AND PELE TOWER *On the A479, a mile south of the A438, between Brecon and Hay, Breconshire.* According to traditional accounts, Talgarth was the capital of King Brychan of Brycheiniog in the fifth-sixth century. Talgarth was said to be raided by King Gwynlliw of Gwent in the sixth century, in search of a bride. St Gwendoline was a daughter or granddaughter of King Brychan who bathed in the pool at Pwll-y-Wrach waterfall, and is buried at the site of the present church, in Talgarth. The church, mainly thirteenth to fourteenth century, was granted to Brecon Priory in 1094 by Bernard of Neufmarche. In 1735, Talgarth saw the birth of Welsh Methodist Revival, when Howell Harris of Talgarth was converted in Talgarth church while listening to a sermon. The revival swept across Wales leading to the development of the Welsh Calvinistic Methodism. It was at Talgarth William Williams Pantycelyn was converted, leading him to become one of Wales' most important hymn writers. Nearby is TREFECA, where Harris established his college. The town was a borough from the early 1300s and had seventy-three burgesses in 1309. The pele tower was built at this time, a defensive residence guarding the river crossing and town. It is now the Tourist Information Office. In a later medieval period a knight from Talgarth occupied the hall house, now the Old Radnor Arms. The medieval Tower Bridge crosses the Ennig in Talgarth.

TALGARTH – CASTELL BWLCH Y DINAS *3 miles south-east of Talgarth, Breconshire.* The first motte on this craggy site may have been built by the Fitz Osberns, in their campaigns in Brycheiniog from 1070 to 1075. The castle probably lost importance, after BRECON Castle was built as the base for the Brecon lordship in 1093. The remaining standing ruins of the castle, the northern gate-tower, possibly date to after October 1233 when the castle was sacked.

TALLEY ABBEY, ABATY TALYLLYCHAU CADW *Near Caio, 7 miles north of Llandeilo, Carmarthenshire.* This was the only abbey in Wales of the Premonstratensians, the White Canons. They followed Cistercian ascetic practice, but involved themselves in undertaking duties in the parish. It was founded by The Lord Rhys around 1184-89, and supported by his descendants. There is a lovely medieval church next to it, which has obviously used stone from the site. The central crossing tower still stands to a height of 85 feet, next to the lakes.

TALLEY, BATTLE OF, 1213 (1214 ACCORDING TO LLWYD) Rhys Grug was defeated near Talley, and fell back to Llandeilo, firing the town and its castle to prevent it being of any use to the English. King John had sent forces to aid Rhys and Owain, the grandsons of The Lord Rhys.

TALLEY CASTLE This is a small motte on an isthmus between two lakes, just north of Talley Abbey.

TALSARNAU – BRYN CADER FANER CAIRN CIRCLE *Near the village of Talsarnau, Porthmadog, Meirionnydd.* Professor Aubrey Burl called this site one of the wonders of prehistoric Wales. It is one of the most beautiful Bronze Age sites in Britain, isolated on a rocky crag. The small cairn is 28 feet wide and under 3 feet high, but eighteen thin slabs lean out of the circle of boulders, like a crown of thorns. It is a combination of stone circle and burial mound. The site was disturbed by nineteenth-century treasure-seekers, who left a hole in its centre indicating the position of a cist or a grave. There may have been about thirty pillars, each some 6 feet long, representing the 'thorns'. The Army, during the Second World War, used the ring cairn for target practice, demolishing some stones on the east side, however. It is almost three miles of boggy terrain to climb from the nearest lane to reach this wonderful, still magical site.

TALYBONT – BEDD TALIESIN *Tre-Taliesin is near Tal-y-Bont on the A487 9 miles north of Aberystwyth and 9 miles south of Machynlleth, Ceredigion.* On the slopes of Moel-y-Garn above the village of Tre-Taliesin is the legendary grave (bedd) of the poet Taliesin. The Bronze Age round-kerb cairn with a cist is around 7 feet long. The capstone has fallen, but some side stone slabs are in their original positions. In 1781, Henry Wyndham observed that Bedd Taliesin, and another cairn nearby 'has, within these five years, been entirely plundered and the broken stones are now converted into gateposts etc.' Taliesin was a famous bard and warrior, perhaps a contemporary of Merlin. In the nineteenth century, local people tried to remove Taliesin's bones to re-inter them on a Christian burial site. During excavation, lightning struck the ground nearby, and the workers fled, never to try again.

TALYLLYN CHURCH OF ST MARY FOFC *Near Llanbeulan, Anglesey.* Eglwys y Santes Fair overlooks Llyn Padrig (Patrick's Lake), and Tal-y-Llyn means 'head of the lake'. This tiny Grade I listed building was one of five chapels of ease in the parish of Llanbeulan, and is sited in a huge churchyard. Its fittings are for the most part eighteenth century, including the communion rails and pulpit. The nave is medieval, possibly twelfth century. The chancel was rebuilt in the sixteenth century and the south chapel added in the seventeenth century. The original twelfth-century font was removed for safekeeping when the church was made redundant, and is now housed in the parish church of St Maelog's, Llanfaelog.

TENBY WALLED TOWN *On the A478 south of Narberth, Pembrokeshire.* The name is a corruption of Dinbych-y-Pysgod (little fort of the fish), and a small fort overlooks the harbour. Tenby is surrounded by four excellent beaches, and some of the thirteenth-century town walls still stand, with medieval gatehouses. The most famous remaining gateway of this gem of a seaside resort is called the Five Arches. The town was attacked in 1153 and in 1157, 'Maelgwn ap Rhys, the shield and bulwark of all Wales, ravaged the town of Tenby and burned it ... who frequently slew Flemings and drove them to flight many a time.' Tenby was attacked again in 1187, and the destruction of the town by Llywelyn II in 1260 showed the Earls of Pembroke that the defences of Tenby were inadequate for the colonisation of South Pembrokeshire. It was thus decided to enclose the entire settlement behind an impregnable ring of walls, towers and gateways. Within these structures the cliff-top castle would form yet another defensive bulwark. At the same time a new street pattern was imposed on parts of the new town. Construction of the new walls began under William de Valence, Lord of Pembroke around 1264. In 1328, Edward III granted Tenby the right to levy dues on merchandise entering the town for the next seven years. Taxes to help with the construction and maintenance of the town wall and defences were called murage; and for the quay – quayage. The funds led to the construction of extra towers in the curtain wall and the outer Barbican tower for the West Gate – the present Five Arches. In 1457, Jasper Tudor made the Mayor and burgesses of the town fully responsible for the upkeep of the walls and the defence of the town. This led to the lower sections of the walls being increased to six feet in thickness, to the walls being considerably heightened, and in many places a parapet walk added. On 7 March 1644, a Parliamentarian bombardment began and continued for three days. The Northgate was breached by cannon fire and the Royalists surrendered. The society painter Augustus John and Robert Recorde, the inventor of the = sign, were born here. From the twelfth-century battles, through sheltering Henry Tudor in the fifteenth century to the First and Second Civil Wars, Tenby has had a turbulent history.

TENBY CASTLE On a rocky headland with a narrow neck, most of the remaining masonry is thirteenth century, and it was captured by the Welsh in 1153. With the town, it was held by Parliament for most of the Civil War, and beat off two sieges by Gerard's Royalists. In 1648, the Royalists held it for ten weeks but were starved into surrender by Colonel Horton, while Cromwell went on to take PEMBROKE.

TENBY – ST MARY'S CHURCH When first built in the thirteenth century, the tower provided a belfry and a first floor chapel, and could also serve as a lookout point and a place

of refuge in troubled times. The spire was added in the fifteenth century, and its height of 152 feet makes it a notable landmark for travellers by land or sea. Most of the church dates from the thirteenth century, with additions in the fourteenth and fifteenth centuries. The thirteenth-century chancel has a 'wagon' roof and the panelled ceiling has seventy-five bosses carved with a variety of foliage designs, grotesques, fish and a mermaid. St Thomas' Chapel was added in the mid-fifteenth century, and the St Nicholas Chapel was added around 1485. The church contains several memorials, including the tombs of Thomas and John White, both Mayors of Tenby in the fifteenth century. Thomas White was famous for hiding the young Henry Tudor from Yorkists in a cellar, still in existence under where Boots the Chemist is now. Fourteen years later, Henry returned to Britain, won at Bosworth Field and richly rewarded White, whose tomb is the finest in the church. Tenby man Robert Recorde was a leading mathematician, the writer of the first English language texts on algebra and arithmetic, and incidentally invented the equals (=) sign, to 'avoid the tedious repetition of equals to'. His arithmetic book went into fifty editions and was notable in being innovative in two respects. It was written as a dialogue between a master and pupil to keep it interesting (shades of *Sophie's World*), and it used the device of pointing fingers (precursing Windows icons!). Recorde studied at Oxford, qualified as a Doctor of Medicine in Cambridge, was a doctor in London and in charge of mines in Ireland, but died bankrupt in prison because of a lawsuit taken out by the Duke of Pembroke. His wall memorial in the church reads:

In Memory of
ROBERT RECORDE
The Eminent Mathematician
Who Was Born at Tenby, circa 1510.
To His Genius We Owe the Earliest
Important English Treatises on
Algebra, Arithmetic, Astronomy and Geometry;
He Also Invented the Sign of
Equality = Now Universally Accepted
By the Civilised World
ROBERTE RECORDE
Was Court Physician to
King Edward IV and Queen Mary
He Died in London
1558

TENBY – TUDOR MERCHANT'S HOUSE – NATIONAL TRUST *Quay Hill, Tenby, Pembrokeshire SA70 7BX*. A fascinating fifteenth-century, three-storey townhouse is on a lane near the church, in the centre of Tenby. The ground floor has been made up into a replica merchant's shop, with a kitchen and range in the rear room. The first floor is the hall and living room, with a latrine in the corner in which a stuffed rat lurks. On the top floor are bedrooms and there is a tiny herb garden.

THORN ISLAND FORT *Off Angle Bay, Pembrokeshire*. This eight-acre island has a large fort built in Napoleonic times, which used to hold a garrison of 100 men. The buildings were converted into a hotel, but it seems to have reverted to private ownership. The film *Whisky Galore*, based on a story by Compton Mackenzie, may have been inspired by the wreck of the Loch Shiel on Thorn Island in 1894. When the boat broke up, its cargo of bottles of whisky and barrels of gunpowder started to drift into Angle Bay. Some looters carted away the barrels, thinking them to be full of whisky. Women packed the legs of their bloomers with bottles, knowing that the Customs and Excise men would not dare to look there. Three people died, two from alcoholic poisoning and one from drowning while trying to gather the whisky. Nearby Sheep Island has an Iron Age fort.

TINKINSWOOD BURIAL CHAMBER CADW *Turn south at St Nicholas on the A48 west of Cardiff.* This is an impressive Neolithic burial chamber of the 'Cotswold-Severn' type, surrounded by other Neolithic remains. The capstone weighs around 46 tons and may be the largest in Britain. It is covered by a mound of earth up to 150 feet long and 75 feet wide and would have stood at least 10 feet high. Some reconstruction makes it a wonderful place, to some extent spoilt by a nearby electricity pylon. Many other countries seem to have far more sympathy for the context of any historic remains. A line from Tinkinswood through St Lythan's Burial Chamber leads to the site of pillow graves, rock-cut graves which this author can no longer find, but were marked on maps west of the Bendricks coast near Barri. To the north the alignment heads to prehistoric mounds near Gwern-y-Steeple. There are hundreds of lines across Wales which line up pre-Norman sites. Many early Christian sites are aligned with tumuli and other prehistoric remains, as they are themselves based upon earlier sites of commemoration or worship. Until the 1940s, the site appears to have been called Tinker's Wood in English, and Castell Carreg (Rock Castle) in Welsh.

TINTERN ABBEY CADW *From Chepstow, take the A460 north for about 5 miles.* A Cistercian abbey, it was founded in 1131 in the beautiful Wye valley. The remarkably complete abbey church was rebuilt in the later thirteenth and early fourteenth centuries, with extensive remains of cloisters and associated monastic buildings. A favourite spot of Wordsworth, this graceful abbey was the second Cistercian foundation in Britain, endowed by the Lords of Chepstow, and the main buildings were completed by 1301. It was, like nearly all the other abbeys in Britain, vandalised in the Dissolution, its roof stripped, windows smashed and estates confiscated. A plaque on the wall of Tintern Abbey recorded the discovery and manufacture of brass, the alloy of zinc and copper, by Cistercian monks in 1568. As the abbey was dissolved in 1536 by Henry VIII, the provenance and proof of this claim needs further research.

TINTERN ABBEY MILL Dating to 1131, this was the original mill, which evolved from a corn mill into a woollen mill, sawmill and even a wire works. The waterwheel has recently been restored to full working order.

TOMEN CASTLE *Just north of the A470, between Blaenau Ffestiniog and Betws-y-Coed.* A mound near DOLWYDDELAN Castle, seemingly its precursor and the birthplace of Llywelyn the Great. The remains are on a rocky knoll in the valley bottom, covered with trees, but traces of a square tower were found.

TOMEN Y MUR ROMAN SITE AND NORMAN CASTLE *Near Maentwrog and 2 miles south of Trawsfynydd in Meirionydd.* The Norman motte was built in the middle of a Roman fort, on the military road between Pennal and Caerhun. There was an amphitheatre, parade ground and bath house, and it was occupied after the Romans left. Aerial photography has revealed a large number of military features from the Roman era. At the heart of the site is the Roman auxiliary fort, which stood in a prominent position on the road from Brithdir near Dolgellau to Segontium at Caernarfon. It was probably founded around 70 CE and abandoned by about 130 CE. The fort lies at the crossroads of four Roman roads: where the road from Caernarfon and Pen Llystyn becomes the road to Caer Gai, which crosses (at a point south of the fort) the road south to Brithdir and north to Caerhun (Canovium). The earthworks make one of the most impressive and interesting Roman sites in Britain, not only because of their sequence of construction, reduction and medieval reuse, but because the fort is surrounded by an exceptionally complete and well preserved series of ancillary buildings: bath-house, mansio (guesthouse), practice earthworks, leats, roads and burial monuments. Outside and to the north of the fort, the clearest of the ancillary earthworks is a small amphitheatre, some 27 yards in diameter and unique in Britain. The fort is referred to as Mur y Castell in the *Mabinogion*, in the legend of Lleu, where his wife Blodeuwedd

attempted to murder him. William Rufus built the original motte, but he was chased out of Wales by Gruffudd ap Cynan. The name Tomen-y-Mur can mean something like 'the walled dung heap', referring to the contempt in which the Normans were held.

TOMEN Y RHODWYDD CASTLE *Near Llandegla in Denbighshire.* Built by Owain Gwynedd in 1149, to complement his capture of this part of Powys, it is a motte and bailey protecting both the Horseshoe and Nant y Garth Passes. It was retaken by Iorwerth Goch ap Maredudd of Powys in 1157 and burnt, but restored by King John in his 1212 invasion.

THE TONYPANDY RIOT 1910 *West of Pontypridd, Glamorgan.* The Naval Colliery Company opened a new seam at the Ely Pit in Penygraig, which was more difficult to work. As miners were paid by the ton mined, not the hours worked, they protested and were locked out of the pit. A strike followed, replacement workers were sent in and the miners picketed, causing riots. Upon 8 November 1910, more than sixty shops in the Rhondda were attacked by miners and one collier, Samuel Rays, was killed by police. Colonel Lindsay, Chief Constable of Glamorgan, asked the Home Secretary, Winston Churchill, to send troops to restore order. First, Churchill sent mounted police and London policemen, and then troops but the troops were thankfully not deployed. The friendship between army officers and pit owners was noted in these days of repression. *The Times* recorded that there was in the Rhondda 'the same oppressive atmosphere that one experienced in the streets of Odessa and Sebastopol during the unrest in Russia in the winter of 1904. It is extraordinary to find it here in the British Isles.' Thirteen miners were tried for 'intimidating a colliery official' but none was imprisoned for more than a few weeks, and matters returned to what passed for normality in these unsettling times of unrest. The fact that Churchill sent troops to the Rhondda is all but forgotten outside Wales.

TRAWSFYNYDD – BIRTHPLACE OF HEDD WYN *In the Snowdonia National Park, just off the A470 south of Ffestiniog, Meirionydd.* The name Trawsfynydd seems to have come from the fact that all its roads lead across mountains, but it was originally called Llanedenowan. St Madryn's Church is the only listed building in the village. St John Roberts baptised there, and possibly received his early education from a dispossessed monk from Cymer Abbey, following the dissolution of the monasteries. He was raised as a Protestant and joined St John's College, Oxford in 1595/1596. While travelling on the continent he became a Catholic and went to a Jesuit College at Bordeaux. After becoming a Benedictine monk, he adopted the name of Brother John of Merioneth. Roberts returned to England and tended the sick and dying during the plague. While taking mass he was arrested by the authorities, and hung, drawn and quartered as a traitor. One of his fingers is at the Catholic Church at Blaenau Ffestiniog. The most famous modern bard, Hedd Wyn ('White Peace'), was the shepherd-poet Ellis Humphrey Evans from Trawsfynydd, who was killed at Passchendaele ('with a nosecap shell in the stomach') in the First World War. He enlisted with the Royal Welsh Fusiliers at the age of thirty, early in 1917, and died on 31 July in the same year, just before he would have received the chief Bardic prize at the National Eisteddfod in Birkenhead. In September, the winning poet was called to take the Bardic Chair for his strict metre poem *Yr Arwr* (The Hero). Hedd Wyn could not reply to the summons, and the Chair was draped in black on the stage. The assembled Welsh wept openly, and the event is still referred to as 'The Black Eisteddfod'. A moving 1992 Welsh-language film commemorating the story was nominated for an Oscar. The lake here is a reservoir formed for Maentwrog Hydro-Electric Power Station, which also provided the cooling waters for the appalling nuclear power station, set in one of the most beautiful spots in Europe. Its life finished in 1993 and it is slowly being decommissioned. Trawsfynydd nuclear power station was the only inland nuclear station to be built in the UK. Llyn Trawsfynydd not only acted as a cooling water, but was also a sink for radioactivity released from the plant. Very large amounts of radioactive material exist in the lake bed sediment levels, making it dangerous to use the lake or eat fish from there. A 2006 Report stated that levels of cancer in the area are 'significantly and alarmingly high'. This author also came upon material which indicates that the nuclear power station is built upon a fault line in the earth's crust. One cannot ever imagine a nuclear power station being built in an area of incredible scenic beauty

in England, let alone in a National Park. Driving towards Trawsfynydd from Ffestiniog, this forgotten blight appears like two squat oppressive Norman castles.

TRECASTLE (TRECASTELL) MOTTE AND BAILEY *On the A40, 12 miles west of Brecon, Breconshire.* Well preserved, it was built around 1095, probably by Bernard de Neufmarche. Over the slopes of Mynydd Bach near Trecastle, there is the route of a Roman road, the remains of two Roman marching camps, as well as stone circles, the sites of hafods (summer dwellings) of the Iron Age, and this Norman motte. The castle was constructed to protect Brecon from attack from the west, and fell to the Welsh in the 1120s. Uprisings continued, and as late as 1295 King Edward I spent three days in Trecastle quelling Madog's uprising. In the nineteenth century, Trecastle had eight annual fairs, its own gasworks, two schools, a corn mill, a woollen mill, two smithies, sixteen shops and numerous pubs. However, the arrival of the railway at Sennybridge led to Trecastle's decline as a market town.

TRECASTLE STONE ROW AND STONE CIRCLES A row of four small stones lies south-west of the smaller stone circle at Mynydd Trecastell, and runs for around 20 yards. Two stone circles lie on the mountain, one to the east-north-east and one to the west-south-west. The smaller circle has only five stones remaining, and is 24 feet across. The larger circle is 76 feet across and has twenty-one stones remaining, around an unexcavated central mound. A fallen stone pillar can be found 150 yard away. Continuing westward for about 600 yards along the Roman road, one will come to the remains of the two superimposed Roman rectangular marching camps of Y Pigwn.

TRECASTLE – PIGWN (THE BEAKS) ROMAN MARCHING CAMPS AND FORTLET *Near Trecastle, to the north of the Roman road between Brecon and Llandovery, surrounding the summit of a 1,350-foot hill overlooking Waun Ddu (Black Bog).* There are two large, superimposed temporary marching camps here. Y Pigwn Camp 1 is 1,380 x 1,180 feet, 37½ acres. Y Pigwn Camp 2 is 1,190 x 930 feet, 25½ acres, lying wholly within the perimeter of Camp 1 on a slightly different alignment. Marching camps were built by the Roman army for temporary protection, with the soldiers digging a ditch and using the waste to form a bank. This small Roman fortlet was placed to guard the main Roman road between the forts at Brecon Gaer and Llandovery. The site was later used to house a Norman motte (tomen). Roman Milestones from Trecastle Hill near Y Pigwn read: IMP DON MAR CASSIANIO LATINIO POSTVMO PIO FEL AVG ('For the emperor, our lord [Caesar] Marcus Cassianius Latinius Postumus Pius Felix [Invictus] Augustus', and IMP C M PIAVONIO ... AIO ... AVG, 'For Imperator Caesar Marcus Piavonius [Victorinus Pius Felix Invictus] Augustus.' Postumus was murdered in 269, and Victorinus was killed in 271. The Roman Practice Works at Cwm-y-Cadno occupy ¼ acre and lie in the valley below the fortlet on Mynydd Myddfai, a mile away.

TREDEGAR HOUSE AND GROUNDS *On the western outskirts of Newport, on the A48 to Cardiff, Monmouthshire.* This extremely fine seventeenth-century brick mansion, on a fifteenth-century core, is the ancestral home of the Morgans, who lived on the site from the fourteenth century to 1951. John ap Morgan was rewarded by Henry VII for his support at Bosworth and built a mansion, and Charles I later was entertained here, after Naseby in 1645. The Morgans were rewarded for accompanying Charles II into exile, so a major rebuilding took place during the Restoration of the Monarchy. Much of the interior dates from this time, with the 'Gilt Room' being one of Wales' great treasures. The superb house and grounds are open to the public.

TREDEGAR – BEDWELLTY HOUSE AND GARDENS *In the Sirhowy Valley, on the A4048 before it meets the A465 Heads of the Valleys road.* Originally a thatched cottage, the house was renovated in 1809 and was totally rebuilt in 1818 as a mansion for Sir Samuel Homfray, whose Tredegar Iron and Coal Works were the main employers. It is now Grade II listed. Homfray was the son-in-law of Sir Charles Morgan, Lord Tredegar, who lived in Tredegar House, Newport. The surrounding twenty-six-acre Victorian park and gardens were designed as a 'Dutch garden' to walk around with no gates or fences. The Long Shelter in the gardens is also Grade II listed, and is

associated with the Chartist Movement. One can also see a single 15-ton lump of coal hewn by miners for the Great Exhibition of 1851.

TREFIGNATH BURIAL CHAMBER CADW *Just west of the A55, when one crosses from Anglesey to Holy Island.* This Neolithic chambered tomb was constructed in three separate phases, around 3750-2250 BCE. Built on a rocky outcrop, is one of a group of 'Long Graves' found on Anglesey. The earliest tomb is at the west, thought to have been a small Passage Grave. The second chamber was built to the east of this tomb, and is a simple rectangular box chamber with two low portal stones and a single capstone. Much stone has been taken from the impressive site.

TREFRIW WELL AND SPA *From the A470, 4 miles north of Betws-y-Coed, a short distance on the B5106, Conwy Valley, Conwy LL27 0NQ.* Two Roman roads meet here, and Romans of the XX Legion based at nearby Canovium tunnelled into a mountain, after finding find mineral-rich waters bubbling up from a fissure in the rocks. In 1833, the old Roman mineral water caves were excavated in an attempt to attract people to them. In 1863, Lord Willoughby de Eresby built a small bath-house and slate bath, replaced a decade later by the larger building. The Victorians laid on steamboats up the river from Conwy to take patients to the chalybeate spa's new pump room. In the nineteenth century Trefriw was also Wales' largest inland port, shipping out slate, sulphur and woollens at high water. The Victorian boom died away, but one can still buy the iron-rich spa water (trademarked Spatone) in liquid or dried form. Llywelyn the Great had a favourite hunting lodge here, and built the Church of St Mary in 1230 to save his wife Joan (Siwan) the steep walk up to LLANRYCHWYN Church.

TREFRIW WOOLLEN MILL Traditional Welsh bedspreads, tweeds and travelling rugs are manufactured here, and there is a visitor centre. It is one of the few remaining working mills of what was once an important Welsh industry. Originally a 'pandy' (fulling mill), it was located on the fast-running River Crafnant to use the water to drive the waterwheels and to wash the wool. The mill had been operating for over thirty years when it was bought by Thomas Williams in 1859, and is still owned and run by the same family.

TREGARON – ANCIENT MARKET TOWN *On the River Brenig, where the B4343 meets the A4845, Ceredigion.* In the Town Square is the eighteenth-century drovers' inn, the Talbot Hotel, on a thirteenth-century site. There is supposed to be an elephant buried in its garden. St Caron's Church is medieval, but was a Celtic foundation, and nearby Cors Caron (Tregaron Bog) is of international importance. There is a statue in the square of the pacifist MP Henry Richard of Tregaron (1812-88), who was known as 'Yr Apostol Heddwch' (The Apostle of Peace) in Wales. Rhiannon Welsh Gold Centre is a visitor attraction, with the widest range of stocks of Welsh gold in the world.

TREGINNIS PENINSULA – NATIONAL TRUST *South-west of St David's and opposite Ramsey Island (RSPB).* This is home to the oldest rocks in Pembrokeshire. Along the coast path at the tiny Porthclais is the RNLI's unusual St Justinian lifeboat station, where there is a funicular railway to carry equipment up and down the steep cliff. Porthclais Harbour was built in the twelfth century to serve St David's, but there are traditions that the sea wall is Roman. Porthclais is also supposed to be the landing place of the Twrch Trwyth, the legendary magical boar which swam from Ireland to confront King Arthur – this is probably a folk memory of the Irish settlements in the south-west of Wales. There are many ancient coastal mine workings around here.

TRELAWNYD (FORMERLY NEWMARKET) – ST MICHAEL'S CHURCH *Just off the A5151 Dyserth to Holywell road, Flintshire.* Trelawnyd is one of the ancient parishes of Flintshire, mentioned in the Domesday Book of 1086, with the church itself being first mentioned in the 1291 *Taxatio*. The church was rebuilt in 1724, and restored between 1895 and 1897. It is very small, being only 55 feet long by 19 feet broad, and has a medieval stone cross in the churchyard. The name 'Newmarket', now discontinued, dates back to 1700, when John Wynne of Y Gop obtained permission to change the

name. He had rebuilt most of the village, established several branches of industry, and set up a weekly market and an annual fair. The village and parish continued to be called Newmarket until 1954, when it was officially returned to its old name of Trelawnyd.

TRELAWNYD – GOLDEN GROVE GRADE I LISTED ELIZABETHAN MANOR

Llanasa, Holywell, Flintshire CH8 9NA. Tel: 01745 854452. Set in 1,000 acres of pasture and woodland, there is evidence of settlement here going back to Neolithic times. The house is now a hotel, and was mentioned in the Domesday Book as Ulversgrave, which may have meant 'Wolves Grove'. The manor was built by Sir Edward Morgan, an official at the court of Elizabeth I. The house was occupied continuously by the Morgan family from 1578 until 1877.

TRELAWNYD – GOP CAIRN AND CAVES – THE SECOND BIGGEST ARTIFICIAL MOUND IN BRITAIN AFTER SILBURY HILL

This enormous cairn-mound is 820 feet above sea level, and still stands 46 feet tall. The limestone blocks were placed in the oval mound about 3,000 BCE. The Gop was formerly known as Kopraleni and Copperleiny, 'the hill summit of Leni'. However, it may be 'Copa'r goleuni' meaning 'the summit of light' (reflected from the limestone). Perhaps white quartz was used as facing stone here, as at Newgrange in Ireland. It could also mean 'the summit of Paulinus', referring to Suetonius Paulinus. Local tradition maintains that he defeated Boadicea here in 61 CE, and it is the sighting place of the ghosts of marching legionaries and Boadicea's chariot. She is also said to be buried here or nearby. Further down the hill are caves used by the people of the New Stone Age, who built the cairn. Burials here date from 6000 BCE, and it is the largest prehistoric monument in Wales.

TRELLECH CASTLE *On the B4293 Chepstow to Monmouth Road, Monmouthshire.* Also known as Tump Terrett Castle, a Norman town was planted by the de Clares next to it. The motte is still 20 feet high.

TRELLECH LOST CITY This is claimed to have been once Wales' largest urban centre, and is presently being excavated. A Manor House with two halls and a courtyard, enclosed with curtain walls and a massive round tower 20 feet across has been discovered. The buildings discovered seem to date from 1300, when the town was reorganised and built in stone, after the attacks by both English and Welsh forces in the previous decade. In 1288, the population of Trellech was larger than that of Chepstow or Cardiff. In the fourteenth century it was the eighth largest town in Wales.

TRELLECH (TRELECH) – ST NICHOLAS CHURCH The medieval St Nicholas' Church in Trellech was endowed by Kings Ffernwael ap Ithel and Meurig ap Tewdrig in the sixth century. The church has a remarkable 1689 sundial showing the Virtuous Well, Harold's Stones and Trellech motte. It is a large and splendidly decorated Gothic church, built after a fire destroyed its predecessor in 1296. The third Earl Russell, the pacifist mathematician and founder of CND Bertrand Russell (1872-1970), was born in Trellech. He has been called 'the 20th century's most important liberal thinker, one of two or three of its major philosophers and a prophet for millions of the creative and rational life'.

TRELLECH STANDING STONES – HAROLD'S STONES AND THE 'VIRTUOUS WELL' The village of Trellech takes its name (tri=three, llech=flat stone) from the three tall Bronze Age stones set in a field close to the Monmouth to Chepstow road, standing in a line 39 feet long. There was a fourth stone, destroyed in the eighteenth century, and they align with Skirrid Mountain, 'the Holy Mountain of Gwent'. The stones may once have been part of an ancient large avenue. There are three legends attached to them: they were placed by Harold to celebrate a victory of the Saxons over the British; they mark the spot on which three chieftains fell in battle with the Roman Harold; and the stones were flung or thrown from Ysgyryd Fawr (Skirrid Mountain), fourteen miles away, by a mythical giant or by the magician Sion Cent. These large monoliths of 'pudding stone' are south of the village. The 'Virtuous Well', also known as St Anne's Well, is east of the village and possessed curative properties.

TRELYSTAN – ST MARY'S CHURCH *On the south of Long Mountain, 3 miles south-east of Welshpool.* On a hilltop, an isolated location, surrounded by ancient yews, this is the only early completely timber-built church in Wales. The recorded history of the church goes back to the early eleventh century, but the first use of the site is thought to be even earlier. The original churchyard boundary is defined by a low circular bank still remaining about 3 feet high, within the present churchyard, and the church seems to be situated on an artificial mound. The known history of the site goes back to 'Edelstan the Renowned' who died in 1010 and was buried in 'Chappel Trest Elestan'. In the Domesday Book it appears as 'Ulestanesmunde' in the Hundred of 'Witenrau'. The original fifteenth-century timber frame survives, although now encased in nineteenth-century white-rendered brick and black timbers. It retains its fifteenth-century arch-braced roof, and the interior is an essay in pitch-pine timber.

TREMADOG – GEORGIAN PLANNED TOWN *On the A487, just north of Porthmadog, Meirionydd.* This is an exceptionally fine example of a planned town, founded by William Alexander Madocks, who bought the land in 1798. The historic centre of Tremadog was complete by 1811, and it remains substantially unaltered. After building embankments to create PORTHMADOG, by 1805 the first cottages for workers were built in what he called Pentre Gwaelod (Lower Village). The most important part of the town was the Market Square. The High Street and Dublin Street form the cross street at the top of the square, lined by the most significant buildings. These are the Town Hall and Dancing Room built in 1805, and the Coaching Inn. The Town Hall (now Siola shop) sits on a plinth of steps. Peniel Chapel of 1809 is unusual as most chapels of that time were very simple, but this is in the style of a Greek temple, the impressive portico being added in 1849. St Mary's Church is one of the earliest Gothic Revival churches in Wales dating from 1811. Madocks' vision for the town included industry, and in 1805 he built the Manufactory. It became the site for one of the first woollen mills in Wales where carding and spinning were powered. Beside the mill was the Loomery, where weaving took place. This building remains and was used from 1835 as a Tannery. Many gentlemen's villas were built in the area. Tan-yr-Allt was Madocks' own home. In order to finance the construction and then the repair of the Cob at Porthmadog, Madocks mortgaged all his properties and let his own house in Tremadog. His first tenant was the poet Percy Bysshe Shelley. Unfortunately, Shelley antagonised local residents and ran up debts with local merchants. He departed hastily after an alleged attempt on his life by a nocturnal intruder at Tan-yr-Allt, without paying his rent or contributing to the fund set up to support Madocks. T. E. Lawrence, 'Lawrence of Arabia', lived as a child at the property now known as Lawrence House, in Church Street.

TREOWEN – EARLY SEVENTEENTH-CENTURY GRADE I LISTED HOUSE *Just north of Dingestow, off the A40, 3 miles south-west of Monmouth, NP25 4DLA.* Treowen was probably built in 1627 by William Jones, after he inherited a fortune from his uncle, a London merchant. Not long afterwards the family added the beautiful storeyed porch on the south front with the Jones shield of arms and a gable embellished with strapwork. Charles Heath wrote in 1787 that its 'staircase two yards wide, of seventy-two steps, with balustrades, the newels on the quarterspaces two feet round, the whole in solid oak, which still remains perfect, stands unrivalled in the Kingdom'. There is a priest's hole, panelled rooms, galleries, a Great Chamber, and the house can be rented out, sleeping up to thirty people.

TRETOWER CASTLE CADW *On the A479, 3 miles north-west of Crickhowell.* Tretower Court and Castle were closed to the public from 2008 to spring 2010, while an ambitious programme of investigation and conservation work took place. This included extensive repairs to the roof, considerable refurbishment of the interiors and a new interpretation centre for visitors. An early motte and bailey here had a stone keep added in the mid-twelfth century, further fortified in the thirteenth century. There is a circular tower inside the remains of the original shell keep. It belonged to the Herberts and then the Vaughans.

TRETOWER COURT CADW - THE MOST EXTENSIVE MEDIEVAL HOUSE IN WALES A late medieval defended house, it was the successor to the nearby castle, from the fourteenth century onwards. This marvellous restored courtyard house was rebuilt by Sir Roger Vaughan in the fifteenth century. Magnificent timberwork survives in the northern and western ranges, with later Classical-style windows dating to the 1630s. There is a small recreated fifteenth-century garden.

TREFECA - HOME OF HOWELL HARRIS *Coleg Trefeca, Trefeca, Brecon LD3 0PP on the B4560 between Talgarth and Llangors, Breconshire*. Trefeca (also Trefecca, Trevecca and Trevecka) was the home of Howell Harris (1714-73), who, with Daniel Rowland and William Williams, led the Welsh Methodist Revival from the conversion of Rowland and Harris in 1735. The Countess of Huntingdon in 1768, established her theological seminary near Trefeca. In 1750, Harris withdrew from preaching to Trefeca where in 1752, he formed Teulu Trefeca (the Trefeca Family), a remarkable experiment in communal living. The additions to his family house were in a very unusual Gothic style, one of the first examples in Wales, completed by 1772. In 1842, the property was handed over to the Welsh Calvinistic Methodists, and in 1872, a Harris Memorial Chapel was added. It is now a listed building, a Lay Training Centre owned by the Presbyterian Church of Wales, and there is a small museum here.

TREVOR HALL - GRADE I GEORGIAN HOUSE *Near Llangollen, Denbighshire. Tel: 01978 810505*. The site is known to be the home of John Trevor, the Bishop of St Asaff who built Llangollen Bridge in 1345. The house was largely reconstructed to its present form around 1742 onwards. It has a handsome, three-storey red brick façade with stone string courses, quoins and a pedimented doorcase, approached by a double flight of steps. The interior plan of the house consists of a medieval H-plan layout, with a grand entrance hall containing a beautiful cut-stone chimney piece on the rear wall. Its scarcity in Wales as an early Georgian brick house gives it Grade I listed status. It has been restored after a severe fire, and can be hired. The estate stretches for eighty-five acres of ancient woodland and includes a stretch of the Offa's Dyke Path. The hall is associated with a contemporary complex of earlier domestic and farm buildings at Trevor Hall Farm, and with the earlier eighteenth-century Trevor Chapel.

TREWERN HALL - TUDOR HALL-HOUSE *4 miles north-east of Welshpool, off the A458 SY21 8DT*. A Grade II listed building, considered an important black and white timber-framed house with four gables. There is a later date of 1610 on the porch of this 1560s hall house in private ownership.

TRYWERYN - SITE OF WELSH PROTESTS *North-west of Bala, in the Afon Tryweryn Valley*. The drowning of Welsh valleys to supply water to England caused a major dispute when Llyn Celyn was built, along the Tryweryn River, to supply Liverpool and Cheshire. In 1965, the valley of Cwm Tryweryn, and the village and chapel of Capel Celyn, were destroyed. A simple slate memorial was erected in 1971 commemorating those resting in the graveyard. Faded graffiti, 'Cofiwch Dryweryn' ('Remember Tryweryn') can still be seen in parts of Wales. Capel Celyn was drowned to satisfy the water needs of Liverpool, despite the fact that water from a valley of a tributary of the Tryweryn could have been taken without destroying any homes. All sixteen farms had Welsh names and Welsh owners. All the people of the doomed village marched through Liverpool, all Welsh MPs except one voted against the Bill in the House of Commons, but the English Parliament voted by 175 votes to 79 in 1979 to kill the community. Five hundred members of Plaid Cymru, led by Gwynfor Evans, badly disrupted the reservoir opening ceremony in 1965, but Capel Celyn is rotting beneath the waters. There were massive protests against Tryweryn including sabotage by Emyr Llywelyn Jones, an Aberystwyth student. Six members of the Free Wales Army were imprisoned four years after its opening in 1965, and given gaol sentences of fifteen months for alleged 'conspiracy' against the building of the biggest dam in Wales, Llyn Celyn. Welsh MPs could not stop any of these reservoirs being built via compulsory purchase. The City of Liverpool in 2005 officially apologised for flooding Tryweryn in 1965. The statement acknowledged the 'hurt of 40 years ago' and 'insensitivity by our

predecessor council'. Liverpool no longer needs the water as its industry has vanished. Would it not be wonderful if Llyn Celyn was drained and the valley reinstated to act as a monument to the wanton destruction of an environment and culture? In 1966, a bomb exploded on the Clywedog Reservoir site near Llanidloes, delaying work by eight weeks, and John Jenkins was later imprisoned.

TWMBARLWM HILLFORT AND CASTLE *The summit of a mountain spur rising above Risca, north of Newport, Monmouthshire.* Twmbarlwm is enclosed by ramparts with a great castle mound or motte 27 feet high, set at its eastern end. These are the remains of a medieval castle, set within an earlier hillfort. At its base is a deep ditch, rock-cut in places. The hillfort itself has a high rampart fronted by a ditch and counterscarp bank, set out to take advantage of the natural slopes.

TWMPATH CASTLE *To the north of Rhiwbina, in the north of Cardiff, Glamorgan.* This is still to be seen, but a similar motte and bailey at nearby Whitchurch was levelled very recently for the temporary boxes which pass for today's housing. King's Castle in Cardiff similarly disappeared, but in supposedly less enlightened times. Twmpath Castle is associated with Iestyn ap Gwrgan, the last Welsh Lord of Glamorgan. The Rhiwbina Twmpath is flat-topped and about 20 feet high, with a ditch. A medieval ridge and furrow system can be seen alongside it. It was probably rebuilt by Normans to resist attacks of the Welsh coming down the Cwm Nofydd pass, one of the routes to the hills that lie to the north of Cardiff. The Twmpath is one of nine known mottes that swept across the north of Cardiff, forming an eight-mile arc between two Cardiff rivers, the Ely and the Rhymni. The other mottes are at Treoda and Castell Coch, which are known to have been medieval manors, and Felin Isaf, Morganstown, Ruperra, Tomen-y-clawdd, Gwen-y-domen and the demolished one at Whitchurch.

TWYN Y BEDDAU, BATTLE OF *About two miles from Hay-on-Wye.* Twyn y Beddau means 'mound of the graves', and the spot is said to mark the site of a battle between Edward I and the Welsh. The Dulas River is said to have run with blood for days afterwards.

TŶ BACH – PRINCESS ELIZABETH'S LOO When the little thatched cottage, which now stands in Windsor Park, was built for the then Princess Elizabeth's sixth birthday, it was originally proposed to name it Tŷ Bach. Someone with knowledge of Welsh, probably its thatcher from the Vale of Glamorgan, must have altered it to became 'Y Bwthyn Bach' (the Little Cottage). Most Welsh houses used to have no internal toilet, but a small building in the garden. It was referred to as the Tŷ Bach - little house, and people still use the phrase when asking where the toilet is. On the other hand, many Welsh villages had a Tŷ Mawr nearby – a Great House – where the local gentry lived.

TŶ ILLTUD LONG BARROW CADW *Near Llanfrynach and Llanhamlach, Breconshire.* This measures 80 feet by 60 feet, is 5 feet high and has a megalithic chamber and forecourt. There are incised carvings on the internal faces of all of the uprights of the chamber. These consist almost entirely of small crosses, some of them enclosed with stars, lozenges, and some with crosslets at the end of their arms. On the stone at the rear of the chamber is what appears to be a five-stringed lyre of a Roman type. The carvings may be prehistoric, but some of the crosses are of a seventh-to tenth-century type which would fit with the tradition that the site was used by sixth-century St Illtud and became a cult centre. Giraldus Cambrensis wrote of Illtud's topographical features around Llanhamlach, including this Neolithic chambered tomb called Illtud's House, an upright stone which formerly stood nearby called Maen Illtud ('Illtud's stone), and a holy well known as Ffynnon Illtud. Gerald relates the story that the mare that used to carry the hermit's provisions was mated by a stag, a union resulting in 'an animal of wonderful speed, resembling a horse before and a stag behind'.

TŶ MAWR STANDING STONE CADW Near Holyhead, Anglesey. This is an isolated standing stone some 9 feet tall, probably of Bronze Age date.

TÝ NEWYDD BURIAL CHAMBER CADW *Near Rhosneigr, heading north from Barclodiad y Gawres, turn left off the A4080; it is a short distance on the right, on the Llanfaelog to Bryngwran road, Anglesey.* The capstone of this Neolithic chambered tomb may have been much larger and the whole monument once covered by a round cairn.

TYWYN – CHURCH OF ST CADFAN *On the A494 on the coast of the Snowdonia National Park.* Tywyn is the home of the Talyllyn Railway, built in 1865 for the slate trade. The quarries closed in 1947. St Cadfan's Church in Tywyn was founded in the sixth century and possesses St Cadfan's Stone, its seventh-eighth-century inscription being the oldest existing example of Welsh writing. This gives strong support to Welsh being Europe's oldest living language. Medieval Romanesque arches survived Victorian restoration, as did two medieval effigies. St Cadfan's is a cruciform monastic church and the massive double-aisled nave is original twelfth century. The 5-foot-high Cadfan or Nitanam stone was found in the early seventeenth century close to the church. The stone had been used as a gatepost and was broken in two, before being brought to the church in 1761. The inscription is written vertically on all four sides, reading both downwards and upwards. It is of major importance as it is the only inscription in Welsh among the early stone monuments of Gwynedd, and is the earliest record of the Welsh language as it emerged as a distinctive form of British Celtic. The inscriptions have been variously translated as 'the body of Cingen ... lies beneath ... the tomb ... four ... Egryn, Mallteg, Gwaddian ... together with Dyfod and Marciau'. It seems that the stone marks the grave of Cyngen and invokes the protection of local saints such as Egryn (Llanegryn), Mallteg (Llanfallteg) etc. A Cyngen is remembered on the Pillar of Eliseg, the last King of Powys, and Westwood believes that Cyngen was Cadfan's uncle and is buried here. Some read the inscription as 'Ceinrwy wife of Addian (lies here) close to Bud (and) Meirchiaw: Cun, wife of Celyn: grief and loss remain: the memorial of four: this is a memorial of the three'. Celynin was a saint of Meirionydd and Caernarfon remembered in Llangelynin. Another reading replaces Gwaddian with Gwyddion, and there is a Llanwddin in Caernarfonshire and a Llanwddyn in Montgomery commemorating that saint.

USK CASTLE *Just north of the town, overlooking the main square. Usk is on the A472, just off the A449 between Newport and Raglan, Monmouthshire.* It is thought to have been founded, with the town, about 1120. The Great Keep, originally the Gate House, was the work of Richard de Clare around 1170, who also gave Usk its first Charter and who founded Usk Priory. Known to history as 'Strongbow', he killed his son for cowardice in battle. There may have been a previous wooden motte and bailey castle, built by William the Bastard's standard bearer at Hastings. The keep was briefly in the hands of Hywel, Welsh prince of Caerleon, who was killed by Henry II's forces during its recapture. It was recaptured by the Welsh in 1138, and again in 1174, although it had been strengthened by Richard de Clare. The Normans retook it in 1184. The Earl of Pembroke, William Marshal, strengthened the castle in 1212-13, but it was captured by Henry III from Richard Marshal in 1233. Glyndŵr burnt the town in 1402 and 1405 but it is thought that the castle was not taken. It is open to the public every day.

USK ROMAN FORT Burrium was built around 54 CE to the south of the town known as Brynbuga (Usk). The town lies above it, and it was built with four gateways, a ditch and a bank for protection against the Silures. The Romans then moved their main fort to Caerleon in 75 CE as the river was not navigable for supplies by sea, and the valley was subject to flooding. It was a huge site stretching from the Priory to beyond where Usk Prison now stands, a base for a legion of 5,000 at a time when the Usk River probably marked the edge of the Roman Empire. When the legion and frontier had moved on, a much smaller base was built within the remains of the great fortress, and a civil settlement was established.

USK ST MARY'S PRIORY CHURCH This was a Benedictine priory church for nuns, founded by Richard de Clare in the 1160s. It has a large Norman tower, Gothic arches, a Norman font, a

fifteenth-century rood screen, an ancient oak chest which held the parish records and an organ which came from Llandaff Cathedral in 1899. The plaque commemorating Adam of Usk (d. 1430) may be the oldest epitaph in Wales, written by him and seen written in Welsh on a brass strip – it is difficult to interpret, but one derivation is 'From fame to a grave above, the strip (comes) / An advocate, the fullness of London. The world's Judge, by right of appeal, to thee / Grant heaven, the house of songs (?) The wisdom by Solomon cogitated / With it Adam of Usk was invested; With him he brought concord, discreet doctor, / A torch full bright he lit in the world of letters.'

VALLE CRUCIS ABBEY, ABATY GLYN Y GROES CADW *Near Llangollen - take the B5103 from the A5, west of Llangollen, or the A542 from Ruthin.* It is named Valley of the Cross because of the nearby Eliseg's Pillar, and was a Cistercian daughter house to Strata Marcella. Its founder was Prince Madog ap Gruffudd Maelor in 1201. Valle Crucis was damaged by English forces in Edward's invasion of 1276-77. It is recorded that the Black Death cut down the numbers of lay brothers and choir monks. The extensive remains date from the thirteenth century, and the east range of the cloister was remodelled around 1400. Many original features remain, including the glorious west front complete with an elaborate, richly carved doorway, beautiful rose window and fourteenth-century inscription 'Abbot Adams carried out this work; may he rest in peace. Amen'. Other well-preserved features include the east end of the abbey, which overlooks the monks' original fishpond, and the Chapter House with its striking rib-vaulted roof. There is a fine collection of medieval memorial sculpture.

VAN LEAD MINE *Van Mine, Brynlludw, Y-Fan, Llanidloes SY18 6NP. Tel: the owners Norman & Rita Roberts at 01686 413766.* The biggest and most successful of the lead mines around Llanidloes was 'the Van'. This site had been worked by different mining companies in the 1850s, but in 1865 a rich seam of lead was found. By 1876 it was producing thousands of tons of lead for piping, roofing, paint manufacture and other uses. As the mine workings needed more and more workers, a new village, Y Fan (Van) was created with its own school and chapels. The mines closed and reopened at various times, but by 1910 what had once been the largest lead mine in Britain was failing, and it closed completely in 1921. As the jobs disappeared the village lost most of its people and many of the buildings became derelict. At the site of the last mine workings, the steam-powered production uphaul and pumping facilities, built from about 1870, and two factory chimneys can still be seen. In the valley below are some remains of the lead and silver extraction site.

WATER Llyn Llawddyn was Wales' first reservoir, built in the 1880s as the biggest man-made lake in the world. In the 1890s, Birmingham bought the Claerwen and Elan valleys, damming them to make huge reservoirs such as Lake Elan, opened in 1904. Claerwen reservoir is leased for 999 years to the Midlands for 5 pence a year. Birkenhead created Alwen Lake in 1907. Trywerin and Clywedog were dammed, destroying ancient Welsh-speaking communities, despite massive opposition. In 1966, a bomb exploded on the Clywedog Reservoir site, delaying work by eight weeks, and John Jenkins was imprisoned. Capel Celyn village and the Tryweryn Valley outside Bala had been drowned in 1965 to supply Liverpool. Welsh MPs could not stop any of these reservoirs being built via compulsory purchase. Because of continuing shortages in the south-east of England, there are plans to divert water from the Severn and Wye into England. The third biggest river in England and Wales, after the Welsh Severn and Wye rivers, the Trent, has had no reservoirs built on it.

WAT'S DYKE *East of Offa's Dyke lies the earlier Wat's Dyke, a double ditch and embankment running from Basingwerk Abbey near Holywell to Welshpool, via Buckley, Hope, Llay, Wrexham, Ruabon and Oswestry.* This is a forty-mile earthwork running from Basingwerk Abbey on the Dee Estuary, east of Oswestry and to Maesbury in Shropshire's Severn Valley, generally parallel to OFFA'S DYKE, sometimes very near, and never more than three miles apart. The precursor to the eighth-century

Offa's Dyke, it was probably built as a border between Wales and England. The successes of King Elisedd (ELISEG'S PILLAR) of Powys seem to have led the Mercian King Aethelbald, who ruled from 716-57, to build the dyke. (He was followed in power by Offa.) This may have been with Elisedd's agreement, for the boundary gave Oswestry (Croesoswallt) to Powys. Old legends say that the areas between Wat's and Offa's Dyke were a sort of 'No-Man's-Land', where Saxons and Britons met to trade. The ditch is on the western side of the bank, meaning that the dyke faces Wales, so it can be seen as protecting the newly gained English lands. The placement of the dyke also shows that care was taken to provide clear views to the west, and to use local features to the best defensive advantage. It is less well-preserved than Offa's Dyke, being mainly ploughed out, sometimes appearing as a raised hedgerow or crop-mark, but it is considered to be better made than the parallel dyke. The average depth of its ditch was 6 feet, the average width of the ditch was 20 feet, and the rampart width was around 28 feet with a height of 7 feet. There is dispute over its dating, as 1990s excavations near Oswestry showed Romano-British pottery and charcoal which has been carbon-dated to around 446, making it far earlier, perhaps an achievement of the post-Roman kingdom of the northern Cornovi. It seems strange that such remarkable monuments as these two huge dykes, of European significance, have stirred little major interest amongst historians and archaeologists.

WELSHPOOL, Y TRALLWNG – HISTORIC MARKET TOWN *Only 4 miles inside the border, where the A458 and A490 intersect, Montgomeryshire.* Welshpool's position in the Severn Valley led to its Welsh name, which means The Swampy Marsh. Its English name was Pool, but the name was altered in 1836 to avoid confusion with Poole in Dorset. It was the capital of Powys Wenwynwyn, after its royal family was forced to escape their court at Mathrafal in 1212. Y Trallwng has had a town market since 1263, holding the largest livestock sales in Wales, and the town is full of Georgian and earlier buildings. The town continues to have the largest one-day sheep market in Europe. The bailey of Dolmen, or Pool, Castle dates from 1196, and is now a bowling green. Another notable building is the six-sided cockpit built in the early eighteenth century. It was in continual use for cockfighting until it was outlawed in 1849, and is the only unaltered cockpit preserved on its original site in Britain. The town is also the starting point of the Welshpool and Llanfair Light Railway, a narrow-gauge heritage railway popular with tourists, and the Montgomery Canal runs through Welshpool. The old Cambrian Railway Station is an extravagant building, resembling a French chateau in style. It was designed to act as the railway company headquarters, although it only remained in this capacity between 1860 and 1862. It is now The Old Station Visitor Centre. The Powysland Museum & Canal Centre is in one of thirty canal warehouses which operated in the nineteenth century. The Red Lion Flannel Factory and Warehouse is one of a number of such factories in the town, indicating the importance of this industry in the nineteenth century. In the High Street are timber-framed buildings dating from the early sixteenth century, such as the Talbot Inn.

WELSHPOOL, THE BATTLE OF, 1400 Owain Glyndŵr's small force was said to have been defeated by Henry Burnell on the banks of the Severn, after they burnt Welshpool, but the circumstances are extremely obscure.

WELSHPOOL, POOL, DOLMEN CASTLE The motte and bailey are in the town, and were important before the mighty Powis Castle was built to the south. It may have been built in 1111 by Prince Cadwgan ap Bleddyn of Powys. Pool Castle was taken by the Normans in 1190, and retaken by Gwenwynwyn of Powys. His son Gruffudd plotted against Llywelyn II in 1174, and imprisoned Llywelyn's messengers. Llywelyn then destroyed the castle and placed his own men in Gruffudd's territories.

WELSHPOOL – THE CHURCH OF ST MARY AND ST CYNFELIN In 1411, the priest at the Church of St Mary and St Cynfelin was Adam of Usk. The church was founded by St Cynfelin during the fifth-to sixth-century *Age of Saints*, and is on steep sloping ground overlooking the town. It has a thirteenth-century tower with nave, north and south aisles, a chancel and organ chamber

representing several building phases from the fourteenth century onwards. As the family church for the Herberts of Powis Castle, it has fine memorials. Its reticulated traceries are rare in Wales, and its painted roof may have come from Strata Florida after the Dissolution. The area between this church site and the Norman motte and bailey castle, linked today by Mill Lane, was the first medieval settlement of Welshpool, established in the early twelfth century by the Normans.

WENTLOOG AND CALDICOT LEVELS – ROMAN RECLAMATION FROM THE SEA

The coastal area between Cardiff and Newport, and between Newport and Usk. Wales has regained land from the sea in the Gwent (Caldicot) Levels and Wentloog (Gwynlliwg) Levels, which make up the most extensive ancient fenland in Wales. The Wentloog Levels are protected from the massive tidal differences in the Bristol Channel by Peterstone Great Wharf, a huge bank of earth. Reens (straightened drainage ditches) cover this marshland between the mouths of the Taff and Usk rivers. When a high spring tide allies with a strong south-westerly wind, the sea can still come over the bank. The 1606-07 floods claimed hundreds of lives here, and the depth of the flood is marked by a plaque on the side of St Bride's Church at Wentloog. Nash and Goldcliff churches also have plaques recording the flood levels. These marshes were reclaimed by the Roman II Legion, possibly using slave labour. They also have strong Arthurian connections, but seem to be doomed by urban planners over the next twenty years. East of the Usk, the Caldicot Levels are marshland silt lying on top of peat, and changes in water levels have led to tilting buildings, for example Whitson Church. Much of the drainage here dates from medieval and probably Roman times. This unique ecological system of reeds, bulrushes and marsh birds is threatened by new housing and industry. These salt-marshes, reed beds, fenland, mudflats and reclaimed grassland are fascinating for the variety of wildlife so close to a built-up area.

WEOBLEY CASTLE CADW *Near Llanrhidian, Gower Peninsula SA3 1HB.* This is a picturesque medieval fortified manor house, with fine views across the Llwchwr Estuary, and its substantial remains date principally from the early fourteenth century. It was probably built around 1300, and was transformed into a defensive mansion by the great warrior Sir Rhys ap Thomas (1449-1525) around 1500. It is an unspoilt and wonderful site.

WHITE, GREY AND BLACK MONKS Fifteen abbeys and priories in Wales commemorate the Cistercian Order, the White Monks. The Grey Friars (the Franciscans) and the Black Friars (the Dominicans) had eight friaries in Wales by 1275. At this time, Llywelyn the Last had cordial relations with all these foundations, and the Cistercians commended him to the Pope in his dispute with the Bishop Anian of St Asaph. (In general, the Welsh and Cistercians/Franciscan had friendly relations, and the opposite was true of the Welsh and the Dominicans.)

WHITEFORD POINT LIGHTHOUSE *A mile offshore, off Whiteford Sands, in the Burry Estuary, a mile off the north-west tip of the Gower Peninsula.* The Whiteford Point Lighthouse of 1865 is a Scheduled Ancient Monument, and is Britain's only surviving iron-clad offshore lighthouse. The tower is 61 feet high and made up of eight courses of cast-iron plates. It was built for the harbours at Llanelli and Burry Port, which are now hardly used for commercial purposes.

WHITLAND ABBEY, ABATY HENDY-GWYN AR DÂF *Just north of the A40, north-east of Whitland, Carmarthenshire.* Whitland derives its English name from the white robes of the Cistercian monks. It was founded in 1140 by the Bishop of St David's. Cistercian monks came here from Little Trefgarn around 1155, and Whitland became the mother abbey to Cwmhir, Strata Florida and Strata Marcella. It was originally near Carmarthen but moved to Whitland in 1257, as the Norman lords of Carew and Cemais had stripped the abbey and killed its servants for supporting the Welsh in that year. It also suffered in Edward I's later invasion. Somehow the *Cronica Wallia*, the most valuable monastic chronicle of the period, escaped destruction. The Lord Rhys, Prince of Deheubarth, became its patron. It was at Whitland that Rhys' son, Maredudd, ended his days as a monk after he had been blinded by order of King Henry II, along with another

of Rhys' sons and two sons of Owain Gwynedd. The abbey constantly suffered for its support of the Welsh cause, and only low grass-covered walls remain.

WHITLAND – HYWEL DDA GARDENS AND INTERPRETIVE CENTRE *Just south off the A40, west of St Clears on the road to Canaston Bridge, Carmarthenshire.* These small gardens commemorate Hywel Dda. In 928, he made a pilgrimage to Rome and by 942 ruled over most of the country and claimed the title 'King of all Wales'. He then summoned representatives from each commote in Wales to an assembly at 'The White House on the Tâf in Dyfed' for the purpose of codifying the laws. Thus the original Welsh name of Whitland was 'Yr Hendy-Gwyn', the old white house. This superb legal system, the finest in the world for hundreds of years (this is not hyperbole), was in force in Wales until the Act of Union with England in 1536. The Memorial consists of six gardens, each representing a separate division of the law. The laws are illustrated on slate plaques illuminated with enamels, in brick pavements, and in the planting scheme based on Celtic tree symbolism. The gardens surrounding the Information Centre are planted with specimens symbolic of medieval Wales. Designs include artwork such as etched and stained glass, ceramics, iron work and enamels, which re-emphasise the Celtic tree symbolism of the gardens.

WISTON CASTLE CADW *5 miles east of Haverfordwest, south of Clarbeston Road, Pembrokeshire.* This well-preserved motte and bailey castle was probably begun by the Flemish settler, Wizo, before his death in 1130. Remains of a later stone shell-keep survive on his motte. It is one of the best-reserved motte and baileys in Wales, and one of only six to retain its shell-keep. Wiston was taken by Hywel ab Owain in 1147, and then in 1193 fell to Hywel Sais, the son of The Lord Rhys. Retaken by the Normans in 1195, Llywelyn the Great took it in 1220 and burnt 'Wizo's town'. It was then abandoned, but the remains of the stone keep are still impressive. It is on the site of an Iron Age settlement.

WORLD HERITAGE SITES UNESCO (United Nations Educational, Scientific and Cultural Organization) World Heritage Sites are places or buildings of outstanding universal value. Wales has three World Heritage Sites, the Castles and Town Walls at Caernarfon, Conwy, Beaumaris and Harlech (listed in 1986); the BLAENAFON Industrial Landscape (listed in 2000); and PONTCYSYLLTE Aqueduct (listed in 2009). The magnificent and well-preserved castles, with planned defended towns at Caernarfon and Conwy, are outstanding examples of medieval military architecture and planning. Beaumaris and Harlech were built by James of St George, the greatest military engineer of his day, as part of Edward I's campaign to conquer and rule the medieval principality of Gwynedd, and by extension, the rest of Wales. The development of coal mining and iron-making industries led to the world's first Industrial Revolution, and South Wales was the major producer of both in the nineteenth century. The area around Blaenafon contains well-preserved material evidence of the industries and the way of life of the people who worked in them: quarries, mines, furnaces, an early railway system, houses and public buildings.

WORTHENBURY – ST DEINIOL'S CHURCH *On the B5069 east of Bangor-on-Dee, south-east of Wrexham, Denbighshire.* For more than 600 years, life in the village of Worthenbury was dominated by the Puleston family, who were the squires of the nearby Emral Hall. A Grade I listed building, this is one of the finest examples of Georgian architecture in Wales. Built between 1736 and 1739, it was designed by Richard Trubshaw, the architect responsible for the remodelling of Emral Hall, (demolished in 1936). St Deiniol's was built with financial assistance from the Pulestons. The exterior is distinctive, in red brick with stone dressings, a fine square tower with a balustrade and urn finials, and the churchyard is fully enclosed by a brick wall with stone copes, and planted with lime trees. There is a triple-decker pulpit and a complete set of box pews, mainly from the eighteenth century, carrying the Puleston family crest. Two have cast-iron fireplaces, and they are arranged in descending order of social standing. On the east side is an armorial stained-glass window taken from the private chapel at Emral Hall. At the west end there are funeral hatchments of the Puleston family. The church is dedicated to St Deiniol, the son of Dunawd, the first Abbot

at Bangor, who died in 544. It was originally a chapel attached to Bangor-is-y-Coed, and first recorded in the fourteenth century.

WOODBURY HILL 1405 – THE FRANCO-WELSH INVASION OF ENGLAND *Near Stanford Bridge, opposite Abberley Hill, north of Worcester, Worcestershire.* This was the last invasion of England before Henry Tudor marched from Pembroke to Bosworth Field. Owain Glyndŵr and his French allies invaded England and sacked Worcester. They waited on Woodbury Hill for supporters to join, who resented Henry IV's usurpation of the English crown. After a few days, Henry IV's army retreated from Abberley Hill to Worcester but the Franco-Welsh army sacked his baggage train. Lacking support and an enemy to fight, Glyndŵr returned to Wales.

WREXHAM, WRECSAM – THE 'CAPITAL' OF NORTH WALES *Where the A534, A526, A5152 and A525 meet, between Oswestry and Chester, Denbighshire.* Wrecsam, near the border, is the most important town in North Wales, and its cattle sales made it a centre for leather-working. In the nineteenth century, the industries of brick-making, coal, steel and brewing helped it to prosper. Britain's first lager was made at the Wrecsam brewery, and Wrexham Lager was for many years the only draught beer available on British ships, normal beer spoiling at sea. This author had his first 'illegal' pint in the tiny thatched Horse and Jockey in Wrexham – Wrexham Lager was then 1s 4d a pint, or fourteen pints to the pound in old money.

WREXHAM – CHURCH OF ST GILES – THE GREATEST MEDIEVAL PARISH CHURCH IN WALES Its 136-foot Perpendicular tower is one of 'the Seven Wonders of Wales' and St Giles is considered the greatest medieval parish church in Wales. Inside, there is a ceiling adorned with sixteen colourful angels playing instruments and singing. There is a sixteenth-century wall painting of the Day of Judgment. One of the oldest brass eagle lecterns in Britain is here, together with fine stained glass, including a window attributed to Burne-Jones and many amusing medieval roof corbels and statues. The Royal Welsh Fusiliers have a chapel in the north aisle. The tomb of Elihu Yale, founder of Yale University, is just outside the west door. The son of a Wrexham man, he was born in America and made his fortune as Governor of Madras, settling back in Britain. In 1718, he made the contribution which set up the collegiate school of Connecticut, which became Yale University. The tower of Yale University's Chapel is based upon St Giles' Tower.

WREXHAM CATHEDRAL This Gothic Revival Roman Catholic church, designed by Pugin, was built in the mid-1850s by Richard Thompson, a local collier and iron master. It became the pro-Cathedral Diocese of Menevia when it was established in 1898. In 1987, it became the Cathedral Church of the newly created Diocese of Wrexham. A shrine to Saint Richard Gwyn (*c.* 1535-84) commemorates his martyrdom in Wrexham's Beast Market.

WREXHAM – MARCHWIEL – CHURCH OF ST DEINIOL AND ST MARCELLA *2 miles south of Wrecsam centre.* A Georgian building dating from 1778-79, containing several monuments to Yorke family of ERDDIG HALL, and some interesting stained glass. Wooden boards on the south wall of the tower staircase read, 'Parish of St Marcella, formerly called St Deiniol, originally part of parish of Bangor-is-y-Coed until *c.* 1535, at which time it became a Parish of itself. On the site where the present church stands was formerly a chapel called St Deiniol's belonging to the Monastery of Bangor-is-y-coed and after its demolition took the present name from materials of which the first church was built viz. strong twigs and mortar, march in Welsh denoting strength and gwiail meaning twigs. The said church was dedicated to St Marcella by Bishop Wharton September 5th 1537. Of its form we know nothing ...' There has been a church building on or near the current site since the thirteenth century. There is a beautiful stained-glass window depicting the Yorke family tree, and below this window outside the church is the family vault.

WRECSAM – MINERA LEAD MINES *Wern Road, Minera, Wrexham, LL11 3DU. Take the A525 travelling east from Wrexham, and turn left onto the B5426, Denbighshire.* There are derelict mine workings, a park and tourist centre, the site dating back to 1296, when Edward I hired miners from here to work his new mines in Devon. In 1845, the mines were modernised, using a Cornish beam engine, and became very profitable. By 1900, the price of lead and zinc had fallen dramatically, while the price of coal used for the steam engine rose. The stationary steam engine stopped work in 1909. The owners sold off the mines and all assets by 1914. The mines were restored and in 1990, the Engine House was rebuilt and fitted with replica machinery.

WYE VALLEY (Area of Outstanding Natural Beauty.) Afon Gŵy is the fifth longest river in the United Kingdom, passing through Rhayader, Builth Wells and Hay-on-Wye, but the area designated as an AONB surrounds only the seventy-two-mile stretch lower down the river, from just south of the city of Hereford to Chepstow. The Wye Valley witnessed the birth of British tourism in the eighteenth century. The area became more widely known following the publication of works by the poet Thomas Gray, and, in particular, *Observations on the River Wye* by the Reverend William Gilpin. Published in 1782, it was the first illustrated tour guide to be published in Britain, helping travellers locate and enjoy the most 'picturesque' aspects of the countryside. Regular excursions began to be established from Ross-on-Wye, the boat journey to CHEPSTOW taking two days. Some of the most famous poets, writers and artists of the day made the pilgrimage to the great sights of Goodrich, Tintern Abbey and Chepstow, such as Wordsworth, Coleridge, Thackeray and J. M. W. Turner. Wordsworth wrote the famous *Lines Written a Few Miles Above Tintern Abbey* in 1798. The first of Britain's great landscapes to be 'discovered', viewpoints were specially constructed, including the Kymin near MONMOUTH, with a round house giving panoramic views across the town. Another highlight for travellers was the cliff ascent and walks at Piercefield.

WYNNSTAY *Wynnstay Hall Estate, Overton Road, Ruabon, Denbighshire.* On the site of the great house of Madog ap Gruffydd Maelor, the founder of Valle Crucis Abbey, it became the seat of the famous Watkin Williams-Wynne family for centuries. As at Llanover Court, this family kept a harpist until the late nineteenth century. In the fifteenth century, it formed part of the estates of John ap Ellis Eyton, who fought at the battle of Bosworth, and whose tomb and effigy is in one of the Wynnstay Chapels in Ruabon Church. After a disastrous fire in 1858, the new mansion was built in the style of a great French chateau, taking six years to complete. Capability Brown laid out the estate, garden, lake and canal. During the Second World War Wynnstay was requisitioned by the military. In 1944, Watkin Williams Wynn became the 8th Baronet, but death duties were crushing. The family's huge estates, accumulated over centuries by inheritance, marriages or purchase, became badly depleted. Sir Watkin moved to a smaller house, Plas Belan, on the edge of Wynnstay Park, and in 1947 a three-day sale saw most of its furniture and effects sold off. The Llwydiarth estate in Montgomeryshire was sold, and the Glan Llyn estate in Merionethshire was also lost, accepted by the taxman in lieu (partially) of death duties. In 1948, Wynnstay itself, five cottages and about 150 acres of land were sold to Lindisfarne College, which closed in 1994, bankrupt. It has now been converted, with its estate buildings, into apartments. Many other great houses across Britain were not so successful in remaining intact after post-war punitive taxation upon large estates.

YNYSCYNHAEARN – CHURCH OF ST CYNHAEARN FOFC *At the end of a lane from Pentrefelin, on the A487 midway between Cricieth and Porthmadog, Llŷn Peninsula.* This is an 1832 rebuild, after the original church fell down. Little is known of St Cynhaearn, but he is pictured with a boat and an oar in one of the windows of the church. Until Llyn Ystumllyn was drained in the nineteenth century, the church was on an island rising above the waters of the lake with a small causeway leading to it. It may have been the site of a crannog, but has never been recorded as such. Just a rough track leads to the disused church, and the graveyard is the resting place of David Owen, the harpist and composer known as 'Dafydd y Garreg Wen', who died in 1749 at the age of twenty-nine. He wrote *The Rising of*

the Lark, on the hill between Borth-y-Gest and Pentrefelin where he fell asleep, woke up and wrote the song. Also in the graveyard is the slab of a black slave, brought to Pentrefelin by a sea captain in the eighteenth century. He became a servant at Ystumllyn House, which is visible across the fields from the church. He was known as Jack Ystumllyn, became a gardener on the estate, married a girl from Trawsfynydd and was finally given his own house. The best pews at the church still carry the names of the families of the estates and the great houses around it, tiered around the altar. On either side of the main aisle are the plainer pews, labelled by each estate, for the servants and farm workers. The nave is twelfth century, the north transept sixteenth century but it is the extraordinary late Georgian interior of 1832 which makes it so special. The church is listed Grade II*.

YNYS DEWI, RAMSEY ISLAND *It lies just off St David's Head, Pembrokeshire.* David's Island was the home of St Justinian, the confessor of St David, and is the third largest island in Wales after Anglesey and Holy Island. It has been a Royal Society for Protection of Birds sanctuary since 1992 and is a SSSI.

YNYS ENLLI (BARDSEY ISLAND) – 'THE ISLE OF 20,000 SAINTS' *Almost two miles off Aberdaron at the tip of the Llŷn Peninsula.* This has been an important religious site since saint Cadfan built a monastery in 516, and by the Middle Ages was an important place of pilgrimage across Europe. The monastery was destroyed in 1537, but the island, an important centre for wildlife, can still be visited. There are claims that King Arthur was buried here.

YNYS PADRIG *The most northerly point of Wales, off Anglesey.* Also known as Middle Mouse Island, it owes its Welsh name to the legend that St Patrick was shipwrecked there.

YNYS SEIRIOL, YNYS LANNOG, PUFFIN ISLAND, PRIESTHOLM *Off south-eastern Anglesey, near Penmon.* It is the site of a monastic settlement founded by St Seiriol in the sixth century. Puffins actually nest there, with razorbills and guillemots, and cruises are available from Beaumaris. Rats are becoming a problem for the birds that live in the burrows. Ynys Seiriol is a SSSI (Site of Special Scientific Interest) and covers seventy-eight acres. The rivalry between King Cadwallon of Gwynedd and King Edwin of Deira reached a climax, when Edwin invaded the Isle of Man and then Anglesey. Cadwallon was defeated in battle and then besieged on Puffin Island in 629, eventually fleeing to Brittany. The *Annales Cambriae* entry records 'The besieging of king Cadwallon in the island of Glannauc'.

YSPYTY CYNFFIN – CHURCH OF ST JOHN AND THREE STONE CIRCLES *Off the A4120, a mile north of Devil's Bridge, Ceredigion.* The small church at Ysbyty Cynfyn was a chapel of ease and may have been a possession of the Knights Hospitaller, a hospice for pilgrims to St David's. The church was rebuilt in 1827 on the site of the medieval building. Several standing stones built into the churchyard wall denote an embanked Bronze Age stone circle, and an early Christian site upon it. The tallest stone is 12 feet high and is known to be in its original position. Nearby is Hirnant Ring Cairn. Coming from Ysbyty Cynfyn drive back to Ponterwyd and turn left on the A44 then take the first right in just a few yards. Head up this mountain lane and pass a small reservoir on the left. After about a mile further you cross a small bridge by a farm. There are sixteen small stones, the tallest being around 2 feet tall in this small circle. A short distance to the north-east is a cairn. Further up the road about half a mile, just before where the rocky gorge starts, there is a second ring cairn with about twelve stones visible.

YSTRADFELLTE – MAEN LLIA STANDING STONE *A short distance from the minor road leading from Ystradfellte to Heol Senni, Breconshire.* This massive monolith stands on the moorlands on an isolated spot in the Brecon Beacon National Park. It is a large diamond-shaped slab of conglomerate, 12 feet high and 9 feet wide, but only 2 feet thick. It is likely that a quarter to a third of the stone is below ground. It lies at the junction of two valleys and its visibility from some distance suggests that it could possibly be a territorial marker or it could mark an ancient trackway across the watershed. In the 1940s, some faint Latin and Ogham inscriptions were still visible. A

legend says that whenever a cock crows, the stone moves off to drink in the River Nedd (Neath). Another tale tells us that the stone visits the River Mellte on Midsummer morning.

YSTRADOWEN (GWYR MAES), BATTLE OF, 1031 OR 1032 *North of Cowbridge on the road to Llantrisant, Glamorgan.* From A *Topographical Dictionary of Wales* by Samuel Lewis 1833: 'YSTRAD-OWEN, or YSTRAD-OWAIN, a parish in the hundred of COWBRIDGE ... Ithel, surnamed Du, or "the Black," Prince of Glamorgan in the tenth century, occasionally resided here; and this place is distinguished in the historical annals of the principality as the scene of a desperate battle between the invading Saxons and the ancient Britons under Conan ab Sytsylt, in the year 1031, in which that chieftain and all his sons were slain. It derives its name from Owain ab Collwyn, who resided here in a palace, of which the site is marked by a large tumulus near the church, now covered with a thriving plantation. In a field near the village were two large monumental stones, rudely ornamented, which were supposed to have been placed at the head of the graves of Owain ab Ithel and his consort, and thence called the King and Queen stones; but they have been removed for some time. Near the churchyard, in a field adjoining it on the west, there is a very large tumulus, of which not even any traditional account has been preserved. An annual assembly of the bards was held here for many years, under the auspices of the ancient family of Hensol, and the meetings were continued till the year 1721, when the male line of that house became extinct ...' The tumulus next to St Owain's Church is a Norman motte. The battle site is recorded on old maps in a field known as Gwyr Maes and dated 1032. Ithel Ddu lived *c.* 970-1041, and Cynan ap Seisyllt is recorded as dying in 1027, before the battle.

YSTRADOWEN MOTTE AND MEDIEVAL CHURCH A large Norman motte, 20 feet high and 75 feet in diameter, it has an incomplete ditch and traces of a bailey. It was attributed to the St Quentin family, who reputedly used the nearby Tal y Fan castle site later. The site was associated with druidical ceremonies up to 1721. Recorded as a possession of Tewkesbury Abbey in 1173, the church was completely rebuilt in 1865 on the site of an earlier medieval church. The circular churchyard is much older than the present church, which is mostly Victorian, as are the gate piers and gates, dating from the rebuilding of 1865-68.

YSTRAD RWNWS, BATTLE OF, 1116 *At the junction of the Rivers Tywi and Cothi.* In 1109, Prince Owain ap Cadwgan of Powys had seized Princess Nest from her husband, Gerald of Windsor. In 1115, Owain was knighted by Henry I for service in France. With a small force, he was on his way south from Powys, either to assist in a new Welsh rebellion or to help put it down for the king. Gerald's Normans ambushed him and he was killed, with Nest returning to her husband. *The Book of Taliesin* records: 'By a tragic chance the Dragon fell, in the treacherous butchery of Ystrad Rwnws, and it was a joy to his attackers'. Maenor Brunus is mentioned in the twelfth-century *Llandaff Charters*, with a chapel at Llandeilo Rwnws on the banks of the Tywi and another near Pontargothi.

References

Primary Sources
Terry Breverton *An A - Z of Wales and the Welsh* (Christopher Davies 2000)
Terry Breverton *The Book of Welsh Saints* (Glyndŵr Publishing 2000)
Terry Breverton *The Welsh Almanac* (Glyndŵr Publishing 2002)
Terry Breverton *100 Great Welshmen* (Glyndŵr Publishing 2001, new edition 2006)
Terry Breverton *100 Great Welsh Women* (Glyndŵr Publishing 2001)
John Davies *A History of Wales* (Allen Lane/Penguin 1993 hardback)
Gwynfor Evans *Land of My Fathers - 2000 years of Welsh history* (Y Lolfa 1992)
Gwyn Alf Williams *When Was Wales* (Penguin 1991 paperback)
John May (compiler) *Reference Wales* (University of Wales Press 1994)
The Rough Guide to Wales (1995 paperback)
Jan Morris *The Matter of Wales* (Penguin 1984 paperback)

Secondary Sources
Terry Breverton *The First American Novel - The Journal of Penrose, Seaman and The Author, The Book and Letters in the Lilly Library* (Glyndŵr Publishing 2007)
Terry Breverton *Glamorgan Seascape Pathways* (Glyndŵr Publishing 2003)
Terry Breverton *The Secret Vale of Glamorgan* (Glyndŵr Publishing 2000)
Terry Breverton *The Book of Welsh Pirates and Buccaneers* (Glyndŵr Publishing 2003)
Terry Breverton *The Illustrated Pirate Diaries* (Harper Collins 2008)
Terry Breverton *Black Bart Roberts - the Greatest Pirate of Them All* (Glyndŵr Publishing 2004)
Terry Breverton *Admiral Sir Henry Morgan - the Greatest Buccaneer of Them All* (Glyndŵr Publishing 2004)
Terry Breverton *The Pirate Handbook* (Glyndŵr Publishing 2004)
Phil Carradice and Terry Breverton *Welsh Sailors of the Second World War* (Glyndŵr Publishing 2007)
Ron Rees *Heroic Science - Swansea and the Royal Institution of South Wales 1835-1865* (Glyndŵr Publishing 2005)
Gideon Brough *Glyndŵr's War - the Campaigns of the Last Prince of Wales* (Glyndŵr Publishing 2002)
Maxwell Fraser *Wales Volume I: The Background* and *Wales Volume II: The Country* (Robert Hale — County Books series 1952 hardback)
W. J. Gruffydd *Folklore and Myth in the Mabinogion* (University of Wales Press 1950 pamphlet)
Robin Gwyndaf *Chwedlau Gwerin Cymru - Welsh Folk Tales* (National Museums & Galleries of Wales 1995 paperback)
John Humphries *The Man from the Alamao - Why the Welsh Chartist Uprising of 1839 Ended in a Massacre* (Glyndŵr Publishing 2004)
John Humphries *Gringo Revolutionary - The Amazing Story of Carel ap Rhys Price* (Glyndŵr Publishing 2005)
David Stephenson *The Last Prince of Wales* (Barracuda 1983 hardback)
Elisabeth Beazley and Lionel Brett *North Wales* (a Shell Guide published by Faber in 1991)
Ralph Maud *Guide to Welsh Wales* (Y Lolfa 1995)
J. Graham Jones *A Pocket Guide to the History of Wales* (University of Wales Press 1990)
David Rees *The Son of Prophecy: Henry Tudor's Road to Bosworth* (Black Raven 1985)
James A. Williamson *The Tudor Age* (Longmans 1964)

William T. Palmer *Odd Corners in North Wales* (Skeffington 1948)

Frank Delaney *Legends of the Celts* (Harper Collins 1989)

Alice E. Williams *A Welsh Folk Dancing Handbook* (The Welsh Folk Dance Society)

Huw Williams *Welsh Clog/Step Dancing* (bought in the Museum of Welsh Life – no publisher indicated)

Dr Peter N. Williams *From Wales to Pennsylvania – the David Thomas Story* (Glyndŵr Publishing 2002)

R. R. Davies *The Revolt of Owain Glyn Dwr* (Oxford University Press 1997)

The Ordnance Survey Guide to Castles in Britain (1987)

Barbara W. Tuchman *A Distant Mirror: the Calamitous Fourteenth Century* (Penguin 1978)

J. Romilly Allen *Celtic Crosses of Wales* (J.M.F. 1978 reprint)

Mark Valentine *Arthur Machen* (Seren 1995)

Dee Alexander Brown *Morgan's Raiders* (Smithmark USA 1995)

Joseph McElroy *Jefferson Davis* (Smithmark USA 1995 reprint)

Alan Roderick *The Dragon Entertains – 100 Welsh Stars* (Glyndŵr Publishing 2001)

Norman Davies *Europe – a History* (Pimlico 1997)

Charles Kightly *A Mirror of Medieval Wales: Gerald of Wales and His Journey of 1188* (Cadw 1988 hardback) – coffee-table quality at a soft-back price, a description of not just the journey, but of Gerald of Wales (translated by Lewis Thorpe)

The Journey through Wales/The Description of Wales (Penguin Modern Classics 1978)

David Parry-Jones (editor) *Taff's Acre – a History and Celebration of Cardiff Arms Park* (Willow 1984)

Eiluned and Peter Lewis *The Land of Wales* (B. T. Batsford 1949)

Alun Richards *A Touch of Glory – 100 Years of Welsh Rugby* (Michael Joseph 1980)

Phil Carradice *The Last Invasion: the story of the French landing in Wales* (Village Publishing 1992)

Gwyn Williams *Presenting Welsh Poetry* (Faber 1959)

Islwyn Jenkins (editor) *The Collected Poems of Idris Davies* (Gomerian Press 1993)
Michael Senior *Portrait of South Wales* (Robert Hale 1974)

David L. Williams *John Frost: A Study in Chartism* (Augustus M. Kelley, New York 1969)

David Blamires *David Jones: Artist and Writer* (Manchester University Press 1978 paperback)

Dafydd ap Gwilym (translated by Rachel Bromwich) *Selected Poems* (Penguin 1985)

Mark Redknap *The Christian Celts: Treasures of late Celtic Wales* (National Museum of Wales 1991)

Aneirin *Y Gododdin* (Gomer Press 1990)

Trefor M. Owen *A Pocket Guide to the Customs and Traditions of Wales* (University of Wales Press 1995)

Tony Conran (translator) *Welsh Verse*

Peter Sager (translated by David Henry Wilson) *Pallas Guide: Wales* (Pallas Athene 1991)

Automobile Association and Wales Tourist Board *Castles in Wales* (hardback 1982)

Chris Barber and David Pykit *Journey to Avalon: The Final Discovery of King Arthur* (Blorenge 1993)

Unknown *Britannia after the Romans, being an attempt to illustrate its Religious and Political Revolutions* – Only 250 copies were printed, at a price of 20 shillings in 1836.

J. A. Brooks *Ghosts and Legends of Wales* (Jarrold 1987)

D. M. and E. M. Lloyd (editors) *A Book of Wales* (Collins 1953)

Dylan Thomas *The Collected Poems* (New Directions USA 1957 hardback)

Meic Stephens (editor) *A Book of Wales – an Anthology* (J. M. Dent & Sons 1987)

R. S. Thomas *Selected Poems 1946-1968* (Hart-Davis, MacGibbon 1973)

Dafydd Jenkins (editor) *Hywel Dda; The Law* (Gomer Press 1990)

Herbert Williams *Davies the Ocean: Railway King and Coal Tycoon* (University of Wales Press 1990)

George Borrow *Wild Wales* (Dent Everyman 1939)

A. O. H. Jarman & Gwilym Rees Hughes *A Guide to Welsh Literature – Volume I* (University of Wales Press 1992)

Charles Squire *Mythology of the Celtic People* (Bracken Books reprint 1997)

Iain Zaczek *Chronicle of the Celts* (Collins and Brown 1996)

Frank Delaney *The Celts* (Harper Collins 1993)

Christiane Eluere *The Celts: First Masters of Europe* (Thames and Hudson – New Horizons 1996)

Mike Dixon-Kennedy *Celtic Myth and Legend* (Blandford 1996)

Lloyd and Jennifer Laing *The Origins of Britain* (Paladin 1987)

T. B. Pugh (editor) *Glamorgan County History Volume III The Middle Ages* (University of Wales Press 1971)

Gwyn A. Williams *Welsh Wizard and British Empire: Dr John Dee and a Welsh Identity* (University College Cardiff Press 1980 pamphlet)

Gerald Morgan *The Dragon's Tongue* (Triskel Press 1966)

Welsh Arts Council *Architecture in Wales 1780-1914.*

Adrian Gilbert, Alan Wilson and Baram Blackett *The Holy Kingdom: The Quest for the Real King Arthur* (Bantam Press 1998)

Carl Lofmarch *A History of the Red Dragon* (Gwasg Carreg Gwalch 1995)

Thomas Pennant, abridged by David Kirk *A Tour in Wales* (Gwasg Carreg Gwalch 1998, commemorating the first edition of 1778)

Other books by Terry Breverton

An A-Z of Wales and the Welsh (Christopher Davies) 2000, 296pp

The Book of Welsh Saints (Glyndŵr Publishing) 2000, 606pp hardback

The Secret Vale of Glamorgan (Glyndŵr Publishing) 2000, 230pp (Millennium Award)

100 Great Welshmen (Glyndŵr Publishing) 2001, 376pp (Welsh Books Council Book of the Month)

100 Great Welsh Women, 304pp (Glyndŵr Publishing) 2001

The Welsh Almanac (Glyndŵr Publishing) 2002, 320pp hardback (Welsh Books Council Book of the Month)

The Path to Inexperience (Glyndŵr Publishing) 2002, 160pp

Glamorgan Seascape Pathways (Glyndŵr Publishing) 2003, 144pp (Arwain Award)

The Book of Welsh Pirates and Buccaneers (Glyndŵr Publishing) 2003, 388pp (Welsh Books Council Book of the Month)

The Pirate Dictionary (Pelican USA) 2004, 192pp

Black Bart Roberts – The Greatest Pirate of Them All (Glyndŵr Publishing) 2004, 208pp

Black Bart Roberts (Pelican USA) 2004, 176pp

The Pirate Handbook – A Dictionary of Pirate Terms and Places (Glyndŵr Publishing) 2004, 288pp (Welsh Books Council Book of the Month)

Admiral Sir Henry Morgan – King of the Buccaneers (Pelican USA) 2005, 128pp

Admiral Sir Henry Morgan – The Greatest Buccaneer of Them All (Glyndŵr Publishing) 2005, 174pp (Welsh Books Council Book of the Month)

100 Great Welshmen (new edition) (Glyndŵr Publishing) 2005, 432pp

Welsh Sailors of the Second World War (with Phil Carradice) (Glyndŵr Publishing) 2007, 432pp (W.H. Smith Book of the Month in Wales Award)

The First American Novel: The Journal of Penrose, Seaman and a Life of William Williams (Glyndŵr Publishing) 2007 432pp

The Illustrated Pirate Diaries – A Remarkable Eyewitness Account of Captain Morgan and the Buccaneers (Harper Collins US & Apple UK) 2008, 192pp

Immortal Words (Quercus) 2009, 390pp

Breverton's Nautical Curiousities: The Book of the Sea (Quercus) 2010, 390pp

Immortal Last Words (Quercus) 2010, 390pp